Merchandising of Fashion Products

Doris H. Kincade

*Department of Apparel, Housing,
and Resource Management
Virginia Tech*

Fay Y. Gibson

*Department of Textiles and Apparel,
Technology and Management
North Carolina State University*

Prentice Hall
Upper Saddle River, New Jersey
Columbus, Ohio

This book is dedicated to our husbands. We thank them for their unending patience and love. With the support of these two wonderful men, this book became possible.

Library of Congress Cataloging-in-Publication Data
Kincade, Doris H.
 Merchandising of fashion products / Doris H. Kincade, Fay Y. Gibson.
 p. cm.
 Includes bibliographical references and index.
 ISBN-13: 978-0-13-173125-7 (pbk.)
 ISBN-l0: 0-13-173125-4 (pbk.)
 1. Fashion merchandising. I. Gibson, Fay Y. II. Title.
HD9940.A2K56 2010
687.068'8—dc22 2008053016

Editor in Chief: Vernon Anthony
Acquisitions Editor: Jill Jones-Renger
Editorial Assistant: Doug Greive
Project Manager: Alicia Ritchey
AV Project Manager: Janet Portisch
Operations Specialist: Deidra Schwartz
Art Director Interior: Diane Ernsberger
Art Director Cover: Jayne Conte

Cover Designer: Margaret Kenselaar
Cover Image: Getty Images
Director of Marketing: David Gesell
Campaign Marketing Manager: Leigh Ann Sims
Curriculum Marketing Manager: Thomas Hayward
Marketing Assistant: Les Roberts
Full Service Vendor: Thistle Hill Publishing Services, LLC

This book was set in New Century Schoolbook by S4Carlisle Publishing Services and was printed and bound by R.R. Donnelley & Sons Company. The cover was printed by R.R. Donnelley & Sons Company.

Pearson Education Ltd., London
Pearson Education Singapore Pte. Ltd.
Pearson Education Canada, Inc.
Pearson Education—Japan

Pearson Education Australia Pty. Limited
Pearson Education North Asia Ltd., Hong Kong
Pearson Educación de Mexico, S.A. de C.V.
Pearson Education Malaysia Pte. Ltd.

Prentice Hall
is an imprint of

www.pearsonhighered.com

10 9 8 7 6 5 4 3 2 1
ISBN-13: 978-0-13-173125-7
ISBN-10: 0-13-173125-4

Contents

Preface

In the global and integrated world of merchandising, divisions among industry segments and stand-alone merchandising activities have become obsolete for many firms. Instead, the divisions are almost seamless for many companies, and the activities are integrated and partnered. This book elucidates a comprehensive view of merchandising in this new global and seamless world from strategic planning, to product concept development (product creation) and line development and management (product preparation), through a buyer's preparation and shopping of the market weeks, to product delivery and presentation to the final consumer. For example, a large retail firm is "delivering a product" when it presents merchandise and displays products to consumers in the retail stores, but this same firm is "creating a product" when the merchandisers at the firm contract with current designers for private label product development.

The book provides a new, fresh, and comprehensive approach to the study of merchandising, an approach that links both manufacturing and retailing to the consumer through the merchandising process. More specifically, it addresses merchandising in the newly reconfigured consumer-driven marketplace and defines the product strategy needed for employees to function successfully in today's global environment.

The book is based on the work experiences, research, and industry study of the two authors. Both authors have owned their own retail businesses, and between the two authors, they have work experience in every segment of the fashion product business. Their current research and consulting experiences help them provide this new approach to merchandising while maintaining a solid foundation in the basic activities that must be done to provide the right product to the right consumer. In addition, the authors have taught in merchandising programs with an extremely high rate of placement for their students in every aspect of the fashion product pipeline. From this wealth of experience, the book contains current but company-neutral examples, illustrations, and other supporting materials, applicable to all areas of merchandising.

A traditional, functional, and narrow approach to merchandising is no longer applicable in the global and consumer-centric fashion world. With a managerial focus on the consumer-centric environment, this book begins with an explanation of the basic tools of merchandising that are used at each level of the industry pipeline. It proceeds to a thorough examination of merchandising activities within product development with consideration for the follow-through of distribution and concludes with extensive coverage of the retail activities of planning, buying, and selling merchandise. The book is filled with processes, procedures, and industry-specific flowcharts, drawings, pictures, and other supportive information.

Acknowledgments

The authors would like to express their appreciation to the following individuals, businesses, and organizations that significantly contributed to *Merchandising of Fashion Products*:

Betsee Isenberg, Owner	*10 eleven Showroom*
Teresa McGee, Sales Executive	*Altizer Company*
Don Scott, III, CEO, Vice President Sales	*The AmeriTech Group, USA, Inc. EarthSpun*
Pamela York Frasier	*The Asiel Snow House*
Jane Niemi, Vice President of Demand Generation	*Carhartt Inc.*
Lindy Bleau, PR/Communications Specialist	
Michael Cohen, Owner	*Cohen Showroom Inc.*
Fiorella Canedo, Showroom Manager	
Kim Kitchings, Senior Director, Global Product Supply Chain	*Cotton Incorporated*
Genessa Fratto, Manager, Supply Chain Planning, Global Product Supply Chain	
John Morgans, Senior Director, Administration	
Sandra F. Emrich, Senior Coordinator, Intellectual Property & Contracts	
Kellye D. Haskin, Licensing Specialist, Corporate Brand Licensing	*Deere & Company*
Gary F. Simmons, President and CEO	*Gerber Childrenswear LLC*
Donna De Boer, Vice President of Merchandising	
Allen E. Gant, Jr., President and CEO	*Glen Raven, Inc.*
Jane Greene, Executive Assistant	
Sally Kay, President and CEO	*The Hosiery Association*
Jenna Sheldon, Executive Assistant	
Jim Althaus, Vice President Sales & Merchandising Special Market Brands	*Jockey International, Inc.*
Michelle Tomlinson, Manager, Merchandising Special Market Brands	
Kelly L. Williams Esq., Senior Attorney	

Casey Rosette, Product & Marketing
Specialist

Karen Kane, Designer and Owner *Karen Kane*

Meg Weddle, Owner *Meg's*

Marshal Cohen, Chief Industry Analyst *The NPD Group, Inc.*

Beth Boyle, Senior Public Relations
Manager

Lisa Grimes, Corporate Marketing

Bill Griffin, Engineer *Snowville Volunteer Fire
Department*

Karen Davis, Manager, *[TC]²*
Administrative Support

Carolyn Egan, Senior Editor, *Tobē*
The Tobē Report

Kay Lambeth, Showroom Manager *Tomlinson Erwin-Lambeth
Directional*

Rose DePalma, Assistant Account *Two by Four Marketing*
Executive

Paul Mason, Director Corporate *VF Corporation*
Communications

Edyie Brooks-Bryant, Marketing
Manager Country Music, Licensing,
Public Relations, VF Jeanswear

Marisa Grimshaw, Public Relations
Coordinator, 7 For All Mankind

Nancy White, Manager of
Marketing Services, Lee® Jeans

Anna Sandelli, Intern

Steven A. Jesseph, Vice Chairman, *WRAP*
President and CEO

Avedis H. Seferian Esq., Director
of Compliance Administration

Other contributors that we would like to recognize include the following:

Jenny Faulkner, Director Community *Alamance-Burlington School
Relations* *System*

Amy Herriot, Fashion Director & *AmericasMart®*
Tradeshow Sales

Tara Tuschinski, Public Relations
Specialist

Catherine Morsell, Executive Director *International Textile Market Association, ITMA Educational Foundation*

Kelly Griffin, Publicity Specialist *Panorama Public Relations*

Judi L. Helsing *JLH Photography*

Ellen Rohde, Consultant and former *VF Corporation*
Vice President Brand Planning

And, a special thank you goes to the following individuals at Virginia Tech and the College of Textiles in North Carolina State University (NCSU):

LuAnn Gaskill, Professor *Department of Apparel, Housing,*
and Department Head *and Resource Management, College of Liberal Arts and Human Sciences, Virginia Tech*

Peggy Quesenberry, Trainer/
Instructor II

Janet Wimmer, Laboratory Specialist

The Rosemont Team: *AHRM4264 Merchandising*
 Brooke Carrico *Strategies Department of*
 Katie Keene *Apparel, Housing, and Resource*
 Kalyn James *Management, College of Liberal*
 Ashley Loudin *Arts and Human Sciences,*
 Rachel Parks *Virginia Tech*
 Brittney Simmons

Nancy Cassill, Professor & *Department of Textile & Apparel,*
Department Chair *Technology & Management, College of Textiles, NCSU*

Cynthia Istook, Associate Professor

Marguerite Moore, Associate Professor

Lisa Chapman-Parillo, Lecturer

The Hot Pink Team: *TAM 384 Visual Merchandising*
 Sarah Giovannini *Department of Textiles &*
 Mark John Keen *Apparel, Technology &*
 Stacey Piner *Management, College of Textiles,*
 Mary Prak *NCSU*
 Melissa Scutt

The Over the Moon Team:
 Lauren Hilgers
 Julie Mischinski
 Weatherly Rose
 Leigh Wilbourne

Roger Barker, Professor & Director *Department of Textile*
T-PACC *Engineering & Chemistry*
Gail Liston, Research Assistant *Science, College of Textiles,*
 NCSU

Kent Hester, Director of Student & *College of Textiles, NCSU*
Career Services

Emily Parker, Director, College *College of Textiles, NCSU*
Relations

Cindy Sears, Director *Trademark Licensing-RMIS,*
 NCSU

We would also like to thank our reviewers: Erin Parrish, East Carolina University; Darlene Kness, University of Central Oklahoma; V. Ann Paulins, Ohio University; Tana Stufflebean, University of Central Oklahoma; Lorynn Divita, Baylor University; and Jane Walker, North Carolina A&T State University.

SECTION

I

An Integrated and Customer-Centered Approach to Merchandising in the FTAR Complex

The fiber/textile/apparel/retail complex, or FTAR Complex, is a unique system of companies producing raw materials that are cut and sewn into apparel and other sewn products, which are usually sold through a retailer to a final consumer. Companies working within the FTAR Complex carry out many types of processes, ranging from compound chemical formulations for man-made fiber production to the intricate and labor-intensive production of a beaded bridal gown. Throughout the development and production of products in the industry, the merchandising function is a critical process in all links of the FTAR Supply Chain. This function is represented in divisions, departments, teams, and individuals in all companies throughout the FTAR Complex. Focusing on the consumer, merchandisers must perform an integration of tasks and skills to bring the product to market.

Merchandising divisions or other organizational structures and personnel across all levels of the FTAR Complex drive product creation, development, and presentation (see Figure S1.1). Merchandisers, employees working in the merchandise divisions, must be creative, yet organized and detail oriented, and they must be bottom line or business oriented, as well as willing to take calculated risks. They must be inquisitive, visualize the future, and adapt the creative concept to meet both the needs and desires of the company image and their company's target consumer. Additionally, these individuals must enjoy

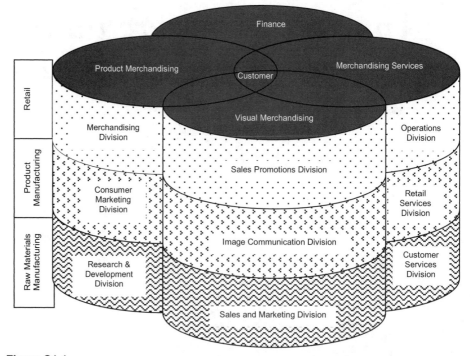

Figure S1.1
An integrated and customer-centered approach to merchandising along the FTAR Supply Chain.

research, travel, the arts and entertainment worlds, and interfacing with the ultimate consumer. These employees play a major role in the success of both the end product and the profitability of the company.

In the global and integrated world of merchandising, separations among industry segments and stand-alone merchandising activities have become obsolete for many firms. Instead, the divisions are almost seamlessly integrated for many companies and the activities are partnered with their suppliers and customers. This book elucidates a comprehensive view of merchandising in this new global and seamless world from strategic planning, to product concept development (product creation) and line development and management (product preparation), through a buyer's preparation and shopping of the market weeks, to product delivery and presentation to the final consumer. For example, a large retail firm is "delivering a product" when it presents merchandise and displays products to consumers in the retail stores, but this same firm is "creating a product" when the merchandisers at the firm contract with current designers for private label product development.

Throughout Chapters 1 and 2, the many types of merchandising in the modern-day FTAR Complex are defined and explained, and related to how companies do business in the new millennium. In Chapter 1, the three major components or functions of merchandising—product merchandising, visual merchandising, and merchandising services—in the major levels of the FTAR Supply Chain are defined and discussed in relation to their organizational locations within specific divisions of FTAR companies. In a customer-centered organization, these functions work together to develop and deliver a product that is right for the consumer and right for the companies that manufacture and sell these products. The goal of every customer-centered firm is to create products that meet the needs of customers and provide profitability for the company.

In Chapter 2, the business operations of a typical FTAR company are explained, including the planning processes that are vital to the development and delivery of the merchandise within each seasonal product line. Planning first exists on the corporate level where executive decisions are made and guidance, such as a mission statement, sales goals and budget amounts, is given to the company divisions for the development and production of product lines. Second, in the planning process, target markets are researched, identified, and analyzed, so the right product can be developed for the consumers in these markets. Third, directives are given to guide the development of product styles and brand images that are identified and developed.

1

Merchandising Defined within the FTAR Complex

Objectives

After completing this chapter, the student will be able to

- Identify the various levels in the FTAR Supply Chain and explain their significance to the pipeline
- Discuss the history of the FTAR Supply Chain and the changing business orientations
- Itemize the uniqueness of the Textile Products in the FTAR Supply Chain
- Identify the organizational structures for firms in the FTAR Supply Chain
- Explain the business orientation (consumerization) of today's FTAR Supply Chain
- Define the types of merchandising at the raw materials, textile production, apparel production, and retail segments of the FTAR Supply Chain
- Explain the relationship of corporate organizational structures to the marketing and merchandising functions within the firms
- Compare and contrast the functions of merchandising in retail, apparel/home furnishings, and raw materials (fiber, yarn, textile) supply firms

Introduction

The **fiber/textile/apparel/retail (FTAR) Complex,** coined the **FTAR Supply Chain** in industry terminology, is a unique and exciting business complex. This supply chain is a **pipeline** of producers and distributors that are changing raw materials into end products and distributing them through various means to consumers (see Figure 1.1). The **supply chain** begins with the raw materials producers, or the fiber and yarn manufacturers and textile mills, supplying product for the product manufacturing firms, which produce end products sold by retailers—either under the manufacturer's brand or as store brands and private label goods. Although the retailer is the final level in the FTAR Supply Chain, the consumer or the ultimate customer has the final say about the product when he or she makes the decision to purchase that product.

Each link in this supply chain does business with its corresponding partners and depends on the other links for all business functions or activities, including profit, and, to a large extent, even survival. For example, the apparel manufacturer buys fabric from the fabric manufacturer, or its **vendor,** or **supplier.** The apparel manufacturer is a vendor for the retailer. The retailer is the **customer** of, or the link that received the products from, the apparel manufacturer. Some links in the chain call the customer their **client,** thereby expressing a professional aspect to the transactions. In this reciprocal action, each link is both a vendor and a customer, with the final customer the **consumer** who buys the products for his or her personal use or for the use of family or friends. Constant and often daily changes in the world create excitement within this industry.

For tax and other government purposes, members of the U.S. FTAR Supply Chain are itemized within U.S. federal codes. The **Standard Industrial Classification** or, as it is more commonly called, the SIC code, was developed in the 1930s to classify all products and services produced in the United States. In 1997, the SIC code was replaced by the **North American Industry Classification System,** or the NAICS code, to reflect the globalization of

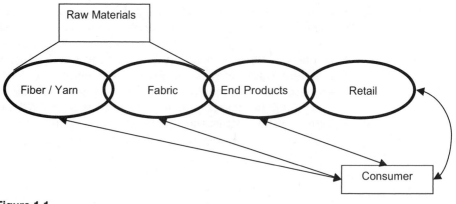

Figure 1.1
Fiber/Textile/Apparel/Retail (FTAR) Supply Chain.

manufacturing and the ever-widening array of products and services that are created and offered in the United States and around the world (NAICS, 2001). The code representing most of the FTAR Complex, including the manufacturing processes and products, are NAICS 31 (formerly SIC 22 and 23) (NAICS, 2005). Most cut-and-sew apparel products and knitted apparel products are included in the manufacturing code of NAICS 315, whereas textile mill producers report under NAICS 313. Retail businesses are covered by NAICS 44-45.

FTAR Supply Chain Members

As shown in Figure 1.1, five major links or segments are represented in the FTAR Supply Chain. The first four segments are the fiber producers, the fabric producers, the end product manufacturers, and the retailers. The chain concludes with the consumer segment, or those customers who purchase products from retailers.

Fiber producers are the most basic raw material producers and a critical business component to all other links in the industry. There are two types of fiber producers: natural and man-made. **Natural fiber suppliers** include farmers, ranchers, silk producers, and any other producers who furnish natural fibers. Natural fibers include cotton, wool, silk, flax, linen, and many other specialty fibers, such as hemp, cashmere, and rubber. These fibers can be used directly from the fiber producers or sent to yarn manufacturers to create yarns (see Figures 1.2a, 1.2b, and 1.2c) to sell to the textile mills. Most **man-made fiber producers,** also known as **synthetic fiber producers,** use petrochemicals to manufacture fibers. Although rayon and acetate are made by treating the natural material (e.g., cellulose) with chemicals, many times these fibers are classified as man-made. Newer man-made fibers may be made from glass, corn, or other products.

Textile mills produce **fabrics** for the final apparel products by using the construction techniques of weaving, knitting, or bonding to interlock yarns to produce woven, knitted, or nonwoven materials. One of these three processes account for the majority of the materials used in the manufacturing of the final product. These producers manufacture fabrics or other **textile products** for home furnishings manufacturers, the automotive industry, and other industrial and medical uses. Fabrics are found in tiny heart valves used in cardiac surgery and in massive road beds used to underlie extensive highway systems. Textile mills sell their products to apparel and other manufacturers, to retailers that are having private label and/or private brand goods produced, and to retailers selling fabrics directly to the ultimate consumer. Converters and jobbers are also clients of textile mills (see Figures 1.3a and 1.3b). A **converter** is a company that buys **greige (gray) goods,** uncolored and unfinished materials, and has the goods dyed, sometimes printed, and then finished to sell these colored fabrics to apparel and/or home furnishings manufacturers. Textile **jobbers** buy fabrics directly from textile mills, converters, and manufacturers and then resell the fabrics to a variety of clients. The fiber suppliers and producers and textile manufacturers are collectively known as **raw materials producers.**

(a)

(b)

(c)

Figure 1.2
Raw materials: (a) yarn plant, (b) open bale of cotton, and (c) cotton yarn preparation.

Apparel manufacturing companies or **apparel manufacturers** and re-
tailers as well as other product manufacturing companies purchase fabrics from
textile mills, converters, and jobbers to produce end products for purchase by the
retailer and/or ultimate target consumer. These **end products** include diverse
items from apparel, including clothing, accessories, and shoes; to home furnish-
ings, including bedding and bath, upholstery fabrics, window treatments, and

(b)

(a)

Figure 1.3
Fabric: (a) textile plant and (b) loom.

carpet and floor coverings; to automotive components, including headliners and carpets; and to industrial and medical materials, including surgical garments, vascular tubing, and absorbable thread. Consumer products made primarily from fabrics are sometimes called **soft goods** or **sewn products.** Many of these products are fashion items; therefore, the products change with climatic or seasonal influences as well as with changes in consumer demand, thus creating added sales, taxes, and employee salaries for the entire complex and global economy.

Among these manufacturing companies are the **manufacturers** that own manufacturing plants for sewing and own support facilities either at the plant or in other locations to provide the pattern- and marker-making work and to cut the fabric. Some of these manufacturers are well known for the brands used for selling their products. Others are less familiar to the general public. Traditionally in the United States, these plants were either located in New York and other major cities with large immigrant populations or in the rural South where working in the plants supplemented incomes for farm families. Many of these rural plants are still standing in small U.S. towns and may be used for niche manufacturing or alternative business purposes (see Figures 1.4a and 1.4b).

In addition to the manufacturer in this tier of the FTAR Complex, numerous **contractors** do portions of the production process. Contractors have primarily been cut-and-sew operations that make the items designed by other companies. Today, contractors do some of the preproduction work, such as fabric design, pattern making, and marker making. Jobbers also exist in this tier of the industry. They do not own production facilities but manage the work of companies that do own production capacity. Finally, there are major **brand companies** who have traditionally been classified as manufacturers; however, most of these companies no longer own domestic production facilities. They do own the brand, the design, and the distribution processes. Nike is an example of a brand company that does not own manufacturing facilities. Independent contractors make their entire product line. Many people in the industry continue to call these companies manufacturers even though they own no production equipment and are primarily marketers of products.

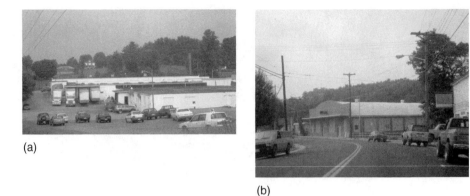

(a)

(b)

Figure 1.4
Apparel manufacturing operations: (a) fabric cutter and (b) sewing plant.

In the FTAR Complex there are some **wholesalers** that act as the middleman between the apparel and home furnishings companies and the retailers. Wholesalers buy product in bulk from one or more manufacturing companies and resell the product to one or more retailers.

The **retailer,** the final link between the producers of products and the ultimate consumer, is sometimes called the "big boss." Its position in the FTAR Supply Chain brings with it the responsibility of procuring products at wholesale from the product producers and selling at retail to the target consumer. These firms include the traditional retail stores in downtown, mall, and other shopping locations, and a myriad of other store and nonstore formats for selling products directly to the consumer. The corporate offices of major retailers are often not located near retail stores and may be in major cities, in office parks, or in small towns important to their owners (see Figure 1.5).

For companies in the FTAR Complex to do business and be profitable, other **auxiliary firms** are needed to supply various equipment, services, and information. Some of these establishments include textile machinery companies, fixturing companies, textile testing labs, and chemical companies as well as financial organizations (e.g., banks and factoring firms). Thread, trim, fastener and other findings suppliers provide items for completing the design concept and are major contributors to the success of the textile industry. In addition, research and marketing firms and advertising, publishing, and packaging and labeling companies play major roles in providing services to the various industry levels. For example, Cotton Incorporated conducts research on the entire FTAR Complex for the use of cotton (see Figure 1.6). Other organizations that provide information and assistance are trade associations and trade publications.

In the current business environment, this unique pipeline is impacted by both globalization of the industry and the direction and rate of fashion change, and it is driven by consumer wants, needs, desires, and demands. Consumer buying patterns and spending behavior frequently determine what is offered in today's marketplace. For example, newly adapted trade legislation, such as the elimination of quota on imported products in January 2005, the opening of new regions or geographic areas for sourcing product or newly developed technological

Figure 1.5
Goody's corporate headquarters.

Figure 1.6
Cotton Incorporated headquarters.

advancements, and major shifts in demographics and the fashion scene can create changes of organizations or operations in the supply chain that remain in place far into the future of the industry. All of these factors impact not only the U.S. economy but also the global economy and create employment for individuals throughout the world, often in developing countries or countries with resources and expertise to produce specific product classifications at high quality levels and at a low cost within specified lead times.

Brief History of the FTAR Industry and Its Changing Business Orientation

For decades, firms that compose the FTAR Complex have been and continuously remain in a constant state of change to compete with and be profitable in both the domestic and global marketplaces. For example, during the decade of the 1950s, textile mills or those companies making fabrics in the United States, England, and Europe controlled the direction of the complex through the research, development, and distribution of fabrications (see Figure 1.7). The apparel and home furnishings manufacturers were at the mercy of the textile firms as to availability of new fabrications and delivery times of product. This was the **production driven** era for the FTAR Complex.

In the decade of the 1960s, U.S. apparel manufacturing companies held the reins on the industry while maintaining a **product driven** industry fueled by brands and designer labels. Possibly because of this state, the decade of the 1970s became known as the **decade of imports.** Designers from several European countries gained international recognition for their products. In addition, countries with low wages began to produce *knockoffs*, or copies of these branded products, and imported them into the United States and other countries with high manufacturing wages. Although many of these early imports had neither the quality of nor the cost-saving advantage over the domestic product that the retailer expected, this phenomenon continued to gain

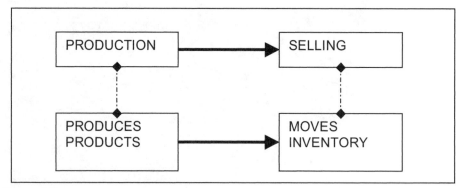

Figure 1.7
Production orientation for an FTAR company.

momentum during the next several decades. In today's market, imports have taken a position as one of the major factors impacting the entire FTAR pipeline.

The decade of the 1980s became known as the **era of the retailer**. During this decade, many retailers established product development/private label divisions within their retail establishments to develop their own private labels and/or private brands (see Figure 1.8). These retailers used these private labels and brands to position themselves in the market and to differentiate from their competition. Retailers used major marketing campaigns to promote these private label brands and, by association, the retail companies to consumers. However, many times these private label products were not a solution to the retailer's problems. Even though these labels provided a less expensive product alternative for the consumer as compared to the national brands, the private label merchandise did not offer the quality or fashion level of their national brand counterparts. For this reason many consumers today still have a distasteful perception of private labels.

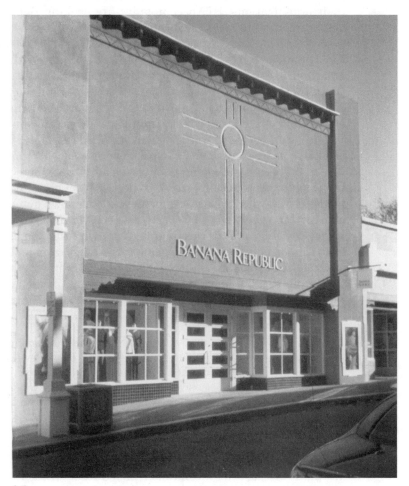

Figure 1.8
Banana Republic in Santa Fe, New Mexico.

During and since the 1990s, the consumer has been the "king" or "queen" in the marketplace for many countries. Even though the era of advanced technology in the textile industry was introduced during the mid-1980s and early 1990s, the consumer is now "driving" the global marketplace with this technology aiding the industry in meeting the desires and needs of the target consumer. The shift from the manufacturing or product-driven market of previous decades through the marketing orientation to the **consumer-driven** concept in the FTAR Complex in the 1990s caused drastic changes within the complex. All links in the chain were forced to focus on consumer wants and needs to be successful. Today, consumers are making the decisions that shape the marketplace. Thus the product must deliver a value system that creates and delivers satisfaction to the ultimate consumer.

The decade of the 2000s is marked by dramatic changes in the U.S. FTAR Complex as companies again reorient their businesses to be *rightsized* and to have a **consumer-focused** orientation. In adjusting the size and operations of their organizations, FTAR companies are seeking the perfect business focus and orientation to meet the needs of the **technology-driven consumer.** Now more than ever this consumer demands the right product at the right price. The right product changes quickly for many consumers. With their fast-paced lives and their use of technologies to go anywhere and to view everything in an instant, these consumers use technology to see new products, compare prices and features, and to bring the world to them. The FTAR firm in the 2000s must be agile—able to produce products quickly and cost efficiently.

Once seen as the world leader in fabrications, major U.S. textile mills went bankrupt, merged with the competition, or sold off profitable divisions. In the United States, large shopping complexes now exist where giant textile mills once stood, and other textile company properties have been imploded to make way for progress. Many U.S. apparel companies no longer own manufacturing plants in the United States; instead, they source product worldwide. Many small fiber, textile, and/or apparel manufacturers and contracting companies in the United States have closed their doors; major home furnishings companies have gone bankrupt or rightsized by selling off or closing divisions. Similar shifts in power within the marketplace are found in many European and some Asian countries. James M. Borneman, Editor in Chief of *Textile World*, in his article "US Textiles' New Reality" (2005), described the changing strategic shifts of the state of the industry:

> Within the United States, a tangible movement away from low-cost-producer strategies toward lower-volume, higher-margin businesses is altering the focus of capital investment. Efficiency and productivity are givens—the search is on for flexibility, market responsiveness and any process or product development that presents opportunity. Global investment is taking place and is transforming some U.S. firms' manufacturing footprints. (p. 10)

The downsizing and closing of textile and apparel manufacturing firms in the United States, the European Union, Japan, and South Korea is mirrored by the dramatic increase in the number of manufacturing firms opening in South and Central America, China, India, other Asian countries, Africa, and other

emerging countries. For example, companies in South Korea and Hong Kong were manufacturing low-cost products but with rising labor rates, these companies converted their product offerings to high-fashion, high-quality, and high-cost products while other companies relocated to neighboring countries with an abundance of low-wage labor to produce lower cost products. Companies from the United States, some European countries, and other postindustrial countries have relocated their plants to these emerging countries, and governments and business in these countries have started firms with domestic personnel and resources. Management in companies should look for countries that have manufacturing facilities and product offerings to match their required assortments. For example, a company preparing and selling high price point towels may use factories in Egypt for utilizing the high-quality Pima cotton available there and the producers who use that cotton in their products. Other companies may choose to select countries and manufacturers based solely on labor wage rates.

Additionally, domestic retailers in many countries find themselves facing the same problems or situations as their textile counterparts. Because of mergers, consolidations, bankruptcies, closings, and rightsizings, many small independently owned retailers are no longer seen in retail landscapes. By the middle of the 2000s, in the United States, Kmart Holding Corporation acquired Sears, Roebuck & Company, Federated Department Stores acquired May Department Stores and other small retailers, and Sak's Inc. has reorganized constantly since being acquired by Proffitt's. In fact, a number of the Proffitt's and McRae's store locations, owned by Sak's, were acquired by Belk Inc., the largest family-owned department store in the United States (Byron & Agins, 2005). Federated Department Stores is now Macy's, Inc., the biggest retail holding company for various apparel retailers. Moreover, Walmart stores can be found in and compete with local, regional, and national retailers in almost every country in the world. Many financial sources speak about the overstoring of retail, indicating there is more square footage in retail stores than people to shop in those spaces. Some retailers remain as privately owned companies. For example, Belk is the largest family-owned department store in the United States (see Figure 1.9).

All of these mergers and consolidations, buyouts, bankruptcies, closures, and rightsizings have changed the face of the FTAR Complex. There are fewer vendors (e.g., yarn and textile mills, apparel and home furnishings manufacturers) from which retailers may procure product as well as fewer retailers for clients of the apparel and home furnishings firms. Thus retailers are now wielding more power in the supply chain and demanding more value-added components in each step of the production stage from their suppliers. This new scenario demands more innovative business procedures for all links in the supply chain. One solution adapted by many U.S. firms is that of reorganizing the organizational structure of the company to reflect a consumer-focused company as opposed to the traditional production-oriented company. In addition to the structural reorganization in these companies, specific activities or business functions, such as marketing, merchandising, product development, sourcing, purchasing, and forecasting, have been realigned to fit into this new business environment.

Figure 1.9
Hudson Belk is a family-owned retailer.

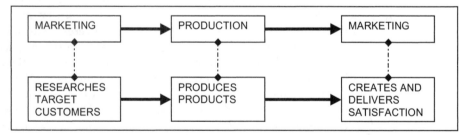

Figure 1.10
Consumer orientation for an FTAR company.

The business concept of the new environment in the 2000s is consumer oriented with a marketing focusing on the needs and desires of the consumer rather than previous orientations focusing on production processes or products generated from the capabilities of the production facility instead of the demands of the consumers (see Figure 1.10). Thus apparel manufacturers and retail firms have been forced to adapt or change business operations, functions, and practices to survive in this new environment. They have had to revert from focusing on processes, raw materials, and equipment to examining the market and the consumers shopping in the market. Impacting this significant change

is the fact that the marketing of textile products, especially fashion products, is different from the marketing of other products. As previously discussed, this changing environment has created new definitions for traditional apparel manufacturing and retail terminology and has demanded a revised or fresh, innovative reorganization of business functions and procedures as well as newly defined roles for employees within these companies.

Uniqueness of Textile Products

The marketing of textile products, specifically fashion products, and their patterns of distribution must be treated differently than other products. **Fashion products** are the selection of merchandise as accepted at a point in time by the target consumer. This selection changes with emerging trends, seasonality, and consumer preferences to reflect an almost continuous change in assortments. Unlike many other industries, one of the most important single selling forces in the FTAR business environment is the force of fashion, which affects products from apparel to home furnishings to automobiles to plumbing fixtures and even paints. The **force of fashion** is a collection of influences, events, and other societal pressures that impact product creation and the consumer's purchases of those products. Fashion implies change and change creates desire and demand for new products (see Figure 1.11). One of the forces that change fashion products is seasonal change or changes in climate.

Fashion change, both in direction and rate, are related to the force of fashion and have a great impact on the sales volume of the apparel company and the retailer, which impacts the business of the other links in the supply chain. With consumer boredom and other forces of fashion, continuous marketing of innovative trends and new items and product categories is necessary to the successful acceptance and sale of fashion products. Change is also caused by competition from companies within a link in the supply chain and other companies in other links within the supply chain. The **influence of competition** is a strong force and creates another unique aspect of the FTAR Complex.

The **importance of price** also impacts the marketing of fashion products. With an overabundance of malls, shopping centers, retail stores, and other places to buy products, the consumer has a choice of not only a variety of products for a specific end use but also the selection of many price points from which to buy that product. Of course, good marketing can create demand and thus boost price for products that are in higher demand by the consumer; and some fashion products are just more price sensitive than others. In contrast, manufacturers, when introducing new trend products, think in terms of consumer acceptance of the innovative product rather than consumer demand. To gain and/or retain consumer acceptance, many times prices are adjusted to assure a substantial sales volume or to assure success of the product. This scenario depicts the "high cost of fame" that confronts the producer of fashion products.

Another unique factor in the marketing of textile fashion products is the channels of distribution. Fashion products are sold through various **channels**

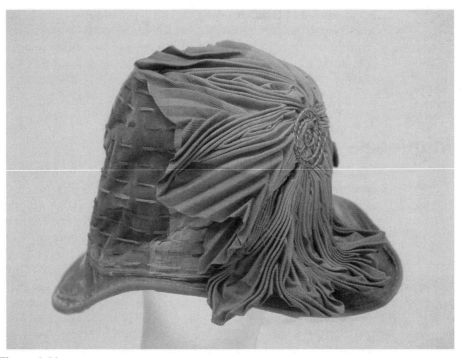

Figure 1.11
Fashion and its associated changes can be a powerful force on product demand.
(Courtesy of Oris Glisson Historic Costume and Textile Collection, Department of Apparel, Housing, and Resource Management, Virginia Tech.)

of distribution (i.e., specialty stores, department stores, chain stores, mass merchants, discount and value stores, Internet, and kiosks) and in various levels within those channels of distribution. Within each channel, the distribution of end products can be restricted or open based on availability of production, product classification, and price points of the product category. Apparel and home furnishings companies adhere to various distribution patterns.

Another significant factor that impacts and increases the uniqueness of marketing textile fashion products is the **organizational operations** within firms, including the importance of teamwork and the influence of competitors and suppliers. Unlike other industries where the manufacturer gives final form to the product and packages and distributes it to all of its clientele, cooperation from every link in the textile supply chain is mandatory to complete the business activities to produce the final textile product. The influence of competitors and suppliers are critical to the FTAR pipeline. For example, the inspiration for a new product may come from a fiber manufacturer, a trade company, or a retail buyer. Thus profit opportunities and even survival of an FTAR company may come from the auxiliary suppliers of chemicals (e.g., dyestuffs, finishes) and/or textile machinery firms or from other links in the chain such as fiber producers and/or yarn and textile mills.

Lastly, **media power** has a strong and unique influence on marketing of a fashion product. Consumer magazines, such as *Vogue, Ebony, Essence, InStyle, Elle, Seventeen, GQ,* and *Esquire,* market directly to the ultimate consumer, train the "fashion eye" of the general consumer population, and create demand for new trends and innovative fashion items. Newspapers such as the *Wall Street Journal, USA Today,* or the *New York Times,* as well as many local and regional newspapers, carry fashion columns, women's pages, and/or business sections that bring fashion to the heartland and all corners of the United States. For companies in the industry, trade publications such as *Women's Wear Daily (WWD), Daily News Record (DNR), Sportswear International, Earnshaw's* (children's), *Home Furnishings Daily (HFD), INSIGHTS, Lifestyle Monitor™, Footwear News Magazine, Accessories Magazine, Advertising Age, Brandweek, Stores, Chain Store Age,* and *Visual Merchandising and Store Design* provide information on fashion trends and industry developments in fiber, textiles, apparel, home furnishings, and retail (see Figure 1.12). Television, radio, music videos, and the cinema are major sources of fashion information and trends for both the FTAR Complex and the target consumer. Designers, merchandisers, and retailers find inspiration, design ideas, and/or new trends from celebrities, movies, plays, and other cultural and artistic presentations. Designers showcase their latest creations on celebrities who attend award shows

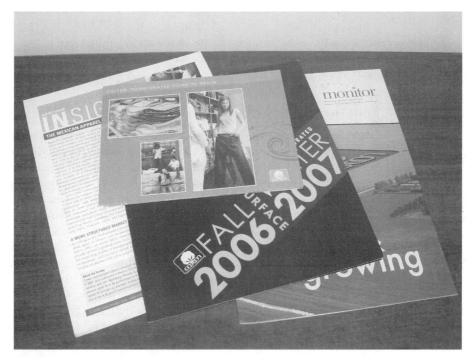

Figure 1.12
Trade media.
(Courtesy of Cotton Incorporated)

such as the Emmy, Tony, or Golden Globe Awards, as well as many industry music award events. Fashion consumers, retailers, producers, and designers all over the world view these fashions simultaneously and create demand for the items within weeks of the events.

Organizational Structure of FTAR Companies

A *company*, or *firm*, is an organization or coalition of individuals (management and employees) who share common company goals and who support and/or reflect the mission statement of the company while implementing the objectives of the strategic plan and maintaining company image, procedures, and policies. Companies should be organized to produce product to meet the needs and desires of the target consumer and to provide a profit so the company may continue to do business, to replenish needed equipment and supplies, and/or to expand the business while paying dividends to its shareholders and compensating employees.

The organizational structure of a company can be depicted as a schematic of the hierarchical relationship of management and company personnel. This schematic signifies in which divisions/departments positions are housed or organizationally located, designates who reports to whom or the relationship of interactions between employees, and shows the roles and responsibilities of the employee as well as the job status of the individual. Placement within the organizational structure affects to whom the employee reports and with whom the employee works, but it does not always indicate where the employee is located geographically.

Functional Organization

Historically, companies in the textile industry had a **functional organization** with specific divisions responsible for executing explicitly defined, assigned business activities (see Figure 1.13). These divisions included an executive management division and the four functional divisions of marketing, merchandising, operations, and finances. Some companies have a fifth function, that of Human Resources (HR). When HR is not a separate function, the activities of hiring, firing, and training are performed by someone in Operations. The structure is also called a linear organizational structure because everyone reports to the person above him or her and the "chain of command" is linear. Employees within the divisions for a company had limited contact with other divisions and were only trained in one specific task; thus they had expertise in only one specific area of the company's activities and functions.

These divisions in companies were managed and operated by top executives within the company. Based on the size of the company and the complexity of product offerings, the executive or top management of the company could include company owner(s), company board of directors, the chief executive officer, the president, the chief operating officer, the chief financial officer, company

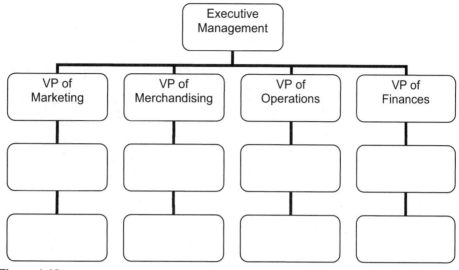

Figure 1.13
Functional organizational structure of an FTAR company.

vice president(s), and the company manager. These executives made all the major decisions for the company. They then communicated these ideas and "commands" down the lines of management from the executive management division to middle management to the employees in the fiber, textile, apparel, or home furnishings plants. This type of management was known as *top-down* management because all major decisions, ideas, and supervision came from top management. This hierarchical organizational structure was accepted by all employees and was the norm of the day. Employees usually followed management's instructions without questioning assigned roles and responsibilities in the company. This type of organizational structure was most prevalent during the span when the production-oriented environment dominated the industry; however, this structure or variations of this organizational structure continue to exist in companies in operation today.

Product Organization

During the product-driven era, companies needed to put more emphasis on specific brands or groups of products to develop the brand image and promote the brand to the customers. The importance of brands, designer labels, and other manifestations of product identity necessitated a change in organizational structure, and the **product organization** was initiated. Managers were installed to supervise all functional areas for a specific product, even though this resulted in duplication of functions and activities across each product area. Figure 1.14 shows the positions that report to the Vice President of Product A. Similar positions would exist to provide the functional tasks needed for each product and would report to one of the vice presidents.

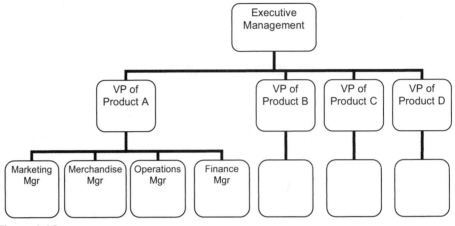

Figure 1.14
Product organizational structure of an FTAR company.

Consumer-Centric Organization

The most recent organizational model of FTAR companies takes into considera-
tion the influences of advanced technology and the better educated, more sophis-
ticated, affluent, well-traveled consumer driving the products in the marketplace.
In today's global environment, many business organizations have been forced to
and/or have found benefits in adopting a business orientation known as con-
sumerization with an appropriate reorganization of the organizational structure.
Consumerization is defined as direct communications with the target customer
to identify the wants and needs of the customer so product can be produced
and value and service can be defined to fulfill the desires and demands of that
consumer. Companies that follow this approach for doing business in today's
competitive environment are known as **customer-** or **consumer-centric com-
panies.** A customer- or consumer-centric company is organized with the major
divisions (i.e., executive management, marketing, merchandising, operations,
and finance) of a traditional company (see Figure 1.15).

The consumer-centric company is based on teamwork within divisions and
across divisions within the apparel/home furnishings firm as well as with sim-
ilar or corresponding divisions within other FTAR companies that compose the
links of the supply chain. Companies using this approach have found benefits,
financial and otherwise, not only for employees within various divisions of the
company to work as teams, sharing information about all aspects of product
creation and production, but also for these same employees to share and col-
laborate with similar divisions in other business links across the pipeline.

No organizational structure is ideal for all companies in the FTAR Complex;
nor is one type best for fiber companies as compared to textile mills or apparel
and home furnishings firms as compared to retail establishments. The company's
organizational structure is many times based on the founders or history of the
company and the industry, product offerings, management's philosophy, and suc-
cessfulness of the company. Additionally, structures change when various new or
innovative business trends or practices are introduced or when research confirms

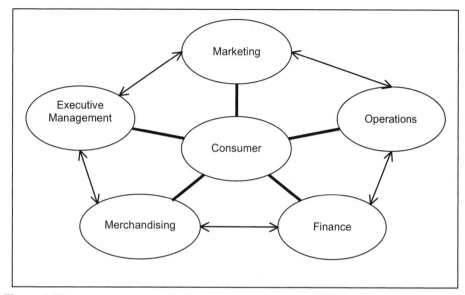

Figure 1.15
Consumer-centric organizational structure for an FTAR company.

the viability of structures for a particular firm or link within the chain. Sometimes the management of a company examines the best practices of several companies and adapts those for the structure of their particular company or divisions. Although no single organizational structure is ideal for all companies within the FTAR Complex, specific divisions, activities, and functions are needed in every company or firm to do business in this global environment. Specific but various organizational structures are found in the current FTAR environment, each with significance to the consumer-centric orientation of the industry.

Overview of Merchandising Activities

Merchandising is an important business process used by all levels in the FTAR Complex to create and/or update product offerings, especially fashion products such as textile, apparel, and home furnishings fabrics and end products, automobiles, and home appliances and plumbing fixtures plus electronics, to name just a few. **Merchandising** is all business activities utilized to create, prepare, deliver and market merchandise assortments and classifications to meet the demands of the target customer while reflecting the company image. Merchandise assortments and classifications are terms used to describe, characterize, and organize the products sold in the FTAR Complex.

The three major components of merchandising are product merchandising, visual merchandising, and merchandising services (see Table 1.1). These three components cover the major organizational functions of a company. Product merchandising is the component that deals most directly with the development of the product within the supply chain. Visual merchandising activities are

Table 1.1

Divisions containing merchandising functions across organizational structure and FTAR levels.

Organizational Functions	Marketing	Merchandising	Operations	Finance
Merchandising Components / FTAR Level	Visual Merchandising	Product Merchandising	Merchandising Services	Finance
Retail	Sales Promotion →	Merchandising →	Operations →	Financial Control
Product	Image Communications →	Consumer Marketing →	Retail Services →	Finance
Raw Materials	Sales & Marketing →	Research & Development →	Customer Services →	Credit or Financial Control

used to promote the sale of the product at retail, manufacturing, and raw materials establishments. Merchandising services covers the activities of providing assistance to the customers that handle the product, in all links of the FTAR Chain. Closely related to this division are the control activities of credit and billing that are organizationally housed in finance but often handled by personnel in merchandising services.

Although general activities within each component are similar, differences in organizational location and specific activities vary across the FTAR Complex because of incoming materials, types of products, production processes, and position in the supply chain. For example, the fiber companies purchase chemicals as their raw materials and produce fibers that can vary in color, composition, and surface, which can be made into a multitude of fabrics by their customers. Meanwhile, retail stores purchase finished end products that are sold through customer services to consumers who are end users. Companies at both stages have suppliers and customers to which they promote products and provide services, but the products and services they render can vary dramatically. These differences in supplies, products, customers, and services lead to variances in organizational structure, definition, and activity variations as described in the following sections.

Visual Merchandising: Operational Definitions and Organizational Locations

Visual merchandising is the integration of merchandise presentation and display techniques combined to enhance the sale of a company's merchandise, whether this merchandise is a raw material product, a finished apparel product, or a service provided by the company. At some levels of the pipeline (i.e., retail), visual merchandising is directed primarily to the consumer. At other levels (i.e., raw materials producers and product manufacturers) promotions are directed both to their customer at the subsequent levels of the FTAR pipeline (i.e., trade visual merchandising) and the consumer (i.e., retail visual merchandising). Overall, visual merchandising should stimulate customer

interest in the merchandise, should increase sales by creating a desire and motivation to buy, and should encourage multiple and add-on sales by facilitating ease of consumer selection through the arrangement and presentation of the retail store itself as well as the store's merchandise categories.

RETAIL: VISUAL MERCHANDISING. Retail visual merchandising is the combination of merchandise presentation and display activities done in the retail store, with catalogs, on a Web site, or through popular print and video media to promote the sale of merchandise to consumers. When used as a team, these merchandising components are most effective for creating and maintaining a constant and consistent store image and for ensuring the realization of meeting the planned sales and profit goals of the retailer.

The **Sales Promotion Division** of a retail organization houses the departments of visual merchandising, advertising, special events or promotions, public relations and publicity, fashion coordination, and sometimes sales training. All major functions or activities provided by the Sales Promotion Division support the (Product) Merchandising Division of the retail store. Each department within the Sales Promotion Division is headed by a vice president, director, manager or coordinator, depending on the organizational structure of the company and the size of the retail organization (see Table 1.2).

Many stores consider the roles and activities of visual merchandisers as one of the most important components of merchandising. Effective visual merchandising and creative display techniques may contribute as much as 30% of the retailer's total sale volume (Show and Tell, 2008). Effective visual merchandising is a "silent seller" that teaches the consumer "how to," that trains the "fashion eye," that convinces the customer of the value of the item, that creates impulse and add-on-sales, that provides meaning to lifestyle merchandising, and that substitutes for absent sales personnel.

Visual merchandisers and other personnel in this division are an integral component of the success of the retail store. These employees not only help present and display the retailer's merchandise mix, they also impact other departments within the Sales Promotion Division by supporting and reinforcing the marketing communication efforts of the other departments. Visual merchandising, advertising, special events, fashion coordination, public relations, and sales training are a merchandising team; maximum value can be obtained from each promotional component if they are used together.

PRODUCT MANUFACTURING: VISUAL MERCHANDISING. Visual merchandising at the product manufacturing level of the FTAR Complex involves activities at both trade and retail level. **Visual Merchandising—Trade** is business-to-business (corporate manufacturing to retail merchandiser/buyer) communications. It is a major and necessary merchandising function to assure the success of both the manufacturer and the retailer. Trade activities often occur at the Market Shows in major market cities such as New York, Paris, Dallas, and Milan. Visual Merchandising—Trade includes merchandise presentation and display for industry trade shows, in company showrooms, and for divisions and departments

Table 1.2
Retail: Sales promotion division.

Job Title	This Person Is Responsible For
Vice President of Sales Promotion	• reporting directly to the company president • directing all activities within the division • overseeing presentation, sales, and promotion of the retailer's merchandise
Visual Merchandising Manager	• merchandising both presentation and display • logically arranging and presenting the store's merchandise in a manner that relates the company and fashion images • matching the available assortments of merchandise classifications to the current lifestyle of the customer • helping the consumer to see the company as a balance between the merchandise assortments, product price and quality, customer service, store personnel, and promotional direction • reporting directly to the Vice President of Sales Promotions
Visual Merchandisers	• reporting directly to the Visual Merchandise Manager • creating a fun, exciting, and enticing retail environment • designing visual displays of the latest fashion trends, new brand offerings, or new merchandise arrivals to the target consumer • supervising display personnel
Display Personnel	• arranging store interior and layout; designing departments, shop concepts, and outposts within the retail store • presenting visual displays of the latest fashion trends, new brand offerings, or new merchandise arrivals to the target consumer
Advertising Manager	• determining the most effective use of media (e.g., newspapers, magazines, radio, billboards, and Web pages) • supervising the creation, execution, and placement of media buys • creating graphics and signage for the retail store
Special Events Manager/Coordinator	• supervising the creation, coordination, staging, and evaluation of all special events or sales promotions
Sales Trainer[a]	• instructing middle-management and sales personnel on effective selling techniques, fashion trends, and company policy and procedures or register training
Fashion Coordinator[b]	• coordinating all fashion events (e.g., fashion shows, seminars, and other educational programs) • traveling globally to major fashion centers, trade shows, and cultural and entertainment events • attending major market weeks to pinpoint and track fashion trends • supervising the personal shopper and wardrobing programs
Publicity Director[b]	• coordinating all publicity events; writing and distributing press releases to appropriate media • promoting the company as an integral member of the community

Note: [a]Sales training function may be handled by Human Resources or the Management/Operations Division.
[b]This position may not be found in all stores.

within the manufacturer. **Visual Merchandising—Retail** is corporate business communications created for the in-store retail presentation that affects the ultimate purchase of merchandise by the retailer's target consumer, the ultimate customer. It includes both merchandise presentation and display to develop in-store account and category specific strategy. Retail activities are done in partnership with the retail customer. In this partnership, ideally the retailer should have the more detailed knowledge of the consumer and the product manufacturer would be the expert on the product so the partnership provides a synergy for visual merchandising to the consumer.

Visual merchandising for product manufacturers is usually housed in the **Image Communications** or **Brand Marketing/Marketing Communications Division** in a customer- or consumer-centric apparel or home furnishings company. This division includes the functions of consumer advertising and graphics, public relations, research (consumer and market and in some organizations product), plus retail presentation/visual merchandising and special product events and promotions. In some companies there are Marketing Managers for each of the functions, such as Advertising Manager and Special Events Manager (see Table 1.3), or there may be a Marketing Manager who oversees all of the marketing functions for specific retail types, such as Marketing Manager, Chain. In other companies there may be only two managers for visual merchandising—one for trade and one for retail. In a third organizational configuration, visual merchandising may fall under the umbrella of another manager, such as the In-Store Marketing Manager.

RAW MATERIALS MANUFACTURING—VISUAL MERCHANDISING. Visual merchandising activities for raw materials manufacturing companies are both trade and retail oriented, similar to those activities performed in product manufacturing. These activities include communications to the company's customer (the apparel/home manufacturing company, the retailer that maintains a private label/product development department, or the converter), the customer of the manufacturer (i.e., the retailer), and the ultimate consumer. For example, a fiber company may promote their merchandise (i.e., a new high-tech fiber) to the fabric manufacturers for use in new fabrics, to apparel manufacturers for use in a new apparel item, and to retailers to encourage the buyer to carry the items in the store. These activities for visual merchandising would be conducted at trade shows and through other industry media. They may also promote the consumption of the new fiber to consumers by placing ads on television shows watched by the target consumer.

In raw materials manufacturing firms and trade associations, the visual merchandising function is usually located in the sales and marketing division of the companies. Based on whether the company organizational structure of a particular firm is configured as a functional, product, or customer- or consumer-centric organization, the company has a product manager or merchandise manager, who is directly responsible for the development of product(s) (see Table 1.4).

All of the visual merchandising activities are organized and implemented to promote the products, to raise awareness and understanding of the products by the customers, and to increase sales of the products.

Table 1.3
Product manufacturing: Image communications division.

Job Title	This Person Is Responsible For
Vice President of Image Communications	• reporting directly to the company president • overseeing all marketing communication functions of the company
Visual Merchandising Manager—Trade	• executing all business-to-business communications of the company • developing and executing exhibit strategies for trade shows • creating and merchandising company showrooms for market week when the retail buyers visit the market to procure merchandise • developing product presentation vehicles to be used in the trade exhibit, show-room, or retail environment • providing visual support for special events and promotions • coordinating brand presentations, new product introductions and initiatives; organizing product presentations • supervising assistants who help with these responsibilities • being a liaison between the visual merchandiser—retail and other marketing departments • reporting directly to the Vice President of Image Communications
Visual Merchandising— Trade Assistants	• executing exhibit strategies for trade shows • merchandising company showrooms for market week when the retail buyers visit the market to procure merchandise • assisting with product presentation vehicles to be used in the trade exhibit, showroom, or retail store by the retail client
Visual Merchandising Manager—Retail	• overseeing corporate business communications to the retailer or the company's client • developing and implementing visual merchandising programs in the retail store, catalog, or Web page by defining and creating product presentations • creating a pleasant in-store or nonstore environment • designing and executing visual product presentations for in-store and nonstore special events and promotions • working directly with the visual merchandisers in the Sales Promotion Division of the retail company • developing new departments, shop concepts, and outposts • reporting directly to the Vice President of Image Communications
Visual Merchandising— Retail Associates	• implementing visual merchandising programs in the retail store by defining and creating product presentations • helping to create a pleasant in-store environment • executing visual product presentations for in-store special events and promotions
Retail Marketers (Retail Merchandisers)	• working at the retail stores to do product merchandising, including stocking, ordering, and product promotions • performing customer research, including collection of research data from the retail buyer, the customer, and point-of-sale (POS) databases • keeping a close eye on the competition as well as happenings in the industry • providing a communication conduit for the retailer's target consumer • providing communications and training for their client, the retailer
Advertising Manager	• performing similar functions as their counterparts in the Sales Promotion Division of the retail organization

Table 1.3
(Continued)

Special Events Manager	• handling similar functions as their counterparts in the Sales Promotion Division of the retail organization
Public Relations Director	• overseeing similar functions as their counterparts in the Sales Promotion Division of the retail organization
Research Manager, Strategic Intelligence Personnel	• conducting and analyzing industry and consumer research • collecting and analyzing market data that might be used by their company • overseeing product testing

Table 1.4
Raw material manufacturing—Sales and marketing promotion division.

Job Title	This Person Is Responsible For
Vice President of Marketing, Director of Marketing, Marketing Manager	• reporting directly to the company president • overseeing all employees performing the visual merchandising functions
Product Manager (Merchandise Manager)[a]	• overseeing the research, product design, sales promotion, sales, and services for a specific product or products • overseeing the development of product(s) • reporting to the Vice President, Director, or Manager of Marketing • working directly with production management • supervising the sales function for the product • interfacing with the sales manager
Sales Manager	• supervising the sales force • assuring that the product is distributed successfully to the company's clients
Promotions Manager[b]	• creating advertising, public relations and publicity, internal sales meetings/shows plus presentations to any internal constituents and external clients • developing sales promotional materials for presentations for use at trade shows and for other customer applications • overseeing activities similar to the Visual Merchandising—Trade activities in product manufacturing • promoting the products at trade shows[c] • supervising assistants in this division
Promotions Assistants	• assisting with advertising, public relations and publicity, internal sales meetings/shows plus presentations to any internal constituents and external clients • executing sales promotional materials for presentations for use at trade shows and for other customer applications • conducting activities similar to the Visual Merchandising—Trade activities in product manufacturing • promoting the products at trade shows[c]

Note: [a]Scope of this position depends on company organization.
[b]May or may not be located in this division.
[c]The trade shows for fiber and fabric products are separate from each other and separate from the apparel market shows but similar in function.

Product Merchandising: Operational Definitions and Organizational Locations

Product merchandising is performed at all levels within the FTAR pipeline. Each company has a set of products or services (i.e., product assortment) it devises to sell to the customer. The activities performed within a company to create or obtain this product assortment as deemed appropriate for the customer is product merchandising. Traditionally, one definition of **product merchandising** addressed the five "rights of merchandising"; however, with today's advanced technology, the following *six rights of merchandising* are now considered as a company completes its product merchandising activities: the right merchandise, in the right quantities, in the right colors, sizes, and silhouettes/styles, at the right time, at the right price, and in the right place.

RETAIL: PRODUCT MERCHANDISING. Retail product merchandising, or simply retail merchandising, is all the internal planning and/or activities and processes involved in the planning, procuring, presenting, and promoting of merchandise. More specifically, it is defined as the internal planning a retail firm conducts to procure, present, and promote merchandise to the target consumer while realizing a profit. Additionally, it is making sure an appropriate merchandise mix is selected to meet the desires and needs of the target consumer so adequate amounts of merchandise and appropriate assortments of merchandise classifications are on hand to be sold at prices the consumer will pay, yet assure a profitable operation for the retailer.

The **Merchandising Division** in the retail store with the merchandiser/buyer as its center is considered to be the hub of the company. The organizational structure of the Merchandising Division in many large retail chains begins with the Vice President of Merchandising, who reports directly to either the Executive Vice President or President of the organization (see Table 1.5). The other major players in the division include the General Merchandise Manager (GMM), the Divisional Merchandise Manager (DMM), the Buyers, and the Associate Buyers, and Assistant Buyers. A number of DMMs may be employed depending on the number and scope of product categories carried by the company. Some firms with a high volume of sales could divide the responsibilities of the DMMs for large product categories of merchandise into smaller segments (e.g., ladies accessories could be divided into jewelry, handbags, small leather goods, hosiery). Each of these employees work as a team with buyers, associate buyers, and assistant buyers as well as with individuals in other divisions to procure, present, market, and sell goods to the target consumer. GMs, DMMs, and the buyers may be geographically located in a small specialty store, a flagship store in a major city, in an office at the corporate headquarters, or a buying office located in a market city.

PRODUCT MANUFACTURING: PRODUCT MERCHANDISING. Apparel product merchandising is developing a cohesive package or line of merchandise for a specific time period. This cohesive package must reflect the image of the company; trend

Table 1.5
Retail: Merchandising division.

Job Title	This Person Is Responsible For
Vice President of Merchandising	• reporting directly to the company President or Executive Vice President • overseeing all employees performing the merchandising functions
General Merchandise Manager (GMM)	• establishing the overall merchandising policies of the store and helps establish and set merchandise policies and procedures • building and maintaining store image and creating a merchandise mix with assortments that are appropriate to meet the needs and demands of the target consumer • meeting the sales, profit, and gross margin goals including gross margin return on inventory/investments planned by the retail company • reporting directly to the VP of Merchandising or Executive Vice President of the store
Divisional Merchandise Manager (DMM)[a]	• directing specific departments housing merchandise for a particular target consumer or product category—for ladies accessories, for menswear (e.g., outerwear, sportswear), for young menswear (e.g., boys), for girlswear, childrenswear (e.g., infants, girls), for shoes, for cosmetics, for home furnishings, and for electronics • reporting directly to the GMM
Retail Buyer (Buyer)	• planning (estimating and budgeting) merchandise assortments for their assigned departments—ex. all ladies sportswear departments (junior, missy, petite, and women/extra-size); one product line within the department such as better juniors; or bottoms or tops within a specific size and price range[b] • evaluating (i.e., anticipating and forecasting) fashion trends • procuring (i.e., searching for and selecting) most appropriate merchandise mix to meet the needs and desires of the target consumer • promoting (i.e., advertising and visually merchandising and displaying product categories) • merchandising (i.e., presenting and arranging seasonal merchandise assortments in a specified space to maximize sales, profit, and gross margin return on investment (GMROI)) • supervising associate and assistant buyers • supervising sales personnel[c] • managing the selling floor: a category of merchandise[c]
Associate Buyers, Assistant Buyers	• Assisting the buyer with all responsibilities for merchandising their assigned products

Note: [a]The number of DMMs depends on the amount of the sales volume and the number of store locations owned by the organization.
[b]Depends on the size of the store organization, the type of store, and/or channel of distribution in which the store does business.
[c]These activities are not done by all buyers.

direction of the market and fashion cycle; price structure of the strategic business unit (SBU); the production, labor structure, and sourcing facilities and capabilities of the company; and maintain the design integrity of the original design concept.

The product merchandising function in a customer- or consumer-centric apparel or home furnishings company is housed in the **Consumer Marketing Division.** The product merchandisers, designers, product development personnel, and sometimes consumer product research personnel are the employees who report to the VP of Consumer Marketing (see Table 1.6). Usually product merchandisers are housed or placed within the organizational structure in strategic business units (SBUs) that reflect the product offering of the manufacturer. Some manufacturers establish SBUs to reflect product and/or brand function emphasis or the gender segmentation (men, women, boys, girls) of the industry; others organize the merchandising division with emphasis on consumer segments (youth, young adults, men). For example, Levi, at one time was structured with a merchandising division for each of the company's three consumer lifestyle segments: Youth/Levi, Young Adult/Dockers, and Business Casual/Slate. Another company organized with the three SBUs of men, women, and boys products. For each of these units, product merchandisers were hired who had expertise in that particular product for a specific consumer segment.

A variety of other employees may work in the Consumer Marketing Divisions depending on the size of the company and the product offering. For example, product development personnel may be located in this division, whereas other companies position these employees in sourcing or other similar departments. Product development employees begin work on the seasonal line before the product merchandisers and after or with the product designers. Consumer product research personnel are a second group of personnel, who may or may not be located in the Consumer Marketing Division. The consumer product research personnel may also be located in the Image Communications Division or the Retail Merchandising Division. Regardless of their physical or organizational location, these personnel must work as a team to build a successful, thus profitable seasonal line.

RAW MATERIALS MANUFACTURING: PRODUCT MERCHANDISING. Raw materials for the FTAR Complex include fibers, yarns, fabrics, and findings. Fibers can vary from natural fibers grown by local or international farmers and promoted by national and international organizations to synthetic fibers created in giant manufacturing plants by major chemical companies. Although these products can be very diverse, the product merchandising activities performed in the related companies and associations can be very similar. Each of these firms seeks to create, through the product merchandising process, an assortment of products that are appealing to their customers and to their customers' customers and so forth down the pipeline to the final consumer. The product merchandising process involves trend research, laboratory and wear testing research, and coordination of the new and old products to present the cohesive package to the customer and to present new and salable ideas for the consumer. Product merchandising can also include the technical expertise for utilizing the attributes and most outstanding features of the materials and assistance in solving problems and finding the most advantageous usage for the product.

Table 1.6
Product manufacturing: Consumer marketing division.

Job Title	This Person Is Responsible For
Vice President of Consumer Marketing	• reporting directly to the company president • supervising all product merchandising in each SBU
Product Merchandisers	• initiating the product development process • creating a collection of seasonal products to attract the target consumer; to meet the image, merchandising policies, and standards of the company; and to realize planned margin and profit goals • conducting market research • traveling the globe, visiting major fashion capitals, or going to a nearby city to observe what the consumer is wearing • analyzing company merchandising statistics to compile data such as sales volume or markdown percentages on specific lines from previous seasons and forecasting volume-trend percentages • managing the line by establishing and reviewing costs, recommended pricing, product specifications, and quality standards • assuring financial accountability by managing inventory • presenting the line, both internally to all company divisions and externally to their clients, the retail buyer
Designers	• creating the initial design concept as an employee of the product manufacturing company
Freelance Designers	• presenting their designs by invitation or appointment to the merchandiser on a self-employed basis
Contract Designers	• presenting their designs on a contract with the company for a specified period of time or job
Stylists	• patternmaking or adapting original designs to meet the needs of the company and target consumer, as company employees
Product Developers	• initiating a trend concept and presenting it to the product merchandiser • developing a new yarn, fabric, print, or color story • conducting similar duties as product merchandisers • conducting market, industry, and consumer research • analyzing what is happening with the retail client, the competition, both the global and domestic markets, trendwise • developing silhouette, color, fabric, and print stories based on fashion trend direction • assisting merchandisers in adapting these trends to target customer needs as well as to company goals and objectives • developing graphics, embroideries, trims, and findings and working with retail buyers in developing products for private labels
Consumer Product Research	• conducting consumer research with the target consumer • handling the product research or testing • analyzing market data that is relevant to the development and merchandising of the product • constantly interfacing with product merchandisers to provide direction, information, resources, and materials

(continued)

Table 1.6
(Continued)

Sourcing Manager	• coordinating and maintaining a reliable vendor base • making seasonal placements • coordinating the handoff to the supply/purchasing team for order placements
Sourcing Assistant	• acting as a liaison between merchandising, design, purchasing, and vendors • providing support to coordinate and maintain a reliable vendor base • communicating and following up with vendors, mills, and business partners daily • monitoring, tracking, and managing critical product development calendar milestones • managing data for weekly production meetings

Through product merchandising, the raw materials companies can be a trend leader and present new products to their customers, or they can be a follower and take their product direction from their customers, or both.

The types of firms involved in product merchandising for raw materials is extremely diverse; however, most of these firms contain a **Research and Development Division** that is responsible for the research for new products and the refinement or maintenance of continuous products (see Table 1.7). For example, fiber producers create new fibers with new characteristics, yarn producers create new yarn dyes and textures, textile mills create new fabrics and improve the characteristics of the ones they are currently making. Trade associations such as Cotton Incorporated, the Wool Bureau, and the International Linen Promotion Commission locate new resources, conduct laboratory research, and provide trend direction. New man-made fibers, new yarns, and new fabrics are usually developed in the Research and Development Division of a company. Employees involved with research may also be housed in another division such as Quality Control, Product Analysis, or Production.

Merchandising Services: Operational Definitions and Organizational Locations

Merchandising services are all the activities a firm uses to provide support to the customer who is purchasing the product. This support or service can include technical, informational, financial, and promotional supports. Consumer- or customer-centric firms realize that customers need assistance in many forms to facilitate the sale and satisfactory use of the products that are sold. Many times the customer or client is noted by the merchandiser or other personnel as an **account,** indicating that one firm routinely does business with another firm and an account or record of all the business transactions are recorded.

RETAIL: MERCHANDISING SERVICES. Retail customer services or the merchandising services provided by retailing are all the activities, including number, types, and levels of those activities, provided for the consumer by the retailer to attract the target consumer to the store, to enhance the shopping experience,

Table 1.7
Raw materials: Research and development division.

Job Title	This Person Is Responsible For
Vice President of Research and Development, Director of Research and Development	• reporting directly to the company president • supervising personnel who direct and conduct research, including consumer, product, and market
Research Manager[a]	• directing research and product design including product development • supervising researchers involved with product-specific, chemical-specific, functional-specific, or other niche research
Product Managers	• evaluating product performance and providing product information to the customer • working with research and development personnel, manufacturing personnel, merchandising services personnel, and the customer to get the right product • working with customers to determine what new products would be effective and desired by the customer • having extensive information about the manufacture and performance of the products • functioning as interpreters between the scientific and engineering personnel in Research and Development and in Manufacturing and the more aesthetic- and outcomes-oriented customer
Product Merchandisers	• performing similar duties to their counterparts in apparel production • tracking trends, predicting popular colors and fabrications • using their products (i.e., fiber, yarns, and fabrics) to project these images and include predictions on end product styling as well as color, fibers, and fabrication
Designers, Production Specialists, Colorists, Textile Designers, Artists	• working with product merchandisers • developing new products or creating images of new products and end use products that could be made from the new products.

Note: [a]In a large corporation, a Research Manager may be needed for each area of research—for example, new product research, protective fiber research, product line research.

and to sell the goods and services offered in a particular channel of distribution. Some customer services are so integral to the retail operation that the customer just expects them to be in place. Others are so unique or costly that the customer might shop that retailer instead of the competition because of the service. These include financial services such as credit, aesthetic services such as air conditioning and lounges, and informational services such as knowledgeable sales staff.

The **Operations Division** of a retail store, catalog company, or Web site is headed by the Vice President of Operations; however, a store, catalog, or Web manager is responsible for the overall day-to-day operations of the retailer. This division may also be called the Management Division because it houses the management operations of the individual store, catalog, or Web units (see Table 1.8). In a multiple store or store and nonstore business, each unit (e.g., store, catalog, Web page) will have its own manager who is responsible for that operational unit.

Product Manufacturing: Merchandising Services. **Retail services,** or the merchandising services of product manufacturers, are those activities provided

Table 1.8
Retail store: Operations division.

Job Title	This Person Is Responsible For
Vice President of Operations	• reporting directly to the company president • supervising personnel who manage and work in the store or nonstore function
Store Manager, Catalog Manager, Web Manager	• setting and enforcing general and merchandising policies and procedures of the retail organization • creating a corporate culture or working environment that is conducive to obtaining maximum employee productivity while servicing the target consumer and reaching the planned sales and margin goals • maintaining a constant and consistent company and fashion image • supervising all in-store or nonstore employees as well as all in-store or nonstore functions • reporting directly to the Vice President of Operations
Assistant Store Manager, Assistant Operations Manager, Assistant Catalog Manager, Assistant Web Manager	• reporting to the manager • overseeing customer service, alterations, receiving and marking, security, maintenance and housekeeping, customer delivery, and warehousing personnel
Customer Service Manager[a]	• resolving customer complaints, conducting customer research, and helping provide the level of customer service expected by the target consumer • reporting directly to the store manager
Receiving Manager, Warehouse Manager[a]	• supervising the activities and personnel within his or her management area • reporting directly to the store manager
Manager of Housekeeping[a]	• supervising the activities and personnel within his or her management area • reporting directly to the store manager

Note: [a]The number of functional managers depends on the size of the retail business (e.g., sales volume, number of store locations).

by the manufacturer for the retailer to enhance the business interactions and transactions between the companies, to assure a proper channel of communications concerning those business transaction processes, and to provide assistance in merchandising goods and creating sales volume, margins, and profits that are beneficial to both businesses. Like the retailer, the manufacturer must pinpoint and define the number, types, and levels of services that are feasible for the firm to offer for a smooth business operation, yet profitable enough so each party involved reaches expected sales, margin, and profit goals.

The **Retail Services Division,** in a manufacturing firm, houses the functions of customer service, account management, scanner data analysis, and retail services coordination (see Table 1.9). This may also be called the **Retail Merchandising Services Division** or the **Retail Marketing Division.**

RAW MATERIALS MANUFACTURING: MERCHANDISING SERVICES. **Customer services,** or the merchandising services provided by raw materials manufacturers, include the activities that support the sale, delivery, and other logistical activities relevant to the successful sale of the product to the customer. Again, these services are designed to support the customer, as are the customer service activities for companies in the other FTAR levels. In some raw materials companies, customer service activities also include technical assistance with the products, but this is more often handled through product merchandising.

Table 1.9
Product manufacturing: Retail services division.

Job Title	This Person Is Responsible For
Vice President of Retail Marketing	• serving as the corporate contact to the retail store • maintaining the success of the merchandising process at both the retail and manufacturer level • reporting directly to the president of the company
Retail Marketing Managers/Directors	• reporting for specified areas in the division to this VP • managing the corporate contact to the retail store • developing the business forecast • collecting market intelligence • giving account presentations to key account top-to-top management
Retail Marketing Assistants	• assisting the managers in all contacts with the retail company
Account Managers	• tending to the product and services needs of the retail customers • assisting with decisions on what products to purchase • making decisions on cash discounts and other terms of sale offered to the retail customer
Sales Representatives	• working with account managers and retail buyers • assisting with presenting the product to the buyers • answering questions about the product before and after the sale

Table 1.10
Raw materials manufacturing: Customer services division.

Job Title	This Person Is Responsible For
Vice President of Customer Services	• serving as the corporate contact to the apparel manufacturer • maintaining the success of the merchandising process at the manu-facturing level • reporting directly to the president of the company
Service Manager	• reporting for specified areas in the division to this VP • managing the corporate contact to the apparel manufacturer • developing the business forecast • collecting market intelligence • giving account presentations to key account top management
Account Executives[a]	• helping the client after the sale to ensure a timely delivery and/or warehouse of the product • providing technical expertise, in all areas of sale, delivery, and use of the product • giving assistance to the customer for the most appropriate or best use of the fibers, yarns, or fabrications, or with other resources that will help the client add value to the product
Sales Representatives[a]	• working with account managers and retail buyers • assisting with presenting the product to the buyers • answering questions about the product before and after the sale

Note: [a]The number of Account Managers and Service Representatives depends on the size of the company (e.g., amount of the sales volume) and the number of customers or apparel manufacturing accounts.

Customer Service may be housed in the **Customer Service Division**, the **Service Division**, or the **Logistics Division**. This division may be directed by a Vice President or a Manager, depending on the size of the company and the number of personnel employed in this area (see Table 1.10). When a company has a large service division, the Vice President may supervise a number of managers who may be organized by function (e.g., service, delivery) or they may be organized by product lines, with separate Service Managers for each product line. The Customer Service personnel works closely with the **Credit Division**. Merchandisers work closely with these divisions because they are often the direct contact with the vendors and customers while providing technical expertise and billing and receiving payments. Because of this contact, they become the image of the company for the trading partners.

Finance: Operational Definitions and Organizational Locations

Finance, or the control function, pays bills, extends credit, and performs other functions relative to the money spent and earned by the company. In addition, other retail merchandising services are provided to a retail store's Merchandising Division by the **Financial Control Division.** Like Customer Service

Table 1.11
Retail store, product manufacturing, raw materials manufacturing: Finance control division.

Job Title	This Person Is Responsible For
Vice President of Finance	• reporting directly to the company president • overseeing the functions of accounting, credit, and merchandising statistics • supervising personnel who work in this division
Controller	• preparing statistical reports used in guiding the retail buyer when he or she is planning merchandise budgets and assortment plans • preparing reports used by the visual merchandise manager when he or she is calculating the visual budget and assisting with establishing the sales promotion calendar
Retail Credit Managers[a]	• interacting with both the target consumer and the retail stores' suppliers and vendors

Note: [a]The number of credit managers and assistants depends on the size of the business (e.g., sales volume, number of locations).

but for financial activities, the Finance Division works directly with customers to extend credit and have bills paid, and it works directly with vendors in the payment of invoices. This division provides financial information to buyers and visual merchandisers as they prepare their work. In addition, this division is responsible for paying the bills incurred by the retailer, merchandiser, or other sourcing personnel, including the purchase of merchandise and for receiving the money owed by customers on company credit cards. Personnel in this division are very important for a smooth operating retail organization and especially to the merchandiser who wants the customer to be happy with the final sale or credit transaction and the vendor to be happy with the timely remittance of a merchandise invoice. Because of the interaction with both vendor and customer, the Finance Division is a fundamental part of the success of a buyer, a product merchandiser, or a visual merchandiser. The job titles and activities within this division are fundamentally the same across all three levels in the FTAR Chain (see Table 1.11).

Summary

The fiber/textile/apparel/retail complex or supply chain is a very unique business complex because different links at each level in the chain depend on the other links for all business functions, activities, and even survival. Also, it is unique with regard to the end products produced and the merchandising techniques used to market those diverse products to the appropriate target consumers. Over time, the FTAR Complex has evolved from a production-oriented industry, concerned with selling inventory, to a consumer orientation, focusing on the needs and desires of the consumer. This new direction has forced some

companies to address the type of organizational structure of their companies. Some have changed from a functional organization, which housed specific divisions that were responsible for executing explicitly defined business activities, or from a product organizational structure, with emphasis on brands and designer labels, to a customer- or consumer-centric company that identifies the wants and the needs of the consumer before the product is designed and produced. Regardless of the specific organizational structure, FTAR companies are organized with similar major divisions of executive management, marketing, merchandising, operations, and finance.

Merchandising is one of the most important business processes that all firms in the FTAR Complex use to create, prepare, deliver, and market merchandise assortments. Merchandising functions exist in the merchandising division as well as in the other divisions of marketing, operations, and finance. The three major types of merchandising are product, visual, and merchandising services. Product merchandising functions take place in the Merchandising Division of the retailer, in the Consumer Marketing Division of the manufacturer, and in the Research and Development Division of the raw material producers; visual merchandising is housed in the Sales Promotion Division of the retailer, in the Image Communications Division of the manufacturer, and in the Sales and Marketing Division of raw material producers. Merchandising services are overseen by the Management/Operations Division of the retail store, in the Retail (Merchandising/ Marketing) Services Division of the manufacturer, and in the Customer Services or Logistics Divisions of the raw material producers. These merchandise functions do and should overlap across the divisions within a company, across the organizational functions, and across levels within the supply chain.

Key Terms

Account
Apparel manufacturers
Apparel manufacturing
 companies
Auxiliary firms
Brand company
Brand Marketing/Marketing
 Communications Division
Channels of distribution
Client
Consumer
Consumer-centric companies
Consumer-driven (orientation)
Consumer-focused (orientation)
Consumer Marketing Division
Consumerization

Contractor
Converter
Credit Division
Customer-centric companies
Customer Service Division
Customer Services
Decade of imports (orientation)
End products
Era of the retailer (orientation)
Fabrics
Fashion change
Fashion products
Fiber producers
Fiber/Textile/Apparel/Retail
 (FTAR) Complex
Financial Control Division

Force of fashion
FTAR Supply Chain
Functional organization
Greige (gray) goods
Image Communications
 Division
Importance of price
Influence of competition
Jobbers
Logistics Division
Man-made fiber producers
Manufacturer
Media power
Merchandising
Merchandising Division
Merchandising Services

Natural fiber suppliers
North American Industry
 Classification System
 (NAICS)
Operations Division
Organizational operations
Pipeline
Product driven (orientation)
Product merchandising
Product organization
Production driven (orientation)
Raw materials producers
Research and Development
 Division
Retail Marketing Division
Retail Merchandising Services
 Division
Retail Services
Retail Services Division
Retailer
Sales Promotion Division
Service Division
Sewn products
Soft goods
Standard Industrial
 Classification (SIC)
Supplier
Supply Chain
Synthetic fiber producers
Technology-driven consumer
 (orientation)
Textile mills
Textile products
Vendor
Visual merchandising
Visual Merchandising—Retail
Visual Merchandising—Trade
Wholesaler

Job Titles
Artists
Colorists
Contact Designers
Controller
Credit Manager
Customer Service Manager
Designers
Director of Marketing
Director of Research and
 Development
Display Personnel
Divisional Merchandise
 Manager (DMM)
Fashion Coordinator
General Merchandise Manager
 (GMM)
Manager for New Product
 Research
Manager for Protective Fiber
 Research
Manager of Research for
 Product Line A
Marketing Manager
Marketing Manager, Chain
Merchandise Manager
Operations/Assistant Store
 Manager
Product Developer
Product Line A Manager
Product Manager
Product Merchandisers
Production Specialists
Promotions Manager
Public Relations Director

Publicity Director
Researchers
Retail Buyer
Retail Credit Manager
Retail Marketers
Retail Marketing
 Managers/Directors
Retail Merchandisers
Sales Manager
Sales Trainer
Service Manager
Sourcing Assistant
Sourcing Manager
Special Events
 Manager/Coordinator
Store Manager
Stylists
Textile Designers
Vice President of Consumer
 Marketing
Vice President of Image
 Communications
Vice President of Marketing
Vice President of Research and
 Development
Vice President of Retail
 Marketing
Vice President of Sales
 Promotion
Visual Merchandisers
Visual Merchandising Manager
Visual Merchandising
 Manager—Retail
Visual Merchandising
 Manager—Trade

Review Questions

1. What are the five major segments or links in the FTAR Supply Chain?
2. How has the focus of the FTAR business changed since the 1950s?
3. What is unique about apparel products, which affects their design, production, marketing, and sale?
4. What is consumer-centric orientation, and how does this affect FTAR companies?
5. What is merchandising, and how is it similar and different across the FTAR Supply Chain?
6. How are marketing and merchandising both similar and different in their functional and organizational purposes?

7. What job tasks are required for apparel merchandisers, and how are these different from apparel buyers?
8. What is a sourcing agent, and how does this job differ from the job of a retail buyer?

9. Why does the retail buyer need to work with the visual merchandiser?
10. What type of tasks does the merchandiser do at the raw materials segments in the FTAR Chain?

References

Borneman, J. M. (2005, May). U.S. textiles' new reality. *Textile World, 155* (5), 10.

Byron, E., & Agins, T. (2005, May 13). Style & substance: Probing price tags; A U.S. attorney and the SEC shine a light on stores' murky 'markdown money'; is it shared risk—or uneven playing field? *Wall Street Journal* (Eastern Edition), p. B1.

Show and Tell. (2008). *Lifestyle Monitor*, Cotton Incorporated. Retrieved May 12, 2008, from www.cottoninc.com/lsmarticles/?articleID=133

NAICS: New code system for NAICS. (2001). U.S. Census Bureau. Retrieved October 15, 2001, from www.census.gove/epcd/www/naicscod.htm

NAICS. (2005). U.S. Census Bureau. Retrieved August 29, 2005, from www.census.gove/epcd/www/naicssect.htm

chapter

2

Strategic Planning

Objectives

After completing this chapter, the student will be able to

- Define the strategic business plan
- Discuss the history of strategic planning
- Identify the steps in the strategic business planning process
- Detail for a company the outcomes of the steps in the strategic business plan
- Compare the two strategic planning paths
- Discuss the process of merchandising within the strategic business plan
- Explain the components of the Profit and Loss Statement
- Identify the budgets that originate from the Profit and Loss Statement
- Define the market plan for a company
- Explain strategic marketing and how it is integrated with the strategic planning process
- Identify the 10 P's and their role in implementing the market plan for target marketing and product positioning

Introduction

Strategic planning is a process involving the top decision makers in the company and resulting in policies and procedures that affect every employee in the company, their customers, and their products. During the strategic planning process, management pinpoints the target consumer, identifies the right product for that consumer, and decides how to position that product to maximize sales to that consumer. To achieve profitability for the company and satisfaction for the target consumer, management must make numerous decisions in strategic planning, including the selection of channel of distribution to best reach the consumer and the identification of vendors to best develop and supply the product.

The primary outcome of the strategic planning process is the **strategic business plan,** a series of documents, policies, and directives. This guideline or map directs the business activities of the firm. In other words, it provides both long-term and short-term objectives by which the firm and employees can carry out business activities to realize the planned sales volume, profit, and market share while building and/or maintaining the company image. When creating the strategic business plan, management is usually influenced and guided by the mission statement. Additionally, management establishes or creates the corporate culture or climate for the working environment of the company. The **corporate culture** of a company, which can be both written and unwritten, is the shared values, norms, procedures, practices, and activities that form the work climate or environment. The corporate culture of a company is one of the most important factors impacting both the retention and productivity of employees.

History of Strategic Planning

Throughout history, some owners and managers have spent time planning how to operate their businesses and others have simply operated on a day-to-day or "seat of the pants" business approach. The study of strategic planning first appeared in the 1960s in schools of business (Hofer, 1976). These studies focused on the activities of firms who were operating in the 1950s. Strategic planning has evolved, prior to and including the 1950s, from the relatively simple process of deciding what product to make to the complex, intensive process of directing the company to meet the needs of its target consumers in the 2000s (see Figure 2.1). In many ways, the history of strategic planning parallels the business orientation history of the FTAR firms; however, because of lag time in implementation or differentials in industry segments, changes in strategic planning may precede or follow changes in the actual activities of the industry.

Planning for Production

In the 1950s and in prior decades, strategic planning was simple because the clear goal for any company was to produce. Companies did limited strategic

Dates	Strategic Concept	Supply Chain Focus
Pre-1960s	Planning for Production	Apparel Manufacturing
1960-1979	Planning the Product	Product Design
1980s	Planning Driven by Retailers	Major Retailers
1990s and beyond	Planning Focused on Consumers	Target Consumers

Figure 2.1
Timeline of strategic planning.

planning during this decade. With consumers being passive recipients of product, the focus was on production, and companies depended on engineers and plant managers to determine capacities of equipment and to keep the equipment producing at full capacity. Productivity was considered extremely important as a measure of success of the company. Looms, sewing machines, and other equipment, running at full capacity for 24 hours a day, were indications to owners and investors that the plant was successful (see Figure 2.2). Metrics or measurements of profitability and growth used by companies were limited because full production has the plant and all equipment running constantly and at total capacity, which is regulated only by the amount of raw materials or supplies that are fed into the system. As textile production firms produced large amounts of fabrics, apparel manufacturers were forced to expand production to use these fabrics. For retail companies, the goal was similar: to sell all product that could be bought and pushed through the store. As long as consumers were able to purchase and were interested in buying as much product as they could, manufacturers at all levels of the supply chain were able to run production facilities at full production levels. Planning was not necessary because raw materials were being pushed through the pipeline and consumed at the end.

Planning the Product

In the 1960s and 1970s, the apparel companies began to control the FTAR pipeline, and the business orientation shifted from production to product. As the business orientation shifted, strategic planning became focused on how many products an apparel manufacturing company could make or could import

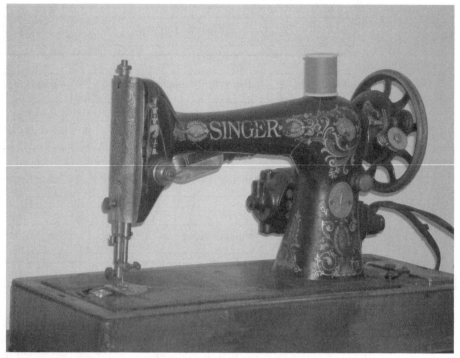

Figure 2.2
Planning for production by determining equipment capacity.

to offer a wide variety of products to customers. Some companies used or created designer labels to create a more impressive product. This type of strategic planning continues to be the orientation for some traditionally operated companies. A product orientation in strategic planning generally depends on an organizational structure that focuses on the product as opposed to focusing on production or the customer. Divisions in the company, such as design, pattern making, and cutting, are characterized by their attention to the product (see Figure 2.3). The goal of the strategic business plan of a product-focused company is driven by an internal focus on capacity and equipment capabilities with limited regard for customer preferences or external environments.

With product-focused strategic planning, textile producers and retail businesses become reactors, not planners, to the products that apparel manufacturers produce. This type of strategic planning by apparel manufacturers results in **push marketing.** Apparel manufacturers pushed product on retailers, who pushed product on consumers. Textile producers made large numbers of fabrics and held large inventories, hoping to satisfy the demands of the product-focused apparel manufacturers. The suppliers of the end product manufacturers had to supply the raw materials demanded by these manufacturers, and retailers, their customers, had to purchase the products that were produced. The products were pushed on the retailers who would push them on the consumer. In

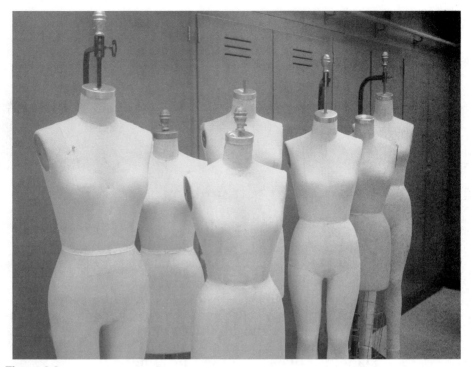

Figure 2.3
Dress forms for product fit and size.
(Courtesy of Department of Apparel, Housing, and Resource Management, Virginia Tech.)

strategic planning for this type of company, executive management would discuss how many salespersons to hire and how to motivate the sales force.

Planning Driven by Retailers

In the 1980s, the balance of power in the FTAR pipeline began to shift, and consequently strategic planning had to change for textile producers and apparel manufacturers to prepare to meet the new demands of retailers. Retailers began to tell apparel manufacturers what products they needed to meet the growing demands of their consumers. With the control of power shifting to the retailers and then consumer, apparel manufacturing companies found they had to plan what product, how much product, and when the product should be produced and sold. No longer could they run factories at full production making large quantities of one product. Retailers would not buy this inventory. With this shift in power, extensive strategic planning became a vital tool for companies that wished to remain in the marketplace. Companies needed to know more about their customers than they had previously known. Strategic planning became focused on the retail customer and then on the retailer's target customer. Companies at all levels of the FTAR Complex had to reformulate many of their divisions from a product orientation to a consumer or customer

(a) (b)

Figure 2.4
Major retailers: (a) Dillard's and (b) Sears.

orientation. Major retailers, such as Dillard's and Sears, became the directors of the FTAR Supply Chain (see Figures 2.4a and 2.4b). Apparel manufacturing companies had to work with the retailers, who switched their strategies from push marketing to pull marketing. With **pull marketing,** they began to use marketing tools to build brand awareness and product desire so consumers would be requesting their products in the retail stores.

Planning Focuses on the Consumer

In the 1990s, many companies realized that just knowing about the customer was not enough to be successful in an increasingly competitive market. Planning had become increasingly important for every company in the FTAR Complex. The focus of strategic planning during this time shifted from knowing about the customer to working with the customer. In the 1980s, many apparel and textile companies had become dependent on the retailer for information about the consumer; however, some of these textile and apparel FTAR firms quickly recognized that they had to work not only with their immediate customers (e.g., the retailers) but also with their final customer, the consumer. *Consumerization*, or knowing about, working with, and planning for the customer, became the mission for companies and the goal of strategic planning. Goals, plans, and evaluation measures, developed in strategic planning, needed to be made with input from the customer. This approach to strategic planning presents a reversal of orientations from previous eras when the company or one of its partners was in control of all decisions made about products.

The focus on the consumer has increased into the 2000s. Many companies in the FTAR Complex now approach strategic planning as consumer-centric companies. During strategic planning, they research in depth about their customers, including those that are their immediate partner, those downstream in the FTAR pipeline, and the ultimate consumer. As part of their strategic planning process, many retailers, such as Chico's, work closely with vendors to get colors and sizes that are unique for their specific customer (Lee, 2005; Weitzman, 2003). Consumer research may be the duty of the retailer, or some retailers expect the manufacturers to know what to produce for the consumer. Companies

that focus on the consumer, involve the consumer in the planning process, and use feedback from the consumer to complete and evaluate the strategic planning process are considered consumer-centric companies. Some firms use consumer boards, surveys, and focus groups to increase the input from the consumer into the strategic planning process. Technology also becomes an important tool in this planning process. Technology can be as simple as computerized cash registers that provide data about what products are sold when and in what combinations to radio frequency identification (RFID) tags that track the movement of the products within the store while in the consumer's cart. Bar codes and electronic scanning devices can be used to collect point-of-sale (POS) data, distribution tracks, and inventory information.

Strategic Planning Process

Strategic planning is the process that helps the company and the merchandiser to answer the following *four questions of strategic planning*: "Who are we?" "Where are we going?" "How do we get there?" and "Have we arrived?" Most companies or firms are established with the functional divisions of Management, Marketing, Merchandising, Operations, and Finance; therefore, executive management is responsible (1) for formulating answers to these four questions that includes the writing of the mission statement and strategic business plan, (2) for establishing the corporate culture of the company, and (3) for assuring that the company operates within legal and ethical realms. The process of answering the four strategic planning questions forms a path or organizational direction for guiding the company (see Figure 2.5).

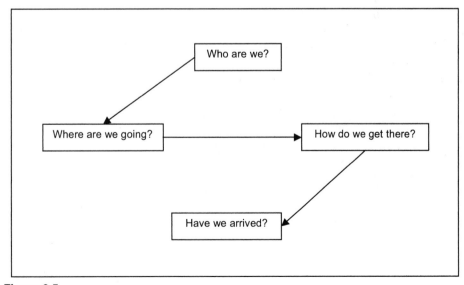

Figure 2.5
Primary strategic planning process path.

Primary Strategic Planning Path

The primary path for strategic planning answers the four questions in the process order of "Who are we?" "Where are we going?" "How do we get there?" and "Have we arrived?" When the answers to the four questions are determined at the company, or macro-level, the merchandiser has a guide or direction for determining many of the decisions that must be made in the day-to-day aspects of his or her job. For example, the dollar amount for a promotions budget is established based on expected net sales, target customer, and plan for growth or change, which are identified and developed in the strategic plan. From the initial allocation of dollars for promotions, a complete and detailed promotions budget is developed that coordinates and supports the promotions plans for the period.

For companies to be successful, strategic planning must be done in concert with trading partners. Those in management that are doing strategic plans must be aware of and work with the strategic plans of their partners. Planners have to understand not only the partner's strategic plan but the corporate culture of those partner firms. The strategic plans of a supply chain must operate in harmony. For one company with a vision of growth in brand recognition to be successful, the trading partners must share and support that vision. For example, a brand can be built with product quality, consistency of fit, and recognizable value. For a product manufacturer to achieve this goal, the fabric suppliers must provide quality fabric that meets required test standards, and findings manufacturers must provide the right findings in an on-time delivery mode. Everything within the supply chain must be delivered as expected and when promised. The retailer who is buying this product line will expect not only to receive this product as ordered but also to maintain a store image through sales associates, promotions, and physical building image to support the brand image. Any firm that does not provide business actions that support the brand image identified in the vision statement will reduce the viability of the entire supply chain. The strategic planning process is a series of stages, as shown in Figure 2.5.

WHO ARE WE? This question is answered by the development of the mission statement. The **mission statement** of the company includes the business philosophy and vision of management. It is usually a written statement that includes "what is the business," "who is the target consumer," "what is unique about the product(s)," "how will the company target and partner with employees, clients, and vendors," and "in what geographic locations and channels of distribution will the product be distributed and positioned." The mission statement of the company is shaped by the history of the business, the current business goals of management, the company's resources, and the distinctive competences of the company, plus current internal and external environmental factors impacting the business practices of the company.

The answer to the question "Who are we?" posed by Company Y (see Table 2.1) is answered by their decision to be a leader in performance fabrics. This decision is the output from the first stage in the strategic planning process and

Table 2.1
Strategic business plan for Fabric Company Y: A case study of strategic planning.

Strategic Planning Stage	Example of Planning Outcomes for Fabric Company Y
Who are we?	Mission statement: As a company we will produce the best high-performance fabrics for special uses including athletics.
Where are we going?	Strategic goal: We will become the market leader in high-performance muscle control fabrics for professional team athletics.
How do we get there?	Action plans: $50,000 will be budgeted for the sock line; marketing will be done in *Sports Magazine*; six ads will be placed bimonthly for the next year.
Have we arrived?	Benchmarks: Sell-thru will increase 10% for the next season; customer returns will decrease 50% in a six-month period.

needed for the next stage to begin. Rarely can a stage be eliminated or skipped in the planning process for a successful company.

The *history of the company* flavors the strategic plan in relation to the product and the target consumer. Among retail firms, Nordstrom is an example of a firm that reflects its history in its strategic plan, its products, and its target consumers. Nordstrom started as a shoe retailer (see Figure 2.6). The company carried high price point shoes that exhibited high-quality, fine leather shoes. And the retailer carried a depth of merchandise not found in many comparable stores at the time. Nordstrom became known to consumers as the place to find a great selection of both fashion-forward and fine classic-look shoes. The shoe department continues to be one of the most popular departments in the stores, and shoes are frequently the product that consumers most often associate with Nordstrom.

A review of the company's history is pertinent to this stage of strategic planning. For example, the Wrangler product was originally developed for rodeo riders. The back pocket was raised because wearing a wallet in the traditional location for the pocket was uncomfortable for a wearer who sat for extended periods in a saddle. The inseam of jeans is traditionally a felled seam but was changed in Wrangler jeans to be a regular superimposed seam with a safety stitch because the felled seam, although secure and flat, rubbed the leg of the rodeo cowboy, who was using his legs to grip the horse during fancy maneuvers in the rodeo ring. Although small changes continue to be made in the Wrangler jeans to accommodate the needs of current consumers, these basic styling changes continue to be used in current jeans. Wrangler jeans continue to be one of the most popular products worn by rodeo riders, race car drivers, and other active working consumers.

Through three centuries of growth, DuPont has built an international business from its original research in explosives and other chemical-based solutions to human problems. The company grew rapidly in the 1940s and 1950s with

The SWOT for Company Y	
Strengths	Has many skilled workers and high-quality equipment
Weaknesses	Has not made a major change in product line in many years
Opportunities	New information has become available about the importance of a specified pressure therapy for sports injuries
Threats	Competitors have new product lines that are already introduced into the sports marketplace with some brand loyalty

Figure 2.6
SWOT analysis for Company Y.

their chemistry-based research that resulted in new synthetic fibers. The name DuPont became synonymous with futuristic, chemical-based research to provide products that improve the everyday lives of its target consumers. Although DuPont restructured and sold some of the divisions that developed and manufactured innovative textiles, the company continues to develop and launch new textile products through partnerships. For example, the new Sorona polymer platform was created from a renewable resource in partnership with a manufacturing firm (DuPont, 2004). Knowing who the company has been, or its history, is a powerful tool to building future plans.

Another task to complete during this stage of the planning process is the assessment of the current *strengths* and *weaknesses* of the firm. Some companies call this a SWOT analysis (i.e., strength, weaknesses, opportunities, and threats) (see Figure 2.6). Management will also identify, if not done previously, the capabilities of the company: This may or may not be strengths depending on the selected mission. The activities done during the identification of strengths and weaknesses include the itemization of equipment including types and capacities, partnerships (long and short term), and technology levels, as well as employees including skill types and levels. Resources of capital or other funding and numbers and skills of employees must also be itemized. A company must have the right employees with the right expertise to match with a new product, a new product line, or a new strategic business. The right employees are ones that have the skills and depth of knowledge to handle the demands of the new situation. These employees often have higher skill levels than previous employees and can garner higher salaries. Training can be used to move some employees from their current positions and status to the new level. Companies also use targeted hiring and firm acquisitions to obtain the human capital needed for new ventures. As part of strategic planning, managers must examine what skills they currently have within the employee pool and hire, buy, or train the needed expertise. This tactic often means that the best manager is

surrounded by employees that represent very different skill levels than the manager. A company active in strategic planning will be aggressive in hiring and training of its employees. In addition to skills and knowledge, competitive firms hire employees who are passionate about their jobs and will nurture and reward this passion. Talented people who are actively involved in the critical decision-making aspects of the job are vital resources for a company.

Companies also examine past products and their performance in the market as well as the known information about consumers. Inputs include new information about both markets and consumers. A staff of researchers and financial planners and analyst are required to supply the level of information needed to provide the foundation for excellence in planning. Financial planners are employees who evaluate the dollars for the company and make important calculations about budgets and future spending. Technology is a vital part of the success of this stage in strategic planning. Financial data, such as sales figures, product costs, and operating expenses, must be collected accurately and continually for the analyst to use. Data are collected at all stages of the pipeline from the sales in stores, the movement of products through distribution, and the preparation of the products in production. In addition, data must be collected from and shared with trading partners. Data can be collected in minute increments. Some product manufacturers and retailers are collecting data at the stock-keeping unit (SKU) level for specific target consumers within single stores, or data can be collected by regions or companywide.

WHERE ARE WE GOING? The response to this question is the result of a critical analysis of the internal and external environments for a business. Many companies call this process an **environmental scan** because the research division is scanning the environment to identify information that will be valuable in planning the business and planning the product. Information from the environmental scan is used in determining the critical issues for a company and the selection of the problem to be solved (i.e., the direction or destination— where we are going). **Critical issues** are ones in the internal and external business environment that can impact the current situation and the future path of the company.

Company Y's decision in the first and second stages of the strategic planning process (see Table 2.1) means they must look at the critical issues for the company. Company Y scans the environment and realizes that many competitors are producing fibers with specific properties as a result of new technologies (i.e., fibers that provide warmth when the body temperature drops). Data can be viewed from the perspective of the retail store, the target consumer, or the product. Macro and micro levels of data for Company Y are shown in Figure 2.7.

The environmental scan can also reveal that other new technology is available for developing fibers to meet additional bodily requirements and that consumers are very interested in and accepting of these new fibers. A scan of the internal company environment shows that the company has personnel with the skills and training to do research and development into this type of fiber. With capital available to perform this research and equipment adaptable for

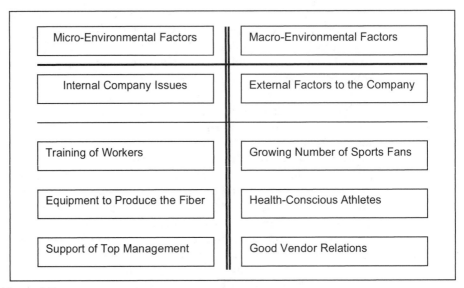

Figure 2.7
Macro and micro environments for Company Y.

producing a new fiber, the company can state in the strategic plan that it is going to research, develop, and produce a new fiber for meeting a particular consumer need. Critical issues for the fabric company wanting to increase its activities in high-performance textiles include level of technology, cost of fibers, consumer interest in and need for these fabrics, customers who are willing to produce products made from these fabrics, and retailers or other distribution channels who will sell products made from these fabrics.

The answer to "where are we going" becomes a **strategic goal** for the company. The strategic goal should include fundamental and broad decisions on what customers, both immediate and downstream in the pipeline, are to be addressed in future planning. In addition, the company will state what products are to be the focus of its plans, and what associated or peripheral products will be included in the merchandise mix sold by the company. Specifics about the number of selling seasons, specific channels of distribution, and geographic distribution patterns will be part of the overall plans developed for the company.

For Company Y, the strategic goal is to produce the best high-performance fabrics for special uses including athletics. To achieve this goal, a number of decisions and changes must be made across many of the functional areas of the company. In addition, top management will want to examine a prediction of how this goal will impact the overall supply chain. For example, the introduction of a new fabric may require raw material vendors to supply new products and customers to make room for a new type of stock. If Company Y makes a fabric that is cut and sewn into an apparel product that must now be folded instead of hung on hangers, new shelving may be needed by the retailers planning to

Figure 2.8
Vendor and customer changes occurring because of Company Y's strategic planning.

carry the new product (see Figure 2.8). Also the company's vendor may no longer be needed for natural fibers, and a new vendor must be found for the synthetic components that are now required. In addition, the company will want to examine how the competition will view and handle this goal. The competition may have a number of possible responses: introduce its own new products, be completely unaware of this trend, or cut the price of its performance fabrics.

Decisions will have to be made relative to the management of the complex mix of merchandise that is carried by even one company in the supply chain. A company will want the development of products that adapt to the identified fashion trends and meet the demands of the target consumer, including quality, price, and fashion change. To implement this goal, management will have to examine functional areas within the company, such as the expertise of the firm's product development staff and the research processes and databases covering the target consumer. The company must tie its supply chain into this goal on a weekly or continuous basis, and it must supply data through information sharing so the suppliers can respond more quickly and accurately in the initial placement and replenishment of product.

How Do We Get There? This question is answered by the selection of specific strategies and action plans to take the company along the planned path to meet the goal. The answers to this strategic question are the details or the road map that will help the company reach the goal. Although the mission statement is set by the executive management of a company, the answer to "how do we get there?" must be answered in conjunction with employees who will perform these tasks. Joint planning sessions that are held in team environments in collaborative and cross-divisional sessions often result in **specific strategies,** which are more focused than the mission statement and also result in insightful, viable, and functional action plans. Target has quarterly meetings that are contests called the "Big Idea" to find the best idea of how to accomplish its goal of new products and distinctive marketing (Schlosser, 2004). The employees at these meetings work in cross-functional teams and are asked to bring ideas to expand and implement at the meeting. They share information and have employees perform tasks that are normally done by another functional area. For example, an employee in finance might work to develop a storyboard for a new ad. New perspectives, created by a cross-functional team, bring new and often innovative ideas to Target's business.

At this point in the planning process, someone must prepare **action plans** to determine who is responsible for doing what activities and if the right equipment, money, and time are available for getting the job done. Identification of these equipment and personnel resources would have been made in response to the previous stage in strategic planning. If in response to the question "Who are we?" these people and other resources are not currently in the company, then decisions must be made about outsourcing or hiring, and purchasing. Action plans would vary depending on the mission statement of the company. With Company Y, the decision to become a leader in high-performance fabrics needs to have detailed action plans (see Figure 2.9). Input to formulate and put into action the strategic plan comes from a variety of sources. Partnerships must be recognized and nurtured while developing and putting the planning process into practice. Company Y must work closely with product manufacturers in testing products to provide assurance to buyers that the product meets consumer expectations for performance. In addition, the company must collect data from retailers that sell products made from its fabrics to analyze the sales for that particular raw material.

Other examples of action plans can be found among many of the textile or apparel companies. For example, North Face has chosen to focus on technical products, so the action plans for this company include activities involving research and development of new products to be sold in the specialty store channel of distribution. In contrast, Walmart's decision to include more fashion products in its apparel lines might require action plans that include trend analysis and appropriate merchandising techniques to create competitive presentations that encourage its consumers to select these products instead of products from the multitude of competitors selling fashion goods. At the end of this stage in the planning, decisions must be made about a timeline for implementation of the activities, critical timing for establishing the completion of

Company Y's Action Plan for High-Performance Fabrics		
Person	Function	Deadline
Ad Layout Artist	Create logo for new product	September 30
Sourcing Agent	Find new vendor for needed chemicals	October 20
Shop Floor Manager	Train floor supervisors on new dyeing process	October 30
Customer Service Representative	Contact retailers about switch from hanging product to folding product	December 1
Promotions Merchandiser	Design new shelving for top-five retailers	January 15

Figure 2.9
Action plans for Company Y.

activities, and an ending point. Action plans are designed to provide detailed direction for the subsequent activities implemented by merchandising. Action plans will include specifics on budget, directions for line planning, key themes, new design concepts, and market plans and calendars.

Have We Arrived? **Implementation** of these plans is the next step. In this step, the action plans are set into motion or are implemented. With implementation must be a plan for **evaluation** or a way to evaluate the question that is posed by "have we arrived?" Companies need **benchmarks,** or criteria, for determining when the goal has been met and how efficiently and effectively it was met. A company must quantify the outcomes of the strategic plan. Management must have a number in terms of dollars and a timeline of dates for implementation and evaluation. For most companies, a level of sales to generate enough revenue for profit in companion with satisfied customers indicates that the company has arrived at the goal. Data from sales and information from interviews, personal feedback, and observations can all be used to determine "Have we arrived?" Retail stores and apparel manufacturers often examine the amount of sales for products to determine if the goal has been reached. When the final customer has purchased the product at the expected or above-expected level, the product is often considered a success. The return of that consumer for more products, whether new or repeat, will signal another level of success in meeting the goal of satisfied customers and profitability for the company.

The examination of markdowns, customer returns, and allowances can be very revealing about the success or failure of a product. Markdowns and returns are a reality of this supply chain, and someone must absorb the costs of

these markdowns. With fashion products, risk is expected, but it must be controlled and handled early in the decision-making process. For example, introducing new products or new styles into the merchandising mix is risky, and the merchandiser must address this risk in the planning stage. The amount of products in various categories would be adjusted relative to levels of fashion risk represented by specific products. Benchmarks indicating what are appropriate in each channel of distribution and for each product category must be set and used through agreements between partners. One segment cannot be expected to absorb the entire markdown for a product because each link in the supply chain contributed to development, distribution, promotion, and sale of the product. Retailers and vendors must share risks in this aspect of the business operations as they must do in all aspects of the pipeline in a consumer-centric supply chain. Knowing when and if a company has arrived depends on knowing what is expected on arrival. **Quantification of expectations,** concrete and numeric ways to measure change, is fundamental to successful evaluation and can be itemized in a company document such as shown in Figure 2.10.

Sales, markdowns, and other financial measures are not the only measures of "arriving." Brand recognition, repeat purchases, good word of mouth, and Web site activity can all be metrics used to evaluate when the company has arrived at the goal of the strategic plan. Determining the appropriate measures and levels needed for those measures is an important part of the strategic planning process. Without concrete measures of success, employees, shareholders, and other interested parties may continually wonder, "Did we do enough?", "Has the goal been met?", and "Is there more to do?" In publicly held companies, most shareholders expect dividends at the end of the business quarter and use the size and frequency of dividends as a measure of company success and arrival at the strategic goal. In addition, measuring, evaluating, and rewarding employee performance is part of this process of determining "Have we arrived?" Evaluations of the outcomes of strategic planning are important in many aspects of the company. Evaluations provide a foundation for decisions on the pay for employees, decisions on the continuation or revision of partnerships, and the maintenance, revision, or dropping of products and product lines.

Company Y's Strategic Planning Goals for High-Performance Fabrics		
Actionable Goal	Benchmark	Date
Sales increase in high-performance fabrics	3% increase	May 1
Market share increase	1% increase	June 30
Profit increase	2.5% increase	Third quarter
Less markdowns	1.5% decrease	Third quarter

Figure 2.10
Company Y's goals and quantification of expectations.

The implementation and conclusion of one strategic plan marks the start of the next strategic plan. Information from the current process is used in doing the critical analysis for the planning of the next strategic goal. For example, in the first six months of the year, the fiber company had brand and product recognition as the strategic goal developed in the planning stage of "Where are we going?" When the desired level of recognition has been achieved (i.e., the first goal was met), the next critical issue is attacked. For this company, achieving sales to equal a 15% market share might be the next strategic goal. For another company with more background in fiber research and a market presence in high-technology fibers, a goal of 30% market share might be selected. Strategic planning is a continuous process when a company wants to remain a viable and competitive force in the market.

Alternative Strategic Planning Path

Following the development of answers for "Who are we?" the primary route in strategic planning for most companies is to next tackle the question of "Where do we go?" and then follow with the investigation of the question "How do we get there?" For example, some companies target their customer (i.e., "Where do we want to go?") and then decide what strategies, products, and services are needed to reach that targeted customer. Some industry analysts express this as **"make, source, and sell."**

However, some companies choose an **alternative strategic planning path** (see dashed lines in Figure 2.11). Following the decisions related to "Who are we?"

Figure 2.11
Primary and alternative strategic planning process paths.

these companies chose to investigate "How do we get there?" and then study "Where do we go?" From either path, the company would conclude the strategic planning process with an investigation of the question "Have we arrived?" to ensure that the mission of the company has been achieved. As an alternative path in the process of determining "Who are we?" the company identifies its resources such as knowledge, expertise, vendors, equipment, production capacity, and channels of distribution. This information forms the basis of "How do we get there?" and the company must find specific products or customers who can be serviced by these resources. This path is often called "produce, distribute, and sell." These two approaches can affect the company's market approaches, such as mass versus niche and generalist versus specialist.

Merchandising within the Context of the Strategic Business Plan

All functions of an organization are involved with strategic planning and the resulting activities. The strategic planning process normally includes the executive management personnel in a company and the Vice Presidents or Managers of functional or divisional areas within the company. Large corporations may have a Planning Department or Division that directs the planning process. These personnel interface with the Executive Management and Vice Presidents to conduct the strategic planning process. Through this planning process, the merchandising function, as well as all other functions in the company, becomes an integral part of the strategic business plan. Through the Vice President or Manager of Merchandising, concerns, needs, and other inputs are entered into the planning process, and target customer information and other research gathered in the merchandising process may also be put into the planning process.

The inputs and outputs of strategic planning are a reciprocal process. **Inputs of strategic planning** include market research about the business environment, sales history, and potential and past target consumers. For example, a buyer would examine a schematic of financial information from the past five years as well as promotional activities and weather conditions. **Outputs of strategic planning** include the immediate outcomes of the confirmation of the target customer and the positioning of the company within the market (see Chapters 5 and 9) as well as the background information for the presentation of the Profit and Loss Statement and the itemization of the budgets, the development of the market plans, and the identification of products in the Line Development Process Cycle or the Buying-Selling Cycle (see Figure 2.12).

Profit and Loss Statements

Financial planning for the merchandising process begins with the development of a **Profit and Loss Statement,** or a **P & L Statement,** from the information collected in the strategic planning process (see Figure 2.12). Some companies

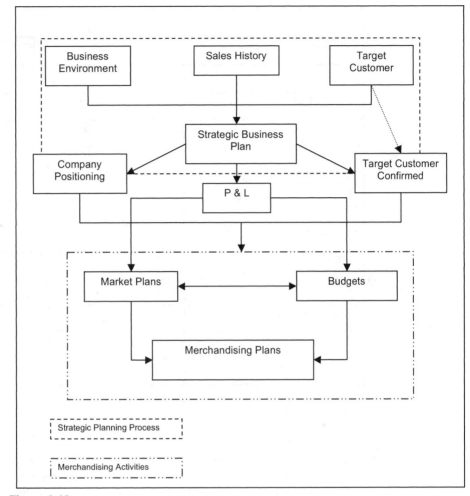

Figure 2.12
Inputs and outputs of the strategic business plan.

may call this an income statement or an operating statement, which reflect the composition or purpose of the plan. A very simple P & L Statement is shown in Figure 2.13. The statement at this stage in the process is a planning tool. As time passes, the financial planners and buyers work to adjust the statement to an actual statement that reflects what expenses and sales the company actually experienced.

The three basic components of the P & L Statement are income, expenses, and profit. For the *income* component, this document details the sales volume goals the company plans to achieve through sales and other money-generating sources (e.g., lease departments). Because the P & L Statement is an outcome of the strategic planning process, the components of the plan are projected or planned for the upcoming season, six-month period, or year and are called the

Retail Store Profit and Loss Statement		
Year: 20XX		Planned Sales: $44,000.00
	$	%
Gross Sales	$44,880.00	102.00%
- Reductions	$880.00	2.00%
= Net Sales	$44,000.00	100.00%
- Invoice Cost of Goods	$21,120.00	48.00%
- Transportation	$880.00	2.00%
= Maintained Markup	$22,000.00	50.00%
- Alterations	$440.00	1.00%
+ Cash Discounts	$2,200.00	5.00%
= Gross Margin	$23,760.00	54.00%
- Operating Expenses	$13,200.00	30.00%
= Operating Profit	$10,560.00	24.00%

Figure 2.13
Sample profit and loss statement.

planned components. The income component in this planning document is often called *planned sales*. The other two major components in the P & L Statement are the *margin* (or *markup*) and the *cost of merchandise*.

For most companies in the FTAR Complex, **planned sales** consist of the dollars generated from sales of their product or services for which they charge. For example, retailers take in income because they sell merchandise to consumers. They may also sell such services as gift wrapping, layaway, personal shopping, and bridal consulting. Some of these services may be included in the cost of purchases and not allocated through separate charges. In addition, companies may have income from rent (e.g., leased spaces within a store or leased properties) and investments or other incomes not directly related to the sale of the product. However, the majority of income for any company in the FTAR Complex is usually from sales of products and services.

Calculations for the P & L Statement usually start with the plan made for the volume of planned sales expected for the company. A variety of methods can be used to calculate sales. The decision on sales volume and any changes from the previous year or the previous season is an outcome of strategic planning. Executive management in conjunction with Vice Presidents makes this type of

decision along with the action plans and other strategic directions for the company. For example, a company that determines a positive forecast from its environmental scan and makes action plans for growth of sales would predict an increase in sales. Recent past sales that show a continued increase could be used by financial planners to justify this planned increase in sales.

Margin includes the subcomponents of **operating expenses** (or expenses) and profit or loss. **Expenses** for retailers include but are not limited to such items as salaries for employees, maintenance of retail stores, expenditures for promotional activities, and other general expenditures for operating a business. Expenses of operating the business could include rent for the space, insurance on the building, if owned, and the inventory of merchandise, fixtures, and other company improvements to the space. Wages for sewing operators in manufacturing, in contrast to salaries for sales associates in retail, are placed in another separate component of the P & L Statement called *labor*.

Retail companies have the costs of purchasing the merchandise offered for sale, and manufacturing companies must purchase the fabrics or other raw materials to make the end products. These costs for merchandise may be included in the expenses component in the P & L Statement; but, more likely, for retailers of fashion products, these costs are in a separate component in the statement called the **cost of goods.** For apparel manufacturers, the cost of goods includes the cost of fabric and findings (e.g., thread, zippers, buttons). Raw materials producers have the cost of the chemicals needed to produce or refine the fibers they manufacture. The component of cost of goods or its equivalent becomes the monies directly allocated for merchandising budgets—in other words, the monies used to buy the merchandise.

Careful planning is critical so that income from planned projections for the P & L Statement is large enough to cover the expenditures for paying the operating expenses, purchasing the merchandise, and allowing for remaining monies to compensate stockholders, owners, and other stakeholders for their investments in the business and to facilitate business expansion or other future plans of the company. These remaining monies are the **profit** from the business or the **loss** if the business has more costs and expenses than income. Profit or loss, the bottom-line component of the P & L Statement, is usually calculated both before and after taxes. The P & L Statement is of major importance because it dictates the dollars available for any function or activities. Sales promotional budgets, number of employees available for working in specific areas of the company, and dollars available for business growth are controlled by this statement.

Budgets

The P & L Statement is essential to merchandising activities. From the dollars indicated in the P & L Statement (see Figure 2.13), the Merchandising Division develops the budgets that will be used for the merchandising activities (see Figure 2.12). Several types of **budgets** providing guidance of total dollar and

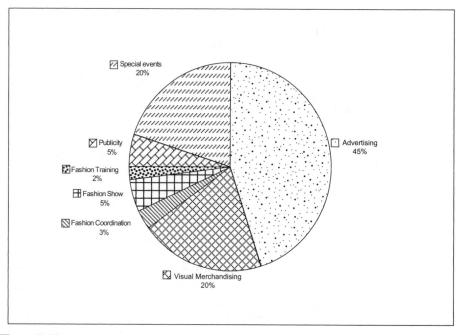

Figure 2.14
Promotions budget.

allotment allowance are frequently generated by the Merchandising Division. They delineate specific dollar amounts to be spent in each category. For example, from the P & L Statement, the buyer receives an allocation of dollars, based on the planned sales for a specific department, for the development of the sales promotion budget. The detailed sales promotion budget must be created by the Sales Promotion Division personnel from those dollars, and any promotional activities planned for that department must be conducted within this allotted budget (see Figure 2.14).

Market Plan

The P & L Statement, along with the company positioning and target customer confirmation, brings information from the strategic planning process to the Marketing and Merchandising Divisions. From this broad background, these Divisions have guidance for their development of the details for the market plan and other merchandising activities (see Figure 2.12). The **market plan,** as an indirect outcome of the strategic business plan, combines information from answers to both questions: "Where are we going?" and "How do we get there?" The market plan as well as the budgets affects the line strategy process (see Figure 2.12). Decisions made in product line planning and product line

development, such as product choices, market trips, and merchandising plans, are based on this information.

The company's reaction to the business environment, especially for a contemporary or consumer-centric company, is driven by the company's **marketing concept** or management's philosophy and system of policies and procedures for meeting the needs and desires of the target customer while conducting a profitable business. Within this concept, **marketing** is defined as all business activities that focus on customer wants and needs, that analyze those customer preferences and demands, and that provide the customer with the desired or needed goods and services. In other words, marketing is the total business interaction that includes the product planning, pricing, promotion, and distribution (place) as desired by the customer (people) which results in a profitable company.

Strategic Marketing

As noted in Figure 2.12, market plans are an outgrowth of the strategic planning process. Preparing the market plan in concert with the strategic planning process is often called **strategic marketing,** a process that results in the market plan. During the strategic marketing process, personnel in the Marketing and Merchandising Divisions work together to analyze the business environment and other business factors identified in the strategic planning process that are affecting their specific business units (Kotler & Armstrong, 2004). Strategic marketing means a company has a plan that is detailed in objectives and activities and targeted to a specific customer or groups of customers. It is guided by the business plan that was created during the strategic planning process. Although fashion appears to be a whimsical and often intangible property, planning for the merchandising of fashion must be a much directed, detailed, and integrated process created by a skilled team.

The basic steps in strategic marketing are (1) identifying company objectives; (2) doing an analysis of the market situation, which includes identification of market opportunities and segmentation of the target markets; (3) market selection, product differentiation, and product positioning; and (4) control throughout the process and evaluation at the conclusion of the marketing process (Kincade & Cassill, 1993). Table 2.2 shows the integration and overlap of these marketing strategy processes within the strategic planning process.

In step 2 of the strategic marketing process, personnel in a company's Marketing and Merchandising Divisions observe all potential customers and see that some customers within the total market have similar characteristics. This starts the process of pinpointing or selecting the exact consumer group (i.e., **target market**) for a company. Step 2 ends with **market segmentation,** or grouping consumers and dividing the market. Most companies do not have the resources to be all things to all consumers; nor do they have the resources to provide all products to some consumers. For this reason, companies seek segments of the market to which they direct their marketing and production efforts. In segmenting the market, researchers in a company look for similarities

Table 2.2
Strategic planning questions and steps for strategic marketing.

Strategic Planning Questions	Strategic Marketing Steps: The Market Plan Process
Who are we?	• Step 1 • Identification of company objectives
Where are we going?	• Step 2 • Analysis of market opportunities • Identification of market opportunities • Segmentation of the market
How do we get there?	• Step 3 • Selection of target markets • Product differentiation • Product positioning
Have we arrived?	• Step 4 • Control and evaluation of market process

and differences among consumers. They then seek to identify groups of consumers who are most similar within the group and very different when compared to other groups. This technique is used by retailers and by manufacturers and producers working with retail customers, when preparing products that are for sale to the final consumer. This marketing tool can also be used when producers or manufacturers are preparing products and developing marketing plans for selling to their respective customers.

A **market segment** is the grouping of people (i.e., customers) identified through market segmentation. This grouping becomes a viable target market when the company can identify the segment, when the people in the segment have needs and wants that can be addressed by the company's products, and when the people have enough money or there are enough people with some money to make the sale of the products profitable to the company. In addition, the people in the segment must be reachable by the company. With Internet advertising and sales, the ability to reach widely dispersed or otherwise inaccessible consumers has become easier. Market segments can be any size, from a segment of one to a segment that includes an entire population.

Products also have characteristics that are observed in the strategic marketing process. In **product differentiation,** these product characteristics can be developed or manipulated to match to the needs and wants of the customers. Trendy and cheap products from H & M and fast-moving fashion products from Zara are examples of retailers who have created product differentiation with a high rate of change in their fashion forward products ("The Future of Fast Fashion," 2005). The specific product is then marketed or positioned to the targeted segment of customers. This **product positioning** matches the right product to the right customer (see step 3 in Table 2.2).

Market Strategies

When market segmentation is linked with product differentiation, four types of market and product groupings and associated **market strategies** emerge. A **mass market** includes the entire population, and the same or an **undifferentiated product** is sold to the entire market. Although marketing strategy is used, segmentation is actually not applied with this market. With today's consumers, few products, if any, can be sold that would satisfy everyone in a large population. Perhaps most consumers would at some point purchase a basic white athletic sock, but even these are sold best if they are offered in variations of ankle height, fabric weight, and stretchiness. At the other end of the marketing strategy spectrum, the **niche market** is identified as one where **specialized products** are offered to only one, often small, market segment. The fur market is a niche market. Only a few people desire furs or have the need or income for furs; many consumers prefer not to own or see fur garments. Fiber producers who make Kevlar fibers and their customers who make bulletproof vests represent another niche market. They produce and market a specialized product purchased by a limited number of customers who need the product for a specific function.

The **segmented market** is one that can be divided into multiple groupings, and a **differentiated product** can be made and sold to each group. For example, the Gap Inc. has three different store groups—Old Navy, Gap, and Banana Republic—the corporation reaches most consumers through one of these retail outlets or channels (see Figures 2.15a, 2.15b, and 2.15c). They offer similar but different products in each retail format. For example, they offer skirts in all three stores, but each skirt is made with different fabrications, trims, or style features that are appropriate for each store, each store's customers, and retail prices. For example, the skirt in Old Navy is made of fabric containing a 50/50 acrylic and polyester blend, the skirt for Gap might be a 60/40 wool/acrylic blend, and the skirt for Banana Republic is fabricated in a 100% wool fabric. In addition, the fabric weight, yarn count, and dye range would vary across the three sets of products. Similar to the segmented market but different is the **multisegmented market,** which contains many segments and a specialized product is offered to each segment. Instead of offering a variation of a miniskirt to each market, the company operating in a multisegmented market would offer a miniskirt to one market, a pair of pants to another market, and a dress to the third market.

Marketing strategies, using market segmentation and product positioning, provide direction for such activities as promotions including advertising and other relations with trading partners, especially partners further down the supply chain. A market plan developed by a raw materials producer will affect activities throughout the supply chain including the retail sale. For example, a fiber producer, through strategic planning, recognizes its strengths in fiber research and in its partnerships with fabric producers. In answer to the questions of "How do we get there?" and "Where are we going?" the fiber producer chooses to conduct research and development in its labs for a new fiber that

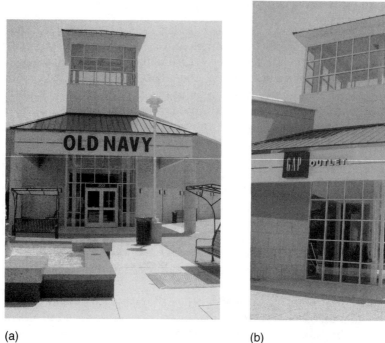

(a) (b)

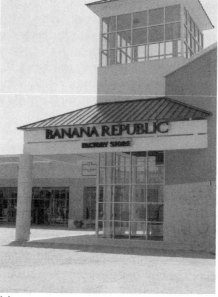

(c)

Figure 2.15 Gap Inc. reaches three market segments through: (a) Old Navy, (b) Gap, and (c) Banana Republic.

reduces body heat, and management decides to deliver the product through three of its top customers (i.e., fabric producers). In the P & L Statement for this fiber producer, planners estimate the potential sales for the product line of the new fiber. These sales estimates can be used to develop specific operating budgets for laboratory expenditures and new hires for laboratory staff and budgets for marketing activities such as advertising. Market plans are developed to provide specific direction for the look, content, and placement of the advertising. These activities by the fiber producer will provide direction for both the production plans and the promotional activities of the fabric producers. The top-three fabric producers will have a new fiber to include in their line planning, in their production and distribution, and in their own promotional activities. In completion of a market plan, a company will conduct a **market evaluation** (see step 4 in Table 2.2) of such measures of profitability as overall sales volume and the sell-thru of products to determine the success or failure of the marketing activities. This evaluation also provides feedback to the next cycle of strategic planning.

Marketing Tools

Traditionally, implementation of the market plan involved getting the right product at the right place with the right price and the right promotion. These steps became the standard **four P's of marketing:** product, place, price, and promotion. Contemporary companies not only use these standard four P's but frequently add *people* as a fifth P to develop their strategic plans and marketing programs. Various marketers have also identified additional P's, such as packaging and presentation, as well as pull-thru, push-thru, penetration, publicity, profit, and pipeline; however, the most commonly used marketing tools implemented by today's major consumer-centric companies are expressed in the **10 P's of Marketing** (see Table 2.3).

Regardless of the exact combination or number of P's selected, the company manipulates the P's to develop its **marketing mix,** the set of tools the firm uses to pursue its market plan in the selected target market. Because each company has its own mission and set of objectives in the marketplace, each P or tool in the marketing mix can hold a unique level of significance for the company as compared to other companies in the FTAR Supply Chain. Decisions about the P's and their prominence or avoidance by a company are a direct result of the strategic plan and market plan created by top management. Companies often seek a differentiation of the P's, especially in comparison to the marketing profile of their competition.

Merchandising Division and Its Relation to Marketing

As discussed in Chapter 1, marketing is one of the basic organizational functions of a consumer-centric company within the FTAR Supply Chain. Even though marketing is often established as a separate function, all functions in a company are accountable for getting the right product sold to the customer and must work together as a team to center on the consumer to provide product

Table 2.3
The 10 P's of marketing.

The Marketing P's	Definitions of the Marketing P's
People	People represent potential customers to purchase the product. In a market plan, people are the target customers for the company. For all companies in a supply chain, the ultimate people are the final customers or the consumers, who buy the product at retail for their use.
Product	Product includes all of the products and services that could be manufactured or sold by a company. The specific products selected represent the product line.
Pricing	Pricing includes the price of the product, the price of the product relative to other products in the company and price of the products produced by the competition, and other cost-related strategies for the company.
Position	Position describes how the company and its products are marketed and subsequently viewed by the customer relative to the competition.
Placement	Placement reveals what channels of distribution are used by the company to market and sell the product to the customer.
Presentation	Presentation of the product consists of merchandising the product in-store, of the fixtures and other display materials utilized to present product, and methods used for showing the product to the customer.
Promotion	Promotion comprises the outcome of decisions on what will be communicated to the customer and how this communication will occur.
Packaging	Packaging is the style, method, and appearance of the package, including hangtags and labels.
Processing	Processing is about the service that will be extended to the customer in the process of selling and maintaining the product and activities and technology needed to manage inventory.
Playback	Playback represents the feedback that is needed and how it will be obtained so the company can better understand the customer and how to market to that customer.

value and services that meet consumer wants and needs. Marketing activities are integrated into the other company functions, especially in the Merchandising Division. The Merchandising Division is closely related to marketing because this Division is responsible for developing or obtaining the product that will be handled by the Marketing Division. At retail, personnel in the Merchandising Division provide support for marketing activities because they are

responsible for planning an appropriate assortment of products, for procuring (i.e., searching and selecting) seasonal merchandise, and for initiating the plans for merchandise presentations for optimal selling to the target consumer. Merchandising employees who work with marketing activities include the product merchandisers who are responsible for developing the cohesive package of merchandise in the retail store. These product merchandisers (i.e., merchandising) work directly with visual merchandisers located in the Sales Promotion Division (i.e., marketing) to present and promote the store's merchandise selection through effective merchandise presentation and promotional activities. Without the Merchandising Division, the products would not be in the store to be promoted and advertised by the Marketing Division.

Coordinating efforts between marketing and merchandising are equally important for product manufacturers as well as retailers. For a product manufacturer, employees in the Consumer Marketing Department (i.e., merchandising) must work closely with the Image Communications Division (marketing) to ensure that the right product is available. Product merchandisers are responsible for developing apparel or home furnishings products and acquiring the raw materials to make those products. These employees must ensure that the products reflect the company's image, price range, available equipment, and labor skills, as well as the merchandise categories and fabric and fiber selections expected by their retail customer and the target consumer. Product merchandisers rely heavily on the skilled researchers in the Marketing Department to collect and analyze consumer data and vital statistics with regard to product and customer. Merchandisers need this information to assist them in developing the right product for the target consumer. Additionally, product merchandisers depend on the Marketing Department to conduct product testing and to collect POS and other retail store data. Of course, the Marketing Department is also responsible for the major marketing functions to help the product merchandiser sell more product to the retailer and to the target consumer.

At every tier in the FTAR Complex, the integration of marketing and merchandising is vital for the success of the market plan. For a raw materials producer, the Research and Development (R&D) Division (merchandising) is most directly involved with the development of new products, specifically new fibers and fabrics. The relationship between Sales and Marketing Departments (marketing) and Product Development Departments (merchandising) is often reiterative and ongoing (see Figure 2.16). Sales and Marketing Departments will provide information to R&D about products in demand by customers and products that they think they can promote and sell. Concomitantly with this activity, R&D will notify marketing of any new ideas for products or revisions on current products that they may develop in their laboratories. Fiber chemists, dye specialists, artists, and finishing experts are constantly searching for new techniques and new formulations for developing new products or improving products for customers. Because companies in this FTAR tier are often equipment intensive, machine specialists will be refining old processes and inventing new processes for producing products in support of marketing.

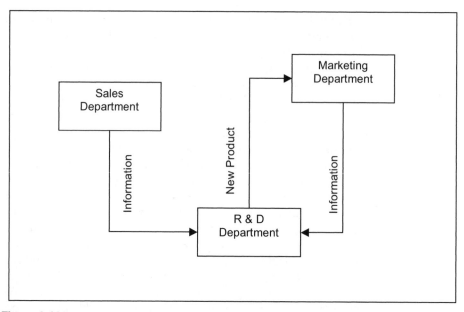

Figure 2.16
Integration of sales, marketing, and product development departments for the success of a market plan.

Other Divisions and Their Relationship to Marketing

At the raw material producer and manufacturer tiers, marketing personnel, along with product merchandisers and designers, team with personnel from sourcing, forecasting, manufacturing, and finance to develop the seasonal line with salable products. Each employee plays a specific role in providing information and support for all the efforts and endeavors of the product merchandisers. For example, at product manufacturers and raw materials production, plant managers must produce the products that are promoted through marketing and meet both quality and quantity in a timely delivery. For timely deliveries, fiber and fabric manufacturers must coordinate delivery times within their product schedules so that fabric can be delivered to cut-and-sew operations for completion and shipping to warehouses or stores. And products promoted in an advertisement must be in the stores at the times at which ads are scheduled to be run in the media.

Activities of employees in the Management Division impact product marketing in the retail store. At retail, store managers (management) must be aware of marketing activities in the market plan and prepare the store and store personnel for housing the merchandise, planning the in-store merchandise arrangement, and overseeing the visual merchandising program. In addition, personnel in Finance, Operations, and Human Resources must perform tasks as assigned to guarantee the smooth running of the company, including the paying of bills, hiring of employees, and maintaining accurate records for accounts. These divisions may also be in position to provide scanner or other data plus timely feedback from customers to be used by marketing and

merchandising personnel. Each person in a company makes a contribution, regardless of its magnitude or importance, to assist with both the marketing and merchandising of product or services so that the producer, manufacturer, and retailer can optimize sales and profit margins while meeting the demands and desires of the target consumer.

Merchandising Plans

The final outcomes of the strategic planning process are the **merchandising plans.** To develop a merchandising plan, the merchandisers and other company employees use all the information that has been collected during the strategic planning process, and they review any subsequent documents from strategic planning, such as the market plans and the budgets (see Figure 2.12). Merchandising plans may differ from company to company depending on a firm's place in the FTAR Supply Chain, but in all companies they should be based on company capabilities and strengths that are identified through the strategic planning process and are implemented within the confines of the finances detailed in the budget and in conjunction with activities delineated in the market plan.

Merchandising plans are guided by the mission statement, management philosophies, and confirmed or selected target customers. At this point, merchandisers determine the type of products to be produced and/or sold to meet the anticipated desires of the target customer and the ultimate consumer. In response to the questions in the strategic planning process, a jeans manufacturer will reply with general plans, such as "We want to increase our sales of jeans through expansion of companion products." In the merchandise plans, the product categories, including styling details, colors, and fabrications, are identified.

In addition to selecting products as part of initiating the merchandising plans, all links in the FTAR Supply Chain must decide on the number of lines offered during a time period as well as which lines will receive the most budgetary support. The decisions of budget, market, and product are not independent and linear but should be integrated and co-made, both with personnel within the company and personnel in partnering companies. Depending on the product classification, the target consumers, the company's sales history, the geographic location of the company, and the associated partnerships in the FTAR Supply Chain, the company will decide how monetary allocations (e.g., income from planned sales) will be made.

Summary

The strategic business plan provides companies with a road map on how to direct the company. In the 1960s, most companies, both manufacturing and retail, were product oriented. But as consumers gained knowledge about products and buying strength through increased wealth, companies were forced to consider the importance of the consumer in planning company activities. The

strategic planning process allows the company to consider company strengths and weaknesses as well as consumer and other market influences when planning the future of the company. Outcomes of the steps in the strategic business plan include the mission statement, strategic goals, action plans, and benchmarks. These outcomes become the input for the merchandising process. For example, the Profit and Loss Statement forms the foundation for the budgets used by merchandisers. Marketing plans are also built based on strategic planning process outcomes and provide direction for the company's implementation of the 10 P's.

Key Terms

10 P's of Marketing
Action plans
Alternative strategic planning
 path
Benchmarks
Budgets
Corporate culture
Cost of goods
Critical issues
Differentiated product
Environmental scan
Evaluation
Expenses
Four P's of marketing
Implementation
Inputs of strategic planning
Loss
Make, source, and sell

Margin
Market evaluation
Market plan
Market segment
Market segmentation
Market strategy
Marketing
Marketing concept
Marketing mix
Mass market
Merchandising plans
Mission statement
Multisegmented market
Niche market
Operating expenses
Outputs of strategic planning
Planned sales
Product differentiation

Product positioning
Profit
Profit and Loss Statement
P & L Statement
Pull marketing
Push marketing
Quantification of
 expectations
Segmented market
Specialized products
Specific strategies
Strategic business plan
Strategic goal
Strategic marketing
Strategic planning
Target market
Undifferentiated product

Review Questions

1. What is strategic planning?
2. Why does a company want or need to do strategic planning?
3. How has the focus of strategic planning changed since the 1950s? Why has this occurred?
4. What are the four basic steps of the strategic planning process? What occurs within each step?
5. What is the alternative path for strategic planning process, and why would a company choose this path?
6. What are the outcomes of the strategic business plan?
7. What are the parts of and the purpose of a Profit and Loss Statement?
8. Why is the Profit and Loss Statement important to planning budgets?
9. What is contained in a market plan for a company? Why is this needed?
10. What are the 10 P's?

References

DuPont. (2004). *Every day science*. DuPont 2004 Annual Review. Dover, DE: Author.

The future of fast fashion. (2005, June 18). *The Economist, 375*(8431), 63–64.

Hofer, C. W. (1976). Research on strategic planning: A survey of past studies and suggestions for future efforts. *Journal of Economics and Business, 28*(3), 261–286.

Kincade, D. H., & Cassill, N. L. (1993). Company demographics as an influence on adoption of Quick Response by North Carolina apparel manufacturers. *Clothing and Textiles Research Journal, 11*(3), 23–30.

Kotler, P., & Armstrong, G. (2004). *Principles of marketing*. Upper Saddle River, NJ: Prentice Hall.

Lee, G. (2005, February 15). Chico's set for major growth. *Women's Wear Daily*. Retrieved February 15, 2005, from www.wwd.com

Schlosser, J. (2004, October 18). How Target does it in a Wal-Mart world. *Fortune, 150*(8), 100–107.

Weitzman, J. (2003, December 3). Chico's comps rise. *Women's Wear Daily*. Retrieved February 15, 2005, from www.wwd.com

SECTION

II

*The Total Product:
Product Demand, Pricing
Strategies, and Channels
of Distribution*

The apparel product is a complex and unique consumer product. The raw materials for this product are varied and range from the soft smooth hand of a Pima cotton knit to the rough stiff hand of a hemp weave. The complexity of the raw materials and the combination of these materials contribute to the complexity and variability of the end product. In addition to the fibers, yarns, and fabrics used to make the apparel product, the product is varied by styles, colors, fit, and other physical attributes that can change with the season, the geographic location, the consumer, and the retailer.

Consumers wear the apparel product on their bodies and oftentimes close to their skin, so some consumers are concerned about the fit and the feel of the product. Apparel products are often manufactured and purchased to be used for multiple wearings; therefore, consumers also consider the postuse care and the life expectancy of the product. Some products are designed to provide the wearer with specialized functions, such as muscle support (e.g., spandex leggings) and protection (e.g., firefighter's coat) and other less specialized functions such as warmth (e.g., a winter coat) and cushioning (e.g., socks). Some of these attributes are created from physical features such as the structure of the fabric, the fiber content, or the finish applied to the fabric. Other features may be generated from the chemical structures of the fibers used in the fabric. In addition, some physical attributes are created by the way the product is designed, the fabric is cut, and the pieces are sewn together. The trim and other findings applied to the product also affect its physical presence.

Beyond the basic intrinsic physical or chemical properties of the product, apparel products have many extrinsic properties associated with these items. For example, most of the apparel products that consumers wear are seen by others (e.g., friends, family, colleagues, strangers). For this reason, consumers are concerned about not only how a product feels and fits on their own bodies, but also how the product appears to others and if their appearances are enhanced by the product. Apparel products can also contribute to a consumer's feelings of wealth, luxury, and status. The brand name of a product, the logo sewn on the outside or inside of the product, the store where the product is purchased, and the price of the product are all extrinsic factors associated with the product. For this reason, the total apparel product can be viewed as a core surrounded by concentric circles of extrinsic attributes that are created through marketing, services, images, and other promotional activities (see Figure S.2.1).

This cloud of extrinsic attributes, surrounding the physical product, may be created by the retailer, the product manufacturer, or by the raw materials producer. The alligator on the chest of a three-button knit shirt or the red, white, and blue flag on a dress shirt readily identifies the product as a certain brand or designer and *announces* to anyone who sees the shirt that this was an expensive shirt and the wearer is given some prestige by those who recognize these brand logos. These extrinsic attributes may also be generated by a trade organization or other auxiliary firms. For example, Cotton Incorporated, a trade organization with the purpose of promoting the use and sale of cotton, often advertises on TV and in magazines to create a certain image about apparel items made from cotton fibers.

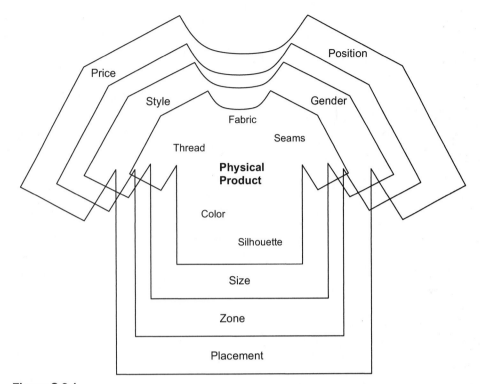

Figure S.2.1
The total apparel product.

In the following chapters, the product, in both its physical attributes and its extrinsic halo of attributes, is examined. Chapter 3 reviews the physical product, including the sizes, style characteristics, and seasonal changes. Chapter 4 explores the price of products, both at retail and wholesale. Chapter 5 covers cues, images, and brands that can be developed to augment the product, and Chapter 6 reviews multitude of retailers that sell the retail product.

chapter

3

Product

Objectives

After completing this chapter, the student will be able to

- Identify the types of merchandise available in the FTAR Complex
- Describe the style structure in the apparel segments of the FTAR Complex
- Explain the product categories according to gender and size
- Itemize the product lines available for each product type
- Identify the zones for the apparel industry in the FTAR Complex
- Describe how zones are formed and their use in the FTAR Complex
- Define the product life cycle as it relates to the sale of fashion goods
- Explain how product classifications can be altered by fashion, season, and trend modifiers
- Describe how the product grid can be used to determine the volume of production and the amount of trend variation

Introduction

Based on the strategic marketing process used by a consumer-centric company, the company would conduct adequate market research on the lifestyle of the consumer, identify the exact product classifications with specific characteristics and merchandise assortments that the target consumer needs and wants, concentrate on focused development of product with a value system identified through consumers' feedback of those desired needs and wants, and then eventually deliver the product in the right channel of distribution to sell the product

to the consumer at a profit. Product differentiation through focused product development and selection is aimed at the profitable initial sell-in to the retailer, push-thru of in-season innovations in a cost-effective manner to the company's client in the various links of the supply chain, and ultimately sell-thru to the target consumer. As part of the third step in strategic marketing, the company must identify which type of merchandise to produce for which target consumer and select which product categories (i.e., gender, size, price, zone), product lines (i.e., seasonal lines), and types of product classifications (i.e., position on Perceptual Map of Product Change) within those lines to produce. Concurrently, the company must pinpoint the fashion taste level of the target consumer and fashion trend direction required in creating the product and define the value system and the quality level to be incorporated into the product.

Types of Merchandise

The type of product produced by a company is usually delineated in the company's strategic plan as part of the question "How do we get there?" Prior to these decisions, a business must determine in what segment of the textile, apparel, or home fashions industries that it wishes to do business. Even established businesses must reassess their product strategies in a highly competitive marketplace. Sometimes the type of product is selected without extensive research because the personal interests or market research conducted by the company owners dictate what type of products will be produced for which target consumer. For example, an interest and ability in sports by the owner and founder was the selection driver behind the formation of the Under Armour brand ("About Under Armour," 2007; Hyman, 2003). For established companies, the existing organizational structure and management style as well as the skill and expertise of the workforce, the factories or available buying structures, the equipment owned by the company, and even patents and trademarks already owned by the company may control what product(s) are produced by a company. Because of capital-intensive or skill-intensive operations, textile, apparel, and home furnishings companies operate in a highly segmented but extremely competitive environment.

For example, a fabric producer must decide what type of fabric will be produced and what segment of the market it wishes to target (see Figure 3.1). In the strategic marketing process, the company must first decide if it will produce product for the apparel industry and what segment(s) of the industry (i.e., women's, men's, children's), the home furnishings industry (i.e., upholstery, window treatment, carpet and floor coverings), the automotive industry (i.e., upholstery, headliners, floor coverings or carpeting), the industrial segment (i.e., medical, protective fabrications, industrial materials), or for several of these segments in the supply chain.

Sometimes the selection of industry segment dictates other decisions. If this fabric producer selects to make automotive fabrics, the fabric will be a knit in a limited range of colors and prints. In another situation, the company's decision might be based on the available equipment that the company wishes to keep in working order or the expertise of the company's workforce. For example, a fabric company that has weaving equipment for making velvet fabrics may choose to

Figure 3.1
Decisions on what merchandise is right for the company.

use this equipment and seek customers and products that use velvet. A home furnishings company must determine if it wishes to specialize in bedding (e.g., mattress pads, sheets, bedspreads, coverlets, duvet covers), in bath products (e.g., towels, mats, shower curtains), in window treatments (e.g., curtains, draperies, blinds), or in carpets and floor coverings (e.g., area rugs, mats) or in two or more of these areas. In fiber and fabric production, most product areas require employees with unique skills and specialized machinery for producing product.

Style Structure

In addition to general type of merchandise, management must select the style structure in which it wishes to operate and the geographic locations of the fashion centers in which it wishes to show product. The **style structure** of the women's fashion apparel industry includes haute couture (i.e., European designer apparel), prêt-à-porter (i.e., European ready-to-wear), designer (i.e., U.S. designer apparel), or ready-to-wear (RTW) (i.e., U.S. mass-produced apparel). **Haute couture** is a French term that translates as fine sewing or custom design, which results in made-to-measure garments fit to one specific consumer. Some well-known European designers are Yves St. Laurent, Karl Lagerfeld, Valentino, Christian Dior, and John Galliano. The House of Dior has dressed women in famous designs since his "New Look" in the 1940s and his H look and A line in the 1950s and 1960s (see Figure 3.2). **Prêt-à-porter** is the French term for ready-to-wear or mass-produced fashion. Mass-produced fashion in France should not be confused with mass-produced fashion in the United States, because prêt-à-porter garments are very costly, yet do not have the exclusivity of designer apparel.

In the United States, designers may own their own companies or they may design for other companies. A designer may create a one-of-a-kind **designer**

Figure 3.2
A Christian Dior-New York label in an evening wear jacket.
(Courtesy of Oris Glisson Historic Costume and Textile Collection, Department of Apparel, Housing, and Resource Management, Virginia Tech.)

garment for an individual consumer; however, because of the cost of operating a business, these designers may also create **signature collections** and **secondary lines** sold to exclusive specialty and department stores. With current industry directions and the present economy, some well-known designers are even designing mass-produced exclusive lines for department stores such as Macy's and Bloomingdale's (e.g., H by Tommy Hilfiger), JCPenney (e.g., Parallel/BCBG Max Azria Group) as well as mass merchants such as Target (e.g., Mizrahi, Mossimo) and Kmart (e.g., Thalia). Well-known American designers include Bill Blass, Perry Ellis, Oscar de la Renta, Ralph Lauren, Calvin Klein, Donna Karan, and Tommy Hilfiger. In the U.S. apparel industry, **ready-to-wear (RTW)** denotes mass-produced merchandise that is sold at all price points to the average population or target consumer. The U.S. ready-made or RTW segment of the apparel industry has its origins in the manufacture of uniforms for the U.S. Civil War and the first commercially available clothing for men ("Standardization of Women's Clothing," 2004). Women's RTW in the United States came much later. RTW for women was advertised in the 1920s as fashionable and modern; however, popular brands and better quality RTW were not readily available until the 1950s.

Retailers carrying women's wear must decide if they will carry designer haute couture or prêt-à-porter apparel from Europe and other countries or if they will buy designer or U.S. ready-to-wear merchandise or imported product from numerous other countries. In between the designer line and the contemporary line is the **bridge line** of clothing. Brands such as Ellen Tracy and Dana Buchman in the 1990s were considered very prestigious bridge lines (see Figure 3.3). Some retailers carry a combination of these products in their merchandise mix. Other manufacturers and retailers produce and/or sell moderately and lower priced **knockoffs,** or copies of high-priced designs.

Menswear manufacturing companies must decide if they wish to produce traditional tailored clothing, sportswear, activewear, or more than one of these categories of product. In addition, menswear retailers must decide if they wish to obtain designer clothing from Europe (e.g., Italy, England) and/or from U.S. designers such as Ralph Lauren or Tommy Hilfiger. Or they might have to make decisions about purchasing traditional tailored clothing from well-known companies such as Hartmarx, Oxford Industries, or other U.S. companies. Additionally, they must consider if a **contemporary line** of trendier clothing for fashion forward consumers is what is needed in their merchandise mix or if a bridge line of clothing (i.e., men's apparel between designer and contemporary) is needed for the target consumer.

Children's wear manufacturers must also determine what types of products they wish to produce, and children's wear retailers must decide if they will carry designer apparel, such as Polo or Dior, or if they will stock national brands, private label, or generic brands. Although designer merchandise is available in children's wear, a more common decision is what type of character, movie, or other licensing agreement the company will use to have the most popular or tried-and-true book, movie, or cartoon characters on the garments. For example, the Disney Company contracts with companies to make apparel and other products containing images of the traditional Mickey Mouse to the latest character

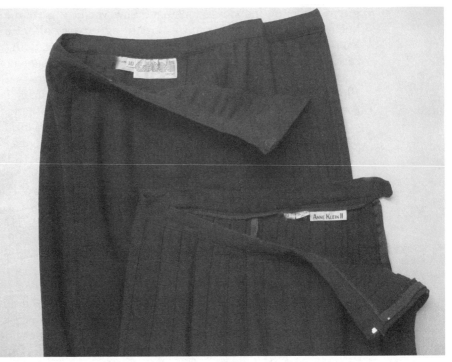

Figure 3.3
Basic black skirts with bridge labels become unique to consumers.

from the newest movie. These items are sold in a variety of retailers as well as in the Disney retail stores. Recently, many companies have decided to license their name to children's wear products. Firms such as John Deere that have never been in the apparel business, are now putting its name on clothing. In addition to decisions on designer versus ready-to-wear merchandise, children's wear companies as well as men's and women's wear companies must decide if they will produce or carry the product under a brand name, a private label, or as a generic classification. Licensing decisions may require legal contracts and other paperwork, such as the licensing product approval form in Figure 3.4.

Product Categories

Within the FTAR Complex of fiber, textile, and retail companies, the apparel industry is segmented into specialized clusters called **product categories.** These categories can be further subdivided into classifications and items (see Table 3.1) and are also segmented by gender as well as size ranges. Each category has unique characteristics with implications for fit, style, and manufacturing requirements. The classifications of the product categories impact the entire supply chain. For example, in menswear, textile mills specialize in fabrics that are

LICENSED PRODUCT APPROVAL FORM

By submitting this product concept for review, it is understood that all trade rights, trademarks, service marks, or copyright, including goodwill, titles and all other rights in product and design are reserved by COMPANY except for licensee's right to use the property as expressly provided in its licensing agreement. LICENSEE acknowledges that it shall be responsible for conducting any intellectual property related clearance of LICENSED PRODUCTS, and for any text or graphics proposed herein for use on LICENSED PRODUCTS. LICENSEE shall be liable for and hold COMPANY harmless from any such infringement claim as specified by the terms of the LICENSEE AGREEMENT. LICENSEE herby agrees to the above.

Licensee Accept above statement: _____*(hand signature or initial*)
Licensee Decline above statement:_____ *(advise why)*

TO BE COMPLETED BY LICENSEE: *DOCUMENT REF* #:_____*(given by licensee)*

Licensee: _____ Date Package Sent to Licensor: _____
Phone: _____Fax:_____ Email: _____ Contact Name: _____

Concept #: _____ / Name: _____ / Style #: _____Season/Year _____
Description: _____ Colorways Submitted: _____

() CONCEPT APPROVAL
Comments from Licensee: _____
Date Rec'd: ___/___/____ Date reviewed: ___/___/___

☐ APPROVED/ PROCEED TO NEXT STEP ☐ NOT APPROVED

☐ CHANGES NEEDED & NEED TO RESUBMIT

LICENSOR SIGNATURES: _____Date_____ / _____Date_____
 Designer Category Manager

() PRE-PRODUCTION APPROVAL
Comments from
Licensee:_____
Date Rec'd : ___/___/___ Date reviewed : ___/___/___
Colorways Submitted: _____

☐ APPROVED FOR PRODUCTION (FINAL) ☐ PRODUCTION SAMPLE REQUIRED

☐ CHANGES NEEDED & NEED TO RESUBMIT ☐ NOT APPROVED

Licensee to submit labeling information in separate sheet, prior to FINAL Approval
LICENSOR SIGNATURES: _____Date_____ / _____Date_____
 Designer Category Manager

() PRODUCTION SAMPLE
Comments:_____
Please Note: All items shipped must have are turn label provided for each box that is to be returned.
Please allow 10 business days for a response.

Figure 3.4
Licensing agreement for product approval.

destined for men's suits to the exclusion of other fabrics; apparel manufacturers who cut and sew tailored suit jackets do not make bathing suits or women's blouses. And retailers specialize in men's suits (e.g., Brooks Brothers) and carry limited apparel in other product categories, or retailers such as S & K Men's Stores and Men's Wearhouse have expanded from suits to broader merchandise

Table 3.1
Examples of basic product categories, classifications, and items.

Product Category	Product Classification	Product Items
Tops	T-shirts	Crew neck, short sleeve, jersey knit Crew neck, long sleeve, jersey knit V-neck, short sleeve, jersey knit V-neck, long sleeve, jersey knit
	Dress shirts	Button-down, long sleeve, plain cuff, oxford cloth Button-down, long sleeve, French cuff, oxford cloth Open collar, long sleeve, plain cuff, broad cloth Open collar, short sleeve, broad cloth
Bottoms	Shorts	Flat front, mini-length, twill Pleated front, mini-length, twill Flat front, walking length, twill Pleated front, walking length, twill Pleated front, walking length, elastic waist, twill
	Pants	Flat front, straight leg, twill Flat front, straight leg, twill with spandex Pleated front, boot-cut leg, twill Pleated front, full leg, elastic waist, twill Pleated front, full leg, elastic waist, twill with spandex

selections. At each level of the supply chain, the firm specializes in the unique skills and knowledge needed to manufacture or sell this product category.

Within product categories are the **product classifications,** the subcategories or smaller groupings of merchandise, which are frequently organized according to consumer use or the occasion of their use. Within each product classification are numerous separate and distinct items of clothing, accessories, and other apparel products, with unique styling features, fabrications, and colors.

Availability of product categories varies according to many consumer or societal influences as well as industry capabilities and technology changes. For example, with the 1990s trend of the business casual workplace, the consumer purchased fewer suits and fewer jackets; therefore, manufacturers began producing fewer of these items in their seasonal lines of apparel. With a more *casual lifestyle* in the United States, many consumers are purchasing fewer dresses, fewer formals, and more sportswear items. Jeans are the norm for fun to formal wear. Traditionally, dresses were top-selling product categories in the women's wear industry; however, with the change in the workplace, the busy lifestyles of dual-income families, and social trend changes, this product category has not returned to the prominence it held in the marketplace during the late 1950s and early 1960s. Dresses are in a revival stage in the mid-2000s with

the preferences of the Generation X and Generation Y customers. Additionally, consumers are "dressing down" for many occasions when previously dress attire was the norm. For example, flip-flop shoes have become acceptable for street wear and are no longer considered just for the beach, pool, or playwear. In the early 2000s, college students began wearing flip-flops to replace the athletic shoe and sandals, and one college sports team made news when wearing flip-flops to the White House. In fact, these hot items are being carried by retailers not only in Shoe Departments but also in Accessory Departments and outposts in the retail store. Additionally, these items are found in all channels of distribution and at price ranges from $5.99 for discount versions to $149.99 for designer versions.

Women's Wear

No segment of the industry is more specialized in producing a multitude of product categories than the **women's apparel** segment. This segment was traditionally called **ladies' wear,** but is more frequently called **women's wear,** and merchandisers see all three terms now used within the industry to indicate the segment of the industry that designs, produces and sells apparel for women. Because of the variety of products, the purchasing power of the consumer, and the impact of the fashion cycle on the product, apparel manufacturers have capitalized on their managements' expertise, skills of a trained labor force, and their factory capabilities and available machinery to produce a specialized product. For example, inserting zippers into denim fabric is very different from sewing on super-smooth heavyweight satin. Because of these production restrictions, the bridal industry operates autonomously from dress manufacturers, and dress manufacturers usually do not produce sportswear or lingerie. All of these products are produced by highly skilled sewers with specialized expertise in sewing a specific product category. Even the market showrooms are separated by location in the garment district or at regionally market centers by product categories. For example, designer dresses may be found on Seventh Avenue; some sportswear is located in a specific building on Broadway.

For the ladies' market, the major product categories include ready-to-wear, sportswear, swimwear, active wear, intimate apparel, and maternity and uniforms for product types and the specific categories within each type (see Table 3.2). Based on the zone of the merchandise including fashion trend direction, discussed later in this section, some product categories are produced under more brands and in more price ranges and sizes than other product categories.

Typical product classifications for women's wear are also listed in Table 3.2. *Ready-to-wear,* which represents a style structure as well as a product classification, has traditionally included most of the product classifications of clothing that many consumers wore every day and classifications of items requiring formal attire. **Sportswear** includes classifications of items that were once reserved for weekends, leisure times, and the golf course or a day on the boat. Now, these specialized use items are worn in everyday situations. This classification represents a major portion of the merchandise mix for many retailers

Table 3.2
Women's wear product categories, classifications, and items.

Product Categories	Product Classifications	Product Items
Ready-to-wear	Outerwear	Coats, jackets, rainwear
	Dresses	One- and two-pieces, jacket dresses, coat and dress ensembles
	Suits	Jacket and skirt unit, jacket and pant unit
	Formals	Cocktail, "After 5," evening wear
Sportswear	Coordinated groupings	Group of product classifications (i.e., jackets, skirts, pants, tops, sweaters, blouses, shirts) that match in color, fabric, pattern, and theme and are sold as mixed and matched units based on consumer preference for needed classifications
	Related separates	Separate product classifications (i.e., jeans, pants, shorts, skirts, blouses, shirts, tops, jackets) that may or may not be sold as units
	Playwear	Casual sportswear classifications worn for street wear to resort wear to active spectator sports
Swimwear		One- and two-piece suits, cover-ups, coordinating items
Activewear	Athletic apparel	Sweats and exercise attire, tennis, golf, running, cycling, skiwear
Intimate apparel	Lingerie	Slips, petticoats, panties, camisoles, pajamas, nightgowns, bodywear
	Foundations	Bras, girdles, shapewear
	Loungewear	Negligees, robes, housecoats, bed jackets
Maternity		All product classifications
Uniforms		Professional and school
Bridal		Bridal gowns, bridesmaid dresses, mother-of-the bride and groom attire

and the total merchandise assortment for some companies. Other classifications are more highly defined and represent specific consumer uses, such as **swimwear, uniforms, maternity,** and **bridal,** which may be offered in ready-to-wear styles but are usually bought as separate product categories because the vendors selling these products are frequently different from other RTW items, and fabrications and seasons are different from the typical selling seasons.

Because of the increased adherence to a casual lifestyle and to save time, women began wearing **activewear** from the gym to the street. These consumers not only wore activewear for the convenience of running from the gym or off the tennis court or golf course to the grocery store or hair stylist but also for making a social statement to imply they were on the same health craze as their

active peers or neighbors. This fitness craze and the casual lifestyle, combined with the emergence of women in college and professional athletics, created a demand for more activewear. Not only did the major athletic companies such as Nike, Rebok, and Adidas cash in on this apparel trend, but other apparel companies with the needed expertise began producing the streetwear version of the product to get in on the action (see Figure 3.5). Additionally, activewear created an industry need for innovative performance fabrics for the active athletic and more design details in the product for streetwear attire. The product change in this category impacted the entire FTAR Supply Chain from fiber producer to retailer store owner. For example, fibers developed for high-performance athletes are now being used in men's dress shirts and children's playwear.

With the trend of innerwear being worn as outerwear, many apparel manufacturers are producing more lingerie or lingerie looks to provide the product requested by consumer demand. This demand also increases the demand for fabrics and trims that are used to make lingerie products. The growth of demand in one area creates an illusion of industry growth; however, when one particular product becomes more prevalent in the fashion cycle, the product it replaces usually fades in importance and in sales volume. For example, when the camisole became an important top and replaced the blouse, fewer blouses were produced and sold; therefore, blouse manufacturers had to adapt and produce the camisole to maintain their annual sales volume or go out of business. And the resurgence of the suit for women has come as a loss to dress manufacturers. Some changeover in product classifications for manufacturing is not easy because of dedicated equipment and sewing operators who have specialized skills.

However, in the 2000s, there has been a return to **professional attire** in the workplace, and the "power suit" for women has made a comeback (see Figure 3.6). In 2008, this trend was further fueled by the pants suits that Hillary Clinton wore while campaigning. When a trend pushes the return of a product category, the consumer will then find these categories produced by many apparel companies under several brand names, in most channels of distribution, and in several departments in the retail store.

Availability of product category is also impacted by the people (i.e., target consumer) or a shift in demographic segments at any given time in the production cycle. When a substantial number of consumers in a large population segment such as Generation Y begin to marry and have children, specific product categories also shift in availability, variety, and/or price. For example, the bridal industry has become very lucrative as affluent consumers have begun buying very lavish gowns and wedding attire for Generation Y brides. Although this market is unique because the product requires custom fittings and specific accessories and innerwear, the industry does not depend on the loyalty of the customer or a return customer because of the nature of the event. In a related example, with Generation X beginning families, the maternity industry is now blooming again. Recent trends such as the increase in numbers of young pregnant women who are working in either a casual workplace or in employment that demands more professional work attire, and the more casual lifestyle have

Figure 3.5
Activewear designed for gym and worn for streetwear.

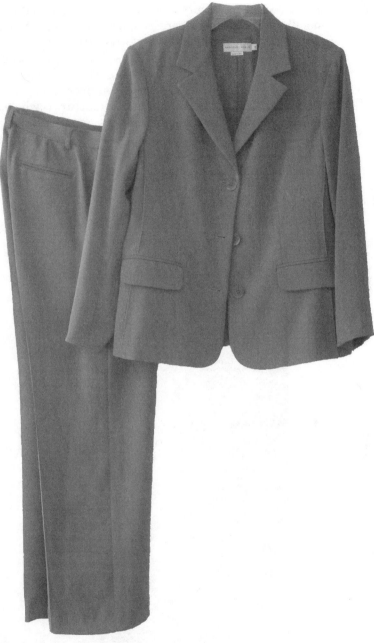

Figure 3.6
Professional attire for women: The Power Suit.

impacted the maternity wear industry. These young consumers are now demanding trendier, easy-care, comfortable, and functional maternity wear. Thus this industry segment has been forced to produce more product categories with more design detailing, which must be sold at higher price points. Another product classification that is changing for women's wear is **workwear,** or clothing for people who work in the outdoors and perform trades type jobs (see Figure 3.7). Several brand-name manufacturers who have traditionally carried overalls, work jackets, and other work apparel items for men are now making these items with fit and design features for women who are painters, carpenters, bricklayers, and other trade laborers (Binkley, 2007).

Figure 3.7
Workwear for women.
(Courtesy of Carhartt Inc.)

Menswear

During the last two decades, probably some of the most remarkable product category revolutions in the textile and industry have taken place in **menswear.** This product category has been impacted by the change in the casual workplace, social norms, and the casual lifestyle. Traditionally, tailored clothing was the norm for the businessman as was the uniform for the worker in certain trades and professions. As long as a gentleman had nice tailored gray, navy, and black suits as well as a week's worth of white dress shirts and several ties, he had a wardrobe for the office. **Tailored clothing,** as the name indicates, may be produced with hand-tailoring techniques and is structured or semistructured (see Table 3.3) for menswear product categories; therefore, it is usually more

Table 3.3
Menswear product categories.

Product Categories	Product Classifications	Items
Tailored clothing	Suits	Two- and three-piece units
	Topcoats, Overcoats	
	Sport coats	
	Trousers	Dress slacks
	Formal wear	Tuxedos, separates
Heavy outerwear	Skiwear, windbreakers	
Sportswear	Jackets	
	Related separates	Knit and woven tops and shirts, casual slacks, dress shorts, sweaters
	Jeans	
Furnishings	Shirts	Dress shirts
	Underwear	Boxers, briefs, undershirts, long johns, innerwear
	Hosiery	Socks
	Neckwear	Neckties, bow ties
	Sleepwear	Pajamas, robes
Activewear	Athletic apparel	Exercise attire, running suits, golf, tennis, cycling, skiwear, extreme sports
Accessories	Belts	
	Gloves	
	Jewelry	Tie pins, cuff links, jewelry (e.g., necklaces, bracelets)
Work clothes	Overalls	
	Coveralls	
	Related separates	Slacks, shorts, shirts, tops
Uniforms	General office	Slacks, shirts
	Specialized work	Medical coats, heavy-duty overalls, protective vests, fire-retardant jackets and pants

expensive. Quality, fit, and durability were the benchmark for tailored clothing product categories. However, today many of the former hand-tailored operations are now sewn automatically by machines. Although automation can lower the labor costs in menswear, the dedicated equipment required to handle these operations restricts the style changes (e.g., changing collar width) that a company can make because style changes require expensive retooling of equipment.

The separate slack and sport coat could be worn for weekend wear or casual occasions, and activewear was worn in the gym, on the tennis court, golf course, or at the shore. Sportswear includes both knit and woven shirts and tops, jackets, casual slacks, shorts, jeans and sweaters; activewear includes active sports clothing for exercising such as running, golfing, skiing, tennis, and other extreme sports as well as attire for the "wannabes" who sit in the stands and observe the active participants. In fact, the introduction of color in men's fashions has been credited to the use of color in athletic uniforms and the acceptance by young men to adopt color in the wardrobe.

Baby Boomers further changed the face of this part of the apparel industry with the casual workplace and "Dress-down Fridays." The casual workplace coupled with a casual lifestyle and extreme sports have created a demand for men's sportswear, activewear, and fashion apparel. In conjunction with the changes in styling, this segment of the industry has also experienced large changes in fibers and fabrics. New fabrications are meeting the demands of this consumer, such as the microfiber content for fabrics that are cool, comfortable, and look great, and the no-iron and stain-resistant finishes so those casual pants are always crisp and the shirts are never wrinkled. These new microfibers are also making the wash-and-wear suit a possibility in menswear (Jones, 2006). Contemporary men are no longer afraid of color, trendy fabric, and fashion silhouettes in their attire.

Another major product category in menswear is that of furnishings. Men's **furnishings** include men's dress shirts, neckwear, underwear, hosiery (i.e., socks), robes, and pajamas. Work clothes and uniforms such as coveralls, overalls, and related separates such as slacks and pants are also product categories in demand by the semiprofessional and trade customer as well as other customers when the fashion trends dictate a certain look that may be achieved by purchasing items in these categories.

Children's Wear

The **children's wear** category is very unique. Manufacturers may specialize by product or size range. For example, a company may produce only infant's knit apparel or only girls' dresses for toddler to preteen or only sportswear for girls ages 7 to 14. However, some children's clothing companies produce both dresses and sportswear unlike most women's manufacturers. Also, the age of the child and the size ranges in children's wear many times dictate the product category to be produced because of society's expectations of what children of a certain age should wear. Another factor to be considered when planning, producing, or buying children's wear products is that some parents are hesitant to

purchase high-priced trendy products for a small child because the child is changing sizes very rapidly. In contrast, as a younger more affluent customer, some parents are now purchasing designer apparel, even at the infant age, for their children, or they are seeking clothing that creates the image of a miniature duplicate of mom or dad (see Figure 3.8).

Major categories for children's wear include outerwear, swimwear, sleepwear, and sportswear (i.e., T-shirts, shirts, shorts, pants, jeans, overalls, jumpsuits, sweatshirts, sweatpants), for both girls and boys, plus girls' dresses, skirts, and blouses, and boys' tailored clothing (i.e., jackets, suits, pants).

For children's apparel, durability, comfort, and ease of dressing and cleaning are very important to many consumers. In addition, this consumer looks for garments that are easy to put on and take off (i.e., large neck openings, snaps on crotches and fronts of garments, and elasticized waistlines and leg openings). Knit fabrics can stretch with the movement of the body, and synthetic fibers are easy to clean and also safe, especially in the sleepwear category. Some of the popular fabrications include cotton knits, fleece, and denim, except for infant's wear because many of the traditional children's wear fabrications cannot pass the strict flammability tests. Designs and styles for children's wear emanates from the junior market and young men's styles as well as the active sportswear category. Designer brands such as Tommy Hilfiger or Polo and store brands such as GapKids are prevalent in this gender grouping.

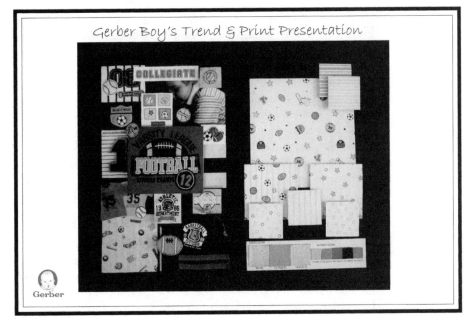

Figure 3.8
Images and patterns for children's wear that imitate what parents wear.
(Courtesy of Gerber Childrenswear LLC)

Product Sizes

Size involves a set of dimensions for the product; however, sizes of apparel products offered in the FTAR Complex vary across gender and style structure in a complex and often mysterious set of terms and dimensions. Product dimensions for many companies are closely guarded trade secrets and key factors in choices made by shoppers. In the United States, the first sizing studies were done in the mid-1800s as the U.S. government prepared for the Civil War. Measurements of soldiers were taken and evaluated. The review of these measurements showed that some body dimensions were commonly found across numerous men. This information led to the first standardization of sizes and the first sizing charts ("Standardization of women's clothing," 2004). Several subsequent studies measured portions of the U.S. population, including studies in 1937 by the Department of Agriculture and in the mid-1940s by the National Bureau of Standards, now the National Institute of Standards and Technology (NIST). The Department of Commerce stopped maintaining a federal standard for sizing in 1983.

Although no federal system is mandated for sizing, the task of measuring the U.S. population was given to ASTM, which maintains sizing standards for apparel products. ASTM provides tables of body dimensions of men, women, and children (ASTM Subcommittee D13.55, 2007). These measurements can be used by companies to develop their own sizing standards with adjustments of the apparel product for fabric hand, ease, style, fashion and desired fit. Standards can also be obtained from the International Organization for Standardization (ISO) relative to apparel sizing. Recently, [TC]², an organization that helps U.S. apparel manufacturers, has worked with retailers and design faculty at several universities to improve the standards for apparel. This research, called the SizeUSA study, measured over 10,000 Americans ("Size USA," 2007). It provides detailed data about the U.S. population generated from technologically sophisticated body scanning. Manufacturers and retailers may purchase the data for a better understanding of the size and shape of their consumers.

Although there is no required sizing system, some similarities across the industry are prevalent. Each product category has different sizing measurements and terminology for the sizes and size ranges. For example, women's wear products use a set of small digit numbers to represent the array of sizes, whereas menswear tends to use the exact dimensions of the product to indicate the sizes. The use of letters to represent lengths is often used. For example T is for tall so a 14T would be an apparel item that is a tall misses in size 14. In addition, to attract and maintain a loyal customer, many companies selling women's wear use **vanity sizing,** or a sizing scale that allows the consumer to buy a size smaller than she might otherwise purchase and get the same fit. Children's wear sizing may be based on body weight or age of the child. In addition to these variations in U.S. sizing systems, the U.S. sizing system is different from metric sizing systems. Merchandisers preparing products for sale in countries different from their domestic location or when working with contractors that are not domestic companies must be very careful to size and label apparel items appropriately.

Women's Sizes

Women's or ladies' sizes reflect body proportions of the consumer, the figure type of the customer, and the weight of the individual. There are actually no specific industrywide standards as to size and fit because each manufacturer bases it sizing scale on the design of the specific product, the fit model or pattern size that reflects the size of the company's target consumers' measurements, and the company's interpretation of the size. Therefore, there are no exact measurements for a size 8 in the industry.

Four major size ranges are used in women's wear: juniors, misses, petites, and womens (i.e., extra size, large sizes, half sizes). Traditionally, **misses'** sizes, which can also be called *misses* or **missy,** ran from 4 to 20, with not all garments or classifications produced in all sizes. Based on the design concept, silhouette, fabrications, and color palette, the apparel item may be cut in sizes 4 to 14 or 8 to 16 or 8 to 18, with very few garments cut in the 20 range. Today some companies regularly cut sizes in 0, 2, and 4. The **meat sizes,** or **core sizes**, are those sizes most often bought by the retail client; therefore, these are produced in more volume so the manufacturer can make a better profit. Sizing is important to retailers and the consumer, but it also affects pattern dimensions, marker making, and fabric utilization.

Misses' sizes are the standard for a company (see Table 3.4 for the comparison of Company X's misses, junior, and petite measurements). Most companies carry misses' sizes with dimensions for a consumer whose height is 5 feet 5 inches to 5 feet 9 inches, with the average height of 5 feet 7 inches. The misses figure is well developed, and the average weight of the target consumer is reflected in the sizing.

The **junior** size is for a figure less developed than the misses' figure. The junior figure is a slimmer figure with a shorter-waist length. Garments are not as wide or long as their misses' counterparts (see Table 3.4). The junior size range runs from 1 to 13 with meat sizes 3 to 11. Traditionally, this area was developed for the teen market; therefore, many of the garments are very youthful and trendy in design; however, junior is not an age but a size or body proportion.

Table 3.4
Comparison of misses, junior, and petite sizes for Company X.

Sizes and Measurement Locations	Junior	Misses	Petite
Sizes	3–15	4–18	2P–16P
Shoulder to shoulder	$13\frac{1}{8}''$	$15\frac{3}{4}''$	$15\frac{1}{2}''$
Arm length	$22\frac{1}{8}''$	$23\frac{5}{8}''$	$22\frac{5}{8}''$
Shoulder to waist	$14\frac{1}{2}''$	$15''$	$14\frac{3}{4}''$
Pants inseam	$28''$	$32''$	$29\frac{1}{2}''$
Rise	$23\frac{1}{2}''$	$26''$	$24''$
Skirt waist to knee	$24\frac{1}{2}''$	$27\frac{1}{2}''$	$25\frac{1}{2}''$

(a)

(b)

Figure 3.9
(a) Talbots Multi-Size Approach for its retail stores with a red door for woman (near left door), misses (middle door), and petites (far right door); (b) CATO also promotes its multi-size approach at its retail store.

The **petites** size is for figures maturely developed with a full bust and rounding hips. However, the frame is many times smaller than the misses' frame, and the figure is shorter in statue than the misses figure (see Table 3.4). Garment proportions in relation to the misses garment are very different with shoulders narrower, armholes higher, sleeve lengths shorter, the waist length shorter, the jacket silhouette slimmer, the distance from the waist to the hip shorter, the rise for the pants shorter, and the hemline on the skirt shorter. A consumer with a petite figure can wear neither the junior nor the misses fit properly because of her body proportions and height. Some companies, such as Cato and Talbots, are carrying major assortments of merchandise in petites as well as other size categories for women (see Figures 3.9a and 3.9b). Additionally, many petites are size 14 and 16; therefore the weight difference between the junior and petite is sometimes very diverse.

With much of the population now overweight, the **womens** size has become more important to the apparel industry. The womens size is easy to confuse with the term "women's wear," but in sizes the term *womens* refers to a specific size that runs 14W to 32W, 1X to 4X, 26 to 52, or sometimes half sizes $12\frac{1}{2}$ to $26\frac{1}{2}$ (usually $14\frac{1}{2}$ to $24\frac{1}{2}$). This size range has a fit for the shorter-waisted woman with a fuller bustline than other sizes. The industry also refers to larger sizes as **Plus sizes,** which are usually size 16 and above when sized with the misses sizing method. Traditionally, the womens size market was noted for the lack of style and limited color with few silhouettes, solid colors, and bright prints, plus budget prices geared toward an older traditional-minded customer. However, most retailers now know that this size range customer is not an age or an income level or a taste level. This customer can be an active, career-oriented person; a student in high school or junior high, or a woman involved in civic or social programs in the community. This customer can be traditional, updated, junior oriented, a wide range of age groups and income levels with purchases from the Popular or Budget to Bridge and Designer Departments. Again, this is a size range, not a specific person. Because of the growing sales volume in this market

segment and the large number of target consumers, apparel companies are now producing more stylish apparel for this segment in a wide price range.

Men's Sizes

Men's tailored clothing is sized in proportional sizes based on chest measurements combined with different figure types. The **cut** (i.e., relative dimensions and seam structures) of the suit is a major fit factor that affects the sizing of the product. The **European cut,** which is used in many designer suits, is a slimmer cut, with a more fitted jacket (i.e., more seams and more shaping) and higher armhole. The suit with a **traditional cut** has a less fitted silhouette than the European cut, and the **executive cut** is an even fuller cut with larger front panels in the jacket and larger waist sizes for the pants relative to the designer or the traditional cut ("Men's Wearhouse Encyclopedia," 2007). To correspond to the cut, suits are sized on the amount of **drop,** or the difference between the chest and waist measurement (see Figure 3.10). Designer suits have a 7-inch drop; traditional suits have a 6-inch drop, and executive suits have less than a 6-inch drop.

Men's wear is sized relative to body measurements, and suits are sized according to the chest measurement with proportioned sizes of 36 to 50 (see Table 3.5 for sizing of men's tailored apparel). Besides the size measurement indicating chest circumference, lengths are also given in the sizing system. For example, a size suit of 46R designates a **regular,** or the suit is of regular length for an average height man, whereas a 46L designates a **long,** or a suit for a man who is taller than average height. Dress shirts are sized by sleeve length and neck size or collar measurements; trousers are sized by waist measurements and **inseam,** or the length from the intersection of the crotch seams to the hem. **Rise** is the

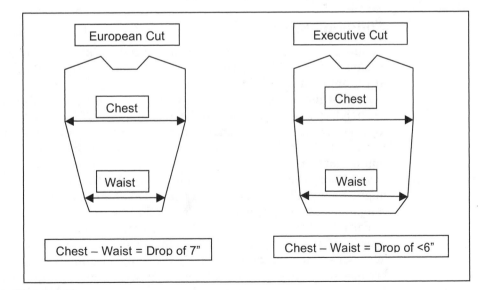

Figure 3.10
Difference in drop with cut of men's suits.

Table 3.5
Menswear tailored clothing sizing for Company X.

Size Numbers	Lengths
Short	36–44
Regular	35–46
Long	27–48
Extra Long	38–50
Portly Short	39–48
Large	46, 48, 50

dimension from the waist on a seated man to the sitting surface of the chair. This measurement, although not given in sizes, is a major consideration when adjusting fit and sizing dimensions for a brand. Sport shirts and sweaters are sized small, medium, large, and extra large (i.e., S, M, L, XL).

Young men's clothing (ages 14 to 20) is sized more like the sizing of women's wear because body dimensions are interpreted into a set of sizes (14 to 20) corresponding relatively to age. Some of the lower priced brands in both young men's wear and men's wear are sized as small, medium, large, and extra large (i.e., S, M, L, XL). In some athletic wear, the size range may extend to double X and triple X (i.e., XXL and XXXL). This sizing technique uses an average of the body dimensions across several sizes, and it allows manufacturers to carry fewer SKUs because the size units are not so finely divided. Although this improves inventory issues for manufacturers and retailers, the consumer receives a less accurate fit with his purchases.

Children's Sizes

Children's wear lines are traditionally sized in categories by age ranges (see Table 3.6 for a children's wear sizing chart). Because children often do not grow at the same rate and the size of children at the same age varies across ethnic market segments, some companies have started providing products sized by the height and weight of the child. For example, a 2T has the dimensions for the average sized 2-year-old toddler. With the trend toward larger babies and improved nutrition for infants and children, these size-to-age ratios may not be appropriate. In this situation, a 2-year-old child whose height and weight are larger than average and are perhaps more similar to that of most 4-year-olds might wear a 4T instead of the 2T or 3T of another child the same age. Many companies use weight instead of or in addition to size dimensions for sizing.

For girls, the size of preteen has been traditionally used for girls that are ages 8 to 14, although the age range may be narrower, such as 9 to 12 or other age spans. This size range is rarely found in clothing designed for young girls because the juniors market has grown; however, some companies market their clothing to this market, such as Forever 21 and Delilah's Clothing.

Boys' sizes have traditionally begun after the toddler sizing and included the younger boys of 4 to 7 and the older boys of 8 to 14 with the young men's sizes

Table 3.6
Children's wear sizing for Company X.

Size Category	Age Range	Height and Weight	Chest, Waist, and Hips*	Sizes
Newborn (Layette: 0 to 11 lbs.)	0–12 months	24–26 in 13–18 lbs	N/A	0–3, 6, 9 months
Infant	12, 18, 24 months	29–31.5 in 22–29 lbs	N/A	12, 18, 24 months
Toddler	2–3 years	34–40 in 29–38 lbs	N/A	2T, 3T, 4T
Little Girls	3–6 years	37–46 in 34–49 lbs	22, 21, 23 to 25, 22½, 26	3–6X
Girls	7–14 years	48–61 in 50–120 lbs	25, 22½, 27½ to 33, 26½, 36	7–16
Little (small) Boys	4–7 years	39–49 in 34–38 lbs	23, 21, 23 to 25, 22½, 26	4–7 regular (also in husky, slim)
Boys	8–20	51–69 in 56–160 lbs	24, 23* to 34, 28½	8–20 regular (also in husky, slim)

*No hip measurement given for boys this age.

for the oldest of the boys' sizing categories. However, a recent trend is to divide the market into young boys or little boys and older boys, called boys, with the size range of 8 to 18 or 8 to 20. The young men's size grouping, as with the pre-teen sizing for girls, has almost disappeared from the marketplace.

A sizing area within children's that is predicted to increase in importance is the plus sizes. With 30% of children in the ages of 6 to 11 in the overweight category and 15.5% of these children classified as obese, the need for plus-size apparel has become a critical issue in the apparel industry ("Plus-Size Children," 2006). Many parents or others buying apparel for these children must *size up*, or purchase larger sizes than appropriate for their age group. This practice often selects clothing that is not proportioned correctly for children with the lengths too long in order to obtain clothing with a large enough girth. And when the sizing-up method means that adult-size apparel is purchased, the styling and colors of the clothing may not be appropriate for the child. Some manufacturers offer apparel with adjustable waists, but many vendors and retailers choose to ignore this market.

Industry Zones

Multitudes of products—unique, basic, and anywhere in between—are made in the FTAR Complex, with variations based on (1) the lifestyle of the target consumer, (2) the fashion taste level of the consumer (i.e., the position of product on the fashion curve), (3) the current fashion trend direction of the market (i.e., theme concepts, silhouettes, color palettes, prints and patterns, trims, and detailing), (4) the retail price, including the value formula applied by the target consumer, of the apparel product classification, (5) the types and quality of fibers, fabric content, and fineness of the fabrications, and (6) the standards of construction quality or workmanship as perceived by the target consumer. By combining

all of these factors (e.g., gender, size, price, fashion level, fashion trend direction) with information about the lifestyle of the target consumer, the industry has created **industry zones**, or, more commonly, **zones**, especially in women's apparel.

These zones guide merchandisers, buyers, and other employees in the industry in creating the right product, at the right price, for a specific target consumer. The grouping of merchandise into zones and the characteristics found within each zone are used most often in the partnership between retailer and product producer; however, this concept can be found in use among fiber, yarn, and fabric producers as they direct their businesses or manufacture product lines appropriate for specific zones. The formation of a zone takes into consideration the level of design, fashion cycle positioning, type of fabrications, price range, sizing, and consumer segment being targeted. The most common zones currently in use in the women's apparel industry include designer, bridge, contemporary, better, moderate, and popular (see Table 3.7 for a concise explanation of the women's wear zones). The price of an item is usually dictated by the zone in which the product is produced or what the consumer will pay for the product. Using a combination of product characteristics, a specific zone would be misses, better sportswear.

Designer Zone

Merchandise in the **designer zone** is created with high-quality, exquisite, expensive, imported fabrications from countries such as Italy or France or from exquisite domestic fabrications, findings, and trims. The fiber content is often

Table 3.7
Women's wear zones.

Zone	Fabrications	Details	Sizes	Selected Examples of Brands
Designer	High-quality, exquisite imported and domestic fabrics; natural fibers	Exquisite stitching, buttons, trims, details	2–12	Donna Karan, Ralph Lauren, Giorgio Armani
Bridge	Exquisite fabrics less expensive than designer, quality workmanship	Nice details with quality buttons, trims, etc.	2–14	Ellen Tracy, Tahari, Emanuel, Sigrid Olsen
Contemporary	Less expensive (better) fabrications	Updated, trendy details	2–14	BCBG, Laundry, Cynthia Rowley
Better	Moderate to high-quality fabrics	Limited; some special details	4–16	Jones New York, Liz Claiborne, Lauren by Ralph
Moderate	Volume mass-produced fabrics	Few details	6–18	Koret, Sag Harbor, Alfred Dunner, Emma James
Popular (Budget)	Lowest price fabrics with lower yarn count, less distinct prints, and lower weight per yard	Few details	6–18	Donkenny, Crazy Horse, Villager

silk, wool, or other specialty fibers, and the printing is usually done with numerous screens that are finely etched. In this zone, the quality of workmanship should be superb, the fashion direction is at the innovative substage of the fashion cycle (see Chapter 10 for fashion cycle stages), and fit will be driven by that fashion direction. Details, features, trims, and findings are many times handcrafted or made from very rare, unusual materials. For example, the buttons may be handmade, hand painted, or produced specifically to match the color or texture of the fabric; or they may be made from rare or expensive materials such as mother of pearl or semiprecious stones set in a gold casing. This is the highest price merchandise and usually found in the signature collections of designers such as Ralph Lauren, Donna Karan, or Calvin Klein and up-and-coming designers or contemporary designers such as Phillip Lim, Anna Sui, Vivienne Tam, and Monique Lhuillier (see Figure 3.11). This high-quality mass-produced merchandise is sold to the selected retailers through exclusive distribution because maintaining the image of the designer is most important. Designer lines set the trend direction for all fashion products, even for home furnishings and automotive fabrications. The price range for products in this zone will be the highest range across all zones.

Bridge Zone

The **bridge zone** is merchandise positioned between designer and contemporary or better merchandise. Products in this zone are made of beautiful, sometimes fragile, fabrications that are many times imported; however, these fine fabrics are not as costly per yard (oftentimes 30% to 40% less costly) as the fabrics in the designer area. For example, a sweater with the 100% cashmere content in the designer zone might be of 80% cashmere and 20% wool content in the bridge zone. Garments in this zone are in the rise substage of the fashion cycle, and design details, garment features, and findings are unusual and oftentimes only used on garments in this zone. Although these findings are very trendy and unique, they are less expensive than designer findings and are a value-added feature for the merchandise. The workmanship in the bridge zone is very high quality, and the styling is from traditional or classic (e.g., Ellen Tracy) to updated or trendy (e.g., Tahari) to advanced styling (e.g., Emanuel by Ungaro) (see Figure 3.12). Some brands in this area include Ellen Tracy, Tahari, DKNY (Donna Karan), and CK (Calvin Klein). Retail prices for products in this zone are less than those found for comparable products in the designer zone.

Contemporary Zone

At various times in the industry, **contemporary zone** merchandise is prominent and at other times it is less important. Merchandise in this zone is very trendy, often made of less expensive fabrications than designer or bridge, but the fabrications are updated and make a statement that supports the design concept and trendy silhouette features.

Figure 3.11
Designers set the trend direction for fashion products.
(Courtesy of The Hosiery Association)

Figure 3.12
High-quality bridge merchandise with a classic twist.
(Courtesy of The Hosiery Association)

[C]ontemporary brands tend to be smaller, risk-taking labels. Their limited distri-
bution and of-the-moment silhouettes are increasingly appealing to a broad cross-
section of fashion-forward women, including hordes of celebrities. . . . A boon for
retailers, which often sell the goods at full price without the need for markdowns,

contemporary clothes also resonate with shoppers at two ends of the spectrum: style-obsessed teens and women in their 30s, 40s, and 50s who are willing to pay a premium for casual looks that project a youthful, yet sophisticate vibe. (Tan, 2007, p. A1)

This merchandise is usually purchased by the fashion forward or young trendy customers who like to express their individuality with clothing. Unusual detailing such as unique prints, decorative trims, innovative designs, and trendy silhouettes are characteristic of this zone. The quality of the merchandise may vary as do the price points; however, the prices are usually less than similar product classifications in the bridge zone. "Just as trendy companies pushed jeans from a commodity product to a $200-plus status symbol, today's contemporary [zone] has legitimized the $170 ruffled tank top and the $500 eyelet minidress" (Tan, 2007, p. A1). Lines available in this zone include brands such as BCBG, Cynthia Rowley, and Laundry by Shelli Segal.

Better Zone

One of the major women's apparel zones for many stores, especially the department store, is the **better zone.** The merchandise selection in this zone is usually priced so a majority of consumers can afford the apparel. The merchandise is in the acceptance stage of the fashion cycle, which is reflected in the classic traditional styling found in much of this product. Product assortments have usually peaked; therefore, consumers have a greater variety of selection and sometimes more brands and lines of merchandise from which to make their selection. Many of the designs and silhouettes in this zone are knockoffs of designer lines or adaptations of a manufacturer's top-selling styles.

In contrast, in the better zone, some of the middle-market apparel companies have created opportunities for their retail clients by producing well-timed, fashion-oriented, exclusive collections for a specific retailer. This type of better merchandise helps that retailer differentiate its product assortment from its competition and provides the consumer with a lower cost product with a more trendy look than the classic style in traditional better merchandise. For example, in 2004, Liz Claiborne developed the exclusive brand Intuitions in the better zone for Dillard's Department Stores; and Federated signed an agreement with Tommy Hilfiger for an exclusive line of "H" by Hilfiger for the 2004 season (Clark, 2004). Since opening Intuitions in 2004, Liz Claiborne has closed that brand and is now focusing more on the "Liz" brands, especially in menswear. Another recent trend within this zone is that of using the pricing structure of "good," "better," and "best" to provide relatively lower, moderate, and higher priced products within the better zone (see Table 3.8). In the fast-paced world of fashion, brands within all zones are frequently sold when the expected profits are not made or when the leadership of or the fashion direction in a company changes; for this reason, the brands indicated in these tables are subject to change.

Table 3.8
Good–better–best pricing structure within the better zone for men and women.

Brand/Price	Good	Better	Best
Liz Claiborne	Claiborne	Liz Claiborne	Concepts by Claiborne
Jones New York	Le Suit	Jones New York Sport	Jones New York Signature

www.lizclaiborneinc.com (2008); www.jny.com (2008).

Table 3.9
Fashion direction of better zone for men and women.

Fashion Direction	Brands by Liz Claiborne	Brands by Jones Apparel Group
Updated	Axcess, Claiborne	AK Anne Klein
Classic/Traditional	Liz Claiborne	Kasper
Casual	Liz & Company	Jones New York Sport

www.lizclaiborneinc.com (2008); www.jny.com (2008).

Some companies are also attempting to create product in three realms of fashion direction, or in the fashion directions of updated, classic/traditional, and casual. In the company of Liz Claiborne and Jones Apparel Group, the brands for these fashion tiers within the better zone are shown in Table 3.9 as they were positioned for 2008.

The fabrications in the better zone are mass produced, moderately to high-priced piece goods; and the quality and workmanship of the sewing are very good to good for mass-produced volume merchandise. Because this zone is shopped by many target consumers, better manufacturers produce product under such brand names as Jones New York, Liz Claiborne, City DKNY, Lauren by Ralph Lauren, and Evan Picone. The retail price range for blazers or jackets in this zone are from $200 to $350.

Moderate Zone

The **moderate zone** is known for classic traditional styles in the general acceptance substage of the fashion cycle as well as simple, uncomplicated silhouettes at affordable prices. Created with less expensive fabrics and few details, the workmanship and quality of the garments may range from good to fair. Manufacturers producing national brands in this zone include Alfred Dunner, Emma James, J.G. Hook, Koret, Sag Harbor, and private label merchandise.

Popular Zone

The **popular zone,** sometimes called **budget,** caters to the mass merchants or discounters. The quality can run the gamut from very poor to excellent. For example, Walmart is noted for buying product in bulk or volume and requiring the

vendor to use Walmart specifications even down to the fiber or yarn level. Many times these products are of high-quality materials, construction, and workmanship. At other times mass merchants offer so-called fashion at a price and cut corners to provide "disposable" clothing for the masses.

The fashion level of the popular zone has definitely undergone a revolution with companies such as Target offering fashion products by well-known designers at value prices. In fact, the company has become so well known for its fashion approach to merchandising that some have coined the word "Tar-shay" (Schlosser, 2004) to describe the company's trendy image for fashion goods, including apparel and home fashions. Some think that Target has taken this concept to the extremes when the company began to carry private label fashion products in their pet departments (Anonymous, 2006). Walmart has also focused and refocused on fashion, especially with ladies' apparel fashions (Zimmerman & Tan, 2008). The company offers the private label "George" for ladies' fashion apparel, and in 2008 it expanded this brand into the home fashions market (Duff, 2008). Since 2006, Walmart has tried several approaches to bring trendy fashion into its apparel products, including enticing designers to create new labels, opening design studios and offices in New York City, and ads in *Vogue* magazines. Some of these tries were a flop, and some have been successful (Zimmerman & Tan, 2008).

The price point of the new fashion items at Walmart are thought to be a sticking point for some consumers, who want to see the basic products at a basic price back in the stores ("Wal-Mart to Lease," 2007; Zimmerman & Tan, 2008). Based on the brand and merchandise category, price points in this zone run the gamut from very inexpensive to the best price level within the zone. A jacket or blazer in these retailers would cost less than a comparable item in the other zones. Typically, this zone has the lowest prices across all of the zones, thus its connotation as the budget zone.

Other Zones

Even though some variations do exist in the terminology of the zones, the six industry zones are used by apparel companies and many retailers to define specific merchandise categories in specified price ranges at certain fashion taste levels for specific consumer lifestyles (e.g., Jones New York in the better zone).

Similar to using product merchandising or industry zones, some chain store retailers may define their store groups as zones by positioning the store and the products in specific channels of distribution, by carrying product at specific price points and fashion levels, or by catering to a specific target consumer whose income falls within a specific range. For example, Gap Inc. has traditionally owned three retail store formats: Banana Republic, Gap, and Old Navy. VF Corporation in 2008 owned numerous brands, including jeanswear (e.g., Wrangler, Lee), outdoor clothing (e.g., The North Face, JanSport, Eastpack), sportswear (e.g., Nautica), and contemporary brands (e.g., lucy, 7 For All Mankind). Each of these store groups or brands target specific customer segments, who possess different fashion taste levels, maintain different lifestyles

and sometimes different life stages, and many times have different income levels as well as types of occupations. The store or the brand becomes the zone.

Apparel companies may produce product in more than one zone. For example, Liz Claiborne oversees the production of the brands of Liz Claiborne in the better zone and Ellen Tracy in the bridge zone. Many retailers, especially department stores and mass merchants, may have departments within their stores designated for several of these merchandise zones (e.g., contemporary, missy better, popular). Or, as discussed in the previous section, some of the chain stores create zones with store groups that are targeted to specific consumers with similar lifestyles, taste levels, and income levels.

Product Life Cycle as Related to Sale of Fashion Products

Most products have a limited life or time span for sale to the customer. During this life span, each product passes through distinct stages. The existence of the product from its first introduction to the customer to its last opportunity for sale is called the **product life cycle** (see Figure 3.13). The cycle starts with the product being introduced, then accepted, and finally in decline (Kincade, Gibson, & Woodard, 2004). Each stage in this cycle is filled with unique opportunities and problems for the raw materials producers, apparel manufacturers, and retailers that source, make, or sell the product. Specialized strategies are needed by the producers, manufacturers, and retailers for maximizing the best sales and profits for the product at the time.

The rationale for the life cycle of the product has its foundation in customer acceptance or refusal of products. When products are new, many customers have high levels of interest and a few are willing to buy the products; however, at the introduction stage, the sales volume of the product is usually low because of a smaller customer base or to a lesser market share for the product. As the product

Stages	Introduction		Acceptance		Regression	
Substages	Innovation	Rise	Acceleration	General Acceptance	Decline	Obsolescence
Sales volume and customer	Limited sales with a slow increase as fashion trend and fashion expert customers shop early		Peak sales as product is bought by the masses—fashion pragmatists and fashion fundamentalists		Sales quickly drop and the product is bought only by the necessity and the deprived shopper	
Time in season	Early		Middle		Late	

Figure 3.13
Product life cycle.
(Adapted from Kincade, Gibson, & Woodard (2004))

continues to be in the market, more customers are interested in the product and buy the product, and the sales volume rises to a peak. After the product has been on the market a period of time and most customers have purchased the product, those early customers who have bought the product lose interest in buying more of the product, causing the product's popularity and sales volume to decline. The wholesale cost per product item and the retail price of the item also fluctuate with the product's position on its product life cycle. Profits for companies selling the product may rise and fall according to the product's position along its life cycle.

The length of the product life cycle and the length of stages within a life cycle vary across product classifications and are affected by consumer demand, company promotion, and a variety of other factors. Some products are considered to have long life cycles and are broadly accepted by a multitude of customers for a long time. Most products cycle through at least three stages, although more stages may be seen in some specialized products or in products that have a second cycle through international or other reintroduction. The three stages of the product life cycle are introduction, acceptance, and regression. The **introduction stage** is the first stage of a product life cycle and consists of two substages: innovation and rise (see Figure 3.13). Merchandise sold at this stage represents the newest products reflecting cutting-edge trends and often are called **trend emphasis** and **hot items.** The customer at the **innovation substage** is the **fashion trend innovator.** This customer will be a leader in fashion and is willing to try new products and wants products before others have them. The customer in the **rise substage** is the **fashion expert,** who is also a fashion forward customer but will be watching the fashion trend innovators before choosing the product. The growth of sales at the rise substage shows the increasing acceptance of customers for this product.

The **acceptance stage** is divided into the acceleration substage and the general acceptance substage (see Figure 3.13). In this stage, the product has become a mainstream item, and most consumers are buying and wearing the product. Knockoffs are often found in this stage, and the product, which was formerly sold in high-priced boutiques, will be found in discount stores. Companies handling the product at this stage will see the maximum number of sales as the product is purchased by **fashion pragmatists** and **fashion fundamentalists.** During the **acceleration substage,** the product experiences maximum market acceptance with rising sales accompanied by substantial profit improvement for companies selling the product. The product is becoming a mature product. The **general acceptance substage** may show a continued sale of the product for some substantial period as seen in a classic, which has reached broad market acceptance and is still satisfying consumers, or, as more typically found in fashion items, a brief period of stable sales followed by a slight decline in sales. During the general acceptance substage, the market is saturated with the product, most people own the product, and fashion leaders who want new and more exciting products will stop buying the product. In contrast, the fashion fundamentalist will be buying the product for features of durability and practicality. After peak sales are experienced by the retailer or the manufacturer, the growth of sales will slow and rapidly decline.

The **regression stage** marks the easily recognized decline in consumer acceptance of the product and includes the two substages of **decline** and **obsolescence.** The regression shows a decline in sales and the diminishing interest of customers in the product. Competition will have increased at this point because many companies will have the product and other companies will be introducing new products, causing a further decline in sales of the product. Customers who shop in the decline substage are **necessity shoppers,** who buy because the product is readily available and priced low. The last substage in the product life cycle is obsolescence. At this stage, the product is no longer worn by most people and is sold only to **deprived shoppers** or other consumers who chose to ignore fashion trends.

Fashion, Season, and Trend Modifiers to Product Classifications

The products carried by any FTAR company are usually grouped according to product categories, product classifications, genders, sizes, zones, or other classification systems. A grouping of products into a cohesive set is called a **product line,** or **line** (see Figures 3.14a and 3.14b)**,** a combination of all of the company's groupings for a season. Product lines can consist of groupings of various product classifications by gender (e.g., boys, girls), a grouping of product class (e.g., jacket, pant, skirt, blouse, sweater), or all of one product classification (e.g., drop-sleeve tees, long-sleeve crew neck). When the content of lines is changed periodically, they are called **seasonal lines.** Most women's wear companies producing fashion apparel carry as many as five to six lines per year; however, companies that are vying for the fast-fashion market may have as many as 24 changes in lines throughout the year or a virtual endless series of changes. **Groupings,** within a product line, are composed of a related assortment of merchandise classifications that are bound together by a major product

(a)

(b)

Figure 3.14
Gerber layette line by gender: (a) girls and (b) boys.
(Courtesy of Gerber Childrenswear LLC)

concept or theme; by select styles, silhouettes, or bodies; by a well-defined color palette; by a coordinating fabric story; and by motifs, patterns, prints, findings, and trims that support the concept. Additional information about selection of lines and groupings is discussed in Chapter 11.

After companies decide on the number of seasonal product lines to produce, they must then make decisions concerning the types of product classifications to include in the lines. The lifestyle of the customer and the occasion for wearing the garment definitely affects the types and characteristics of the fabrications the textile mill produces for the garment. For example, a textile company producing fabric for a ladies' spring apparel line has numerous decisions to make. Decisions must be made about what product classification will be targeted: career wear, business casual apparel, sportswear, playwear, or formal evening wear. This decision impacts the characteristics of the fabric. The fabric producer who makes fabrics for the career wear will develop a fabric with a twill weave and a weight appropriate for suiting, which may contain wool, a texturized polyester, or a new microfiber. Wrinkle-free and stain-resistant finishes are now in demand for fabrics for this classification. The choice to make fabrics for formal wear, in contrast, involves producing satins with a highly lustrous polyester or nylon fiber. Very different equipment and various suppliers are needed to make the two fabrics.

When apparel companies are developing their seasonal lines, decisions must be made about the product categories or groupings (e.g., career wear, business casual, sportswear) to be included in the line and then determining what product classification (e.g., blazers, sweater sets, tee tops, blouses) to include in each grouping. Many times these product classifications are based on the fashion level of the industry zone in which the apparel company operates, on the season (i.e., spring, summer, fall, winter) of the year, and general cultural trend modifiers. A schematic representation of the fashion, season, and trend variations in product is called a **perceptual product cylinder,** and in the industry lingo sometimes called the **perceptual map.** Using the two axis across the horizontal plane of the schematic along with the central core of the cylinder, the merchandiser can plot the fashion level, the season of the year, and any general trends that need to be addressed for the specific product classification that are carried (see Figure 3.15). Trend modifiers can include such product variables as levels of luxury; attention to environmental, green, or social issues; and channels of distribution.

Across the horizontal plane of the cylinder on one axis, a high fashion product is positioned in contrast to a very basic product. The most **basic product** changes very little in styling and fabrication from week to week and year to year; it remains in the consumer acceptance stage for a relatively lengthy period of time. For example, a simple white knit T-shirt or men's white briefs are basic products. The opposite of the basic product is the **fashion product,** which changes continually. When products are positioned toward the fashion end of the basic-fashion continuum, they can range from moderately **trendy fashions,** including some new colors or styling changes to very outrageous and new items with complete changes from previous styles. That basic white brief is now found in fashion colors, may have a trendy logo or a designer label, and

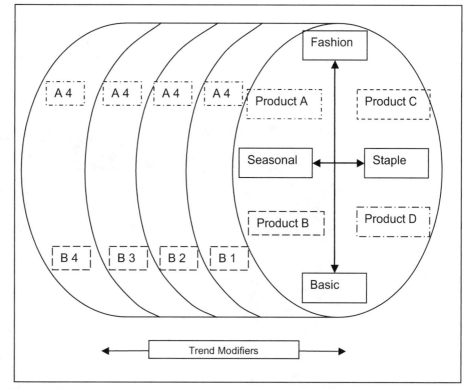

Figure 3.15
Perceptual product cylinder of fashion, season, and trend modifiers.

is promoted by one or more well-known athletes. The new and extreme fashions are generally considered to be **fashion forward.** The placement of the product on this range of fashion is considered to be the **fashion level** of the product. Fashion products are in a constant state of change and thus create excitement and ideally more sales in the fashion arena.

The other axis of the horizontal plane of the schematic contains staple products at one end and seasonal merchandise at the opposite end. **Staple products** are in continuous demand throughout the year, regardless of the weather conditions or the seasonal temperatures. An example of a staple product would be a pair of natural-colored panty hose, which may be worn year round regardless of the climatic environment. **Seasonal products,** or **seasonal merchandise,** is product that experiences drastic product change based on the season or time of the calendar year. For example, the majority of swimsuits are sold in the spring and summer months; heavy wool coats are usually purchased in the fall and winter months.

In addition, the product grid is elongated into a cylinder because many **trend modifiers** can be applied to a product category to further distinguish one product from another. Trend modifiers include the characteristics of green, luxury, comfort, brands, and other popular cultural features. **Green products** are those

manufactured and sold with a concern about the environment (see Figure 3.16). Products can be made and packaged with renewable resources, with manufacturing processes that protect the environment, and with organically grown products. In addition, this trend modifier may also consider **social accountability** of producers for the treatment of labor including the working and living conditions of sewing operators and other workers. Products can also be made with limited

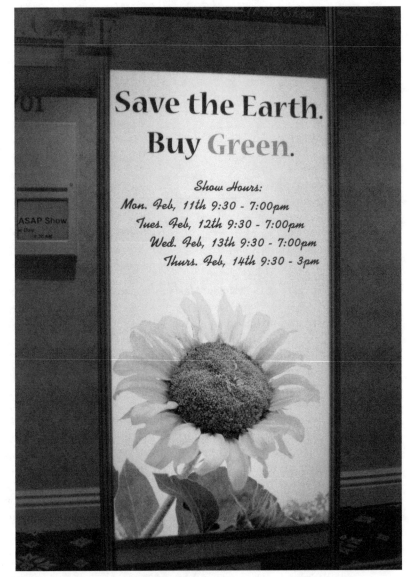

Figure 3.16
ASAP Global Sourcing Show, Las Vegas, Nevada.
(Photographer: Laura Sampson)

or no concern for the environment or the worker beyond what is legally required at the point of manufacture or sale, which can be very limited in some countries.

Luxury is another trend modifier that can be applied along with the dual axis schematic of season and fashion. According to the Boston Consulting Group, luxury has remained a strong trend modifier of apparel products (Tatge, 2005). According to Marshall Cohen (2006) of NPD, luxury goods range from **aspirational luxury,** through **affordable luxury,** to **pure luxury.** At the upper end of the continuum is the pure luxury product or the innovative designer product at a high price point with specialty fabrications and exclusive design features. In the middle of the range is the affordable luxury product that might be sold in any specialty store. At the aspirational level or lower end of the continuum are the knockoffs by a name designer found at a store such as Target that sells luxury goods at discount prices (Agins, 2007). So luxury products can range from the exquisite diamond ring sold in a Tiffany jeweler to the pretty cubic-zirconium ring sold at a major discount chain. Luxury products can give the consumer a sense of well-being and wealth and can be an advertisement to friends and colleagues about a chosen lifestyle. Over time, trend modifiers may become more or less important to the products sold in a specific market segment. In addition, some trend modifiers such as luxury become important to the mass market and are found in some degree at all product markets.

Some companies create their product lines with most or all of these product variations, whereas others concentrate only on products in one quadrant and/or one level of the perceptual product cylinder. For example, products that have both a *seasonal* and *fashion* orientation (see Product A on Figure 3.15) change the most often and are the most risky product to carry in stock for both the manufacturer and the retailer. These products may also be further modified by a trend such as luxury, and Products A1, A2, and so forth, can be developed. For example, the various levels of luxury can be applied to the product, resulting in a seasonal and fashion-oriented product that ranges from the 100% cashmere sweater sold in Neiman Marcus's Christmas catalog to the 100% acrylic sweater sold by Target under the Cherokee label. This product has a shorter life cycle because of the constant change in demand by the consumer. Many apparel companies have to reduce the wholesale cost of the product to get the retailer to purchase leftover product, or the retailer must reduce the retail price to move the inventory from the retail establishment. However, anywhere from 35% to 45% of product in the market is classified in this category and must be sold within 10 to 20 weeks for the companies to make a profit. Having the shortest selling life, these products require the most complex planning and merchandising techniques.

Basic products that have a *seasonal* orientation (see Product B on Figure 3.15) usually can be used for several seasons and sometimes even years. Even though they are directly related to a specific season, the product styling remains basic. An example of basic seasonal merchandise is men's winter underwear. When merchandising basic seasonal products, the merchandiser must know when to schedule delivery on the goods because timing is very critical for this type of

merchandise, know what price the consumer will pay for the product, and know what quantities to produce or stock. These basic/seasonal products can also be altered by the trend modifiers so that Products B1, B2, B3, and others can be designed. Men's underwear can be offered in seasonal colors, such as white with red hearts for Valentine's Day, and may be offered in a variety of fabrications from luxurious Pima cotton to very short and inexpensive cotton.

Fashion merchandise that is a *staple* product (see Product C on Figure 3.15) is purchased year round; however, styles change with fashion trends. An example of fashion, staple merchandise is designer bed linens. Although these products are bought throughout the year and in standard sizes and fiber contents, features on these products must change as fashion changes to meet the preferences and demands of the target consumer. *Basic staple products* (see Product D on Figure 3.15) are sold year round and change very little with changes in fashion cycles or with change in seasons. Each of these fashion and seasonal combinations can be also modified by trend factors. Basic staple products are often purchased by a computerized plan without input from a buyer or store manager.

Summary

Products including apparel items, accessories, shoes, and other fashion-related items are designed by manufacturers and sold by retailers. Most of the products sold in the FTAR Complex are made of textiles and are sewn together; however, some products are made of leather, fur, or other raw materials. Regardless of the raw materials, products in this supply chain are often driven by consumer demand and change with fashion trends. Products are usually classified by gender, usage, size, and price. When these product features and other factors are combined, industry zones are created that address the demands and interest of a target market. Studying the product life cycle of a fashion product can assist a merchandiser in making calendar-appropriate decisions about the product's popularity with the consumer. Seasonal product lines are created through the year to provide consumers with a continuous change of products. Products within classifications can be varied depending on the amount of change in their seasonality, their fashionality and their compliance with trend modifiers. The amount of variation in products from one season to the next season can depend on many factors including color and style. Merchandisers track the changes and develop their assortment plans through trend variation and production volume in their product grids.

Key Terms

Acceleration substage	Aspirational luxury	Bridge line
Acceptance stage	Basic product	Bridge zone
Activewear	Better zone	Budget zone
Affordable luxury	Bridal	Children's wear

Contemporary line
Contemporary zone
Core sizes
Cut (men)
Decline substage
Deprived shopper
Designer garment
Designer zone
Drop
European cut
Executive cut
Fashion expert
Fashion forward
Fashion fundamentalist
Fashion level
Fashion pragmatist
Fashion product
Fashion trend innovator
Furnishings (men)
General acceptance substage
Green products
Groupings
Haute couture
Hot items
Industry zones
Innovation substage
Inseam
Intimate apparel
Introduction stage
Junior (size)

Knockoffs
Ladies' wear
Line
Long (men)
Luxury
Maternity
Meat sizes
Menswear
Misses (size)
Missy (size)
Moderate zone
Necessity shoppers
Obsolescence substage
Perceptual map
Perceptual product cylinder
Petites (size)
Plus sizes
Popular zone
Prêt-à-porter
Product categories
Product classifications
Product life cycle
Product lines
Professional attire
Pure luxury
Ready-to-wear (RTW)
 (product classification)
Ready-to-wear (RTW)
 (style structure)

Regression stage
Regular (men)
Rise (pants)
Rise substage
Seasonal lines
Seasonal merchandise
Seasonal product
Secondary lines
Signature collections
Size
Social accountability
Sportswear
Staple product
Style structure
Swimwear
Tailored clothing
Traditional cut
Trend emphasis
Trend modifiers
Trendy fashion
Uniforms
Vanity sizing
Women's apparel
Women's wear
Womens (size)
Workwear
Zones

Review Questions

1. Identify and explain the diversity of merchandise types available within the FTAR Supply Chain.
2. Describe the style structure of the FTAR Supply Chain.
3. What are the range of fashion styling available in women's wear?
4. What are the product categories that are found in the FTAR Supply Chain, and how are they subdivided?
5. How does the sizing compare across women's, misses, and juniors sizes?
6. How does the sizing in children's wear differ from that in women's wear?
7. What is a zone, and how does a merchandiser use zones to market to the target customer?
8. How does style vary within and across a zone?
9. How can product classifications be altered by fashion, season, and trend modifiers?
10. What are some recent trend modifiers?

References

About Under Armour. (2007). *Under Armour History*. Retrieved June 19, 2007, from http://www.uabiz.com

Agins, T. (2007). Rethinking expensive clothes. *Wall Street Journal*. Retrieved April 12, 2007, from http://www.wsj.com

Anonymous. (2006, April 10). Bold merchandising efforts chase four-legged customers. *DSN Retailing Today, 45*(7), p. 36–38.

ASTM Subcommittee D13.55. (2007). *Committee D13.55 on Body Measurement for Apparel Sizing*. ASTM International. Retrieved September 6, 2007, from http://www.astm.org

Binkley, C. (2007, May 17). Style—Fashion Journal: Finally, women's wear for the hard-hat set. *Wall Street Journal*, p. D8.

Clark, E. (2004, June 23). Claiborne's reality check. *Women's Wear Daily* [online]. Retrieved June 1, 2007, from http:///www.wwd.com

Cohen, M. (2006, October 17). *The new consumer*. Executive-in-Residence Program. Presentation at North Carolina State University, Raleigh.

Duff, M. (2008). Big-boxes out to grab more of domestics basket. *Retailing Today, 47*(5), 28–30.

Hyman, M. (2003). How I did it. *Inc. Magazine*, p. 102.

Jones, L. (2006, June 29). Is America finally ready for the wash-and-wear business suit? *Winston-Salem Journal*, p. E1.

Kincade, D., Gibson, F., & Woodard, G. (2004). *Merchandising math: A managerial approach*. Upper Saddle River, NJ: Prentice Hall.

Men's Wearhouse Encyclopedia. (2007). *Men's Wearhouse*. Retrieved June 19, 2007, from http://www.menswearhouse.com

Plus-size children apparel's forgotten customer. (2006). *DSN Retailing Today, 45*(7), 16.

Schlosser, J. (2004, October 18). How Target does it. *Fortune, 150*(8), 100–107. Retrieved October 6, 2004, from http://www.fortune.com

Size USA. (2007, August 12). *The measure of mankind—Lucky us: We're living in the golden age of anthropometrics*. [TC][2]. Retrieved September 6, 2007, from http://www.tc2.com/whatsizeusa/index.html

Standardization of women's clothing. (2004, October 8). *NIST Virtual Museum, National Institute of Standards and Technology*. Retrieved September 6, 2007, from http://museum.nist.gov/exhibits/apparel/index.htm

Tan, C. L. (2007, May 18). Fashion's newest stars: Edgy styles from upstarts. *Wall Street Journal*, p. A1. Retrieved May 18, 2007, from http://www.wsj.com

Tatge, M. (2005). Seven signs of retail mergers. *Forbes*. Retrieved January 25, 2005, from http://www.forbes.com

Wal-Mart to lease studio in fashion-expansion bid. (2007, July 12). *Wall Street Journal* (Eastern edition), p. B2.

Zimmerman, A., & Tan, C. L. (2008, April 24). After misstep, Wal-Mart revisits fashion. *Wall Street Journal* (Eastern edition), p. B1.

chapter
4

Price

Objectives

After completing this chapter, the student will be able to

- Define the price terminology of retail price and wholesale costs
- Discuss product value and how it is developed for a product
- Explain the various perceptions of price across the FTAR Supply Chain
- Define pricing
- Identify the internal company components and external factors that affect pricing strategies of a firm
- Describe the overall pricing strategies that businesses use to meet profit and marketing goals
- Define markup, markdown, and other price-related terms
- Explain specific pricing polices a company may select to develop techniques for its pricing strategy
- Identify action plans for pricing strategies
- Discuss additional price adjustments and the reasons retailers and manufacturers use these

Introduction

Pricing is one of the most complex components of the marketing mix. If the price is too high, customers will not buy and there is a loss of sales, and if the price is too low, the sales may not cover the planned expenses and margins and there is a loss of revenue, profit, or even company or brand image. Each producer and manufacturer must set a price for the product so that (1) his or her business can sell enough products at the right price to meet planned sales goals, margins, and profit expectations, and (2) the retailer may set a retail price on the product to attract shoppers and meet the expectations of its target consumer (see Figure 4.1).

Pricing Terminology

The retailer refers to the price of merchandise as the **retail price,** or price, which is the value or amount the consumer will pay to the retail establishment for the sale or exchange to receive the goods or services. This unit price corresponds to net sales for the total business. In contrast, the selling price of products by an apparel manufacturer is the **wholesale cost.** Depending on who is talking about the wholesale costs, these may also be called the **billed wholesale cost, invoiced cost of goods, invoiced cost of merchandise,** or sometimes the **billed cost of goods.** However, **billed cost,** the actual cost to the retailer as shown on the invoice (see Figure 4.2), and the **list price,** the cost of the products when seen by the retailer as samples, can vary based on the price negotiations made between manufacturer and retailer. Typically, the invoiced cost of goods is the initial wholesale cost of the merchandise minus cash discounts and trade allowances plus transportation and insurance charges. (See Chapter 12 for details on manufacturer's costing procedures and Chapter 15 for retailer's pricing procedures.)

In addition to setting the wholesale costs, the manufacturer may make suggestions to the retailer for the retail price of the product. When the manufacturer's merchandiser is costing or pricing products for the seasonal line, he or she must be aware of the potential retail price of a product. The **manufacturer's suggested retail price (MSRP),** also called MSR for short, might be listed in the catalogs or other marketing information about the products when the manufacturer is promoting the product to the retailer. These are only suggestions for the retailer because the manufacturer cannot control the retail price when selling the product to a retailer. The manufacturer cannot set the retail price and cannot require a minimum retail price. Such actions are illegal in the United States. The MSRP, as a suggestion, should be based on extensive market research performed by the manufacturer's merchandiser in preparing the product for sale.

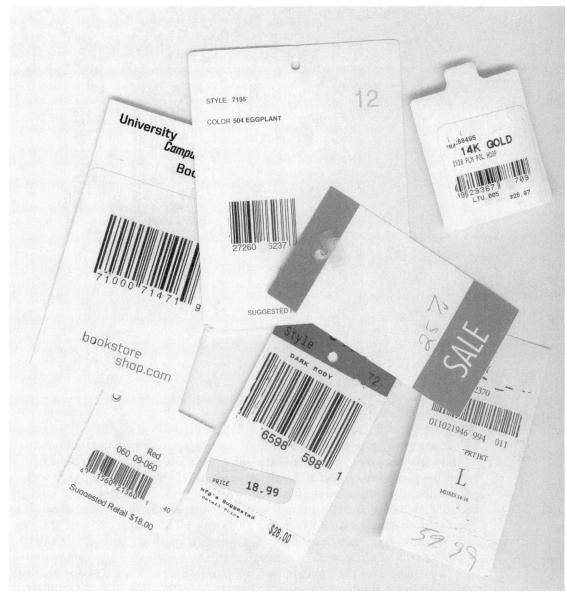

Figure 4.1
Retail sales tags.

Figure 4.2 Sales tag showing MSRP and store price.

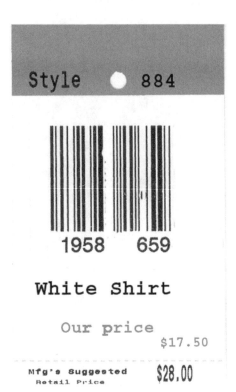

Product Value

Although many consumers interchange the concepts of price and value in their mind while shopping, price is not the same as value. Price is the dollar amount paid for the product. **Value** is an integration of that price and the product characteristics, which might be a mixture of physical attributes of the product, quality of the product, retailer's services, retailer or brand image, or other product benefits. As products move along the FTAR Supply Chain, they are transformed from raw materials to a finished product. At each link in the chain, changes occur, which add value to the product in the perception of the consumer and the companies that handle the products. These changes, called **value-added components,** include specific additions of product features as well as services and other product benefits. For the consumer, these components include product features such as the fiber, fabric, and styling, along with the consumer's perception of the retail store or brand (see Figure 4.3).

When developing, selling, selecting, and/or purchasing products, merchandisers can use the consumer value equation to understand and evaluate the consumer's perception of the product. The **consumer value equation** is stated in Figure 4.4.

Based on the company's strategic mission and management's merchandising philosophy, as established through strategic planning, a company must decide

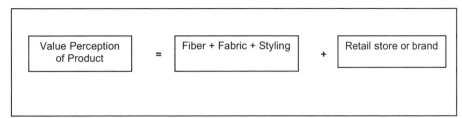

Figure 4.3
Value-added components to analyze the consumer's value perception of the product.

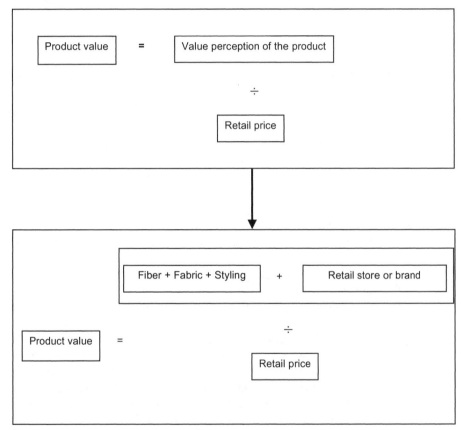

Figure 4.4
Consumer value equation for determining product value using value perception
and retail price.

what value-added components must be incorporated into the final product. These decisions affect many other activities including the price of the merchandise. The value-added components become the **value system** for the product (see Figure 4.5). All physical attributes and benefits added to the product from the fiber and textile companies, to the manufacturer, to the wholesaler or retailer contribute to the value system for the finished product. For some

Figure 4.5
Value system equation for the consumer when evaluating the retail store as well as the product.

Figure 4.6
Example of a product value system for a high-quality but moderate-priced T-shirt.

products, this value system is determined by all companies, in the various links of the FTAR Supply Chain that provide fabrications and materials, production, and marketing for the product for a collaboratively driven value system.

At other times, the value of the product is determined by the demands and desires of the target consumer, or the value system may be formed by a combination of both consumer needs and some links in the supply chain. For example, in a collaborative value system, the fiber may be a combed, long staple cotton and the yarn may be a heavyweight in its category; therefore, the fabrics produced from these yarns are of a better quality than those made of short staple cotton and lightweight yarns (see Figure 4.6). These fabrics may then be made into basic products, making them a higher quality as compared to other products in that same product classification, or these fabrics may be incorporated into a trendy contemporary fashion product that sells at a very high price point. In either case in this scenario, each product has value-added components, whether or not they were added at all links in the supply chain or whether they are evident to the final consumer.

Components in the value system can include many factors, and these components may not even be inherent in the physical product. For example, the brand name of the manufacturer or the store location of the retailer becomes more important to the consumer than a high yarn count or an extra long staple cotton. Instead of these physical attributes, customers may look for specific

price points for the item, the availability of the items at the retailer, and the image and ambience of the store (e.g., perceived safety and lighting of the parking lot) or the number and quality of customer services offered by the retailer. Each company in the FTAR Supply Chain must determine what product attributes, benefits, services, and brand or company images will be perceived as value-added components. The company wants to attract the largest number of target consumers yet produce a profit for all links in the supply chain.

Through the quality component, this equation incorporates product features and attributes. (Product quality is discussed further in Chapter 12.) The assortment, convenience, store image, and services represent components that are contributed by the retail store. The target consumer's attitude is represented in the time and stress components. Additionally, the cost component or the retail price is addressed in the equation as a relation to the consumer's perceptions of the product. Although the value system for a product may be clearly expressed by the merchandisers within one company, few companies and even fewer customers define value in the same terms or with the same definition or meaning. For example, one company making basic fashion khaki pants and jeans surveyed its target consumers to ascertain how they defined value when purchasing their products. To their surprise, this company found that although they were providing value-added benefits such as flat felled seams, the customers neither recognized nor cared about these physical attributes as adding to the value of the product. Therefore, the customer did not perceive the product as a better value than the company's competition!

The value system equation helps a retailer or manufacturer perceive what is important for the product according to the consumer. For example, a T-shirt is made of long staple fibers and a heavyweight fabric so the fabric hand is very pleasing. The stitching used and the seam types make flat soft seams that are comfortable to the wearer. However, to reduce costs the manufacturer uses the same pattern piece for the front and the back of the shirt, and the arm holes are cut in a straight line instead of rounded to fit the upper arm (see Figure 4.7). The fit is therefore unnatural and uncomfortable to the wearer. Although the price is low and most of the product attributes are very acceptable, the shirt is not a good value to the consumer. Every time the shirt is worn, the wearer considers it to be uncomfortable. With the value equations, merchandisers are not required to find actual dollar values to fill this equation but use this to better understand and express what the consumer expects from a product. Merchandisers working for apparel manufacturers often forget that the product is more than fabrics, trim, seams, and hangtags. Consumers often evaluate products with their emotions rather than their knowledge of textiles and sewing.

For the manufacturer and the retailer, the value-added components that combine to form a value system or a value network are more operational than those for the consumer. The value network for the supply chain members requires partnerships, flexibility, and communication. Companies must engage with their partners and be creative together as they plan, produce, and sell products. The four main principles of a value network are openness, peering, sharing, and globalization (Todaro, 2008). These components are shown in the **value network equation** (see Figure 4.8).

Figure 4.7
T-shirt that is cut to sell for low cost and not for fit to the body.

Perceptions of Price

When the supply chain members understand consumers' perceptions of products and the values they expect to be inherent in the products, they can then begin to set the price for the product. Price for a product is not only about the cost of the raw materials used to make the product but also about the perception of the product held by the consumer. In addition, apparel companies, retailers, and consumers must evaluate or describe prices in relation to their particular position within the supply chain. For example, the apparel manufacturer, when pricing the company's product offerings, may consider the product to be of primary importance when making pricing plans, whereas a retailer might have more concern for how well the consumer will accept the price and how well he or she can cover the expenses for service and sales to the consumer.

Figure 4.8
Value network equation for FTAR Supply Chain members.

Consumers tend to be consumer focused and are looking for the right product at the right price, without regard for the manufacturer's expenses or the retailer's profit. The equation or logic used to create the price for the product can vary depending on the perspective of the merchandiser or the point of emphasis when setting the price.

Product Emphasis of Price Perception

The product emphasis for pricing is most often used by apparel manufacturers because they are usually the companies that create the product; however, retailers can also have a product emphasis in their pricing perceptions. Using the product emphasis perception, the apparel manufacturer determines how the fashion level as well as the product attributes, features, and image components of the product impact the costing of that product. Whether the product is considered a basic or fashion product, its fashion level is very important when determining the price. When thinking of price the manufacturer or other personnel using the **product emphasis of price perception** or the **product price equation** would consider a number of variables as represented in the conceptual equations in Figures 4.9a and 4.9b.

(a)

(b)

Figure 4.9
Product price equation for (a) basic products and for (b) fashion products.

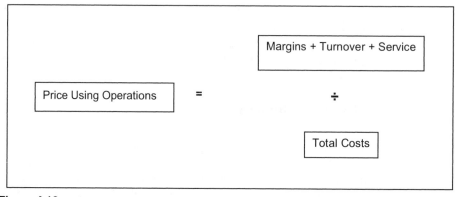

Figure 4.10
Retailer price equation.

Although exact numbers would not be used in finding a specific dollar amount, these formulas show the relative importance of various characteristics and operating expenses. In other words, the manufacturer determines costs based on his or her perception of the value of the product to the consumer and relative to the business costs of manufacturing and selling the product. For basic goods, most consumers want to pay the least expensive price for the most value attributes and services while that same consumer may pay extra for fashion products with exclusive product features and unique brand image attributes or special customer services.

Operations Emphasis of Price Perception

In another perspective, some companies, especially the retailer, must primarily consider components of the P & L Statement that show the profitability of the company. When setting the price of a product, these components include margins (e.g., gross margins, GMROI), turnover, and costs of customer services. The equation that describes the **operations emphasis of price perception** is often stated in the industry as the **retailer price equation** (see Figure 4.10).

Consumer Emphasis of Price Perception

In contrast, consumers view pricing very differently. Most consumers want the most value for the least expenditure and are looking for a bargain or good buy. Some consumers who desire prestige, premium, or designer products will pay the higher price for exclusive and differentiated products, especially those products that are fashion oriented. The **consumer emphasis of price perception,** or the **consumer price equation,** is expressed in the conceptual formula in Figure 4.11.

Although consumers may not insert exact dollar amounts and use a calculator to determine the price they are willing to pay, many consumers when shopping do consider the importance of product attributes, store or brand image, and other product and business features relative to the price of the product.

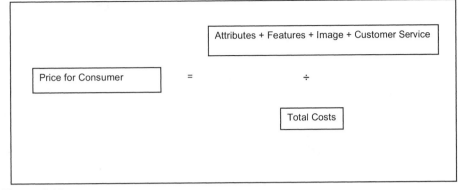

Figure 4.11
Consumer price equation.

For a company to remain financially stable, any pricing plans must cover costs of goods sold, planned profit and margin goals, overhead operating expenses, and reductions. The company must make a profit on products that are sold unless the company makes a deliberate decision to price below product costs to achieve a specific market goal. In that situation, additional moneys must be collected through other means or other products to recover the loss. Additionally, price must be coordinated with the other marketing mix elements and also be targeted within the price goals of the company's target consumer.

Pricing

Pricing usually refers to the assignment of the retail price of merchandise done by a retailer and may be used for any activities involving the setting of prices for products, whereas **costing** usually references the price activities of a manufacturer. However, the activities are often the same, although components within and the concerns about the price may vary at each link in the supply chain. Pricing of a company's products or services is a complex process that depends on understanding a large amount of information about the business environment, the product, the competition, and the customer. Some of the major external environmental factors that affect pricing consist of the state of the economy (e.g., interest rates, recession, inflation), consumer and industry trends, government regulations, and social concerns relative to pricing. Pricing may be based on the target customers' perceptions of price and value, the costs of producing the product or service, the competitors' prices, and the channels of distribution in which the company operates as well as the company's goals and objectives in relation to expected profits, market share, customer satisfaction, and company image.

How the product is positioned in the marketplace and the fashion level of the merchandise as well as product attributes (e.g., appearance, care, fit, quality), product features (e.g., color, construction details, fiber/fabric, style), and prod-

uct image factors (e..g., brand, presentation, packaging) also impact the pricing of the merchandise (see Figure 4.12). Additionally, when pricing product, internal company factors must be considered. Some of those components include the overall company objectives as stated in the company's strategic plan, information from the P & L Statement (e.g., planned sales volume, gross margin, operating expenses) plus the type of products and operations handled by the company's supply chain partners.

Therefore, to compete in today's complex marketplace and be profitable, retailers, apparel companies, textile firms, fiber producers, and other raw materials providers must develop an effective and sound pricing strategy. A **pricing strategy** includes the pricing policies of the company, techniques for planning specific pricing policies, action plans to implement those policies, and methods to adjust prices to meet the demands of the target consumer as well as the marketplace. **Pricing policies** are procedures and management guidelines that must be followed when implementing the pricing strategies. The pricing strategy is developed from the marketing objectives, which are part of the market

Figure 4.12
Product, company, and supply chain characteristics that impact pricing.

plan that originates from the strategic business. Knowing the answers to the questions "Who are we?" and "How do we get there?" helps financial planners give specific directions to pricing policies.

Specific Pricing Strategies

No one pricing strategy is perfect for all products, channels of distribution, consumer segments, or markets. Based on the strategic planning process and the merchandising planning activities, including philosophy of management, the mission statement of the company, market conditions, the external environment, and the target consumers' values and perceptions of price; a company must evaluate its alternatives and then establish its marketing strategy. Many companies use strategies based on the newness of the product, consumer demand, product and operating costs, product value, or the price that the competition offers. Table 4.1 outlines pricing strategies and types.

New Product Pricing

For a business, pricing new products, especially those just being introduced into the market, is very risky and complicated. When developing **new product pricing,** the company must consider not only the position of the product in the product life cycle but also must take into consideration how easily it will be for the competition to enter the market, if the competition can undercut the price easily, or what type of demand there is for the product.

The three types of new product pricing are market skimming, market penetration, and market trial pricing. **Market skimming** is pricing a product with unique attributes, features, or image attributes at a premium or **prestige price** so the company can skim or achieve high profits per unit, even if there are not high sales volume from the product. With the market skimming strategy, the prestige price of the product must be accepted by the target market or the target consumer must recognize that the uniqueness or exclusivity of the product has value-added attributes that are worth the higher price. With exclusive or new products, some consumers are willing to pay these extra-high prices for the prestige of having something that is new and not owned by other consumers. Consumer demand for the product must be high enough so the costs of production can be covered and all companies involved can make enough profit to be successful with the pricing strategy. And competitors should not be able to enter the market quickly, thus forcing a quick reduction in the retail price.

After an introductory period when the original company has experienced exclusive sales of the product, a competitor enters the market with the same or similar product. The length of this introductory period depends on the uniqueness of the product, the strength of consumer demand, and the difficulty in making or replicating the product. To compete in the marketplace, the original company will reduce the price of the original version of the product

Table 4.1
Pricing strategies and types.

Pricing Strategy	Types	Definitions	Retail or Brand Examples
New Product Pricing	Market skimming	Using prestige prices to create a high-price image with new or unique products	Citizens of Humanity jeans
	Market penetration	Pricing at a price lower than prestige to gain customers in the market	Walmart, Target
	Market trial	Using a price to introduce new products at a very low price and increasing price with demand	Any retailer with a promotion on a new product
Demand (Consumer) Oriented Pricing	Target costing	Setting the price relative to the demand consumers' demand for a quantity	Any retailer with markdowns
	Yield management pricing	Pricing the same product at different prices to different customers in different markets	Some chain retailers with stores in various markets
Cost Oriented Pricing	Markup pricing	Basing the price on the addition of the cost components such as operating expenses and profit	Traditional retailing
Value Based Pricing	Everyday fair pricing (EDFP)	Placing moderate prices on products with moderate to high quality	JCPenney
	Everyday value (EDV) pricing	Pricing products with an emphasis on how much product the consumer gets for the dollar	Macy's, J. Crew, Talbots, Ann Taylor
Competition Oriented Pricing	Competitive pricing	Doing an analysis of similar retailers or products to obtain a price that is comparable to the other sellers	Dillard's, Belk
	Above-market pricing (prestige pricing)	Using prices to create an image of the product as an expensive product	Neiman Marcus
	At-market pricing	Having prices for products that are similar to prices on similar products	National brands
	Below-market pricing	Using loss leaders or smaller markups to have products that are priced lower than the competition	Dollar General, Dollar Stores, outlets

and continue to sell the product or will stop offering that product. By the time of the competitor's full entry into the market, the original company should have made enough profit to recoup the high dollar costs of the research and development plus promotional costs for the new product.

An example of market skimming is found in the premium-denim jean market. In 2000, the denim manufacturer 7 For All Mankind introduced a premium-denim jeans line and became very successful in selling those jeans for $150 to $250 per pair. This introduction was accompanied with a huge demand for premium-denim jeans (see Figure 4.13). Karen Short, a market analyst with Friedman, Billings, Ramsey & Co. explains, "Premium denim is accepted. People who would never have considered paying more than $80 aren't blinking at $170 [a pair]" (Dickler, 2007, para. 3). With the explosion of this product category, other manufacturers such as Citizens of Humanity, Joe's, True Religion, and Rock & Republic entered the premium-denim jean market, "each trying to distinguish itself with different trims, washes, construction and—especially—stitching on the back pockets" (Dickler, 2007, para. 4). At this introductory stage in the product life cycle, profitability per unit is very high in this category, demand remains high with little consumer price resistance, and specialty stores as well as upscale department stores are stocking the product. The exclusivity and differentiation of product, consumer demand, and placement of the product in select channels of distribution have created an ideal environment for market skimming pricing strategy for companies that have early entry into the premium-denim jean market.

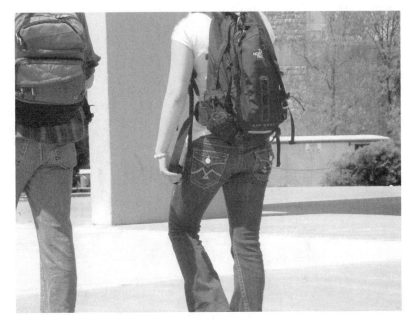

Figure 4.13
Premium jeans are often sold with prestige pricing.

Market penetration pricing is based on introducing a new product at a low price to attract a large number of consumers so the company may build a high sales volume and create a large market share for the product. With the larger sales volume, the costs per unit for producing the product should be lowered; therefore, the retail price can also be reduced. When using mass production techniques and computerized replenishment of stock, operating costs can be lower for companies along the FTAR Supply Chain that are in partnership with this strategy (Kim & Kincade, 2006). Walmart uses this strategy effectively with its **everyday low prices (EDLP)** strategy. Vendors for Walmart (e.g., apparel manufacturers) can make some products very quickly and repeat the manufacture of those products with limited product costs and constantly send a steady flow of items to Walmart (see Figure 4.14). For this strategy to be profitable financially, the customer must be price sensitive and competitors are not willing to enter the market because the prices are so low.

Lastly, some companies use the market-trial pricing strategy to introduce a new product. With **market trial** pricing, the product is introduced at a very low price to attract as many customers as possible. As the demand for the product increases, so does the price of the product. As long as demand stays constant or increases, the retailer and the manufacturer can continue to increase the price. With this strategy, the low price of the new products is presented to the consumer as a promotional price. The satisfied customers who buy the product at the promotional price advertise the product by word of mouth to other consumers, which creates added demand for the product. The second wave of consumers want the product to have the benefits that their friends, family, and neighbors are advertising and are willing to pay the higher price to get the product and realize they are second on the product and must pay a higher price.

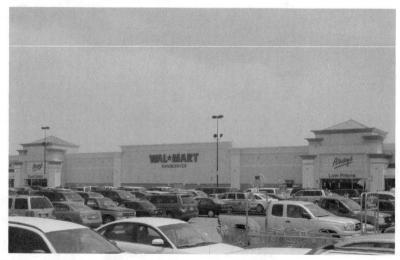

Figure 4.14
Walmart is a retailer with market penetration pricing.

Demand (Consumer) Oriented Pricing

With **demand oriented pricing,** the retailer must ascertain the relationship between consumer demand and the quantities that customers will buy of the product when the product is offered at various prices in different markets. Or, a company must estimate what quantity of demand for each price in each market is acceptable for the company to be profitable. The demand floor with the lowest price for the product must be determined as well as the demand ceiling with the highest price for the product.

Price elasticity of demand, or how consumer demand will fluctuate with a change in price, must be determined. If a change in price causes a significant change in the quantity demanded by the consumer, the demand is termed as **elastic demand.** If the change in price causes little change in the quantity demanded by the consumer, the demand is then **inelastic demand** (see Figure 4.15). With elastic demand, the demand for the product or the quantity bought varies rather dramatically as the price changes. Whereas with the inelastic demand, the number of items bought remains relatively stable in comparison to the elastic demand, although the price changes drops from $120 to only $20 per item.

With demand oriented pricing the company must consider the price-to-quality relationship for the product, as perceived by the target consumer. Sometimes consumers equate high price with high quality and vice versa. Many times consumers are less price sensitive if the product is a prestige or exclusive product or if the product is difficult to find in the marketplace.

Two of the demand oriented pricing strategies are target costing and yield management pricing. With **target costing,** instead of beginning the product development process with designing the product and then costing it based on the product attributes, the manufacturer asks the consumer what the ideal price of the product is in relation to the product attributes desired. Then the company develops the product with those attributes demanded by the consumer and ideally with the requested prices, so the consumer will buy the product. Consideration must also be given to the costs of the product so the company will make a profit. With **yield management pricing,** a company sells the same product in different markets to different customers at different prices. In other words, the company prices the product to yield maximum sales across various customer markets.

Cost Oriented Pricing

Cost oriented pricing is the simplest type and most widely used method of pricing. **Cost oriented pricing,** also known as **markup pricing,** consists of adding the costs of the product, the operating expenses, and profit to calculate the selling price. This pricing strategy can be used by retailers to set a retail price or by producers and manufacturers to establish a wholesale cost. The **markup** within a price is the difference between costs of goods (wholesale costs) and retail price of those goods for a retailer or the difference between costs of manufacturing and

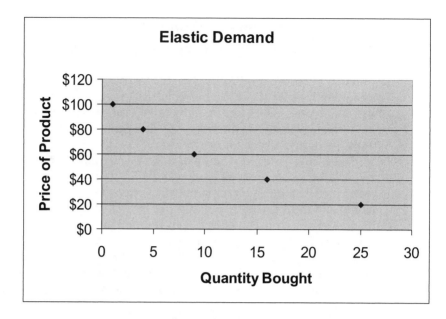

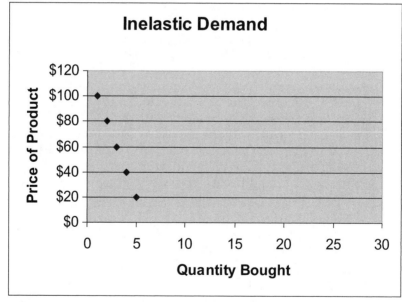

Figure 4.15
Comparison of price elasticity of demand for a product with varying prices.

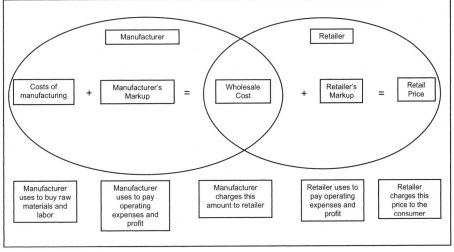

Figure 4.16
Prices are quoted as manufacturer's wholesale cost and retailer's price.

the wholesale cost for a producer or manufacturer (see Figure 4.16). Markup must cover operating expenses, profit, and reductions (i.e., markdowns, discounts, shrinkage). The size of the markup usually varies across product categories (even within the same product classification), the company's planned markup goals, the channels of distribution, and different business types.

For retailers, markup may be calculated based on the cost of goods or on the retail price. Because most retailers now operate on the retail system and calculate gross margin, retail expenses, profit, and retail reductions as a percentage of **sales volume** (i.e., net sales), markup is usually calculated on the retail price. Additionally, retail sales and retail percentages are usually quoted by the industry for comparisons and planning, and psychologically, retail markup is smaller than cost markup when being viewed by the consumer or employees. Markup for manufacturers or producers may be calculated on projected retail price, on wholesale costs, or on manufacturing costs. Many retailers use a **keystone markup,** or a markup that doubles the wholesale cost of the merchandise. For example, a product that had a $50 wholesale cost would have a $100 retail price (or 2 × $50 = $100).

Value Based Pricing

Value based pricing takes into consideration what the customer perceives as the value of the product and what price reflects that value. The product is then designed to reflect the value desired by the customer. With this type of pricing the manufacturer must determine what the value is worth in dollars, or a set price, to the target consumer. This is not an easy task. Although value is often associated with low price, especially in the eyes of the consumer, the two are not synonymous. When a moderate price, quality products, and other desirable

product characteristics are associated together, this pricing might be considered as **everyday fair pricing (EDFP).** Some department stores such as JCPenney (see Figure 4.17) are attempting to use this type of pricing and are staging fewer sales during the peak selling periods while attempting to promote more private label or store brand goods with value-added benefits. Macy's is calling this value-based approach **everyday value (EDV)** pricing (O'Donnell, 2006).

To achieve value based pricing, some stores may offer a less expensive rendering of a branded product. For example, in the men's department of a department store, a shopper might find a short sleeve, three-button knit shirt with Label X and Label Y, with both shirts developed and marketed by a major designer (see Table 4.2). The Brand X shirt may be of a fabric with higher cotton content and higher yarn count along with other value-added details; the Brand Y shirt is found in a fabrication with a lower yarn count and a small percentage of polyester, along with fewer colors for a lesser price.

Retailers, especially specialty stores, may also limit the quantities of the fashion products that are offered. Customers soon find that if they see a new fashion item and they like that item they should buy it now at the initial price because it will not be in the store when the sales are started. This EDV practice is being used by J. Crew, Talbots, and Ann Taylor (see Figure 4.18) to move fashion goods, to reduce sales, and to increase the number of items sold at the

Figure 4.17
JCPenney is known for its value-pricing strategy.

Table 4.2
Comparison of product characteristics for knit shirts across two brands.

Product Characteristics	Brand X	Brand Y
Fiber content	100% Pima cotton	90% cotton/10% polyester
Yarn count	Higher	Lower
Hem allowance	1″ hem	½″ hem
Seam for hemming	406 Double Needle Mock Cover Stitch	103 Hemming Stitch
Length of center back	Longer	Shorter
Color assortment	Wide array of colors	Limited selection of colors
Available sizes	Sold by chest size	S, M, L, XL
Price	Premium price	Moderate price

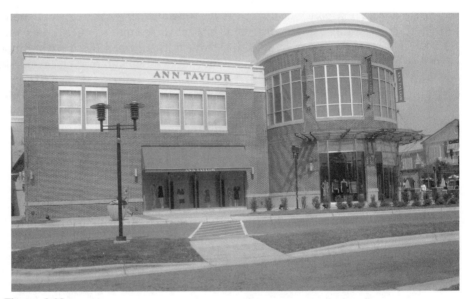

Figure 4.18
Ann Taylor has value-based pricing for its customers.

initial price (O'Donnell, 2006). When EDLP is used continually to price goods at low prices and reduce the number of sales and price reductions, it is also used as a type of value pricing. This has been an effective strategy used by Walmart and other companies.

Competition Oriented Pricing

Competition oriented pricing requires a company to conduct a competitive product analysis of similar or identical product categories it purchases for its

merchandise mix and the competition also stocks. This pricing strategy can also be called **competitive pricing.** Many times the price at which the competition sells a product dictates at what price a company may sell a similar product to maintain its planned sales volume. This may or may not allow the company to be profitable. Using the Internet and catalogs, the consumer can rather easily compare prices of well-known brands as well as compare the offered benefits, features, and attributes of other competing brands (Kelly & Allen, 2007). Sometimes using this pricing strategy determines the nature and amount of competition. When a company can price a product slightly below the competition and still maintain the planned margins for the company, the firm may be able to reduce the number of buyers at the competition and ultimately reduce the number of competitors. This type of pricing is often found when the product is easy to obtain or produce, many consumers are interested in buying it, and differences in the product across brands is basically not noticed by the consumer.

When competitors are using competitive oriented pricing, a company must have a policy of how to react to the pricing strategies of the competition and must also determine what impact the competition will have on its bottom line. Companies must often use three options when faced with competition-oriented pricing. These choices include above-market pricing, at-market pricing, and below-market pricing. **Above-market pricing,** or **prestige pricing,** consists of pricing a product with a higher markup than usual. This is similar to the new product pricing strategy of market skimming. To compete, a company may use above-market pricing only if the firm has an upscale decor and image attributes, exclusive and differentiated products with large or targeted assortments, value-added customer services, and a desired location and very few competitors (see Figure 4.19). Many retail stores along 5th Avenue in New York City from approximately 47th Street to 59th Street and on Rodeo Drive in Los Angeles are prestige stores with this type of pricing. Prestige pricing is based on the emotional, psychological, or status aspects of pricing instead of logical, rational pricing.

At-market pricing is probably the most often used type of competitive pricing. With the **at-market pricing** strategy, the company prices similar product classification near or at the same price of its competition. In the retail link of the FTAR Supply Chain, many national brands are bought by many retail stores of similar and varying types, which are located in the same geographic vicinity; therefore, location alone sometimes dictates the use of this pricing policy for the retailer. For example, this author owned a small specialty retail store where she sold better to designer merchandise in a midsize town in the southeastern United States. This specialty store was located a few miles from one of the first established outlet centers in the Southeast. The store owner realized that if an outlet purchased the same product classification, especially with the same brand name, and sold the product at a lower price, the merchandise in the specialty store would stop selling. One consumer brought back an item because she could purchase it at 88 cents less at the outlet, even

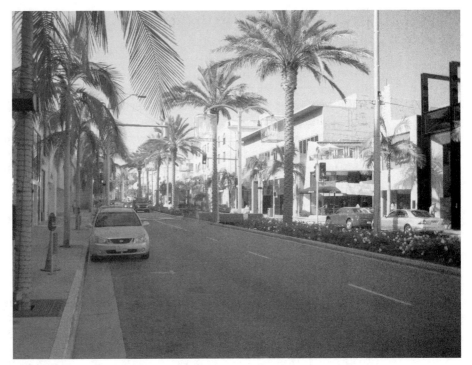

Figure 4.19
Rodeo Drive is a prestige retail address.
(Photographer: Eunju Ko)

though the specialty store had many value-added customer services, such as alterations, free gift wrap, wardrobe-building classes, and targeted special events.

Sometimes companies sell the same product at a lower retail price than its competition. This competitive strategy is known as **below-market pricing.** To use this strategy, the company (1) must be able to take a smaller markup and still maintain its planned sales and profit goals, (2) may be using the product as a **loss leader** or (3) is selling product at below or near cost to bring in additional customers. Changing the markups or expected profits can be achieved for various reasons. The company could be located in a less desirable and therefore lower rent location, or it could have less costly overhead expenses from reduced advertising or fewer employees than its competition and can afford to sell the product at a lower markup. If the below-market pricing brings in an increase in buying customers, the company may achieve higher sales goals with the same expenses and therefore have the same or higher profits. With any pricing strategy, the company must consider the price appeal to the customer and the impact of that strategy on the components of the P & L Statement and the guidelines developed in the market plan and the budgets.

Action Plans or Pricing Policies for Pricing Strategies

After deciding on the general pricing strategies, a company must adhere to specific pricing policies to implement the strategy. Many different alternatives must be considered when finalizing the pricing strategy. Sometimes the type of store or channel of distribution dictates these policies; at other times the policies are impacted by consumer and industry trends. Pricing policies are generally established by executive management and must be followed by personnel in the Merchandising Division as they establish and adjust prices. Some of the major tactics include product line pricing, zone pricing, prestige pricing, EDLP, EDFP, promotional pricing (high-low), odd price endings, one price only, multiple-unit (bundle) pricing, segmented pricing, geographic pricing, global pricing, and fast-fashion pricing.

Product Line Pricing (Price Lining)

One of the most common tactics for pricing is product line pricing, where, there is a floor and a ceiling of prices for specific product classifications in the product line (see Figure 4.20). And with **product line pricing,** or **price lining,** each specific item of the same product classification is assigned a specific **price point** (level) that falls between the floor (lowest) and ceiling (highest) price or **price range** of that particular product category. The price points are usually based on the quality of the item as well as the value-added attributes possessed by the specific item. Sometimes these price points are designated as good, better, and best prices.

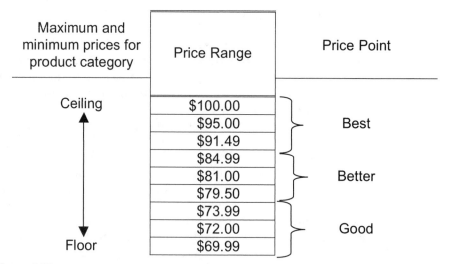

Figure 4.20
Use of price lining to set price points and price ranges.

Zone Pricing

Zone pricing assists a retail buyer in implementing price lining. **Zone pricing** is dictated by the fashion level and design influences, construction details, types of fibers and fabrications, and sizing of merchandise found within each particular women's wear zone of designer, bridge, contemporary, better, and popular or budget merchandise (see Chapter 3). As the zone names imply, price ranges and points are formed based on the criteria for each zone; therefore, specific price points are found within each zone for various product classifications. A white shirt in the designer zone may be created by a famous name designer, may be executed in a 100% silk fabric, and may have intricate stitching details, whereas a similar style in the bridge area is made of 100% Egyptian Pima cotton with mother-of-pearl buttons and basic top stitching. The designer blouse may cost over $1,000, and the bridge blouse may be retailed at $500 (see Table 4.3).

Promotional Pricing (High-Low Pricing)

Promotional pricing, or **high-low pricing,** consists of establishing a premium price for a product and then reducing the product temporarily to create consumer traffic. Many times the retailer may buy promotional merchandise from the manufacturer (or merchandise priced below average wholesale price offered especially for this purpose), and price the merchandise at the high price for an established period of time and then reduce the price of the merchandise for a special event or sale promotion. By purchasing the merchandise at a reduced or promotional price, the initial markup goal may be obtained even though the merchandise is sold at the reduced price.

Discount and Mass Merchant Pricing

Sometimes the channel of distribution influences the specific action plan for implementing the pricing policy. For example, in the discount and mass channel of distribution, retailers usually exercise odd price endings, one-price-only pricing, or multiple-unit or bundle pricing. In **discount and mass merchant pricing,** pricing merchandise with **odd price-cent endings** such as $11.99 is a psychological pricing strategy to make the customer think that the product

Table 4.3
Comparison of prices across zones for blazers.

Zones	Zone Pricing				
	Budget	Moderate	Better	Bridge	Designer
Prices*	$79	$150	$250	$700	$2,000
Brands	Jaclyn Smith	Sag Harbor	Jones	Ellen Tracy	Oscar de La Renta

*Prices are approximate values to show relative costs.

price is lower than if it were priced at the even dollar amount of $12.00. Discounters and mass retailers have used this pricing strategy for so long that the consumer usually views this pricing to equate to discounted, lower price, or bargain merchandise. Usually product priced at even dollar amounts such as $99.00 is considered to be of higher quality or a luxury item than a product priced at $98.99. In fact, in the designer, bridge, contemporary, and better zones of merchandise, unless the items are offered at a reduced or "sale price," the dollar endings are always even. In contrast, moderate, popular price or budget, or other low-end merchandise is usually priced with odd price-cent endings.

Some variety firms, carrying odd lots and broken sizes of merchandise, price their entire merchandise mix at the same price or use the **one-price-only strategy.** For example, some of the *dollar stores* use this type of pricing strategy. Many *warehouse clubs,* such as Sam's Club and Costco, use multiple-unit or bundle pricing (see Figure 4.21). With **multiple-unit** or **bundle pricing,** the customer receives a discount for buying a specific product classification in a quantity or product bundle such as six or twelve pieces of the identical item. Some bundle pricing is also found in mass merchants such as Walmart and Target. Menswear items, such as white athletic socks and white underwear briefs, are usually sold with this strategy at discount stores and warehouse clubs.

Retailers may also use **quick markdown pricing** to generate interest among consumers. With this type of pricing, retailers mark product down at

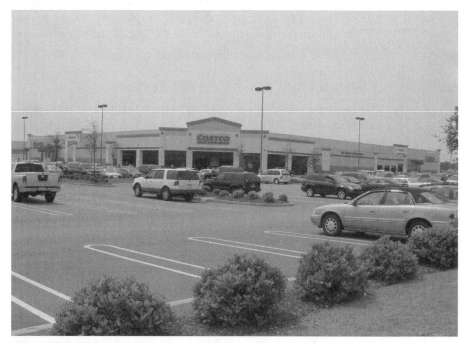

Figure 4.21
Costco is a retailer that uses bundle pricing.

specified time intervals to create a repeat customer base and to build high volume. Some retailers have used this strategy to the point that customers wait until the sale to buy. This waiting does not benefit the retailer because of limitations on cash flow. In addition, when all customers wait until the sale, the retailer never sells any merchandise at full price.

Fast Fashion Pricing

One of the latest pricing phenomenon is the fast fashion pricing strategy, as practiced by such retailers as H&M (Hennes & Mauritz), the Swedish retailer; Zara, the Spanish company; and Topshop, a British company, as well as the American mass merchant Target. With the **fast fashion pricing** strategy, a retailer offers a high fashion or updated fashion product at low prices, which is contrary to the normal pricing policies for pricing fashion merchandise (see new product pricing strategies in this chapter). In *Newsweek*, the author Keith Naughton (2007), explained the concept: "H&M has transformed the calculus of cheap chic. With an in-house staff of 120 designers and a nimble network of Asian and European factories, the Swedish retailer can move the latest look from runway to rack in three weeks. And H&M sells high style at crazy-low prices ($3.90 necklaces, $29.90 minidresses)" (para. 2). In the same article, H&M chief designer, Margareta van den Bosch, explains the concept: "We don't copy the catwalks. . . . We take inspiration from what's happening in the culture, with celebrities and on the catwalks" (Naughton, 2007, para. 4).

H&M's "fast-fashion formula puts a twist, like a different color or fabric, into a look seen in Milan or Paris. It also mixes street with runway" (Naughton, 2007, para. 5). With regard to creating and pricing the fast fashion, the company attracts celebrities and name designers (e.g., Madonna, Karl Lagerfeld, Stella McCartney) and hires them to create "cut-rate couture for H&M. The hook: their collections are in stores for only a few weeks" (Naughton, 2007, para. 5). This timeline is in contrast with the typical time to market of six months to two years to get a product line from concept to retail sale.

In the United States, Target has been a leader in the fast fashion movement. "From the start, Target found ways to sell style as well as steals. Even back in the 1960s, shoppers noted the company's Parisian flair by dubbing the discounter 'Tar-zhay'. . . . Target would license hot fashion-name brands that were suffering financially on their own and remarket the lines to the masses" (Schlosser, 2004, para. 11). For example, Target hired designers such as Isaac Mizrahi and Mossimo Giannulli to design exclusive lines for its stores and then sourced "high-end manufacturers to offer exclusive product to its shoppers" (Schlosser, 2004, para. 13).

Other Pricing Action Plans

Other action plans for implementing a company's pricing strategy include segmented, geographic, and global pricing. In the **segmented pricing** strategy, different customer segments, different store locations, or different product versions

are always sold at different prices even though the cost remains constant and the pricing strategies may change for the company or product line. For example, the same branded items placed in older retail stores in a company may have lower prices than the same products in newly opened stores for the same company. **Geographic pricing** takes into consideration the distance of the customer from the manufacturer and the shipping costs to get the product to the retailer, whereas **global pricing** takes into consideration the country where the product is sold and the pricing strategies and legal requirements used in that particular country. Policies that depend on the philosophies of prestige pricing, everyday low pricing (EDLP), and everyday fair pricing (EDFP) were discussed in the pricing strategies section of this chapter.

Markdowns

Markdowns are price adjustments that the retailer, manufacturer, or producer makes at some point in time, after the initial markup is placed on the wholesale cost. No merchandiser expects to sell all products at the first price or with the total initial markup placed on a product. There are many reasons that product does not sell at the first or initial price. For example, fashion goods may become obsolete, seasonal goods may be in stock during an inappropriate time period, or other merchandise may become soiled or distressed. Or companies may use special reduced prices to entice customers to view the merchandise, to control the amount of inventory on hand, or to promote a special event or happening.

Markdowns are used everyday in FTAR company operations to conduct business and are a central factor in any merchandising strategy. They must be planned for in the merchandising budgets. With markdowns, merchandise is reduced in price for temporary or permanent promotions, end-of-month or clearance sales, employee discounts, customer returns and allowances, and any other purchases that require a reduction in the selling price of an item. Depending on the philosophy, merchandising policies, and strategies of management, markdowns may be considered as a *necessary evil*, or, in contrast, as a merchandising tool that assists the retailer in building profits, maintaining specific inventory levels, and creating cash flow. Markdowns are most useful if considered as a merchandising tool and planned as a guide, not a goal, to carry out the merchandising strategy of the company.

When calculating the merchandise plan and associated budgets, the retailer must plan both the markdown dollar amount and the percentage of markdowns expected for a specific selling period. In fact, the retailer buys additional merchandise to generate sales to cover the loss of the reductions from the markdown dollars. Markdowns are taken as a percentage of the retail price (or the price to the customer), and the first markdowns are based on the initial or original price. The amount or size of the markdown is usually controlled by the original retail price and the timing of the reduction. In retail, it is customary for buyers to begin with a 20% or 25% reduction in the original price on the

first markdown reduction. Then many retailers take a 33⅓ % to 40% markdown for the second reduction and try to move all leftover merchandise from these assortments at 50% off the original retail (see Figure 4.22). Any merchandise left is then either sold to jobbers or other retail outlets to remove them from the inventory, or the items are marked below cost using an odd-cent pricing structure to indicate to the consumer that the price is severely reduced.

Reasons for Markdowns

Markdowns can be both planned and unplanned. Obviously planned markdowns are more desirable than unplanned ones. When markdowns are unplanned they may reduce profit, retard cash flow, and damage the possible advancement of a merchandiser's career. Planned markdowns are those controlled by management to move inventory and are created by promotions personnel to generate interest in and sale of the products. Markdowns are used by FTAR companies for the following three major reasons: (1) to assist management in operating the business or controlling financial situations such as cash flow or overhead expenses, (2) to create sales promotions or special events that attract additional customer traffic and ideally additional sales volume, and (3) to move inventory that is not selling because of buyer error, mistakes made in planning or inventory selection, or other pricing errors. Although the third reason is for unplanned errors, a wise merchandiser makes some plans to accommodate these unplanned but often not unexpected markdowns.

MANAGEMENT OR OPERATIONAL DEVICES. To control inventory levels and to assure that merchandise assortments are balanced and salable, many times buyers and store merchandise managers use markdowns to sell *odd lots* or

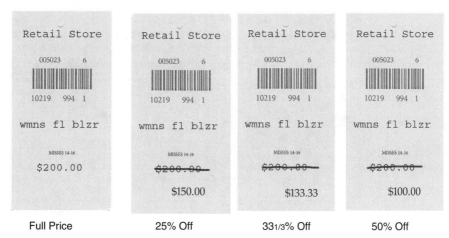

Figure 4.22
Sales tickets for $200 blazer with markdowns.

leftover SKUs of related groupings or SKUs that are in stock in *broken sizes* (i.e., not a full run or range of sizes) or *imperfect* merchandise (e.g., soiled or damaged items). Imperfect merchandise may occur in several ways. For example, when merchandise is kept in stock for a lengthy time or featured on display, it may become soiled or damaged. Merchandise placed on hangers when it should be folded may get snags or lose buttons; merchandise tried on by numerous customers may be stained with makeup. Occasionally, merchandise arrives at the store in a very wrinkled or damaged condition and cannot be returned to the vendor for various reasons. All of this merchandise must be reduced to keep the inventory clean and fresh and to provide a variety in selection of merchandise for the target consumer. At other times, management reduces select merchandise to meet the retail prices of the competitors or to meet customer demand. Many retailers run end-of-month (EOM) sales to rid their assortments of merchandise that is not current or does not fit with new receivables.

MERCHANDISE DEVICES TO PROMOTE SALES. To create store traffic and to provide *retailtainment* for the consumer, many retailers stage elaborate special events or temporary sales promotions featuring marked-down goods (see Figure 4.23). To have merchandise for these events, the retailer may purchase **special cuts,** or merchandise specifically produced for promotions. For various reasons (e.g., lesser quality fabric, fewer color options), this merchandise is available to the buyer at a lower wholesale cost than the merchandise normally purchased.

On this lower cost merchandise, the retailer may take a **long initial markup** for the original retail price or a markup larger than the usual markup on similar but regular-cost merchandise. They may also buy close-outs, which would be at a lower wholesale cost, to take the additional or long

Figure 4.23
Liz Claiborne coupon provides customers with a temporary sales promotion opportunity.

markup. The merchandiser may also use the long initial markup with merchandise that does not carry a national or known brand. When the merchandiser applies the larger than normal markup, the merchandise may have a slightly higher initial price than comparable items, but without the comparison to known brands, the consumer may not notice the higher price. With the larger than usual markup, the retailer is able to take a markdown without reducing the expected markup or can take a deeper markdown than possible with the usual markup. Thus it is very important to examine markup in relation to markdown as the greater the original markup the less effect of the markdown on the retailer's profit or bottom line. For example, retailers may use private label or private brand merchandise for special sales promotions because private label goods, at a wholesale cost lower than national brand goods, allows the retailer to take a greater markup; therefore, the effect of the markdown had less impact on the amount of profit that the retailer will realize.

Errors in Buying and Selling. Many times buyers overbuy because of unrealistic sales planning. Or they buy what they like instead of what the customer desires because they have not pinpointed the store's target customer or do not understand the buying patterns of that customer. If the buyer does not plan the timing for the delivery of merchandise to meet customer demand, the merchandise arrival becomes another error in buying and selling. If the goods are delivered too early, the merchandise many times becomes shopworn or soiled or is incorrect for the season. If delivery of goods is late, the retailer does not have enough time in the selling season to get rid of the goods at regular price. Also, merchandise may be ordered in the wrong size, color, or style. Additional errors occur when merchandise first arrives in the store and is not inspected immediately for defects or is not returned when of poor quality. Poor housekeeping, lackadaisical departmental maintenance, and careless handling of some fragile merchandise cause additional markdowns.

To avoid these types of markdowns, many merchants use the inventory rule of **first in first out (FIFO).** This rule requires that merchandise received early in the selling season must be sold first before additional or similar items are offered for sale to the target consumer. However, many times sales associates, when working with customers, do not follow this policy nor do they sell product they do not like. These errors cause unsold merchandise to remain on the selling floor. Markdowns must be taken on this merchandise to make it more desirable to the customer.

Controlling Markdowns

Markdowns are unavoidable expenses that must be constantly monitored and controlled or kept within planned limits. For most retailers, markdowns are a huge expense that impacts their bottom line or profit. Retailers that use markdowns as a merchandising tool based on a plan are more successful in controlling

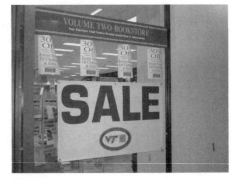

(b)

(a)

Figure 4.24
Retail store windows with sales signs (a) and (b).

their bottom line (see Figures 4.24a and 4.24b). A plan for reducing inventory is based on past experiences, economic conditions at the time, customer expectations, and company policy. As a rule of thumb, the first markdown of merchandise is less costly than subsequent markdowns. This situation is especially true for fashion merchandise because there is a strong relationship between a fashion item and the time of season when it is marked down. When the season ends the popularity of most fashion goods fade with that seasonal ending and those goods, regardless of the retail price, are no longer in demand or wanted by the target consumer. Additionally, with technology, fast fashion goods available in today's marketplace, and the cost of storage space, retailers have found it is no longer feasible to carry over seasonal fashion merchandise for the same season the next year. By this season next year, the consumer has moved on to the next fashion trend and will no longer purchase the leftover items at any price. Delaying a markdown of a slow-moving style or a fashion item received late in the season usually results in more markdowns with lower price levels and deeper cuts in prices.

Moreover, an early markdown of fashion goods ensures that the retailer has enough time in the selling season for a second or third markdown on goods that did not sell at the first markdown price. Early markdowns not only generate cash flow, but they also allow the buyer to plan for fresh deliveries of wanted merchandise or to reorder goods that sold quickly. And the more merchandise sold at the first reduced price means the less amount of markdown dollars the

retailer will have to incur. However, the retailer must never take first mark-downs too early nor too deep; markdowns must be timed to coincide with what the customer will pay for the product and what amount of inventory the retailer needs to maintain for a variety of selection of specific product classifications for the target consumer.

There are many ways to minimize markdowns. First the buyer must determine customer demand by analyzing past sales as to which styles sold quickly and which styles sold slowly or did not sell at all, which vendors performed best delivering on-time merchandise and delivering complete orders and which did not, plus which sizes sold best and which did not. Additionally, buyers must place timely reorders of best selling merchandise to prevent stock-outs and to sell in-stock inventory. Another way to minimize markdowns is in buying merchandise. Instead of marking down regular price merchandise, buyers should procure special cuts and closeouts to create special sales promotions and events. Developing key vendors that supply the right merchandise at the right price of the right quality at the right time is of the utmost importance to minimizing markdowns. Furthermore, buyers must organize markdown procedures, be selective on merchandise SKUs to be marked down, and must take timely markdowns to control the amount of markdown dollars. Other merchandising techniques may also be used to minimize markdowns. For example, the simple activity of rearranging or displaying slow-selling merchandise will decrease the amount of markdowns and simultaneously increase sales volume.

Other Price Adjustments

Occasionally, retailers mark down or reduce the price of an item and then decide to mark the product back to the original price; this price adjustment is known as a **markdown cancellation.** If markdown cancellations are taken, the value of this adjustment can be added back into the markdown budget to be used again at a later date. However, this type of price adjustment is used very seldom for apparel items in today's competitive marketplace, but it may be found in other product classifications such as home building products or home fashions where the merchandiser marks merchandise down for an announced sale and the unsold merchandise is returned to full price after the sale dates pass.

Additional markups, or increases in retail price of an item, are not used often by the retailer because the customer is not usually happy to pay the higher price for a product that he or she bought earlier at a lower price. The market trial pricing strategy is an exception to this markup policy. When the retailer uses additional markups, it may be due to an increase in the costs of merchandise, incorrect pricing initially, or an increased demand for a product classification when the supply is not sufficient to meet that demand.

Summary

The pricing of merchandise is a very complex responsibility for both the manufacturer and retailer. For a manufacturer or producer, price reflects the company image, the type of product, the complexity of the production process, and a newness of the item. For retailers, price reflects a retailer's channel of distribution, store type, and merchandise mix. Price of any firm's products and services impacts sales volume, profit, market share, company and fashion image, and merchandising philosophy and techniques. Price also many times determines the target consumer of the entire FTAR Supply Chain for a product line, the types and quantities of special promotions and events, and the success of all the firms in that partnership and particularly the success of a retailer in a specific geographic location.

Key Terms

Above-market pricing
Additional markups
At-market pricing
Below-market pricing
Billed cost
Billed cost of goods
Billed wholesale costs
Bundle pricing
Competition oriented pricing
Competitive pricing
Consumer emphasis of price perception
Consumer price equation
Consumer value equation
Costing
Cost oriented pricing
Demand oriented pricing
Discount and mass merchant pricing
Elastic demand
Everyday fair pricing (EDFP)
Everyday low prices (EDLP)
Everyday value (EDV)
Fast fashion pricing
First in first out (FIFO)
Geographic pricing

Global pricing
High-low pricing
Inelastic demand
Invoiced cost of goods
Invoiced cost of merchandise
Keystone markup
List price
Long initial markup
Loss leader
Manufacturer's suggested retail price (MSRP)
Markdowns
Markdown cancelation
Market penetration
Market skimming
Market trial pricing
Markup
Markup pricing
Multiple-unit pricing
New product pricing
Odd price-cent endings
One-price-only strategy
Operations emphasis of price perception
Prestige price
Prestige pricing
Price elasticity of demand

Price lining
Price point
Price range
Pricing
Pricing policies
Pricing strategy
Product emphasis of price perception
Product line pricing
Product price equation
Promotional pricing
Quick markdown pricing
Retail price
Retailer price equation
Sales volume
Segmented pricing
Special cuts
Target costing
Value
Value-added components
Value based pricing
Value network equation
Value system
Wholesale cost
Yield management pricing
Zone pricing

Review Questions

1. What is the difference between retail price and wholesale cost?
2. What is the meaning of value to the consumer?
3. How does value affect the retail price?
4. What components change to make the perception of price vary across the FTAR Supply Chain?
5. How do retailers determine a price?
6. What other factors besides the cost of the product or the cost of raw materials are used in pricing?
7. What is markup for a retailer? For a manufacturer?
8. How is markdown related to markup?
9. Define three pricing strategies and their associated action plans.
10. What other price adjustments do retailers make after the first retail price is calculated?

References

Dickler, J. (2007, February 23). It's all in the jeans. CNNMoney.com. Retrieved March 1, 2007, from http://money.cnn.com

Kelly, L., & Allen, K. (2007). Crossing the great channel divide. *Retailing Issues Newsletter*. College Station, TX: Center for Retailing Studies.

Kim, S-K, & Kincade, D. H. (2006). The model for the evaluation of retail institution types in South Korea. *Journal of Textile and Apparel, Technology and Management, 5*(1), 1–29. Available from: http://www.tx.ncsu.edu/jtatm

Naughton, K. (2007, June 10). H&M's material girls: The retailer speeds ahead with fast fashions. *Newsweek* Web exclusive. Retrieved September 6, 2007, from http://www.msnbc.msn.com/id/19143111/site/newsweek/

O'Donnell, J. (2006, September 25). Retailers try to train shoppers to buy now. *USA Today*. Retrieved September 28, 2006, from www.usatoday.com

Schlosser, J. (2004, October 18). How Target does it. *Fortune, 150*(8), 100–107. Retrieved September 6, 2007, from http://www.fortune.com

Todaro, M. (2008). Value networks. American Apparel Producers' Network. Retrieved January 15, 2008, from http://www.aapnetwork.net

Positioning

Objectives

After completing this chapter, the student will be able to

- Define company positioning
- Explain how product positioning is important in addition to company positioning for some companies
- Identify the retail cues
- Describe a company or product image and how it is developed
- Explain how retailers manage the retail cues strategy mix to position the store and its products
- Define the variety of brands available for use in merchandising
- Explain how brands and branding of merchandise, stores, and services affect positioning of products, retailers, and services
- Discuss the importance of private labels to a brand strategy
- Discuss the reasons why a company develops a brand portfolio

Introduction

Positioning as one of the 10 P's (see Chapter 2) is identified in a company's marketing plan and provides the company with a direction for implementing other marketing plans. As the executive management considers in strategic planning the questions of "Who are we?" they consider positioning. With the complex global competition that faces most companies in today's market, knowing who

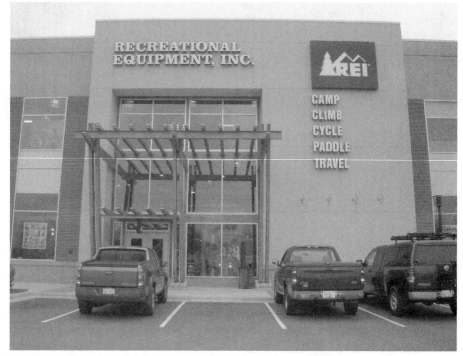

Figure 5.1
Storefronts can quickly position the retailer in the consumer's mind.

the company is becomes very important to the company's success. Companies must distinguish themselves from other companies and must create and/or sell products that are unique and will be desired by the customers. Accurate and well-planned positioning will help the company stay focused and reach its goals of profitability and company mission. REI is a company that has positioned itself as an outdoor adventure company that provides high-quality gear for their customers. On the REI Web site, they say "we love to get outside and play" (About REI, 2008). Their storefronts reveal this information to every passerby in malls and other retail places around the United States. A quick look at a storefront with the wooden lattice, fir tree symbol, and list of outdoor sports, and the prospective customer immediately knows what's inside the store (see Figure 5.1).

Definition of Positioning

In today's competitive market, all FTAR companies find they must posture or position their products and services along with their companies so the desired customers or target consumers select their product or service instead of their competitors' products and services. Companies must be very clear on the

response to the strategic planning question of "Who are we?" or how they position themselves in the marketplace. The tactic of **positioning** is creating a company image and designing the company's products and services or value offerings so the segment's customers understand and appreciate who the company is in relation to the competition. In other words, companies must know what makes consumers buy one company's product instead of that same product from the company's competition. Or, they must know what consumers' needs one particular company is satisfying with more value or in a better method and timeline than the company's competitors. During strategic planning, executives and other personnel must identify and establish the company's **competitive advantage(s),** or outstanding strength(s), unique qualities, and attributes to position the company so the products and services of the company are recognized and desired by the target customer and the ultimate consumer. Exclusivity and differentiation in product, placement, promotions, and other tools among the 10 P's are used to create a competitive advantage and distinguish a company from its competition.

Cues

Businesses, whether operating as fiber and fabric producers, apparel manufacturers, brick-and-mortar retailers, Internet entities, or catalog companies, manipulate identity cues, components, or attributes to build both a visual and mental perception of the company and its products in the minds of their customers and/or target consumers. Major components, or **cues,** for a company or product include traditional attributes (e.g., history of the business or product), physical attributes of the business (e.g., geographic location of the firm, the architectural and design characteristics of the company's buildings, plants, stores, or other facilities) or the product (e.g., sizing, colors, logos, details, fabrication), the channel of distribution in which the company trades or the product is sold (e.g., number and type of vendors and customers), merchandise policy (e.g., characteristics of assortments), and personnel and customer service attributes associated with the company or the product (e.g., quantity and quality of customer services, training of sales associates, availability of personal shoppers) (see Table 5.1).

Numerous other merchandising-related characteristics may be associated with a company or product, such as the merchandise mix, fashion levels/zones, brands, and price ranges and price points of the product classifications offered, and the pricing strategy. **Exclusivity,** having merchandise with unique features not carried by other companies, is one cue that can be used by a retailer, an end-product manufacturer, or a raw materials manufacturer for differentiating itself from the competition and positioning the establishment as having a "reason for being." Neiman Marcus is known for its fantastic Christmas catalog that includes many exclusive items. One year his and her automobiles were offered. Another year a top item was a catered party complete with an orchestra, and, with another gift, the recipient received a concert and kept the grand piano.

Table 5.1
Examples of cues used for positioning.

Cues	Types of Characteristics	Dillard's Cues*
History of the company	Amount of time in business Who and why the company started Who currently owns the company	Dillard's was founded in 1938 by William Dillard.
Company environment (or physical attributes)	Location of the corporate office Location of the stores or other facilities Architecture of the stores, plants, or other buildings Web page design or catalog cover and layout	Little Rock, Arkansas, is the location of the corporate offices. Stores are located throughout the Southeast, Midwest, and southwestern United States. The first department store in a mall was located in Austin, Texas. Dillard's online shopping site is www.dillards.com.
Product characteristics	Sizing (e.g., range of sizes and types of sizing) Colors generally available and distinctive patterns or prints Logos or other distinct images Stitching or styling details Fabrication (e.g., weaves, knits, fiber content)	Dillard's carries a full range of quality, fashion-oriented apparel products.
Channel of distribution	Exclusive Mass	Dillard's sells products both in brick-and-mortar stores and through its Web site.
Services available	Parking Free shipping Personal shoppers Gift wrap Credit card	Services at Dillard's include a store credit card, personalized online shopping, gift wrapping, vacation and travel services, wedding and gift registries, catalogs, and salons and spas.
Pricing policies	Prestige Below-market Competitive	Pricing policy for Dillard's is to offer quality merchandise at a fair and competitive price.
Merchandising policy	Merchandise mix (e.g., assortment depth and breadth) Product quality Brands carried	Dillard's merchandise assortment is both deep and wide within the category of apparel products. They carry an assortment of women's clothing, junior's clothing, handbags, shoes, lingerie, cosmetics, menswear, children's wear, and some home fashion items.

Note: Information for Dillard's cues was collected from www.dillards.com on May 12, 2008.

Figure 5.2
Types of merchandise mix for product assortments.

Many times a FTAR company attempts to achieve exclusivity through manipulating the merchandise mix of the company. **Merchandise mix** refers to the array of products offered by a company. Some companies may offer only one product classification such as shirts; other companies may offer a wide variety of product classifications, such as shirts, shoes, bathing suits, handbags, and cosmetics. A company with only one product classification would have a **narrow merchandise mix,** which is usually a **deep merchandise mix,** meaning that many variations of the one product class are offered (see Figure 5.2). With a deep merchandise mix, a retailer may sell only T-shirts but offer each style in several solid colors plus many different patterns or prints. In contrast, the company that offers a wide variety of product classifications is considered to have a **wide merchandise mix,** which consequently is often a **shallow merchandise mix** or an offering of few variations within one classification. The retailer that sells many product classifications usually limits the number of each classification due to space and budgeting. This retailer may carry one or two of the same T-shirts as the previous retailer but may offer them in only one or two colors so many other styles of shirts may be offered in the company's assortment mix.

Image

The combining or blending of all of the cues becomes the **image,** or the personality, character, or mental impression that the company, brand, or store represents to the customer. Some merchandisers call this image the **company**

(a)

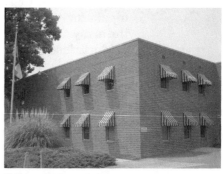

Figure 5.3 A consistent company image and
product image (a) and (b). (b)

image to distinguish it from other images created for various marketing pur-
poses (see Chapter 16). For some products, the image may be synonymous with
the brand of the product or the retail store where the product is purchased,
whereas the actual company producing the product may be unknown to the
consumer. Glen Raven, located in Glen Raven, North Carolina, manufactures
the Sunbrella fabric used for camping, boating, awnings, and other outdoor pur-
poses (see Figures 5.3a and 5.3b). Boaters, campers, and other sports enthusi-
asts have been buying many of these products. These consumers are often

ardent environmentalists. Glen Raven through its products, designs, production, and corporate activities reflects this green approach to production and sales. Glen Raven has a written environmental policy that directs their manufacturing facilities to produce "products that have a minimal effect on the environment" (Glen Raven, 2008, p. 1). They implement this policy by "monitoring pollution prevention results and environmental programs through periodic audits [and by] ensuring the safe release or disposal of any residuals that cannot be prevented, recycled or treated" (Glen Raven, p. 1). This environmentally concerned corporate attitude is part of the brand.

Because an image is such a powerful tool in getting customers to be aware of products and to purchase those products, companies attempt to pinpoint unique and attention-getting cues or attributes, or methods and techniques to position their companies in the marketplace. There are many factors that companies can create, design or manipulate to assure that the company stands out in the crowd. Some retail companies use store characteristics, including in-store presentation, signage, or colors to create image, whereas fiber producers, apparel manufacturers, or large retail corporations may use advanced technology for processing data or proprietary research and development techniques to differentiate their product and services from their competition. For example, one major jean company strived to maintain a dominant position with regard to product presentation, including fixturing, to promote better brand communications when the product was located in mass merchants. But in other retail types, the same company used its high-tech data processing system to offer various replenishment options to account for the different customer segments and the retail technology owned within each of its retail clients.

Another major technique for positioning a company or store is to differentiate the product or service and brand. To attract a new target consumer, Gap Inc. decided to improve the shopping experience for the consumer and concentrate on social interaction by designing a new store format concept, Forth & Towne. The experimental stores were designed with illuminated circular walls, niches filled with mannequins, and an "elaborately decorated 'fitting salon,' which [was] the centerpiece of the store experience—and, by extension, the Forth & Towne brand itself" (Blum, 2005, para. 3). By creating a unique image with store decor and architectural elements, Gap Inc. positioned these stores as a meeting place to define its new store brand. However, with all of this high-level strategy and positioning, the new store concept was unsuccessful, and Gap Inc. closed these stores after only a few months of operation. Several reasons have been given for this failure, including the wrong fit for the clothing items and the continued confusion over the identity of Gap Inc. stores (Harris, 2007). Even though the ambience of the Forth & Towne stores was well planned by a noted architect, the combination of store environmental cues, in combination with the product style and fit, resulted in a retail store that was not all that appealing to its targeted consumers (Blum, 2005). This is an excellent example of how all cues must complement one another and how these components must be coordinated for the retailer to create a unique position that is well accepted by the target consumer.

Positioning can be important at any price point or fashion level. An example of focused and successful positioning is Target, one of the three top mass merchandisers. To achieve this position, the retailer combined the cues of distinct products and a unique Product Development Process, discount or below-market pricing, a unique marketing and promotional mix, and eye-catching colors and logo on packaging as well as a well-executed merchandise presentation to position itself as a trademark of the affluent at a discounted price point. Target leveraged all of the marketing P's to position itself as a retailer selling designer and brand-name products (Schlosser, 2004), an image it has worked hard to maintain. Employing fashion designers such as Isaac Mizrahi and Michael Graves, Target created fashionable product lines at a price that is lower than department store pricing. Through advertising and placement of product in the store, Target also used product, packaging, and placement to turn little known brands into household names and co-branded with known companies to offer product exclusive to the Target Stores. Additionally, to help position the company, Target used its consumer-centric organizational structure to encourage everyone in the corporation to find, create, or design the next "big item" in the merchandise mix. Company management held contests among all employees (e.g., marketing, product development, finance personnel) to locate the next great selling product or exciting promotion idea (Schlosser, 2004).

Continuing to use an assortment of marketing tools, the company has docked a floating shop (USS *Target*) of holiday goods in the New York harbor, staged a Mizrahi shop in Rockefeller Center, set up a temporary shop in Times Square of which the sales benefited breast cancer research, staged a fashion show on the sides of a skyscraper in New York City, and drove rickshaws around the Jefferson Memorial tidal basin in Washington, D.C. However, with all of the fast-paced positioning, some things never change. The company logo using the Target red with the two-ring bull's-eye, along with the Target mascot, a white bull terrier named Bullseye, are positioning constants (see Figure 5.4). These visual cues help the consumer quickly remember the Target image of high style and bargain prices (Schlosser, 2004).

Brand Strategy

Presently, branding is one of the most important factors in positioning as the brand becomes a major marketing tool to assist the company in not only communicating its products and services but also its mission and core values. A **brand** is a name, symbol, character, logo, slogan, graphic, trademark, colors, or a combination of these components used to identify or denote a business, a product, a service, a retail store, an apparel company, an organization, a place, or even celebrities such as movie stars, athletes, or other famous individuals.

The importance of branding as a marketing tool began in the 1960s when retailers and manufacturers realized they needed some tool to distinguish themselves among the myriad of products being offered to the demanding Baby Boomers. The plans for developing, positioning, and maintaining a brand

Figure 5.4
The Bullseye mascot is seen in a stuffed toy, one of many ways to communicate
Target's image.

became the **brand strategy** for a company. With only three major television
networks, FTAR companies, using this new marketing medium in the 1960s
and 1970s for advertising, brought their named products into the homes of the
American family and created a shortcut in the communications process to mar-
ket that product effectively and efficiently to the target consumer (Keller,
2005). Many times consumers use these brands or mental shortcuts implied by
the brand to identify quality of a product or service or to estimate price of that
product or service.

Throughout the decades of the 1970s, 1980s, and 1990s, this marketing trend
spread beyond the television media to movies, music videos, and other media,
and the branding phenomenon evolved into creating a relationship or connec-
tion between the consumer and the brand. This process is known as building
and marketing **lifestyle brands,** or brands that connect the consumer both ir-
rationally (emotionally) and rationally (cognitively) to the company and its
product (McDonald, 2007). VF Corporation has several brands they are mar-
keting to the consumer (see Figure 5.5). Because of the popularity of brands to
the consumers in the 2000s, marketplace brands actually help drive business
decisions and impact global markets in such product categories as active
sportswear (e.g., Nike, Adidas, Reebok) ("Brands Continue to Drive," 2005).

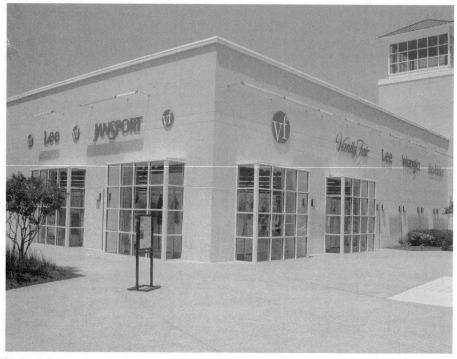

Figure 5.5
VF Lifestyle Brands are displayed on the storefront as part of positioning strategy.

Modern-day companies strive to build **brand recognition** to make sure their brand is the first brand that comes to the consumer's mind when the consumer considers buying a particular product. Most companies attempt to promote brand recognition by developing that unequaled logo, jingle, or graphic that automatically attracts the attention of the target consumer. With that single word, logo, or tune, the consumer knows the product, remembers the product characteristics, and thinks about the pleasant associations it has with the product and the company. Nike with its globally recognized single "swoosh" graphic or its logo of "Just Do It" automatically communicates a wealth of information about its product and the company with its target consumer. Other well-known images are the star symbol of Macy's (see Figure 5.6) that first appeared on its flagship store in New York City on the corner of 34th Street and Broadway and is now seen as the red star on Macy's packages, Web site, and stores. Other images include the logo of "takes a lickin' and keeps on tickin'" for Timex watches, the intertwined C's for products from the design house of Coco Chanel, the Lacoste alligator that has crawled across many three-button shirts, and the talking fruit promoting Fruit of the Loom products.

Celebrities can also be used for strong brand recognition. Michael Jordan has continued over many years to be the spokesperson for Hanes, although his commercials have begun to feature other celebrities to provide an updated image.

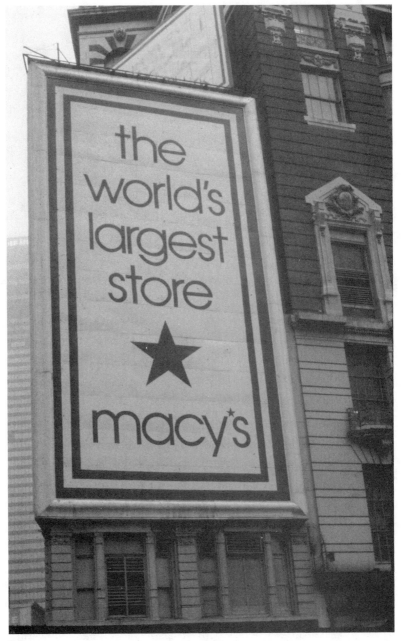

Figure 5.6
Macy's star on the front of the New York store communicates the retail brand.

Figure 5.7
Information on a storefront is part of the positioning strategy.

In the early 2000s, Sarah Jessica Parker was the spokesperson for Gap Inc. Celebrity endorsements can change quickly if the popularity of the celebrity drops. The noted fashion trade newspaper *Women's Wear Daily* (*WWD*) regularly surveys consumers for their brand recognition. The Hanes megabrand, known for underwear, bras, shapewear, casualwear, and hosiery and formerly a unit of Sara Lee Corporation in Winston-Salem, North Carolina, has remained one of the highest rated brands for brand recognition (The WWD 100, 2006). Another prominent brand, Levi's, the jeanswear brand of Levi Strauss & Co., is continually listed among the top WWD 10 brands for consumer recognition.

Marketing gurus state that a company's brand should be recognized with or described in no more than three words (Ries, 2005). In reviewing the positioning of the retailer, Walmart (see Figure 5.7), Ries (2005) explains that in the 1990s,

> Outside of every Walmart [were] the words, 'We sell for less.' In every Walmart ad [were] the words, 'Always low prices, Always.' What word does Walmart own? It's 'cheap.' Not a bad word. It has made Walmart the world's largest retailer. Does 'cheap' appeal to everybody? No. That's why you know 'cheap' is a good word to own. (para. 2)

Additionally, companies must identify what it is about their brand that differentiates it in some manner from other products or the competitions' brands in the same classification. "The differences can be rational or more emotional but

they have to be there" ("Top Ways to Keep," 2004). In other words, the brand message must be consistent but updated so it continually reaches both the hearts and minds of the target consumer. The message must address the core values of the consumer. Also, a brand must create a sense of need, bond with the consumer, and connect to the consumer's perception of value to create customer loyalty.

When the customer is aware of or familiar with the brand name and its symbolism and this name or symbolism holds some strong, favorable, and unique brand association in the memory of that consumer, the brand holds high **brand equity.** All companies attempt to market their brands so those brands hold the most power and value in the minds of the consumer in the marketplace for that specific product category. When consumers become extremely loyal to a brand, are emotionally involved with brand, they select that brand over other available brands or merchandise. Some companies attempt always to exceed in providing what they have promised in product quality and value to build a loyal customer following and to build and maintain their brand recognition and build brand equity.

Strong brand recognition that can be parlayed into valuable brand equity is important to the successful attraction of shopping and buying customers. Customers, whether retail buyers shopping at the multitude of apparel manufacturers, designers selecting fabric for a new product, or consumers buying a pair of shorts for a child, use brands as cues to simplify the decision-making process when selecting product. They also use brands to reduce risks as to the predictability of the product performance when making the final purchase decision (Keller, 2005). Recognizing the importance of brands, many companies in the FTAR Complex have historically built their companies based on brand names and lifestyle marketing. Worldwide, consumers know the names of Playtex, L'eggs, Reebok, and Adidas, to name just a few, and the names are often used on packaging, storefronts, and take-away bags to help the consumer find, remember, and identify with the product. When consumers see readily recognizable brands written on the outside of the store, they immediately "know" the product quality, pricing strategy and sizing, or fit of the product (see Figure 5.8). In a highly competitive marketplace, companies are using brands to position their companies and to differentiate themselves from their competition as well as to offer product exclusivity to their target consumer.

Branding has also become a way of articulating the core values of the corporation ("The Good Brand," 2004). Some modern-day brands have moved from product identifiers to personal identifiers by emitting cultural and political statements about the user. For example, the retailer Benetton has created advertising that calls the customer's attention to social conditions throughout the world. Although some viewers find many of the Benetton ads very controversial, the ads do connect directly to the target consumer and remind the customer at all levels of the FTAR Complex about the company. This brand recognition provides equity for the company and can increase sale of product, even though the retailer's product are never promoted in the ads.

Figure 5.8
The multiple brands of the Hanesbrands Inc. store.

Types of Brands

In a consumer-centric company, as with other successful business operations, one of the major decisions to be made with regard to branding is what types of brands to offer to the firms within the FTAR Complex and to the target consumer. The types of apparel brands include designer, licensed, national, private label, private brand, store brand, and generic brands.

Designer Brands

Designer brands are created by well-known designers, recognized by the target consumer, and usually marketed nationally and internationally through print, broadcast, and Internet media with pull marketing techniques. They attract a loyal consumer following. The 2003 Brand Keys Fashion Index compiled by Brand Keys, research consultancy based in New York City, listed the strongest designer apparel brands as Ralph Lauren, Armani, Donna Karan,

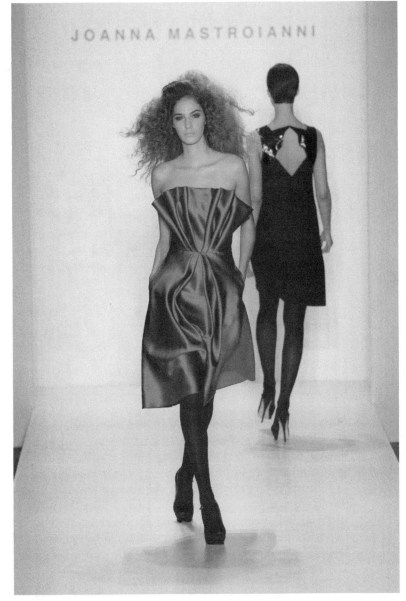

Figure 5.9
Runway photo shot of a collection by top designer.
(Courtesy of The Hosiery Association)

and Chanel ("Top Ways to Keep," 2004). Often on the runway, the style of the products are so closely linked to the brand image that consumers, photojournalists, and forecasters can distinguish among the designer products (see Figure 5.9).

Figure 5.10
Familiar image on the Tommy Hilfiger store.

Examples of some other well-known designer brands are Calvin Klein, Tommy Hilfiger, and Vera Wang. One look at the red, white, and blue flag emblem, be it on a shirt, jeans, or the storefront, and many consumers know that the product is a Tommy Hilfiger brand without looking closely at the label (see Figure 5.10).

Another current trend with designers is to produce **exclusive designer lines** for select retailers. For example, BCBG Max Azria Group signed an exclusive distribution agreement with JCPenney to sell its Parallel brand in the midtier department store format. Other designers have developed below-market-priced designer lines for the fast fashion and mass merchant retailers. The brand Isaac Mizrahi has been created exclusively for Target; other designers have created brands for Kmart and H & M.

In 2007, Polo Ralph Lauren Corporation established The Global Brand Concepts group to develop specialized brands for specialty and department stores (Staff, 2007). The Polo Group handles the design, operations, marketing, merchandising and advertising for these new brands. JCPenney became the first customer of the Global Brand Concepts group; this group created an exclusive lifestyle brand for the JCPenney chain called American Living, to differentiate it from Polo and other brands owned by the corporation. The brand covers women's, men's, and children's wear, plus accessories, intimate apparel, and home furnishings (Karimzadeh, 2007).

Some apparel manufacturers also have bought designer labels (or brands) and relaunched these lines in department stores. For example, Jones New York bought A/Line, the secondary line of Anne Klein, and sold it exclusively to Sears (Clark, 2004). This brand strategy has been used mostly recently by discount stores. They have bought brand names that were abandoned by their original manufacturers or have claimed ones whose trademarks have expired. With minimal changes, the retailer rereleases the product. Immediate brand equity is gained when consumers have fond memories of the product. For example, Walmart carries the brand names of White Stag and Faded Glory. Both of these brands were formerly national brands produced by major apparel companies and are familiar to Baby Boomers from their teenage years.

Licensed Brands

To extend their brand name into product categories that complement their apparel, many times designers license their name to other companies to produce product using the designer's name on the label. Other companies that have created cartoon characters, mascots, or other popular images also allow licensing of these graphics. A **license** is a legal agreement between a designer or other holder of the image, name, or concept, who is the **licensor,** and the manufacturing company or retailer, the **licensee,** who wishes to use the name or image with the product. The licensee pays the licensor a **royalty** or a percentage of the wholesale price of the goods sold for the use of the designer label or the designer's name. Brands created through this method are called **licensed brands.** This brand extension can further spread the recognition of the brand. Because of the importance of brands to the profitability of the owner company, brand licensing is rigidly controlled and the standards by the licensor must be maintained by the licensee.

Disney grants licenses to apparel manufacturing companies that create items covered in printouts of Disney characters for children. Images of the traditional Disney characters of Mickey Mouse and Cinderella continue to be in demand as well as characters from more recent films such as the *Pirates of the Caribbean*. This movie spawned a licensing frenzy as manufacturers and retailers clamored for the right to print pirates, skulls with crossbones, and other symbols depicting the pirate scene on their products. Some companies produced authentic wearable replicas of the key to Pirate Captain Davy Jones's treasure chest and Tia Dalma's necklace replica products. The images from the movie have appeared on T-shirts, baseball caps, knit scarves, zip-up hoodie sweatshirts for children and adults, as well as baby and toddler onesies/creepers. The Harry Potter books and movies have generated an interest among preteens for witches costumes, wizard robes, and wire-rimmed glasses.

In a specialized area of licensing, companies wishing to print university logos, mascots, or other trademarked images on their products must make a licensing agreement with the university (see Figure 5.11). The licensing agreement delineates the conditions under which the graphics (e.g., word, logo, picture) can be used on the product and often the price that can be charged and

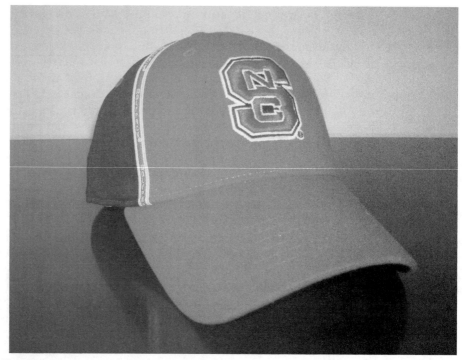

Figure 5.11
NCSU logo on a cap is a licensed product.
(Courtesy of North Carolina State University)

the location or placement of the products. Some universities require that the licensee strictly regulate the colors of the graphics and the products so they remain the official colors, which requires extensive quality control during manufacturing. A licensor wants to retain some control over the use of the graphics image so it is always positioned to reflect the image of the designer or company. In addition, the licensor may require that the logo remain intact without additions, deletions, or other changes.

Some companies, schools, and even towns and cities try to market themselves through branding. This popular method of marketing has created a phenomenon of printed T-shirts, which can be seen with the names of rock groups, towns, resort spots, schools, and personalized information (see Figure 5.12). The Hanes brand provides a specialized Web site called Hanes by Me that allows its customers to create their own custom T-shirt.

National Brands

National brands are names, symbols, or logos, owned by a manufacturer, that are immediately recognized by or have brand recognition from a large group of target consumers. They are marketed in consumer magazines, newspapers,

Figure 5.12
Use of T-shirts for positioning cities and schools.

television, radio, and other media types for pull marketing of the product. National brands are very important to manufacturers and retailers because they usually communicate directly to the consumer the quality, the fit, and the status and image of the product. Brands may also be created by fabric or fiber companies. Russell Corporation has created and marketed the Jerzee brand of fleecewear that can be found distributed through a number of retail types. The tropical look of a shirt including the silky feel and fresh colors tell many consumers that the product is a Tommy Bahamas shirt, and shout to those who see him or her wearing the shirt that he or she had the money to buy this brand. DuPont is known for its branded performance fibers, Kevlar and Nomex. Kevlar is used in protective apparel for astronauts, law enforcement officers, and military personnel; Nomex is found in uniforms of firefighters and race car drivers (see Figure 5.13).

Manufacturers build these name brands by creating massive marketing and advertising campaigns; by creating special locations within a retail store to attract the target consumer; and by producing a product that fits the industry zone, price point, and quality expected by the target customer. This advertising of national brands by manufacturers provides both benefits and risks to retailers. Advertising of national brands can create intense competition among retailers who carry the same brands. One of the most competitive product

Figure 5.13
Uniform using high-tech fibers for protection.
(Courtesy of the Snowville Volunteer Fire Department, Snowville, VA, Bill Griffin, Engineer)

categories is the denim market. Advertising is used intensely by manufacturers and retailers to promote demand for their brand (see Figure 5.14).

Examples of national brands in the athletic shoe classification include Nike, Reebok, Adidas, and New Balance. With heightened competition from many manufacturers in multiple channels of distribution, this sector of the market depends on the brand name to sell the product and has mastered the art of selecting an outstanding sports celebrity to wear and thus promote the brand.

Figure 5.14
Manufacturer's advertisement for a national brand product.
(Courtesy of VF Jeanswear)

In fact, "more than 75 percent of the active sportswear market is dominated by branded items and almost 80 percent of the athletic footwear is sold under brand names" ("Brands Continue to Drive," 2005, para 3). Nike is the "master of marketing" when it comes to selecting the right sports figure to market a specific product category. Signing the famous basketball player Michael Jordan, it

has marketed the Air Jordan athletic shoe with great success, and as this image has aged, Nike has signed LeBron James, a newer NBA star, plus Alex "A-Rod" Rodriquez, a pro baseball player, to attract a younger and more culturally diverse consumer market. Nike has also marketed products for other sports, such as golf shirts and equipment through the famous golfer, Tiger Woods. In the early 2000s, it was the young female golfer Michelle Wie, and in 2007, Nike was sponsoring the Manchester United professional soccer team.

National brands are very important to retailers because they realize these names attract a large amount of their target market. However, the value of national brands has diminished in the past decade. Many retailers are buying the same national brands, with many of them discounting the prices, and some national brand products are also appearing in outlets and off-price stores. For these reasons, some retailers have found it difficult to maintain their profit goals when carrying only national brands. Therefore, the private label product has become very important in today's marketplace.

Private Labels

A **private label** is an exclusive label or brand produced by a parent company or individual company for only that particular company. When this type of label first appeared on the retail scene, it was usually a basic product that the company offered to its customers at a low retail price; sometimes these products were used as promotional tools for the retailer. However, with the present economy, many retailers are now creating private labels to differentiate from their competitors and to offer exclusive product to the target consumer. Because the consumer must come to that particular retailer to purchase the label, the retailer can control the price, markup, and markdown of the product and many times realize a higher markup and greater profit on the label than on the national brands, which the company carries in its product mix. Private label lines can also help the retailer create loyal customers who make repeat purchases. Macy's, Inc. and JCPenney are recognized in the industry for developing outstanding private label programs. Macy's, Inc. is well known for its I.N.C. private label, and JCPenney is known for its Stafford, Worthington, and St. John's Bay, to name a few. Belk has a number of brands that it sells in its 300 stores across the 16 southern states in the United States. Belk has private label brands for both men and women. These labels include Kim Rogers, JKhaki, Saddlebred, and Madison Studio (see Figure 5.15).

With a private label, the retailer can control the entire Product Development Process for the private-label line, determine the quality of the merchandise, and set the specifications for each merchandise category. Instead of adhering to vendor purchasing requirements, the retailer can carry each product classification in what colors, sizes, fabrications, and zones it has documented will best provide a desired merchandise assortment while making greater profits for the company. The process of developing and marketing a private label includes extensive research on both the target customer as well as the company. In

Figure 5.15
Belk private label merchandise.

addition, the company with a private label will have personnel either on staff or on contract completing the Product Development Process prior to selling the product at retail. The buyer will be involved with product development instead of sourcing products.

Some well-known manufacturers produce proprietary private label brands for some retailers; other store-owned private label product is produced by unidentified contractors or sourced (Beal, 2005). **Proprietary private label** are those brands developed by the manufacturer and sold to only one store group. Ownership of the label stays with the manufacturing company, which may manufacture other products sold under other labels. For example, the Life brand and the Thorobred brand are owned by a major manufacturing company but sold in major retailers (see Figures 5.16a and 5.16b).

JCPenney is one retailer that has taken its private label business to new heights by building private labels into private brands. Probably the most recognized private brand for JCPenney was Arizona. That private label has such strong brand recognition that supposedly during a worldwide soccer match in New York City some of the tourists and players who came for the matches went to Macy's and asked for the Arizona brand! A **private brand** is a private label product that has developed its own personality, that has its own product integrity and identity, and that has come into its own, and thus is recognized by the target consumer as a major brand. It can be marketed as if it were a national

Figure 5.16
Proprietary private label brands: (a) Life® and (b) Thorobred®.

brand and can be promoted in consumer media channels because it has brand recognition by the consumer. A new trend in the retail industry is that of creating brand management divisions to oversee the development of these brands. JCPenney established a new brand management division and appointed a Vice President, Director of Brand Management to oversee and further strengthen its "Big 7" private brands ("Penney Creates New Division," 2005). Walmart has also established a Senior Director-Brand Management to oversee all private-label brands (Frazier, 2006). "Walmart is the biggest retailer of house [or private] brands in the world, from Sam's Choice, a brand banner on everything from cola to cookies, to Great Value and even the nation's No. 1 selling dog food, Ol'Roy" (Frazier, 2006, para 8). "Target is developing true brands, often at higher prices than national competitors" (Frazier, 2006, para 5). "What's unusual with Target is they are taking their own brands to the level where it is the most important on the shelf, said Brian Sharoff, president of the Private Label Manufacturers Association. Target comes from a department-store mentality. You create a brand in a department and give it the same status as a [national] brand" (Frazier, 2006, para. 6). Both private label and private brands have become very important to the retailer in this competitive environment and changing economy.

Figure 5.17
Private label with store name and location.

Store Brands

Store brands are private label brands that are developed and sold by one specific retail company such as Gap, Victoria's Secret, Ann Taylor, Talbots, Brooks Brothers, J. Crew, L.L. Bean, or Abercrombie & Fitch. These specialty stores have developed store environments to build, promote, and enhance their brand. Many of these stores have found it necessary to change their product and brand philosophy as their target consumer ages and changes; others have been very successful in targeting new consumers for the same store brand. Some stores use the store name and location as the brand for the apparel items sold in that store (see Figure 5.17).

Generic Brands

Some merchandise is not branded and does not have a recognized name label. This unbranded product is considered to be a **generic brand.** Most of the time generic brands are basic goods sold to the mass market. The goods are usually a less expensive product that is sold in discount and off-price retail outlets. Across the types of brands for these products, the wholesale costs vary and can provide retailers with more markup or products at lower retail prices than competitive products.

Groups of Brands

When a company owns a number of brands that are sold across various retail partners and appeal to an assortment of consumer markets, the company owns what is know in the trade as a **brand portfolio.** A company known for having a large brand portfolio is Liz Claiborne. This company has purchased other companies to acquire brands in all industry zones, purchased defunct brand names, produced exclusive brands for selected department stores, and produces licensed product for other companies and designer lines. However, recently, management at Liz Claiborne Inc. has decided to sell off some of these recently acquired brands to concentrate on the company's core business segments. Management is creating a new organizational structure with the two segments consisting of its retail-based Direct Brands (e.g., Juicy Couture, Kate Spade) and the wholesale-based Partnered Brands (e.g., Liz Claiborne family: Claiborne, Concepts by Claiborne, Liz & Co.; DKNY Jeans group) to meet the needs and desires of partners and consumers. The company is attempting to focus the Direct Brands segment on expanding its retail store base, expanding product categories, and creating brand-centric and e-commerce strategies. In the Partnered Brand segment, the company will be concentrating on collaborating with department stores and midtier retailers ("Liz Claiborne Inc. Unveils," 2007). Table 5.2 provides a partial listing of the brand portfolio of Liz Claiborne Inc. Partnered Brands for 2007 and the adjustments made to this portfolio in 2008.

Other Partnered Brands include cosmetics and fragrance lines (e.g., Bora Bora, Curve, Curve Mambo, and the Monet group with jewelry brands (e.g., Marvella, Monet, Trifari) ("Liz Claiborne Inc. Unveils," 2007).

In 2003, The NPD Group, Inc., a marketing research company, reported that designer brands represented 7% of the apparel market, national brands represented 34%, and that private label and private brand merchandise represented 36% of the total apparel market. Private label sales in the mass market represented 51% of total apparel sales ("NPD Report," 2003). In a *WWD* roundtable session in 2004, Weintraub, president and CEO of his own marketing firm, stated that "about 30 percent of the fashion apparel is in the hands of private brands while 40 percent is controlled by high-profile brands. The remaining 30 percent is supplied from the unbranded segment, companies that mostly fall into the mid-market segment" (Zaczkiewicz, 2004, para 8).

Summary

Many manufacturers, such as Jockey, may produce national brands, private label brands, proprietary private label brands, store brands, and licensed goods (Beal, 2005). Or, a manufacturer may develop only a national brand or several national brands; others may provide only generic brands. Likewise, the retail client may carry in its merchandise mix only store or private label brands, and another retailer may purchase only national brands or only private label and

Table 5.2

Liz Claiborne Inc Partnered Brand portfolio for the Liz Claiborne family of brands and the Monet Group in 2007 with the 2008 status.

Partnered Brands	Market Channel	Product Description	Partnered Brand Status for 2008*
Axcess	Kohl's, Fred Meyer	Updated, affordable, modern	Yes
C & C California	Department, specialty stores, online	Chic, comfortable, California inspired	No
Claiborne	Department, specialty stores, online	Updated, comfortable, innovative	Yes
CONCEPTS by Claiborne	JCPenney, exclusively	Updated, modern, versatile	Yes
Dana Buchman	Exclusively for Kohl's	Modern, feminine	Yes
DKNY Active/ DKNY Jeans	Department, specialty stores	Hip, sexy, urban, energetic	Yes
Ellen Tracy	Upscale department, specialty stores	Sophisticated, luxurious, lifestyle	No
Emma James	Department stores	Affordable, feminine, classic	No
Enyce	Department, specialty stores	Hip, young, streetwear	Yes
First Issue	Sears, exclusively	Versatile, affordable, casual	No
Intuitions	Dillard's, exclusively	Vintage, feminine, contemporary	No
JH Collectibles	Department stores	Feminine, relaxed, affordable	No
Kensie	Department, specialty stores, Kensie retail stores	Elegant, raw, fresh	Yes
KensieGirl	Department, specialty stores, Kensie retail stores	Sophisticated, innocent, whimsical	Yes
Laundry by Design	Better department, specialty stores	Cool, inspired, sexy	No
Liz & Co.	JCPenney, exclusively	Casual, versatile, affordable	Yes
Liz Claiborne	Department, specialty stores, online	Feminine, confident, versatile	Yes
Mac & Jac	Department stores	Modern, sensual, confident	New in 2008
Narciso Rodrigues	Luxury retailers worldwide	Clean lines, precision tailoring, luxurious fabrics	New in 2008
prAna	Specialty stores, online— Canada, Europe, Asia	Aware, active, creative	No
Sigrid Olsen	Department, specialty stores, Sigrid Olsen stores	Artistic, relaxed, stylish	Yes
Stamp 10	Kohl's, exclusively	Authentic, casual, contemporary	No
Tapemeasure	Department stores	Modern, flirty, confident, feminine	No
TINT	JCPenney, exclusively	Affordable, on trend, denim	No
Villager	Fred Meyer, Kohl's exclusively	Affordable, classic, versatile	No

*Information for this table was gathered from www.lizclaiborneinc.com, May 20, 2008.

generic brands. A third retailer may buy several types of brands such as designer, national, private label, and generic. The decision as to what type of brands to carry by the retailer is usually determined in the strategic plan and the mission statement of the company and interpreted into the company's brand strategy. Although some retail companies have a narrowly focused brand strategy, in today's marketplace, it can be risky to carry only one specific type of brand because the consumer is constantly changing and now has the ability to purchase product from many retail types and store formats and through several distribution channels.

Key Terms

Brand
Brand equity
Brand portfolio
Brand recognition
Brand strategy
Company image
Competitive advantage
Cues
Deep merchandise mix
Designer brands

Exclusive designer lines
Exclusivity
Generic brand
Image
License
Licensed brands
Licensee
Licensor
Lifestyle brands
Merchandise mix

Narrow merchandise mix
National brands
Positioning
Private brand
Private label
Proprietary private label
Royalty
Shallow merchandise mix
Store brands
Wide merchandise mix

Review Questions

1. Why is positioning important to an FTAR company?
2. How are cues used to help customers know about the company and its products?
3. How is the history of the company related to the positioning of the company?
4. How is an image developed?
5. What are the many types of brands?
6. How is a national brand different and similar to a store brand?
7. Why are celebrities important to the marketing of brands?
8. What is a private label, and is it a brand?
9. Why would a company want the extra work of developing a private label?
10. Why do brand portfolios change over time?

References

About REI. (2008). REI. Retrieved February 1, 2008, from http://www.rei.com

Beal, B. (2005, March 30). Global logistics. Paper presented as part of the Executive-in-Residence Program, North Carolina State University, Raleigh, NC.

Blum, A. (2005). Forth & Town: The store's the thing. *BusinessWeek*. Retrieved September 20, 2005, from www.businessweek.com

Brands continue to drive global sportswear market. (2005, March 11). *Just-style*. Retrieved March 11, 2005, from www.just-style.com

Clark, E. (2004, June 23). Claiborne's reality check. *WWD*. Retrieved June 23, 2004, from http://www.wwd.com

Frazier, M. (2006). It's cool, just don't advertise. *Advertising Age* (Midwest edition), 77, 46.

Glen Raven. (2008). *Glen Raven's environmental policy*. Informational Sheet. Glen Raven, NC: Author.

Harris, R. (2007, March 26). Falling out of fashion. *Marketing, 112*(6), 11.

Karimzadeh, M. (2007, February 1). An all-American man: Ralph, Penney's link to create new brand. *Women's Wear Daily*. Retrieved February 1, 2007, from http://www.wwd.com

Keller, K. (2005, September 14). Building strong brands: Lessons from the world's best marketers. Paper presented as part of the Executive-in-Residence Program, North Carolina State University, Raleigh, NC.

Liz Claiborne Inc. unveils long-term growth plan. (2007). Business Wire Press Release. Retrieved July 11, 2007, from http://www.lizclaiborneinc.com/company/overview.htm

McDonald, M. (2007, April 11). Apparel Research with Consumers. Presentation presented as part of College of Textiles Leadership Honorary, North Carolina State University, Raleigh, NC.

NPD Report. (2003, July 21). NPD reports private label apparel sales up in a down market. Retrieved July 21, 2003, from http://www.nahm.com/npd/pressrelease.html

Penney creates new division. (2005, July). *Home Textiles Today*. para. 1. Retrieved January 8, 2007, from www.hometextilestoday.com

Ries, A. (2005). Why a brand must be described in three words. *Advertising Age*. Retrieved June 30, 2005, from www.adage.com

Schlosser, J. (2004). How Target does it in a Wal-Mart world. *Fortune, 150*(8), 100–107.

Staff. (2007, January 8). Polo Ralph Lauren forms lifestyle branding group. *Home Textiles Today*. Retrieved January 8, 2007, from www.hometextilestoday.com

The good brand. (2004, August). *Fastcompany, 85*, 47. Retrieved June 30, 2007, from www.fastcompany.com

Top ways to keep a rock-solid brand. (2004, March 29). *Just-style*. Retrieved March 29, 2004, from www.just-style.com

The WWD 100. (2006, July 26). *Women's Wear Daily*. Retrieved August 8, 2006, from www.wwd.com

Zaczkiewicz, A. (2004, August 16). Expert second opinion. Reported by AAPN. Middle market growth strategies, your perspective. Symposium conducted by *WWD* roundtable.

<div align="right">

chapter
6

</div>

Placement

Objectives

After completing this chapter, the student will be able to

- Describe the channels of distribution
- Explain the characteristics of various channels of distribution
- Identify retail types and store formats by ownership and retail cues strategy mix
- Identify traditional store-based retailers and their retail cue strategy mix
- Identify non-store-based retailers and their defining characteristics

Introduction

Placement, as one of the 10 P's (see Chapter 2), is identified in the company's marketing plan. As executive management considers the question of "How do we get there?" they are considering and deciding on placement. Companies must distinguish themselves from other companies and must find ways to sell products differently from the competition. A single firm has many choices as to which partners to choose and where to place the products it creates and/or sells.

The process of moving the product through the supply chain from the raw materials producer through the manufacturer and retailer to the final consumer is called **placement.** Decisions on placement encompass the level of distribution, channel of distribution, the geographic locations of the channel, and to some extent the coverage of the distribution and the inventory levels within

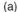
(a)

(b)

Figure 6.1
Semitrailers move product through the FTAR Supply Chain (a) and (b).

that coverage, plus the transportation and storage or warehousing of goods. The package of placement decisions becomes the **distribution strategy** of a firm. Channels of distribution are very important in the FTAR Supply Chain because they provide for the physical distribution (i.e., logistics of warehousing, transportation) of the product (see Figures 6.1a and 6.1b). In addition, the distribution strategy denotes the exact numbers and types of firms that will handle the product through the various supply chain links to the final consumer.

Depending on the mission of the company, the type of product being produced, the industry zone in which the product is presented to the target consumer, and the price range of the merchandise, the manufacturer and retailer must develop a distribution strategy. If a manufacturer is producing an expensive bridge line of ladies' apparel such as Ellen Tracy, the manufacturer would not want to place the expensive goods with a mass merchant or discount store because the target customer at those firms might not be familiar with or interested in the exclusivity of the line or wish to pay the prestige prices to purchase the merchandise. Affluent customers who might visit the mass merchant or discount store and recognize the product brand would not want to purchase this exclusive, expensive product when it is also shown in an expensive specialty store. In addition, the consumer might think the merchandise in the discount store was a knock-off or other cheap imitation. The discount store image, especially in types and quantities of customer service attributes, does not support the image of the line. This placement of exclusive and expensive merchandise would not attract a sufficient number of consumers in the mass merchant or discount store to make the sale through that distribution channel profitable. In this scenario, neither

the manufacturer, nor the retailer, nor the consumer would be happy with the merchandise placement and selection. Neither the manufacturer nor the retailer would realize their planned sales or profit goals; and both companies would more than likely lose good customers and target consumers.

Levels of Distribution

When establishing the distribution strategy, the first decision a firm makes is that of the **distribution level** because this decision will also impact the selection of channel types to consider. The three levels of distribution include exclusive, limited or selective, and intensive or mass distribution. A certified manufacturer with highly trained sewing operators partnered with a high fashion specialty store in a certain city may be the only firm that produce and carry a designer line of apparel. This is **exclusive distribution** and gives that specific retailer the opportunity not only to differentiate from its competitor but also to provide distinctive merchandise that builds customer loyalty or a repeat customer base. A fiber company with a specific patented process for producing a weather-resistant fiber may allow only certain textile mills that have passed rigorous inspections to make fabric from the fiber. These mills may only partner with a restricted number of apparel manufacturers and retailers to make the product and sell to consumers.

In contrast, a manufacturer may choose to sell to more than one specialty store in the same geographic area but may not sell to a nearby department store that has neither the store image nor target consumer to be successful with the company's product. This type of distribution is called **limited distribution.** Again this manufacturer will be fairly restrictive on selection of textile mills so that the fabric used in the product will meet the exacting requirements of the selected retailers. In the third level of distribution, a manufacturer may buy fabric from numerous textile mills, depending on price and type of fabric, and may sell the end product to any retailer that desires to purchase the company's product in a specific geographic area. This type of distribution is **intensive distribution,** or **mass distribution.** Many times these products are basic or commodity products that many retailers, especially mass merchants, offer for sale to the consumer.

Channels of Distribution

Producers, manufacturers, and retailers must determine the best channel or distribution channels to assure that the desired or needed product reaches the right target consumer in a timely manner. A distribution channel, or **channel of distribution,** is the set of trading partners along the FTAR Supply Chain that will be used by any one company. The channel is made of a series of suppliers or customers, where one or more companies from each link or level in the distribution channel will be transferring goods to the next link until the goods reach the final customer or consumer. Several primary channels of distribution are found in the FTAR Supply Chain. Each channel has a unique configuration of firms from

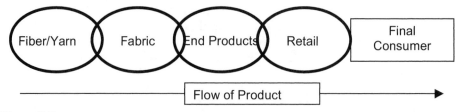

Figure 6.2
Traditional channel of distribution.

producers to consumers. The traditional channel of distribution is pictured in Figure 6.2 and contains all the major links in the FTAR Supply Chain. This channel has individual firms creating value-added attributes from raw materials production to end product with sale to the final consumer through a retailer.

The companies along one channel of distribution may be owned independently of their partner firms or may be owned by the same firm. When one company owns firms in each segment or in several segments of the supply chain or distribution channel, the company has achieved an organizational structure of **vertical integration.** If a company owns several firms within the same link of the distribution channel, it has a **horizontal integration** structure. Owning dissimilar firms along the supply chain can enhance distribution but also requires extensive resources for the company.

Alternative channels of distribution may be composed of only the producers and consumer; a producer, retailer, and consumer; or they may consist of any number of combinations of the producer, manufacturer, retailer, and consumer along with a middle man that could be a wholesaler, agent, broker, or jobber (see Figure 6.3 for alternative channels of distribution). When an apparel product manufacturer chooses to open a store that sells directly to the consumer, distribution channel A may be used (see Figure 6.3). A fabric company that works with a fiber company using a very exclusive high-performance fiber that is made directly into a finished product may use distribution channel B (see Figure 6.3). Manufacturers that basically follow the traditional distribution channel but have their products handled through a wholesaler who may also handle products from a number of other manufacturers will be using distribution channel C (see Figure 6.3). A **dual distribution system,** or selling products both at wholesale to retail clients and at retail in a company-owned store to the target consumer, originated with menswear manufacturers; however, this form of distribution is common among many major branded manufacturing companies.

Overview of Retail Categories, Retail Types, and Store Formats

As producers and manufacturers select their channel of distribution, they frequently must select a retail firm to be a partner in the channel. This retail partner can have a number of various characteristics. Understanding the

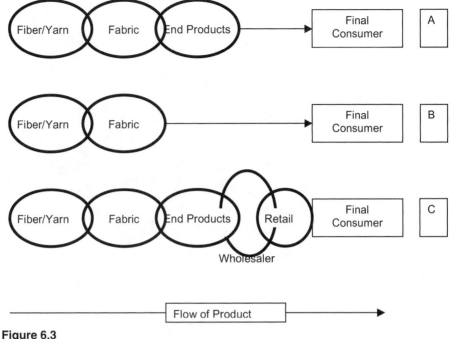

Figure 6.3
Alternative channels of distribution.

characteristics can help a merchandiser select which retail partner is best for the product, the company, and the channel. Two **retail categories** have traditionally existed: store and nonstore, with various retail types within the categories. The primary distinction between these retail categories has been that the traditional store was a physical location. A consumer could drive or walk to the store, enter the building, feel the merchandise, try on the products, purchase items, and then return home. This store-based retailing or physically located store is often known as the **brick-and-mortar store,** or simply as the **store.** The nonstore retailers traditionally have had no physical location. When these retailers are online retailers for their distribution, they are known as a **click store.** With the growth in popularity and availability of the Internet, many retailers now have brick-and-mortar stores and click stores; these stores are called **brick-and-click stores;** some sources call these click-and-mortar stores. Any combination of store, catalog, Internet, and other retail types may be found within one retail firm.

The traditional store-based retailers include the following retail types: specialty stores, department stores, discount stores, mass merchants, and private-branded hives (PBHs). Nonstore retailers include the following retail types: direct mail, mail-order advertising, and catalog; electronic retailing, including online or e-tailing (B2C) as well as direct sales via Internet-based advertising; television home shopping, infomercials, and direct-sales via radio; CD-ROM shopping; door-to-door direct selling, including in-home, one-on-one contact, or planned parties;

Figure 6.4
Resort locations have unique places for apparel shopping.

telemarketing; and kiosks plus vending machines. In addition to these retail types that have apparel as a primary merchandise or service category in the business, grocery stores, drugstores, restaurants, hotel gift shops, and duty-free shops often carry apparel merchandise as part of their product and service offerings. Shops and restaurants located in tourist destinations (see Figure 6.4) may have as much as 30% of their income dependent on the sale of apparel-related items (Kincade & Woodard, 2001). For some consumers, shopping is the destination.

Airport shops, another nontraditional retailer, are an aid to travelers who may need to pick up a forgotten item or spend some wait-time browsing, and they are easily recognized when they are branded companies (see Figure 6.5).

With the rapid growth of retail store formats along with the intensive growth of nontraditional retailing formats and nonstore retailing, the retail market is often seen as **overstored,** or as containing too many places for consumers. More retail square footage exists than is needed to satisfy consumers and more inventory is held than would ever be bought by consumers. This overstoring has led to fierce competition among all retailers. Considering the retail square footage in traditional retail stores, the numbers of home pages shown by Internet retailers, and the nontraditional places where apparel is now sold, consumers have a seemingly infinite number of places to shop for apparel.

Within each retail type, variations also exist based on several characteristics, such as store ownership and retail store cues mix. The firms created by the variations in these characteristics are known as **store formats. Retail cues,** or a narrower version of cues as discussed in Chapter 5, are the mix of products offered, store size, services offered, pricing strategies, and history of the store. Although the definition of many of these retail types and formats are blurring, in the following section the most commonly used definitions of each of these firm formats are described.

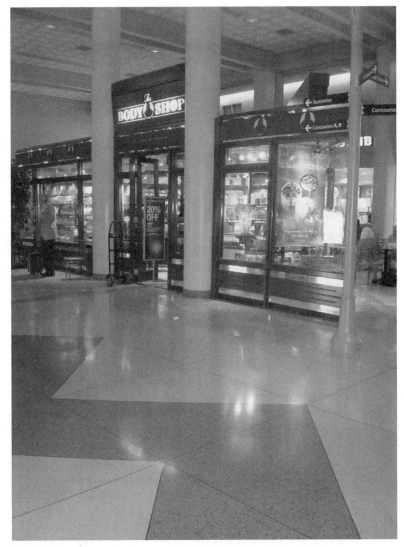

Figure 6.5
Places to shop in airports benefit the consumer and the retailer.

Traditional Store-Based Retail Types

Specialty Stores: Overview

A **specialty store** is a retailer that carries one category of goods or related categories of goods. The store usually carries a narrow but deep assortment or limited line of goods with a wide selection in the few classifications carried. The specialty store usually caters to a niche market or a specific target consumer segment. Many of these stores offer fashion or trendy merchandise, maintain

exclusive distribution on some vendor or designer lines, and stress augmented customer services, including trained sales personnel who are knowledgeable about both the product and the target consumer.

There are several formats of the specialty store type. Some of these are described as business ownership or business organizational types; others are defined by the **retail cues strategy mix,** or use of company image cues such as physical location, management's philosophy and mission with regard to store operation and merchandising, retail/vendor matrix and merchandise mix, price points of merchandise, sales promotional mix, marketing communications mix, and customer services available. A chain store, independent store, or franchise is considered a business ownership type, whereas boutiques, category killers, "gnategory" killers, and showcase stores or supermerchandisers are described using the retail cue strategy mix.

SPECIALTY STORE FORMATS CLASSIFIED BY BUSINESS OWNERSHIP. A **chain store** is an organization that operates multiple store units (i.e., **doors, rooftops**) under a common corporate management with the executive management function located at the corporate headquarters. This specialty operation is unique in that the centralized decision making, centralized purchasing and buying, and centralized merchandise presentation and sales promotion functions are planned and executed by personnel at the headquarters location. Management in the headquarters also establishes all merchandising and management policies and procedures for all the stores. For all of its store units, a chain benefits from the standardized decor, fixturing, and visual presentations and promotions. The consumer readily knows what to expect in the store and can shop in any of the chain's stores with the same value expectations. Examples of chain stores with centralized operations are Gap Inc. (i.e., Gap, Banana Republic, Old Navy), Talbots (i.e., Talbots, Talbots Woman, Talbots Petites); Chico's FAS Inc. (i.e., Chico's, White House/Black Market, Soma, Soma Intimates) (see Figure 6.6), and Ann Taylor (i.e., Ann Taylor, Ann Taylor Loft). As noted, many firms that own chain stores own several different stores. This ownership structure is called a **store group,** or in this instance, specifically, a **chain store group.**

Some retail chains are moving to decentralization of the chain and are forming the **"store of the community"** (Bowers, 2007, para. 3). This store changes images based on geographic profiling and is becoming more common among chains in an attempt to better meet the consumer's unique and changing demands. At the store level, which is usually in a variety of geographic locations, sometimes even international, the local management and selling functions are handled by the individual store units. In addition, this decentralized system gives management at the store level responsibilities for making limited to extensive decisions on merchandise assortments and promotions. With limited merchandise selection options, the store managers pick merchandise from lists preset by the corporate buyers. With extensive merchandise selection, managers are able to negotiate directly with vendors for merchandise selection. This decentralization allows retail chains and local store managers to provide their target markets with unique merchandising customized to the local level,

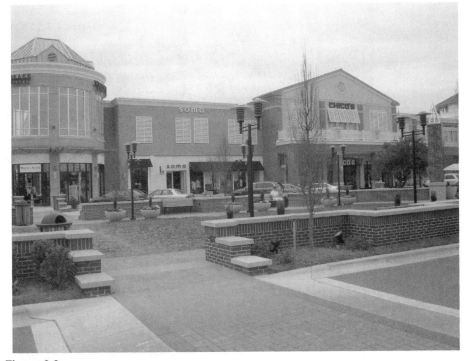

Figure 6.6
Chain store group with three different stores in one center.

which is often reflected in the exterior of the store as well as the merchandise (see Figures 6.7a and 6.7b). In contrast to its strengths, decentralization negates the power in the supply chain gained by centralized merchandising functions and dilutes the power of the unified retail brand.

An **independent store,** formerly coined as a Mom and Pop Store, is a single store owned by an individual or a partnership and recognized for building relationships with its customers who are usually very loyal to that particular retailer. Thus the buying function is directly related to the needs and wants of specific target consumers and usually performed by the owner who is the store manager. Usually there is a limited quantity of employees; however, each employee may have a return-customer client base that is very devoted and loyal to that particular sales associate. The owner may serve as the manager, buyer, merchandiser, visual merchandiser, and advertising and promotion manager, as well as the janitorial service. The owner/manager maintains total control over business operations and makes all major business decisions. The independent store is usually located in neighborhood locations, and the store image is tailored to that particular geographic region and that target consumer (see Figure 6.8). Additionally, these stores usually offer specialized services to attract and maintain the target customer base. Because of economic conditions, intense competition and competitive pricing from chain stores, and changing

(a) (b)

Figure 6.7
Stores of the community fit their looks to the locale. (a) Chico's in a lifestyle center and (b) Chico's at the beach.

Figure 6.8
Mom and Pop retailers are often located in downtown shopping districts.

consumer and industry trends, very few of this store type are left on the retail landscape in the United States.

Not as common in the apparel retail business, as in food establishments, are the franchise stores. A **franchise store** is established as a contractual agreement between a **franchisor** (e.g., manufacturer, wholesaler) and **franchisee** (i.e., retailer). The franchisor has exclusive rights to distribute specific goods and/or services. The franchisee buys the rights to conduct business under the name of the franchise within a specific geographic location and is required to

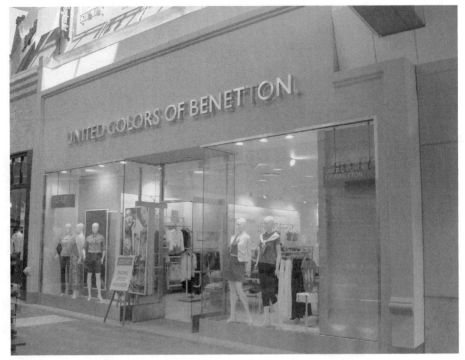

Figure 6.9
Franchise store with international image recognition.

conduct business operations using the guidelines, policies, and procedures established by the franchisor. The franchisee must pay a monthly percentage of gross sales to the franchisor for the exclusive rights to sell goods and services in the specific geographic area. An example of a clothing or apparel franchise is Benetton. When the manufacturer first came to the United States to do business, it sold franchises to individuals who wished to sell merchandise designed and produced by Benetton. These Benetton stores were very successful in the beginning, even though the company required all franchisees to select products from its entire assortment selection to maintain a uniform stock in all Benetton stores. Many of these stores became overstocked because of the high minimum requirements established by the Benetton parent company.

When the company sold too many franchises in the same geographic area, the Benetton stores could not compete, and several of them closed. Additionally, the parent company (i.e., franchisor) ran advertisements that were considered controversial by some consumer groups and offended many target consumers in the United States. This merchandising decision added to the demise of some of the U.S. franchises. After regrouping, the company continues to sell franchises in the United States, such as the one located at The Streets at Southpoint, a lifestyle shopping center in Durham, North Carolina (see Figure 6.9), and also continues to create controversial advertisements. Many U.S. Benetton customers are accustomed or indifferent to the ads and continue to buy the

Figure 6.10
Big box stores in a new center.

product, although the store image and product direction have changed since its first introduction in the States.

SPECIALTY STORE FORMATS CLASSIFIED BY RETAIL CUES STRATEGY MIX. **Boutiques** originated from a specialty store concept in France and the word is translated literally as "little shop." This particular type of specialty store targets a specific customer niche and carries avant-garde merchandise. The boutique concept became so popular in the United States that many upscale department stores housed their designer and bridge lines as a boutique or **shop within a store;** thus the **shop concept** for department stores originated.

Category killers, or power retailers, feature an enormous selection in a specific category or related categories of goods and usually offer the products at a lower price than department or smaller specialty stores that carry a similar or identical product. Sometimes these stores are called **Big Box stores** or superstores. Examples of category killers are Bed Bath & Beyond, Best Buy, Staples, and Office Depot (see Figure 6.10).

"Gnategory" killers are defined as micro-specialty stores specializing in one item within an already narrow category. The stores may be found as very small entities in a mall, such as kiosks, or as free-standing stores in malls or downtown shopping districts. Examples of these stores include sunglass shops, cap shops,

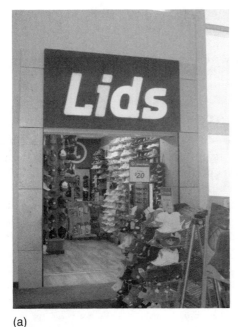

(b)

(a)

Figure 6.11
Examples of gnategory stores in (a) airport and (b) outlet center.
(Photographer: Laura Sampson (a))

T-shirt shops, sock shops, or other single-item shops (e.g., a jewelry case spot-lighted in the middle of a mall). Some of these shops offer customized services, such as personalized embroidery on caps or T-shirts. Retail chains that are gnat-egory killers are Lids, Just Add Water, and Gold Toe (see Figures 6.11a and 6.11b).

One of the newest formats of the specialty store is that of the **showcase store,** or **super-merchandiser.** Plunkett Research (2007) provides the following description of these very popular stores:

> Super-merchandisers . . . spend huge amounts of money on the construction of unique (and often entertaining) stores and devote large portions of these spaces to non-retail purposes, either for ambiance and style or for demonstrations and prac-tice areas for their products. The stores, which are also known as 'showcase stores,' are also staffed with the most qualified people available, people who are knowledgeable about the products and use of them. (Section 9, para 1)

Products merchandised in these stores include items such as hunting and fish-ing gear and attire, fashion apparel, and housewares. Cabela's and the Bass Pro Shop are two of the sports shops that originated around this format. The cus-tomer who is buying a hunting bow or a new fishing rod may go into the stores, find a wide selection of items in that product classification, talk with very well-trained sales associates about the products, and have the opportunity within the store to use the product to determine the best item to purchase for his or her specific needs. At the Bass Pro Shop, for example, a consumer can try on

hunting vests, caps, and other apparel items while trying out the newest guns, sights, and tripods (see Figure 6.12). Nike, in the Nike Town Stores, has created these entertainment or showcase stores with a mix of apparel and sports venues within the store, and VF Corporation is also testing the concept in some of its outdoor-apparel retail stores.

Department Stores: Overview

The second traditional store-based retailer type is the department store. Since the 1980s, department stores have undergone revitalization, with mergers, consolidations, buyouts, bankruptcies, and closures. This retail sector has gradually leveraged its channel power in the supply chain and is now creating dramatic changes in today's overstored retail environment. For example, Federated, which was known in the 1990s as a major holding company that owned numbers of retail department store chains, has now branded itself as Macy's. They have changed all of the various store names to the Macy's name. The store chains, once called Marshall Field's, originally in Chicago; Hecht's, originally in Richmond; and Atlanta-based Rich's have become Macy's. Macy's now has tremendous channel power with its merchandise suppliers, or vendors, and presently is emphasizing its private label lines as well as exclusive branded lines created by leading manufacturers for the Macy's conglomerate.

Figure 6.12
Showcase stores provide demonstrations and ambience as well as merchandise.

Traditionally, to be classified as a **department store,** a merchant had to sell both hard goods (i.e., furniture, electronics, appliances) and soft goods (i.e., apparel, home furnishings), had to hire 25 or more people, had to provide a variety of customer services, and had to be organized into separate departments for buying, sales promotion, financial control, and management. When there were multiple units to these stores, the store executives were usually housed in the original, or **flagship store,** which was usually located in a downtown area. Macy's famous flagship store, which opened in the 1930s and has experienced several major renovations since that time, is at the corner of 34th Street and Broadway in New York City (see Figure 6.13). The other stores, usually located in the suburbs, were coined as **branch stores,** or **twigs,** of the parent store. Department stores continue to carry a broad line of goods and a wide assortment in their merchandise mix; however, because of difficulty in meeting sales and profit goals as well as planned margins, many department stores have discontinued hard goods lines such as furniture, electronics, or sporting goods. These merchandise categories demanded a large amount of floor space but did not yield high **sales per square foot** (i.e., amount of dollars sold in a square foot of floor space). Nor could they compete with specialty retailers or big box stores carrying similar or identical products. Additionally, inventory costs were huge on these merchandise classifications because of an item's size and the fact that the merchandise did not maintain a high turnover or sell quickly.

Figure 6.13
Macy's flagship store in New York City.

DEPARTMENT STORE FORMATS CLASSIFIED BY BUSINESS OWNERSHIP. As with specialty stores, department stores may be classified by ownership type. There are several chain department stores, such as JCPenney, Sears, and Dillard's. This format follows the same organizational business structure and other features as the chain specialty store. There are also independent, privately owned department stores, such as Belk, Inc., headquartered in Charlotte, North Carolina, which also have multiple stores.

DEPARTMENT STORE FORMATS CLASSIFIED BY RETAIL CUES STRATEGY MIX. When classified by retail store cues, department store formats include the traditional department store, full-line discount department stores, junior department stores, and specialty department stores. Plunkett Research (2007) explains concisely that

> Today, most 'department' stores are actually mall-based apparel, accessories and cosmetics stores, with a few also offering a reasonable depth of housewares. If they offer any other types of merchandise, such as furniture or electronics, they are often in small, under-stocked sections that don't compete well against big box specialty stores such as Best Buy. . . . 'Department store' is a misnomer at this point. (Section 3, para. 5)

Because of economic and competitive pressures, very few traditional department stores remain in the United States. Many of the original ones in the United States have either closed, gone bankrupt, or reorganized. However, in Korea and other Asian countries, the department store is a recent and continuingly popular store format (Kim & Kincade, 2006) (see Figure 6.14).

Even with the removal of some product categories or departments, the **traditional department store** houses extensive merchandise assortments with both depth and breadth, enforces a fixed-price policy that is usually advertised in a public medium, guarantees its products and services, and usually carries national brands, private labels, and generic brands.

Many of today's department stores are classified as **junior department stores** because these retail establishments carry a limited number of product classifications and maintain fewer departments than the traditional department stores. These stores not only carry no hard goods but also limit the soft goods classifications. Any **department store group,** or a company that owns several department stores, may operate a junior department store, along with its traditional department stores, based on the store location and the concentration of the target consumer base. An example of the department store group is Belk, which is a leader in selling fashionable merchandise with a quality and selection that appeals to its customers ("About Belk," 2008).

A **specialty department store** features high-end, exclusive, and differentiated merchandise and customer services beyond those offered in traditional department stores. Usually these stores are located in prime retail space to reach a specific customer base or niche market. Some well-known specialty department stores include Neiman-Marcus with its extraordinary Christmas

Figure 6.14
Department stores are popular in China.
(Photographer: Sookhyun Kim)

catalog and its sister company, Bergdorf Goodman on Fifth Avenue in New York City (Figure 6.15). These stores not only offer unique merchandise assortments but they also provide outstanding customer service in order to build a repeat clientele. This department store format is thought to be one of the answers in addressing the problems of the department store type.

In reviewing the growth of specialty department stores, Plunkett Research (2007) states the following about the placement of these stores within the distribution strategies of some major retailers:

> On the luxury end of the spectrum, several new initiatives are in the works to court young, wealthy shoppers. Children of Baby Boomers (which include the 30-somethings of Generation X) are some of the wealthiest consumers in history and high-end retailers are hoping to lure them with merchandise and marketing strategies while keeping their parents happy. Neiman-Marcus has opened four Cusp stores targeting the younger generation with hip merchandise and kicky décor that sets it apart from the understated elegance of the Neiman-Marcus brand. (Section 3, para. 13)

Discount Stores: Overview

In the last 20 years, discounters have changed the face of the retail scene in the United States. Customers have been conditioned to **cross-shop** or look for similar merchandise classifications in several different channels of distribution.

Figure 6.15
Specialty department stores have unique merchandise assortments and outstanding customer service.

As previously explained, **discount stores** sell branded goods at below-market price and/or other inexpensive goods, many times with value-added benefits. The business model for the discounter is based on high volume, low margins, self-service, and low operating expenses. Many of the buildings are warehouses or buildings with very little decor in low-rent locations. Emphasizing price, discounters usually advertise aggressively.

DISCOUNT STORE FORMATS CLASSIFIED BY BUSINESS OWNERSHIP AND RETAIL CUE STRATEGY MIX. Business ownership and retail cue strategy mix can also be used to distinguish among the discount store formats. When examining business ownership, discount stores can be privately owned with one or more stores or can be corporately owned with many stores (i.e., a chain format). These store formats have the same characteristics as found across store ownership in specialty and department stores. Each store within a corporate chain is usually identical in store features and carries much of the same merchandise. In many retail outlet centers, customers oftentimes find unique, one-of-a-kind **independently owned discount stores.** Product classifications in these stores run the gamut from food to lawn products to crafts to apparel. Some of the products may be one-of-a-kind items or may be an imported item sold in high volume.

Using the retail cue strategy mix, discount stores may be in the format of off-price stores, full-line discount department stores, variety stores, factory outlets, or membership clubs. The **off-price discounter** features brand-name merchandise at below-market prices. However, this merchandise is usually purchased opportunistically; therefore, the product cannot usually be reordered,

Figure 6.16
Off-price discounters offer customers brand-name merchandise at lower prices.

and missing sizes, stock in only one color, and other stockout problems are often found in this store format. The stores for this format feature little to no decor, self-service, community dressing rooms, centralized checkout, and no special customer services. Most of the off-price stores are large corporately owned chains and have many of the same features as do other chain stores. Examples of the off-price discounters, which are chains, are Burlington Coat Factory, Marshalls, Hamrick's, and Ross Stores (see Figure 6.16).

A major discounter format that has reappeared in the forefront of retailing recently is the variety store. Variety stores were very popular in the 1950s and early 1960s before the invention of the mass merchant and other major discounters. **Variety stores** do not carry full lines of product classifications; however, they do carry a wide variety of goods. These stores are not segmented into departments. Nor are they known for their customer services. The merchandise in these stores is very inexpensive or popularly priced goods and is presented in the store on shelves or fixturing for easy self-selection. An emphasis on seasonal apparel, such as knit tops in the summer, and home fashions, such as curtains, dish drainers, and pillowcases, along with other products for use in the house and for children are found in many of the stores. The principal variety store remaining in the retail landscape in the United States is Roses (see Figure 6.17).

The major number of stores in the discount format is identified as a dollar store or closeout store. **Dollar stores** are known for their one-price pricing strategy. In some stores, everything in the store costs only one dollar per SKU. Stores may carry merchandise as varied as branded underwear, wrapping paper, and dishwashing detergent. Some dollar stores make special agreements with major consumer brand product manufacturers for selling smaller sized packages of items that typically sell in giant size packages in the major

Figure 6.17
Variety stores carry a wide merchandise mix.

discounters (Zimmerman, 2004). A few dollar stores sell items costing as much as $10, and Dollar General has begun selling fresh food. Three well-known dollar store chains are Dollar General, with headquarters in Goodlettsville, Tennessee; Dollar Tree, headquartered in Chesapeake, Virginia; and Family Dollar, headquartered in Matthew, North Carolina. Dollar stores are located in small towns throughout rural United States and in some urban areas in direct competition with major discount chains (see Figure 6.18).

Closeout stores purchase the leftover goods of the manufacturer, many times at the end of the season; the overstock or returns to vendors of other retailers; or leftover product in odd lots and broken sizes. These stores operate on a very low-cost basis. In fact, some of these retail outlets require customers to bring their own shopping bags to take the goods from the store; others display merchandise in opened cardboard boxes so customers may make their selection. One of the best known closeout chains, taking its name from the type of merchandise purchased, is Big!Lots (see Figure 6.19).

Some discounters began as **factory outlet stores,** or stores owned by a manufacturer that sold the company's overruns, closeouts, slightly irregulars, returned merchandise, back inventory, canceled orders, and discontinued styles. Originally, these stores were located onsite at one of the manufacturing plants and were opened to the public only on specific days and hours of the week, and were otherwise only available to employees and family. The stores were usually in stock rooms or areas not being used by the business, and many

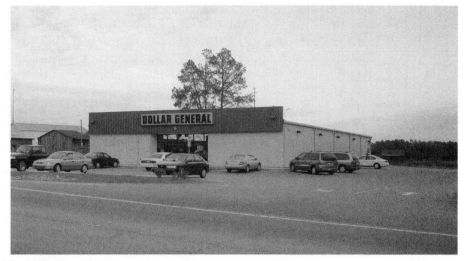

Figure 6.18
Dollar stores are often found in rural locations.

Figure 6.19
Big!Lots is a well-known closeout chain.

times the locations were in the back of the building. These stores were opened with little or no merchandise presentation and no planned decor or customer service. Customers sifted through boxes of goods or tables and shelves of merchandise to make their selections. Since those early days of outlet stores, the outlet mall has become a destination for shoppers and the environment of the mall has drastically changed. Many outlet stores today are clustered in **outlet malls** and have become vacation destinations for consumers who like to shop. Many of these outlet malls are located in luxurious settings with stores containing merchandise that ranges from discount goods and unbranded merchandise to higher priced goods and designer labels (see Figure 6.20).

In the 1970s, factory outlets became very lucrative to the bottom line of the manufacturer. With the potential high profit, many manufacturers began (1) producing special product lines for these stores, (2) sourcing other merchandise classifications from other vendors, and (3) choosing profitable locations in retail outlet centers to take advantage of the "right" location for the stores. One of the best known factory outlet chains is HANESbrands Inc. (Monget, 2006). This business was spun off the Sara Lee Corp. HANESbrands Inc. is known for its L'eggs Hanes Bali Playtex Factory Outlet chain of outlet stores, which are also called the HANESbrand stores. These stores are well merchandised with planned decor, some customer services, and sales promotional plans to support the many product classifications. Many of these outlet stores are located in the same vicinity of other retailers who carry the HANESbrands products as major merchandise sources for their stores. This apparel maker has skillfully developed product lines

Figure 6.20
Luxurious settings for outlet malls.

to target many channels of distribution, meet the demands and needs of the target consumers in each channel, and assist its retail customers in successfully selling the HANESbrands line of goods (see Figure 6.21).

Another popular type of discount retailer is the membership or warehouse club. **Membership clubs** require a customer to pay a fee to join, operate approximately 10% above costs (whereas other retailers operate from 30% to 100% or more above cost), and use a warehouse decor with minimal fixturing. Located in low-rent areas, these retailers emphasize self-service and limited advertising. In this channel of distribution, merchandise is oftentimes packaged in bundles or multiples and sold at very low prices. Stores such as Sam's Club and Costco are examples of this store format. Many of these stores carry food, healthcare products, and general merchandise categories with a limited assortment of apparel merchandise. Many of these warehouse clubs also have a pharmacy, optical services, a gas station, photo developing, and many other amenities.

Full-line discount department stores are identified in the section on department stores because of their wide assortment of product categories. Because of their pricing strategies, these firms could also be described within the discount store type. The few independently owned stores with this merchandise and pricing strategy may be categorized as discounters; however, the largest of these stores (e.g., Walmart, Target, Kmart) are more accurately identified as mass merchants.

Figure 6.21
An outlet store showing the multiple brands carried by the company.

Mass Merchants: Overview

Mass merchants sell to a target consumer wanting the most value for the least money spent; operate with a business model of high volume, high turnover, low expenses, and self-service; and present a wide and deep merchandise selection in a bare minimum decor. The **mass merchant** carries branded products, including soft goods, hard goods, and groceries. Besides food and groceries, apparel and home furnishings, fine jewelry, electronics, appliances, and many other varieties of merchandise classifications, these stores usually maintain a pharmacy, an optical office, a branch bank, a beauty salon, a florist, a gas station, an auto services department, a greenhouse for shrubs and gardening, and sometimes even a "mini medical clinic," or a McDonald's restaurant or Starbuck's coffee shop. The top three stores in this category are Walmart, Target, and Kmart (see Figure 6.22).

This retailer presents its merchandise at discounted or "everyday low prices" or at competitive prices in less expensive buildings with less elaborate decor and fewer fixtures than the traditional department store format and with a broader merchandise assortment than the regular discount stores or the specialty stores. Operating on a high-volume, lower cost business model, this retailer format usually maintains fewer sales associates (i.e., self-service) and uses shopping carts, centralized checkouts, and a customer service center. This business model is based

Figure 6.22
Mass merchants have a wide and deep merchandise mix.

on high sales per square foot, higher productivity per employee, and higher sales volume. Many times these stores are located in small towns, rural areas, or in low-rent areas of a large city to take advantage of less competition and to secure the lower operating costs such as lower taxes, rental fees, and wages for employees.

Private-Branded Hive (PBH): Overview

The **private-branded hive (PBH)** store type was created in the Dong Dae Moon district (DDM) in South Korea in 1998 (Kim & Kincade, 2006). The PBH provides high quality and fast new fashion with low prices. Since the opening of the first PBH, named Miliore, many such retailers have appeared in South Korea (e.g., Doo-San Tower, Preya Town) and in other Asian countries. Merchandisers must be very aware of international retailing and trends in retailing that may soon affect their domestic market. The PBH store is similar to the Silk Street stores that have appeared in China (Kim & Kincade, 2007). A district similar to the DDM in Seoul, Korea and the Supply Chain City in China is being planned for the town of Wigan in the United Kingdom ("UK: Chinese Firms," 2008). With the globalization of the FTAR industry, understanding international retail formats may easily be part of a merchandiser's job.

A PBH contains more than 2,000 booth-style stores that sell their own private-branded apparel items. In the five-to-ten-story building, the tiny stores on each floor are devoted to one product category (see Figures 6.23a and 6.23b).

(a) (b)

Figure 6.23
PBH retail in Seoul, South Korea (a) and (b).
(Photographer: Sookhyun Kim (a and b))

In the PBH, the first-floor stores carry accessories; the second-floor stores carry women's wear; menswear stores are located on the third floor; and upper floors carry children's wear, shoes, and imported apparel items. The PBH provides a wide variety of customer services and uses all types of promotional activities. The store owners in a PBH are also the store managers and the designers, who design, oversee the manufacturing, and sell the fashion-forward products for their own store. So far, this retail type has only appeared in select geographic regions, such as the DDM district, which is the center of the textile and apparel industry in South Korea. Thousands of supply channel members for the FTAR Complex are located in the DDM. This location makes the time from design to market very short, so that fashion-forward products are always in a PBH.

Nonstore Retail Types

"Direct selling through online retailers, catalog companies and home-shopping television channels continues to increase" (Plunkett Research, 2007, para. 5, Section 7). Sales through Internet shopping have risen dramatically, specifically the sales of apparel items. Additionally, CD-ROM shopping, catalogs, direct mail, and mail-order advertising; television home shopping and infomercials and direct sales via radio; plus telemarketing are very competitive channels that compete with store-based retailers. Other direct selling techniques include in-home parties, kiosks, and vending machines. All of these channels have become popular with some consumers who value convenience and time-saving methods for purchasing products and services or those who want variety, depth of assortment, and information for product comparison.

Nonstore retail formats can provide consumers with the convenience of shopping at home as well as a wide variety of choice in prices and styles. The retailer and manufacturer benefit from this store format because they have a limited investment in real estate and in inventory in comparison to traditional brick-and-mortar stores. The retailer also must contend with increased numbers and costs of returns because the consumer often orders multiple sizes and colors of products to have the shopping experience and then returns the unwanted items. The retailer will also have increased expenses of shipping if he or she chooses to offer free shipping and free return postage to the consumer.

Internet Retailing

Electronic, Web-based, **online retailing** or **Internet retailing** consists of shopping in a "virtual store." In the early development of the Web-based retail type, some consumers were hesitant to buy apparel via the Internet. Without trying on the merchandise, many customers did not think that they could determine the correct size or view accurate colors on the computer screen. Additionally, consumers could not touch the fabric to get some idea of the quality of the merchandise, and many consumers were also unsure about the security of credit

information when purchasing online. However, when major national brand names were offered online and trusted brick-and-mortar stores offered product online, the loyal customers of these brands began making more online purchases. With the techno-savvy of Generation X and Generation Y and increased computer usage by Baby Boomers and the mature or gray market, this retail type is growing by leaps and bounds. Sales generated by Internet shopping have continued to rise over the past several years, and sales of apparel have surpassed the sales of computer hardware, electronics, and books, which have been the mainstay of Internet retailing (Kittle, 2006). Target and Macy's both have experienced double-digit growth in Internet sales and report that this retail format is the fastest growing part of the company ("Macys.com," 2007, "Target online," 2005). In addition, the Internet has become a way for manufacturers, raw materials producers, and auxiliary businesses to interact not only with their customers in the supply chain but also with consumers (see Figure 6.24).

Online retailing can provide customers with a wider variety of products than store-based formats, and product descriptions can give consumers in-depth information about sizing, fabrications, product care, and fashion. Many online sites provide dictionaries of fabric and style terms, fashion tips, and seasonal or new fashion information. In addition, some sites allow consumers to see what

Figure 6.24
Web page supports virtual shopping.
(Courtesy of Tomlinson Erwin-Lambeth Directional)

the product looks like when worn, including sites that allow consumers to upload self-images and place clothing on the image or provide sample body types that can be dressed by the shopper. Lands' End, which offers both a catalog and an online retail type, allows customers not only to see products on their body images but also allows customers to create products. **Made-for-me products** allows customers to select components of products, select color combinations, or personalize embroidery or other customization and then see or visualize the products online (DesMarteau & Speer, 2004). These online enhancements have consumers shopping online first before traveling to brick-and-mortar stores. Nike and Hanes both offer these customized product services to their online customers.

Additionally, **Internet-based retail sites** such as Amazon.com are convenient for online purchasing for everything from home furnishings to electronics to apparel. Companies are also now using e-mail to target their most loyal clientele. Many consumers list their e-mail addresses with their favorite retailers so that the retailers may send advertisements, sales notices, or other important information to alert the target consumer of happenings in the brick-and-mortar stores. One of the newest combinations of this retail type is the **clicks-and-calls** shopping experience, where a customer is online observing a product assortment while talking on the phone to a knowledgeable sales associate for that retailer.

Catalogs, Direct Mail, and Mail-Ordering Advertising

Because of the costs of publication and mailing expenses, the lengthy lead time for production and the social concerns related to paper usage, many companies have discontinued the printing of large multipage catalogs. However, some retailers continue to create successful **catalogs,** or printed books or pamphlets, containing a limited number of pages with dramatic product photos and descriptive information explaining those photos. These retailers have found that they can create market share and offer a convenient channel of distribution to time-starved customers as well as consumers in remote locations. Catalogs are used by retailers to reach customers where the retailers have no brick-and-mortar presence, and by some retailers whose only presence is through these print media. Some companies offer merchandise at better prices in their catalogs or offer different product lines in the catalog than in their other retail types.

"Catalog retailing remains an immense business [in the 2000s]. About 20 billion print catalogs were mailed to U.S. households in 2006, in addition to billions of direct-mail offerings via letters, brochures, flyers and postcards" (Plunkett Research, 2007, Section 7, para. 9). Successful catalog companies and store-based retailers, using the catalog as part of their marketing and promotional mix, have found it lucrative to target a specific consumer segment with a unique, exclusive, or luxurious line of products or product classifications. L.L. Bean, Lands' End, and Victoria's Secret are known for their unique product

offerings in catalogs. Some store-based retailers such as Cold Water Creek and Chico's are noted for featuring their seasonal or catalog-exclusive product selections in their catalogs.

Irrespective of catalog mailings, many store-based retailers send to their target customers **direct mail** and **direct-mail advertisements** in the form of circulars, flyers, brochures, and even letters and advertisements in their credit billings. These marketing techniques have been very successful for those stores with advanced marketing techniques to target the customer, especially relative to the brand and product classification previously purchased.

Television Home Shopping, Infomercials, and Interactive Television

The major **home-shopping television** show in the United States is QVC, Inc. It is broadcasted into the majority of U.S. homes. "The [Home Shopping N]etwork broadcasts themed shopping programming 24 hours a day, 365 days a year, with operators continuously available to take calls and process orders" (Plunkett Research, 2007, Section 7, para. 10). Product classifications such as jewelry and accessories are the items purchased most frequently from this company. Another well-known home shopping channel is the Home Shopping Network.

Additionally, interactive television is becoming more popular with many customers. With **interactive television,** customers who are watching a movie or a concert on television may order products they see demonstrated or used on the show, immediately when watching the show. Consumers can use their TV remote to respond to information on the screen and to indicate purchase preferences. Weekly shows on both cable and national networks have offered product through this retail type. This technique can be combined with the practice by some companies of paying large fees to have their products featured or highlighted on specific television shows.

Infomercials, or paid programs that combine an advertisement of products with a demonstration of product benefits and satisfied customer testimonials through the talk show format, have become very popular in today's busy world. Examples of merchandise sold on these infomercials include a variety of product classifications from cosmetics to small kitchen appliances to vacuum cleaners to tools to cars and services such as law firms and home builders. These are popular programs for Saturday and Sunday morning viewing.

Telemarketing and One-on-One Marketing

Telemarketing, or selling product and services via telephone, was very popular with sellers until the Federal Trade Commission created the "National Do Not Call" listing of customers' names who did not wish to be contacted for advertising or selling via the telephone. Many companies that used only this technique to reach the customer found themselves without customers when

they had to curtail their calls. However, some companies are still using this channel to reach the consumer.

One-on-one marketing such as contacting the customer in **door-to-door home calls** or at large offices as well as **in-home parties** have traditionally been used by many companies as their major channel of distribution. For example, the cosmetic companies of Avon and Mary Kay have used the door-to-door channel and in-home party techniques to build huge customer followings. Privately owned companies such as Patsy Aiken Designs (www.patsyaiken.com), a children's manufacturer, has marketed product to mothers who want to "design" that special custom-made product for their children.

Summary

Many companies operate within the global market. Apparel products are sold in stores, on the Internet, through catalogs and direct sales, and other locations. A company has an unlimited choice of what type of company to be, what company image is to be developed, and where the products will be sold. Creating an image that is unique and profitable is an important task for each company. A vast array of retail types and formats is available for the marketer, manufacturer, and retailer to reach the target consumer. Although many choices of formats, types, and subsequently channel formations are possible, analysis of research data has revealed facts to substantiate the fact that retailers, trading through more than one retail type or store format, are the most successful. Brick-and-click stores have become the most successful store format. Many specialty retailers have been most successful in marketing and selling its products through brick-and-mortar stores, catalogs, and its online site, which includes a click-and-call option. When these innovative retailers are partnered with fashion-sensitive product developers and flexible and responsive manufacturers, they can form extremely successful channels of distribution.

Key Terms

Big box stores	Clicks-and-calls	Door-to-door home calls
Boutiques	Closeout stores	Doors
Branch stores	Cross-shop	Dual distribution system
Brick-and-click store	Department store	Exclusive distribution
Brick-and-mortar store	Department store group	Factory outlet stores
Catalogs	Direct mail	Flagship store
Category killers	Direct-mail advertisements	Franchise store
Chain store	Discount stores	Franchisee
Chain store group	Distribution level	Franchisor
Channel of distribution	Distribution strategy	Gnategory killers
Click store	Dollar stores	Home-shopping television

Horizontal integration	Mass merchant	Shop within a store
Independent store	Membership clubs	Showcase store
Independently owned discount stores	Off-price discounter	Specialty department store
	Online retailing	Specialty store
Infomercials	Outlet malls	Store
In-home parties	Overstored	Store format
Intensive distribution	Placement	Store group
Interactive television	Private-branded hive (PBH)	Store of the community
Internet-based retail sites	Retail categories	Super-merchandiser
Internet retailing	Retail cues	Telemarketing
Junior department stores	Retail cues strategy mix	Traditional department store
Limited distribution	Rooftops	Twigs
Made-for-me products	Sales per square foot	Variety stores
Mass distribution	Shop concept	Vertical integration

Review Questions

1. What is a channel of distribution, and why is it an important choice for a company?
2. How is the traditional channel of distribution different from the channel that includes a wholesaler?
3. How does a specialty store differ from a department store?
4. What features are found in discount stores?
5. How are chain stores different from independents?
6. What are the unique features of a dollar store?
7. How have factory outlets changed from their origins to today?
8. What are the advantages and disadvantages of nonstore retailing?
9. What are some of the new nontraditional retailing formats?
10. Why has the sale of apparel grown on the Internet?

References

About Belk. (2008). Belk. Retrieved May 20, 2008, from www.belk.com/main/about_belk

Bowers, K. (2007, May 2). Apparel key to Wal-Mart community effort. *Women's Wear Daily*. Retrieved May 2, 2007, from www.wwd.com

Kim, S-K, & Kincade, D. H. (2006). The model for the evaluation of retail institution types in South Korea. *Journal of Textile and Apparel, Technology and Management, 5*(1), 1–29. Available from http://www.tx.ncsu.edu/jtatm

Kim, S-K, & Kincade, D. H. (2007). Evolution of retail institution types and consumers' store patronage behavior: A cross-cultural comparison among consumers in China, India, and the United States. *Journal of Shopping Center Research, 14*(2), 79–106.

Kincade, D. H., & Woodard, G. (2001). Shopping for souvenir clothing. *Pacific Tourism Review, 5*, 159–165.

Kittle, B. (2006, February). Online Christmas 2005: Search engines power up shopping. *Retail Education Today, 26*(3), 18–27.

Macys.com heading for $1 billion in sales. (2007, April 27). *Home Textiles Today*. Retrieved April 27, 2007, from http://www.hometextilestoday. com

Plunkett Research, Ltd. (2007). Retail industry trends. Section 3, 7, 9. Retrieved July 20, 2007, from www.plunkettresearch.com

Monget, K. (2006, September 5). A new apparel giant: $4.5B Hanesbrands to make NYSE debut. *Women's Wear Daily,* p. 1.

Target online in triple-digit growth. (2005, October 21). *Home Textiles Today Extra.* Retrieved October 21, 2005, from http://www. hometextilestoday.com

UK: Chinese firms plan Europe's largest textile city. (2008, February 21). *Just-style.* Retrieved February 21, 2008, from www.just-style.com

Zimmerman, A. (2004, December 13). Behind the dollar-store boom: A nation of bargain hunters. Retrieved December 14, 2004, from www.wsj.com

SECTION
III

*Tracking Trends
to Forecast Fashion
Change, Its Movement
and Direction*

I n a consumer-centric company, creating a new seasonal line begins with the customer and ends with the customer. Developing a new line begins with all major divisions within the company conducting market research to evaluate, anticipate, and forecast what will satisfy consumer wants and needs as well as consumer desires and demands. From six to nine months in advance of developing the seasonal line, major companies research macro- and micro-environmental trends, both domestic and global, that will impact the composition of the seasonal line. Research for the consumer-centric company is a never-ending, continuous process that connects consumer needs and wants to the company's plans for line positioning, product development and merchandising, planning and forecasting, and marketing strategy.

In the strategic planning process, executive management and its support team perform and review environmental scans to provide background for strategic decision making. This broad market research provides a foundation for the additional research done by the merchandising and market research teams to prepare for line product development. Before, during, and after each seasonal line process, the merchandisers must be forming, maintaining, and adjusting their snapshot of what is happening in society, socially/psychologically, and then pinpoint how the impact of demographics, psychographics, lifestyles, and life stages of the consumer will be reflected in the next seasonal line. These trends are examined and evaluated for their influence on the company business plan that was formulated in strategic planning. In addition, economic trends, political happenings, trade and legislative trends, and technological as well as environmental trends are followed closely because any one of these factors may influence consumer buying patterns and success of the retailer. The merchandiser also investigates trends about the consumer. For example, the merchandiser follows changes in consumer demographics, geographic shifts in population, and the shopping behaviors and purchase preferences of consumers.

Environmental forecasting and fashion forecasting are done to some extent by all firms, raw materials producers, sewn product manufacturers, and retailers, throughout the FTAR Supply Chain (see Figure S.3.1). Firms scan the environment, analyze the collected data, evaluate these findings, anticipate and forecast the trends, and then translate this information into usable segments for planning. This research information can be gathered by collecting information about a firm's consumers, scanning the market activities at the major design shows and market centers for trends in apparel manufacturing, and reviewing general business and industry information (see the dashed lines in Figure S.3.1). Many firms also purchase research reports from an auxiliary business or service firm (see the dash and double dotted lines in Figure S.3.1). Each of these auxiliary businesses, such as a buying office or color forecasting office, have their own market research divisions that are independent of their partner firms. They also collect data from a variety of sources; conduct in-depth analysis; translate the forecasts into merchandise potential selections; and report color, trend, style, and other information to their partners. In addition to collecting information from in-house Research Departments and from purchased reports, in an integrated supply chain with the focus on the consumer,

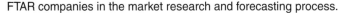

Figure S.3.1
FTAR companies in the market research and forecasting process.

merchandisers in companies along the supply chain share information with their trading partners (see the dotted line arrows in Figure S.3.1).

With the collection of this company, consumer and environmental research information, the merchandiser must anticipate how to translate the trends that are identified so the right merchandise will sell in a specific geographic location or to a specific customer segment for his or her retail organization. Sometimes the merchandiser must determine how to adopt a portion of the trend or how to modify that trend to meet the consumer demands for the company's products. In addition, the merchandiser analyzes the positioning and importance of brand types (e.g., national brands, private label brands, store brands). From this general business and fashion information, the merchandiser has to

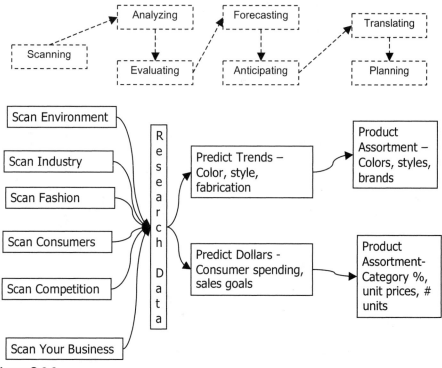

Figure S.3.2
Details of the market research and forecasting process.

make specific decisions about design concepts, line composition, and even the numbers and sizes of each style for each retail store (see Figure S.3.2).

At any one point, the typical apparel product merchandiser is working with a designer on conceptual ideas for season A, with cut-and-sew plants for production samples in line development on season B, with a retail buyer on season C for an upcoming order, with the same buyer on some returns from the current selling season (season D), with the staff in consumer marketing and retail services on evaluating the sell-thru of season E, and with the consumer marketing team on incoming data to drive season F. Similar scenarios are happening each day in the offices of retail merchandisers and raw materials merchandisers. Each level of the FTAR Complex must spin on cycles that support the ever-changing demands of the consumer for new products.

Chapter 8 examines the many facets of the consumer and his or her patronage behaviors. This chapter includes consumer demographics and generational divisions, geographic differences, and shopping and purchasing behaviors. Chapters 7 and 9 cover the process of market scans and the processes of forecasting the trends for the firm, the customer, and the final consumer.

chapter
7

Market Research

Objectives

After completing this chapter, the student will be able to

- Explain the importance of research to the planning process
- Discuss the difference between qualitative and quantitative research and the reasons for using each type
- Identify the types of data used by consumer-centric companies
- Explain the difference between qualitative and quantitative data
- Identify the sources of data available to a merchandiser
- Discuss the importance of safety and accuracy in data handling
- Explain why data quality is key to the viability of the data for a merchandiser
- Identify the types of technology that can enhance the use of data
- Discuss how the merchandiser can use data to make decisions during the merchandising process

Introduction

One key to a successful business is planning, and the basis for good planning is quality research. Merchandisers take information from the strategic plan (see Chapter 2) and, using additional research, build their plans for products, promotions, and other aspects of merchandising. In a consumer-centric company, to develop and produce the right product at the right price for the right place or channel of distribution, the merchandiser must tap into and analyze data from

in-depth market research to identify the value-added product benefits and features that will satisfy the company's target consumer.

Market research is the process of collecting and analyzing data across numerous sources that impact and contribute to the company, its customers, its vendors, and its products. Market research becomes an important tool for the merchandiser and is initiated by defining a problem. This definition usually originates with the strategic planning process and decisions made by top executives. The market research process continues when employees are collecting and analyzing data for forecasting and planning. Once the problem is defined, this is communicated to merchandisers, buyers, market researchers, and others who will be involved in the process.

Market Research Process

Merchandisers along the FTAR Supply Chain begin each seasonal Buying-Selling Cycle with intensive planning. They work with executive or top management to receive company directives for image, promotions, and other guidance in creating and delivering the right product for the right customer. As the season progresses, the merchandiser constantly monitors the line concept and the product line for trueness. He or she must be vigilant that the right product is developed and produced. As soon as the products in one season begin to sell, the merchandiser begins an analysis of the sales figures and other pertinent information. An evaluation of this information becomes the directives for the next cycle (see Figure 7.1).

Evaluation is an important step in preparation for market research. With each cycle, the merchandiser gains information about what sells and what does not sell. By studying the research on the processes and other information from vendors and customers, he or she can use this information to learn more about the consumers' preferences for products and the vendor's abilities to supply the materials needed to complete the line. Merchandisers are very busy people who are constantly planning, activating the plans, and evaluating the outcomes. As each season continues, a new season must be started. At times the merchandiser may have four or five seasons in active process. Market research from each seasonal line provides information for the coming seasons. Sometimes the best feedback comes from this season last year, but each season can provide insights into changing demographics, shifting shopping patterns, and other customer or consumer behaviors.

For merchandisers in the fashion world, this cycle of planning and evaluating is often very short, perhaps a few weeks, and must be continuously pursued to have fashionable products that are right for the consumer. Some retailers have new products entering the stores every two or three weeks. With 18 or more turns in a year, the apparel merchandiser is very busy with planning, implementing, evaluating, and starting over. For example, the following information is reported about Zara, the successful Spanish-based FTAR company.

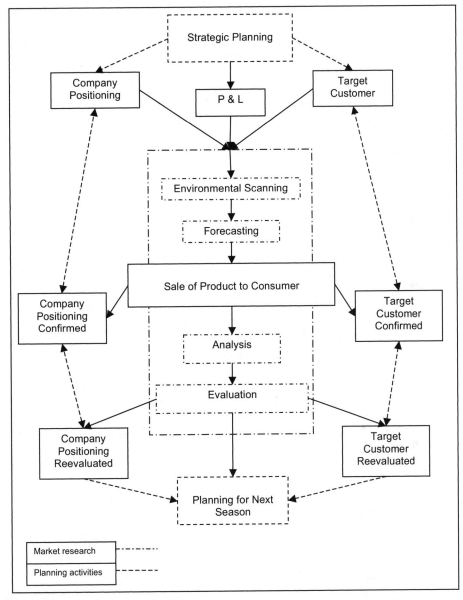

Figure 7.1
Market research as part of merchandising activities in preparation for a new season.

Instead of delivering products only seasonally, Zara has twice-weekly deliveries at its 600 stores around the world. Instead of producing two or three hundred different products a year, Zara comes out with more than 20,000. It does not overstock, and unsuccessful designs are often whished off the shelf in the space of a week, so the company doesn't have to discount or slash prices. All of Zara's store managers are

equipped with handheld devices that are linked directly to the company's design rooms in Spain, so that managers can make daily reports on what customers are buying, what they're scorning, and what they've asked for but could not find. (Surowiecki, 2004, Chapter 10)

Doing market research requires comprehensive, accurate, and organized data. Market research data must be appropriately collected, stored, and managed for it to be useful to a merchandiser. Merchandisers must understand many aspects of data, including types of research, types of data, sources and quality of data, and issues of data management and analysis.

Types of Research

The data collected from past and current sales, and lack of sales, become tools for use in planning the future. However, the merchandiser must have more than sales history for future planning. In addition to past and current sales, the merchandiser also uses data from the Marketing Research Departments in his or her company. Both the Image Communications Division (i.e., market researchers, retail marketers, visual merchandising—retail) and the Consumer Marketing Division (i.e., merchandisers, product development personnel) of the company conduct research to determine the mindset of the consumers. Plus, the merchandiser works closely with suppliers and customers to examine the sales data and market research data that are collected by their marketing and merchandising divisions. Team work is important to achieving the right product and in identifying the right consumer for that product or in finding the right customer and creating the right product for that customer. As noted in Chapter 2, strategic planning can follow either of the two paths to sales success.

Researchers and merchandisers may conduct product and consumer tests for developing new product (i.e., fit, fabrics, silhouettes) and revising older products; for testing new packaging concepts, new retail displays or point-of-sale concepts, or new advertising ideas; and/or for developing brand extensions. By listening to the consumer, the market research personnel, merchandisers, and product development personnel conduct primary research or they may obtain the results from other organization's research. This type of research information obtained from primary research can be applied in the design activities for creation of the product, in product development, and in merchandising of the seasonal line. It may also be used for developing store image and layout plus in-store merchandise presentation and brand positioning. Research for merchandisers may be quantitative or qualitative.

Quantitative Research

Quantitative research is objective and counts how many people know, feel, or act a certain way about a product or the research problem. This type of research provides the ability to look at consumer demographic and lifestyle

profiles; their behavior toward specific products and services, including promotional events; and their selections or opinions about various products and other merchandising issues. Using quantitative research techniques, a few, usually simple, questions are asked of many people. This type of research does not obtain depth of understanding but rather gives the researcher information about a lot of people. If the participants in this research are randomly selected, the results can be statistically analyzed and inferences can be made about how the entire population would respond even when only a portion of the population is questioned. In **random selection,** each person in the population of interest (e.g., people who buy T-shirts) has an opportunity to be chosen for the study. This is usually accomplished through a random number assignment or with some type of random drawing of names.

Quantitative research generally involves the use of a questionnaire. It could be a paper-and-pencil questionnaire or a set of questions on a Web site (see Figure 7.2). When the questionnaires are short and easy to answer, they can be given to many people with various abilities. Simple questionnaires can even be given to children and persons who cannot read. Quantitative research methods include various marketing surveys and specific questionnaires used with product testing.

Figure 7.2
Sample questionnaires for collecting data.

Qualitative Research

Qualitative research provides a rich context for investigating and understanding the consumer mindset. It is often used to gain insight into a problem and helps to define the underlying issues or underlying concerns of the target consumer. This type of research can be quickly administered, although extensive planning is needed to do a large study using qualitative methods, and an interview can take much longer than some questionnaires. When done informally, qualitative research is relatively inexpensive; however, when large panels are interviewed with videotaping and professional moderators, this type of research can be very expensive.

Qualitative research is conducted through a number of methods, including consumer panels, focus groups, and one-on-one interviews. When the subject matter is sensitive or in-depth information is needed, the market researcher or the merchandiser may conduct personal interviews with the target consumer. Most often this research is conducted through face-to-face interaction between the interviewer and one or more interviewees. Sometimes diaries or other written forms are used in this type of research. Qualitative research is thought to provide depth of understanding for the research about the issues being investigated. It helps the researcher to narrow down a broad range of ideas and understand the *why*. For example, qualitative research explores why people feel the way they do or what they believe.

Types of Data

Data are bits of information collected and stored along the entire FTAR Supply Chain that a merchandiser may use. A few examples of data are the characteristics of a product, such as the color, size, and fabrication; the price of a product at wholesale, retail, before and after a promotional sale, and the cost of the components in the product; vendor profiles, including names, addresses, contact information, ratings for delivery and other services; customer information that would be similar to vendor information except ratings would include speed of payment and sell-thru; production information about any stage in the process from raw material weights to wages for sewing operators; and consumer characteristics, including demographics, lifestyles, preferences, shopping patterns, and patronage habits. As evident from this list, data may be **primary data,** or data collected by research that is designed and conducted for a specific purpose to answer an identified question or to solve a specific company problem (see Table 7.1). In contrast, **secondary data** results from research or data collection that is not focused on the problem at hand but does contain information that could contribute to the merchandiser's understanding of the problem. Because of the expense of collecting primary data, many FTAR companies use secondary data to solve company product and marketing problems or to answer pressing questions that must be resolved with regard to product offering, company services, or promotional techniques.

Table 7.1
Examples of primary and secondary data.

Types of Data	Examples
Primary data	• Person-to-person interviews done by the researcher or an assistant about the research problem • Paper-and-pencil surveys created by the researcher for the purpose of collecting information relative to the research problem • Original company documents (e.g., 10K, annual reports, sales figures when the researcher wants data about the company) • Observations of shoppers in a mall made by the researcher or assistants when the research wants shopping behaviors
Secondary data	• Census data from the U.S. Census Bureau in the U.S. Department of Commerce • Reports of the number or dollar amounts of apparel or textile imports prepared by trade organizations (e.g., National Retail Federation), research companies, or a government department or agency (e.g., Federal Trade Commission) • Articles about company activities (e.g., sales, mergers, stock values) as reported in newspapers and other trade journals, such as *Women's Wear Daily* or the *Wall Street Journal*

Data used by merchandisers may be qualitative or quantitative or a combination of both. Most merchandisers have access to **quantitative data,** or numeric data (see Table 7.2). The most common example of quantitative data is the dollar figures from product sales. Companies in each level of the FTAR Complex are concerned about the direct sale of their products and the more indirect information of the sale of the product to the final consumer, or the sell-thru. Sales can be reported in retail dollars or in terms of the sales of products to the consumer or may be reported in wholesale dollars representing sales from one FTAR company to another. At wholesale and retail, the sale of products is a constant measure of the success of a product or product line or a company. Sales can also be reported in **numbers of units,** or how many products of one type are sold (i.e., data at the SKU level). **Ratios,** or percentages, are also used to examine how much product sold either in units or dollars in relationship to how much product was available.

In addition to quantitative data, merchandisers also want to analyze and evaluate qualitative data. **Qualitative data** is represented in pictures or words instead of numbers (see Table 7.2). Examples of this type of data are the feedback from consumers who ask questions of or voice their opinions to sales associates on the sales floor, the comments from consumer panels or other focus groups, complaints from consumers, and comments from any personnel who work with the product or service customers. Many times companies use forms with numbers or check boxes to itemize qualitative data into quantitative form. For example, when a consumer returns a product, the sales associate completes a form and asks for the reason for the return. The consumer is given three choices: It didn't fit, doesn't match, or didn't like it. A number 3 on the form

Table 7.2
Examples of quantitative and qualitative data.

Characteristic Observed	Quantitative Data Examples	Qualitative Data Examples
Clothing preferences	The average consumer owns five national brand T-shirts.	The average consumer would rather buy store brands instead of national brands.
Shopping behaviors	The time-pressured woman shops one time per month for clothing.	Time-pressured shoppers often feel very irritated when sales associates are too busy to "ring up" the sale.
Company vendors	The X Fiber Company has a total of ten vendors that send supplies three times in a season.	Company vendors that are in formal partnerships have often been with the company longer than other vendors.
Product quality	The XYZ product had 55% returns.	Consumers were unhappy with the XYZ product.
Store promotions	The store spent 10% of this month's promotion budget on public relations.	Public Relations Departments in companies try to have a number of events each year that get publicity.

probably does not capture all of the feelings, thoughts, and qualitative feedback that the consumer could have supplied to the merchandiser.

Other qualitative data are the files of pictures that every merchandiser keeps, either electronically or in paper form. Pictures of colors, textures, fabrications, and other products can be used in concept development to stimulate planning. Pictures of a sweater that shrank when compared to an unwashed sweater or a red stripe that bled on a white shirt are strong statements on the satisfaction or rather dissatisfaction of a product's performance.

Sources of Data

Data can come from numerous sources throughout the FTAR Supply Chain and from companies that provide services to these supply chain members. Most merchandisers use the data from retail stores when sales of products are made to the final consumer, but sometimes they use data that comes from the production plants and may even be involved in using data from fiber or fabric producers. In addition, data may come from account executives or sales reps hired by the company to service the customer accounts and may also come from outside sources such as marketing firms and Internet searches. The number of data sources is actually endless for most merchandisers because they are always searching for information to help them make the best decisions on customers and products.

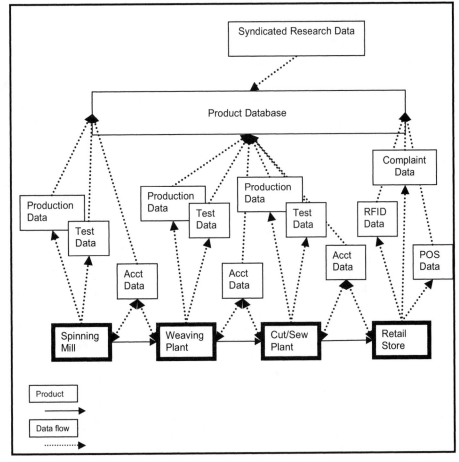

Figure 7.3
Product and data flow in FTAR Supply Chain to form database.

Retail Sales

One primary source of data for merchandisers is the retail sales reports that are generated from the **point-of-sale (POS) systems** when the consumer buys a product. This data is called **POS data** or **scanner data** (see Figure 7.3). This data is stored into the computer when the scanner on the computer, in a wand, at a scanning station, or on a conveyor reads the bar code on the product. The most typical source of this data is scanners at the checkouts or cash registers in retail stores. In a survey of major retailers, *Women's Wear Daily* reported that 81% of the respondents had updated or started an update of POS technology in the past three years (Millstein, 2005).

Data from bar codes may also be entered into computers from scanners that are used within the factory floor or at loading docks from any of the FTAR companies. POS data from retail generally includes information about the SKU

that was sold, such as price, any discounts, size, color, style, and brand. When the retailer is a multistore company, the data also includes the location of the store where the product was sold. Information about plant locations, manufacturers, and other suppliers may also be captured with POS data. However, POS data does not reveal what product the customer wanted but could not find in the merchandise mix of the store.

New **radio frequency identification data (RFID)** are now available for some companies. This data is generated from the **RFID tags** imbedded in products. These tags, which include an antenna and a microchip, give off electronic frequencies that can be received by monitors in a store ("Dillard's RFID," 2008). The tags and the resulting electronic waves can be used to track the product from the shelf to a dressing room and into the shopping cart (Feder, 2005). The shopping cart when passed through a monitor at the checkout is analyzed for products, and a cost is totaled for the customer without lifting one item from the cart (see Figures 7.4a and 7.4b).

Major retailers, such as Dillard's, see the benefits to the use of the RFID tracking system ("Dillard's RFID," 2008). The immediate benefit to customers is that the information from these tags can improve inventory and stocking processes and ensure that the right products are in the store. The RFID tags store more data than that of bar codes and can provide information about the movement of products from loading docks through distribution centers into retail stores and finally through sales checkout stations without any handling costs. As costs of labor increase, the replacement of remote, hands-off tracking can reduce costs. In addition, knowing the activity of products by store placement and the combination of products in shopping carts provides companies with valuable information for product differentiation and product positioning when planning product sales. Reorders for low inventory can be done without a physical count of the shelves because that information is accessible by checking the frequencies emitted from products remaining on the shelves ("RFID," 2003). For merchandisers, many future uses of RFID data are possible.

(a)

(b)

Figure 7.4
RFID scanning equipment (a) and (b).
(Courtesy of College of Textiles, North Carolina State University (a and b))

Although this system of data collection has high benefits for retailers, the future of the system is uncertain. Consumer groups have objected to the RFID use because the tags allow companies to track the movement of the products in the consumer's possession, which can be viewed as an invasion of privacy (Feder, 2005). Consumers also worry about the potential for companies to track products outside of the store and into the consumer's home. Another worry is the fear that the radio frequencies may be harmful to human health. High initial costs for investments of the receivers, low numbers of manufacturers willing to implant the tags, and intensive consumer resistance have kept many companies from implementing the system. In addition, problems with hardware complicate a smooth and rapid implementation. Future improvements may result in more collection of data from this source.

Production

Production data and test data may also be collected from the product at each step in the FTAR process. **Production data** include information about the production processes such as plant location, delivery dates, and operators (see Figure 7.3). Textile and sewn product **test data** come from laboratory tests performed on the fiber, the fabric, or the sewn product. The input from these data sources can follow a product from the fiber source to retail store. At the beginning of the production process, a bar code identifying a bale of cotton can be read by a scanner as the cotton is unloaded onto the factory floor for processing. The bar code may contain information about where the cotton was grown, who was the farmer, what futures market was used for selling the cotton, and price of the sale. The bar code will initiate or be fed into a database to hold information about this product. When the fibers are processed and the cotton yarn is ready for shipping to the fabric producer, this information can be joined by information about the sale of the finished yarn to the fabric producer.

Characteristics about the yarn that were identified in laboratory tests, the price of the sale, the plant used in producing the yarn, and the destination of the yarn are data pieces that may be added to the database being built about this cotton. At this point, the producer may already know the season, coloration, product line, and other downstream information about the product for which the cotton is destined. As the cotton becomes a fabric, it is colored, finished and inspected (see Figure 7.5). Additional identifying information about the finished fabric is added to the database linked to the bar code that is now on the roll of fabric. In addition, laboratory tests may have been performed on the fabric, and these test results also become part of the database. The roll of fabric is now shipped to a cut-and-sew plant that will make the apparel product. Specifications and the standards for measures within the specs can also be appended to the data about this product, including data on sizes, fit, and packaging of the finished product. The database continues to grow with information such as the additions of the location of the cut-and-sew plant, the delivery date for shipping the final product, and the retail customer. When the boxed products are shipped to the retailer, the bar code will now reveal shipping dates, lot numbers, plant location, and distribution information for the retailer.

Figure 7.5
Fabric inspection frame.
(Courtesy of College of Textiles, North Carolina State University)

Account

Information or data may also be gathered by account executives or sales repre-
sentatives. The account execs keep track of traditional **account data,** such as
customer purchases in numbers of SKUs and product classifications, and style
and color assortments (see Figure 7.3). These personnel collect information
about both the customer and the product. Account execs from fiber producers,
fabric producers, and apparel product manufacturers work with customers, so
that between each supplier and customer pair there are meetings with account
reps and the customers. In their work for a fiber, fabric, or apparel company, they
may have information about both their immediate customer and the final con-
sumer. Customer data may already be part of the company's database from a
buyer's order or from shipping and delivery information. In a digitally integrated
company, the data will not be redundant but will be kept in one major system
and accessed as appropriate by various users. In addition to more traditional
account data, account reps also have access to vital qualitative information.
They talk frequently with customers, hear customer complaints, receive happy
e-mails when products are selling quickly, get frantic phone calls for reorders
when products are selling too quickly, or receive suggestions for product improve-
ments for future deliveries. These reps hear information about what colors are

selling first, which styles seem most popular, and whether products are missing from assortments. This data is an excellent source for what is not selling and what the customer wishes they had that is not in the product offerings. These comments from customers should be "captured" and made available to merchandisers, designers, and the product development team who are planning the next season's assortments. Many companies have informal ways of sharing this information—random e-mails, a chat at the coffee station, or a phone call when the situation is negative. Other companies hold scheduled meetings to share and discuss the impacts of this data on both their company and their customer's company. However, computer software is available to handle qualitative data and should be used so that this valuable information is not lost.

Product

Retail marketers (retail merchandisers) for either the retailer or the apparel manufacturer collect an abundance of data while they work directly on the retail sales floor. These employees can track sell-thru to the SKU level, calculate sales per square feet, and informally chat with both retail personnel (i.e., buyers, sales associates, department managers) and the retailer's customer, the target consumer. In addition, the data from **consumer complaints** and **consumer returns** can be collected and analyzed (see Figure 7.6). Many times consumer complaints and returns are the *first alert* that there is a problem with a product

Complaint Log

Date	Style Number	Consumer Complaint at the Time of Return
01/03	2211	The red color faded when it was washed.
01/05	2211	The color was bright and then it turned dull after I washed it.
01/05	2215	This was a size 10 and after it was washed it was about a size 00.
01/10	2211	This thing turned all of my other clothes red when I washed it.
01/11	2211	I wore this one day and the red color rubbed off on my new white pants.
01/15	2215	I washed this and it no longer fits.
01/18	2211	When I washed this it turned the water red and everything in the load was ruined.

Data from Log

Style Number	Complaint Code	Tally
2211	Fading	4
2211	Crocking	1
2215	Shrinkage	2

Figure 7.6
Sample consumer complaint log for January with results from data analysis.

or a promotion. E-mails, phone calls, letters, and actual returned products can be analyzed, with trends tracked over a period of time, not only to assist the product merchandiser and retail buyer in evaluating their vendors but also in finding ways to meet the value-added expectations of the target consumer. Product manufacturers will track returns from their retail customers. These may be products from consumers that are passed through to the vendor or they may be products that the buyer or merchandiser sees at the loading dock and refuses to allow the shipment to be placed on the sales floor.

Additionally, these market researchers conduct **competitive analysis** and then report this information to their management at the apparel manufacturer. They review what products are carried by competing retailers. They then identify what missing product classifications are needed in the line; what silhouettes, colors, patterns, and sizes are selling better by the competition; and at what price points the target consumer is purchasing more units. The retail marketer (retail merchandiser) is the connection between the retail store and the apparel manufacturer. Gathering data from the retail store and relaying it to the apparel manufacturer, these employees are a vital link to analyzing, understanding, and evaluating the data to the benefit of both the retailer and the manufacturer, and ultimately to the consumer. This relationship may also exist between a fabric firm and an apparel manufacturer, where an employee of the fabric producer may maintain an office in the apparel manufacturer's production facility or design area in order to link the fabric production more closely to the apparel or home fashions production.

Consumer

The Marketing Division in any FTAR company, as well as the account reps and merchandisers, will be compiling information on both consumers and products. Consumer data will be of two types: target consumer data and new consumer data. Collected by the Marketing Division, **target consumer data** includes all there is to know about the company's target consumer. For fiber, fabric, and apparel companies, the target consumer data may be joined with **target customer data.** Each company in the FTAR Supply Chain needs to know about its customers or trading partners and about the final consumer. For example, a fabric company can benefit in its product development and customer services by knowing about the apparel company that will cut and sew the fabric, the retail store that will sell the product, and the final consumer who will purchase the product for his or her use. Target consumer data includes information needed for segmentation, as discussed in Chapter 9. This includes ages, gender, spending patterns, lifestyle choices, and patronage behaviors. The marketing personnel will also investigate what products, which product features, and what prices are appealing to the consumer. The profile of the customer is developed from extensive data gathered over time about the current customers of a company. This information is used by merchandisers in planning all the implementation of the marketing plan for improved sales. These data are gathered from marketing consulting firms, trade associations, consumer panel groups, house charge

cards, corporate charge cards, and store records. The marketing personnel will also gather information from sales promotional events that require participant registration. In addition, information about the general categories of consumers represented by the company's customers can be obtained from the Internet, trade organization, news media, and paid consultants.

The Marketing Division is also responsible for research and data collection about potential new customers. When seeking to expand to new market segments and to sell more products, companies have their marketing research personnel gather data about potential new customers resulting in **new consumer data.** Each company in the FTAR Supply Chain is interested in new consumers, and many companies are also interested in possible new customers (e.g., apparel manufacturers for a fabric producer) to help bring that product into a reality and into the stores for that consumer. The retailer would focus on the final consumer, but companies in other upstream levels would be interested both in potential new consumers and potential new customers. This data would be gathered from doing research with consumer panel groups, hiring marketing consultants to search for consumer information, and gleaning information from the multitude of resources offered on the Internet and in print form about today's consumers. This type of environmental scanning is discussed in Chapter 8.

The Marketing Division has as another responsibility the collection of product data. For marketing employees, product data are usually information about new products. **New product data** or ideas can be gathered by marketing employees doing research on cultural, technological, economic, and other societal changes. Information from the environmental scan, done as part of the strategic plan, will cover all aspects of the business world and the fashion world, and it can be used to inspire the design team for new products. Although gathering new product data may be a responsibility for marketing personnel, information and ideas about potential new products are gathered by almost everyone in a company. Account execs may also hear comments from customers that can become new product data. For example, when account execs hear over and over that customers wish a product had X or wish the current product did Y, they can bring this new information back to their company's marketing department. Ideas that merchandisers or buyers obtain when attending trade shows, shopping the competition, or traveling to other countries can be collated into new product data. Designers and the product development team are also collecting data for ideas about new products. Pictures, products both in similar classifications and very different classifications, news articles, and other qualitative data can be used as inspiration for new products. New product data can also be quantitative data, including numbers of requests for specific product features, the amount of stock outs for product SKUs, and the count of products that did not sell well or were often returned. Analyzing what did not sell can be a key to understanding what will sell.

In addition, consumer data may also be purchased from companies that provide **syndicated research data** or **panel research data.** This type of data is collected via mail, telephone, or Internet from a nationally representative sample of consumers. Consulting firms and other organizations maintain these panels to collect consumer data on many types of products. Participating families

share all of their consumer purchase information with these firms. For example, The NPD Group, Inc., a New York consulting firm, is noted for collecting a vast amount of data on manufacturing, retailing, and marketing and preparing very insightful and useful reports (see Figure 7.7). Marshall Cohen, Chief Industry Analyst of apparel and footwear for the company, is noted for sharing his

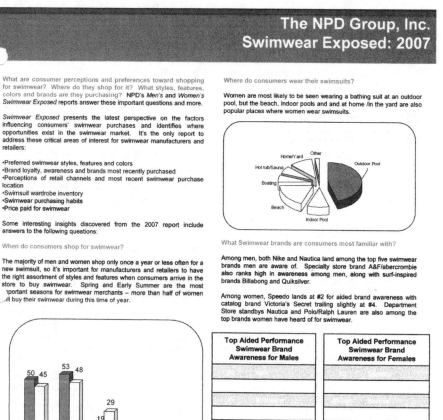

Figure 7.7
Research report on swimwear product classification.
(Courtesy of The NPD Group, Inc.)

expertise on major television shows and in articles in consumer magazines and business journals. All merchandisers in the FTAR Supply Chain must use research data to be successful in carrying out their job responsibilities. Consumer research, product testing, market analysis, and competitive analysis data assist merchandisers in determining market size, market composition, advisable pricing patterns, sales potential, profit possibilities, life expectancy of the product, and specific selling techniques. This data also help the merchandiser in solidifying line positioning, in carrying out product development and line development activities, and in planning and forecasting lines and developing marketing communications.

Methods for Conducting Merchandising-Related Research

A number of research methods or techniques are used for **data collection.** Some of these methods, such as consumer panels, focus groups, and mall intercepts, are used by any marketing groups collecting consumer-related data. Other techniques are unique to the preparation and sale of the apparel product. These include wear testing, fastrack or floor set, and quick test, explained in the following sections.

Consumer Panels

Some companies ask their loyal customers to meet periodically throughout the year to discuss topics such as product issues, lifestyle demands, and other pressing issues that the company wishes to research. These customers are usually selected from target cities across the country where the company's major retail clients are located and where the product and brand has high brand recognition. This group of consumers forms the **consumer panel** for the company. During these panel discussions, the researcher attempts to understand why the consumer purchases the product, and then uses the information to make minor product changes, to identify future opportunities, or to position the product in the seasonal line.

Focus Groups

Focus groups are groups of customers who may meet only once to answer specific questions or provide detailed information concerning an immediate problem or question. Focus groups give the researcher insight on the consumer's brand perception, purchase and usage behavior, consumer attitudes, and lifestyle activities. Focus groups are also used to determine (1) the amount of marketing support needed by the company to communicate with the target consumer, (2) the types and numbers of opportunities that a particular product category might contribute to the merchandise mix of the seasonal line, and (3) how to position the product to maintain or gain market share for that product classification.

Mall Intercepts

To initiate research with a **mall intercept,** the researcher approaches a customer in the mall and asks the customer to complete a questionnaire or participate in an interview about a particular product, brand, or even the retail store. Usually the customer receives an incentive for participation, such as a gift certificate for product or some unusual gift developed by the company conducting research. Mall intercepts can be conducted using a questionnaire, which asks the customer to assist in solving a problem concerning the product or the marketing of the product. Mall intercepts are useful in obtaining opinions from typical customers.

Wear Testing

Wear tests are utilized to collect information about the durability, wearability or comfort, care, and quality of the product. After wearing and laundering or dry cleaning the product, the participating consumer answers a questionnaire regarding the fit of the garment, the appearance of the item, and the durability of the construction and design details. Also, based on the wear test, consumers are usually asked about their intent to purchase the garment in the future. After the garment is returned to the manufacturer for lab testing, the consumer is usually provided with a similar product or the actual wear-test product on which the research was conducted.

When testing of garments could be dangerous to humans, the tests can be performed on a life-sized manikin. For example, Pyroman was invented at North Carolina State University's College of Textiles, Textile Protection and Comfort Center (T-PACC) to test protective clothing materials and garments under flash fire conditions in a controlled, fire-resistant room (see Figure 7.8a). Pyroman has 122 individual heat sensors that send information to a computer (Pyroman, 2008). This testing is valuable for race car drivers, firefighters, and emergency responder personnel (see Figure 7.8b). Equipment for simulated wear testing is available at other university research centers and at independent testing laboratories and can provide needed data for merchandiser's market research.

Fastrack or Floor Set

Traditionally, the **fastrack** or **floor set** was a test often used by companies that were selling trendy fashion products. Today, because of the speed to market demand by the target consumer, many companies are not using this technique for research as often as in the past. However, these tests are excellent for determining, in advance of the season, the best styles, colors, and sizes in a particular product classification. For example, during the line development process and before shipping the seasonal product line to the retail client, manufacturers select six to ten major retail client locations representative of regions and distributions across their sales territory, to merchandise new product offerings in all colorways and in all size ranges. Then from point-of-sales information,

(a)

(b)

Figure 7.8
Textile Protection and Comfort Center (T-PACC) (a) and (b) Pyroman in test chamber.
(Courtesy of College of Textiles, North Carolina State University, (a) and © Roger W. Winstead,
Photographer, North Carolina State University. (b))

both the manufacturer and retailer can determine the best selling styles, colorways, and sizes of the product offering. Therefore, by tracking the in-store sell-thru and the "real-life" consumer responses, both the manufacturer and retailer can adjust their merchandise assortments to match the demands of the target consumer. Early placement in key retail doors helps the manufacturer determine the potential demand for product and also provides a measurement of consumer acceptance for the product fit, price, and the consumer's intent to purchase. Traditionally, The Limited Inc. has been highly recognized for its expertise in using floorsets to provide the right product in the right style, color, and size for its target consumer.

Quick Test

A **quick test** is a version of the mall intercept. However, it is used to gather information on appearance and hand, but not on fit and price of the product. Many companies target approximately four major retail clients and interview

in-store from 100 to 125 target consumers in a four- to six-hour period. Consumer feedback from these tests is used to assist in forecasting of product and determining the need for fastrack testing.

Handling Fashion-Related Data

Handling data about fashion products can be an awesome task for **information technology (IT) managers** because of the complexity of the fashion product, the number of users, the frequency of change, the variety of data types, the number of persons inputting data, and the high value of the data. Often, FTAR companies employ IT personnel to handle the data that is used within the firm. These employees are highly skilled computer personnel who understand about bar codes, data bases, standards for data sharing, and data storage systems. The IT personnel may be a separate support function beyond the basic functions in FTAR companies or they may be organizationally situated within one of the traditional functions. Frequently for some companies the IT function is within the Operations Division, such as Customer Services for raw materials producers. This location is usually an outgrowth of the place where most data resides or comes into the company. In contrast, some companies contract with consultants or other suppliers for someone to handle the IT functions of the company. Although data management may be the task of in-house departments, some companies outsource these tasks to firms that specialize in computer security and storage.

Apparel and home fashion products may seem to be common household items to most consumers, but they are complex in how they are produced, and in the myriad of physical characteristics and performance capabilities that can be developed. Apparel and home fashion products have many, many characteristics that a buyer or merchandiser might like to track. For example, for one product, the merchandiser will want to capture color, style, size, fabrication, brand, price, season, store location, and placement in the store. In addition, other personnel in the company may want to track shipping dates, billing amounts and deadlines, test data, complaints, and other account information. Merchandisers may request information about the consumer who buys the product and the companion products purchased with this product. Hundreds of pieces of data may need to be known and stored about one product. This complexity of product results in large volumes of data. The specificity of the data that can be retained is often a function of how much information can be packed into a bar code and how much computer storage space is allocated for the data. Many of the commonly used bar code formats and database systems are not large enough to handle the amount of data needed at the SKU level. Specialized industry or company-specific codes, scanners, and software may be developed into exclusive systems for companies and their trading partners. Walmart, Federated Department Stores (Macy's Inc.), and JCPenney organizations are known for developing unique computer systems for their individual retail operations.

In addition, VF Corporation is well known in the FTAR Supply Chain for its complex and sophisticated computer system. This system was implemented as part of their Market Response System (MRS). The MRS included an automatic

inventory management system and was developed as part of a corporate reengineering effort to handle the volume of data from the multiple divisions acquired through their brand development effort. The MRS system gathered POS information from retail stores to share with VF's designers, fabric buyers, and manufacturers (Kolodziej, 1995). Market research is so important to VF that they have an entire building for their data information facilities.

Value of the Data

Data carefully collected by merchandisers and marketers are valuable to the success of the company. For example, information about a finish of a high-performance fiber or the skew amount and direction of a bias cut pattern may be the key to product differentiation and the reason that consumers demand that product. Levi and its associated denim suppliers have long guarded the secret of their denim fabrication for making the fit and durability of their jeans to the exact expectations of their customers. Although a company might, with strict and exclusive agreements, share this information with customers and suppliers, the company would not want this information made available to its competitors.

Companies spend thousands and sometimes millions of dollars on marketing research to understand their customers. This knowledge allows the company to target consumer segments with highly differentiated products. The implementation of this knowledge is often the key to the profitability of the company. Data that provide information about a firm's product and its customers are very valuable and must be protected. Regardless of who collects, maintains, or uses the data, data security is extremely important to all participating users. Such information must be strictly guarded. Passwords, firewalls, encryption and other protection devices, and rigidly adhered to computer protocol must be used to maintain limited but ready access to the database. In addition, extensive backup systems must be used constantly to ensure the data are not lost. Companies that become dependent on data and its analysis for planning and control must take steps to ensure the data are always there. This may include daily, hourly, or more frequent backups of the data and storage of these backups in multiple locations. Audit trails are also important aspects of a good database so that accuracy of information is monitored, dependable, and guaranteed.

Quality of the Data

The quality of the data, including the accuracy of the information and the appropriateness of the information, are important considerations when making decisions based on that data. **Data accuracy** indicates that the data is free of human errors, biases, computer programming errors, and other flaws. **Data appropriateness** indicates that the data contain or reveal information that the merchandiser can use to make decisions. An abundance of data can be collected on the sale of a product, but that data may be inadequate in explaining the lack of sale or the potential future sale of a similar product. Extensive calculations

with statistical analysis may be helpful in analyzing the data, but again if the original data have errors or are not applicable to the situation, the findings are not valuable. To ensure the continued value of data, the merchandiser should seek information about the quality of the data used, and if involved in data collection, he or she should seek to remove errors and biases from the data.

Biases and Errors

Biases and errors can enter databases in a number of ways. Data such as the POS data, which start in an electronic form, are easy to store, easy to share, and easy to lose. In general, POS data are considered accurate because human error is not introduced into the data set if the scanners are properly used. With bar codes, humans are not needed to type in codes or dollar amounts when using scanners (see Figure 7.9). However, a sales associate can create errors; for example, he or she scans one item and keys the purchase of three of the same items, instead of separately scanning each of the three items. Although the three items seem to be identical to the sales associate, the stocking date varied across the three items and this information would be available only through the individual bar code. This tracking information is now lost to the merchandiser.

At any point in the collection of data, errors and biases can be introduced into the database. Data keyed into the computer by typing are always open to human error. People transpose numbers, hit the wrong keys, take shortcuts, and misread handwriting when doing data entry. Biases can be introduced into survey data when the survey is created. Biases can also be introduced into qualitative data through the interpretation of the data. When words or pictures are transformed into numbers for computer entry, the interpretation may be inaccurate or misleading. People working with data must report exactly what they see, not what they wish they knew about a situation. For example, a customer reports the reason for a return is that the color ran. The sales associate

Figure 7.9
Bar codes can be used to input data for accuracy.

who took the information or data entry clerk who enters the information in the computer must decide if "running" is the same as fading because fading is the only color failure in the choice of reasons. Personnel trained in textiles and dyeing know that fading and running are not the same, and the best choice is "other" with an explanation, but the personnel handling the data entry may not know this product-specific information.

Data Applicability

POS data or any other data are also only valuable or considered to be quality data when the data are applicable to the situation. As noted, the information from POS data may depend on the bar codes and software used. If the level of detail does not contain the information desired by the merchandiser, the data are not helpful, regardless of how many products are sold and scanned. Merchandisers should work closely with marketing and IT personnel to ensure that the data collected contain information that will be useful. In addition, much of the data that are collected reflect the situation and the times in which the data are collected. Sales data reveal what sold but provide no information about what did not sell. Current sales may give some hints about future sales, but their most valuable input is about current sales not about future sales. Information from focus groups provides some insights into consumer behavior, but comments made in a corporate board room with sample products do not duplicate the actions of consumers in the store. Marketing data help in decisions about products, but merchandisers should not depend on past data and consumer panel data to be 100% accurate in predicting the future sales of products, either current or new products.

To ensure **data availability** of quality data, the marketing personnel, employees in IT, and merchandisers should work together to plan the development, maintenance, and life expectancy of any database. Good research habits are necessary for quality data. Decisions about the use and purpose of the data should be made before collecting any data, and decisions about the storage, access, and protection of the data should also be determined. After data are corrupted or lost, it is too late for deciding how to secure the database. As the old saying goes, that is closing the barn door after the horse is out.

Data freshness is also important. In the fashion world, popular styles, favorite colors, and consumer preferences are constantly changing. Merchandisers must be always collecting and analyzing data. Before the work on one season is completed, the merchandiser must be collecting data that will help him or her with the coming seasons. To ensure that fresh usable data are always available, the merchandiser must be on the constant lookout for information. Every trip, each walk through a store, a newspaper to read, a movie that is watched, or an item on a newscast could be a key to the next big fashion change. Merchandisers must be vigilant. This constant need to collect data also means the merchandiser must develop some system of note keeping that is neat, organized, and usable. Merchandisers take notes when they attend forecasting seminars, trade shows, and other market research resources (see Figure 7.10).

Figure 7.10
Page of handwritten notes from a buyer.

Data Instrumentation and Collection

When the basic parameters of the data are determined, the merchandiser or marketer can develop the instruments needed to collect the data and determine the exact techniques or methods used to collect the data. Data collection methods must be selected that fit the product, the retailer, the company, and the

research questions. The right data collection tools collect the right type of market research data. Data collection tools are best created by personnel who know the product and the customers, understand the purpose of the data, and have the research skills for quality data collection. These tools should be pilot tested and refined prior to putting into use. Once the instrument is used in a situation, the data collection moment has passed and will not return. If the bar code does not contain the information needed about a consumer purchase, the merchandiser cannot ask the consumer to return to the store and shop again. For example, the merchandiser decides after seeing the most recent POS data that he or she would like to know what pants were purchased when certain shirts were purchased. If companion purchases are not noted when the sales are scanned, the opportunity to know that information is lost.

People collecting data usually get only one chance at capturing data for any single transaction. In another example, the merchandiser at the end of a season realizes that when walking on the floor of one store that suits with gold buttons remain on the rack and all other suits are sold. If the merchandiser wishes to explore the sale of suits according to trim (i.e., buttons), this is not feasible if the information has not been recorded about the product. Knowing which products were made in which manufacturing plants might be important if some products are returned for seam failures, but if only the manufacturer, and not the exact plant location, is recorded, this investigation is probably not possible. Some of this information will have to be made available through partnership with suppliers. Merchandisers should keep careful notes on what they want from databases and changes they would like to make in previous data collection processes so they have reliable information to use when discussing this with their suppliers and marketing researchers.

Data and Technology

When merchandisers are making decisions about types of data and methods of data collection, they should also consider the technology needed to collect and store the data they need. These decisions may be made independently by IT personnel but, if asked or in the absence of IT specialists, merchandisers should have input about these issues. Bar codes and software for data collection and storage may be created for company-specific use or may be purchased from outside vendors. Selection of the technologies used for data collection, storage, and analysis are particularly important if the data will be shared among trading partners.

Most companies use some form of **electronic data interchange (EDI)** when conducting their business and accessing data. Several variations of EDI are on the market. The most common type used by U.S. companies is the ANSI X-12; however, UN/EDIFACT is the type more frequently found in use by European countries ("Good ol' EDI," 1999). The EDI standards currently available represent general processes of business-to-business data exchanges across open Internet exchanges. Some companies may wish to have specialized closed or private business-to-business exchanges and must select hardware and

Figure 7.11
Companies must make major investments in computer equipment for market research.

software that will be workable for their business partners (Sweet, 1999). Companies must make large financial investments when they select and implement electronic tools for data collection and storage (see Figure 7.11). They need to be sure they select the equipment and software that will help them link with a current trading partner and potential new partners. In the fashion business, this year's trading partners may not be the vendors and customers of choice in the future. In addition, when companies are trading with firms around the world, they must consider questions of operating systems, language capability, linkages to partners, and growth potential.

Ownership and Management of Data in a Consumer-Centric Partnership

Quality customer and product data are almost priceless. With this valuable commodity, the ownership and management must be clearly identified. Who owns the data, who has access to the data, and where data are stored are all questions that must be answered in this technology and data-dependent business world.

Data can be stored or reside in several locations. Some companies use **in-house hosting** of data; in other words, computers housing the data and

software to manage the data are owned by and located on corporate facilities (Turetsky, 2005). When this happens the company must purchase software licenses and hardware to support all the activities needed for use of the data. Any updates, service needs, or other computer changes are the responsibility of the owning company. Other firms choose to outsource the housing of data and use **vendor hosting,** where the vendor of the software and/or hardware houses and maintains the database. Other alternatives including hosting by a third party are possible options for housing databases. Decisions on housing data must take into consideration issues of cost—both initial investments and long-term costs, control of the data, access and availability of the data for queries, and security. Regulatory requirements should also be considered both within the country for the hosting company and in any countries for trading partners.

Sharing data and the access to the data are other aspects of data ownership and management that must be determined. In an open partnership, data entered at the beginning of the process will remain with the product from the bar code identification of the fiber and fabric, through cut-and-sew operations, until the finished product reaches its final destination in the shopping cart of a consumer. Plant managers will be accessing some of the data shared by the fabric producer when making decisions about equipment adjustments to be made on the sewing floor. Also, they will be entering data such as results of tests on the product, numbers of units sewn on specific days, and final inspection dimensions and other inspections. Account execs from the fiber and fabric producer, the apparel manufacturer, and the retailer will be accessing the data to check on delivery dates, costing information, availability of product and scheduling of production, plus other information to check specifications. The retailer buyer or merchandiser may have access to all of this information and can observe the product as it develops from a bale of raw cotton, through weaving of the denim, to the sewing and shipping of a finished pair of jeans. The data become a history of the development and life of the product and become a tool for the sale of that product.

Use of the Data

Data can be used for a variety of purposes within the FTAR Complex. Data are important in making evaluations of the past and in planning for the future. Rewards and acknowledgments of past or current jobs well done and decisions about future products, consumers, and vendors can be improved when made using quality data.

Profitability and Rewards

Data supply information about profitability that enable managers to give rewards when goals are met or exceeded. In strategic planning and in the business plans that follow, goals are set for a variety of merchandising actions. For example, sales goals are set for the amount of product, measured by dollars or SKUs, which should be sold within a season, a month, or a day. POS data can

enable the manager to verify sales. With the right computer software, managers can quickly determine top sales associates, products that are performing at or above expectations, and deliveries that are on time and full volume. In addition, underperforming units can also be identified. In many FTAR companies, employee pay is tied often to his or her individual performance as measured through sales or productivity goals and to the performance of his or her department, division, product line, or team. In planning for the upcoming season, the manager and employee set performance goals, such as the amount of sales to make in a period or the increase in sales expected for the coming period. With POS data or other sales data, the manager and employee can review the period and determine the employee's performance. An employee that meets his or her individual sales goals will help the company meet its sales goals. Bonuses can be made based on performance goals and data to support the action of each employee.

Product Planning

Product planning is another task that depends on the availability and analysis of data. Data collected on past sales volume, the quantity of SKUs for a product classification, or the quantity of yardage of a particular fabrication sold are analyzed and evaluated. Through the interpretation of this analysis, the data become the basis for the next season's sales goals, production schedules, and raw materials purchases. Major decisions about the company's future may also depend on the data collected and used by the company. As one cycle of strategic planning ends with analysis and evaluation, the next cycle begins with assessments of the company's strength and weaknesses and a thorough review of the critical issues within the internal and external environments for the company. Quality data are at the heart of these planning steps.

Data mining is a tool that companies in the FTAR Complex use to analyze, evaluate, and plan for future business decisions. **Data mining** analyzes databases of information to provide support and direction for decision making (Anderson & Kotsiopolis, 2002). The analysis uses extensive statistical and mathematical calculations with the assistance of computer software to search for relationships among the data pieces (see Figure 7.12). The decision tree in Figure 7.12 was developed using chi-square automatic interaction detector (CHAID). With large and rich databases, merchandisers can use these techniques to identify consumer segments and profile the behaviors of these consumers. Data mining can also be used to forecast future purchases of consumers based on extensive information about past purchases. In planning for summer seasons, particularly in the southern region of the United States, Walmart has used data mining to examine the purchases of consumers before, during, and after hurricanes to improve their allocation of products to stores ("Private FEMA," 2005). With this technique as well as other data uses, the merchandiser must always employ common sense and good merchandising judgment in addition to using results from data analysis. Fashion is difficult to predict and always changing, and consumers are changing today more than any previous time.

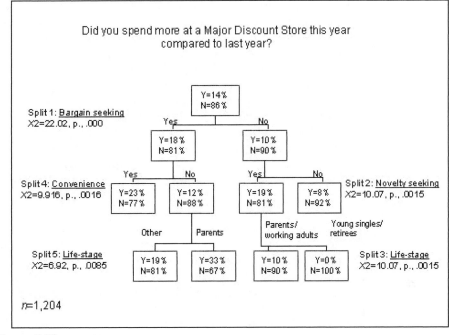

Figure 7.12
Data mining with advanced statistics can provide a retailer with in-depth target consumer information.
(Courtesy of Marguerite Moore, College of Textiles, North Carolina State University, and Jason Carpenter, College of Hospitality, Retail and Sport Management, University of South Carolina)

Evaluation of Vendors

One use of data is to evaluate the performance of vendors. Companies should determine what vendors provided them with the best service and assisted them to meet their sales goals. Retail buyers routinely do vendor evaluations as they prepare for market trips. In addition to evaluating past performances, data are used to make decisions about the future use of vendors.

Vendor evaluation is similar to the vendor analysis the merchandiser should do to select the vendor or supplier (see Chapter 13). If the merchandiser has a certification program in place for selecting vendors, then the evaluation procedure will follow a check against this benchmark. However, the vendor selection may or may not be formalized, requiring a more elaborate evaluation procedure. This procedure is not to be viewed as adversarial. Good vendor partnerships are the result of clear communication and hard working people with talent, who have spent time developing and earning trust. When vendors know that merchandisers will evaluate their performance, they tend to improve the performance of their company and try to prevent problems.

Numerous criteria may be used to evaluate vendors, but six general categories cover most of the common vendor activities: design, delivery, flexibility, cost, quality, and reliability (Teng & Jaramillo, 2005; Todaro, 2005a). These six or more criteria can be culled into three key areas for vendor evaluation: collaborate, communicate, and discipline (Todaro, 2005a). To collaborate with your vendors means they are working with you to design the products you need. This often includes using the same technologies and being flexible in some aspects of the design or the delivery of the product. In addition, the vendor must be flexible to allow for changes as dictated by the consumer and the retailer. These retailer's customers are the final consumers and the ones driving the decisions on style, color, and quantity. Communication is so important in partnerships with vendors. This criterion implies that a company will agree with the vendor on costs and other financial issues and will be upfront on the completion and shipping of the products. Finally, discipline for the vendor includes measures of quality, reliability, and compliance. The vendor must deliver the product expected on time and in complete volume, as ordered. In addition, companies and their customers are now concerned about the performance of the vendor relative to human rights, environmental issues, and other social compliance.

When selecting evaluation criteria, companies must decide what is most important to them (see Table 7.3). Some companies want only to know the financial outcomes. Did products from the vendor help us sell our products? Or how much did it cost? Was it the cheapest source? Whereas other companies may be interested in the operational performance issues of on-time delivery, product quality, lead times, and inventory turns (Gordon, 2005). Business processes and practices may also be important and can include the answers to questions such as how the vendor runs its business, what did the vendor do to improve product value, and what did the vendor require of the customer.

Table 7.3
Vendor criteria chart.

Vendor Criteria	Vendor A	Vendor B	Vendor C
On-time delivery	100%	One late shipment	All shipments late
Sell-thru	85%	65%	50%
Margin	45.6%	42.5%	32.0%
Returns	No returns	One out of ten returned	Five out of ten returned
Shipment completion	100%	95%	79%
Markdowns	Standard rate	Needed extra for the one late shipment	Had to mark down over 62% of the items
Consumer appropriate	Basic goods well accepted; a few fashion items were not well received	Fashion items were ok but did not sell as well as planned	Terrific looks and in demand but not in the store on time

Regardless of the criteria selected, the company should send a performance report to the vendor. Vendors need feedback on their performance, and a two-way flow of information is very important (Gordon, 2005). In addition, the company must develop an evaluation measure that is robust or one that will gather lots of useful information for the merchandiser. Third-party standards such as those from ISO can be used if the merchandiser needs assistance in developing an evaluation instrument. Finally, to ensure the data are useful, fresh, and applicable, the merchandiser will want a reliable data collection process about vendor performance.

The purpose of vendor evaluations is not to punish bad vendors but to help companies build strong vendor relationships that lead to collaboration, sharing of information, and planning. Companies must work closely with their vendors to build the relationship. Buying from a vendor can be more than a procurement and purchasing deal; it can be a partnership that results in the right products at the right time and for the right price for the company and for their customers (Todaro, 2005b).

Summary

Analysis and evaluation are key steps in initiating good planning. Strategic planning and many decisions throughout the product life cycle require analysis of data. Data must be collected well, analyzed carefully, and guarded securely. The work of many people within a company is necessary for the merchandiser to have sufficient data to make important decisions.

Key Terms

Account data
Biases
Competitive analysis
Consumer complaints
Consumer panel
Consumer returns
Data
Data accuracy
Data appropriateness
Data availability
Data collection
Data mining
Electronic data interchange (EDI)
Fastrack
Floor set

Focus groups
Information Technology (IT) managers
In-house hosting
Mall intercept
Market research
New consumer data
New product data
Number of units
Panel research data
Point-of-sale (POS) systems
POS data
Primary data
Production data
Qualitative data
Qualitative research

Quantitative data
Quantitative research
Quick test
Radio frequency identification data (RFID data)
Random selection
Ratios
RFID tags
Scanner data
Secondary data
Syndicated research data
Target consumer data
Target customer data
Test data
Vendor hosting
Wear test

Review Questions

1. Why is market research so important to a FTAR company?
2. How does qualitative research differ from quantitative research?
3. When should a merchandiser use qualitative research and why?
4. What is production data?
5. How is POS data different from account data?
6. Why is data safety important to an FTAR company?
7. Who should manage the data and why?
8. What can data mining do to help a merchandiser?
9. Why is bar coding useful in having accurate data?
10. How and when does the merchandiser use data in making decisions throughout the merchandising process?

References

Anderson, J., & Kotsiopolis, A. (2002). Enhanced decision making using data mining: Application for retailers. *Journal of Textile and Apparel, Technology and Management, 2*(3), 1–14. Retrieved June 30, 2006, from www.jtatm.ncsu

Des Marteau, K., & Speer, J. (2004). Entering the third dimension. *Apparel Magazine, 45*(5), 28–34.

Dillard's RFID. (2008). *Dillard's*. Retrieved May 29, 2008, from www.dillards.com/info/fridInfo.jsp

Feder, B. J. (2005, June 14). I.B.M. expands efforts to promote radio tags to track goods. *New York Times*. Retrieved June 14, 2005, from www.nytimes.com

Good ol' EDI. (1999, July 26). *Infoworld. www.infoworld.com—E-commerce Special Report Part One, p. E4.*

Gordon, S. (2005, August). Seven steps to measure supplier performance. *Quality Progress*, pp. 20–25.

Kolodziej, S. (1995, February 27). Stocking the data warehouse. *Network World, 12*(9), S44.

Millstein, M. (2005, February 15). Big picture spend trend. *Women's Wear Daily*, Section II, pp. 8–15.

Private FEMA. (2005, September 8). *Wall Street Journal* (Eastern edition), p. A18. Retrieved September 8, 2005, from www.wsj.com

Pyroman. (2008). *Textile Protection and Comfort Center*. Retrieved May 29, 2008, from www.tx.ncsu.edu/tpacc/protection/pyroman.html

RFID: It's here to stay. (2003, August 1). *Apparel Magazine*. Retrieved August 1, 2003, from www.apparelmag.com

Surowiecki, J. (2004). *The wisdom of crowds: Why the many are smarter than the few and how collective wisdom shapes business, economies, societies and nations*. New York: Doubleday.

Sweet, L. L. (1999, July 26). Giving them the business. *Infoworld. www.infoworld.com—E-commerce Special Report Part One,* pp. E1–E3.

Teng, S. G., & Jaramillo, H. (2005). A model for evaluation and selection of suppliers in global textile and apparel supply chains. *International Journal of Physical Distribution & Logistics Management, 35*(7), 503–523.

Todaro, M. (2005a, July). Sourcing criteria. A presentation as part of *Summit: CAFTA* meeting. San Salvador, El Salvador. American Apparel Producers Network.

Todaro, M. (2005b, March). *Vendor relationships. AAPN Sourcing Executive Roundtable.* American Apparel Producers Network.

Turetsky, L. (2005). Models for application delivery. *QuestaWeb, Inc.* Retrieved June 1, 2005, from www.questaweb.com

chapter
8

Scanning of the Environments

Objectives

After completing this chapter, the student will be able to

- Identify the various components of the environment that are to be scanned for market research
- Define an environmental scan
- Itemize the types of characteristics to observe for sociological forces scanning
- Explain the issues related to merchandising and the natural environment
- Discuss how technology affects merchandising decisions
- Identify the indicators used for doing a business environment scan
- Discuss how economic and political trends can affect an FTAR company
- Explain the issues to be investigated in the FTAR environment
- Describe a competitive product analysis

Introduction

Knowing about your customer, your suppliers, and the general market conditions became important weapons in the fight to become and to stay competitive. As a firm positions itself as a consumer-centric company, it needs the best information about the entire market and the customer it is trying to serve. Understanding the environment in which a firm operates becomes a key to its survival. The

environment for a consumer-centric firm includes the macro-environment (actually the whole world and everything in it) and the micro-environment (the activities, players, and changes happening in the FTAR Complex). To foster this understanding throughout the company and with trading partners, merchandisers must work with the Market Research Department or with other planners to facilitate market research.

Gathering information about the macro- and micro-environment or the environmental scan is a process of continually gathering information or conducting research on external events and happenings outside of a business to identify and pinpoint how potential trends might impact the business, its products, and its target consumers. The environmental scan includes a wide variety of activities: (1) market research about the cultural, natural, and technological environments, (2) business market research of the current industry, retail, advertising, and visual merchandising trends in the various channels of distribution that could impact merchandising the line; (3) consumer research to determine what is happening with the target consumer; (4) a competitive product analysis of the major products carried by competing companies and also desired by a firm's target customers; and (5) a fashion trends analysis. Additionally, the manufacturer and retailer must also scan their past performance and current activities to forecast, anticipate, and plan for the future. Macro-environmental trends typically emanate from the cultural environment (sociological and psychological forces), from economic and political factors, from trade and legislative impacts, and from technological and environmental influences as well as globalization of the industry (see Figure 8.1). The micro-environment involves activities, processes, and trends in the FTAR Complex, including changes initiated by vendors, customers, and competitors.

Many forces and trends in one area of the macro-environment are often interrelated to the other aspects of the macro-environment and are filtered into the micro-environment, which are examined in strategic planning (see Chapter 2). The environments surrounding consumers can be hierarchical, holistic, integrated, and coactive (Beach, Kincade, & Schofield-Tomschin, 2005). Doing market research in the FTAR Complex can be very daunting for the merchandiser and requires an amount of market savvy as well as diligent data collection methods (see Chapter 7). The merchandiser must examine all aspects of the macro-environment and then determine what rules, actions, forces, trends, changes, and other factors from the broader environment (see Table 8.1) and what trends in the micro-environment will affect the firm's target consumer. Not every customer will follow the fashion dictates of a well-known singer or a political leader, and not every customer wants something avant-garde or untested. And not every trend will be accepted and followed by every firm. Merchandisers must use their knowledge of the customer and the product to filter, analyze, and otherwise translate these factors to their customer and their product. These population trends impact products produced by the apparel manufacturer, as well as the raw materials created by textile producers and the product choices or the merchandise mix presented by the retailer.

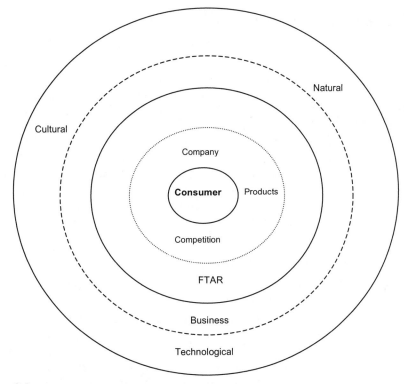

Figure 8.1
Environments surrounding the consumer and an FTAR company.

Table 8.1
Factors within the macro-environments.

Environments	Factors—with Examples
Cultural	• Sociological—age of population, composition of the family, role of an individual in the family • Psychological—values, spiritualism versus materialism
Natural	• Availability of resources—sources, costs • Waste disposal—landfills, postconsumer waste • Pollution—damaging waste, carbon footprint • Weather—temperature averages, rainfall and other precipitation • Sustainable design—product life cycle, resource use
Technological	• Equipment—body scanning, computer-aided design (CAD) • Customer shopping—online shopping, made-for-me, customization • Engineered textiles—antimicrobial fabrics, protective fabrics, high-performance fibers • e-textiles—smart clothes • Business processes—POS, JIT, QR, CAD/CAM, bar codes
Business	• Economic—interest rates, exchange rates, savings rates • Politics—legislation, trade regulations, trade zones, human rights

Cultural Environmental Scan

The cultural environment in which the consumer lives and in which the FTAR businesses operate is multifaceted and constantly changing. This **cultural environment** is an integration of the sociological and psychological forces that affect the daily lives of all consumers. People in the world, living in groups and singly, tend to create norms, standards, habits, and mores that guide their lives and their interactions with each other (Beach et al., 2005). Ideal ways of life are upheld through the cultural environment and become goals for many consumers. Cultural icons such as movie stars, political figures, and television personalities become the focus of media and the discussion of many consumers. Movies, books, government legislation, popular songs, and other written, verbal, and visual articles are part of the cultural environment. All companies and consumers operate within the mélange of this cultural environment.

Sociological Forces

The **sociological forces** that could influence business practices and products selected in the FTAR Supply Chain include many various components. Sociology involves the study of people as they interact with each other in groups—small groups, such as the family, and large groups, such as crowds at a ball game or students in a classroom. Many sociological group structures are formalized (e.g., partnerships in marriage, siblings and parents, sorority sisters); other groups are informal clusters of people (e.g., members of a chat room, a set of friends). These groupings provide structure for an individual and provide forces to influence his or her behavior (Beach et al., 2005). Sociological characteristics and the changing forces interacting in these groups include the current characteristics of a population or target consumers and the shifts in those populations, including geographic locations, racial and ethnic diversities, and the roles of individuals within small groups.

An example of a sociological characteristic that can affect products and FTAR companies is the birthrate and the number of children in each family. In the early 2000s, a global trend in some countries was that of having fewer children per family. This trend was formalized in some countries, such as China, which have legislated that only one child may be born into each family. The natural selection of lifestyle choice and these legislative forces have led to a declining birthrate in many countries and have potential to affect the spending patterns of consumers. These single-child families often spend their incomes very differently than families with multiple children. The single child in a family in China is often called the "little emperor" because he or she has often been the recipient of the parents' total resources (see Figure 8.2). Merchandisers find that children raised in this environment may have excessive spending habits (Kim & Kincade, 2007). Little emperors may be responsible for and the recipient of as much as 66% of the combined incomes of their parents (Cheng, 1993). Young consumers who are used to heavy spending on self are often very fashion conscious and brand oriented. These young, and often considered spoiled,

Figure 8.2
China's one-child policy may affect the spending patterns of parents.
(Courtesy of Cotton Incorporated)

consumers can be major targets for merchandisers who are planning product developments and assortments.

The average **age of a population,** or the age grouping with the largest number of persons, is another sociological characteristic with associated trends that may shape consumer spending. The decline in birthrates and the increased longevity of individuals is causing a continual rise in the average population age, or **graying of the consumer,** in some countries. Because any sociological change affects where and how people spend their money, the increasing medical expenditures of aging Baby Boomers (Paul, 2003) will take monies away from the Boomers' discretionary income for optional products and services, such as new and fashionable apparel.

Merchandisers must be careful to see the complete cultural environment and not focus in the early stages of market research on their own target consumers. A trend in one population segment may be echoed in a different trend in another sociological grouping. The aging population in some countries is in stark contrast to the youth trend in other countries. In India, approximately 50% of the population is younger than 25 years old, and this age group is expected to rise in size through several decades (Chugh, 2006). Most of these young people are educated, seeking higher income jobs, and living in urban areas. Their general

buying habits are sharply different from the purchasing patterns of the U.S. aging Baby Boomers or the young emperors in China. Merchandisers must target their markets very specifically.

Another sociological characteristic is the structure and formation of the established groupings or units in the culture. For many ethnic groupings, the family is the core sociological unit; therefore, the **composition of the family** is a sociological force that can impact the FTAR market. To understand changes in the composition of this sociological unit, the merchandiser must first consider the definition of "what is a family?" In the United States and in many other countries, the traditional family unit contained a father, a mother, and two or three children. In this idealized family, these members lived in a family-owned home with several bedrooms and a yard with a garage and a car (see Figure 8.3a). This idealized family is now only a small portion of the families in the world. The family of the 2000s may consist of a single parent with one or more children; two parents of the same gender with children; a middle-age couple with one or more older parents and teenage children; single individuals sharing a house; or numerous other combinations of several generations or multiple people of one generation.

Various forces, including divorce rates, remarriages, legislation defining marriage, immigration, job relocation, and other sociological mores affect the structure of any sociological unit, including the family unit. The family unit becomes the grouping of people who live in a dwelling, share chores and expenses in caring for and living in that dwelling, and often purchase products for each other or for group use. As societies adjust to the legitimacy of nontraditional family units, products and services must be generated to meet the needs of these units. The purchasing patterns of the individual as well as those for and of the family members become a sociological force that merchandisers must review. Various styles of family units tend to purchase different products, various brands, and varying volumes of products (see Figure 8.3b). Further discussion of the purchasing patterns of individuals and groups is given in Chapter 9.

(a) (b)

Figure 8.3
Various modes of housing (a) single-family dwellings and (b) townhouses.

The **role of an individual within the family unit** is another sociological characteristic that can change. The answers to "who does what" in a family become forces affecting the purchases made by that family. Simple questions of who cooks, who cleans, and who takes out the garbage must be investigated by merchandisers and researchers who want to understand where consumers will spend their money. For example, working women are now common roles for the adult female in a family or in a single-person household. Women who work tend to buy more career clothing and other work-related expenses, and they spend money on prepackaged foods and other household conveniences. This woman may choose to spend money on accessories for a home office instead of accessories for a new fun outfit. Decisions on what products are purchased, where they are purchased, and which payment type is used may now be determined by more than one family member.

Where people live, work, and play is another sociological characteristic that is operating in the cultural environment. Traditionally men went to the office in a city and women stayed at home. Some people lived and worked on farms, and others chose to live in urban apartments or single-family dwellings in suburban neighborhoods. The geographic locations where people live, the types and numbers of houses in which people live, and the locations where people work does affect their spending habits and the products and services they seek. For example, "there are about 14 million Americans telecommuting at least part time in 2004, and an additional 7 million running businesses from home, according to the most recent Labor Department data" (Foss, 2006, p. E1). Home offices, telecommuting, and the evolution of the casual lifestyle greatly impacted the tailored clothing market during the 1990s and the early 2000s. Another trend in affecting this sociological characteristic is the growing number of families with two partners, who pursue dual careers in separate geographic areas. Of these "dual-career couples, who are married but separated most of the time by their jobs, [d]emographers report that there are more than 1 million of them in the United States" (Large, 2006, p. D1). This phenomenon calls for establishing two households, for accumulating additional travel expenses, and for purchasing new technology to maintain contact. In contrast to telecommuting, some people are choosing to live where they work. Mixed-use buildings, especially within downtown areas, are becoming popular again. In such buildings, retail businesses and office spaces occupy the lower floors of a multistoried building, and condos and apartments occupy the upper floors (see Figure 8.4). Workers can live in the same building or they may work in nearby buildings that they access by walking or taking public transportation.

Other sociological characteristics with the potential to change and cause disruptive forces in the cultural environment include but are not limited to the number of immigrants entering or exiting a country; the types of jobs that people seek and find; and the music, entertainment, books, and other cultural communications that people share. The forces generated by the continually changing sociological profile of the world create a global marketplace that must be scanned and understood by the merchandiser. The forces listed in this section are about the people who live in this world and the family groupings and

Figure 8.4
People live where they work with a combination of housing and retail.

other structures that they create as they interact together. These listed are but a snapshot of the possible sociological forces that a market researcher may find when scanning the environment. A constant surveillance of this aspect of the cultural environment is necessary to find new trends and to acknowledge the continuation or dismissal of old trends.

Psychological Forces

Psychological characteristics relate to the mental processes of the individual and the resulting behaviors. Understanding the psychological characteristics of consumers helps the merchandiser know how the individual consumer thinks, feels, and reacts. For example, to create an effective ad, the merchandiser needs to know what motivates the person, what they value, who are their idols or role models, and what processes they use to make decisions.

One of the characteristics that the market researchers and merchandisers should observe when examining psychological forces is the **values** that individuals hold as important. By knowing what things, relationships, people, and other items a consumer believes to be valuable, the marketer can devise advertising and the merchandiser can develop products that will appeal to the consumer. If the consumer places a high value on brand names, then the development of a consistent brand image will be an important part of product development.

Knowing how the consumer thinks can help the merchandiser plan promotional events and design Web pages and floor layouts. The way in which consumers process information is a key to how they will shop, what information

Figure 8.5
Lee National Denim Day® encourages consumers to participate in a charity event
supporting breast cancer research.
(Courtesy of Lee®)

they need as a purchase decision is made, and what product characteristics,
store, or Web decor must be available and what customer service must be in
place for the final decision to be made to buy a product. Additional information
about consumer shopping behaviors is discussed in Chapter 9.

Psychological scanning can include an examination of a consumer's spiritu-
alism versus materialism; their attitudes toward volunteerism, charity, and
other altruistic ventures; and their feelings about their country and their level
of patriotism (see Figure 8.5). Such activities often result in commemorative
T-shirts, hats, or other apparel items. Participants can be recognized by the im-
prints on their apparel. In addition, the merchandiser needs to know how
closely the target consumer adheres to or abides by the standards, norms, and
mores of the sociological groups to which the consumer belongs. "What motivates
a consumer" and "against whom the consumer makes comparisons" for develop-
ing a self-image are important psychological forces shaping the behaviors of a

consumer. Adoption theory, as discussed in Chapter 10, makes application of the psychological and sociological forces that affect how and when a consumer will choose to follow a fashion trend. Again, the various components of the environment as well as components of other environments are interrelated within the behaviors of one consumer.

Researching the Cultural Environment

The cultural environment surrounds everyone so the merchandiser may feel this is an easy environment to scan. Several pitfalls will meet a merchandiser who mistakenly makes this perception. The forces driving the cultural environment for the merchandiser may or may not mirror the forces affecting the target consumer. The merchandiser must always be certain that his or her personal biases are not clouding the market research. In addition, with the complexity of today's societies and the shrinking of the world in terms of communication and travel, the merchandiser must look around the globe for any and all sociological forces that may affect the firm's consumers.

Popular culture as represented in the media is a great source for scanning the cultural environment. Movies, DVDs, television shows, and other recording media show what is new to view for many consumers. In addition, the personal Web sites such as facebook.com, utube.com, and myspace.com provide real-time and very intimate views of the sociological and psychological forces affecting a portion of the consumer population. Basic television and Internet news shows are another source of communication media that provide insights into the current cultural environment. Shows such as CNN and ESPN are constantly broadcasting cultural information to people throughout the globe. Other sources of information include personal observation as the merchandiser is in the stores, on the streets, and at major sporting or social events. Cultural researchers must always be on the lookout for something new.

Finally, or maybe initially, anyone doing market research should look for solid and reliable statistics about the population of interest. Government statistics are available from many of the world's countries. In the United States, the U.S. Census Bureau is an excellent source for information about birthrates, numbers in a family, size and types of dwellings, and a multitude of other population characteristics. Similar sources are available in other countries. The market researcher should always search for reliable and firsthand sources of information (for further discussion on quality research, see Chapter 7).

Natural Resources Environmental Scan

The natural resources environment is the one environment often envisioned when someone says "the environment" or "environmental issues." The **natural environment** is the environment that contains the world with its air, water, animals, plants, and humans. For hundreds of years, the world's population has used and lived in this environment without giving its existence or condition

Figure 8.6
The unspoiled natural environment.

much thought. However, with the growing populations in many countries and the rapid consumption of the world's resources (e.g., oil, coal, wood), the fast reduction of these resources along with the increases in pollution, the environment is changing. Many consumers and companies have begun to be concerned about the condition of the natural resources environment. Al Gore, the former Vice President of the United States, received much attention with his Academy Award winning movie, *An Inconvenient Truth,* and his Nobel Prize, awarded for his focus on the climatic change and the need for concern about the world's natural resources ("The Risk of Climate Change," 2008). Many companies within the FTAR Complex are changing how they do business because of their concern for the natural environment. When people or companies are interested in preserving, saving, or otherwise operating in a way that protects, heals, or helps the natural environment, these strategies are called **green strategies.** Being green is associated with a positive attitude toward the natural environment (see Figure 8.6). Companies that are green companies or have green products are using less energy and creating less waste (Corsano, 2007).

Availability, Sources, and Costs of Natural Resources

The natural environment contains the air we breathe, the water we drink, and the earth with its plants, minerals, and other resources. The **natural resources**

found within this environment include food, or resources used in making food, and energy, or resources to generate energy. Natural resources are needed and used by people as they live and work on the planet Earth. The availability or lack of availability of natural resources affects the costs and availability of raw materials, energy, and other means with which companies operate. Availability of natural resources also affects the costs of these resources and the disposable incomes of consumers.

As people select how and where to spend their money, they must consider the purchase of basic goods in the marketplace. Energy to heat or cool homes, to fuel automobiles or buses and other transportation, and to power work equipment are all resources used by most people. There is a global disparity in the dispersion of these natural resources. However, recently many consumers and companies have experienced restrictions in water, fuel, and other natural resources. Often consumers and companies are competing for available natural resources.

Understanding what natural resources are needed, how much they cost, and how readily available they are is important to a company. The company must consider both its own costs in selecting and using natural resources as well as the expenditures of consumers as they determine how and where to spend their incomes. If fuel costs rise, consumers may spend more on buying gasoline for their cars and purchasing electricity for their homes and have less money available to spend on elective purchases such as apparel. Rising fuel costs also affects the operating costs for a company and can in turn cause a rise in product prices. Rising prices for apparel products combined with rising energy costs can greatly impact the discretionary income that consumers have for buying new apparel.

As companies seek to manage the natural resources that they purchase and those in which they live and work, they may consider alternative forms of energy and relocation of production facilities to geographic areas with lower costs or more available resources. Although these actions may require initial investments, the company with a long-term plan for handling natural resources may choose to take action. In addition, this green strategy may be marketable to the consumer.

Waste Disposal

As the populations of the world grow in numbers and the industrialization increases in countries, people and companies must consider **waste disposal**— methods, costs, and its impact on the natural environment. Many companies in the recent past paid no heed to how and where they disposed of wastes from their production facilities. Consumers would toss trash in any location and give no thought to sizes of landfills as long as they were not located near their homes. With growing mountains of trash, including some waste that is harmful to the environment, companies and consumers are facing issues of location of waste, reduction of waste, and recycling of waste. Some companies have taken proactive steps to help consumers recycle by placing bins within buildings (see Figure 8.7a) and by having collection processes for the company's recyclable wastes (see Figure 8.7b).

(a) (b)

Figure 8.7
Recycle bins (a) in office spaces and (b) at convenient collection sites help companies and consumers care for the environment.

A major consideration in waste disposal is the appropriate disposal of scrap fabric. Apparel manufacturers who cut fabric for products often have dumpsters full of scrap fabric. Although designers and marker makers work diligently to maximize the marker and waste as little fabric as possible, some scrap fabric is always left from a cut, and fabric waste is a major issue for these companies. Fabrics from 100% cotton can be reused for rags or other commercial uses; however, most of the time, the fabric cannot be easily recycled because of the use of blended fabrics, incorporating both natural fibers and synthetic fibers. In addition, the use of plastics for vacuum-controlled cutting complicates the fabric waste disposal. This type of cutting is becoming more common with increased technology use in the industry. Vacuum cutting tables with automated cutters are used in mass customization to cut fewer layers of fabric with more variations in a faster cycle. The mix of plastic in with the scrap fabric renders the waste unusable for recycling, and separating the plastic from the fabric is too labor intensive and expensive for most manufacturers to have done (see Figure 8.8).

Many consumers and companies recycle product containers such as plastic bottles and aluminum cans. Companies should consider recycling when planning packaging and other marketing communication tools. Using packaging that can be recycled and packaging made from recycled materials or **postconsumer use** products are options that companies can consider. Target in 2006 cut their waste disposal by 70% by using reuse and recycling programs, specifically aimed at the recycling of millions of pounds of cardboard used in transporting of products to the stores (Corsano, 2007).

Pollution

Closely associated with waste disposal is **pollution** of the natural environment, which can negatively affect the air, water, land, and the plants and animals that live on this planet. Pollution results not only from improper waste

Figure 8.8
Plastic among the fabric scraps from cutting must be hand sorted before recycling.

disposal but also from the use of certain chemicals, fuels, and other natural resources. Some segments of the FTAR Supply Chain historically have been polluters. Traditional dyeing and other fabric processing methods are water dependent. Fabric manufacturers often need water to complete many of the processes in textile production and locate their plants near rivers. Unfortunately, some manufacturers have not been good stewards of this natural resource and not only used the water but also dumped wastes from the processes back into the water. In the United States and some other countries, strict government policies control the placement of chemicals into the earth's water. Factories that use petroleum products for synthetic fiber production also have the potential for excessive pollution of ground water.

Regulating pollution from factories is a major role of the U.S. Environmental Protection Agency. Many FTAR companies are good stewards of the environment and are very conscientious of their proximity to and use of the natural resources (see Figure 8.9) and coexist well with natural resources that are used for recreational boating and other family-related activities.

Companies are now measuring the effects of their operations by the **carbon footprint** they leave. In other words, how much did their actions change the planet or how much energy or other resource is consumed and how much pollution is left in place of the resources used? This issue is of specific importance for modes of transportation, which are vital to the FTAR Supply Chain. Few manufacturers are located close to the millions of retailers throughout the world. The

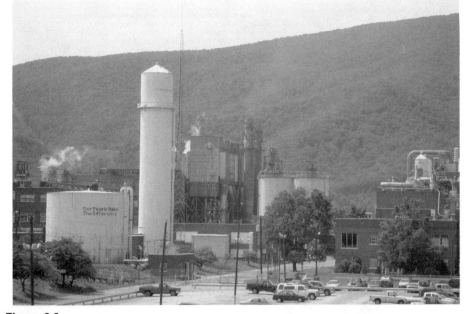

Figure 8.9
Raw materials manufacturers located on the rivers for water and energy.

carbon dioxide (CO_2) emissions from one container vessel, used by manufacturers and retailers to ship product from China to the United States, is 8.5 g/ton per kilometer (IFEU Institute Heidelberg, 2007). Air freight scores a much higher CO_2 carbon footprint than shipping methods by rail, truck, or seagoing vessel. The consumer's desire for speed is countered by the increased use of resources and generation of pollution. Retailers that consider the cost of energy and the amount of pollution generated for transportation as part of their decisions in selecting a manufacturer may choose a domestic manufacturer who has higher per unit costs than a foreign manufacturer who is located a long distance from the retail stores.

Companies who actively seek ways to reduce their carbon footprint may find they are not only supporting the care of the environment but also are appealing to consumers. Although the consumers' interest in environmental responsibility has varied over time, numerous articles are being written in the mid-2000s about the need for companies to be green (Corsano, 2007). Companies are evaluating how they are manufacturing and transporting products. Walmart announced in 2007 a companywide initiative called "Sustainability 360" to examine their shipping procedures and the procedures of their customers and vendors.

Weather

Related to energy use, waste disposal, and pollution are concerns about the weather and global warming. The weather and its cycles and trends of warming and cooling are important to the sale of fashion items. In addition, the amount and timing of precipitation can affect sales. A fall that is unusually

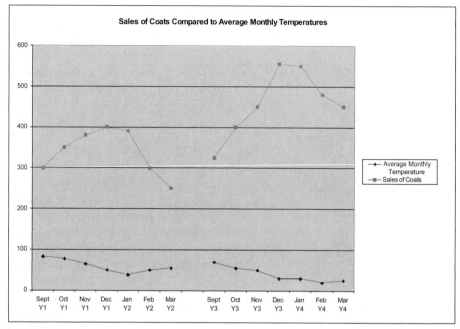

Figure 8.10
Sales of coats fluctuate from the warm winter of Y1 to Y2 compared to the cold winter of Y3 to Y4.

warm will negatively affect the sale of sweaters, coats, or other heavy apparel and outdoor gear, even though the fashion forecasters may have predicted a good season for this apparel category (see Figure 8.10). Extra heavy snow, rain, or other extreme weather may close retail business and result in loss of incomes and/or damage to inventory and failure of shipments to arrive. Businesses closed because of weather-related events, or stock-out problems that result from a run on products that are weather related, or shortages developed from deliveries that cannot be made because of weather, always result in lost sales, which are never regained in apparel retailing.

The weather trends have become so important to companies that many firms are adding climatologists or meteorologist to their employee rosters (Barbaro, 2007). Determining when seasons start and when seasonal products should be shipped, placed in stores, and advertised are important decisions for getting the right products to the right consumers at the right time. If products arrive at retail and the weather is not product appropriate, they may not sell well. For example, a buyer has a huge shipment of sweaters shipped to the stores by early September, but the weather remains warm until late October. By the time the weather has changed and the consumer is looking for a sweater, those sweaters that have been on the shelves for six weeks are old news in the store. When a product does not sell well quickly, the buyer may have to take unplanned markdowns to get the products to move, which will be a detriment to the planned profits for the retailer.

Sustainability and Other Green Strategies

Interest in the well-being of the earth has roots in many cultures but is often masked or forgotten when the people in a country seek to improve economic growth through industrialization. Sensitivity to the natural environment, to the use of natural resources, and to pollution and methods of waste disposal were important to a segment of U.S. consumers in the 1960s. With the campaign of "Keep America Beautiful" in the early 1960s (Corsano, 2007) and the positive support by Lady Bird Johnson as First Lady in the United States, much activity was energized to remove pollution and to beautify the natural environment.

In the early to mid-2000s, consumers have again expressed concern for the environment and are seeking ways to reduce use of natural resources, to recycle a variety of materials, and to dispose of wastes without harming the natural environment. Companies need to understand how sensitive their consumers are to pollution, recycling, and other natural environmental issues. Some consumers are willing to pay for products that exhibit good stewardship of the natural environment. Some consumers change their patronage behavior based on marketing campaigns and realized actions designated as environmentally friendly, eco-savvy, or green. These practices may not only market well to consumers but may be profitable for the company.

Some consumers and companies are looking for sustainable designs for subsequent products. **Sustainable design** and the resultant products are those that are environmentally friendly at each step in the life cycle of the product. The **product lifecycle** is measured from the design to the disposal of the product. Products that qualify for this type of label are made from materials that are either easily renewable or are made from reused items. Shoes made from old tires are an example of reuse. A new process used by a North Carolina manufacturer is converting blue plastic water bottles, brown plastic beer bottles, and green soft drink bottles into polyester fibers. These fibers are mixed with cotton fibers that are reclaimed fabric wastes from T-shirt manufacturing. The new fibers are knitted into garments (see Figure 8.11 for bottles of scrap, yarn, finished fabric, and garment). Sustainability is more than just a product type; it can also describe the business practices for an FTAR company (McAllister, 2007). Sustainable manufacturing practices include using procedures that are cost efficient, have low energy consumption, reduce the amount of chemicals and other wastes put into the environment, and maintain natural habitats ("Sustainable Manufacturing," 2008).

One sustainable process is the use of organic farming and manufacturing, resulting in organic products. The use of organic cotton, which is grown with reduced pesticide use, is appropriate for sustainable design (Burke, 2008). **Organic,** as a label on a product, must be certified by one of several agencies. In the United States, cotton and cotton products can be certified through a procedure documented by the U.S. Department of Agriculture (USDA) and their respective agents ("U.S. Cotton and the Environment," 2008). The National Organic Program (NOP) was established by the Agricultural Marketing Service of the USDA to set production and handling standards as well as labeling standards and certification standards ("National Organic Program," 2008). Certification of organic products

Figure 8.11
Shirt made from cotton fabric scraps and water bottles (blue), beer bottles (brown), and soft drink bottles (green).
(Courtesy of EarthSpun)

in other countries can be handled through the Organic Exchange or the certifying bodies approved by the International Working Group of the Global Organic Textile Standard (GOTS) ("The History," 2008; "Introduction to Organic," 2008; McAllister, 2007). Merchandisers must be very careful as they source raw materials and prepare products that they are aware of the legality of the claims placed on their products and are accurate in the promotional materials generated to sell these products. Using organic cotton does not automatically certify an apparel product as organic ("National Organic Program," 2008).

Other raw materials used to create so-called organic products include bamboo, hemp, and coconut fibers (McAllister, 2007). In addition to using the eco-friendly raw materials, the FTAR company with a sustainable business operation ensures that the process of making the product is also compatible with the natural environment. Manufacturing processes that create products while operating with reduced greenhouse emissions and lower carbon footprints from reduced transportation distances are all sustainable practices. And, finally, the wearing of the product and its ultimate disposal must also be such that the environment is not harmed.

All firms within the FTAR Supply Chain must clearly understand their customers and target the final consumer with the appropriate environmental messages. Most sustainable designs and other eco-friendly practices require higher operating costs. Some consumers are willing to pay these higher costs and other consumers are not. Although the concern for the environment should be of interest to all people living on the planet Earth, the reality in merchandising is that some consumers are sensitive to messages in marketing communications about the natural environment and others are not.

Another consideration in the use of resources is the adaptive reuse of retail spaces. With the excess of retail or the overstoring and the continual change of retail to follow fashion change, the number of vacant and underutilized retail space is growing in the United States. Local zoning laws, federal grants, and other forces may encourage retailers and other builders to renovate spaces instead of building new construction. For example, vacant retail spaces can be reused for other public functions. Large empty department stores can be converted to classroom and other school functions. Entire shopping centers can be converted to spaces for retirement apartments or other housing needs. The existence of food facilities, elevators and escalators, and other physical features aid in the reuse plans for these buildings. This former shopping center in New Orleans was converted to a conference center by Tulane University, including some shops, apartments, and a farmers' market (see Figure 8.12). In addition, old vacant public school buildings that are replaced with new and larger schools because of population growth can be converted to shopping spaces and mixed-use spaces. In urban areas, large downtown buildings are being converted to mixed-use spaces, where people can live and work in the same space (see the earlier section on sociological forces).

Technological Environmental Scan

Technology is the equipment and processes that convert raw materials and information into usable outputs (Ko, Kincade, & Brown, 2000). These outputs can be used by internal or external customers along the supply chain. New equipment and new processes are both important aspects of technology. Some technologies require expensive equipment and advanced software programs, such as the supercomputers with their proprietary programming needed to do data analysis on the giant databases generated by companies with hundreds of thousands of SKUs and thousands of customers and vendors. The technology

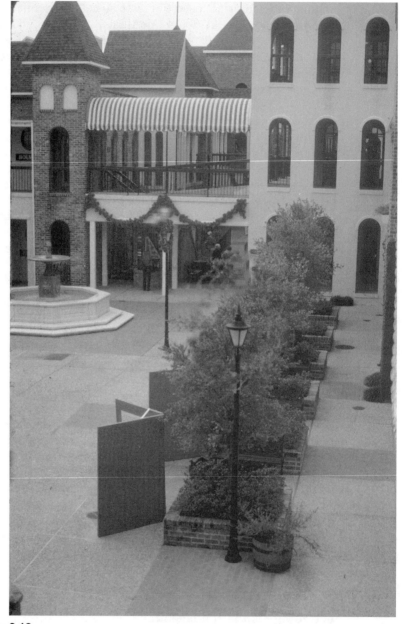

Figure 8.12
Adaptive reuse of old retail space in an eco-friendly way to help the environment.

Figure 8.13
Data point output from body scanning.
(Courtesy of [TC]²)

for body scanning and capturing all of the data points needed to develop a customized pattern for one customer involves the use of a dressing room and the scanner, including white light technology with a focusing of light beams, as well as the computer and measurement extraction software needed to convert the optical points into digital readings and then into visual drawings ("Size USA," 2007). The scanners can capture up to a million data points to create a customer's image (see Figure 8.13). These body scanning units are extremely expensive and many companies cannot afford them, but they are available in some universities, research facilities, and a few large companies. In contrast, some technology is relatively simple, inexpensive, and easy to use, such as the software packages that allow merchandisers to plan displays and set up plan-o-grams for stores. These planning software programs can load on any computer and be used by novice users.

Technology has changed rapidly with the introduction of the computer and the associated products, which contain computerized memories, processors, and other computer features. The explosive growth of the Internet has provided a superhighway for communication among computers. Cell phones, digital cameras, personal music players, DVD players, and other personal computerized devices have allowed people to carry pictures, data, and other

information with them in a compact and convenient form. This information, in digital form, can be shared quickly and easily with someone or many people around the world. The possibilities now seem endless in how frequently, quickly, and thoroughly people can communicate with each other for business and for personal reasons.

Although many companies have created positions such as IT departments with supervisors, computer programmers, and database managers, most companies also expect employees to have a working knowledge of computers and the ability to use the basic software of the industry. Ability to do word processing, spreadsheet calculations, digital imaging, and printing are fundamental skills for FTAR employees, including merchandisers. Within merchandising, technology affects three main areas of the industry: customer shopping, the product, and business processes.

Technology and Customer Shopping

Technology has changed not only the relationship between one FTAR business and its vendors and customers in the supply chain, also called business-to-business (B2B) relationships but also the relationships between a business and its consumers (B2C). Because of technology, consumers now have a wide variety of places to shop for products and ways to view products. As discussed in Chapter 6, online shopping has grown rapidly in the new millennium. With improved connections in speed and an upgrade in the quality of visual images from enhanced graphics, monitors, and cameras, the quality of images that a consumer can view online has become so good that many consumers say that shopping online is similar to the in-store experience. This technology has created retail companies that have multiple venues for shoppers. Some retailers have brick-and-mortar stores, online sites, and catalogs. Other retailers have only one format but must compete with all retail across all formats. Technology has increased the competition among retailers and has allowed manufacturers to enter easily into the retail arena. Some manufacturers now have Web sites so consumers can shop directly from them without using a retailer.

Some online companies provide product images from various viewpoints (e.g., front, back) on their Web sites. They also provide detailed or closeup views and can now offer product animation for consumers' viewing so they can see how the fabric drapes, folds, or wrinkles. Interactive shopping is possible on some Web sites as consumers enter their preferences and price ranges, and the Web site's computer selects products specifically for the consumers. With some technologies, online companies can take the consumer's measurements (entered by the consumer) along with body type selection and create a 3D likeness of the consumer. Consumers with scanner or digital camera devices can find Web sites that allow them to enter their own images so they do a virtual "try on" of the product. Numerous variations of this online clothes try-on are available from the Web sites of Home Shopping Network (HSN), Kenneth Cole, Kohl's, Lands' End, and a variety of other retailers. Consumers can also visit some retailers

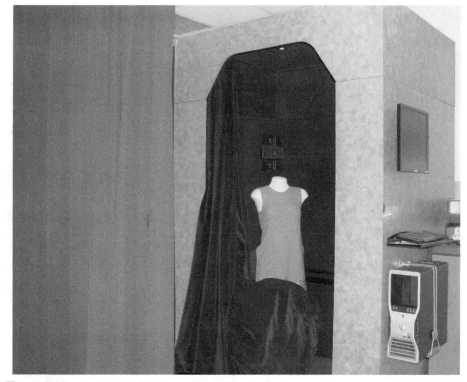

Figure 8.14
Body scanning booth with computer station.
(Courtesy of College of Textiles, North Carolina State University)

or other custom clothing manufacturers for a personal body scanning. In body scanning, consumers step into the scanning booth (see Figure 8.14) and have the silhouette of their body dimensions scanned and registered in a computer for custom pattern making.

In addition to actual product selection and purchase, the technology of the Internet and Web sites allows consumers to browse sites for information about apparel prices, styles, and brands. Over the past decade, browsing for apparel has increased from 7% of women shoppers to 52% of women shoppers, according to a survey done by Cotton Incorporated ("The Bionic Consumer," 2008). By browsing online, consumers are able to comparison shop easier than when they had to go from store to store. This more knowledgeable consumer becomes a bigger challenge to the retailer and the manufacturer. This technology-driven form of shopping may be challenging to retailers and manufacturers, but it also allows the firms to have direct contact with consumers to collect data about products and customer preferences and to market aggressively to these consumers by sending electronic ads and other forms of marketing communication.

Figure 8.15
Technology's influence on product design is illustrated by a cell phone pocket in a jacket.

Technology and the Product

Technology has become a major aspect of not only how the product is created but what the product is. As acknowledgment of how important electronics is to everyone's lives, apparel items are designed with places to place our cell phones, personal listening devices, and other electronics. For example, pocketbooks, tote bags, coats, and jackets contain pockets shaped especially for cell phones (see Figure 8.15). Ski jackets and other outdoor garments have tiny tubes and specialized holes for threading ear cords from a device in a pocket to the wearer's ears without interfering with zippers, buttons, and other standard openings.

Engineered textiles are providing a wide range of characteristics and services for the user. **Engineered textiles** are altered in their fiber content, in the fiber and fabric structure, and through finishes. Textiles can be made that protect the wearer from bullets, the sun, and flying insects (Scalia et al., 2006). As with organic labeling, the merchandiser must be very aware of the legal requirements for and ethical considerations when labeling clothing as providing sun protection. Comfort as well as protection is possible with textiles developed through new technologies. Engineered textiles can keep the wearer dry and cool. In addition, textiles can provide support for muscles, improve athletic performance, and enhance body wellness.

Other engineered textiles include **performance enhancement fabrics,** such as ones that cushion the body, protect muscles, or increase blood flow in an area of the body. Socks that provide cushioning for the feet when running or

jogging and the pants and shirts created by Under Armour are examples of products with performance enhancement features ("About DeFeet," 2008; "About Under Armour," 2007; "A Brief History," 2008). Other engineered textiles include fabrics used for medical purposes, such as sutures, heart valves, and hernia repair ("People of the College," 2008), and items that give antimicrobial protection to the wearer, including a mask made of antiviral fabric to protect the healthcare worker (People of the College," 2008).

In addition, wearable electronic textiles or e-textiles have become a reality in the new millennium. **e-Textiles** provide a merger of traditional fabrics with computational components (Edmison, Kim, & Lui, 2007). Apparel products made with e-textiles are aware of the environment and can provide changing protection to this environment. Products made from e-textiles have the potential to help people achieve better lives through the use of the computer components within the textiles. For example, gloves with lasers can sense the position of fingers. This technique can be used in computer games but also can be used in physical therapy in training stroke victims to learn to reuse their hands. Some sources refer to these products as "smart clothes" (Crumbley, 2006). The e-Textile group in the Bradley Department of Electrical & Computer Engineering has performed extensive research on smart clothes and other applications of e-textiles. **Smart clothes** "appear and feel normal but can sense their own shapes, the wearer's motions and the positions of the sensing elements" (Crumbley, 2006, para. 3). Smart carpets are useful in industrial and home settings where they can identify fire, advertise products, and guide walkers with their integrated sensors, computer components, and voice or visual responses (Anderson, 2007). The computer components in e-textiles can be inserted into the fiber, yarns, fabrics, or topical components of the textile as well as added as trim or other finishing agents to the product.

Technology and Business Processes

Since the industrial revolution, the FTAR business has changed continually due to technology changes. Early changes in the late 1700s and early 1800s were marked by the switch from hand power in weaving and spinning to steam power for looms and other fabric manufacturing (*Encyclopedia of Textiles,* 1980). Since those decades, few years have witnessed the changes encountered in the later part of the twentieth century (see Table 8.2). Changes in the 1970s and 1980s focused primarily on the improvements in manufacturing in the raw materials segment of the supply chain. Automation of spinning, weaving, and other fabric processes were recognized as technology-driven improvements that lead to better products and faster production of volume goods (Office of Technology Assessment, 1987).

In the 1980s, the rapid acceptance and improvements of the computer allowed firms to store and analyze large amounts of data as well as share that data with their trading partners. The implementation of Quick Response (QR) depended on the use of these computer-based technologies (Kincade, 1995). Bar coding, POS data, automated sewing, and other computer-dependent technologies are

Table 8.2
Timeline of technology changes in the FTAR industry.

Dates	Strategies or Movement	Specific Technology Processes
1970s	Product quality control	Automation of spinning and weaving; increased inspection and certification
1980s	Automation	Computer-assisted design and manufacturing (CAD/CAM)
1980s–1990s	Just-in-time (JIT) and Quick Response (QR)	Bar coding, sharing POS data, CAD design, automated sewing
1990s	Supply chain management	Computerized communication, electronic networking
2000s	Mass customization	Body scanning, 3D product representation

Adapted from Park and Kincade (2008).

all part of the QR strategy. Many of these data-based technologies were discussed in Chapter 7. When companies linked with other companies to share data and to deliver a better product to the consumer, the strategy of supply chain management developed (see Chapter 13).

The development and improvement of graphic features related to computer usage has been the technology behind computer-assisted design and manufacturing (CAD/CAM) usage in the industry. Technology allows pattern makers to draft patterns by computer drawing packages, print patterns quickly on lightweight paper, make changes easily on drafted styles, and store hundreds of patterns on a small disk. Likewise, designers can draw, color, add fabrics, change patterns, and otherwise create and change product images using rapid response computer software (see Figure 8.16). Images can be shared almost instantaneously with trading partners and fellow employees around the world. Decisions can be made quickly without investments in fabric, shipping, and sewing labor. The technology in business processes allows the manufacturer or retailer to develop and deliver the right product to the right customer at a fast rate. Further discussions of technology used in product development and product production are found in Chapters 11, 12, and 13. As technologies change, the opportunity to improve the process further, to involve the consumer and all other trading partners in product process decisions, and to eliminate waste in the pipeline become more than desires. They become reality. Merchandisers must find ways to harness the benefits of technology to improve their product development, buying, distributing, and selling processes.

After the product is created, technology through bar codes improve the flow of shipments of products with scanning done on boxes, on truckloads, and in warehouse storage. Automation of pick and pack has created some warehouses that are lights-out facilities. Computer-driven machines roam the warehouse, select the right products from the right bins, and place the products in cartons

Figure 8.16
Using technology is an important skill for employees in the FTAR Complex.

for automated packing, labeling, and shipping. Technology makes the warehouse efficient and cost effective.

Retailers use technologies for all aspects of their business. Retailers must plan, buy, and sell products. Throughout each step of the retail process, they are using technologies. Computers with spreadsheet software can be used for planning. Using cell phones, faxes, Internet connections, e-mail and other technology-driven tools, the buyer can communicate with vendors and customers to relay information about ordering, invoicing, tracking, and the shipping and arrival of

products. Getting the right product to the right customer can be easier and faster with technology.

Summary of Technology

Merchandisers must learn many skills in preparation for their jobs and must continually train and learn new skills as they work. Keeping up with changing technology affects the merchandiser's job not only at all stages of the FTAR Complex but also with his or her relationship with the customer. The merchandiser must know and use the technologies required to do the job within the company and with vendors and customers. In addition, the merchandiser must know the technologies used and expected by the customer. With the rapid pace of technology change in the 2000s, the merchandiser must constantly monitor or scan the technology environment to master the latest information.

Business Environmental Scan (Macro-Market Scan)

Companies operating in the FTAR Complex must constantly monitor their business environment. The **business environment** contains the market features including information about the well-being of the economy and the political situations that impact business activities. Concerns about the economy include not only the health or ambiance of the economy for the FTAR company and its related industry partners but also the view of the economy for the customers, especially the target consumer. The economic climate provides companies with a measure of how much money is available for business growth and how much discretionary income will be available for consumers. A measure of discretionary income or the amount of income one can spend on luxury items and non-necessities is important for apparel purchases. In general, most apparel purchases are based on want not need. Although consumers often feel they need or must have a certain fashion item, consumers actually need very few apparel items for their personal use. For many consumers, the choice of spending money on apparel is balanced by their choices to spend on their cars, their homes, and their leisure or sporting activities or other pastimes. Apparel spending is particularly restricted when consumers must choose between buying the essentials of food and gasoline or buying items of apparel. The wise merchandiser needs to know about the economy and the general inclination or disinclination of spending for the company and for the consumer.

Economic

A wide variety of economic measures are used to evaluate the economic environment. Measures of general economic well-being are evaluated through the gross domestic product (GDP), the rates of employment and unemployment, cost of living indexes, manufacturing indexes, and the rise or fall of the stock market.

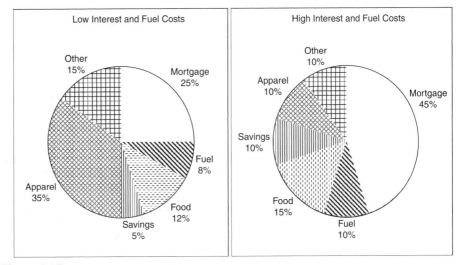

Figure 8.17
Amount spent on apparel, depending on other personal expenses.

The **interest rate** is amount of money that banks charge for lending money. The value of the interest rate can be a measure of what money will cost for the company when it must borrow money. Higher interest rates tend to slow economic growth and cause companies to spend more when opening new stores and buying new inventory. Cash flow continues to be a major problem within the FTAR Complex, and many companies must borrow money to pay bills and to have money available for purchasing raw materials or buying new inventory. High interest rates also affect the consumer. With high interest rates consumers tend to save money and need more of their income for paying for home mortgages and automobile loans. Consequently, they will have less money for buying apparel (see Figure 8.17).

Savings rates, amount of credit used by consumers, and the rate of interest on credit provide information to the merchandiser on how much money consumers will have for buying apparel. Not only do these provide indications of available money but also provide merchandisers with information about consumers' willingness to spend. If consumers are experiencing high credit card debit and high credit card interest rates, they may be unwilling and even unable to continue to spend for apparel items. A general positive economic environment promotes spending among consumers even when actual income, salary, or discretionary monies are not readily available for some consumers.

The value of the domestic dollar relative to the money in other countries is critical for FTAR companies. Because many products are made in one country and sold into other countries, the exchange rates are vital components of an economic environmental scan. **Exchange rates** are the amount of money offered for one country's currency when exchanged for another country's currency (see Figure 8.18). When the exchange rate is good, Country X would get more than

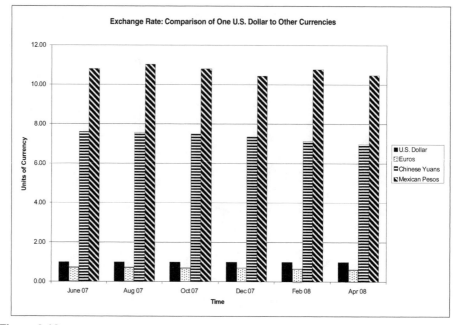

Figure 8.18
Comparison of exchange rates with one U.S. dollar as the base rate.

one unit of value in the other country. When the exchange rate is poor, Country X would get less than one unit of value in another country. For example, when exchange rates are bad for the U.S. dollar, a merchandiser may find that for every U.S. dollar spent in Country Y, she or he only receives $0.75 in Country X's currency. Consequently, the cost of the product will have to rise in the United States to accommodate this unfavorable exchange rate.

Politics

The government in any country regulates trade and commerce through various means. **Legislation,** or laws passed by the governing body of the country, can control how, when, and where businesses can operate within the country. These laws may change when different political parties are in control of the government. Because the FTAR companies operate within a global economy, merchandisers must know the laws affecting businesses within their own country as well as other countries where they are doing business.

Understanding and identifying **trade regulations** are also important because these regulatory policies affect trade between countries. The World Trade Organization (WTO) is one of the major governing bodies that regulate trade for textile and apparel items. The WTO can set policies relative to restrictions or flow of products across countries' borders. Countries may also make regional pacts with countries in close geographic proximity. Regional pacts that have affected trade for U.S. companies include the North American Free Trade Act

(NAFTA) and the more recent Central American Free Trade Act (CAFTA). These policies have created **free trade zones,** where products can move between the member countries without restrictions on volume (i.e., quotas) and without fees (i.e., customs taxes). Chapter 13 provides additional information about some of these trade policies.

Human rights or the treatment of workers is one issue often regulated by federal governments. In the United States, federal organizations such as the Occupational Safety and Health Administration (OSHA) regulate the physical environment in which workers work. Treatment of workers and working conditions vary greatly across countries. Apparel merchandisers, retail customers, and consumers are often concerned about the conditions in which sewing operators work (see Chapter 13 for an additional explanation of human rights related to apparel production). Although the emphasis at times seems to be on production workers, federal and state laws also regulate the conditions for retail workers. This is especially true for wages. In the United States, federal laws regulate minimum wages that must be paid to workers.

Federal legislation may also be passed in countries that regulate the treatment of consumers. The consumer movement in the 1960s pushed legislators to create many laws that protect consumers from the profit-motivated activities of businesses. Laws governing truth in lending affect the use of credit—rates, minimum payments, length of lending periods—and laws governing truth in advertising regulate the activities of marketing communication personnel. For example, merchandisers need to know what laws are affecting the types of advertising that can be promoted in a country and the content of those advertisements. Countries vary in their leniency in advertising content relative to their cultural mores and regulatory policies.

FTAR Industry Environmental Scan

As the merchandiser works through an environmental scan, he or she changes focus from the macro-vision of the natural and social environments through the more closely aligned business environment to the FTAR industry environment. The FTAR industry environment contains the raw materials, products, and businesses found along the FTAR Supply Chain. Regardless of the position of the merchandiser's company along the FTAR pipeline, the merchandiser will investigate information about all segments including trends for product and company. The merchandiser needs to know in-depth information about both vendors and customers. The scan includes an investigation of the FTAR segments: raw materials producers (i.e., fiber, yarn, and fabric companies), apparel producers, and retailers.

Business Trends

Scans of business trends within the FTAR Complex are more narrowly focused than the scan done in the business environment. The merchandiser specifically investigates what is happening to FTAR companies. Mergers, consolidations, and

Table 8.3
Horizontal diversification for noncompeting product lines.

Product Lines	Brands for VF Corporation*
Jeanswear	Wrangler®, Lee®, Chic®, Gitano®
Outdoor	The North Face®, JanSport®, Eagle Creek®
Contemporary Brands	lucy®, 7 For All Mankind®

*Information from this table was gathered from www.vfc.com in 2008.

buyouts constantly affect the industry. One method of business growth for a firm is to buy preexisting companies. Companies may participate in **horizontal diversification** when they choose to buy other companies that make products in their FTAR segment, usually noncompeting products. GAP Inc. owns Gap, Old Navy, and Banana Republic, which gives the company diversification across price points and some image and style diversification. VF Corporation has also achieved market growth with this diversification strategy. Within their jeanswear products, they have jeans that appeal to a variety of market segments. The Wrangler® customer is often a very different market segment from the customer that buys Chic® jeans or Gitano® jeans (see Table 8.3). By using this strategy, they own companies that are noncompeting because they market similar but different products to different market segments. For VF Corporation this strategy includes allowing the companies to maintain their executive management and their corporate images, separate from the VF Corporation images.

In contrast, companies may purchase other companies that supply them with the materials they need or buy the products they make. Companies may also merge with other companies to create a bigger presence in the market or to control more of the market share. For additional information about channel decisions, see Chapter 6.

With the importance of brands, many companies buy other companies so they will own a brand. The **business portfolio** of a company explains who they own, particularly what brands they own. This concept is a broader business strategy than the brand portfolio discussed in Chapter 5. For raw materials producers, apparel producers, and retailers, brand utilization is an important decision for merchandisers. **Brand utilization** is the way the company in its strategic planning process decides to market the brands and promote the brands to the customers and to the consumers. Along with brand utilization, the use of private label in product development, advertising, and retail distribution is an important decision. As discussed in Chapter 5, private labels can provide the company with its own brand, and products can be configured and sold especially for one type of customer. How much of the product for most retailers is carried as private brand versus national brand or unbranded goods is key when making decisions on brand.

Other business decisions are related to channels of distribution. With the growing availability and acceptance of the Internet, companies are making

decisions about how best to use this mode of product and service delivery. Companies that used to see Internet sales as separate from their traditional store sales are now merging these businesses into a unified organization. Research shows that consumers see the Internet site of a retail company as one aspect of the retail business. Aligning these various modes of distribution becomes significant consideration for a merchandiser (Tan, 2008).

In addition to channels for distribution, the merchandiser must determine exactly how and where the consumer will view the product and obtain the services. The availability of products on the Internet was discussed earlier in this chapter. Other retail formats include trends in mall structures and sizes. Malls can vary in size and composition. Their changing structures and content are often a reflection of societal changes as well as business changes. Consumers who are seeking the total package when shopping and merchandisers who want to provide consumers with a complete shopping experience are revising the traditional mall with two end anchors and are creating lifestyle centers, power centers, and power towns. **Lifestyle centers** are the smallest of these new retail areas with only 150,000 to 600,000 square feet of shopping space (Bradford & McLauchlin, 2007). These centers contain upscale specialty stores in combination with businesses that offer dining and entertainment opportunities. The focus on lifestyle centers is specialty retailing, and for this reason some of these centers have no major retail anchors. In addition, lifestyle centers include outdoor spaces for shoppers to sit, congregate, eat, and socialize. Southern Village, outside of Chapel Hill, North Carolina, is an example of a lifestyle center (see Figures 8.19a, 8.19b, 8.19c, and 8.19d). A church, the town hall, an elementary school, a variety of retail stores, and various types of housing are all within walking distance of the town square. **Power centers** are retail shopping areas that contain a mix of major anchors (e.g., three or more big box retailers) and a limited number of small stores. This retail mix is in contrast to the traditional shopping center, which had two or three major retailers as anchors and a multitude of small stores. **Power towns** are the largest of these new retail areas, as the name suggests, and may include up to 1 million square feet of space (Bradford & McLauchlin, 2007). These new towns include three or more major anchors (usually big box retailers), a number of specialty retailers, and businesses that provide dining and entertainment services. Again, these spaces are designed to include outdoor participation for shoppers. Both power towns and lifestyle centers may include multiplex cinemas.

At the local level, the merchandiser can look at business indicators to determine the viability of any one market. Measures such as numbers of business licenses and new building permits indicate the opening and closing of businesses. Highway construction and road changes can bring traffic to a shopping center or stand-alone business or can divert traffic away from the business. Any new construction for houses, apartments, retail and other businesses, and medical facilities can be indications of new customers, a vital economy, and the potential for sales (see Figure 8.20).

Finally, as the merchandiser scans the FTAR environment—globally, nationally, and locally—he or she must consider how the producers and retailers are

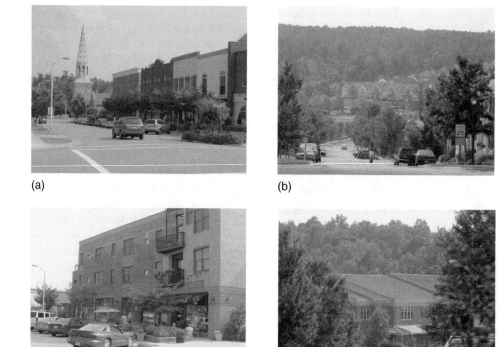

Figure 8.19
Lifestyle Center (a) church and retail, (b) townhouses and detached houses, (c) condos and retail, and (d) public school.

Figure 8.20 New construction is a sign of economic growth in a business environmental scan.

reaching the consumer. Advertising, visual merchandising, and other marketing communication trends must be identified. The merchandiser needs to know what is being promoted, how it is promoted, and what is being said or shown in the promotions. Over time ads have changed in their content and approach to consumers. For example, ads may be realistic and show product in actual use, or ads

may be filled with imagery that creates a feeling or urge for the consumer without actually displaying the product. The merchandiser needs to understand what is popular and acceptable in advertising as well as what is legal and ethical.

Scanning the retail environment, along with doing the other scans, can take a large portion of the merchandiser's time. Savvy merchandisers learn to collect information about the environments on a continual basis. When shopping for personal needs, when going to market, and on trips dedicated to checking out the competition, merchandisers are always observing, asking questions, and making notes. Merchandisers also want to spend time talking to their vendors and customers and gathering their impressions of what is happening in the market. In addition, the account executives, sales representatives, sales associates, or other personnel who work with customers and vendors can provide merchandisers with information about what is happening in retail. Seminars for training sales associates can also be used to gather information as well as share information. Sales associates in retail stores, working with the target consumer, and sales representatives in manufacturing facilities, working with the customer, often know much information about the customer with whom they work and the business or environment in which their customer operates, and they are rarely asked to share this wealth of knowledge.

Product Trends

In addition to general and specific business trends, the merchandiser can observe product trends. Product trends for the raw materials producers include changes in fibers, yarns, and fabrics. The merchandiser needs to know what new fibers are available. Often fibers that are created in one product area are translated in time for use in other product areas. Topics such as performance fibers, nanontextiles, medical textiles, nonwovens, and geotextiles can be investigated as part of the scan. In the apparel sector, trends in color, style, and fabric use are examined. These trends are explained in the forecast activities discussed in Chapter 10. Services as well as products are scanned in the retail sector. The merchandiser should know who is offering what services to which consumers.

Competitive Product Analysis

In doing a scan, the merchandiser should research and analyze specific competitors in global, national, and local markets; in other words, retail merchandisers conduct a **store image analysis.** Other companies in the FTAR Complex do a similar analysis but focus on the competition at their FTAR level. In addition to examining companies, the merchandiser may also do a **competitive product analysis** (see Figure 8.21a). These analyses begin with the process of collecting information about products and companies that compete directly with the merchandiser's product and company. Once the data is collected, the merchandiser builds tables for comparisons, makes grids and charts, and uses other graphic tools for analyzing the result of this research. The merchandiser

should examine three or four competitors selling the same or similar products, reaching the same target consumers, and using the channels of distribution and retail formats. A retailer who has a brick-and-mortar store must not assume that only other traditional store formats are the competition. Competition may come from many formats including the Internet.

Data collected about competitors include information on store image and product attributes (see Figure 8.21b). Store image includes store location with details on type of mall or other retail complex and the tenant mix in the complex; store appearance, both interior and exterior; customer services, including those offered by the store and the center or complex; and the marketing communication mix. In addition to examining many aspects of the store and the product, the analysis would also include data about the store personnel, such as their knowledge of the product and the number and availability of employees. Community service, public relations, or other outreach from the store to the surrounding community should be noted. (Further information about product attributes and store image was covered in Chapters 3 and 5).

The types and varieties of products the store carries is also part of its image. Information about merchandise mix, assortment type, retail vendor matrix, uniqueness or exclusivity of product, and product price points should be collected. In addition, the merchandiser should do a hands-on examination of a sampling of products in the store. Data should be collected about the fiber, fabrics, silhouettes, styles, colors, and patterns of the items. Product attributes

Brand	Item	Colors	Fabrics	Price Points	Seams	Neck Finish	Hem Types	Size	Lengths				Trim	Styling
									Underarm	Inseam	Center Bk	Sweep		
Baby Jams	Sleep shirt	Blue, pink	100% poly knit FR*	$19-16	Safety stitch	Narrow binding, w/ piping	Curved shirt tail with single layer overcast & ruffle	6	ss	-	30	18	Sleeves w/ blue & pink print w/ color wash. cute sayings	Imitation of popular toy
Dreamy Baby	Gown	Blue, pink	100% poly knit FR	$25-20	Single overcast	Narrow ft binding, bk folded w/ facing, low yoke & buttons	Two length multiple ruffle. Clean edge finish	6	ss	-	30	20	Ruffle on gown sewn into round front yoke	Full flowing gown
	Sleep shirting	Pink stripe, blue stripe	100% poly knit FR	$29-32	Safety stitch	Crew neck in contrasting binding	Curved shirt tail type hem w/ clean finish	6	ss	-	33	14	Screen print numbers to match stripes	Basic T-shirt shirt
Joanie's Girls	Baby doll gown	Crayola brights in pattern	100% poly knit FR	$25-20	Single overcast	Tube and folded edge	Top-clean finish, bottom elastic	Not apply					Abstract diamond embroidery	Full gown w/ fashion trend
	Wrap shirt	White	100% poly knit terry FR	$15-19	Single overcast	Wide binding folded & chain stitched	½" turned and stitched	6	ss	-	23	2	No other trim	Basic

Note: *FR=flame retardant

(a)

Figure 8.21
Pages from market research reports: (a) competitive product analysis and

Store	Belk	Macy's	Nordstrom	JC Penney
Entrance				
	Interior Entrance: has same illuminated sign as exterior Sensory factors: lit sign helps consumers remember location – aroma from perfume department is often overwhelming due to large size Focal point: any special ongoing promotion (cosmetic bag was the latest promotion) Effectiveness: always tends to draw consumer to cosmetics or fragrance, but rarely depicts store's fashion or image	Interior Entrance: has same sign as exterior Sensory factors: sign helps consumers remember location especially with red star – lighting is very bright & no "bells and whistles" on entrances Focal point: sale display matching whichever department is closest to entrance Effectiveness: doesn't really entice customers to look beyond that particular department, Macy's name carries much of the store's credibility	Interior Entrance: has same illuminated sign as exterior Sensory factors: lit sign helps consumers remember location, piano player is very unique to this store – shiny floors Focal point: tends to be very open so as to entice customer to choose where to go Effectiveness: seems to be more effective in displaying image as upscale, yet affordable when people browse around	Interior Entrance: has same illuminated sign as exterior Sensory factors: lit sign helps consumers remember location – bright lighting makes apparel less appealing Focal point: is often a round stack of catalogs Effectiveness: helps to promote entire store and immediately show store's sense of fashion, but the store is overcrowded most of the time with overstocked merchandise
Interior Decor	Dominant theme: beige and teal are the theme colors – very neutral – something for everyone	Dominant theme: red, white and black are the signature colors but change with every department – vibrant in some sections and conservative in others	Dominant theme: white and black create a classic look which gives the look of high society and more expensive taste	Dominant theme: white and off-white are used throughout with no difference between departments – looks less appealing
Customer Service Attributes	• Customer Service desk, Belk credit card, gift wrapping, Bridal & gift registry • Consumers enjoy the free gift wrapping services	• Customer Service desk, Macy's credit card, Bridal & gift registry • Consumers enjoy the three tier rewards program benefits from the credit card	• Customer Service desk, Nordstrom credit card, gift wrapping, Bridal & gift registry • Consumers enjoy the gift registry because of the availability of more upscale merchandise	• Customer Service desk, JC Penney credit card, gift wrapping, Bridal & gift registry • Consumers enjoy the option to make special orders from the catalog inside the store
Product & Price Attributes	• Refer to Competitive Product Analysis • Retail price points are appropriate for store image and target consumer • Belk has a variety of brands and an abundant stock of merchandise	• Refer to Competitive Product Analysis • Retail price points are appropriate for store image and target consumer • Macy's has a fair variety of brands and a	• Refer to Competitive Product Analysis • Retail price points are appropriate for store image and target consumer • Nordstrom offers additional premium brands that are not offered at other	• Refer to Competitive Product Analysis • Retail price points are appropriate for store image and target consumer • JC Penney's offers less of a variety of brands and carries less merchandise

(b)

Figure 8.21 (b) competitive retail analysis.

would also include brands, size ranges, quality standards, country of origin, and care instructions and should be noted carefully for an assortment of products.

The merchandiser may work for a company that has a research division that collects this type of data or the merchandiser may collect this data while doing other scans. Or the data may be purchased from hired companies. Firms that use buying offices may find that their buying partners will provide this data. Some commercial sources of consumer data are The NPD Group, Inc. and the Rand Corporation. Many other companies are available that can provide merchandisers with consumer data including panel data. The merchandiser should review the processes for obtaining quality data (see Chapter 7) and inquire about the company's research methods before purchasing data from any source.

Summary

No company in the FTAR Complex operates alone. Each company has suppliers, customers, and competitors. Companies also operate within their near environments or the environments of the FTAR Complex and the larger business environment as well as the broader environments of society, nature, and technology. As merchandisers forecast trends, plan assortments, and sell products and services, they need to know about the environments that will impact their companies, their trading partners, their competitors, and their target consumers.

Gaining this understanding involves extensive research or environmental scans. Merchandisers will investigate what is happening and what is forecast to happen in each of the environments that surround their company, products, and consumers. When merchandisers gain in-depth knowledge about environments, they are able to make strategic decisions about products, prices, promotions, and other merchandising issues.

Key Terms

Age of a population
Brand utilization
Business environment
Business portfolio
Carbon footprint
Competitive product analysis
Composition of the family
Cultural environment
Engineered textiles
e-Textiles
Exchange rates
Free trade zone
Graying of the consumer

Green strategies
Horizontal diversification
Interest rate
Legislation
Lifestyle centers
Natural environment
Natural resources
Organic
Performance enhancement fabric
Pollution
Postconsumer use
Power centers
Power towns

Product lifecycle
Role of an individual within the family unit
Smart clothes
Sociological forces
Store image analysis
Sustainable design
Technology
Trade regulations
Values
Waste disposal
Where people live, work, and play

Review Questions

1. What environments should the merchandiser scan and why?
2. How is an environmental scan performed by a merchandiser?
3. What are the factors to be scanned in the natural environment?
4. What factors compose the sociological environment, and how do these factors affect consumers?
5. What are three ways that technology affects an FTAR company and its products?
6. How is organic apparel similar or different from apparel created by a company that uses sustainable design practices?
7. Select one political factor and explain how that affects consumers when they are shopping for apparel items.
8. What indicators should be observed when scanning the business environment?
9. What are lifestyle centers, and how are they affecting the way consumers shop?
10. Why does a merchandiser need to do a store image analysis of the competition?

References

About DeFeet. (2008). Defeet. Retrieved May 30, 2008, from http://www.defeet.com/info. php?s=about

About Under Armour. (2007). *Under Armour History*. Retrieved June 19, 2007, from http://www.uabiz.com

Anderson, A. (2007). e-Textile carpet via an integration of agent-based simulation into 3D Studio MAX. Bradley Department of Electrical and Computer Engineering, Virginia Tech, Blacksburg, VA. Retrieved February 7, 2008, from http://www.ccm.ece.vt.edu/etextiles/-projects/

Barbaro, M. (2007). Meteorologists shape fashion trends. *New York Times*. Retrieved December 2, 2007, from http://www.nytimes.com

Beach, J., Kincade, D., & Schofield-Tomschin, S. (2005). Human complexity: Development of a theoretical framework for the clothing and textile field. *Clothing and Textiles Research Journal, 23*(1), 28–42.

The bionic consumer: Retailers have the formula and technology. (2008, January 23). *Women's Wear Daily*. Retrieved February 7, 2008, from http://www.wwd.com

Bradford, R., & McLauchlin, K. (2007). Plug into power towns. *Retail Traffic Magazine*. Retrieved June 8, 2007, from http://retailtrafficmag.com/development/trends/retail_welcome_power_towns

A brief history of foot protection. (2008). THOR•LO Socks. Retrieved May 30, 2008, from http://www.thorlo.com/ ws6/press_releases_full.php?press_id=31

Burke, G. (2008, January 4). Sustainable fashion hits catwalks and gives farmers a hip new market. *Atlanta Journal Constitution*. Retrieved January 4, 2008, from http://www.ajc.com

Cheng, C. (1993). Little emperors make big consumers. *China Today, 42*, 48–49.

Chugh, G. (2006, November 15). Entertainment: Multiplex magic: The fastest growing lifestyle segment. *The Research Department of ILandFS Investment Securities Limited*. Retrieved May 18, 2007, from http://www. investsmartindia.com

Corsano, A. (2007). Going green, seeing green. *Forbes*. Retrieved November 1, 2007, from http://forbes.com

Crumbley, L. (2006, July 27). Engineering researcher honored at White House for advancing e-textiles. *Virginia Tech News*. Retrieved February 19, 2008, from http://www. vtnews.vt.edu/story.php?relyear=2006&itemno=394

Edmison, J. N., Kim, S., & Lui, K. (2007). *Shape sensing, context aware garment*. An unpublished paper from ECE 5984 Wearable & Ubiquitous Computing. Bradley Department of Electrical and Computer Engineering, Virginia Tech, Blacksburg, VA. Retrieved February 7, 2007, from http://www.ccm.ece .vt.edu/etextiles/projects/Shape_Sensing.php

Encyclopedia of textiles by the editors of American Fabrics and Fashions Magazine. (1980). Englewood Cliffs, NJ: Prentice Hall.

Foss, B. (2006, March 19). Outside the box: Telecommuters say working away from the office allows creativity and the freedom to think. *Greensboro News and Record*, pp. E1, E2.

The history. (2008). The International Working Group of the Global Organic Textile Standard. *Global Standard Organization*. Retrieved May 30, 2008, from http://www.global-standard .org/left_nav.htm

IFEU Institute Heidelberg. (2007). Transportation and environment. *IFEU Institute Heidelberg— Institute for Energy and Environmental Research*. Retrieved November 19, 2007, from http://www.ifeu.org/english/index

Introduction to the organic exchange. (2008). *Organic Exchange*. Retrieved May 30, 2008, from http://www.organicexchange.org/intro.php

Kim, S-H., & Kincade, D. H. (2007). Evolution of retail institution types and consumers' store patronage behavior: A cross-cultural comparison among consumers in China, India, and the United States. *Journal of Shopping Center Research, 14*(2), 79–106.

Kincade, D. H. (1995). Quick Response management system for the apparel industry: Definition through technologies. *Clothing and Textiles Research Journal, 13*(4), 245–251.

Ko, E., Kincade, D. H., & Brown, J. R. (2000). Impact of business type upon the adoption of quick response technologies: The apparel industry experience. *International Journal of Operations & Production Management, 20*(9), 1093–1111.

Large, E. (2006, March 19). Careers prompt rise in couples living apart. *Greensboro News and Record*, pp. D1, D2.

McAllister, R. (2007, March 7). AAPN: Strategies for change marketplace. *AAPN*. Retrieved March 7, 2008, from http://www. apparelnews.net

National organic program. (2008). USDA Organic. Agricultural Marketing Service. U.S. Department of Agriculture. Retrieved May 30, 2008, from http://usda.gov

Office of Technology Assessment. (1987). *The U.S. textile and apparel industry: A revolution in progress*. Washington, DC: U.S. Congress.

Park, H., & Kincade, D. H. (2008). The impact of environmental factors on business strategies in U.S. apparel manufacturing industry, 1970–2005. *Proceedings of the Annual Spring Meeting of the American Collegiate Retailing Association*, pp. 1–4.

Paul, P. (2003, March). Targeting boomers. *American Demographics, 25*(2), 24.

People of the college. (2008). College of Textiles. North Carolina State University. Retrieved May 30, 2008, from http://www.tx.ncsu.edu/ faculty_center/directorydetail.cfm?id

The risk of climate change. (2008). The Nobel Peace Price 2007. *Nobel Prize*. Retrieved January 28, 2008, from http://nobelprize.org

Scalia, S., Tursilli, R., Bianchi, A. Lo Nostro, P., Bocci, E., Ridi, F., & Baglioni, P. (2006). Garments as solar ultraviolet radiation screening materials. *International Journal of Pharmaceutics, 308*(1–2, 3), 155–159.

Size USA. (2007). Size USA—U.S. anthropometric survey. *[TC]² Turning Research into Reality*. Retrieved September 6, 2007, from http://tc2.com/what/sizeuse/index.html

Sustainable manufacturing. (2008). *Cotton Incorporated*. Retrieved May 30, 2008, from http://www.cottoninc.com/Sustainable-Cotton-Manufacturing

Tan, C. L. (2008, January 31). CEO pinching Penney in a slowing economy. *Wall Street Journal*. Retrieved February 4, 2008, from http://www.wsj.com

U.S. Cotton and the environment. (2008). *Cotton Incorporated*. Retrieved May 30, 2008, from http://www.cottoninc.com/sustainability/ Cotton-Sustainability-Questions-and-Answers

chapter
9

People

Objectives

After completing this chapter, the student will be able to

- Explain the purpose of understanding the people or potential customers for firms in an FTAR Supply Chain
- Describe the demographic variables that can be used in segmenting the market
- Identify unique characteristics of several market segments within the fashion markets
- Explain how geographic locations and ethnicity are related to shopping preferences of consumers
- Discuss the use of psychographics and lifestyle segmentations in understanding the target consumer
- Explain how companies can use shopping behaviors as a way to segment consumers

Introduction

The retailers, manufacturers, and producers that are successful in researching their customers and forecasting, developing, and providing the design characteristics, product features, and product benefits desired by the final consumer, as well as any partner customer segments, are the most successful at satisfying their customers and in selling their products. Subsequently, the products of

their trading customers or partners are also successful. Therefore, all companies in the supply chain reach their own company sales volume and profit goals. For this reason, understanding the **people,** or potential customers, in the target markets become the first and most important tool in marketing.

When analyzing markets in the strategic marketing process, retailers, manufacturers, and producers segment and target customers who are the best fit for their companies, their products, and the services they render. In other words, they select customers who wish to purchase their product and services at a designated price. For successful implementation of the market plan, a retailer's target consumers must feel an identity with the retailer's shopping environment and fashion image, and they must be satisfied with the retailer's merchandise assortments, price ranges, and quality of products, customer services, and expected value offerings.

The success of the entire strategic marketing process and its planned outputs depends on the correct segmenting and targeting of the company's customers and the final consumers. Numbers of variables can be used to segment and target a market. Sometimes more than one variable is used in combination with other consumer variables. The criteria most often used with customers within the FTAR Supply Chain include demographics, geographics, psychographics or lifestyles, and behavioristics. For example, Cotton Incorporated conducted research on the Mexican consumer to identify the retail channels that the population shopped most often, the consumers' value equation, and their desire for denim products (see Figure 9.1).

Demographics: Generational Divisions

The **demographics** of a population are fairly easy to recognize and identify. They include age, gender, income, occupation, social class, family size/structure, housing type/location, and race and ethnicity. These are characteristics that can be counted, measured, and otherwise quantitatively evaluated.

The consumer segments for age, to which retailers and manufacturers target, are often divided according to **generational divisions** and named as follows: children, including newborn and infants; Tweens, previously called preteens; Teens; Generation Y; Generation X; the Baby Boomers, the Silent Generation; and the GI Generation. Although the generations are divided into the eight brackets, some demographers combine the older two generations, which results in a segment of 55 to 70+ year olds coined as the **gray market** or **mature market** (see Table 9.1).

In today's environment, three major generational divisions are being targeted frequently by manufacturers and retailers: the Baby Boomers, Generation X, and Generation Y. Generation X is also known as Gen X or the Baby Bust Generation. Generation Y is also called Gen Y or the Echo Boomers, and they are the children of the Baby Boomers. However, three other noticeable generational segments that are now impacting the market and attracting the attention of marketers and all FTAR companies alike are children, Tweens, and Teens.

Figure 9.1
Trend research for a market segment.
(Courtesy of Cotton Incorporated)

Baby Boomers

Due to their sheer size (i.e., 77 to 78 million consumers) and their accumulated wealth (i.e., inherited and earned wealth), **Baby Boomers** are a major force in the marketplace. These are the consumers who adopted divorce, blended families (my children, your children, and our children), and the casual lifestyle. They fought for civil rights; other social freedoms, including acceptance of the woman in the workplace; and sexual and racial diversity with expanded lifestyle rights.

Table 9.1
Generational divisions and birth years.

Generation	Birth Years
Children	2000–2006
Tweens	1994–1999
Teens	1986–1993
Generation Y	1978–1985
Generation X	1965–1977
Baby Boomers	1946–1964 (1946–1954 and 1955–1964)
Silent Generation	1925–1945
GI Generation	1901–1924

This generation saw the public deaths of President John Kennedy, his brother, Bobby Kennedy, and Dr. Martin Luther King, Jr. The generation also saw man's first walk on the moon and lived through the Vietnam War and Watergate. Individuals in this generation witnessed, as well, a revolution in music and social changes (e.g., feminist rights, gay rights, handicapped rights, privacy rights) that became permanent fixtures in our society. These Baby Boomers grew up with a new genre of music called rock 'n roll that introduced such celebrities as the Beatles, Led Zeppelin, Bob Dylan, and Bruce Springsteen to the world. They celebrated this new musical find collectively at Woodstock, a music and art fair that was attended by 500,000 Boomers. These spirited youth were also antiwar protesters, Black militants, antigays, legalize drug advocates, antigovernment advocates, and Vietnam Veterans (www.woodstock69.com). The women of this generation earned college degrees and entered the workforce in numbers while still rearing children (see Figure 9.2). However, many of these women delayed families until they ascended the corporate ladder and they began their families in their late 30s and early 40s.

The Boomer population questions authority and focuses on youth, individuality, and self (Schewe, 2002). In fact, the present youth trend that Faith Popcorn, the futurist, coined as "down aging" is more prevalent than ever. Boomer men are having cosmetic surgery, coloring their hair, having pedicures and manicures, and using beauty and health products just like their female counterparts. These consumers also attempt to stay in good health, like to travel and garden, and spend time on spectator sports plus physical activities that condition both the body and spirit (Reda, 2008a).

Because of the large size of the Baby Boomer market segment, some authorities divide these Boomers into two age segments. Susan Reda (2008a), in her article "Five Things You Don't Know About Baby Boomers" in *STORES* magazine, states there are two faces to the Boomer generation, that of the older boomer born between 1946 and 1954 and the younger boomers born from 1955 to 1964 (see Table 9.1). Companies and marketers must look at the life stages of the Boomers. For example, some of the older boomers are now empty nesters and thinking

Figure 9.2
Corporate attire for the busy Baby Boomer.
(Courtesy of The Hosiery Association)

about retirement; some of the younger Boomers are presently having children. Additionally, Reda states that in the "Pepsi-Turned-Pepcid Generation," there are 24 million Baby Boomers described by McKinsey as "financially unprepared" (Reda, 2008a, para. 35). She further explains that "McKinsey researchers coined the phrase 'U-Boomers' to describe this segment" and "While they can't match the Mercedes lifestyle of their wealthier counterparts, U-Boomers will account for almost 25 percent of total U.S. consumption by 2015." (Reda, 2008a, para. 37).

The Boomers can also be subsegmented by other demographic criteria and are thus known as the following: (1) OINKS (i.e., one income, no kids), (2) DINKS (i.e., dual income, no kids), and (3) SWELLS (i.e., single women earning lots and lots). Additionally, Baby Boomers are known as "the sandwich generation." They are now sandwiched between their elderly, sometimes ailing, parents and their adult children. Adult children are returning home in record numbers, some just graduating college and others who are divorced parents themselves. Some authors label this trend "boomerang kids" (Harvey, 2006). Many times these adult children bring with them their children or the grandchildren of the Boomers. Some Boomers are now rearing their grandchildren. Reda (2008) explains that "Grandparents are Nana from Heaven" (para. 28) and that the average Boomer grandparent is "young and hip, not to mention well off and doting" (para. 28). Boomers are often surrounded by multiple generations (see Figure 9.3).

Boomers are known for typically being big spenders and not saving money. The Boomers are the generation that invented the use of the credit card if there was

Figure 9.3
Fountains and sculptures at a mall are gathering places for multiple generations.

no money to make the luxury purchase. Boomers, both single-income individuals and their married counterparts, are usually optimistic about being secure economically. However, one author states that "Knowing that single boomers can deliver as much revenue to a retailer as married boomers shakes up perceptions a bit. Moreover, the data show that single boomers are much more likely than married ones not to have preferences for particular retailers" (Reda, 2008a, para. 18).

Although the older Boomers are reaching retirement age, many of them are not ready to retire. Many have not prepared for retirement; and, as previously discussed, many are caring for ailing parents and adult children plus grandchildren and have maxed out their credit cards to buy luxury items they could not afford otherwise. Additionally, the Boomers have used their incomes to send children to college, to travel, and to buy second vacation homes. Many of them will remain in the workforce longer; others will retire and begin a new second career or become entrepreneurs.

PRODUCT CHARACTERISTICS. "At the peak of their careers, these women [Baby Boomers] have more discretionary income than ever and make most of the purchasing decisions for their household" ("Marketing to Baby-Boomer Women," 2007, para. 1). In apparel items, Boomers like comfort, quality, and aesthetic attributes that help them feel youthful and attractive. As one author stated, "Most middle-aged women are looking for clothes that offer both comfort and good looks. But if you're selling youth to them, choose your words carefully. Boomers aren't 'aging.' They're just trying to look good" (Braus, 1995). For example, "When youth-oriented baby-boom women confront middle-age flab, they buy body-shaping undergarments—but they don't call them girdles" (Braus, 1995). The latest body shapers, hosiery, tights, and shapewear can be found under the Spanx label designed by Sara Blakely. Boomers definitely look for clothes that are slimming but are also comfortable (see Figure 9.4). Redesigning and relabeling products appear to be the answer for Boomers who are defying aging and attempting to look younger and thinner.

Because Baby Boomer women still feel young, they do not want to be referred to as "golden," "mature," "seniors" or "middle aged." "While they don't want to see clothes modeled by an airbrushed beauty with perfect proportions, they don't want to look at a close-up of a wrinkled hand on a jewelry ad either. They like to see themselves represented in a vital way" ("Marketing to Baby-Boomer Women," 2007, para. 4). For example, unfashionable reading glasses have become fashion accessories that are purchased in numbers to complement different ensembles. Another example is that of the Dove advertisements using ordinary-looking women, one of whom was a 46-year-old woman with gray hair and wrinkles. The caption to the ad read: "Why aren't women glad to be gray?" ("Love Those Boomers," 2005).

Some retailers have recognized the Boomer woman's fixation with youthfulness and have also recognized that "These women spend more than previous generations did at their age" (Agins, 2007, para. 2). These women do not want to shop in stores labeled for the mature woman.

Bloomingdale's addressed these qualms of the Boomer woman by creating a new department, "Quotations." Professional Boomers can find casual clothes that are suited for both their bodies and their busy lifestyles. Teri Agins in her

Figure 9.4
Baby Boomers seek styles that are youthful and slimming.
(Courtesy of The Hosiery Association)

article, "The Boomer Balancing Act" states that "The idea is that by pitching to boomers as well as younger women, Quotations will have a hip vibe that will appeal to a broad cross section. Each department is positioned next to contemporary labels like Juicy Couture, which are favored by women in their 20s, and has a diverse range of separates" (Agins, 2007, para. 3).

The Boomers are a diverse group of shoppers who shop all price ranges and all industry zones. They cannot be targeted by designers and retailers as one market segment but must be addressed as subsegments. They want the same styles as their younger counterparts but want them to be redesigned to fit their middle-age bodies. For example, Bloomingdale's created the Quotation Department to resemble a boutique setting and selected styles such as tank tops with wider straps to cover bra straps and tops with three-quarter sleeves in sheer fabrics that resembled those worn by the twentysomething generation. At Nordstrom (see Figure 9.5), Boomers are able to find a great fit in the "Tummy Tuck" jeans by the label, Not Your Daughters Jeans (Agins, 2007).

Contrary to popular belief, Baby Boomer women are loyal to companies rather than brands. "Unlike men who show habitual buying patterns as they age, sticking with the same brand because it's easier, boomer women are choosey about finding the best quality, service and deals. They also pay attention to a company's reputation, especially in terms of community involvement and social responsibility" ("Marketing to Baby-Boomer Women," 2007, para. 2). In other words, the Baby Boomer woman wants to build a strong customer relationship with a company and expects the company to understand her needs. Chico's has become one of those companies that understands that Boomers want comfortable, quality clothing that is also stylish or current.

Figure 9.5
Nordstrom is a retailer with products for Baby Boomers.

Additionally, age only is not a label that can describe the Baby Boomer. As previously discussed, life stage is more important in determining what the Baby Boomer consumer desires and demands in a product. For the consumer "may be an empty-nester, a doting grandmother, a small business entrepreneur and a dating single—all at the same time. Boomer women are looking for products and services that appeal to their sense of adventure, curiosity, renegade energy and continuous development" ("Marketing to Baby-Boomer Women," 2007, para. 5). Retailers that provide entertainment, the correct signage, and an inviting store environment are the ones the Boomers frequent (see Figure 9.6).

MARKETING TECHNIQUES. Because Baby Boomer consumers influence almost every category of product offered in the marketplace as well as impact the costs of these products, it is very important for companies to communicate directly with the Boomers. This was the generation that grew up with the television. Marty Horn of DDB advertising agency in Chicago explained how to communicate with the Boomers when stating, "Baby Boomer media habits, formed early on, haven't changed dramatically in terms of television, radio and print. Baby Boomers have stuck with what they've known over the years, but they're also embracing the new" (Paul, 2003, p. 24). Another source explains, "They still read the newspaper and listen to radio, and research shows boomers use both old and new media to make purchasing decisions. A whopping 95 percent watch TV,

Figure 9.6
Boomers shop where retail environments are inviting.

with 77 percent viewing occurring between 7:30 and 11 p.m. Two thirds of the Boomers subscribe to cable TV, but they're selective about what they watch; data shows they're most likely to be tuned into Discovery Channel, A&E, the Food Network, ESPN and Fox News" (Reda, 2008a, para. 22). Boomers are not the viewers who watch reality shows; they are looking for shows that are more intelligent and sophisticated with "in-depth" programming (Paul, 2003). Because many advertisements on television are directed toward youth, marketers may want to take notice of this Boomer population.

On the radio, Boomers listen to talk shows, news, and music, especially during the morning drive-time. However, "They surf the 'net. They use e-mail and they instant message (IM). Some Baby Boomers blog, some use iPods and may have PDAs" (Reda, 2008a, para. 22). Studies show that Boomer women consult Web sites before making purchases just as much as Gen-Xers and that all Boomers go online more frequently than most Americans (Paul, 2003). In other words, Boomers use many forms of media. Because these consumers are time starved, stress driven and seeking convenience anywhere they can in their lives, retailers and marketers alike must consider how to communicate the most effectively and efficiently with the Boomer generation.

Generation X

Generation X is the generation known as the "Baby Bust" because the birthrate of this generation is comparatively low as compared to those of the Baby Boomers and Generation Y. Individuals of Generation X were born between 1965 and 1977 (see Table 9.1). They are the 44 to 49 million strong generation hidden between the larger Baby Boomer Generation and Generation Y ("Farther Along the X Axis," 2004). This generation is also known as the Gen Xers, the Shadow Generation, Nikes, the Indifferent Generation, the Thirteenth Generation, and the Invisible Generation. Individuals of this generation witnessed the first Gulf War, the fall of the Berlin Wall, the *Challenger* explosion, Watergate, and the O.J. Simpson trial. Gen Xers grew up with MTV, the rise of AIDS, and a changing corporate America.

In the early 1990s, Gen Xers were described as skeptical, cynical, unmotivated, and apathetic. Older generations labeled them as "slackers." This slacker label was coined because Baby Boomers thought of Gen Xers as having few values and little work ethics. However, today, instead of being called slackers, this same generation has been redefined as only having different values than those from previous generations. Gen Xers observed their parents, who worked long hours and were dedicated and loyal to one company for the duration of an entire career, being laid off and losing their retirement benefits. Witnessing this changing workplace, along with recessions, economic downturns, and the downsizing of American companies, Gen Xers now question the motives of big business and corporate America. Therefore, these Xers distrust both corporate authority as well as other authority figures. "The majority of Gen Xers believe that it is more likely they will see a UFO than a Social Security check with their name on it. And they are saving money at a rate that far exceeds what the boomers were saving at the same age" (Trask, 2005, para. 8). This generation wants to work

but enjoy the work, have more time with the family, and have more leisure time to create a balance in their lives (see Figure 9.7).

This market segment is also known as the "latchkey" kids because many of them grew up in single-family households and had to be responsible for

Figure 9.7
Working Gen X mothers want careers and families.
(Courtesy of The Hosiery Association)

Color Plate 1 Runway photo shot of a collection by top designer. (Courtesy of The Hosiery Association)

Color Plate 2 Designer zone merchandise reflects a fashion image. (Courtesy of The Hosiery Association)

Color Plate 3 Echo Boomers shorten the fashion cycle through net surfing.
(Courtesy of The Hosiery Association)

Color Plate 4 A fashion trend can be interpreted into all items of apparel such as hosiery.
(Courtesy of The Hosiery Association)

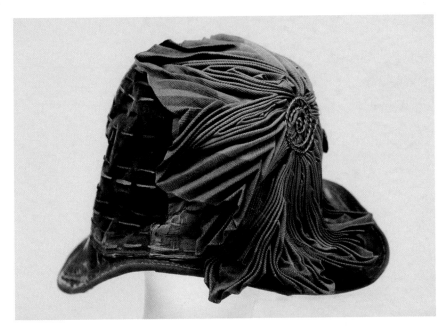

Color Plate 5
Fashion and its associated changes can be a powerful force on product demand.
(Courtesy of Oris Glisson Historic Costume and Textile Collection, Department of Apparel,
Housing, and Resource Management, Virginia Tech)

Color Plate 6
Girl's story board.
(Courtesy of Gerber Childrenswear LLC)

Color Plate 7 Shirts made from cotton fabric scrap and water bottles (blue), beer bottles (brown) and soft drink bottles (green).
(Courtesy of EarthSpun)

Color Plate 8 Historical hosiery ads for 1960s and 1970s.
(Courtesy of Glen Raven, Inc)

Color Plate 9 Awnings support the store image.

Color Plate 10
Boomers shop where retail environments are inviting.

Color Plate 11 PBH retail in Seoul, South Korea.
(Photographer: Sookhyun Kim)

Color Plate 12 Ethnic models in runway shows.
(Courtesy of The Hosiery Association)

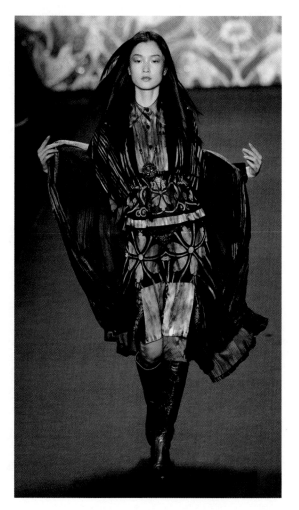

Color Plate 13 Justice is a retailer just for girls.

Color Plate 14
Story board for forecasting information at the buying office.

SPRING INTO ACTION

Color Plate 15
Location in the right place for a retailer.

Color Plate 16
A dramatic store entrance.

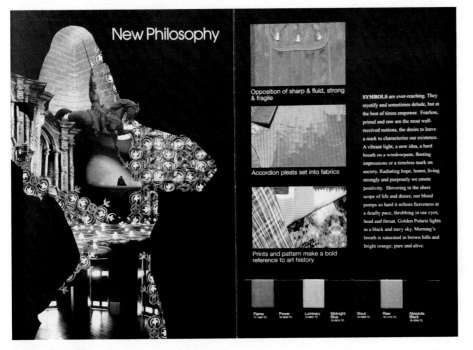

Color Plate 17
Trend information providing inspiration, color and fabric.
(Courtesy of Cotton Incorporated)

Color Plate 18

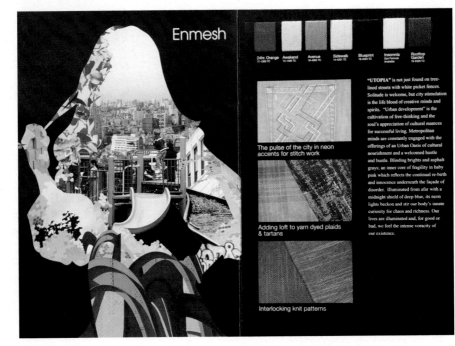

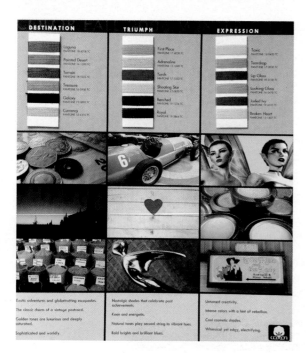

Color Plate 19 Trend information from
Cotton Incorporated.
(Courtesy of Cotton Incorporated)

Color Plate 20 Trend information
from the COTTONWORKS® Global
Fabric Library.
(Courtesy of Cotton Incorporated)

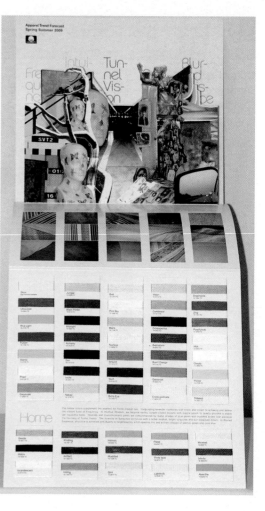

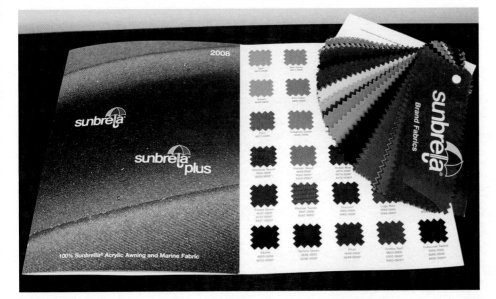

Color Plate 21
Colorways for the Sunbrella® line.
(Courtesy of Glen Raven, Inc.)

Color Plate 22
A marketing "take-away" for a retail buyer.
(Courtesy of Tobē)

This season there is a definite shift in fashion. Women are moving into an active position in all aspects of life including the way that they dress. The Player is the CEO, not just the CEO's wife. The Creative is no longer the artist's muse, she is the artist. The Avatar becomes the hero rather than a damsel in distress. The Nomad travels, shops, eats or wears things from everywhere. This is the beginning of a major creative cycle, a realization that we are each a single unit within the global family.

Players are the power brokers of fashion. They are confident enough to dress in softer clothes with feminine styling, colors and sheer attributes. Classics are reinterpreted in new fabrics. Suits can be sleeveless or paired with shorts. This is a new interpretation of sportswear.

The Creative is a sculptor, director, architect or musician. She becomes the creator by actively pursuing artistic fields. Women have always been "those who create, the mother" and now they are entering one of the most creative fashion cycles. The muse is now the artist. These clothes are fluid, they play with construction, as well as pattern.

Super women hunt in intergalactic space. Via the Internet the victim morphs into the Avatar, she can redeem injustices. This new fashion persona is constantly evolving and can change with a click of the mouse. High performance techno fabrics are essential as fashion's new body armor. In cyber-space, mortals become divine. Avatars are the saviors of cyber worlds and galaxies.

An awareness is growing—a willingness to embrace other cultural heritages. High-tech civilizations need and are grounded by ordinary everyday objects, common materials and simple traditional patterns or styles. Rustic, handmade articles and ancient printing techniques create one-of-a-kind originals and so take on greater importance. The Nomad is a collector who travels the globe or Internet to create her style with a diverse mix of cultural artifacts.

Color Plate 23
Products and materials with a Southwest theme.

Color Plate 24
Color matching with black, gray and white, and other colors.
(Courtesy of The AmeriTech Group, USA, Inc.)

Color Plate 25 Textile Protection and Comfort Center (T-PACC) with Pyroman in testing chamber.
(© Roger W. Winstead, NC State University)

Color Plate 26 Uniform using high tech fibers for protection.
(Courtesy of the Snowville Volunteer Fire Department, Snowville, VA, Bill Griffin, Engineer)

Color Plate 27 Manufacturer's advertisement for a national brand product.
(Courtesy of VF Jeanswear)

Color Plate 28 Story board in computer flats.
(Courtesy of The AmeriTech Group, USA, Inc.)

Color Plate 29
Right quantity for better selection.
(Courtesy of The AmeriTech Group, USA, Inc.)

Color Plate 30
Grouping of styles such as long sleeve tees.
(Courtesy of The AmeriTech Group, USA, Inc.)

Color Plate 31 The North Face
uses store image to position its
lifestyle brand in the marketplace.
(Courtesy of The North Face)

Color Plate 32
The North Face targets the authentic sports enthusiastic and the aspirational
athlete with its performance products.
(Courtesy of The North Face)

themselves during after-school hours and even sometimes during the evening hours. Being unsupervised, they were reared under very permissive parenting (Appel, 2005). Thus individuals in this generation became self-sufficient and very independent. Generation X also grew up with legalized abortion, available contraception choices (e.g., birth control pill), liberalized divorce, and an influx of women into the workforce. Gen Xers are the best educated generation in the history of the United States, with more women earning degrees than the men of the generation. "Almost half of Gen X women have a two- or four-year college degree, and more than one in 10 has a graduate degree. This high level of education has allowed these women to jump headfirst into the workforce and contribute to the household income in greater numbers than any previous generation" ("Beyond the Boomers," 2008, para. 5).

Gen Xers will have from 10 to 12 jobs during their employment years and three to four careers. They are creative and many have become entrepreneurs; yet, on the job, in corporate America, they are more collaborative and independent, more skilled in management, comfortable with women bosses, and good at accepting change (Appel, 2005). Xers view their careers as experiences that are interspersed with happenings in their lifestyle. This generation is now reaching its peak earning years. The fastest growing population segment, the Xers are establishing households, buying homes, and having families.

Because many Xers grew up in single-parent homes, they considered their friends as family. However, as these same Xers came into their childbearing years, they are creating their own families (see Figure 9.8). "Gen Xers' attitudes about family and home have already begun filtering into American society, culture and business . . . they're [Xers] often trend and opinion leaders" ("Farther Along the X Axis," 2004, para. 11). Many Xer women are staying home to rear their children, and most fathers of this generation are taking more responsibility for the care of both the children and the home. For example, some fathers are "choosing a more moderate career path to spend more time with their families. In fact, there has been a 54 percent increase in stay-at-home dads since 1986" (Trask, 2005, para. 12).

PRODUCT CHARACTERISTICS. This generation invented cross shopping. They desire quality products at the most reasonable price but will pay more for items their peers are purchasing or for goods that are of unique design or provide their lifestyle image. Presently, they are purchasing more children's clothing and home furnishings items because of their life stage. When shopping for home furnishing purchases, Xers who rent shop at outlet stores and mass merchants; Xers who are home owners frequent national specialty stores, and both groups shop at Target (see Figure 9.9). For many products, Xers do not shop at any one particular store, but they frequent different stores based on the product, their knowledge of the product attributes, and how much assistance or customer service they will receive when purchasing the product (Moran, 2005). These Xers are bargain hunters or they want "the most bang for their buck." Thus Gen Xers rarely make impulse buys and usually select merchandise that

Figure 9.8 Maternity wear for Gen X
mothers-to-be.
(Fashion Designer: Amber Roth)

is functional, economical, and high quality with a long lifespan. Maintaining cautious spending patterns, these Xers usually do not purchase extravagant or overly excessively priced merchandise.

"Gen X home owners tend to be more brand-name oriented and want appliances that match. Purchases are driven more by quality, brand name, and

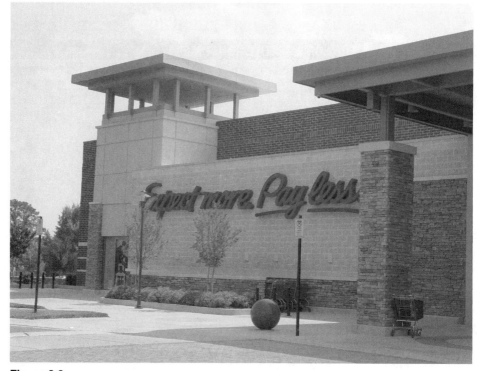

Figure 9.9
Xers are bargain hunters.

looks than by price" (Moran, 2005, para. 18). However, Gen Xers are less brand loyal than Baby Boomers. In fact, one study revealed that 65% of the Gen Xers surveyed ". . . held no loyalty to any retail brand" (Grimm, 2004, para. 11). The Xers think of the home and home furnishings as fashion. "They may buy an expensive antique dresser or a Sub Zero refrigerator, but they'll also buy a funky red sofa at Ikea that they won't mind getting rid of when they're tired of it" ("Farther Along the X Axis," 2004, para. 20). As in clothing, this generation will mix and match the quality of items to create their desired home decor. More Gen X men as compared to men of previous generations are helping select major home purchases of items from china to sofas ("Farther Along the X Axis," 2004). To reach these target consumers, merchandisers have to shop both apparel and home fashion markets (see Figure 9.10).

MARKETING TECHNIQUES. Having grown up with the media and every marketing gimmick imaginable, Gen Xers are very skeptical about advertising claims; therefore, they look for companies that provide straightforward and honest

THE HOME TEXTILE CONSUMER

to 30% for towels, 41% to 34% for sheets, and 48% to 42% for bedding. As a result, women actually reported spending slightly more on home textiles than in the 2006 survey. These results suggest that women are stocking up on home textiles when they find bargains.

WHAT WOMEN LOOK FOR IN HOME TEXTILES

Women overwhelmingly prefer to decorate their own homes (95%), rather than have someone else do it (5%), and economic conditions have not dampened their enthusiasm— 80% like to shop for home textiles, up from 77% in 2006. Even more women enjoy shopping for home textiles than "like or love" shopping for clothes (53%, according to Cotton Incorporated's 2007 Lifestyle Monitor™).

Consumers also care more about environmental friendliness in home textiles than in apparel. When shopping for home textiles, 20% of women put a lot of effort into finding environmentally friendly products, compared with 16% of those shopping for apparel (according to Cotton Incorporated's 2008 Consumer Environment Study). In the Home Fabrics Survey, close to half of women said that environmental friendliness was a very important feature (41% for towels, 45% for sheets, and 46% for bedding). According to the Consumer Environment Study, nearly three quarters of consumers believe that natural fibers are better for the environment than synthetic fibers, and they consider cotton to be the safest fiber for the environment.

The feature consumers care least about in home textiles is brand name—for each product category, nearly a third of women rated brand name as not at all important. The features they considered most important depended on the product, but price never topped the list.

KEY FEATURES

% who consider the feature very important*

Bath towels	
Softness	87
Size	85
Durability	83
Easy to clean	82
Absorbency	80
Sheets	
Size/fit	95
Softness	91
Price	89
Durability	87
Color/pattern	84
Bedding	
Size/fit	93
Wash at home	88
Easy to clean	87
Price	87
Color/pattern	86

*8 to 10 on a scale of 1 to 10
Cotton Incorporated's Home Fabrics Survey

COTTON—THE PREFERRED FIBER

Cotton is still the preferred fiber for home textiles—together, 100% cotton and cotton blends were preferred for towels by 97% of consumers, for sheets by 89%, and for bedding by 90%. The majority of women are willing to pay a premium for all-cotton home textiles, and the percentage willing to pay more for 100% cotton bedding increased significantly from 2006 to 2008 (from 51% to 56%).

Nearly all bath towels (98%) offered at retail are 100% cotton (according to Cotton Incorporated's Retail Audit). No women reported dissatisfaction with the performance of all-cotton towels, and the percentage who were "very satisfied" increased significantly, from 62% to 67%, indicating that the industry is paying attention to what features consumers want in their all-cotton towels.

The percentage of women who considered 100% cotton to be a very important feature in home textiles was up significantly from 2006 to 2008 for all three product categories, climbing 15 percentage points for towels, 18 points for sheets, and 18 points for bedding. The top reason women gave for purchasing 100% cotton home-textile products was the unparalleled comfort and feel of cotton.

COTTON GREW IN IMPORTANCE

% who considered 100% cotton to be a very important feature

■ 2006 ■ 2008

	Bath towels	Sheets	Bedding
2006	53	47	36
2008	68	65	59

Cotton Incorporated's 2008 Home Fabrics Survey

Figure 9.10
Xers, as first-time buyers, think of home furnishings as fashion.
(Courtesy of Cotton Incorporated)

advertising. These individuals want a savvy approach, sometimes encased in humor, from companies marketing product, not frills and whistles. They are the generation that researches the product before shopping, conducts a competitive product analysis on the Internet, talks to family and friends about product attributes, and then goes to the store to talk with sales experts before purchasing the product. When purchasing home furnishings, "This generation's design ideas are influenced by catalogs, merchandising displays, at national retail chains (vignettes/lifestyle/room settings), galleries, and stores outside of their income level, friends and neighbors, and television shows, such as those of Christopher Lowell and Martha Stewart" (Moran, 2005, para. 19).

Gen Xers also like marketing communications that convey cultural and social awareness or address the charitable intentions of the brand or company. Companies may reach these Gen Xers through cable television, digital television, and high-speed Internet service because Gen X individuals look at this technology as necessities rather than frills ("Beyond the Boomers," 2008). Although this generation has fewer numbers, they will be the future generation driving the marketplace. They will be replacing the Baby Boomer Generation in both the workforce and as a primary market for almost every product category available.

Generation Y

Generation Y consumers are identified by numerous taglines such as Gen Y, Echo Boomers, Millennials or M Generation, iGeneration, Internet or Net Generation, Einstein Generation, Google Generation, Boomlets, Nexters or Next Generation, Digital Generation, and Nintendo Generation. Although there is some dispute over the decades that this generation spans, most authorities agree that individuals born somewhere between the years of 1978 to 1985 compose the bulk of the generation (see Table 9.1). Others define the dates between the years of 1977 to 1994. Counting only those individuals born between the years of 1979 and 1990, there are 43 million Echo Boomers (Conlin, 2008).

Generation Y are children of the Baby Boomers; thus they have been tagged with the titles of Echo Boomers and Boomlets. Baby Boomers delayed having children to climb the corporate ladder, but in the 1980s large numbers of these Baby Boomers focused on having families. Echo Boomers are the second largest generation in U.S. history. These Gen Y children are the most wanted children in the history of the nation. Generation Y individuals have been coddled and protected their entire life span. They were the first to wear helmets when riding a tricycle or bike, the first to be strapped into baby car seats, the first to watch movies in a car, the first to wear very adult-like clothing as small children, and the first to have more choices, such as flexible times to go to bed, or what activities to do when or what to eat and where to go for dinner. They were the first to help make purchasing decisions as children.

Gen Yers experienced very structured childhoods as parents became very involved with their children's activities. For example, one author states that "After finishing 'Mommy and Me' and 'Gymboree,' children went to exclusive playschools

and arranged 'play dates.' Soccer practice, music lessons and other structured and scheduled time slots filled the week" (Trask, 2005, para. 17). Some grade school children were carrying Day Timers or scheduling calendars to school. Fathers were involved with raising the children and parents took a hands-on approach to become involved with the day-to-day happenings in the lives of the Gen Yers. Because of this family closeness, today's Millennials indicate that they like their parents; however, this trend has evolved into the "helicopter parents" that are constantly visiting their offspring at any time for any event at colleges and universities throughout the United States and across the globe.

This generation grew up with a world filled with technology or digital media, which they have extended to include their work at school (see Figure 9.11). Technology was introduced to the Boomlets at birth with toys and games that used the latest technological developments. All Gen Yers have computers, cell phones, and iPods. "Millennials are 'natives' of this new, digital, consumer driven, flat, networked, instant satisfaction world" (Sweeney, 2006, para. 3). This generation also grew up with MTV, reality TV shows such as *Project Runway*, and portable electronic music. Thanks to technology, Gen Yers have become multitaskers and are the best at juggling several tasks at once. Some authorities believe that being able to retrieve information at an instant has caused this generation to become impatient and to want instant gratification

Figure 9.11
Gen Yers are achievement as well as community oriented.

in all aspects of their lives. Through the technology of instant messaging and text messaging, Millennials communicate with friends and family constantly and expect this communication mobility to be available at all times or 24/7. This Net Generation believes that technology provides flexibility and convenience options. The Net Generation wants to "time and place shift" so they have the best option at any one given point in time (Sweeney, 2006).

Generation Y is defined by the Internet chat room, the Oklahoma City bombing, the World Trade Center attacks, the events of 9/11, the Iraq War, the shootings at Columbine and school bullies, Enron, presidential scandals, the death of Princess Diana, the return of Hong Kong to China, Y2K, anthrax scares, SARS epidemic and avian flu, plus other occurrences such as Hurricane Katrina and the Indian Ocean tsunami (Yan, 2006). Even though this generation has seen terrorism and catastrophic natural events in action, it has also seen heroism through the work of police officers, firefighters, and civic servants who addressed the events and moved the country forward. Patriotism has been renewed by this generation.

Individuals of Generation Y have been described as "sociable, optimistic, talented, well-educated, collaborative, open-minded, influential, and achievement-oriented" (Raines, 2002, para. 2). Also, Gen Yers are confident, hopeful, and community oriented or civic minded. They embrace diversity and are the most racially and ethnically diverse generation in history. In fact, one in every three individuals is a member of a minority group ("Generation Y", 2006). Gen Yers think that diversity is the norm and do not think the word "minority" describes them. Additionally, they feel empowered and entitled because their parents overindulged them with materialistic goods as well as showered them with the idea that they could be anything they wanted to be and have it all.

PRODUCT CHARACTERISTICS. Mary Beth Whitfield, senior vice president with TNS Retail Forward, explains, "By 2015, Generation Y will account for 25 percent of the U.S. population and will be responsible for a disproportionate share of spending on household purchases and apparel" (Misonzhnik, 2007). And, according to the Bureau of Labor Statistics' Consumer Expenditure Surveys, average Gen Yers spend 116% of their after-tax income (Francese, 2003). Generation Y shoppers already have their own individualistic personalities and look for clothing that reflects those personalities. They also influence what their parents and older family members buy. In fact, the new trend of moms and daughters shopping together and sharing clothes is definitely accepted by most of the Millennials.

However, these Millennials expect a multitude of choices and a voluminous array of product and services because of the choices they have found at their fingertips when surfing the Net. "They have grown up with a huge array of choices and they believe that such abundance is their birthright. . . . They desire ultimate consumer control: what they want, how and when they want it" (Sweeney, 2006, para. 7). These Echo Boomers surf the net to find the best products and deals, and then they ask their friends to give their opinions on the product before they purchase. Echo Boomers will pay a higher price if there is a reason behind

the price. For example, they want as much customization and personalization as possible when it comes to product and service selections. Customization can range anywhere from a personalized ring tone on the cell phone to a handbag or pair of jeans made especially for the individual Echo Boomer.

This generation has an eye for what is upcoming and new; therefore, they purchase instantly whatever catches their attention rather than a specific brand. In fact, Gen Yers are known for being notoriously brand disloyal and are infamous for being compulsive shoppers, thus making online shopping popular and convenient (Sebor, 2006). Also, because of the Internet, the Echo Boomers have shortened the fashion cycle because they see global trends at the same time and can adapt them immediately (see Figure 9.12).

Gen Yers like to give their business to retailers and brands that are socially responsible and civic minded; therefore, if they find a company or brand with these qualities they will be fiercely loyal. Brands that the Echo Boomers consider hip and cool are the ones that are purchased frequently. However, these brands must deliver consistent quality, and the price of the product must compete with that of the competition. Gen Y consumers shops in groups; they do not mind shopping in malls but would rather shop in stores with image and a reason for being. In addition, they may shop with their parents but often want to shop in a store designed for them. The retail store Pink is often positioned next to Victoria's Secret in shopping centers so mothers and daughters can shop together but for their own products (see Figure 9.13).

MARKETING TECHNIQUES. For this media-soaked, tech-savvy generation, there are three major marketing techniques to remember. First, Gen Yers want straightforward, stripped-down marketing communications without hype and popular slang with which they might address their friends. Companies that use simple, honest messages that are customized and speak directly to the consumer are successful in reaching the Echo Boomers (Seber, 2006). These Echo Boomers like simple, eco-friendly packaging without frills and excess.

Secondly, companies must reach the Millennials online and offline at events and locations where they congregate. Online the visual style is very important because this generation has grown up with graphics, vivid colors, audio, and animation. Marketing that engages the Yers and gives them control of the process are effective in reaching this generation. Also, companies that are successfully marketing to the Yers are posting advertisements on Web pages, e-mails, and ATM machines (Seber, 2006). Offline, companies and brands must go to events and visit places that Echo Boomers frequent. Companies and brands have found that special promotions, giveaways, interactive games at concerts, sporting events, campus and school activities, and even bars are effective in reaching this generation. Some companies have even used graffiti and chalking advertisements as well as free tickets to events or free product to reach this market segment. Third, word-of-mouth advertising is one of the best ways to reach the Echo Boomers. Sell the friends and peer groups of Gen Yers on a product and service and you sell other Gen Yers, for these individuals make their buying decisions based on peer recommendations. And, lastly do not talk down

Figure 9.12
Echo Boomers shorten the fashion cycle through surfing on the Net.
(Courtesy of The Hosiery Association)

Figure 9.13
Mother and daughter shop together.

to the Echo Boomers because they do not trust slick advertisements that attempt to push product on them.

Teens, Tweens, and Children

Teens, Tweens, and children are three other market segments that will have to be reckoned with in the near future. **Teens** are those fickle customers that are 13 to 19 years old (see Table 9.1). Having such a wide age span, this market segment is usually divided into subsegments by age groups. For example, the younger Teens center their lifestyle around school, whereas the older Teen may be completing high school, attending college, working, or starting a new household or career. Teens help to create fashion trends; they love to shop and consider it an enjoyable experience. However, they operate on a double-edge sword; they value individualism yet want to fit into their peer group and be accepted. And the majority of Teens love to shop for apparel over other product categories.

The "later aged female Teen" considers shopping as a very important activity because it affects both the peer group with which the Teen is affiliated and the position of influence the teen holds within the group. Older Teens feel that brand, including the fit, look, and style of the apparel, is a very important attribute to consider when making apparel purchases. Although these Teens are brand conscious, they are not necessarily brand loyal (Taylor & Cosenza, 2002).

Teens consider the type of store and the location of the store when shopping. They like to shop in malls and specialty stores (Taylor & Cosenza, 2002). But they will also shop department stores if there is "variety, sales, and service." They look for the right price and focus on quality. Teens like stores that have an appealing, exciting look and portray a specific lifestyle. And Teens like stores that have hip and cool unique offerings, but they do not want fashions that are exactly like all other Teens (Gogoi, 2007, para. 4).

Although Teens do not frequently buy online, they begin their shopping experience online as they research a purchase before going to the store. At the click of a mouse they contrast and compare product and prices. Mandy Putnam of TNS Retail Forward has researched Teen shopping online and states, "while young people prefer the 'sensory stimulation that accompanies shopping with friends at stores,' per-shopping online is training Teens to be smart shoppers and to stretch their dollars" (Reda, 2008b, para. 25). This preshopping online should be an indicator to retailers that a store's Web site should be exciting, should take a multimedia approach, stimulating the senses with visual graphics and color plus music, and should involve the viewer. For example, Abercrombie & Fitch uses a "flat merchandise presentation" to promote a variety of product categories, and Express has a virtual changing room for the customer to create a unique or personalized ensemble on screen (Reda, 2008b).

STORES magazine indicates that such stores as Abercrombie & Fitch (A&F), American Eagle Outfitters, Express, Aeropostale, Urban Outfitters, and Pacific Sunwear (PacSun) are some of the stores that Teens shop most often. A&F builds its brand by attracting children first with its kids' divisions and then offering Hollister, A&F, RUEHL, and Gilly Hicks to middle and high school Teens and college students. Some stores such as Old Navy, American Apparel, H&M, Zara, and Forever 21 that feature fashion at-a-price are also successful in attracting the Teen population (see Figure 9.14).

Teens have eclectic shopping patterns for several reasons. When fashion trends change Teens look for stores that have the next new thing. For example, Teens may leave a well-known retailer and drift to a unique store such as Buckle that is known for its denim (Gogoi, 2007) (see Figure 9.15). And another reason is that "On one hand, they're locked into shopping where Mom and Dad shop; on the other, they often seek out different items based on their sense of style and their desire to either fit in or express their individuality" (Reda, 2008, para. 12). However, the final purchasing decision for Teens remains in the hands of their parents who approve the purchase and pay the bill.

The second major market segment of this group is the **Tween** population. Tweens are the fashion savvy shoppers from the ages of 7 to 14 years old. These "in betweens" are more mature than children with sophisticated tastes, yet their

Figure 9.14
Fashion at-a-price for teens.
(Photographer: Alice E. Dull)

bodies have not developed to the point that they can wear teen clothing. However, they want to wear what the "twentysomethings" wear and sometimes are encouraged by some of their parents to dress sexy. Because of the Internet, cable channels developed just for them, magazines, catalogs, and stores, these customers know what is "cool" or what is "in" with their peers. This market segment is driven by imitation of both peers and celebrities. Tweens are influenced by the attire of celebrities, so they select brands the celebrities wear (Kennedy, 2004). For example, Hilary Duff and Hannah Montana are two of the major celebrities the Tweens follow. However, many times designs for these Tweens become blurred with those of their parents. For example, 7 for All Mankind, Polo, and Tommy Hilfiger are advertising and selling product to this market segment.

Because parents are the economic power behind the Tween market segment, the challenge of marketing to these Tweens is not to offend the parents while appealing to the Tween population. Most parents want a balance between trends, age-appropriate designs, quality, and price. They also want a shopping venue that is Tween friendly and appropriate, whereas Tweens like to shop in bright, eye-catching stores. Two popular stores owned by Tween Brands Incorporated, Limited Too and Justice, cater to this market segment (see Figure 9.16). Justice is found in strip or lifestyle centers, carries a narrower assortment than Limited Too, and has merchandise priced about 25% lower than Limited Too apparel (McCormack, 2007, para. 4).

Today's **children** are more astute and savvy than those of previous generations, and fashion has become a part of their lives as self-expression. They like

Figure 9.15
Teens shop in unique stores.

to shop, and some are even participating in the selection of their own apparel. However, when designing product and marketing to children, the company or brand must also satisfy the needs and desires of the parents of those children, because the parents control the purse strings of these small customers. Satisfying those parents does not appear to be a problem in today's market. There are two major sets of parents searching for children's clothing: the Gen X parents and the younger Baby Boomer parents.

Gen X parents in their 30s are having children at a higher rate than ever before. Additionally, most Gen X households are composed of dual-income families with more discretionary income than those of younger couples. Not only are the Gen Xers buying more maternity clothing for themselves, but they are also buying clothing for their children as a display of status. As Marshal Cohen of NPD explains, "Having a baby now is like having a country house or an SUV" (Orecklin, 2003, para. 10). "Those intent on having the best-dressed child on the playground can swathe their offspring in luxury labels as Burberry, Donna Karan and Versace, all of which offer clothes for the teething set" (Orecklin, 2003, para. 10).

Besides these high-priced designer brands, parents are buying the somewhat lower-priced designer brands, such as Polo, Tommy Hilfiger, and Liz Claiborne. Additionally, for everyday wear, these same parents are purchasing the midpriced products produced by Old Navy and the Gap plus the lower-priced private labels of many retailers such as Walmart, Target, and other

Figure 9.16
Justice is a retailer just for girls.

stores (see Figures 9.17a, 9.17b and 9.17c). In fact some of the discount stores have produced a line particularly for the Hispanic population, presently the largest minority group in the United States. Target has licensed product from the show Dora the Explorer, whose title character is Latina (Orecklin, 2003, para. 12). And the grandparents are known for making large-ticket impulse buys for these same children.

The other market segment having children are the younger subsegment of the Baby Boomers. "The concurrent trends of older moms and dads and an increase in dual-income families mean that many boomer parents are not only richer but also ready to spend lavishly on their little darlings" (Betts, 2008, para. 2). These

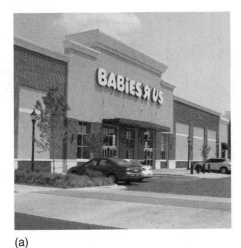

(a)

(b)

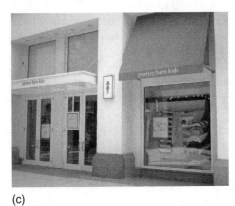

(c)

Figure 9.17 Places to shop for children (a), (b), and (c).

parents are buying premium denim brands such as 7 for All Mankind and Rock & Republic jeans for toddlers. Marshal Cohen of NPD explains this phenomenon as a status symbol for the parents and further explains that kids raised in such a culture influence the purchasing decisions of those parents. Cohen states, "As early as age 6, kids are getting more and more involved in choosing the products, including what they wear" (Betts, 2008, para. 5).

In summary, teens, tweens, and children are the future drivers of the market and the economy. They are multitaskers, they have to be entertained with sensory stimulation, they expect information instantly, they want to be interactive with a company and its products, they are techno-savvy, and they are socially conscious and very ethnically diverse (see Figures 9.18a and 9.18b). Companies and brands must meet them on their playing field and must differentiate between their needs and wants.

(a) (b)

Figure 9.18
Entertainment at the West Edmonton Mall (Alberta, Canada) (a) the beach and (b) ice rink.

Ethnicity

Ethnicity has recently been identified as a variable for some segmentation. **Ethnicity,** as a marketing variable, represents not only the race or biological heritage of a group of people, but also implies that the people within these groups share common cultural traits and interests and often have similar body types and skin, hair, and eye coloring (see Figures 9.19a, 9.19b, and 9.19c). These biological characteristics, combined with the recognition of cultural heritage, can be addressed in product development and marketing efforts to the applicable consumer segments. Ethnic segments within the United States that are recognized by a number of FTAR companies include the Hispanic/Latino consumers, the Black/African American consumers, and the Asian American consumers.

Hispanics

The Hispanic population is growing rapidly; it represents the largest and fastest growing ethnic market segment in the United States. This segment is composed of individuals from 30 different countries; however, the majority of the **Hispanic** population has immigrated from Mexico, Central and South America, Puerto Rico, and Cuba (Wesley, Fowler, & Vasquez, 2006). Hispanics value family, religion, and the ethic of hard work.

Most of the buying power for Hispanics is held by teenage and young adults of the population, and this purchasing power is growing three times faster than the rate of the entire United States (www.ahorre.com, 2006). The Hispanic consumer is a fashion-forward, brand-conscious, Web-savvy consumer ("Latina Fashion," 2005). Young Hispanic women are major trendsetters; they love to shop and will sacrifice comfort for fashion in apparel selections ("Latina Fashionistas," 1999). These consumers are brand aware and loyal to specific brands. One authority states that they want designer brands signifying luxury goods, such as Louis Vuitton, Gucci, Armani, Calvin Klein, Ralph Lauren, and Donna Karan, or more affordable brand names if they are in the medium and lower income brackets ("Latina Fashionistas," 1999).

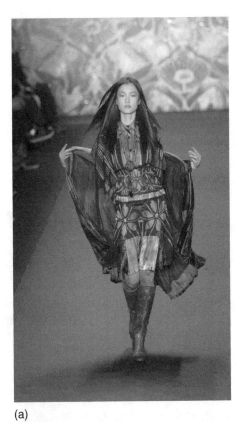

(a)

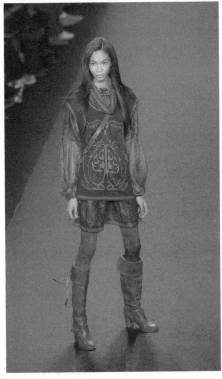

(b)

(c)

Figure 9.19 Ethnic models in runway shows (a), (b), and (c).
(Courtesy of The Hosiery Association (a, b, and c))

Hispanic women enjoy shopping as a social experience; and, being family oriented, they also like to shop with friends and family. A Hispanic OmniTel Retail Study indicates that the types of stores in which the Hispanic consumer likes to shop include national discount chain stores such as Walmart or Target, national midpriced department stores such as Kohl's, Sears, and JCPenney, and specialty clothing stores such as the Gap or Old Navy. This population also likes the national upscale department stores such as Macy's, Nordstrom, or Lord & Taylor ("Where Hispanics Shop," 2008) (see Figure 9.20).

Figure 9.20
Some market segments seek upscale department stores for shopping.

Sears advertises to the Hispanic market through customized Spanish advertisements; and in 2004, the retailer built Multi-Cultural Aspirational Concept (MAC) stores throughout the United States and hired bilingual sales associates to work in the stores. Kohl's is carrying a clothing line designed by Latina superstar Daisy Fuentes, and Kmart carries a line by Thalia Sodi ("Latina Fashion," 2005). "[F]ashion powerhouses such as Carolina Herrera, Oscar de la Renta, Narciso Rodriguez and Louis Verdad are taking Hispanic fashions from the street to the runway" ("Latina Fashion," 2005, para. 6). This market segment is directly impacting the design and availability of product in the mainstream United States and impacting what all fashionïstas are wearing.

Black or African American

Black or **African American** consumers want to be included in the mainstream of design and marketing and do not want to be singled out. For example, Pamela Macklin, fashion director of *Essence* magazine, explains that all customers like to see images of their population and that they also like to be represented in a group of diverse models; however, one model cannot depict an entire population ("Color My World," 2001). African Americans love to shop socially, shop more times per month than their White and Hispanic counterparts, try new trends earlier, and believe it is important to keep their wardrobe updated with trendy apparel ("Latina Fashionistas," 1999). Fashion and beauty are important to this market because the consumers in this segment tend to dress up for church, community, and special occasions ("Color My World," 2001). The African American customer searches for deals on products and services. However, the price of the item is not an issue, if the item is trendy and of good quality ("Color My World," 2001). Research by Cotton Incorporated's *Lifestyle Monitor*™ found that African American women would pay more for an item of better quality ("Color My World," 2001). Also, the fit of an apparel item is very important to this consumer when finalizing the purchasing decision.

African Americans follow the fashion trends of music icons. The Hip-Hop movement has greatly influenced fashion in the recent decades, and music icons such as Beyonce and Missy Elliot are now promoting the "luxury urban movement" of a more sophisticated and glamorous look. Designer lines and luxury items from companies such as Louis Vuitton (see Figure 9.21) and Christian Dior as well as Oakley sunglasses are examples of this urban luxury movement (Thompson, 2005).

Music icons and the entertainment industry, television channels such as Black Entertainment Television (BET), Music Television (MTV), and TV One, and consumer magazines such as *Ebony* and *Jet* will continue to influence the apparel selections of the African American consumer and impact the entire fashion industry.

Asian American

The term **Asian American** describes people from more than 11 different backgrounds, cultures, and languages. These 11 Asian groups include Asian Indian,

Figure 9.21
Glamorous products from designer stores are an example of the urban luxury movement.
(Photographer: Sookhyun Kim)

Cambodian, Filipino, Hmong, Japanese, Korean, Laotian, Pakistani, Thai, and Vietnamese. The U.S. Census Bureau defines the term *Asian* as people with origins from the Far East, Southeast Asia, and the Indian subcontinent. Asian groups are not only classified as nationalities but also in ethnic terminology such as "Hmong" (Reeves & Bennett, 2004).

Asian Americans maintain many aspects of their traditional culture and are perceived to be hard working, family oriented, and highly educated. Thus they earn higher salaries than those individuals in the total population of the United States. This market segment is also thought to be socially conscious. However, each major group of Asian Americans (i.e., Chinese, Filipinos, Asian Indians, Koreans, Japanese, Vietnamese) possess different values and maintain different buying practices. Therefore, marketing to this population is very difficult. For example, some groups are brand loyal and purchase high-end quality products; other groups consider price and are true bargain hunters. However, the bargain hunter also wants quality items ("Crossing Cultures," 2002).

Dressing well for the Asian customer is considered a matter of politeness and respectfulness as well as intrinsically important. From research conducted by Cotton Incorporated, there are two distinct Asian customers: the younger 20- to 30-year-olds who live in large urban areas and those over 35 who are conservative career dressers ("Crossing Cultures," 2002). "Asian American women have two main complaints with the fashion industry. One, the lack of

attractive, well-fitting clothing and two, a dearth of advertising and marketing messages that accurately reflect the number of Asian American women in the U.S. population" ("The Asian Boom," 2000, para. 3).

Many Asian Americans have long torsos and short legs; therefore they need petite sizes and smaller sizes. And, these petite sizes fall into two categories as one customer explains: Petites are "either for gray-haired little old ladies or for really tiny junior people who want tight clothes" ("The Asian Boom," 2000, para 8). Also, there is a limited selection of petite apparel in most stores.

As with the Hispanic population, Asian Americans desire Asian models in advertising pieces and want companies to address fit and variety of selection in products. JCPenney has addressed both of these desires. Some other retailers such as Banana Republic, J. Jill, Ellen Tracy, Kenneth Cole, and Prada (see Figure 9.22) have included Asian models in their advertising ("The Asian Boom," 2000). Regardless of the age or size, many Asian American consumers have money to spend, but the major problem is the incompatible fit and variety of selection in apparel products.

Demographic variables have traditionally been the major variable in segmenting apparel and other consumer product markets. Using age or other demographic variables for some strategic marketing continues to be part of a successful market plan; however, today's consumers often defy segmentation by demographic variables, especially in the income variable. For example, consumers with high incomes shop at discount stores, and consumers with low incomes may use much of their money for one major purchase or may use credit to purchase something beyond their ability to pay in the short- or long-term future.

Geographics

Geographics use the boundaries of a country or regions within a country or across several countries to identify a grouping of consumers. This segmentation also works well for some groupings if the geographic segmentation aligns with weather-related activities such as beach going or specific sports such as winter sports. Additionally, consumers in some geographic areas have developed particular tastes levels and product preferences founded on the heritage of the country from which their relatives migrated or based on traditional regional customs. Geographics in this instance is similar to ethnicity and overlaps the demographic variable when the population within a region has a homogeneous biological or cultural background. For example, in the areas along the Mexican border in the United States there are many consumers with Hispanic backgrounds and with much evidence of Hispanic culture in the marketplace. Signage is often in Spanish, Mexican and Spanish foods are the major offerings in restaurants, and the native building materials of clay tiles and adobe walls are used for many retailers. With a concentration of ethnicity among consumers within a geographic area, some cultural groupings

Figure 9.22
Some retailers advertise to ethnic markets.

can be identified using geographics; however, with the mobility of people within some societies and the ready availability of communications and travel, consumers are not as geographically isolated as in previous marketing periods; therefore, this variable is not always successful in current markets. Some marketers also use the distinctions of urban versus rural when

segmenting, but again, with technologies of cell phones, satellite TV, and the Internet, plus the ease of travel, rural customers may have seen the same movies or watched the same news and otherwise experienced the same fashion influences as urban customers.

Psychographics and Lifestyle Segmentations

Psychographics and lifestyle segmentations use combinations of variables for generating market segments. **Psychographics** include the values, ideas, ideals, attitudes, and mores of a population. **Lifestyle segments** are composed of the age of the target consumer crossed with the life stage and combined with the consumers' choices for the types of leisure activities; interests such as the arts or sports; opinions on politics, religion, and organized groups or club organizations; avocations; hobbies; and place of residence plus types of occupations held by consumers in the segment. In other words, how does the consumer choose to spend his or her time and money, and what preferences does the consumer consider to be valuable or important to maintaining his or her lifestyle? For example, a young upwardly mobile professional businesswoman may drive a BMW to support her particular lifestyle while her husband, who works in the building trades, selects a new shiny truck with every extra available (see Figure 9.23).

Two common segments used within this marketing segmentation include age and life stage groupings and interests, opinions, and personalities groupings.

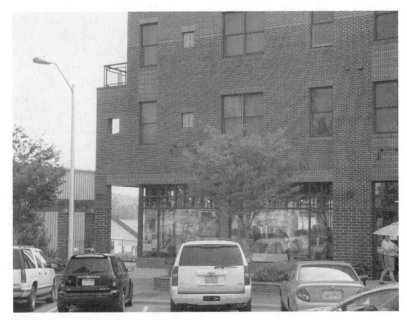

Figure 9.23
Lifestyles segments dictate consumer choices.

The **age and life stage groupings** create segments by combining the typical age variable with other family and housing situations that affect consumers. Numerous marketers have discussed this grouping, calling it life stages, life-cycle stages, family life cycles, and ages and stages. Regardless of the terminology, this segmentation method has been used with success because it groups consumers according to their needs and the types of products they buy. For example, a young couple with several small children has needs for products involving child care, family activities, and a constant expansion of clothing and footwear items. In contrast, a couple of the same age with no children might be spending money for clothing to be worn on a cruise or for dining at fancy restaurants. Age alone is not able to provide the distinction among these consumers' spending habits; however, the combination of age, life stage, occupation, and interests does define the market segment. In similar analysis, life stage alone does not define a specific segment. For example, a divorced Baby Boomer, who has recently remarried and begun a new family, may have entirely different consumer preferences from the young couple that is recently married and just beginning a family. The Baby Boomer with an established house and a small mortgage payment, a great job with a large salary, and ample health benefits may be shopping at a trendy designer store for maternity clothing. Meanwhile the wife of the young couple, with her partner in graduate school, two car payments, and outstanding college loans, may be shopping at a discount store for practical and versatile maternity outfits.

Other lifestyle and psychographic segmentations use psychological profiles of or interests and opinions from consumers to identify the segmentation boundaries. Several profiling processes are available for use by marketers. **LOV** is a scale to which consumers respond by itemizing a list of values such as a sense of belonging, the need for economic security, and a level of self-respect (Kahle, 1986). In the analysis, the marketer examines what values consumers hold as important in their lives. These are used as variables for segmentation. Incorporating both psychographics and lifestyle variables, the **VALS™2** uses a survey that asks questions about both a consumer's values and their lifestyle activities and links these to their demographics (SRI-BI, 2006). These personality traits are tied to behavior and can be used to predict shopping activities. An additional segmentation tool is the **Rokeach Value Survey (RVS)** that focuses on the personal value systems of a consumer (Rokeach, 1973).

Understanding the consumer across many variables is helpful for all firms along the FTAR pipeline. For example, fabric producers, using psychographic and lifestyle information, could make new products for their apparel manufacturing customers and their retailers. Their marketing research employees could identify, through psychographic profiling, that the consumers in the target market segments for their partner companies value time and family closeness. The target consumers are dual-income families who spend most of their leisure time in sports activities involving family outings. These families often go camping, hiking, and canoeing (see Figure 9.24). Because these families have both parents working, the amount of time spent on household chores such as doing laundry is minimal, and they choose to spend time with the children

Figure 9.24
Retailers provide products for family outings.

instead of time on these chores. These consumers also value fashion leadership and the opinions of their friends. To provide products that will satisfy these consumers, the complex of companies—a fiber producer, a fabric producer, an apparel manufacturer, and a retailer—partner to find products that are comfortable, attractive, and easy care. The fiber and fabric companies work to identify and manufacture a fabric that can be dyed in fashion colors, does not fade

or shrink, and dries quickly with no wrinkles. The apparel manufacturer works with the retailer to identify current styles and fit requirements that will appeal to the target consumers. As a team, these companies design, produce, and sell a line of products that will be satisfying to consumers with the identified values and lifestyle characteristics.

Behavioristics

To segment the market, marketers using **behavioristics** directly examine shopping behaviors related to a consumer's interest in fashion, retail stores, and other buying-related habits. **Shopping orientation,** a behavioristic segmentation method, uses a wide range of consumer attitudes and preferences to identify how a consumer shops. Many researchers have examined this topic. The resulting shopping segments that commonly appear from this segmentation method are economic shoppers, apathetic shoppers, and involved or active shoppers (Shim & Kotsiopoulos, 1993). The active or highly involved shoppers are of most interest to many merchandisers because these are the consumers who like to shop; they shop often and buy many products, especially products that are new or fashion forward. The behavior of economic shoppers is driven by financial or time-related variables. These consumers can also be a viable market segment for companies if the company can meet the requirements of the consumer. Time economy means that a shopper wants a store that is easy to locate, has ample and accessible parking, uses clear signage and wide aisles for locating products quickly within the store, and hires enough checkout personnel so the consumer never has to stand in line to buy the product. These time-driven consumers will buy products if the process is fast, easy, and hassle free. Consumers driven by financial concerns do price comparisons and buy products solely on the basis of its price. These consumers often make pricing comparisons using the Internet, catalogs, and in-store sources for obtaining information (Kelly & Allen, 2007). These consumers are also a viable market for a company if the price is right.

Behavioristics can also be used in segmenting a business market in addition to consumer markets. Fabric producers know that some customers (e.g., companies that buy their fabric) may value fashion-forward fabrics. To service these customers, producers must have a fast turn on dyeing and printing to offer the most up-to-date colors and patterns. In addition, the producers must be able to ship the product quickly and sell in small lots. In contrast, an apparel manufacturer who is cost driven is buying fabric that has a competitive price relative to other fabrics that he or she may choose, and the color or performance of the fabric is a secondary consideration or may be of no concern to the merchandiser who is buying fabric for the apparel manufacturer.

Another common behavioristic segmentation variable is the patronage habits of consumers. **Patronage** is used by research marketers to determine where consumers choose to shop and the reasons they make these choices. Today's consumers have a variety of retail locations from which to choose products and services. They may find the same product or similar products at a

brick-and-mortar store, a click-and-mortar store, in a catalog, over the Internet, on TV, or even at home parties or from direct sales personnel who will deliver the product to their office or home. With the retail landscape being overstored and overmalled, it is more important than ever for companies to build a solid customer base, encouraging repeat customers who are loyal to a particular retail establishment or who visit or patronize the firm regularly.

Retailers, as well as all other vendors, must determine why a particular customer segment frequents their business and continually returns to buy their merchandise or services. In the retail setting, these **patronage motives** can be combined into a profile of the type of retail business that the consumer desires for shopping, and then are addressed through the marketing P's—especially in product, price, and positioning. Consumers' desires for characteristics in the retailer's environment can be interpreted into the store's layout, décor, and convenience (or the layout of the catalog or look of the Internet home page); the merchandise mix and assortments as well as price ranges and points carried by the retailer; the fashion level (fashion image) of the merchandise; customer services (e.g., gift wrap, gift cards, personal shoppers) that are offered by the retailer; and the available quality and quantity of sales associates or online help, plus many more features that customers choose to demand. For example, some customers frequent a retail store because of its convenient location to their home or work; others may become loyal to a store because of its helpful sales personnel or because of the quality of the merchandise in relation to the price charged by the retailer. Customers like to know exactly what to expect from a store, and they want the desired factor to be constant and consistent so they may depend on the store under any circumstances.

Other behavioristic motives include rational motives and emotional motives. **Rational motives,** considered by the customer segment when purchasing, may include price, care characteristics, quality in relation to price, practicality, and serviceability as well as guarantees and safety associated with the product. The customer who lives on a limited budget is often affected by the state of the economy and must consider the price of the item, especially if it is a fashion product and not particularly needed, before making the purchase because household necessities must come first when paying the bills. If these consumers have any money for purchasing fashion items, they might frequent a discount store such as Target for their fashion needs. Conversely, consumers with ample discretionary income may decide to spend money on large luxury items and buy fashion at the initial retail price; therefore, these consumers might frequent a high-priced specialty boutique for their fashion needs such as Gucci or Kate Spade (see Figure 9.25).

Emotional motives include such criteria as status, prestige, or acceptance, to name just a few. Some consumers pay higher prices for status or prestige items because of the logo, an insignia, the designer name, the country of origin, or the source of the product. For example, if the designer label is Ralph Lauren, Armani, or Prada, consumers may pay a higher price for a product with these labels even though they can get a similar item of the same or better quality but without the label.

Figure 9.25
High-priced specialty boutiques for luxury items.

Because the demographics, psychographics, lifestyle, and other attributes of consumer populations change constantly, merchandising and marketing teams should research the most current information available when developing product for and marketing to a particular segment. Companies that do not constantly monitor their target customers as well as their customers' target consumers find that many times they are left behind in the competitive marketplace. Many of them go out of business and never realize why or what actually transpired to cause their demise.

Summary

Merchandisers must understand the people that their companies serve: the target customer and the target consumer. Much of their market research must be focused on the target consumer because no matter where their company is on the FTAR Supply Chain, they will have to understand and meet the needs and wants of the final product user, the target consumer. To better serve these consumers by providing them with the products and services that consumers want and need, merchandisers must know not only the basic demographic information about these consumers but also how the consumers think, feel, and react to the marketing environment. Merchandisers research who is the consumer, what product characteristics the consumer desires, and what marketing techniques will reach the consumer. Using generational divisions, geographic and ethic segmentation, lifestyle segmentation, and psychographics, the merchandiser can profile the consumer with finite detail.

Key Terms

African American
Age and life stage groupings
Asian American
Baby Boomers
Behavioristics
Black
Children
Demographics
Emotional motives
Ethnicity

Generation X
Generation Y
Generational divisions
Geographics
Gray market
Hispanic
Lifestyle segments
LOV
Mature market
Patronage

Patronage motives
People
Psychographics
Rational motives
Rokeach Value Survey (RVS)
Shopping orientation
Teens
Tweens
VALS™2

Review Questions

1. What is the purpose of understanding the people who are potential customers for firms in an FTAR Supply Chain?

2. What are the demographic variables that can be used in segmenting the market?

3. Why is generational segmentation useful for target market segmentation?

4. How do Baby Boomers differ from Generation X in their desired product characteristics?

5. What marketing strategies can be used to reach Generation Y consumers?

6. How does the geographic location of a retail store help a merchandiser understand the target consumer?

7. Why is ethnicity useful for market segmentation for a merchandiser?

8. Why are psychographics useful to the merchandiser?

9. Why can a merchandiser market with similar techniques to two generations who are in the same lifestyle segmentation?

10. How can behavioristics be used for marketing?

References

Agins, T. (2007, November 3). The boomer balancing act. *Wall Street Journal.* Retrieved June 9, 2008, from http://online.wsj.com/public/article_print/SB119403698280880824.html

Appel, N. B. (2005, April 1). Generations: Dealing with boomers, Gen-X, and beyond. Seminar presented to *Practice Management Digest Breakfast.* Available online at www.aia.org/nwsltra_pm.cfm?pagename=pm_a_20030801_genx

Betts, K. (2008, January 17). Downsizing style. *Time.* Retrieved June 9, 2008, from www.time.com/time/printout0,8816,1704695,00.html

Beyond the boomers: Millennials and Generation X (2008). *Ketchum's Online Magazine.* Retrieved June 17, 2008, from http://resources.ketchum.com/web/boomers.pdf

Braus, P. (1995, February). Boomers against gravity. *American Demographics, 17*(2), 14–18.

Color my world: African-American women have money and the desire to buy apparel—now if only marketers would realize it. (2001, May 31). *Lifestyle Monitor* Cotton Incorporated. Retrieved June 21, 2008, from www.cottoninc.com/lsmarticles/?articleID=156

Conlin, M. (2008, January). Youthquake. *BusinessWeek.* Retrieved January 10, 2008, from http://www.businessweek.com/print/magazine/content/08_03/b4067000290367.htm

Crossing cultures: Aspirational shopping is strong among different ethnic groups. (2002, May 30). *Lifestyle Monitor* Cotton Incorporated. Retrieved June 5, 2002, from www.cottoninc.com/lsmarticles/?articleID=116

Farther along the X axis. (2004, May). *American Demographics, 24*(4), 20–25.

Francese, P. (2003, September 1). Ahead of the next wave—Generation Y. *American Demographics, 25*(7), 42–43.

Generation Y: The Millennials ready or not, here they come. (2006). *NAS Insights.* Retrieved June 18, 2008, from www.nasrecruitment.com/TalentTips/NASinsights/GenerationY.pdf

Gogoi, P. (2007, August 10). How fickle teens flummox retailers. *BusinessWeek.* Retrieved September 24, 2007, from www.businessweek.com/print/bwdaily/dnflash/content/aug2007/db2007089_407269

Grimm, M. (2004, April). Gen X wants no-debt home ec. *American Demographics, 26*(3), 42–43.

Harvey, K. (2006, March 31). Financial gurus help parents cut the purse strings. *Burlington Times News,* pp. D1, D6.

Kahle, L. R. (1986). The nine nations of North America and the value basis of geographic segmentation. *Journal of Marketing, 50,* 37–47.

Kelly, L., & Allen, K. (2007). Crossing the great channel divide. *Retailing Issues Newsletter.* College Station, TX: Center for Retailing Studies.

Kennedy, D. G. (2004, April). Coming of age in consumerdom. *American Demographics, 26*(3), 14.

Latina fashion: From vogue to Kmart. (2005, October 5). Cotton Incorporated Press Release. Retrieved March 10, 2008, from www.cottoninc.com/PressReleases/?articleID-354

Latina fashionistas: Trendsetting Hispanic women are a marketer's dream. (1999, November, 18). *Lifestyle Monitor* Cotton Incorporated. Retrieved June 18, 2008, from www.cottoninc.com/lsmarticles/?articleID=222

Love those boomers. (2005, October 24). *Business Week.* Retrieved June 8, 2008, from www.businssweek.com/magazine/content/05_43/b3956201.htm?chan=search

Marketing to baby-boomer women. (2007, April 4). *Business Toolbox* (NFIB). Retrieved June 8, 2008, from www.nfib.com/object/IO_32916.html

McCormack, K. (2007, August 22). A tough break for tween brands. *BusinessWeek.* Retrieved August 23, 2007, from www.businessweek.com/print/investor/content/aug2007/pi20070822_980958.htm

Misonzhnik, E. (2007, November 1). Back to the future. *Retail Traffic, 36*(11), 58–66.

Moran, M. (2005, February 1). Grading the generational curve. *The Gourmet Retailer,* Retrieved June 18, 2008, from www.gourmetretailer.com/gourmetretailer/esearch/searchResult.jsp?keyword=Gradi

Orecklin, M. (2003, July 14). Spending it all on the kids. *Time.* Retrieved June 19, 2008, from www.time.com.time/printout/0,8816,1005199,00.html

Paul, P. (2003, March). Targeting boomers. *American Demographics, 25*(2), 24.

Raines, C. (2002). Managing Millennials. *Connecting generations: The sourcebook.* Retrieved October 17, 2007, from http://www.generationsatwork.com/articles/millenials.htm

Reda, S. (2008a). Five things you don't know about Baby Boomers. *STORES.* Retrieved June 3, 2008, from www.stores.org/Current_Issue/2008/06/Cover/index2.asp

Reda, S. (2008b). Talking on teens. *STORES.* Retrieved June 3, 2008, from www.stores.org/Current_Issue/2008/06/Edit1/index.asp

Reeves, T., & Bennett, C. (2004, December). *We the people: Asians in the United States. Census 2000 Special Reports.* U.S. Census Bureau, CENSR-17, 1–20.

Rokeach, M. J. (1973). *The nature of human values.* New York: The Free Press.

Schewe, C. (2002). Baby boomer market. *The National Tour Association's Research & Development Council.* Retrieved March 14, 2008, from www.ntaonline.com/staticfiles/car_boomr.pdf

Sebor, J. (2006). Y me. *CRM Magazine, 10*(1), 24–27.

Shim, S., & Kotsiopoulos, A. (1993). A typology of apparel shopping orientation segments among female consumers. *Clothing and Textiles Research Journal, 12*(1), 73–85.

SRI-BI. (2006). VALS™: Psychology of markets. Retrieved March 28, 2006, from www.sri-bi.com/VAL/

Sweeney, R. (2006). Millennial behaviors & demographics. Retrieved June 19, 2008, from www.library1.njit.edu/staff-folders/sweeney/Millennials/Article-Millennial-Behaviors.doc

Taylor, S. L., & Cosenza, R. (2002). Profiling later aged female teens: Mall shopping behavior and clothing choice. *Journal of Consumer Marketing, 19*(5), 393–408.

The Asian boom: Growing Asian-American population requires better understanding. (2000, February 17). *Lifestyle Monitor™* Cotton Incorporated. Retrieved June 21, 2008, from www.cottoninc.com/lsmarticles/?articleID=214

Thompson, S. (2005). Hip hop lines go from bling to black tie. *Advertising Age, 76*(47), 5–8.

Trask, T. (2005, February 9). Getting to know 'Gen X' and 'Net Gen' as jurors. Retrieved June 18, 2008, from http://sss.law.com/jsp/law/LawArticleFriendly.jsp?id=900005542190

Wesley, S., Fowler, D., & Vasquez, M. E. (2006). Retail personality and the Hispanic consumer: An exploration of American retailers. *Managing Service Quality, 16*, 167–184.

Where Hispanics shop. Retrieved June 21, 2008, from www.ahorre.com/negocio/where_hispanics_shop.htm

Yan, S. (2006, December 8). Understanding Generation Y. *The Oberlin Review.* Retrieved March 20, 2008, from http://www.oberlin.edu/stupub/ocreview/2006/12/08/features/Understanding_Generation_Y

chapter
10

Fashion Forecasting

Objectives

After completing this chapter, the student will be able to

- Define the fashion terminology that relates to analyzing and evaluating fashion trends
- Explain the theories of fashion adoption
- Identify the factors that inspire and influence fashion trends
- Identify techniques to track and interpret the fashion trend elements of silhouette, color, fabrication, and pattern
- Interpret trends for specific target markets
- Identify trend forecasting services and resources

Introduction

Fashion is big business; it affects all aspects of our lives. Traditionally, fashion influenced mainly women's clothing and home furnishings. Now it has an impact not only on women's and children's clothing and home furnishings and furniture, but it also has an influence on men's and boys' clothing as well as home appliances, cars, technological apparatuses, architecture, and even food, landscaping, and lifestyles.

Fashion is configured of diametrically opposing elements. It is both an expression of one's individual personality and at the opposite extreme it is mass

acceptance of a concept or idea. Fashion is a form of nonverbal communications to individuals that one encounters for the first time, or it can be a blatant self-expressional statement as when one wears designer apparel to indicate a specific social status.

Fashion is both an art and a science. Fashion is wearable art (see Figures 10.1a and 10.1b). From textile designs to logos on classic silhouettes and uncomplicated fabrics, artists have expressed ideas on every subject from religion to politics to current societal happenings through fashion. In the 1960s, the T-shirt went from underwear to become a symbol of the "hippie movement," symbolically communicating liberation, freedom, and disapproval of the war in Vietnam. In contrast, fashion is a science because technology is now driving the fashion industry and sometimes even the major fashion trends for a period.

Fashion mirrors society as to what is happening socially, economically, politically, culturally, and technologically. One of the best examples of fashion mirroring society is that of designer-created styles during wartime. During World War II, much of the fabric produced in the United States was needed to make products used by the military. Nylon, usually used for fashion hosiery and underwear, was needed to make parachutes for the armed forces (see Figure 10.2).

Because of fabric restrictions, designers were limited to how much fabric could be used in creating and developing a new design. Suit-weight fabric was often used for uniforms, and the shorter, fitted skirt was the norm of the day. After the war, Christian Dior introduced a more feminine silhouette with a long, full skirt and a fitted-waist jacket. Due to the psychological climate, Dior's new design gained instant acceptance, reflecting the desires of the consumer and the cultural environment. Many other designers followed this fashion lead with full flowing skirts and rich embellishment. Balenciaga's early designs showed this full rich silhouette, with later designs becoming more tubular but retaining back or other fullness (see Figure 10.3).

(a) (b)

Figure 10.1
Fashion is art: a 1960s hat made of silk fabric leaves and a rose (a) front and (b) top.
(Courtesy of Oris Glisson Historic Costume and Textile Collection, Department of Apparel, Housing, and Resource Management, Virginia Tech. (a and b))

Raincoat with matching sou'wester hat, VIVATONE®
awning stripes, Custom Fabrics Div.
Pleated dress in GLENSTRIPE, Warp Knit Div.

Fringed awning of SUNBRELLA®, Custom Fabrics Div.

Figure 10.2
Historical ads for hosiery from the 1960s and 1970s.
(Courtesy of Glen Raven, Inc.)

Thus many historians study fashion magazines to determine societal trends, the climate, and happenings during a specific period of time.

Fashion also mirrors the lifestyles of the consumer. Activities, interests, and work environments call for specific apparel and dictate many trends. For example, when casual wear was introduced into the workplace, menswear companies producing tailored suits found that their businesses changed dramatically. Eventually "casual Fridays" developed into everyday dress at work. Men who had worn long-sleeve white dress shirts, neckties, and tailored suits found themselves shopping for sportcoats, polo shirts, and khaki or more casual pants. This casual work attire spilled over into other societal trends and influenced other product categories such as home furnishings and weekend wear.

Figure 10.3
Balenciaga gown with the rich full sweep of the 1950s style.
(Courtesy of Oris Glisson Historic Costume and Textile Collection, Department of Apparel, Housing and Resource Management, Virginia Tech.)

Fashion Terminology

If fashion is so powerful and plays such an important role in our lives, what is "fashion"? Which is correct: "being in style" or "being in fashion"? What is a "design"? What is a "classic" and what is a "fad"? What is "fashion forecasting"? How does one spot a "fashion trend," and what makes a fashion concept develop into a fashion or a trend?

A **style** is the silhouette of the garment combined with all of its unique and distinctive components. The combination of these distinctive components, attributes, and design elements differentiate this garment from other products of the same or similar type. Once developed and accepted, it remains a style; it may be reinvented or altered to reflect the needs and direction of another time period, but it does not change. For example, a blazer has a very distinctive appearance, but for some fashion periods, it may be double-breasted and at other times it may be interpreted as a single-breasted jacket. However, the silhouette and unique characteristics of the blazer never changes. No one will ever confuse the blazer with a safari jacket or with a cardigan jacket. A style is not a unique phenomenon of apparel but is also prevalent in architecture, automobiles, furniture, and many other aspects of our lives.

A **design** is an individual interpretation of a particular style. When the fabric, trim or findings, or other design elements of a style is varied, a distinctive design is created. For example, one straight-leg jean may have a highly distinguishable embellishment on the leg and front pocket, and another jean has a unique wash and features a back pocket with logo stitching. These individual versions of the jean or versions of the same style are designs.

In addition, fashion is the change element in the style-versus-fashion equation. **Fashion** is the prevailing style at any given time accepted by a substantial group of consumers. Fashion changes constantly and thus impacts the economy of many types of businesses. Many fashion products exist simultaneously because different groups of consumers accept different styles at any given time. A style is a fashion as long as a substantial group of people accepts it. However, when the popularity of the style wanes and another style takes its place, the style is no longer the fashion. Fashion is constant change, whereas styles are always styles after once created.

A fashion or fashion products have a distinct product life cycle, showing slow growth upon initial introduction with increased growth over time and a gradual decline as fewer and fewer consumers are interested in the product. The life cycle of the fashion product is usually represented by a bell-shape curve (see Figure 10.4). A style that remains in fashion or is accepted over a long period or lengthy duration of time is known as a **classic.** Examples of classics include blazers, cardigan and turtleneck sweaters, oxford cloth shirts, T-shirts, and denim jeans and khaki pants. The continuing popularity of the white, oxford cloth button-down collar shirt shows that it is a classic, as is the simple tailored navy blazer with gold buttons that so many people

wear. In Figure 10.4, the classic trend is depicted with the long continuous broken line to illustrate how a classic remains for a long period of time.

Many classics remain season after season and year after year; however, they are usually reinterpreted to fit the environment or fashion trend period of the times. One season the turtleneck sweater may be offered in a cotton knit, cable-patterned fabrication with a more fitted silhouette and short sleeves. The next season the same turtleneck may be executed in a fine cashmere fabrication in an oversized silhouette with long sleeves. Both sweaters are turtlenecks and become constants in the seasonal line of the manufacturer. Usually classics are simple in design and are not as easily dated as fashion designs.

At the opposite extreme of the classic style or design is the **fad,** a style or design that gains a sudden popularity with a group of consumers, is quickly bought in volume by the consumer segment, and then disappears as quickly as it appeared on the fashion scene. Fad products have short product life cycles and are often seen in lower priced products or accessories (see Figure 10.4). Many fads last only one season; therefore, the consumer is unwilling to invest much money in the product. One of the most recognized fads of the past decades is that of the Nehru collar jacket; a recent fad may be the grunge movement.

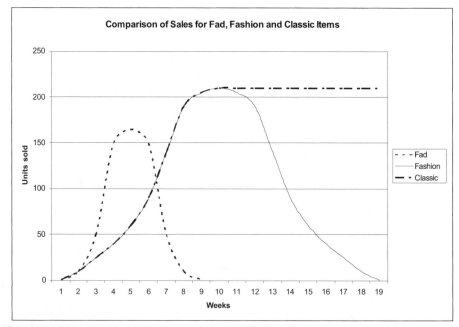

Figure 10.4
Comparison of units sold over time for fad, fashion, and classic items.

Forecasting of Fashion Trends

To determine what the consumer will buy in the future, the designer, merchandiser, product developer, retailer, and other individuals in the fashion industry must predict what the consumer will want and need 6 to 18 months in advance of when the consumer makes the purchase. Therefore, the fashion industry must identify and predict or **forecast trends** in a particular industry zone that will be accepted by the target customer for a future selling season.

A **trend** is the direction of movement of a particular concept, product, or design idea. This is also described as the prevailing tendency or inclination or preference of design characteristics for a particular consumer group, or a current style or preference (K. Gordy-Novakovic, personal communication, November 2003). Trends indicate the direction and movement of fashion. To predict future trends, fashion forecasters conduct an environmental scan, including social, psychological, cultural, political and legislative, economic, environmental, and technological trends that are impacting the fashion industry (see Chapter 8). Additionally, the forecasters observe the lifestyle and life stages of the target consumer and pinpoint retail, media, and advertising trends (see Figures 10.5a and 10.5b). Forecasters then determine how these trends impact fashion and its direction and movement.

Fashion Direction and Movement

As previously discussed, fashion changes constantly because most consumers become bored quickly with a color, silhouette, or fabric. Or because of the happenings of the time period, consumers are forced to select merchandise based on external factors that drive a new trend or type of merchandise. For example, the casual dress mode of the 1990s enduring into the 2000s for office attire is presently being questioned by top management of many companies. The casual look is now evolving into a "dressy casual" or more professional look with a new twist. Most fashion trends are **evolutionary trends,** and most times they slowly evolve onto the fashion scene without the consumer actually recognizing the trend or articulating its importance. In fact, the evolutionary nature of fashion, instead of a revolutionary nature of fashion, is recognized by fashion forecasters as one basic principle for the basis of forecasting fashion trends. There are few times when fashion trends appear on the scene in a revolutionary manner. Those times would be some natural catastrophic happening, such as the horrific weather events of hurricanes and floods or other societal events such as wars and legislation that impact the fashion industry.

Also, to create additional business and more profit, designers create fashion change to tempt consumers with new lines of unique designs each season; manufacturers knock off or copy those new designs and offer them to the retailer to sell to target customers; and, then consumers attempt to create their own individual trends from those offerings. Thus fashion change is a constant and is impacted by the industry, the consumer, and happenings in the societal context.

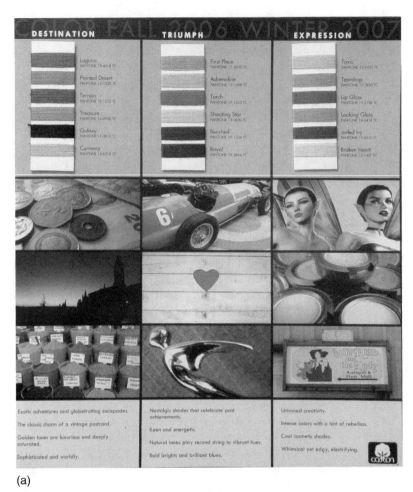

(a)

Figure 10.5
Trend information from Cotton Incorporated (a) and (b).
(Courtesy of Cotton Incorporated (a and b))

Fashion forecasters must observe and track all of these factors to predict an incoming fashion trend (trending trends and fringe trends) and to identify the outgoing fashion trends.

Fashion Cycle

Fashion trends may begin with new fiber developments or fabrications that impact a specific segment of the fashion industry, or they may begin with new themes or inspirations and color palettes or reinvented styles and silhouettes or even with embellishments, trims, and findings. Tracking and predicting fashion trends is very difficult, especially when the consumer is so fickle and technology has impacted all aspects of the supply chain and the speed of product development.

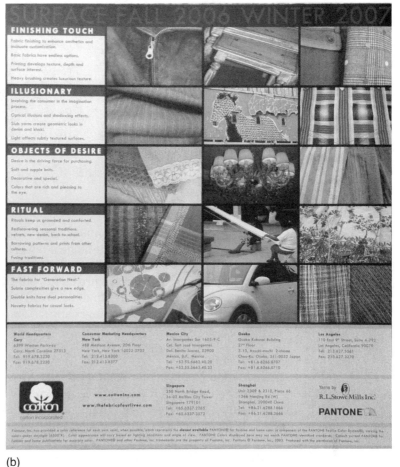

(b)

Figure 10.5 *(Continued)*

However, the **fashion cycle,** or bell-shape curve, is a tool trend forecasters have used for decades to predict the evolution of a trend (see Figure 10.6). This bell-shape curve helps forecasters trace the speed of the movement and endurance and direction of the trend. Not all fashion cycles can be easily analyzed because not all fashion cycles have the same endurance length; nor do they peak at a specific time or with a particular depth. Additionally, several fashion cycles at various stages are in play at any one given time, and these cycles tend to overlap as simultaneous happenings.

All fashion cycles have definite stages. The fashion cycle or bell-shape curve begins with the **Introduction Stage,** composed of the substages of *innovation* and *rise* (Kincade, Gibson, & Woodard, 2004). The cycle passes to the **Acceptance Stage** with substages of *acceleration* and *general acceptance* and culminates in the **Regression Stage** with substages of *decline* and *obsolescence.* In each substage of

Stages	Introduction		Acceptance		Regression	
Substages	Innovation	Rise	Acceleration	General Acceptance	Decline	Obsolescence
Customer	Fashion Trend Innovator	Fashion Expert	Fashion Pragmatist	Fashion Fundamen- talist	Necessity Shopper	Deprived Shopper
Merchandise Type	Designer & one-of-kind fashions	New prophetic styles	Wardrobe- building garments	Durability & practicality in product	Markdown & off-price goods	Clearance merchandise

Figure 10.6

The Fashion Cycle Curve: Its evolution and decline.

(Adapted from Kincade, Gibson, & Woodard (2004))

the three major stages specific target consumers have specific merchandise needs, wants and desires. By pinpointing in what stage a particular product category is positioned, both the manufacturer and retailer will know how to identify which consumer to target and how to forecast what product to offer in what channel of distribution and what type of merchandise to make available. In the Fashion Cycle Curve (see Figure 10.6), the fashion cycle stages and substages with customer types and merchandise types are briefly depicted. (To view how the Fashion Cycle Curve impacts the entire supply chain, refer to its integration into the Buying-Selling Curve in Chapter 14.)

In the Introduction Stage of the Fashion Cycle Curve, the consumer in the first substage or the innovation substage is known as the *fashion trend innovator*. This consumer selects designer items or one-of-a-kind goods while the *fashion expert*, or "fashionista," in the rise substage selects knockoffs or adapted versions of the designer items and usually purchases those items in the Bridge and Contemporary industry zones. These two consumer types are the fashion leaders in their communities, and their attire is usually copied by the fashion followers in the acceptance stage of the Fashion Cycle Curve's bell shape.

The two substages of the acceptance stage are acceleration and general acceptance, and the customer types are the fashion pragmatist and fashion fundamentalist, respectively. Manufacturers adapt the incoming and current fashion trends for customers in these substages to appeal to the mass market. These substages are most important to the industry because the main volume of the business is realized in the peak of a trend. In the acceleration substage, the *fashion pragmatist* might purchase the trend product that has been interpreted for that particular segment of the mass market at a department or specialty store and more than likely will purchase the trending product in the Better and Moderate industry zones. This merchandise is at a position in the cycle where it can be integrated into an existing wardrobe and can be worn for several seasons. The *fashion fundamentalist* buys product at the peak of the Fashion Cycle Curve and looks for durability and practicality in the product. This consumer may buy regular price product at a department store or off-price product at a discount store or mass merchant.

In the Regression Stage, the *necessity shopper* buys markdown and off-price merchandise, whereas the *deprived shopper* buys clearance merchandise that is an outgoing trend and no longer desired by the other consumers. Although the term "deprived shopper" is associated with the obsolescence substage, it does not always imply that the consumer does not have the income to purchase in the other stages of the Fashion Cycle Curve. Sometimes, these consumers are not interested in fashion and will not pay the price for trendy merchandise that has no appeal for them.

Paul Poiret, a historic Paris designer, is said to have stated that "all fashion ends in excess." Trend forecasters throughout the decades have paid close attention to this principle when analyzing the Fashion Cycle Curve. When a fashion is no longer in vogue, regardless of the retail price or the amount of advertising and sales promotion, the merchandise will no longer sell. Also, when extremes are reached in a specific fashion, forecasters immediately look for the next incoming trend.

Many fashion experts believe it is much easier today than in the past to predict trends. David Wolfe, Creative Director for Doneger Group, a retail trend-consulting company, stated that he believes two factors impact the endurance of a trend: "comfort and sex appeal" (Tan, 2008, para 2). Additionally, he stated, "If it suits the way people live today" (Tan, 2008, para. 2) or speaks to the lifestyle of the customer, the trend will remain longer and have more staying power. "Another way to [figure] out whether a trendy item will last is the level of exposure it gets" (Tan, 2008, para. 2). If an item gets multiple press coverage (i.e., magazines, television, and Internet) after the staging of the seasonal runway designer fashion shows, if fast-fashion retailers copy the look immediately, and if multiple designs of the original design concept reaches stores before or at the same time as the designer merchandise, the trend becomes overly saturated and only lasts for a few seasons instead of a few years as in the past (Tan, 2008). Fast-fashion retailers such as H&M, Zara, Topshop, and Mango have had a huge impact on the development, movement, and direction of modern-day fashion trends.

The Pendulum of Fashion

Another curve that assists fashion forecasters in predicting incoming, current, and outgoing fashion trends is the **pendulum of fashion**. As previously stated, the principle that "all fashion ends in excess" implies that a trend has run its course and has gone to the farthest extreme of interpretation as possible. If comparing the trend to the swinging of a clock pendulum, the trend begins in its simplest state at the beginning of the swing of the pendulum (see Figure 10.7). As the pendulum continues to swing or move toward the center or arc of the swing, the trend picks up speed and intensity as it moves. As the pendulum continues to swing in the opposite direction from where it began, the trend becomes so extreme, so exaggerated, and overly saturated, the consumer becomes bored and will no longer purchase the product. Therefore, a trend many times begins in a subtle manner and then ends in its most extreme rendition; thus, it swings back and forth.

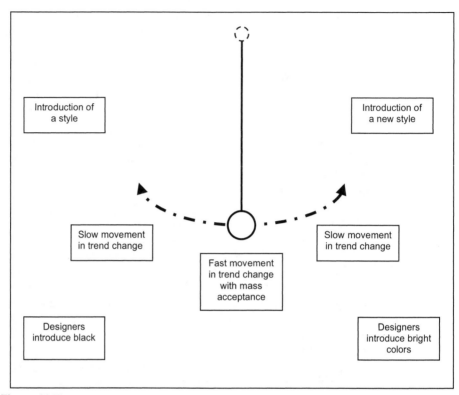

Figure 10.7
The Pendulum of Fashion swings from one extreme to another and can be used to predict trends.

Black is an example of the popularity of a color. For three decades, designers and the fashion industry have offered numerous designs in many shades of the color "black"; and customers purchased the color until it became oversaturated in their wardrobes. Therefore, European fashion designers reintroduced bright colors to their lines to create newness in the market and renew the color palette. Another example of the fashion pendulum swinging from side to side is the overembellishment or overdetailing of apparel designs. From this overembellishment and overdetailing, designers and the industry turned their focus to the simplicity of the silhouette with no embellishment. Clean shapes and chic, slim silhouettes coupled with bright color and prints translate into the new "minimalism" trend (Wolfe, 2008). Going from overly exaggerated embellishment to no embellishment at all, the pendulum swing completed an entire cycle and swing. The swing of the fashion pendulum indicates an incoming trend direction and brings a newness and calm to the fashion scene.

Wolfe (2008) also believes the fashion pendulum not only swings from side to side but also from top to bottom. At any given time, streetwear trends or

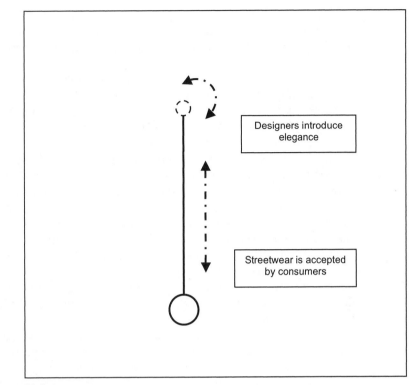

Designers introduce
elegance

Streetwear is accepted
by consumers

Figure 10.8
The Pendulum of Fashion can also rise and fall.

designer trends may drive the industry. After streetwear has influenced the market for several decades, the fashion pendulum begins to rise (see Figure 10.8). The rise equates with the upper aspiration of the consumer and culminates in acceptance of designer trends such as the movement away from flashy overembellishment apparel to understated elegance with retro glamour and status style. The element of contrast brings newness to fashion and signals the beginning of a new trend.

Another example of the fashion pendulum's rise and fall is the importance or lack of sex appeal as a trend (Wolfe, 2008). Many modern-day forecasters follow the use of the sex appeal factor to determine how the next big trend will arrive on the fashion scene. This factor can be tracked through the observation of the **shifting erogenous zone** phenomenon. Some fashion experts hold to the belief that designers, when creating their apparel silhouettes, concentrate on uncovering one major erotic (sexually stimulating) zone or part of a woman's anatomy (shoulders, breast, neckline, waist, hips, derriere, legs) as a point of emphasis while totally covering all other parts of the body. Early psychologists thought that a designer could concentrate on only one erotic area of a female body at a time and as the eye became bored with that part of the anatomy, then the designer selected another or new erotic zone. Thus the terminology *shifting*

erogenous zone was coined in the fashion industry. After overdressing and underdressing a selected erogenous zone, the fashion industry moves to another part of a woman's anatomy to accentuate or expose. After the major exposure of that particular part of the anatomy and the covering of that zone, another erotic zone is selected. The former erogenous zone is known as being in the state of **classic compromise.**

A good example of the shifting erogenous zone is that of the positioning of the neckline of a garment (see Figure 10.9). When trends are more classic, preppy, or conservative, many times the turtleneck sweater is a very popular top to be worn with the classic blazer. More than likely the waistline or leg is the part of the woman's anatomy that designers are emphasizing. As the eye becomes bored with the classic look, designers begin a new trend by lowering the neckline of the turtleneck to become a scoop neck or v-neck silhouette. As seasonal lines are introduced, the neckline slowly plunges, revealing more and more of the bustline. In recent times in fashion, necklines have actually plunged to the waistline with the manipulation of the halter dress neckline, exposing most of a woman's breast. Or see-through blouses reveal the totality of the woman's anatomy. A newer rendition of this exposure might be the bra, formerly an undergarment, being worn as an outer garment in combination with the sheer shirt or an open-front blouse.

Although all fashion experts do not agree with the shifting erogenous zone phenomenon, tracking the seduction attraction of apparel has become an excellent method for identifying incoming and outgoing trends. Any new occurrence in fashion is a significant factor that forecasters must track and analyze. When put together, the fashion pendulum with its swing and its rise and fall provides merchandisers with a complex and valuable tool for analyzing current trends and predicting future trends (see Figure 10.10).

Figure 10.9
Silhouettes showing the shift of fashion from bateau neckline to plunging V neckline.
(Fashion Designer: Amber Roth)

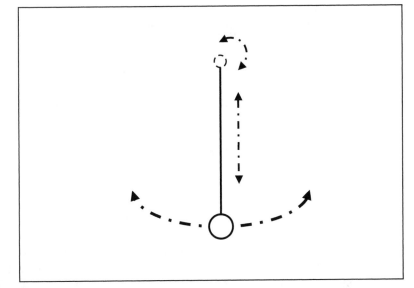

Figure 10.10
The movement of the Pendulum of Fashion can be a valuable tool for fashion trend analysis.

Fashion Adoption Theories

The constant in fashion is change. Some consumers believe that businesses in the FTAR Complex attempt to force change in fashion by introducing new trends to create more sales and thus create obsolescence in well-established trends. Traditionally, it was thought that designers forced the change and that the fashion media and retailer assisted the designers in pushing this change onto to the consumer. However, in today's marketplace, many forecasters believe the consumer is creating the change and that the trends are coming from the street or from subcultures such as extreme sports, musical groups, technology, and globalization.

Tracking changes in fashion trends is a continuous, arduous, and a time-consuming process; yet, in many cases, fashion drives all segments of the FTAR Complex and the development of the seasonal merchandise line. Although the flow and developmental direction of fashion trends are sometimes elusive and difficult to pinpoint, traditional theories of fashion adoption can guide the merchandiser and provide insight into the fashion cycle in all links of the FTAR Complex (see Table 10.1). Those theories include the trickle-down theory, the bottom-up theory, and the horizontal flow or simultaneous adoption theory.

Trickle-Down Theory

The **trickle-down theory** indicates that an innovative fashion must begin and be accepted at the top of the social ladder with the affluent customer who can afford designer or innovative product. The fashion taste level (i.e., fashion stage of the product) or description of this consumer would be known as the

Table 10.1
Examples of fashion movement and the fashions created.

Movement Theory	Direction	Fashions
Trickle-Down	Fashion Elite → The Masses	• Glamorous designer dresses • Elegant power suits
Bottom-Up	Street → Elite	• Jeans and T-shirts • Grunge • Black leather jackets and pants
Horizontal	Everyone at Once	• Luxury sweaters • Exotic leather pocketbooks

fashion innovator or in some geographic locations as the *fashion expert* (see Figure 10.6). Once the wealthy consumer and/or fashion elite accept the style, then the middle-class consumer will imitate the fashion trend; and, lastly the lower social class customer will purchase the product. The pill box hat, such as the Dior hat in Figure 10.11, was made famous in the 1960s when worn by Jacqueline Kennedy and other celebrities. The small boxy hat perched atop a bouffant hairstyle was soon adopted by most female consumers, and practically every woman in the United States had some variation of the hat.

By the time the middle-class consumer or the *fashion pragmatist* and/or *fashion fundamentalist* accepts the fashion product, the fashion innovator or the upper-class fashion elite consumer has already discarded the fashion trend and moved to another innovative trend (see Figure 10.6). As the trend becomes more popular with the masses, the price of the product is less; therefore, a consumer in a lower social stratum can afford to purchase the product. Historically, members of royalty were the fashion elite, and these individuals were imitated by nobility and then by the members of the middle class who had wealth. Some fashion experts believe this theory is not as applicable in today's marketplace as it was in the past. However, when taking into consideration the many major societal changes, some trend forecasters believe the adoption theory is still applicable in modern-day society.

On today's fashion scene, there is a new fashion elite composed of designers, celebrities, movie stars, and well-known business, media, and political personalities who may be the fashion trend influencers at any given time. Celebrities many times are the driving force behind new fashion trends. Several Hollywood celebrities, photographed wearing a particular color and style of jacket, influence the trend direction on that particular product category and color palette for the same season of the next year (Wolfe, 2008). Even if the fashion elite decide to ignore fashion or dress casually in premium denim jeans and designer tees, these fashion leaders are still imitated by the masses.

Both imitation to fit into a peer group or class structure and differentiation to express one's own individuality through fashion are basic human needs that perpetuate the trickle-down adoption theory. Also, fashion elite as well as fashion followers at any given time base their purchases on the nature of the

Figure 10.11
Fashion-forward styling for the fashion innovator in the 1960s.
(Courtesy of Oris Glisson Historic Costume and Textile Collection, Department of Apparel, Housing, and Resource Management, Virginia Tech.)

economy and social and psychological happenings in society. Although times are different today than when the trickle-down theory originated, the fashion elite and the fashion imitators must still be tracked to help the forecaster develop a clear picture of what is happening with fashion trends.

Bottom-Up Theory

The **bottom-up theory** indicates that a fashion trend may begin on the street, usually with young consumers who may be from both low-income and high-income families. The fashion elite then adopt the trend from the youth culture. As the mass market observes both the fashion elite and street culture wearing the trend, the middle-age, more mature consumer adopts it. Additionally, many times clothing worn by ethnic groups, blue-collar workers or organized groups and clubs, or product classifications originally produced for one occasion or use of wearing is adapted as a fashion item by the youth on the street. Then these trends are adapted by the mass population, produced at all price levels, and worn by all social levels.

Black leather garments worn by motorcycle riders were adapted as fashion during the 1950s. And, in the 1960s, the fashion look of the day for the young

consumer was the T-shirt, formerly worn as underwear, and the Levi jean or denim work pant. More recently, underwear has been worn as outerwear, with bras becoming a fashion statement. And sometimes styles from various minority groups are accepted by the fashion elite. Music and the Hip-Hop scene influenced the dress of Teens to young adults during the decade of the 1990s and into 2000. The oversized garments not only caused a revolution of sizing in the garment industry, but also appeared to some authority figures to influence the behavior and attitudes of high school students. Because of this social phenomenon, many schools are now stipulating a dress code and requiring students to wear school uniforms approved by the school district (see Figure 10.12).

Figure 10.12
Bottom-up theory explains (a) Hip-Hop fashions and (b) uniforms for Tweens.
(Fashion Designer: Amber Roth)

The bottom-up or streetwear adoption theory is one of the most important theories impacting modern-day fashion. In fact, many consultants are now tracking trends of youth all over the globe. A major consulting company tracking global youth and street trends in the United States is Label Networks located in Los Angeles, California. Also, in Japan, there is a Frenchman, Loic Bizel, who has established a business of showing global businessmen the street scene in Toyko. This tour guide that has made it a business to track street trends in tiny boutiques is known as the "cool hunter" (Kageyama, 2004). This businessman or "cool hunter" has the mission "to uncover the ever-changing street fads of Japan and translate them into a language the rest of the world can understand" (Kageyama, 2004). Translating these trends into fashion trends throughout the world is a formidable task for designers, fashion forecasters, and merchandisers in both apparel and retail firms. A fashion trend can be interpreted into all items of apparel as well as shoes, hosiery, and hats (see Figure 10.13).

Horizontal Flow Theory

The **horizontal flow theory** implies that fashion change trickles horizontally across consumers in similar social levels and that within each socioeconomic group, there are fashion leaders. Due to the technologies of rapid communications, computer-aided design and computer-aided manufacturing and mass distribution, every social level (i.e., mass market) in every geographic location may view and purchase a fashion trend at or near the same time.

The horizontal flow theory is also known as the **simultaneous fashion adoption** theory. Fashion acceptance today is influenced by everyone viewing the same fashion innovation simultaneously. In fact, with digital technology, an item may be copied on the television screen in seconds, sent to the manufacturer to be knocked off within days, and be on the retail selling floor within three weeks. "Computer-aided design has also made it a cinch for fast-fashion specialists, such as Inditex SA's Zara and Polo Ralph Lauren Corp.'s Club Monaco, to produce affordable designer knockoffs that often beat the designer originals to stores" (Agins, 2004, p. A1).

An example of the simultaneous fashion adoption theory is that of the luxury goods market. One consumer might buy a 100% cashmere sweater and pay "top dollar" at a well-known specialty department store such as Neiman Marcus (see Table 10.2). Another consumer might buy a cashmere blend of 65% cashmere and 35% acrylic at a specialty chain such as J. Crew or Abercrombie & Fitch and pay half the price of the sweater purchased at the specialty department store. Meanwhile, the aspirational luxury customer may buy a blend of 10% wool and 90% acrylic at a discount store. All of the sweaters look like cashmere, all of the sweaters fulfill the same wardrobe needs of the consumer, and all of the sweaters are trendy fashion items; however, each consumer had different criteria for the selection of the product and used a different value formula for evaluating the quality, attributes, benefits, and price of the purchased item.

In fact, designers are now producing expensive designer collection lines for the fashion elite and other lines for the specialty and department stores as well

(a)

(b)

Figure 10.13 A fashion trend can be interpreted into all items of apparel, such as hosiery (a), (b), and (c).
(Courtesy of The Hosiery Association (a, b, and c))

(c)

Table 10.2
How a fashion product spreads simultaneously throughout the market with horizontal movement.

Brand	Store Format	Fiber Content	Price Point
Designer	Specialty department store	100% cashmere	Designer
Private label	Specialty chain store	65% cashmere / 35% acrylic	Better
National brand	Department store	55% cashmere / 45% acrylic	Moderate
House brand	Fashion department store	10% wool / 90% acrylic	Popular

as for the mass discount stores. Even though these lines are usually developed by different design staffs and are not always copies or knockoffs of the designer's major collection, they still carry the name label of the designer and have certain design attributes that makes the merchandise identifiable by the end consumer as that of the major designer's creations.

Theories in Combination

Some forecasters believe that consumers in the 2000s are coupling the horizontal flow with the bottom-up flow and are mixing luxury products with popular-priced or budget products in the same ensemble to create their own individual style. Many consumers no longer purchase product or fashion trends dictated by the industry, the media, the runway, or even the street. They create their own style.

Another combination theory is the blending of the horizontal flow theory with a geographic movement. The fashion trend may begin on the East Coast, flow to the West Coast, and then conclude in the Midwest. Therefore, there are many consumer groups who define fashion in their own terms and create different fashion markets. Within each group of consumers there is a fashion innovator or fashion expert that influences fashion adoption in a particular geographic region. Thus retailers have found that analyzing market segmentation in relation to geographic segmentation, or the study of **geodemographics,** is most important in meeting the wants and needs of the target consumer.

Factors Impacting or Influencing Fashion

Many factors either impact or influence fashion. Forecasters must constantly observe and pinpoint how these external factors or elements influence fashion direction because at any one given time in history a combination of those factors helps shape what is accepted as the fashion trend of the day. The influences may affect only the silhouette of the garment and at other times only the color palette of the designer's line. Or the influence may impact the theme of the season, the type of fabrications used in developing the line, or the findings and trims of a particular grouping of merchandise.

Some of the major factors that influence fashion include historic design and inspirations; social values, attitudes, and movements; current events and happenings; celebrities, sports personalities, and famous business, media, and performing artists; media, movies, and plays; art and museums; music and books; politics; travel and ethnic cultures; architecture and home furnishings, and science and technology.

If social and economic conditions in a time period are similar to those of a previous era, many times colors, shapes, fabrications, and product categories of that era are reinterpreted and found in a modern line of a designer or manufacturer. However, seldom will a historic theme or design idea repeat itself exactly as it was first presented. More than likely one outstanding element of the design idea or color scheme will resurface or an outstanding detail will come to the forefront and combine with a current design idea or trim. For example, a silhouette such as the halter top will be prevalent in combination with a pant in one year, and several years later the halter is reintroduced as the bodice of a dress. David Wolfe of the Doneger Group believes that not only one decade of fashion may influence a designer's seasonal line, but there might be a mix of details from several decades that influence a new trend; who is the customer and where that customer is located helps determine how design concepts are recycled (Wolfe, 2008).

Historic Costume Collections and Vintage Clothing

Historic costume collections and vintage clothing, as well as attics, thrift shops, and flea markets, hold countless historic inspirations for themes, color schemes, and fabrics for new lines of apparel. The environmental scan discussed in Chapter 8 provides essential knowledge for the forecaster to identify the societal and economic conditions and to link those conditions to other historic periods. Being a history buff is an asset when it comes to connecting the important past happening to a current happening and then translating those happenings into future trends. Many times the terminology **retro** is coupled with a major style or trend to indicate that past fashion details are influencing the trend (see Figures 10.14a and 10.14b).

Social Values, Attitudes, and Movements

Social values, attitudes, and movements also influence fashion trends. The casual lifestyle of Americans has revolutionized the fashion industry over the past few decades. Clothing from "out of the gym onto the street" has become commonplace, with athletic wear worn as casual apparel. The warm-up suit has been revived as the new attire for daytime wear for activities from grocery shopping to sporting events. Probably one of the best examples of this type of movement is college students wearing underwear and pajamas to class or to run errands (see Figure 10.15). Men's boxer underwear in newly rendered fabrics with numerous patterns and updated pajama bottoms were the norm of the day in the late 1990s. Also, another good example of social values and

(a) (b)

Figure 10.14
Fashion repeats in cycles: (a) pedal pushers, 1960s, and (b) Capri pants, 2005.
(Courtesy of Oris Glisson Historic Costume and Textile Collection, Department of Apparel, Housing,
and Resource Management, Virginia Tech. (a))

Figure 10.15
Warm-ups and gym shorts come out of the locker room.

movements influencing fashion is the impacts of the Tween demographic
buying patterns and children influencing not only product offerings but also
marketing techniques in fashion trends.

A second example of social values and movement influencing fashion is the
introduction of the pant for women to wear in public. During World War II, be-
cause so many men had to serve in the armed forces to defend our country,
women were called to leave their comfortable homes and children to go into
factories to produce goods needed for the war effort. Because dresses were

prohibitive to modesty, safety, and production efficiency, women began wearing pants in the workplace and at other events (see Figure 10.16). The trend remained after the war, and women continued to wear pants in public; however, many companies had strict rules about women wearing pants in the workplace. After the 1940s, women were not actually permitted to wear pants in the workplace again until the introduction of the modern-day pantsuit in the 1970s.

Many times current social trends gain momentum because of a change in attitudes perpetuated by unusual natural circumstances. After much press

Figure 10.16
Woman in jeans in the early 1950s.

on global warming and its effect on our environment, many companies are now moving toward a "green movement" to attempt to save the planet. Companies such as H&M, Marks & Spencer, and Walmart are now advertising the availability of 100% organic cotton clothing in their retail establishments. Other manufacturers and retailers are promoting the fact that they are using recycled packaging or saving on energy by changing the type of light bulbs or by better organizing their transportation logistics. This new movement is definitely influencing fashion, its movement, and direction in some product categories.

Current Events and Special Happenings

Current events and special happenings that attract many market segments tend to impact fashion trends (see Figure 10.17). For example, when the Olympics occur every four years, not only do designers design and develop national uniforms for the Olympic athletes, but they also many times borrow details, color schemes, or ornamentation and motifs from this event to incorporate in their seasonal lines of clothing. Or, if major disasters occur such as 9/11, the entire fashion industry is impacted. Although this particular event was concentrated in New York City, the fashion capital of the United States, and definitely affected the business and the economy of the city for months to come,

Figure 10.17
A major event can be documented through apparel products.

other similar events in other cities and even foreign countries also impact the direction and movement of fashion.

Popular media events such as the Emmys, Oscars, and Tony Awards, as well as musical awards such as the Country Music Association (CMA) Awards featuring the recognition of the entertainment industry, always impact fashion trends down to the color, silhouette, erogenous zone, and even accessories that are seen in future fashion offerings. The media and new developments in technology help disseminate fashion trends as they appear on "the red carpet." To show off their latest designs, designers compete for the opportunity to dress the "stars" who participate in the events. However, many times these garments are knocked off immediately and appear in retail stores all over the world within a few days.

Celebrities, Sport Personalities, and Other Rich or Famous Business, Media, or Political Personalities

Strong influences on the fashion scene and those that impact volume or mass fashion are celebrities, sport personalities, and other rich or famous business, media, or political personalities. During her lifetime, Princess Diana had great impact on fashion, as did Caroline Bisset Kennedy, wife of John Kennedy, Jr. Even some consumers observe the attire of female newscasters to determine what trend to purchase. For the mass market, sport personalities probably have the greatest influence on fashion. Most everyone recognizes the names Tiger Woods, Michael Jordan, Alex Rodriguez, Brett Favre, John McEnroe, and Lance Armstrong. All of these athletes are famous for their skills in their respective sports, and many of them have their own clothing lines or endorse many national clothing brands. Everyone can relate to the sport celebrities by wearing items from their apparel lines, wearing brand-name garments endorsed by these celebrities, or copying a trend that the celebrity has created.

One well-known celebrity who revolutionized the fashion world was Madonna, the Material Girl, with her use of underwear and lingerie as outerwear. Rock stars, Hip-Hop artists, and country music singers have all made an impact on fashion with their individualistic interpretations and modes of dress (see Figure 10.18). More recently Jennifer Lopez designed her own line of clothing, J. Lo, for the junior customer.

Cultural Events and Places

Television, movies, dance, operas, theater, and Broadway plays also have an influence on fashion trends. Television stars such as Sarah Jessica Parker on the popular television show *Sex and the City* had a great impact on the fashion scene, as do other movie stars, television, and entertainment celebrities. A classic example of movies influencing fashion is that of Woody Allen's 1977 movie, *Annie Hall*. Diane Keaton, the actress who played Annie Hall, had a distinctive flare for dressing. Layering oversized garments, she created an ensemble of mannish blazers and vests, billowy trousers, long skirts, and boots and even a

Figure 10.18
Hip-Hop, Grunge, and other music styles become the inspiration for Gen Y fashions.

Ralph Lauren tie. The look was so influential that the fashion trend became known as the "Annie Hall Look" or the androgynous look of fashion. Women everywhere were adapting the look for their wardrobes. Periodically, the androgynous look or bits and pieces of the Annie Hall Look resurface as a newly reinvented rendition.

Any time a new Broadway play opens, the fashion industry pays close attention. Many apparel and retail merchandisers view those plays to determine the impact of the costuming on fashion trends. There may be one item, such as a distinctive blouse or a particular jacket, that becomes a bestseller or "hot" item in the fashion world. Operas and ballets as well as theatrical productions throughout history have influenced fashion trends, their movement and direction.

Other influencers on fashion are art and museums. Artists many times influence the direction of color for a seasonal line, and apparel exhibits in museums influence themes, silhouettes, and the fabrics, trims, and accessories that designers use in their seasonal lines.

When there is an art exhibit by the masters such as Monet, Matisse, or van Gogh, those palettes may spill over to color palettes for fashion apparel. Or, more recently, the pop art and colors of Andy Warhol are influencing current-day fashion. And historic fashion collections, folk costumes, and cultural exhibits in museums may inspire designers to select a specific motif, fabrication, or trim.

Additionally, music and books have great influences on certain categories of fashion. For example, music is a very special influence on streetwear fashions. In the 1990s, the Hip-Hop music influence was interpreted in apparel as sweats, baggy pants, athletic jerseys, and expensive athletic shoes. Kathleen Gasperini, Co-founder and Vice President of Label Networks, states that rock singers, as well as Japanese pop and rock singers (i.e., J-Pop, J-Rock), and DJs are presently providing inspiration for the global youth culture streetwear and contemporary fashions (personal communication, February 13, 2008). And, on the Tween scene, Hannah Montana or Miley Cyrus has become an icon for both fashion and music. Gasperini also believes that youth are reading collector comic books, which also influence the youth culture and fashion. And the well-known Harry Potter series of books by J. K. Rowling has had a great impact on both children and Tweens.

Politics

Politics also influence fashion. Everyone is familiar with the Camelot era of John and Jacqueline Kennedy in the White House. Mrs. Kennedy was a connoisseur of designer fashion and her style of dress and hairstyles were copied by the masses. She was well known for her pillbox hats and bouffant hair style. During the extravagance and overindulgence of the 1980s, Nancy Reagan was known for her chic, elegant designer gowns and classic style. During the 1990s, Hillary Clinton was known for classic suits, especially the pantsuit, but the decade was known for the casual dress movement.

In the 2000 decade, Hillary Clinton, a candidate for president of the United States, was recognized for her enormous collection of stylish pantsuits. During the 2008 presidential election, *Vogue* magazine featured magazine layouts of the wives of both a Democratic and Republican nominee. Cindy McCain, wife of John McCain, selected to be photographed in a pair of jeans and a beautiful shirt. Fashion analysts believe her selection reflected the environment of the times and that jeans are as "American as apple pie"; therefore, her selection was most appropriate for the casual lifestyles of the American consumer. In contrast, Michelle Obama, wife of Barack Obama, selected a black lace dress with pearls. First ladies and other political figures have a great impact on fashion and help set trends that many American women imitate. For fashion forecasters it is easy to track the attire of first ladies and to forecast the impact of the trend based on the platform of those in the White House.

Ethnic Cultures

With globalization, ethnic cultures are now having a huge impact on the direction of fashion. Kathleen Gasperini of Label Networks also believes that ethnic

or multicultural influences are influencing the streetwear fashion. For example, she stated that the Hispanic influences, especially from Cuba, are impacting the trends as well as Mexican designers (personal communication, February 13, 2008). With more trade agreements being finalized with Central American countries, ethnic influences are likely to show up in color palettes, fabrics, motifs, and detailing. Carolyn Egan (2008), Fashion Editor of Tobē, a New York fashion retail consulting firm, indicated at the MAGIC trade show in Las Vegas that inspiration for fashion was coming from both South America and Africa. In fact, Egan explained that one major trend recently forecasted by Tobē was "Nomadic," or "a willingness to embrace other cultural heritages." The Nomad is a collector who travels the globe or Internet to create her style with a diverse mix of cultural artifacts (Egan, 2008). With the opening of trade with China and the sourcing of apparel in other countries such as India, Malaysia, Indonesia, and Turkey, Asian influences are also evident (see Figure 10.19). Additional information about ethnicity and market segments are discussed in Chapter 9.

Home Fashions

Traditionally, trends of color and fabrications in home furnishing followed those of apparel trends. However, with today's technology and the impact of fashion on many product categories besides apparel, fashion designers are finding ideas and concepts for apparel lines from those in home furnishings,

Figure 10.19
Asian influence in current design.

furniture, and architecture. For example, when furniture manufacturers began producing casual lines of furniture and covering the upholstered pieces with denim, the apparel market picked up the trend readily and reinvented the entire denim category (see Figure 10.20). Thus denim product classifications became "dressy casual" and were worn for not only work but also for various and sundry social occasions.

Another example of home furnishings impacting apparel was cited in the *Wall Street Journal* article, "Fashion's 'It' Colors": "How Runway Dresses,

Figure 10.20
Denim in apparel and home fashions.

Cars—Even Washer-Dryers—Turned Shades of Blue, Brown." It explains how one important color trend taken from a home furnishings magazine became a major color palette for fall 2005. When the designer, Tracy Reese, saw a home furnishings magazine with a bedroom done in blue and brown tones, she included the color scheme in her fall 2005 line at Fashion Week in New York City (Beatty, 2005).

Science and Technology

Other factors that impact fashion are *science* and *technology*. Technology has highly impacted fashion in the last two decades. Computer-aided design (CAD) and computer-aided manufacturing (CAM), body scanning, and digital printing are technological advances that impact the direction and speed of fashion trends. And scientists are now developing not only performance fabrics but also medical and industrial textiles that are revolutionizing those industries and impacting the FTAR Complex in general.

Forecasting Fashion Trend Elements

Although much information can be obtained from scanning the environment, industry trends, consumers, and the competition and all the other external factors influencing fashion, fashion forecasters must also scan fashion happenings throughout the globe. Then these forecasters must determine how all of the external trends will impact the fashion trends and how to interpret those fashion trends for a particular target consumer and a specific industry zone. Thus fashion forecasting is a very difficult task, part scientific, part artistic, part instinctive, and part luck.

The fashion **trend elements** that must be forecasted and identified for developing and merchandising a seasonal line are *theme*, *color*, *fabrication and pattern*, and *style and silhouette*, plus *trims* and *findings*. Fashion forecasters, designers, product development personnel, and merchandisers at both the manufacturer and retail level must identify, analyze, and forecast these elements for every seasonal line. Each of these elements is addressed in the following discussion in relation to fashion forecasting.

Theme

For every major fashion season, fashion forecasters identify themes that are driving fashion trends. Designers, merchandisers, and product development personnel then select which of these themes reflect the image of their company and its mission; and, more importantly, they must pinpoint those themes that can be translated into seasonal lines that will attract the target consumer of the company. Major forecasting companies begin with theme forecasting, and for each theme they pinpoint color palettes, key silhouette items for selected genders, fabric, and patterns, and sometimes even the accessories needed to complete the

theme idea. A few of the major forecasting companies noted to be experts in the field of fashion forecasting include The Doneger Group, Design Options, Directives West, Promostyl USA Inc, Tobē (see Figure 10.21a), and WSGN. In addition to these organizations that cover the entire FTAR Complex and product mix, some organizations such as The Hosiery Association (see Figure 10.21b) focus on one product classification.

Themes evolve from all the factors previously discussed that impact and influence fashion, especially if a grouping of those factors is prevalent and reflect the global happenings of the times. Because all fashion forecasters, designers, and merchandisers visit the same fashion capitals, read the same trade journals, attend the same fabric fairs, travel to global trade shows and world events, and through technology view the world through the "same eyes," most fashion forecasting firms, designers, and merchandisers many times offer seasonal lines with similar themes, colors, and silhouettes. Even if the same terminology is not used to describe the themes, the meanings and compositions of the themes mirror each other in some respects.

For example, recently at a trade show two of the major forecasting companies presented trends for two different fashion seasons (i.e., fall for 200X and spring for 200Y). Both of the fashion forecasters described a theme of "the return of the

(a) (b)

Figure 10.21
Leading trend forecasters: (a) Carolyn Egan of Tobē and (b) Sally Kay of The Hosiery Association.

classics." One fashion consultant called the theme "Players"; the other called the company's take on the same theme "Reassuring Classics" (Egan, 2008; Wolfe, 2008). The individual forecasters adapted the theme to both the fashion season and the climatic season. However, some of the same wordage was used to describe the new classic trend.

Traditionally, some fashion themes reoccur and must be reinterpreted for an apparel company's seasonal line based on the climatic season of the year. For example, the "classic" theme is recycled continually. Sometimes the theme might be called "preppy," and the next time it might be "classics with a twist" or "modern classics." The classic theme is popular for both fall and spring seasonal lines. For fall, the major themes for women's wear that are recycled more often are "menswear with femininity" and "modern classics." For spring and summer, reoccurring trend themes are "nautical" and "safari." The Southwest theme is another classic choice for many markets in the United States. Designers using this theme draw inspiration from the many beautiful products made by Native Americans in the Southwest (see Figure 10.22).

Understanding and interpreting the theme to attract a company's target consumer is critical to the success of the company. Even though themes are recycled, they never reappear in the same form as previously rendered. They will be reinterpreted, reinvented, recolored, restyled, and refabricated as the current time period demands. However, themes many times dictate the color

Figure 10.22
Native American art influences fashion design.

palette, the fabrics and trims, and sometimes even the silhouettes offered in a seasonal line. For example, for the interpretation of a classic theme for a fall season, more than likely navy and gray would play a major role in the color palette; flannels, gabardines, and oxford cloth plus sweater knits would be featured as the fabrics; and argyles and stripes would be the patterns interpreted more than likely in sweaters and shirts, respectively. The silhouettes would consist of blazers, trouser pants, slim skirts, button-front blouses and shirts, sweater vests, and turtleneck sweaters.

Not all fashion themes are as easy to predict and forecast as the reoccurring fashion themes. New themes from the street scene or new themes from designers call for more analysis, evaluation, and forecasting. For example, the Metropolitan Museum of Art featured the "Superheroes: Fashion and Fantasy" exhibit recently. For the opening, designers and Hollywood celebrities were asked to wear costumes in which a modern-day superhero would be presented. The theme of the event was SuperHeroes. The theme played on historic comic heroes such as Superman. These historic heroes are seen as "avatars" or conduits of hope, dreams, and desires for the human spirit. These SuperHeroes through fashions symbolize freedom to fantasize and escape the real world. They are also metaphors for social and political realities and sexuality (The Color Association, 2008). One fashion editor from Tobē, "fashion's retail consultants," translated this trend for the modern-day market in the following descriptive: "High performance techno fabrics are essential as fashion's new body armor" (Egan, 2008).

There is more risk for the entire supply chain when there is a dramatic theme that has not been tested in the marketplace. And, sometimes, if a reoccurring theme is recycled too soon, consumers do not want to pay the price for purchasing the same themed product classifications that were so recently seen in their closets. Many times a theme is the thread that binds the color palette, fabric story, and styles or silhouette into a unified seasonal line or grouping within a seasonal line.

Color Forecasting

Color is the number-one artistic element that attracts the consumer and assists that consumer in making purchasing decisions. In fact, it is the first element in visual merchandise presentations that attracts attention; therefore the use of color in developing a seasonal merchandise line is critical to the success and profit of the entire supply chain. The selection of the **color palette** (i.e., range of colors) many times initiates the design process. Designers influence what color palettes are offered seasonally and from those develop **color stories** (i.e., a combination of colors that tie solids, prints, yarn-dyed fabrics across all styles in line) for their seasonal lines; however, major color forecasting organizations help guide the direction of color in fashion, home furnishings, home interiors, architecture, paint (e.g., Ralph Lauren paints), automotive and industrial design, home appliances and technological apparatuses, and even graphics (see Figures 10.23a and 10.23b). All of the factors that impact color and the selection of color stories for a seasonal line are described briefly in this section.

(a)

(b)

Figure 10.23
Cotton Incorporated provides (a) general color forecast information and (b) specific colors for apparel and the home.
(Courtesy of Cotton Incorporated)

First designers, merchandisers, and color forecasters must address the effect of color on the target consumer. There is a psychology to color that affects the viewer's perception of the color. Also, colors are symbolic. For example, seeing the color yellow may create a feeling of happiness for a consumer or it may imply brightness, cheerfulness, aliveness, and vitality for that same consumer. Thus the yellow color might create a mood of optimism or relaxation. It may also suggest change, challenge, and innovation or be symbolic for spring, summer, or the Easter season. Or if the yellow becomes more saturated and turns to gold, it may be symbolic for autumn leaves or the fall season.

Colors are personal, private experiences that are influenced by culture, status, geographic regions, ethnicity of the target segment, the age and gender of the target consumer, the social mood and economic status of a country, and the happenings of a particular time period. All individuals react to various colors with different emotions based on past experiences and influences of those colors within their life stages. For example, the color red might mean danger to one consumer because as a child this consumer was taught not to go near the flame of a fire or not to cross the street on a red stoplight. Or the color might bring excitement and joy to the individual because it is one of the major colors of the holiday season. Or being a warm color, red may make the wearer more active or may make the wearer unhappy because of its connotation of suffering or being hurt.

Designers and merchandisers must always be aware that colors have different meanings and symbolism in different cultures. For example, red is the color for brides in China, whereas white in many countries symbolizes the color of bridal attire. And, in some countries, white signifies the color for funeral attire, but most Americans consider black the color of mourning based on its historical use for that particular occasion. In today's society with a greater ethnic and cultural diversity than in past decades, younger consumers tend to look at color

"through the eyes" of many cultures instead of just their own culture. "Each generation has its own history," says Kathy LaManchusa. "They grew up with different values and ideals, were exposed to different cultural trends and ethnic influences. Today, people are surrounded by many more cultures, which makes younger generations more open to cultural influences, and it comes out in color preferences a great deal" (Paul, 2002, p. 34).

COLORS AND CULTURE. In some periods of history, color has signified the status or class of an individual. Because the dye for the color purple was so rare and expensive, in historic times in Europe, it was reserved for royalty and nobility. In contrast, many consumers in the Mature segment of U.S. society associate the tint or lighter rendition of purple, specifically lavender or lilac, with funerals because, in early periods of U.S. history, shrouds or clothing for the deceased as well as the inside of some coffins were lavender. More recently, gangs have adapted specific colors of apparel to signify membership in a particular gang and to identify the members of the gang from those in rival gangs. Specific colors of military uniforms identify in which branch of the armed forces the individual is serving.

Sometimes certain geographic locations have specific color stipulations or requirements. These requirements could stem from the religious affiliations of the consumer, from the historical ancestry of the individuals in the regions, or from unique regional preferences. For example, in the southeastern region of the United States, the color story of kelly green (bright green) and pink was very prevalent with the preppy look during the 1970s and 1980s. Many times other areas of the United States did not buy this color story because it was "too preppy" or classic for the fashion forward in those areas.

A study commissioned by *American Demographics* found "A relaxation of color alignments associated with gender, the increased prominence of ethnic groups with different color traditions, the aging of the Baby Boom generation and the growing influence of their offspring are bringing about broad changes in the palette U.S. consumers find appealing" (Paul, 2002, p. 31). Designers have found that the ethnicity of the individual consumer group must be considered as well as the age and gender of the target consumer when planning color palettes. For example, many Hispanics like bright colors that remind them of their homelands; however, not all Hispanics like the same bright colors because they are from different Latin American countries, and each consumer from a particular country has different color preferences (see Figure 10.24). "Hispanics veer toward warm colors, but variations do exist. When it comes to apparel, Mexicans are more traditional (i.e., reds, blues, black) and Puerto Ricans are drawn to livelier colors (i.e., pinks, purples). In Florida, a Cuban palette of pastels, flamingo pink, and salmon dominates fashion as well as exterior and interior design" (Paul, 2002, p. 35). Sometimes even the climate and natural environment of a country affect the color preferences of individuals because the fauna and flora in one country may be very different shades and colors from that of a sister country. Or a sunny climate might encourage bright colors, whereas one covered with snow and ice might encourage another color palette.

Figure 10.24
Mexican serape in red, black, and green.

The age and gender of the individual is also important when considering color. "Traditionally, men and women have had different tastes in color, with women drawn to brighter tones and more sensitive to subtle shading and patterns. The differences are attributed in part to biology, since females see color better than males do . . . and in part to socialization, with girls more likely to be steered toward coloring books and art supplies. American men . . . have traditionally avoided brighter, more complex and warmer hues in favor of darker, richer neutrals and blues" (Paul, 2002, p. 33). However gender is less important now than in the past, especially among individuals younger than 30. Leatrice Eiseman, former Director of the Pantone Color Institute, stated "previously rigid gender roles have loosened up, and the stigma formerly attached to women who stick with charcoal gray or men who opt for softer shades has receded. Another influence, she says, is the world of sports, where aggressively masculine men do wear uniforms with teal and purple, instead of the primary colors that once reigned supreme" (Paul, 2002, p. 33).

Baby Boomer and Mature generation men were taught that the color pink was for baby girls (see Figure 10.25) and women and that pink was not a

Figure 10.25
Girl's storyboard.
(Courtesy of Gerber Childrenswear LLC)

masculine color. With the exception of a very short period in the 1970s, the men in these two generations have never worn pink. In the 1970s, designers such as Alexander Julian and many other designers dressed men in pinks, aqua, yellow, and other "peacock" colors. In 2000, designers indicate that Generation X and Y men are more likely than their fathers to buy hot pink ski gear without even thinking about the masculine connotation (Paul, 2002). However, one expert states that color selection by gender "depends on context. You can't put GI Joe in pink. But can Diesel do pink men's clothing? Absolutely" (Paul, 2002, p. 33). The selection of color for baby girls' and baby boys' clothing and nurseries have changed from light pink and light blue, respectively, to a variety of pastel colors, primary colors, and even bright colors that are prevalent in home decor at the time. One author states that young children are exposed to a wider color palette than children of former generations and they see more complicated computer graphics "That makes 'tween and teen preferences unusually sophisticated. . . . Preferences run to offbeat combinations and color effect such as glitter, translucence, pearlescence and metallics" (Paul, 2002, p. 34).

 The social mood of a period and the economic status during that same period are many times reflected in the color story of fashion products. For example, when the economy is beginning to slow and consumer confidence is down, many times the colors become darker and consumers see color palettes of black, gray, navy, and brown surface. However, if the sluggish economy continues for some time period, the consumer mood might swing when boredom and despair

sets in; the customer will then want color to lift the spirits and stimulate the psyche. At any given time in history, one can observe how the social and economic happenings impact the prediction of the color palette of the day.

COLOR CURVES AND COLOR CYCLES. Two tools that help the color forecaster and fashion designer predict color trends are the color curve and the color cycle. Colors tend to run in cycles because all fashion trends and newly introduced colors tend to evolve through a bell-shape curve similar to the fashion curve. When new colors are introduced into any product category, they usually are accepted slowly as are new innovative fashions. New colors usually appear in the Designer, Bridge, and Contemporary industry zone. Fashion innovators and fashion experts accept these new colors first. Next, these colors are accepted by the masses and are included in product categories in the Better, Moderate, and Popular industry zones. After this mass acceptance, another color usually appears on the scene.

Also, there may be as many as four to eight color stories trending at once. Different product categories with various end uses and occasions of wear, different market segments, different genders and age segments, and different ethnic groups and geographic areas demand different colors for various seasonal lines. For example, color forecasters develop color palettes for men's, women's, and children's apparel, as well as for sportswear, athletic apparel, and home furnishings and interior decor for the same seasonal line.

Currently there is no definite duration for the lifecycle of any one color. Some colors may remain as long as a decade; others may remain only three years or even less with the current trend of fast fashions. Additionally, sometimes after colors decline, they return in a few years or even a decade or so later in a new **shade** (i.e., color with additions of black) or a new **tint** (i.e., color with additions of white) with a higher level of popularity than the previous rendition.

Color cycles also help color forecasters predict incoming colors. As previously discussed, cultural shifts, economic and societal changes, and many other factors may affect the color cycle. However, color forecasters believe that a color cycle begins with bright colors, evolves to multicolors, then moves to subdued colors to earth tones to achromatic colors to the purple phase. The color purple indicates that a new color cycle is ready to evolve (Brannon, 2005). Color forecasters look at how long a color has been prevalent in a particular product category, its degree of saturation, both colorwise as well as how many industry zones are featuring the color, and how the consumer reacted to it in the former season. They also look at how the color is combined with other colors, or if it is featured in prints only or in solid colors. Trend and color forecasting companies create colorful and exciting brochures to depict these colors, prints, and graphics for their inspirations (see Figures 10.26a and 10.26b). Many times, new colors are introduced in prints to get the "fashion eye" accustomed to the new color. In other words, these forecasters are attempting to determine in what stage of the cycle the color is positioned and how it is evolving. Of course, the acceptance of a color is the final decision of the consumer. If the consumer becomes bored or if new technology impacts the color selection or if there is a societal shift, the color may not complete the cycle.

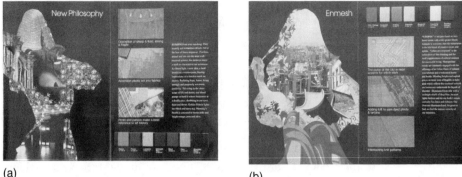

(a) (b)

Figure 10.26
Trend information providing inspiration, color, and fabric, (a) and (b).
(Courtesy of Cotton Incorporated (a and b))

COLOR STORIES. High-fashion designers usually help set the direction for the color palettes of seasonal lines. However, designers as well as apparel and home furnishings manufacturers and retailers rely on color forecasting agencies and organizations to forecast the colors for specific product classifications for seasonal lines. These organizations work well in advance of the designers' and merchandisers' needs and may trace the evolution of a color as early as five years in advance of its acceptance by the designer or marketplace. Usually, the color forecaster must predict the new color palette at least two to three years in advance. One of the major trade shows that assist these forecasters in solidifying their predictions is Premier Vision, the international textile trade show held in Paris (see Chapter 12).

There are several major color forecasting organizations or firms on which the industry relies for color direction. One of the oldest is Color Association of the United States (CAUS), which was founded in 1915. Other major color forecasting resources include The Color Box, Color Marketing Group, Color Portfolio, THE COTTONWORKS® Global Fabric Library (see Figure 10.27), Eiseman Center for Color Information and Training, Huepoint, and Pantone Inc. Many of the fashion trend forecasting companies, such as The Doneger Group, Promostyl USA Inc, and Tobē Report, also include color forecasting in their reports.

Pantone Inc. is the colors standard company that many industry personnel use for color matching and color direction. This company is noted for talking with designers and textile companies as well as attending major fabric, trend, and other trade fairs to track color trends. The company also monitors all external factors that impact fashion and the macro environment in which trends are formed.

In the supply chain, textile companies are the first to pinpoint new colors and color trends. Fashion designers then select these new innovative fabrics that are offered in the new colorways. For example, during one Fashion Week in New York,

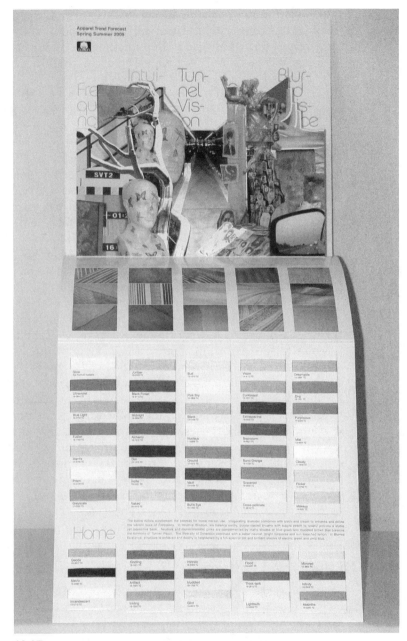

Figure 10.27
Trend information from the COTTONWORKS® Global Fabric Library.
(Courtesy of Cotton Incorporated)

the new color story of blue and brown was introduced. Three major designers featured this color story in their collections. One cited that her inspiration came from a home furnishings magazine, another contributed that her ideas came from her vacation travel, and a third gave credit to a painting for his inspiration. However, Leatric Eiseman, former Director of the Pantone Color Institute, indicated that the company had been tracking the evolution of this color story for the previous five years. She explained that when black was the major color story, brown was "snubbed as a 'dirty' color," but as the "Starbucks phenomenon in the 1990s escalated with expresso, latte and other coffee colors becoming prominent on the scene, brown came to the forefront. Additionally, Eiseman explained that in about the same time period, United Parcel Service Inc. introduced its marketing blitz "What Can Brown Do for You?" These events, coupled with designers seeing the blue and brown color story at Premier Vision in Paris two years before and Ralph Lauren introducing his turquoise and camel collection, set the brown and blue color story into motion (Beatty, 2005).

Selecting the color palette and forming the color stories for the seasonal line is one of the most important decisions that a merchandiser must make. The selection must be done with careful consideration of what color story was selling last season, how many seasons have those particular colors been in the line, and what seasonal colors are expected by the target consumer. For example, in some spring seasons the nautical theme is prevalent. Traditionally, the theme was executed in the color story of navy blue, red, and white. However, to add newness, freshness, and sophistication to the theme, designers began featuring the color story in marine blue, bright yellow, and white or in navy blue, coral, and white. Keeping the same types of silhouettes and trims, the old traditional nautical theme appeared new and exciting to the target consumer.

For marketing purposes, naming the color story and colors composing the story to reflect the theme of the line or grouping within the line is very important. The merchandiser must consider the primary color's (**hue**) name, such as brown. Then the factors of **intensity** (i.e., brightness or dullness) and **value** (i.e., lightness or darkness) must be expressed as well, as if the color is situated in the warm or cool family of colors. The color name should also relate to societal happenings as well as to what the target consumer understands about color.

Fabrics and Patterns

Trend forecasters also provide fabric and pattern trend direction for the seasonal lines. These forecasters attend fabric shows and view prototype garments made from the new fabric (see Chapter 12). Designers and merchandisers as well attend these shows and obtain fabric samples or order sample yardage to use when developing their new lines. Trend forecasters, designers, and merchandisers also follow the latest happenings with new technological developments in fabrics. They look for new fiber and yarn innovations, for innovative fabrics being developed by textile mills, for new surface treatments created by the dyeing and finishing processes, and for fabrics used in an atypical manner. For example, designers have been known to use flannel fabrics in their evening wear selections

or create an innovative design by manipulating the fabric. Fabrics intended for one purpose such as performance wear may show up in a designer's career wear line one season. A simple change in fabrics can make the same style look very different (see Figure 10.28).

In addition to attending trade shows and visiting textile mills, trend forecasters read textile trade publications, travel to cities known for producing beautiful fabrics and trims, and observe European designer lines to find the next big fabric, trim, or finding. Additionally, fiber councils and trade organizations promoting specific fibers, both natural and man-made, are available sources that provide fabric information for the trend forecaster, designer, and merchandiser. These organizations not only support research for new development in fiber usage, yarns, and fabrics, but they also promote the fiber and its many uses to the end consumer. Some of the well-known fiber organizations are Acrylic Council Inc., American Wool Council, Cotton Incorporated, Masters of Linen, and Mohair Council of America. For example, Cotton Incorporated is known for its fabulous fabric library and for its trend and color direction forecasting and seminars. In fact, the organization has an online directory where designers and merchandisers can locate woven fabrics, knits, home furnishings, and lace/trims containing 100% cotton or at least 60% cotton fabrics. At the organization's THE COTTONWORKS® Global Fabric Library, designers and merchandisers may view fabric samples from mills, knitters, and converters.

Fabric trends usually appear before major fashion trends. In fact, fabric may create the theme of the line or impact the color story or call for specific silhouettes

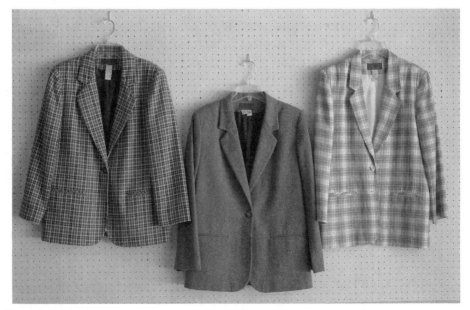

Figure 10.28
Same-style jacket looks different with different fabrics.

and design elements. Types of fabric are dictated by the season of the year and the climate of a specific geographic area where the apparel manufacturer distributes its merchandise. Fabrics are usually developed 18 to 24 months in advance of the beginning of the design and merchandising of the seasonal line. Patterned or printed fabrics are cyclical, as are other trends in the apparel industry. The children's wear market is noted for using prints in most seasonal lines.

At the beginning of the product development cycle, designers and merchandisers develop fabric stories for their seasonal lines. Unique prints may be purchased from freelance designers, designed in house, or bought from print studios and agents. Designers and merchandisers select fabrics with attributes that depict the theme of the collection, fabrics that fit the climatic season of the line, fabrics that accentuate the style and silhouette of the garments, and fabrics that meet the expectations of the target consumer. For example, if the seasonal theme is "menswear with femininity," the designer will more than likely select flannel and wool fabrics for the major silhouettes and then accent with satin blouses or oxford cloth shirts. Trims may be lace or other feminine detailing. If the theme is safari, the merchandiser will select cotton twill and poplin fabrications and accent with knit tops and bright floral wovens. Accessories such as rope braided belt, wooden and ivory plastic jewelry, and leather touches round out the fabrications of the safari theme.

Style and Silhouette Direction

Most designers and merchandisers believe there are three major silhouettes from which to build their seasonal lines. These shapes include the bell shape, the tubular, and the back bustle silhouettes. Silhouettes vary in proportion and fit to meet the demands of the day. The silhouette pendulum swings from very fitted to oversized with changes in detailing. Small changes in styling can make a basic product seem very different (see Figure 10.29). Trend forecasters, designers, and merchandisers analyze the changes in silhouette by observing what is happening in the fashion capitals of the world. They can observe what well-known designers are showing on the runways or what emerging designers are showing in their boutiques, what styles are being shown in the major showrooms of designers or Bridge and Contemporary companies, or what the street culture is wearing.

One of the biggest responsibilities of designers and merchandisers is selecting styles or silhouettes for the seasonal line that are the most appropriate for the theme and mood of the line, executable in fabrics that reflect current fashion trends, representative of the company's image, capable of being produced within a price range that is profitable for the company, and salable to the consumer the company is targeting. By analyzing the Fashion Cycle Curve (see Figure 10.6), the merchandiser can determine the length and duration of time that a particular style and silhouette has been in the company's seasonal line and how that relates to what is happening on the runways and on the street.

Styles and silhouettes tend to remain on the fashion scene for a longer time than do colors, fabrics, and trims and findings. Styles can easily be recolored and refabricated to reflect the current fashion trend or to support the current

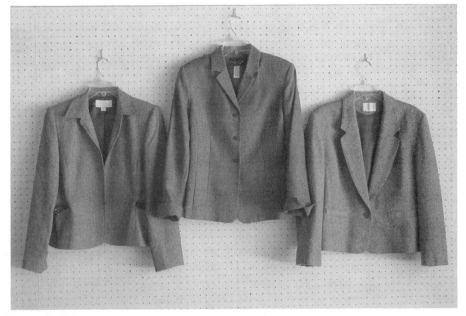

Figure 10.29
Same fabric looks different in different styles.

theme of the line. Other than the position of the style in the fashion cycle, two other major considerations for the merchandiser when considering the silhouette is the fit and proportion of the style. If the silhouette is too oversized for the current trends or is too closely fitted to the body for a particular target consumer, regardless if the silhouette is current, the garment will not sell. Garments in a seasonal line that are offered with incorrect fit and proportions become dated quickly and tend to cause both the manufacturer and retailer to accumulate heavy inventories and thus heavy markdowns.

Designers and merchandisers must also make sure the silhouette is not too trendy or too young looking for the target consumer. For example, if the style of the garment has the styling features for a young Teen and is incorporated into a Moderate Missy line of apparel, more than likely the target consumer will not purchase the product because it is not flattering to the body of the mature consumer nor is it appropriate for the end use of the wearer. Being on target with the most appropriate styles and silhouettes that translate the current fashion trend to the selected target consumer is critical to the success of a seasonal line.

Techniques for Tracking Trends

One technique that fashion forecasters, designers, merchandisers, product development personnel, and retail buyers use to track fashion trends is **shopping the market,** or visiting countries and cities (both domestically and internationally) known as fashion capitals. Based on the target consumer, the product

classification, price points of merchandise, and number of seasonal lines the company offers, fashion forecasters must determine what countries, cities, and special areas (e.g., SoHo in New York City) in those cities or countries will provide the most lucrative trend direction for their company (see Figure 10.30). Domestically, most forecasters, merchandisers, and buyers visit stores, museums, artistic endeavors, and other current happenings in New York City, Los Angeles, Chicago, Dallas, and Atlanta, plus other cities with regional merchandise marts or those sponsoring well-known events. In these cities fashion forecasters observe what people on the street are wearing, what type of merchandise is available in the major retail stores, and what unique and atypical trends are happening in those geographic regions. These same forecasters may visit Paris, London, Milan, Hong Kong, and Toyko or other recently identified global fashion hot spots such as Dubai, India, and China, plus Brazil and exotic destinations where they can collect information on their particular product classifications and industry zones (Pantone consultant, personal communications, February 12, 2008). From all of the information gleaned from these travels, forecasters attempt to identify reoccurring trends in all the locations as well as unique or atypical trends that would translate into concepts for a particular market segment.

Sometimes on these fashion scouting trips, forecasters and merchandisers buy actual garments to take back to their respective companies. These finds are used as examples for future trend direction. For example, this author went on a "power shopping trip" with designers, merchandisers, and product development personnel of a well-known jean company. These fashion experts went into stores on Madison Avenue in New York City to identify color and fabric trends.

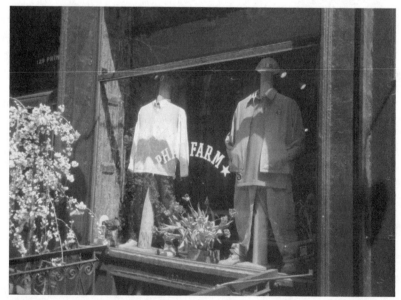

Figure 10.30
Trendy shop in SoHo.

Buying table linens, designer apparel, and accessories, these individuals purchased items that were not to be knocked off for the next season's line but were to be used for fabric and pattern direction and color trends.

Trade publications are another vital source of information that fashion forecasters and fashion experts track to identify and forecast major trends. These trade publications are usually available for only personnel employed in the FTAR Complex and auxiliary industries. For all the major markets and selected product categories, there are specific trade publications featuring not only fashion trends and business trends but also political, legislative, social, and technological trends. One of the best known newspapers for women's fashion is *Women's Wear Daily* (*WWD*), the "bible" of the industry. The menswear companion to *WWD* is the *Daily News Record* (*DNR*). The trade journal for sportswear is *Sportswear International* and for children's wear companies *Earnshaw's* and *Children's Business* journals are published. For the accessory market, *Accessories Magazine* and *Footwear News Magazine* are major publications for industry personnel. There are also industry magazines (e.g., *Apparel Magazine*, *Textile World*), advertising and marketing journals (e.g., *Advertising Age*, *Adweek*, *Brandweek*), retailing journals (e.g., *Chain Store Age*, *Journal of Retailing*, *Retail Store Image*, *Stores*), and visual merchandising and store planning journals (e.g., *Display & Design Ideas*, *Views & Reviews*, *Visual Merchandising & Store Design*) as well as international sources that provide fashion forecasters, designers, and merchandisers with valuable information on tracking fashion trends.

Summary

Fashion trend forecasting is exciting, yet frustrating, if the forecasted trend does not fit the taste level and needs of the target consumer. Fashion trend forecasting is part science, part art, part history, part instinct for what the consumer will accept and part luck; and it is all the above synthesized into one package. Fashion trend forecasters, designers, and merchandisers must not only look at historical fashion adoption theories, current happenings in global society, and all the factors that impact and influence fashion, but they must also observe any small, or what some would think is a trivial, sign that is an indication of the direction and speed of the fashion trend.

Forecasters must analyze the current mood of the times and determine what themes, colors, fabrics, and silhouettes reflect those times. They must also track several trends simultaneously by analyzing the bell-shape Fashion Cycle Curve, the swing of the fashion pendulum, and the erogenous zone positioning of the fashion silhouette. Forecasters, designers, and merchandisers must observe all apparel product categories to ascertain how a particular product classification is trending and how it will impact other product categories. Unique design concepts as well as reoccurring design concepts across designer collections and other seasonal lines must be pinpointed, analyzed, and evaluated. And, in the end, it is the forecaster's job to combine all of the available information to predict what the next trend will be to attract the target consumer.

Key Terms

Acceptance stage	Forecast trends	Shifting erogenous zones
Bottom-up theory	Geodemographics	Shopping the market
Classic	Horizontal flow theory	Simultaneous fashion
Classic compromise	Hue	adoption
Color palette	Intensity	Style
Color stories	Introduction stage	Tint
Design	Pendulum of fashion	Trend
Evolutionary trends	Regression stage	Trend elements
Fad	Retro	Trickle-down theory
Fashion	Shade	Value
Fashion cycle		

Review Questions

1. How are the terms *style*, *fashion*, and *design* related and used by merchandisers?
2. What is the difference between a fashion and a fad?
3. How does a fashion become accepted according to the trickle-down theory?
4. Explain how a music genre can be an influence to fashion through the bottom-up theory.
5. Select a fashion trend and explain three factors that were an inspiration to designers for that trend.
6. What techniques should merchandisers use to research information on fabrication?
7. What are some of the major resources that a merchandiser could use in researching color trends?
8. How does a merchandiser interpret silhouette into the product line for next season?
9. What are two major trend forecasting services?
10. What information can a merchandiser receive from a trend forecasting service?

References

Agins, T. (2004, September 8). As consumers mix and match, fashion industry starts to fray. *Wall Street Journal*. Retrieved September 22, 2004, from www.wsj.com

Beatty, S. (2005, February 4). Fashion's 'it' colors. *Wall Street Journal*, p. B1.

Brannon, E. (2005). *Fashion forecasting* (2nd ed.). New York: Fairchild Publications.

The Color Association. (2008, May). Colorful individuality: Celebrity super fashion. Retrieved May 30, 2008, from http://www.metmuseum.org/speical/Superheroes

Egan, C. (2008, February 12). *Tobē next spring 2009—themes, key items, color*. Seminar presented at MAGIC, Las Vegas, Nevada.

Kageyama, Y. (2004, February 7). The 'cool' consultant. *Herald-Tribune*, pp. D1, D3.

Kincade, D., Gibson, F., & Woodard, G. (2004). *Merchandising math: A managerial approach*. Upper Saddle River, NJ: Prentice Hall.

Paul, P. (2002). Color by numbers. *American Demographics, 24*(2), 30–36.

Tan, C. L-L. (2008, January 4). In closet clutter: Here's how to streamline your wardrobe for seasons ahead. *Wall Street Journal, Asia Edition*. Retrieved January 4, 2008, from www.wsj.com

Wolfe, D. (2008, February 12). *What's next for fall 2008—The Doneger Group*. Seminar presented at MAGIC, Las Vegas, Nevada.

SECTION
IV

*Line Development
Process Cycle*

A ll members or companies in the FTAR Supply Chain must address and in most cases complete specific stages in the merchandising process to produce, deliver, and sell product. In textile and apparel companies, merchandising is the process flow or cycle of activities that begin with the creation, development, and execution of the company's merchandise offering or product lines and that culminate with the presentation and delivery of those product lines to the client or customer. For the manufacturer or raw materials provider, this process may be described as the *Line Development Process Cycle,* which consists of all the processes and activities within those processes that the manufacturer must complete to design, develop, produce, present, and promote the seasonal product line to the company's retail customers (see Figure S.4.1). This cycle is discussed in Chapters 11, 12, and 13. A similar merchandising

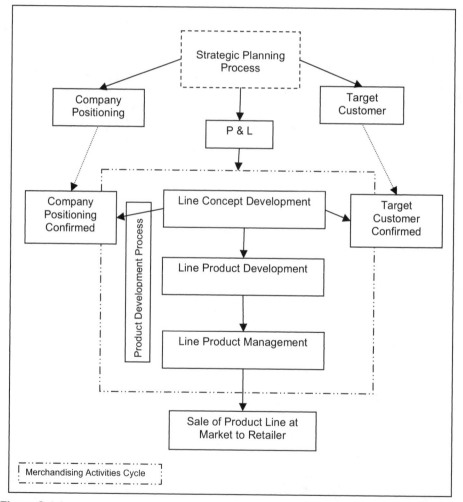

Figure S.4.1
Merchandising activities for the Line Development Process Cycle.

process flow or cycle of activities for the retailer is described as the *Buying-Selling Cycle*, which is discussed in detail in Chapters 14, 15, and 16.

The Line Development Process Cycle is based on company capabilities and strengths that are identified through the strategic planning process and implemented through the finances detailed in the budget and the activities delineated in the marketing plan. The Line Development Process Cycle is guided by the company mission statement plus management's merchandising philosophy and the company's target customers, which are selected through the strategic planning process. Executive management of a company determines the major parameters in which merchandising functions within a company. For example, management has already (1) identified the channel(s) of distribution and distribution patterns, (2) pinpointed the market segments or target consumers that the company will attempt to attract with its positioning plan, (3) determined the number of seasonal lines and their composition, (4) identified the marketing venues to be used by the company, (5) determined product positioning strategy, (6) made numerous business decisions, and (7) constructed the company's marketing plan, which will guide and sometimes dictate the happening of the Merchandising Calendar and Line Plan Summary.

The merchandiser in a textile or apparel manufacturing company must be an expert in collecting data in regard to all aspects of the market environment, developing workable tools such as the Merchandising Calendar and the Line Plan Summary, creating and developing the Seasonal Product Line, and understanding and contributing to activities and processes in Line Product Development and Line Product Management. To carry out all of these responsibilities, the merchandiser must work as a team member with marketing, design, production, forecasting, planning, sourcing, quality, finance, and sales personnel.

The timing of each step in this merchandising process for every company is critical to the development, acceptance, and success of any apparel product. To achieve the right product, retail merchandisers must be explicit about delivery dates and manufacturers, and raw materials providers must attempt to offer products to their clientele at the beginning, or early in the cycle, of a major fashion trend, in advance of the competition, and definitely before the retail client's consumer demand is at its peak. Stage gates or major decision points are noted in any merchandising plan, along with the timing and personnel responsible for these decisions.

11

Line Concept Development

Objectives

After completing this chapter, the student will be able to

- Identify the Line Concept Development Processes and activities in the Line Development Process Cycle
- Pinpoint the use and importance of the Marketing Calendar, Merchandising Calendar, and Line Plan Summary to the merchandiser
- Explain the use of market and trend research in developing the product line
- Identify and explain the importance of the product attributes to a manufacturer's Seasonal Product Line
- Describe the Line Plan Summary and how it is developed
- Draw a product grid with an explanation of the components
- Discuss how the merchandiser works with the Image Communication Division to ensure the appropriate marketing plan for the product line
- Explain the importance of working with the retailers in a review of the same season last year

Introduction

In the merchandising process for textile producers, merchandisers and product development personnel produce product lines of fabrics based on the product's end use, market and fashion trends, capabilities of the company, and their clients' demands. In apparel companies, product merchandisers and product

development personnel develop a cohesive package or seasonal line of end product merchandise that reflects the company image, trend direction of the market and fashion cycle, and price structure of the business. A company may have from one to numerous seasonal lines, depending on the size and structure of the company. Some firms, such as VF Corporation or Liz Claiborne, chose to have separate functional or strategic business units for each of its product lines or groupings of similar apparel items (see Chapter 3). These **strategic business units (SBUs)** are often named for the brand or the apparel product that is made by the unit.

Line Concept Development is the first major step in the entire **Line Development Process Cycle** and documents the development of a textile or an apparel company's line(s). This development of a seasonal line is a process flow of activities that must be completed to develop a cohesive package of merchandise for the retail client and ultimately the target consumer of the retailer. The Line Concept Development Process has the following three stages: (1) planning and research development, (2) creative development, and (3) tools development (see Figure 11.1). Line Concept Development begins with the planning and research stage. At this point, the merchandiser will be doing the following three background activities: (1) reviewing the strategic planning outputs, (2) developing the Marketing Calendar and Merchandising Calendar, and (3) conducting market, consumer, product, competitive, and trend (i.e., industry, fashion) research. Many times these three major activities are conducted simultaneously by several employees in many divisions of the company. Based on

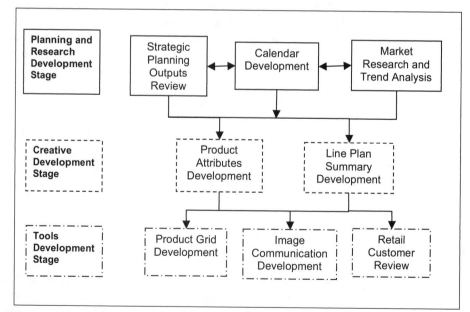

Figure 11.1
Line Concept Development Process.

information found from the planning and research activities, the creative development stage of the line concept is formulated when the merchandiser identifies and develops product attributes and develops the Line Plan Summary.

The final stage in the line concept process, or the stage for tools development, contains the following activities: developing the preliminary product grids, identifying the initial image communications needs as related to the line theme and lead product strategy, and reviewing the retail client environment and needs of the company's retail customer (see Figure 11.1). In this stage, the merchandiser works with many personnel across multiple functions in the company to review the strategic planning outputs and to begin developing broad concepts to direct the formation of the company's line(s).

Strategic Planning Outputs Review

The first task that the merchandiser must perform in Line Concept Development is to review and interpret the information that had been developed in the strategic planning process. Throughout the strategic planning process, top management has made decisions that must be used as guides for the merchandising activities. Broad decisions about channels of distribution, market segments, seasonal product lines, marketing venues, and company positioning will have been determined as top management (e.g., CEO, CFO, president of the company, vice presidents of major company functions) decides on the mission statement for the company and formulates answers to the questions: "What is this company?" and "Where is this company going?" These executive decisions or output become the parameters for all merchandising activities.

Channels of Distribution and Distribution Patterns

Based on company strengths and capabilities as well as product offering, management decides in which channels of distribution to market the product and what retailers to target when selling the products. This decision may be multifaceted because of the competitive forces facing many companies. For example, mass merchants may demand exclusive product lines, which would require that the company produce more samples for the seasonal line, adding costs to product development. Many manufacturing companies produce different lines to sell in different channels of distribution. For example, companies are producing both national branded product to sell in specialty and department stores and proprietary private label lines to sell to mass merchants. Or the company may be producing product for a major catalog and a major store chain. If the company wishes to expand its sales volume or product offering it has a choice of selling more of the same product in the same market, the same product in a new market, a new product in the same market, and/or a new product in a new market. This type of decision is made at the managerial level (e.g., Vice President of Merchandising, Merchandiser) with much input from personnel in the Market Research and Finance Departments. The merchandiser must determine from this information the type and style of products that are to be produced.

Market Segments

As management discusses "Where is this company going?" they will be deciding on what consumer to target. The consumer that the company can best service the most profitably is the one that must be targeted. With multiple available market segments, management, with the input of merchandising and marketing, must decide "Who is the consumer?", "What product attributes does this customer desire?", "Where does the consumer go for fashion direction?", "How does the company communicate with the customer (i.e., media, special events and promotions, retail environment)?", and "What price will the customer pay for the end product?" The merchandiser may diagram a product matrix to help examine which markets are being targeted with what products from the line (see Figure 11.2). Many companies go one step further and break down a customer segment into subsegments based on the buying patterns, demographic and psychographics, and lifestyles of those consumers in relation to product attributes and pricing. For example, the merchandisers along with executive management in one company, identifying a specific jean customer within a premium jean market, identified three subsegments: "Leading Edge," "Upscale Utilitarians," and "Discretionary Enthusiasts" (Personal communication, with B. Stec, August 2, 1995). This terminology describes the customer subsegments so finely that the company could differentiate product offering, its communication techniques, and its price points to attract all of those subsegments within the large segment.

Seasonal Product Lines

Management also determines the number of product lines that a company offers within a retail year. Many companies develop their lines around coordinated groupings or related separates hoping to sell more merchandise. For

Target Customer / Price Point	Tween	Gen Y	Gen X	Baby Boomers	Seniors
Designer	Brand X	Brand XX			
Moderate				Brand T	Brand TT
Budget	Brand Y				Brand U

Figure 11.2
Matrix of product line decisions for target customer markets.

example, a company offering missy better sportswear might develop from five to seven groupings for its seasonal line. One grouping could be coordinated product classifications, including jackets, blazers, blouses, tops, sweaters, pants, and skirts that can be mixed and matched to create numerous ensembles (see Figure 11.3). More than likely this grouping would be based on a fashion theme, have its own specific color palette, fabrication, and print story, and be offered within a specific price range based on the industry zone in which it is produced as well as the expectations of the company's client and the end consumer. This grouping could be targeted to the working woman who needs to look professional in the work environment. Each product classification in the grouping is a different style and should relate to all the other styles in that same group so there is a commonality among the merchandise categories. Most times these groupings reflect the lifestyle of the target consumer, the occasion for wearing, and the current trend offering in the market.

For apparel companies, the number of lines is often dictated by the type of product, the number of delivery periods within each season, sourcing capabilities (e.g., construction techniques for select style production), and personnel expertise to produce a product line for on-time delivery and/or the marketing venues used by the company. Most women's wear companies producing fashion apparel carry as many as six lines per year, which follow the six seasons of the

Figure 11.3
Grouping of items in career wear.

Table 11.1
Women's wear apparel seasonal lines of apparel.

Seasonal Line	Market Date	Delivery Date
Spring	October	Late December–Early March
Summer	January	March–April
Early fall	January/February	June–July
Fall	March/April	July–October
Holiday	August	October–November
Cruise/Resort/Early spring	August	November–December

fashion calendar. These seasons include **spring, summer, early fall** or **transition, fall** or **winter, holiday,** and **cruise seasons** (see Table 11.1). The cruise seasonal line may also be called **resort.** Depending on the product line and the merchandise classification, a company may produce another additional line known as **early spring** for shipping during or directly after the shipping of the cruise or resort line. Each season has specific market dates and dates for the usual delivery of lines to the retail firm.

Men's fashion traditionally has not had as many seasonal or fashion changes; therefore, men's tailored clothing companies may offer only two lines of clothing—spring/summer and fall/winter—per year. However, with young men's apparel and sportswear becoming more fashion oriented, some menswear companies are now producing more than the two traditional seasonal lines. And some children's wear companies producing fashion goods may produce four lines: spring, summer, back-to-school or fall, and holiday each year. Although there is some overlap between children's and women's wear seasons, the **Back-to-School season** is unique for the fall seasonal children's wear market.

The **seasonal line cycle** is never ending as before one line is completed for distribution to the retailer the next is near the production stage, another is in the development stage, and another may be just an idea or concept in the mind of the merchandiser or designer. To prepare the line, to meet the delivery date required by the retailer, time must be allotted for all line concept development activities along the entire supply chain. The apparel merchandiser, although he or she does not do these activities, must allow time for fabric dyeing and product sewing, including time for ordering, sampling, processing, correcting, and shipping. Throughout this time, the merchandiser is collecting data on what is selling at the retail level for the apparel company's current line. Merchandisers often comment that they go to work and are surrounded by holiday merchandise while wearing their summer shorts, and they may be working on bathing suits at work while having to scrape ice off their windshields to drive home. Working in this environment of forecasting and planning takes special skills and insights for a merchandiser. A good calendar is important to help the merchandiser stay on task (see Figure 11.4).

Time	Activity	Season	Completed/Tasks Remaining
8:00 – 8:30am	Dept meeting with staff and market researcher	Various	Check on shipment
8:30 – 9:00am	Check email and return phone calls	Various	Call backs needed
9:00 – 9:30am	Review strike-off with assistant (Jane)	Fall	Jane will resubmit
9:30 – 10:00am	Meet with market research about consumer panel data	Summer	
10:00 – 10:30am	Check trim vendors for the gold trim needed on top	Holiday	
10:30 – 11:00am	Meet with Promotions Director and Special Events Coordinator for ideas on Special Event at Canton Trade Show	Fall	
11:00 – 11:30am 11:30 – 12:00	Meet with ADB Fabric vendor to select top-weight fabrics for the new blouse line	Spring	
12:00 – 12:30pm	Catch a quick sandwich in the Company Café and review fabric samples (ask Vendor to join me if still meeting)	Spring	
12:30 – 1:00pm	Return phone calls and check email	Various	
1:00 – 1:30pm	Fit Session with Amy and Donna on the new sculptured top	Fall	
1:30 – 2:00pm	Check on markdowns with DB Retailer – get ready for complaints – Do conference call with Retail Services	Early Fall	
2:00 – 2:30pm			

Figure 11.4
A portion of a typical day for an apparel merchandiser.

Content of product lines or the product mix carried by each FTAR company at every linkage in the FTAR Supply Chain must be determined by each company based on the needs of the company's clients as well as the goals and objectives of the company. Apparel companies can choose to base the content of the seasonal line on the targeted consumer, type of merchandise produced (e.g., style structure, market dates), or product types handled (e.g., gender, sizes, price points, zones). These decisions are part of the marketing plan for each company. The content of a line is changed periodically to reflect fashion, climatic changes, and company directives.

Marketing Venues

To market these seasonal lines, management (e.g., VP of Merchandising, VP of Marketing) at an apparel manufacturing company must determine when and where to show their company's line. In other words, they must choose in what marketing venue(s) the product will be offered to the client (i.e., the retail buyer). Many apparel companies maintain year-round showrooms in major market centers as well as at regional marts (see Chapter 15 for details on all the markets). Management may alternatively choose to show the line only at a specific trade show or at the headquarters of the company. Some companies hire account executives to service major accounts and to travel to those accounts to secure purchase orders. To reach major retail clients, a company usually uses a combination of the venues just described.

Market dates for apparel companies to show these wholesale lines to their retail clients are established by traditional industry calendar dates and the mart owners or organizations, and they are influenced by the various trade organizations for the specific type of product (see Table 11.1). These dates are extremely important for planning and scheduling the Line Concept Development activities. The furniture mart, which affects the fashion industry, especially textile producers, is a good example of the importance of these market dates. In the past, the only major U.S. mart for furniture retailers was the International Home Furnishings Center located in High Point, North Carolina, (see Figure 11.5). Each year in April and October, thousands of furniture, home decor/accessories, and home furnishings retailers descended on the city "to shop the mart" and preview the biannual lines of the furniture manufacturers. However,

Figure 11.5
International Home Furnishings Center located in High Point, North Carolina.
(Photographer: Alice E. Dull)

a second market recently opened in Las Vegas at the World Market Center, and this competition has caused a change of scheduling for some of the market dates. This market change has also affected the timing and growth of the apparel markets that are held in Las Vegas.

Many times, the mart that holds the seasonal market at the earliest date may have the competitive advantage because many buyers may be restricted by travel budgets to attend only one market. Or, the buyer may tie up all the season's budget with vendors at one mart and not have the money budgeted to purchase additional goods at the later market. The timing of market dates is most important to both the manufacturer and the retailer. Also, some seasonal marts are more important, because of the type of product and the geographic location of the retailer, than other seasonal marts to select retailers. Therefore, buyer attendance at specific markets during specific seasons impacts the offering and the number of showings presented by the manufacturing company. The opening of a new market building and the excitement that generates would also be important in the selection of market venues for the apparel manufacturer (see Figure 11.6).

Figure 11.6
New Mart building located in Los Angeles.

Product Positioning

Combining much descriptive information about the company and its product lines (e.g., company image, merchandise classification type, fashion level of the product) in addition to decisions about price of product, target consumer, and activities of the competition, management establishes guidelines for its products and its positioning. The combination of consumer and product information this company is offering can be seen in Figure 11.7. The company already produces products that are conservative and at a best price point and in the traditional category at a good price point; therefore, the niche of updated and better price point might be an option for positioning a new product offering (see Figure 11.7). The positioning of the product within the context of the price, the consumer, and the fashion level is the **product merchandising strategy grid** that the company will use. Using this strategy grid, the top management, planners, and merchandisers can determine how to price and style the product to be different from current products.

The new cell in Figure 11.7 indicates that the company is developing an updated or trendy product at a better price point for the fashion-forward customer. By using this grid, merchandisers automatically know the parameters for the selection of themes, styles, and fabrications as well as for colors and sizing. With a product with a better price point and an updated fashion look, the merchandiser might have to limit the cost per yardage for fabric to stay within the better pricing scale or the merchandiser may have to translate a haute couture style to be understandable and salable to this particular customer. All of these factors will impact the development of the seasonal line and guide the merchandiser when completing future tasks, including what price point to target and which retail client will purchase the seasonal line.

Other Business Decisions

Top management must also make other business decisions about the company's product offering based on the financial plans and budgets of the com-

Consumer/Fashion ⇒ Pricing ⇓	Conservative	Traditional	Updated
Best	▓▓▓		
Better			**New offering**
Good		▓▓▓	

Note: ▓▓▓ represents current product offerings

Figure 11.7
Product merchandising strategy grid for a new product line.

pany. The following questions must be answered: "What are the planned markup and markdown goals?" "What inventory turns are desired or needed for a profitable operation?" "Does the company want year-round coverage in its targeted channels of distribution?" "What are the planned margins and profit goals needed by the company to operate a successful business?" Based on company goals and direction, there could be many more questions addressed by management before releasing the annual Marketing Calendar to the various company divisions.

Calendar Development

The sequence and scheduling of activities throughout the Line Process Development Cycle, including all activities in the Line Concept Development Process, must be carefully timed to meet the market dates, the customers' demands, the selling periods, and the consumers' interest. Coordinating the hundreds of activities that must happen throughout the FTAR Supply Chain requires extensive time and effort by merchandisers and other planners within each company. At any point in time, they are ordering fabrics from textile companies and buttons from findings vendors; meanwhile, they are placing orders for cut-and-sew operations and scheduling fittings and final reviews for one to five or more product lines. These processes must often happen in a simultaneous and overlapping mode (see Figure 11.8).

Further complicating the timeline for firms operating in this supply chain is the fact that the companies upstream (e.g., fiber producers, textile mills) often work months in advance of the retail sell date to provide the right product at the right time in the right quantities at the right price for the companies downstream and ultimately the final consumer. Raw material producers may work 18 to 24 months in advance of end product manufacturers, and these manufacturers work 6 to 18 months, or on an average of 40 to 42 weeks, in advance of major market weeks to provide the right product for procurement by the retail buyer at those markets. And the retail buyer makes critical decisions six months to a year in advance of the actual merchandise presentation on the retail sales floor to assure that the arrival of goods to the retail establishment is timely and to assure also that an appropriate selection of merchandise is available for purchase by the target consumer during peak selling periods.

Some companies are moving toward faster product development and some retail buyers are trying to purchase closer to the selling season, but much of the FTAR industry continues to operate in a mostly linear process in combination with some simultaneous processes. Zara, the popular Spanish retailer, has cut the traditional time of 40 weeks for a product to go from an idea in design to the retail selling floor to a mere 5 weeks. With this short development time, the company is cycling fashions as fast as 25 shipments throughout the year instead of the traditional five or six major seasonal shipments ("The Future of Fast Fashion," 2005). Zara is able to deliver approximately 11,000 new items to

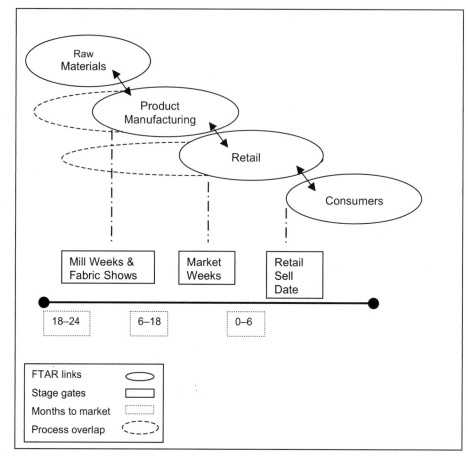

Figure 11.8
Simultaneous development and selling processes in FTAR Supply Chain.

its target consumers, whereas Gap averages 2,000 to 4,000 new units per year. They work with their parent company, Industria de Diseño Textile (or Inditex) to achieve these fast line development times (Tagliabue, 2003). Similar fast fashion, or short line development times, are being managed by Sweden's H&M.

Marketing Calendar

A key tool that guides all merchandising processes and activities developed by executive management, along with key executives in all divisions of the company, is the Marketing Calendar. The **Marketing Calendar** is the major guideline for all other marketing calendars and merchandising and manufacturing plans in the company (see Figure 11.9). This calendar provides the number of seasons or seasonal lines produced by the company, the selling and shipping dates for each season, and the units and dollars planned for each season. Specifically, the Marketing Calendar or the chart that accompanies the cal-

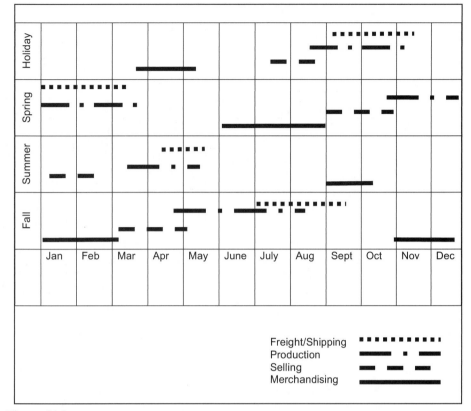

Figure 11.9
Marketing Calendar or schedule of work for an apparel company selling a women's wear line to boutiques and specialty department stores.

endar denotes the **line preview date** (i.e., the company's seasonal sales meeting), the **line release date** (i.e., full line is ready and sales associates samples are available), the **start to ship date** (i.e., manufacturer has stock to ship to fill the retailer's purchase order and product mix), the **season ship complete date** (i.e., final date to ship without incurring cancellations and returned deliveries by retail client), the **shipping by month figures** (i.e., dollars, units, and SKUs for each month or the season), and the **line on sale by month figures** (i.e., sales by month). In the Line Development Process Cycle, the Marketing Calendar is the major document that contains the information for future financial activities.

Merchandising Calendar

Based on the parameters set by management in the strategic planning process, the merchandiser develops a Merchandising Calendar and the Line Plan Summary to guide the Line Development Process Cycle. A **Merchandising Calendar** is a compilation of each major event needed to produce a seasonal

Merchandising Calendar Log	Design	Prod	Sales	Merch.	Season: Fall Date Scheduled	Date Completed	Season: Holiday Date Scheduled	Date Completed	Season: Spring Date Scheduled	Date Completed
Key Action Items										
1. Market Research			X	X	January 8		March 19		June 4	
2. Review sales and business history			X	X	January 8		March 19		June 4	
3. Make initial volume selections			X	X	January 8		March 19		June 11	
4. Shop fabric and trim markets	X		X		January 15		April 2		June 18	
5. Select colors & prelim style concepts	X		X	X	January 15		April 2		June 18	
6. Order sample fabrics and trims	X			X	January 22		April 2		June 18	
7. Review line plans			X	X	January 29		April 16		July 6	
8. Start prototypes	X				January 29		April 16		July 6	
9. Develop quick costs				X	February 5		May 14		August 3	
10. Meet for initial line adoption			X	X	February 5		May 14		August 3	
11. Forecast review (line slush meeting) with line sheets	X	X	X	X	February 12		May 17		August 6	
12. Approve lab dips				X	February 12		May 17		August 6	
13. Quantify trim				X	February 12		May 17		August 6	
14. Sew samples	X				February 12		May 17		August 6	
15. Complete costings—costing meeting			X	X	February 19		May 21		August 11	
16. Finalize specifications		X		X	February 19		May 21		August 11	
17. Final line adoption meeting	X	X	X	X	February 19		May 21		August 11	
18. Review manufacturability		X		X	February 19		May 21		August 11	
19. Line release			X	X	March 5		May 28		August 18	
20. Prepare market materials			X	X	March 5		May 28		August 18	
21. Sales meeting & first orders booked			X		March 5		July 16		September 9	
22. Make production patterns	X	X			April 2		August 18		September 28	
23. Receive production fabric (buy early)		X			April 2		August 18		October 5	
24. Grade patterns and make markers		X			April 9		August 19		October 18	
25. Ship to customers		X			July 9		September 9		January 3	

Figure 11.10
Traditional Merchandising Calendar for Company B.

product line accompanied by the completion date for each of those events (see Figure 11.10). A Merchandising Calendar is based on the company's annual Marketing Calendar. For each seasonal product line there is a Merchandising Calendar to be used as the guide or map for developing that particular seasonal line. In fact, there might be several Merchandising Calendars each season for any one company based on the product type(s) produced by the company. Usually personnel from technical design, sales, finance, purchasing, sourcing, manufacturing, and various other divisions, depending on the company organizational structure, assist the merchandiser in the development of this calendar.

The events in a Merchandising Calendar are often called **stage gates,** or critical decision points that must be completed at specific times during the line development process, and, at a minimum, the following critical meetings are found on all Merchandising Calendars: (1) Line Concept Meeting, (2) Line Development Meeting, and (3) Line Freeze or Line Release. The Merchandising Calendar may have as few as 10 or 15 stage gates or as many as 50 gates based on the detail of the calendar and company requirements for developing the calendar. A typical Merchandising Calendar has the following meetings and decision dates: Trend Concept Meeting; Strategic Intelligence Meeting; Line Concept Meeting; Product Strategy Meeting/Line Development Meeting; Manufacturing Meeting; Line Pricing Meeting; Merchandising, Planners, Account Managers Meeting; Line Freeze Meeting; Marketing Freeze Meeting; Line Release Date; Sales Meeting; Start Ship Date; and End

Ship Date. The Merchandising Calendar may span from four to six months depending on company guidelines and the speed at which the company can get the product to market. Having fast product development times is an advantage to a company that wants to have fashion forward apparel that is appealing to many of today's consumers. Terminology of the meetings and dates on one company's calendar may vary from another company's calendar in the same segment of the FTAR Complex; however, all companies are concerned with time to market and meeting the deadlines of its internal functions and those of its vendors and customers.

The Merchandising Calendar and other outputs from the Line Concept Development step must be developed based on top management decisions with regard to the company's mission statement, merchandising philosophy, marketing objectives, and the company's annual Marketing Calendar. Thus merchandisers must work within the parameters set by management to develop a seasonal line that will be profitable for the company and meet the needs and desires of the retail client and, in the end, the target consumer of the retailer. Although merchandisers are usually creative individuals with many artistic or aesthetic talents and a taste level for trendy fashion, these employees must work closely with the details and quantitative information given in the strategic plan outputs and must develop a business sense that allows them to translate the artistic endeavor into sales and profit for the company and the company's clients.

Market Research and Trend Analysis Activities

The development of a seasonal line must be based on market research, market and fashion trend analysis, and business data analysis. Market research may be handled by a separate division within the company, may be performed jointly between market research personnel and merchandisers, or may be the sole responsibility of the merchandisers. Chapters 7 and 8 examined market research and trend analysis techniques in depth. The following section discusses how these techniques are used specifically for Line Concept Development.

Market Research

All merchandisers, regardless of company support, will be evaluating, anticipating, and forecasting the market research information to make it usable in the line development process. Market research starts with an in-depth macro global and domestic environmental scan (i.e., social, psychological, political and legislation, economical, technological, and environmental factors impacting the line development process). In addition to this information, the product merchandiser conducts an in-depth evaluation of (1) POS data of the firm's major retail clients, (2) retail marketers/merchandisers and account executives feedback of actual happenings on the retail sales floor of major customers, (3) market data from professional marketing firms, such as The NPD Group, Inc. (see Figure 11.11), and (4) data of the line's performance for the company during the

Figure 11.11
A report providing apparel industry insights for buyers.
(Courtesy of The NPD Group, Inc.)

same season of the previous year. In some companies the product merchandiser is required to interface with the end consumer at special events and happenings or in retail stores to observe the tastes, attitudes, and buying patterns of those consumers. The merchandiser uses this market research to formulate a snapshot of what is happening in society and in the market to develop the line to meet the needs of the end consumer.

Also, product merchandisers and product development personnel examine happenings in each channel of distribution; current retail environments and store planning trends; and new, innovative marketing and advertising trends as well as the most up-to-date visual merchandising trends in the industry. Additionally, tracking economic trends, such as the cost or supply of a currently popular fiber or the demand for a large quantity of a specific fabric, such as denim for fashion products, or recognizing a sudden swing in the location for sourcing a product, are vitally important for every company in each segment or link of the industry because a trend in one area affects all links of the FTAR Supply Chain. For example, the cost of cotton may determine how much of the cotton fiber would be used in a fabric blend by a textile mill to produce a trendy fabric (see Figure 11.12). If the cost rises to a high price point, the fabric manufacturer may have to reduce the amount of cotton from 100% to 65% in the fiber blend for fabrications used in products for the mass market. Fabrics for products going to discount retailers might have a fiber content of 35% cotton with 65% lower priced fibers. Fabrics containing 100% cotton would be sold only to manufacturers marketing products for specialty department stores or other high-price retailers.

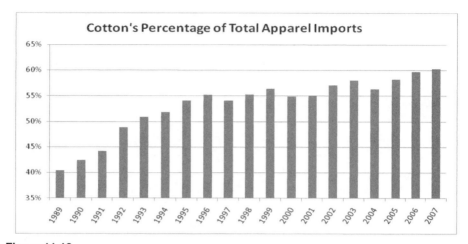

Figure 11.12
Data about the cotton trade of apparel imports.
(Courtesy of Cotton Incorporated)

Past, current, and future industry, fiber, textile, home furnishings, and apparel trends must also be tracked and evaluated by product merchandisers, product development, and research personnel in the manufacturing and raw materials areas. Merchandisers and other personnel collecting information for developing the seasonal line may visit global fashion centers to observe what is being worn by the person on the street; attend designer showings or major fashion shows in fashion capitals throughout the world, or attend European fabric fairs, trade shows, or mill weeks to gather information on fiber, fabric, and color trends in addition to reading trade magazines and meeting with vendor representatives.

The Image Communications Division or Sales and Marketing Division personnel, along with the product merchandisers, summarize their extensive consumer, market, competitive, and product research in a **Strategic Intelligence Report.** These market research findings and industry trend analysis information are shared with vice presidents or directors of product development and vice presidents of all SBUs in the merchandising area as well as with product merchandisers and their staff plus image communications personnel and selected finance and planning personnel. The meeting for reviewing the market and industry direction and summarizing historical statistics in some companies is known as the **Strategic Intelligence Meeting.**

Product Trend Analysis

Product development personnel and merchandisers must also examine product specific apparel and home furnishings trends in a **product trend analysis.** These employees evaluate each product classification produced by the company, analyze its position in the fashion adoption stage of the product, as well as its position on the Perceptual Map (see Chapter 3). This product classification analysis

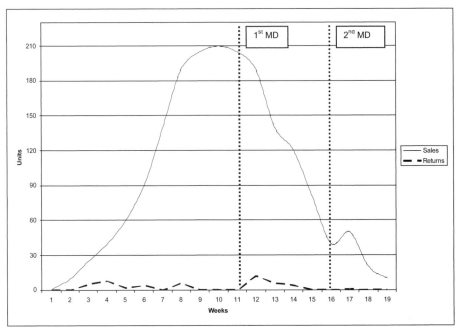

Figure 11.13
Sales units and return units with first and second markdown (MD) information from retailer.

is important to understanding the company's products, its past performances in sales, and the retailer's and consumer's perceptions of the product. The merchandiser wants to know not only how and to whom the product sold to the retail customer but also how well the product sold to the retailer's customer, the consumer. Sales figures from the account representatives who service the retail accounts would be important market research at this stage in Line Concept Development (see Figure 11.13). In addition to sales, the merchandiser will want to know about returns from the retailer and returns from the consumer. Knowledge of the retail selling price will be important to planning for the new seasons.

Additionally, emerging trends in related product classifications are pinpointed and the impact of these trends on the products of the manufacturer is anticipated. Describing the performance of the line for the same season of the previous year, a **Sales History Report,** especially an analysis of figures consisting of a sell-in and sell-thru of product categories and full price versus markdown merchandise, a return-to-vendor report, will be compiled. **Sell-in** of products refers to the number of products that were sold to the retail clients relative to the number of products that were carried in the product line (see Figure 11.14). **Sell-thru** is the quantity sold of each SKU to the retailers' customers as calculated as a percentage of the total number of that same SKU ordered by the retailer. A five-year sales curve would be developed to show trends in sales for the product or similar products over the past five years and would present information for developing the seasonal line.

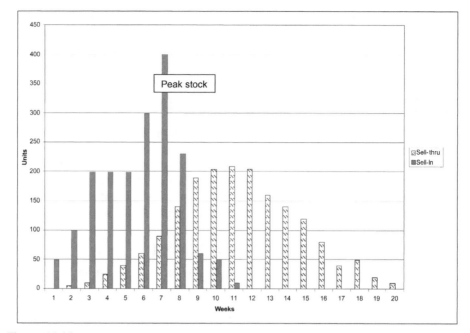

Figure 11.14
Sell-in and sell-thru information for a retail account.

In addition, the merchandisers for an apparel manufacturing company would want to analyze trends related to their vendors or suppliers. When manufacturing a product, the merchandiser will have ordered numerous supplies for the product. Apparel products contain not only the raw materials of fabric but also the findings and sometimes accessories. Findings include thread, buttons, zippers, trim, interfacing, and other related products. Although the raw materials for T-shirts may be as simple as a tubular knit fabric and thread, a tailored jacket may contain ten or more raw materials, and most of these would come from different vendors. In addition to noting the vendors that supply the selected products, the merchandisers would also determine the shipping dates, returns, order fulfillment, on-time and late deliveries, and other supplier characteristics about the vendors that have been used. As a result of the Sales History Report and further vendor analysis, merchandisers for product manufacturers would identify which vendors were supplying the production of the best selling products and construct a **Best Vendor List,** for analyzing their fiber and/or fabric suppliers. This list is similar to the Retail/Vendor Matrix used by the retailer (see Chapter 14).

All fashion trend information from all segments of the FTAR Complex would be collated into a **Trends Concept Report** and discussed with management and all merchandising and marketing personnel in a **Trends Concept Meeting.** Some companies develop a comprehensive **Market Research Report** from information contained in both the Strategic Intelligence Report and the Trend

Concept Report. Additionally, some companies combine the Strategic Intelligence Meeting with the Trends Concept Meeting. This type of meeting may then be known as the **Merchandising Planning Meeting.**

Creative Developmental Activities

After evaluating all of the market research and trend analysis information, merchandisers interface with designers to review new design concepts (i.e., new silhouettes, styles, or bodies of product classifications and fashion theme trends). At this point in the line development process, the merchandiser then begins to conceptualize and develop themes and fabrications plus the style and color direction of the line (see Figures 11.15a and 11.15b).

Product Attribute Development

The product merchandiser has his or her own unique techniques for addressing the steps in identifying, analyzing, and developing product attributes that fit into the theme of the seasonal line. These product attributes or characteristics must reflect the fashion image of the company and the market trends for the season. At the same time, the product attributes must satisfy the needs and desires of the retailer and target consumer. Company policy including the selected product classifications dictate the sequence in which some of the product attribute development activities, functions, and meetings take place. Not every merchandiser, for example, begins the process with the same attribute. Some start with theme selection, some with fabric selection, some with color selection, and some with style selection. In addition, a combination of these elements may be the inspiration for the merchandiser. For example, a particular theme demands a specific color palette and/or a specific fabrication and trim. Sometimes the company may own fabric that must be used; thus the style development will be based on the fabric selection dictating the theme of the line or grouping. In addition, the retailer or the raw materials producer may provide the lead for product development.

Regardless of the sequence for creative development activities used by the merchandiser or dictated by the company's Marketing Calendar, all merchandisers have the following responsibilities when developing the season's product line: (1) anticipating and forecasting the major themes for the overall seasonal line and each grouping within the line, (2) selecting fabrications, trims, and findings, (3) developing styles or bodies, (4) selecting the color palettes as well as graphics and patterns, and (5) planning the number of sizes to offer in each style. Ultimately all of these tasks must result in a product that will best reflect the company's fashion image, can be produced profitably by the manufacturer, will best attract the company's client or the retail buyer, and will meet the needs and desires of the retailer's target consumer. Not only will the direction of the process vary from merchandiser to merchandiser both within and across companies, but also the timing of a few or several of these activities may vary widely from company to company and product classification to product classification.

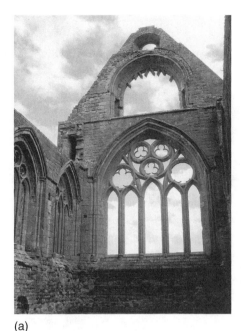

(a)

(b)

Figure 11.15
A designer uses (a) architectural inspiration to develop and (b) the fashion sketch.
((a) Photographer: Amber Roth, (b) Fashion designer: Amber Roth)

THEMES. Usually themes for a seasonal line are based on the inspiration of the design concepts provided by the designer or by the overall direction and climate of the market itself. When the seasonal line composition is composed of different groupings of merchandise, there must be some commonality that ties the groupings together, and the **theme** usually becomes that commonality. In another approach, the merchandiser may select a specific theme for each grouping and then tie the line together with fabrications, color palettes, or prints and patterns. Many designers and merchandisers travel the globe to find themes on which to base the product line; others are inspired by movies, Broadway plays, and artistic endeavors such as the ballet, opera, or art exhibits; and some are motivated by nature, by history, or by current events. For example, the merchandiser based the seasonal line on a southwestern theme; therefore, the color palette of earth tones (i.e.,

Figure 11.16
Products and materials with a southwestern theme.

browns, beiges, rusts, olives, dark khakis, gold—inspiration of the desert and mountains) paired with brights of coral, turquoise, and gold tones would be prevalent in the line. These colors are not only in the natural environment of the U.S. Southwest but also are colors associated with beautiful fabrications woven by the native population in the geographic area. This merchandiser would also include assimilated coral, turquoise, and wooden trims for the garments and accent the grouping with coral, turquoise, and wooden accessory items because of the associations most consumers make for these materials with this region. Regardless of the source of the inspiration, the theme is a most important component of the development process because many times the theme impacts not only the silhouette shapes but also the color palette and fabrications. Therefore, one season a merchandiser may begin with fabric and color selection, and that same merchandiser the next season may initiate the line development process through style development. Concept boards are used by many merchandisers to show the pictures, raw materials, and other inspirations that are used to develop a theme. **Concept boards** may be created as a collage of gathered items (see Figure 11.16) or may be made with a merger of digital pictures or a combination of pictures and things. Concept boards are useful in illustrating to others the elusive feelings, colors, textures, and other materials that are being used to express the theme.

FABRICATIONS. **Fabrications** are the raw materials used to create the sewn products of apparel and other soft goods. Apparel fabrications typically include

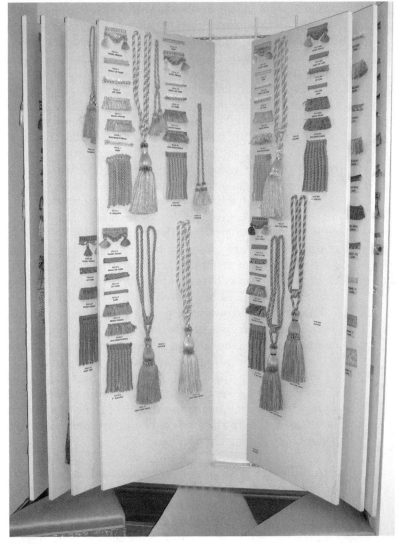

Figure 11.17
Trim board at a market showroom.
(Courtesy of Tomlinson Erwin-Lambeth Directional. Photographer: Katie Banner)

the piece goods, fabrics or textiles, and the findings used in the cut-and-sew process of apparel production. Fabric selection and adoption are critical to developing and delivering the seasonal line in a timely manner. Many times the merchandiser must commit for piece goods (i.e., fabric) before the seasonal line can be solidified, or sometimes the line is composed of styles based on the availability of the fabric selection. Also, if special findings (e.g., buttons, trims) are needed to execute the theme of the line, these items need to be researched and ordered early in the developmental process (see Figure 11.17). It is not

unusual for a merchandiser to work on the perfect match of a trim for several months if that particular feature is a part of the fashion statement or a "vehicle" for carrying out the theme of the product grouping.

Fabric is usually selected early in the Line Concept Development Process to calculate the company's cash flow commitment to piece goods in advance of final costing and to determine the amount of fabric needed for each product classification. The information is also used to determine the costs of the average price per unit. Thus the number and prices of fabrications must be carefully planned and many times limited not only to control costs of products in the line but also to control the manageability of production and inventory. However, there are some exceptions to limiting fabrications. Some of the exceptions might include when the fabrications themselves are the fashion component of the line; or if the fabric is a very special fabric that makes the line "pop," pulls together the styles, colors, and theme for the line; or is a fabrication for only one style in the line or grouping that might be the loss leader, or minimal profit generator, with regard to profits but that adds the "frosting on the cake" for that particular line or grouping. If this special fabric is very costly, the style might be kept simple so as to use less fabric yardage, or other fabrications such as buttons and trim might be limited on the style using the costly fabric.

Fabric type and quality are usually dictated by the apparel zone in which the product classification is positioned, by the financial budget set by company management, by the fashion trends for the season, and by what the consumer expects in product attributes including quality from the brand or company. Fabric may be the component of the product that creates the fashion statement or it may be the background the merchandiser uses as the foil for creating the style, the color palette, or the theme of the collection (see Figure 11.18). However, the costs of the fabric is most important because it is one of the major components for pricing the SKU.

STYLES/BODIES. As previously discussed, a seasonal line is a collection of various groupings or related merchandise classifications or a single product classification. Each style or body of merchandise in the line or grouping is the distinctive look of the product. **Styles** are named combinations of product parts. For example, a sheath is a simple straight dress with no sleeves, a scoop neck, and a knee-length hem. A blazer is a jacket with two or three buttons, a two-part sleeve with buttons at the wrist placket, and a notched lapel with a collar. Thousands of styles exist in the fashion world and can be drawn on by designers and merchandisers for completing the line. The company may be known for a specific set of styles or fashion looks. Customers may expect to see some of these favorite styles, or **good bodies,** with current trend updates, to be featured in the line when shopping the seasonal lines of that particular vendor. Consumers may also expect to see some of these bodies when shopping the line. For example, the product line from the House of Chanel often contains some simple straight skirts and rather simple jackets that have no collar, a rounded neckline, and an overlapping front with a row of elegant buttons. This style is so often associated with this designer brand that many people refer to

Figure 11.18
One style in multiple fabrications.

that jacket style as a "Chanel-type" jacket even if they bought it in a local discount store. Although this is common practice, this nomenclature is very much discouraged by the House of Chanel. Merchandisers should be aware of such legalities as they develop names, images, and symbols for their product lines. The intellectual property rights of designers and brand owners can be protected by federal trademark laws and covers registered logos, brand names, and distinctive patterns (Winograd & Tan, 2006). These legally protected images must be respected by other merchandisers. Variations of styles may appear as fashion trends create changes.

As the styles are established for the product line, each style or body is assigned a manufacturer's or vendor's **style number** and is cut in specific fabrications, in selected colorways, and in a specific size range. The style number is unique for the product and provides information about the product line, color, and other features of the product. Most style numbers are now communicated with bar codes and can be shared with the retailer and used to track the product throughout the Line Development Process Cycle. From this point forward in the process, a merchandiser or other authorized personnel, without leaving the office, can determine where the product is in the process by using the bar code and the computer. With an integrated computer system, a product can be tracked from the time the style number is assigned through sample making and production into shipping and retail floor presentation to the purchase by the consumer. This information becomes very important when meeting deadlines and when informing retail customers about their orders.

Unless the merchandise item is a basic or commodity product, the style or silhouette of the design is usually one of the major fashion components of the

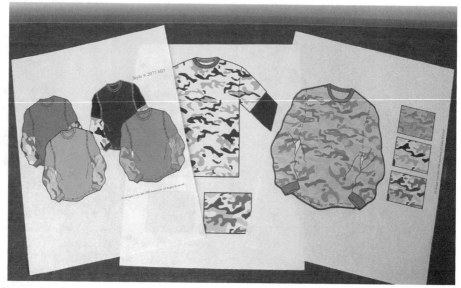

Figure 11.19
Grouping of styles such as long-sleeve tees.
(Courtesy of The AmeriTech Group, USA, Inc.)

line. The popularity of a style or silhouette for a product changes constantly, and it may evolve into the next fashion trend for that particular product classification. Each current style is evaluated in the product trend analysis for its contribution to the total season's sales volume. At this point, the merchandisers also evaluate the product for its fashionability and its stage in the product life cycle. Merchandisers must predict whether the product with its current styling will continue to be accepted by consumers and will sell well or if the product has become boring to consumers and a small adjustment in style is needed or a major change is what will appeal to consumers. Most items in a grouping must have some appeal to the retailer and the consumer and present as a cohesive package to promote more sales (see Figure 11.19). If the merchandiser is correct in the forecast, the product will be a stellar selling item. If the merchandiser is wrong, the product will be obsolete before it leaves the production plant. These results seem simple, but the profitability of an entire company rests on the accuracy of these predictions. Decisions on which and how many styles to include in the line or grouping is made early in the line development process, and many times it is based on either the volume contributed as determined by previous sales or the intrinsic value added to seasonal sales.

COLOR PALETTES. Color is the number-one component of an item that attracts the target consumer. The consumer sees color before he or she examines the silhouette, the size, or the price of the merchandise. For this reason, the selection of the color palette(s) for the seasonal line and the selection of

Figure 11.20
Colorways for the Sunbrella® line.
(Courtesy of Glen Raven, Inc.)

colorways for specific garments are one of the most important responsibilities of the merchandiser. **Colorways** are the combination of colors used within the product line. Based on the theme, based on the placement of colors in a color wheel, or based on a print or patterned fabric, an assemblage of colors is selected. For example, a print fabric may contain the colors of blue, green, and yellow in various tones and shades. The colorway for the product line contains a set number of colors in the blue, green, and yellow variety (see Figure 11.20). The number of colors to include in a colorway depends on company policy, theme, designer input, and product line size. Each color can be used individually in a fabrication or can be combined with solids and prints.

Color is fashion and fashion is color. For example, a basic T-shirt may be offered in fashion colors and therefore sell as well as a trendy silhouette T-shirt in a limited number of fashion colors. There are many color resources (see Chapter 10) to guide the merchandiser when selecting the color palette for the season. Colors change with fashion trend changes and with climatic changes. Many times the theme of the line dictates the color scheme for the line as does the fabric selection. However, the number of colors must be controlled in order to control the amount of fabric purchased and the amount of product inventoried and to gain efficiencies from economies of scale.

Textile and fiber producers must anticipate the best way to introduce the color or pattern on the fabric. Their merchandisers must consider if the color or pattern should be applied at the raw fiber stage (i.e., solution dyed or fiber dyed), yarn stage (i.e., different colored yarns dyed to create stripes, plaids,

chambrays, etc.), fabric stage (i.e. piece dyed), or garment stage (i.e. garment dyed). This decision is usually based on the quality demanded by all clients, especially the end consumer, within the supply chain; the specific channel of distribution where the product is sold; the speed to market expected by the product manufacturer and retailer; and the type of equipment and expertise of the raw materials producer. The later the application of color, the more flexible the raw materials producer can be with shipping deadlines and color assortments, especially on reorders.

Sizes. Based on the product category, the silhouette and design of the item, and the fabrication in which the item is executed plus the industry zone in which the item is positioned, the merchandiser must determine the range and number of sizes in which to offer each item. If the item is constructed in a knit fabrication or is in the budget or lower price point zone, the merchandiser may work with the sizes of S-M-L. Based on the fashionability of the item, the target consumer and the industry zone, the merchandiser might add the additional sizes of XS and XL. In a woven fabric, the merchandiser might plan the size range for a trendy item to run from sizes 4 to 12 or from 6 to 14. Petites or junior sizing may be added to the product line if the item is for a broader consumer market. Many times company management dictates the size range and type based on its fashion image, planned yield of units per yard of fabric, or expectations of the retail client or target consumer. A basic jean may be produced in sizes 8 to 18 and in petites and women's sizes, whereas a fashion jean may range from size 2 to 14 in misses and petites only. In addition to determining the size range, the company also has unique product dimensions. Specific dimensions of a product for each size varies by company so that a size 8 sold by one company may be very different in dimensions from the size 8 sold by a second company (see Chapter 3). The number of sizes must also be considered and possibly limited to realize the most items for the fabric yardage and to provide the right size in the right merchandise for the retail client.

Raw materials producers are performing similar functions of evaluating, anticipating, and forecasting fabrications, colors, and fabric utilization; however, they are examining not only retail sales and product trends but also trends in the seasonal fabrications to be produced for the product manufacturer. They must decide if they wish to build specific qualities into the textile product through manipulating the fiber or yarn construction at the beginning of the development process or if they can achieve the same effect by applying a dye, a finish, or other treatment on the surface of the fabrication later in the process.

Line Plan Summary Development

Product merchandisers are the central point in the company for coordinating development, production, and delivery of the seasonal line. At this point, big concepts have been formulated in the planning and research stage, and the merchandiser is developing product attributes such as' theme and color.

The next and almost simultaneous step is to develop the **Line Plan Summary,** or as called by some merchandisers, the **Merchandising Plan Summary.** This summary delineates the number of styles (i.e., silhouettes, bodies) to be included in the seasonal line, the number of colors in which each style is to be produced, plus the number of fabrications in which each style will be offered to the retail client. This information dictates the number of SKUs as well as the number of related SKUs to be coordinated with the styles. In addition, the Line Plan Summary restates the total dollar sales volume and number of units to be sold, as planned earlier by management and found on the Marketing Calendar. This Line Plan Summary is another guideline the merchandiser uses as the basis for continuing to develop the line.

The development of the Line Plan Summary is scheduled early in the Line Development Process Cycle so that all deadlines listed on the Merchandising Calendar may be met. The Line Plan Summary may start with a **Line Plan Meeting** to discuss the calendar and product attribute information. Merchandising, sales, marketing, and manufacturing personnel provide the most current company information in the Line Plan Meeting. From information presented in this meeting and the calendar meetings, the merchandiser develops the **line composition** (i.e., line content, timing, and pricing). However, some of the details of the Line Plan cannot be finalized until product attributes are determined. For example, the merchandiser can review past sales and see that 100 dozen of a specific shirt sold well for this season last year; however, that same designer, from the analysis of market research, is encouraging the incorporation of some very expensive trim to meet the fashion trends forecast for the upcoming season. The cost of the trim may reduce the overall number of units sold because of the total costs involved in ordering and housing the trim.

To build the Line Plan Summary, the merchandiser must forecast the **initial line composition.** The line composition, or **line content,** is determined by pinpointing the lead product strategy and by formulating the product assortment mix or product assortment through identification of new styles and **carryover styles** (i.e., repeat styles). The **lead product strategy** identifies the major classification(s) that will be highlighted in the product line, which gives further direction to the theme or image planned for the line. At this point, what the product line is "saying" must be very clear to all involved in the process. The amount of style change is related to the product classification, the fashion level of the line, and the company's position in the market. Most merchandisers create a **Line Composition Grid** to designate clearly how many styles and fabrics will be carried over and how many new styles and fabrics will be added. For example, in the Line Composition Grid for a trendy line of contemporary merchandise, the merchandiser may have 35% of the styles as fashion-forward styles, 35% in fashion basic styles, 25% of "tried and true" carryover styles, and 5% in high fashion styles that add "spice" to the line but will be produced in limited volume (see Figure 11.21). In contrast, a manufacturer producing a one-category line of knit T-shirts may retain 65% to 75% of its styles from the previous season but recolor and refabricate them for the current season, thereby adding only 25% to 35% new styles. The Line Composition Grid

Company Image ⇒ Styling ⇓	Trendy	One-line Basics
High Fashion:New	5%	0%
Fashion Forward:New	35%	25%
Carryover: Limited Updates	25%	65%
Basic:Classic Look	35%	10%
Total Merchandise Mix	100%	100%

Figure 11.21
Line Composition Grid showing percentages of product styles carried by two apparel companies.

may be made as a spreadsheet or a table and provides a snapshot of the product merchandise mix for the line.

Raw material providers also begin with developing color palettes, identifying fabric trends such as textures, patterns, fibers and yarn composition, fabric blends, and construction techniques to use for producing fibers, yarns, and fabrics. As their merchandising counterparts in end product merchandising, they begin to make concrete their forecasts with the initial line plan by pinpointing the lead product strategy and formulating the product assortment by identifying new and carryover or repeat fabrications.

However, for all merchandisers who are trying to finalize plans for a product line, the number of colors per style, as selected in the analysis of product attributes and based on the Market Calendar and other management decisions, must also be included so the total number of SKUs may be estimated. Usually, for coordinating groupings, two to three fashion colors and a neutral or basic color compose the color palette of the line; however, not all product classifications in a grouping are cut in every color. For example, if there is both a blazer and a novelty jacket in the grouping, the blazer may be cut in one fashion color and the neutral color and the novelty jacket may be cut in two to three of the fashion colors. This combination limits the number of SKUs for production and also helps control fabric inventories and costs for production. In another product line, a pattern such as a stripe may be cut in three to four colorways for a fashion top, and a basic style of T-shirt may be cut in both fashion and basic colors and offered in as many as 10 to 12 colors. In contrast, some items are cut only in basic or neutral colors while others are offered in only fashion colors, depending on the fashion level of the product category and the planned volume of the item. Additionally, the number of sizes for each style must be determined to complete the initial line plan.

From the information on styles, colors, and sizes, the total number of SKUs in the product line can be calculated. By multiplying the number of styles in the line by the number of colors in which each style will be produced and by the number of sizes in which each style will be produced, the merchandiser will be able to determine the number of SKUs and thus analyze the manageability of the line. This summary becomes the **Initial Line Plan Summary,** and these parameters become the guideline for developing the product distribution for the seasonal line. This plan must be approved by executive management before the line development process may proceed. The **Line Plan Approved** or **Line Plan Approval** is then distributed to all divisions of the company so it may be used by all personnel to develop the seasonal line in a timely manner.

At this point in the Line Development Process Cycle, a **Line Concept Meeting** is held to share all happenings in each division. This meeting is sometimes called a **Slush Meeting** because although some parts of the line are formalized (e.g., numbers of units and colors), only style concepts and colorways are determined and exact details of each product are not always firm. Executive management, vice presidents, and directors of all divisions, including image communications and consumer marketing as well as managers or directors of operations, finance, human resources, and production, attend the meeting, along with other merchandisers and their staff, product development personnel, market research personnel and trade and retail image communications personnel, plus planners, and production managers (i.e., product, purchasing, technical). In this meeting, merchandisers present the overall line theme and lead product strategy; a seasonal line forecast; the Initial Line Plan Summary, including carryover, new styles, and new fabrications; and graphic development needs. Additionally, product development personnel present major product concepts with themes, and the Retail Marketing Division personnel give a review of the retail client summary.

Tools for Development Activities

At this point in the Line Concept Development Process the merchandiser will take all input from the discussions at the Line Concept Meeting and develop two tools that will provide more concrete direction for the product line development stage of the entire Line Development Process Cycle.

Product Grid Development

In a summary of what was decided in the Line Concept Meeting and the adjustments that were made to the Line Composition Grid, the merchandiser develops product grids or charts to pinpoint the exact percentages and volumes of each product to be produced. The **Product Grid** is a schematic to delineate the number of products to be completed and manufactured in the core, alternative core, basic fashion, and trendy fashion levels plus any fringe product classifications to be offered to the retail customer (see Figure 11.22). This grid is more

Figure 11.22
Company B Product Grid.

concrete and descriptive of the products than the general directions offered in the Line Composition Grid. The Product Grid shows the **product change strategy** of how fashion level and sales volume will change along the product assortment, with levels ranging from the basic products that are well known to the company to very trendy items that show the results of the newest market research, plus the range of sales volume associated with this style change.

The **core product** is the most basic product offered by the company and will, for many companies, require a large amount of the company's resources and is often the most recognizable product the company handles. The core product must produce volume and have staying power in the line; therefore, the core product is a basic product that should produce high sales volume. To complement the core product or "cash cow" of the line, companies also develop an **alternative core product** to reach another market segment, to present another price point in this structure, or to further penetrate the market of their core target consumer. For this part of the product line, the company uses seasonal fashion products, which are updated core products. A selection of new colors, new fabrications, or a few minor style changes such as a new collar or cuff detail could be used to update these products. For years, The Limited offered a basic pullover sweater that was available in several new fashion colors each season, and the scoop of the neck varied slightly with the fashion styles; however, the

overall shape of the sweater, the inset of the sleeves, and the fit for the sweater body remained the same. Their loyal customers always knew how the sweater would fit and look when they selected their usual size. These alternative core products are very important for the fashion store because both the retailer and consumer already recognize and understand the product or brand. Also, the sales force and manufacturing personnel are familiar with the product; therefore, there is a savings of both time and money in the production and sales of the product line.

When the core product is further updated with more trendy details, this product becomes the **basic fashion product** for the line (see Figure 11.22). It is freshened with new product attributes identified in the market research, such as novelty stitching, trims, or other fashion details, or it is produced in new fashion colors and fabrications or rendered in new washes or patterns but remains basically the same core product. Depending on the sophistication and fashion level of the retail client and the end consumer, the basic fashion product may be the product type that occupies the major percentage of the line while the core and alternative core are staples for the retailer.

Trendy fashion products are those products based on fashion trend changes for the season and show very trendy fashion-forward silhouettes. These products are very important for the company because the trendy fashion products are needed to build fashion image and company credibility in fashion leadership. Even though this product is the smallest volume and SKU percentage of the line, it is needed to attract the attention of both the retail buyer and the end consumer. Also, these new trendy items can be used to test the marketplace for acceptance and viability for further development in future lines. Many times the trendy fashion item of one season becomes the basic fashion item for the next season.

Other types of products important to the product change strategy are the **fringe products,** or **secondary products.** These products are added to the product lines to support the core and basic fashion products and provide the consumer with product choices while continuing to buy within the same brand or from the same company (see Table 11.2). For example, at the strategic planning process level, the goal of increasing sales volume for a jeans manufacturer is general, such as "We want to increase our sales of jeans through expansion of companion products." At the Product Grid level, the product categories are identified. Based on production capabilities and employee expertise, a jeans maker may decide to offer the retailer related separates such as shirts, sweaters, and tee-tops in hopes of selling more jeans. The core product for the manufacturer is the basic jeans, the fashion basic product is the jeans with some trim details, and the related separates are the fringe or secondary products. Decisions will have to be made as to how to allocate the budgeted dollars across the product classifications.

To build these grids and to allocate the budgeted dollars across the product classifications, the merchandiser must determine not only the number of product classifications in each fashion level to include in the line but also calculate the percentage of each style as well as the percentages of each color and fabrication per style. Therefore, the merchandiser must have a good idea of the buying patterns of the retail clients as to product type, color preferences, and size

Table 11.2
Volume of secondary products as support for the primary or core products for a pant manufacturer.

	Products	Style Numbers	Percentage of Mix	
Core	Twill pant—straight leg, slash pocket	2415	10%	80%
	Twill pant—straight leg, patch pocket	2425	10%	
	Canvas pant—straight leg, patch pocket	2426	9%	
	Canvas pant—straight leg, pleated pocket	2436	11%	
	Twill pant—boot cut leg, slash pocket	2515	8%	
	Twill pant—boot cut leg, patch pocket	2525	12%	
	Canvas pant—boot cut leg, patch pocket	2526	10%	
	Canvas pant—boot cut leg, pleated pocket	2536	10%	
Secondary	Top—short sleeves, scoop neck, knit	5121	4%	20%
	Top—short sleeves, v neck, knit	5131	6%	
	Top—short sleeves, band collar, woven	5172	5%	
	Top—short sleeves, petal collar, woven	5182	5%	

ranges. In fact, sometimes the merchandiser conducts product research with its major retail clients by **pre-lining,** or asking the retail client to preview the line during the developmental process and to provide feedback on line direction, styles, colors, and fabrications. Without this knowledge, the merchandiser will be working at a disadvantage when planning the product mix distribution for the season and could make decisions that would jeopardize the success of the seasonal line. The more market research done, especially targeted research on the retail customer and the target consumer, that can provide concrete information into this process of prediction, the more successful many companies are with selling their product line.

Image Communication Marketing Tools

Personnel in the Images Communication Division must develop marketing tools to sell the seasonal line. These tools are the **Image Communication Plan,** which is one part of the overall Marketing Plan. Working with the merchandiser and depending on the theme of the line and the marketing budget, the advertising manager, special events manager, graphics coordinator, visual merchandiser—trade, visual merchandiser–retail—develop advertisements (e.g., television, radio, billboards, in-store, magazine, newspaper), create plans for special events for both in-store as well as trade shows and consumer events, design gifts to be given away or products to be bought with products for reduced prices, and create unique packaging. In addition, these personnel create POS visuals to carry out the theme of the seasonal line. Depending on the channel of distribution and the retail type, many times individuals in this division create new fixturing or signage for specific retailers and/or develop specific plans for how to promote merchandise and arrange products in the stores. Although

the graphic work and specific promotional plans are created by the skilled Image Communication Division personnel, merchandisers work closely with this division to assure that the line theme is represented accurately and all marketing pieces support the product and reflect the fashion image of the company. Many times, the merchandise may provide the "big idea" for the marketing piece or supply product information that will spark the creative process for a particular line concept.

Retail Customer Review

Merchandisers, with the assistance of personnel in the Retail Services Division or the Retail Marketing Division, study not only happenings or trends that are developing in the overall retail environment, they also analyze the happenings of the same season of the previous year of their major retail clients. Merchandisers must track constantly what is happening with retail sales volume; what product classifications are in great demand; and what new trends are developing in retail types, store formats, store design; and even what is happening in retail advertising and visual and promotional trends.

For each retail customer, merchandisers look at both sell-in and sell-thru of seasonal lines as well as the performance of specific product classifications. In addition, the merchandisers analyze markdowns and attempt to determine why a product did not sell at the retail level. Many times merchandisers talk with the retail buyer or retail merchandiser to ascertain the needs and wants (i.e., trend direction, styles, colors, fabrications) of the retail client for the upcoming season. With this type of information, the product merchandiser is better able to project the preliminary sales volume for specific retail clients as well as the overall sales volume for the company and to plan the seasonal line composition. The product merchandiser will have more concrete information to use when planning the product attributes for specific product classifications that will meet the needs and demands of the retail customer and the target consumer.

After merchandisers formulate the preliminary Product Grid and image communications personnel begin the initial development of the marketing tools for the seasonal line, a **Line Development Meeting,** or as sometimes called a **Product Strategy Meeting,** is held. Product merchandisers, designers, product development personnel, marketing personnel, and executive management plus planners and production personnel (i.e., purchasing, product managers, pattern makers, engineers, operation personnel, technical personnel) finalize the carryover core product and solidify the lead product and overall line theme as well as discuss the major trend direction that should be targeted for development of the various groupings of merchandise. Additionally, the preliminary Product Grids are distributed, and marketing needs and progress on preliminary marketing activities are reviewed. The major marketing activities are identified to initiate the development of marketing graphics and other marketing pieces. At this point in the Line Development Process Cycle, the product merchandiser has completed the Line Concept Development activities and is ready to proceed with assisting in Product Line Development and in managing and marketing the seasonal line.

Summary

The Line Concept Development Process provides a broad but concrete foundation for the product line. This process involves intensive market research and an analysis of the past sales history. Previous products are analyzed for their sales volume, their acceptance by retailers and consumers, and their contribution to profits. Colorways, carryover and new bodies, and other product attributes are selected. A theme is given to the product line. After numerous meetings with personnel in other functional areas of the company and with top management, merchandisers finalize their ideas for the line and recheck them to be assured the line will fit the company image, be attractive to the retail customer, meet all plan and sales goals, and be desired by the target consumer.

The merchandisers and designers at the end product manufacturer have enormous power in the market. By the selections that are made and the product colors and styles that are not selected, the merchandisers have begun to direct what will be shown in the markets to retailers and what will be shown to consumers in retail sales. Manufacturers produce a specified number of styles from which retail buyers select only those styles in the line that they think will be most profitable for the retail establishment and will meet the needs and desires of their target consumers. The consumer then shops the edited merchandise assortments of the retailers.

Key Terms

Alternative core product
Back-to-school season
Basic fashion product
Best Vendor List
Carryover styles
Colorways
Concept boards
Core product
Cruise season
Early fall season
Early spring season
Fabrications
Fall season
Fringe products
Good bodies
Holiday season
Image Communication Plan
Initial line composition
Initial Line Plan Summary
Lead product strategy
Line composition
Line Composition Grid
Line Concept Development
Line Concept Meeting

Line content
Line Development Meeting
Line Development Process
 Cycle
Line on sale by month figures
Line Plan Approval
Line Plan Approved
Line Plan Meeting
Line Plan Summary
Line preview date
Line release date
Market Research Report
Marketing Calendar
Merchandising Calendar
Merchandising Plan Summary
Merchandising Planning Meeting
Pre-lining
Product change strategy
Product Grid
Product merchandising
 strategy grid
Product Strategy Meeting
Product trend analysis
Resort season

Sales History Report
Seasonal line cycle
Season ship complete date
Secondary products
Sell-in
Sell-thru
Shipping by month figures
Slush Meeting
Spring season
Stage gates
Start to ship date
Strategic business unit (SBU)
Strategic Intelligence Meeting
Strategic Intelligence Report
Style number
Styles
Summer season
Theme
Transition season
Trends Concept Meeting
Trends Concept Report
Trendy fashion products
Winter season

Review Questions

1. What are the activities done within the three stages of the line development process?
2. How is the Marketing Calendar used to help the merchandiser during the line development process?
3. Why does the merchandiser also need a Merchandising Calendar?
4. How is market and trend research used in the line concept development?
5. With how many seasons will a merchandiser be working during one day? Why?
6. How does an understanding of product attributes help the merchandiser develop the product line?
7. What is in a Line Plan Summary?
8. How does the product grid help the merchandiser make decisions about the line?
9. How does the merchandiser work with the Image Communication Division during line concept development?
10. What information about the same season last year is used by the merchandiser that he or she cannot get from the previous season?

References

The future of fast fashion; Inditex. (2005, June 18). *The Economist (US)*. 375(8431), p. 57.

Tagliabue, J. (2003, May 30). Spanish clothing chain Zara grows by being fast and flexible. *New York Times*. Retrieved June 3, 2003, from www.nyt.com

Winogard, B., & Tan, C. L-L. (2006, September 11). Can fashion be copyrighted? Designers want to halt knockoffs but some say they spur sales; "Few people can spend $4,000." *Wall Street Journal*, p. B1. Retrieved September 11, 2006, from http://www.wsj.com

Line Product Development

Objectives

After completing this chapter, the student will be able to

- Delineate the process of getting samples prepared for approval
- Identify the specifications used for an apparel or home furnishing item
- Explain the importance of specifications to a consumer-centric company
- Discuss how specifications are developed in a collaborative environment
- Explain how specifications are approved, monitored, and controlled
- Calculate a quick cost for a product
- Discuss how the determination of manufacturability can affect the initial design of a product
- Calculate final wholesale cost
- Identify the importance of feedback to the consumer-centric company
- Discuss the final adoption and approval processes for the line products

Introduction

The product concept or idea must be converted into an actual product. Merchandisers at each level of the FTAR Complex must struggle with turning the dreams of consumers into producible products. This sounds fairly easy until someone thinks about consumer's dreams. "I wish I had a blue blouse." "Give me something that is warm and fuzzy." "I want to look terrific." Even

the wish of a blue blouse can be complicated when trying to specify or give critical details to this product. The merchandiser must wonder, What color blue is wanted to please the customer? Is it cobalt blue? Aquamarine blue? Navy blue? Baby blue? The choices seem endless. Then, the merchandiser must consider the blouse. What is a blouse? Does it have sleeves? How long are the sleeves? Do the sleeves have a cuff? A placket? Are the sleeves straight, full, pleated, puffy, shaped? Finally, the merchandiser must consider the fabric. Will the fabric be woven or knit? If woven, what weave—twill, oxford cloth, plain, satin, basket? The merchandiser must also consider the fiber content, the yarn type, the finish, the yarn twist. Fabric characteristics blend together to yield strength, durability, and hand of the fabric—again an endless list.

Consideration of abstract needs and wants for consumers compounds the problem of getting the right product. Merchandisers must make great efforts to understand the consumer and to be able to interpret what is "warm" or "fuzzy." Each consumer differs in his or her ability to feel and sense sewn product characteristics. A soft feeling wool sweater to one consumer might feel scratchy to another consumer. A lightweight jacket might be warm enough for one consumer and leave another consumer feeling cold. Issues such as "looking terrific" or "feeling great" are certainly open to interpretation by both the wearer and the viewer, and they are often cast in context of culture, economy, and other societal features. Needless to say, the sewn product, both apparel and home furnishings, although seemingly very simple and definitely an intimate part of all consumers' daily lives, is actually a very complex and multifaceted product.

The process of deciding and then producing the right product involves a number of steps. Issues of color, style, and fabrication, selected in the line concept development stage, must be actualized during the line product development. The steps of **Line Product Development** move the product from the line concepts of designers, merchandisers, and product developers to an actual sample product (see Figure 12.1). In Line Product Development, product merchandisers for raw materials producers and for end product manufacturers initiate and execute creative and applied design activities as well as technical design functions and activities to begin the season line development and to implement the initial line plan. The technical design aspects of the line are developed so that the conceptual designs forecast in Line Concept Development become concrete products in Line Product Development. A number of guidelines, samples, CAD drawings, computer files, and other technical documents are developed to assist with this transformation from conceptual visions of the line to concrete products for the line. Tools and processes used in product line development include technical design and samples, product specifications, pattern and marker development, and a check for manufacturability and quality assurance.

Figure 12.1
Line Product Development Process.

Initiating the Line Product

In line product development, designers, merchandisers, and product development employees work with a variety of tools to develop a visualization of the product. Some designers work with plain paper or an empty CAD tablet and

Figure 12.2 Fashion sketch.
(Fashion Designer: Amber Roth)

hand sketch their ideas. Hand sketching can be with paper and pencil or with a computer stylus and pad. Sketches done at this step are usually **fashion sketches** that interpret the line concepts including color and image or the big concept (see Figure 12.2). Other designers work with fabric and drape the fabric on a form. In other product development scenarios, merchandisers and designers work with products from other companies or with photographs of known products to develop their new product.

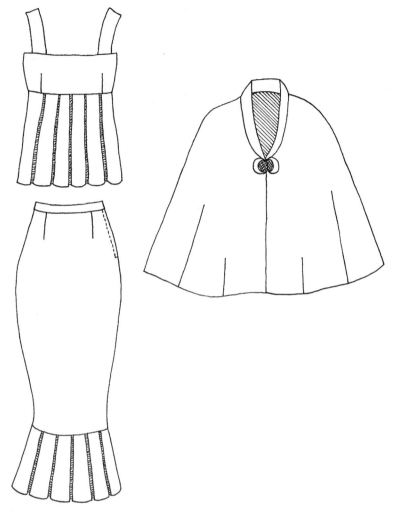

Figure 12.3
Flats, technical sketches for the fashion sketch in Figure 12.2.
(Fashion Designer: Amber Roth)

The fashion sketch may be redrawn by a technical designer to show more exactly the colors, proportions, and construction details of the product. This sketch is called a *technical sketch* and most likely done on a computer. Many times this technical sketch is done in a 2D rendering with the product in a spread-out form, as if the product were being pressed flat or ironed. This type of technical sketch is called a **flat** (see Figure 12.3). Flats can be easily stored in a computer database and can be altered on a computer with minimal work. Using a computer to develop and store flats saves the merchandiser time and money at this stage of the process. Some computer programs are capable of

converting the 2D flat to a 3D drawing. This feature allows the merchandiser to check that the flat does appear to represent the sketch first created by the designer. When only minor changes are made in a product from one season to the next or from one product to another product, the flats stored in the computer can be quickly retrieved and altered for the new product. Companies that have specific brand images may have style parts such as a collar, a placket, or a waistband that are always used on the product. These features can be stored in flat form and used readily when creating the flat, thereby ensuring the consistency of the product image.

Samples

Regardless of the way the ideas are initially expressed, the merchandiser is responsible for taking the product ideas originating from Line Concept Development and turning them into samples. The first sample that is made is the **design sample** or design **prototype.** The process of making the sample from a sketch is often called **prototyping.** The merchandiser must have ordered sample fabric in time for cutting and sewing the design sample. The design sample is usually made in the facilities at the corporate offices, where the design and merchandising teams are housed. That location makes the coordination between sample makers and designers an easy process. **Sample room hands,** or sewers working in the design offices, make samples for the designer. These sewers are often highly skilled operators who have worked with the designer for many years.

Even with skilled sample hands, creating an accurate prototype from a fashion sketch is often difficult because the fashion sketch is created to show image, style, and coloration and not technical detail. Some designers and product development teams work with half-size design samples and half-scale forms, but most merchandisers prefer full-size samples in a standard size that can be fitted on a live model (see Figure 12.4). When using the software that allows for 3D modeling, some merchandisers are choosing to avoid making the design sample. The computerized sample can be quickly shared with a trading partner and reduces the need for sample fabric. This technique reduces costs and time; however, some merchandisers feel that only the actual fabric created into a real sample will give the exact look and feel of the product. An approval of the design sample is needed for the Line Product Development Process to continue.

Line Sheets

Line sheets are developed along with design samples to guide costing and other subsequent activities. These are used by planners, forecasters, and personnel in costing and graphics in executing their responsibilities in developing products for the seasonal line. These sheets are precursors to the full set of product specifications that will be developed in the next set of activities. The **line sheets** provide merchandisers and other personnel involved with product

Figure 12.4
Half-scale dress form compared to full-size form.
(Courtesy of the Department of Apparel, Housing, and Resource Management, Virginia Tech.)

development and with production with some basic information about the product, such as the style number, a technical sketch, and price range or price point, along with deadlines for several decisions (see Figure 12.5). In addition, line sheets contain the information about the pertinent season, a fabric swatch, if fabric has been selected, and the desired trim and colors. If the fabric has not been selected, the line sheet has a sketch, picture, or other graphics information that will be used for sourcing the fabric. Line sheets are also called

Season: Holiday	Date: June 6	Delivery Date: Oct 28	Company Name: Rose & Company Company Address: 101 S Street City, State, Zip
Style # 1001	Style Name: Sweetheart Dress	Price Range: $150–$185	Contact Information: Mercy Merchandiser mm2@roseco.net

Pattern Notes: Use bodice from Style #0112 with fitted skirt, 3 to 1 shirring for front with inset bra	Sketch
Colors: Brown with Blue Tweed; Rust with Orange Tweed; Hot Orange with Blue Tweed	

Fabric # & Description	Fabric Vendor	Trim Description	
#115	100% poly, plain weave	Nick Tex	Zipper – invisible – 22"
#128	65%Poly/35% wool	Nick Tex	
Fabric Swatch		Thread – poly-core	

Order Fabric by: Aug 15	Order Trim by: Aug 4		

Other Notes: Get sample of fabric to match with zipper. Fit – full coverage of front bodice, may need stays in sides – check at fit session. Length is high knee.

Figure 12.5
Line sheet.
(Fashion Designer: Katie Keene)

protospecs because they are the preliminary spec sheets that belong with the prototype or sample products.

The line sheets may be paper sheets or they may be part of a computerized data management system used by a company. This system tracks the progress of the line's development and helps merchandisers manage the activities pertinent to the process. The computerized system requires passwords for the personnel who have access to the product and has dates and reminders for personnel who need to approve or sign off on a decision about the product. Some raw materials producers and some end product manufacturers allow retail buyers also to have limited access to the database so these buyers can check the progress of their orders and check colors and prints for coordinating products.

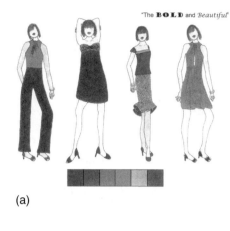

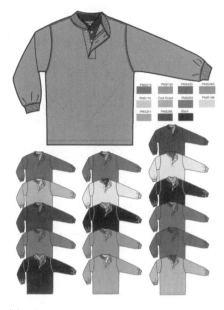

(a)

(b)

Figure 12.6
Storyboard with (a) sketches and (b) computer flats.
(Fashion designer: Ashley Loudin (a); Courtesy of The AmeriTech Group, USA, Inc. (b))

Style Adoption

A meeting is needed to conclude these activities. At the **Style Adoption Meeting,** merchandisers meet with sales personnel, top management, production managers, and other decision makers to confirm the styles that will be part of the seasonal product line. Some companies refer to this meeting as the **Line Development Meeting.** Some companies have this meeting very early, as early as three to five weeks after the Product Strategy Meeting. **Storyboards,** or **style boards,** contain visual images of the styles, as proposed for the seasonal line, and they may also include other graphics such as colorways, logos, prints, or fabrics. Storyboards can be prepared with fashion sketches (see Figure 12.6a) or with technical sketches or CAD flats (see Figure 12.6b). Originally, storyboards were actual artwork boards, made of tag board, foam core, or other substantial material. Today many designers and merchandisers work with storyboards that are printouts of digital work. With digital images, they are sharing files and video conferencing with their product development team members who are located in diverse regions throughout the world. When companies have Line Development Meetings early in the seasonal development calendar, merchandisers and designers may use storyboards, instead of sample garments, at the Style Adoption Meeting. However, not all companies hold meetings for style adoptions early in the seasonal development calendar. Some

companies may hold confirmation of products or style adoptions until added information is established and pricing and other factors are more concrete.

During the Style Adoption Meeting, the decision makers determine which carryover styles will be continued and which new styles will be accepted. A company may have some carryover styles and develop some news styles and/or adapt styles from previous seasons. Some aspects of the product or the product line are constant across all products and styles, especially if the products are branded. The styles selected must adhere to the brand image.

Additionally, the merchandisers must review information from the budget and other merchandising and marketing plans to ensure that the content of the line is consistent with the company's strategic planning information. A review of the target consumer and the retail customer are appropriate for this meeting to be certain the product line stays "on track." In addition, the merchandisers review all samples to be sure they express the theme and other parameters established for the seasonal line.

Product Specifications

Product specifications, or **spec sheets,** are technical guidelines that interpret the design features, concepts, and ideas about the garment or home furnishings article into product and production terminology. These specifications are usually written guidelines including technical terms and drawings covering all aspects of the product. Most spec sheets contain a header or other blocked area of information that is consistent on all spec sheets containing contact information about the company, the company logo, the season, a current date, the product class or product line, and a style number. This information is important for tracking, storing and retrieving information about the product.

The **style number** is a unique identifier for the product and may contain letters or numbers that also indicate the classification or product group to which the product belongs and the season. For example, a style number could be 210612. The first three numbers 210 would be the number of the vendor, indicating the product line and exact style of the item. The number 6 indicates the color code as determined by the vendor or the retailer. For example, the number 6 might be the color navy blue. The last two numbers, 12, would be the size, so this is the style number for a size 12. The style number for the retailer may not be the same style number used by the partnering apparel manufacturer, but using the same style number results in less confusion. This coordination of style numbers in a spec set can be achieved through partnership agreements. One solution to this problem is for retailers and manufacturers also to have identification codes for the company as part of the style number (see Figure 12.7). In addition to identifying the product in the spec database, a style number can also be used for creating bar codes for identifying products from design idea through distribution and sales and finally in the analysis of sold products.

With specifications, the merchandiser is more assured of having a product that meets not only the designer's original plan but also the consumer's fondest

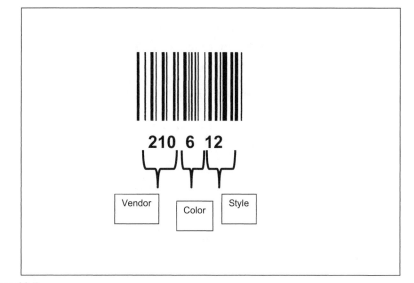

Figure 12.7
Interpretation of a simple style number for vendor or retailer.

desire—in other words, a product that will sell. Without specifications, the merchandiser for the producer, manufacturer, or retailer may make selections of fabrics, findings, and other components based solely on price. With no specifications, the plant manager or sewing operator may choose the process that is the quickest to complete or the finding that is the easiest to handle or is readily available. These inputs may not correspond to the product image or features that the merchandiser planned or the consumer anticipated.

Product Quality

When the product is designed and produced according to specifications based on the expectations of the customer, the product has the desired or the right **quality.** To get the right product, the merchandiser must specify the right components for the development and production of that product. Merchandisers in any FTAR company must examine product assortments and determine which merchandise categories, merchandise classes, or products best reflect the quality philosophy of management and the image of the company. To build a repeat customer following, those products should be at the standards expected by the immediate customer (i.e., the retailer) and the final consumer. The right quality is also important for the retailer. The quality of merchandise helps establish a consistent and constant retail image; therefore, any retailer must pay close attention to the quality of all merchandise offerings and services rendered. To maintain this image, the retailer depends on the apparel manufacturers and their suppliers to provide the right quality merchandise.

Some lesser important classifications may be of a different quality level, if the consumer does not expect or wish to pay for the added value in some

merchandise. For example, an apparel manufacturer went to great lengths to make denim skirts and jeans with extra stitching at the bottom of the pockets to keep the pocket from tearing when the wearer's hands were inserted into the pockets. After conducting market research, the apparel manufacturer found that the consumer who wore the product did not recognize the extra step in construction and definitely did not want to pay extra for this value-added quality in the product. Many times the price and level of fashion items dictate consumer expectations, and retailers and manufacturers must react to the expectations of these final customers.

Specifications are used by merchandisers at all levels of the FTAR Complex to identify, measure, and evaluate quality. At each step in the design and production process, the merchandiser and production employees focus on only one aspect of the product; however, the total product must be considered at each level because of the integrated and essential nature of the raw materials in correlation to the final product. A fabric manufacturer is primarily concerned with the fiber and fabric specifications. Initially those specifications are determined so the fabric is sewable on a production sewing machine, will drape as planned when worn, and will be cleanable as noted on the care tag in postuse care. However, the consumer is concerned with how the product fits, looks, and lasts. For this reason, each merchandiser at every FTAR level must request specifications to ensure that each decision on the long journey from fiber to finished product is made to ensure the right product for that final consumer.

Spec Book

A total set of specifications for a finished apparel or home fashions product is called the **specification book,** or the **spec book.** For an apparel product, this set may contain any number of specifications, including those for design, fabric, findings, cutting, sewing, sizing, fit, and final inspection. Various companies may have additional specifications or may have additional specifications for some products, and they may ignore some specifications for certain product classifications. For example, if a product is designed to be one size fits all, then the fit specification may not be important. If a product is designed for children's sleepwear, the fabric specification may have additional information about fabric flammability that is not contained on specs for misses' sleepwear.

The spec book may be an actual book, such as three-ring binder with printed sheets, or the spec book may not be a physical book but information contained on a computer. A number of software programs exist that can be used for data management including product specifications. These software programs are often called **PDM** for **product data management.** They may be created by some of the major industry equipment companies, such as Gerber Technology, a division of Gerber Scientific Company, or they may be built especially for a company and be a proprietary-type of software. Either way, the computerized spec book can contain the same types of technical data and product pictures contained in printed spec books (see Figure 12.8). In most systems, the database can be searched by a number of fields, including style number, color, fabric type,

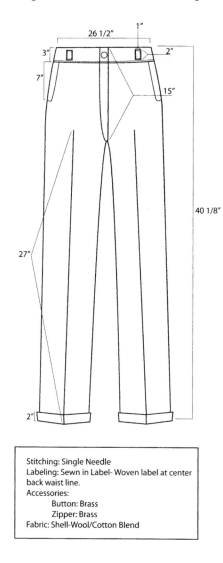

Figure 12.8 Computerized spec sheet.
(Designer: Mor Aframian)

Stitching: Single Needle
Labeling: Sewn in Label- Woven label at center
back waist line.
Accessories:
 Button: Brass
 Zipper: Brass
Fabric: Shell-Wool/Cotton Blend

and product classification. The advantage of the computerized spec book is the ability to share, instantaneously and easily, the specifications throughout the company and with the company's trading partners, anywhere in the world. Sharing information on the right product is vital to the successful outcome of the sale to the consumer and is necessary because multitudes of employees, working in teams both inside and outside the company, are often involved in making the product become a reality. The spec sheets in a computerized spec book can be easily updated, amended, and stored.

When using a computerized product specification set, many employees have read-only access to the specs; some employees have permission to add

information; but only the product manager can initiate new specs or alter existing specs. Employees who have permission to add to the spec are merchandisers who are responsible for finding costs, sourcing raw materials, and seeking other information. Product development employees are able to add information such as sizing standards from company databases and pattern pieces and markers from computer files or from new work.

DESIGN SPECS. **Design specs** contain a technical drawing of the product and detailed text about the styling of the item. Comments are made or pictures given about the placement of seams, the type of openings, expected trim, and other structural lines on the product. The merchandiser uses the design specs to interpret the designer's fashion sketch, illustrating the color and style of the product, into a technical drawing with notations about production and fabrication details (see Figure 12.9). Information is given about the type of fabric and fiber desired, and colors are noted including combinations of colors. If the merchandiser predicts that combinations of pastel colors will be popular, a pair of shorts may be planned in pale blue with a pink and blue stripe cuff, a second version of the short is planned in pink with a pink and lemon yellow stripe cuff, and a third pair of the shorts is planned in the combination of lemon yellow with a pink and yellow stripe cuff. These designs and combinations are noted on the

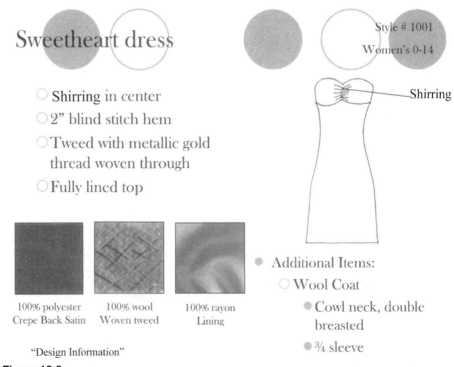

Sweetheart dress

Style # 1001
Women's 0-14

○ Shirring in center
○ 2" blind stitch hem
○ Tweed with metallic gold
 thread woven through
○ Fully lined top

———Shirring

100% polyester
Crepe Back Satin

100% wool
Woven tweed

100% rayon
Lining

● Additional Items:
 ○ Wool Coat
 ● Cowl neck, double
 breasted
 ● ¾ sleeve

"Design Information"

Figure 12.9
Design spec.

Table 12.1
Fabric tests with standards included on a fabric spec for a popular price range child's knit shorts.

Desired Fabric Criteria	Test	Standard
Fading	AATCC 61	3 Gray Scale
Pilling	ASTM D 3512	3
Shrinkage Filling	AATCC 135	<3%

spec. Coordinates are also noted. On the shorts, a note indicates the coordinate with a knit top that is made in pink, pale blue, green, and lemon yellow.

FABRIC SPECS. Information about the fabric construction and content is included on a **fabric spec.** For companies that have standards of quality, durability, protection and other product characteristics, textile tests are listed along with the characteristics to be tested and the standards for evaluating the test results. Merchandisers should be very specific about which tests are listed. For example, a fabric specification may contain information about fabric tensile strength including the tests used to measure the strength and the **standard** or expected value outcome for the test (see Table 12.1). Testing fabric and finished products is expensive and time consuming. Many companies have to employ independent laboratory facilities to have the tests performed. For these reasons, the number and types of tests should be limited to those that reveal information that is beneficial in selecting the right product to satisfy the consumer. Listing a large number of tests and getting satisfactory results does not guarantee the right product. Having the fabric pass a large number of tests may sound as if the product is very valuable and significant to the consumer because of the time and expense in testing. However, if the tests are not chosen carefully, the end result is a highly tested product but not necessarily a desirable product. Many tests are not the best spec; instead the carefully chosen tests that evaluate characteristics valuable to the customer are the best tests. Tests are important only if they reveal information that helps the merchandiser judge the value of the product for the target consumer.

Information about finishes for the fabric are included in the fabric spec if the finish is applied to the flat fabric and not to the completed garment. Product or garment finishes would be listed in the final inspection spec or the sewing spec; or, if complex, they may be listed as a separate specification. Apparel and home fashions manufacturers may also want to include information about the fabric and fiber producers who will be selected to supply the fabric. The merchandiser includes information about the cost or cost range of the fabric and the style numbers for the fabric (see Figure 12.10). This information is important to a product merchandiser who may need to reference the fabric once the decision to order is made; however, it is not important to a retail merchandiser or a buyer unless they are working on private label merchandise and will be selecting fabric styles as well as product styles.

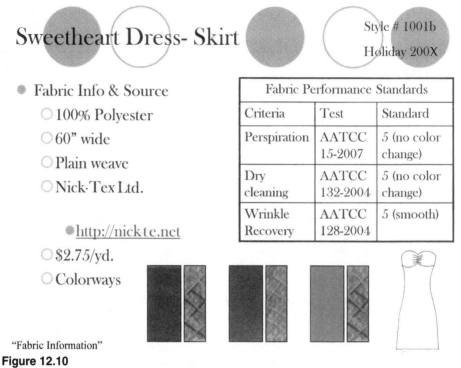

"Fabric Information"
Figure 12.10
Fabric spec.

FINDINGS SPECS. Information about findings may be included with the fabric spec or may be placed on a separate spec page. **Findings specs** have the particulars about all of the findings, which may include zippers, buttons, thread, lace and other trim, interfacings, and labels used in the product. **Findings** can be any raw material that is not made from the base fabric of the apparel or home fashions product. Some retail merchandisers and apparel manufacturers seek findings that are very unique and help distinguish their products from the competition. Many designers have buttons, labels, or other findings that are manufactured specifically for their products. Labels may be woven with a unique design or thread colors that quickly say to the customer this is a certain brand. Unique findings help the merchandiser develop and support the brand image, and help the consumer to recognize rapidly and select with confidence the desired product.

Findings specs contain detailed information about each finding, such as the price per unit, content, size, shape, and source of a button. For thread, the spec includes the twist, color, structure, fiber content, source, and price of the thread. As the merchandiser is selecting these findings and making decisions on the characteristics, he or she must be considering how these findings will impact the performance, the looks, and the price of the product.

Figure 12.11
Directional fabric with flower motif.
(Artist: Katherine Helsing)

CUT SPECS. Cut specs are used primarily by the product manufacturing sector of the FTAR Supply Chain. **Cut specs** include information primarily about the layout of the fabric for cutting and the markers used for arranging the pattern pieces on the fabric. In addition, the cut spec includes any special handling information needed for spreading the fabric or laying the patterns. For example, the designer may have selected a fabric that is extremely stretchy. Warnings may be made in the cut spec that the fabric is not to be overstretched in spreading and a hand spread method must be used when placing the fabric on the cutting tables. Fabrics that have distinctive patterns, directional patterns, or nap must also have specified information in the cutting spec. The spec must indicate how the direction of the fabric is to be placed on the table and how the pattern pieces need to be placed on the fabric. For example, if a designer plans to use a fabric with a floral print, the merchandiser must indicate on the cutting spec the direction of the flowers along each pattern piece (see Figure 12.11). With the correct information, the flowers will appear in their natural order on the finished product; otherwise, the flowers on some parts of the garment might appear to be growing naturally and flowers on other parts of the garment may be upside down.

A cut spec may also include the manufacturer's specific information about the type of cutting tables to be used, the order of cutting various markers, and the equipment or personnel needed for cutting. This detailed information about the cutting equipment and procedure is termed **cut order planning** and is needed to determine the equipment and time needed for cutting multiple layers of fabric for multiple pattern pieces and various sizes of a product. The **cut order,** or the request to have the markers cut from the specified fabric, identifies which sizes and how many units of each size must be cut. To create the cut

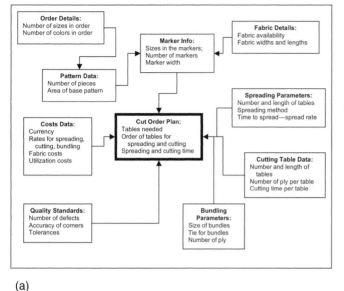

(b)

(a)

Figure 12.12
Simplified system of parameters used to
develop a (a) cut order plan for (b) cutting
tables.
(Courtesy of Karen Kane (b))

order, the merchandiser must know an array of information (see Figure 12.12a). Cutting table data is an important component of cut order information. Cutting tables in manufacturing can be as long as 300 feet (see Figure 12.12b). Markers of various dimensions with multiple pattern pieces require different amounts of time for cutting (The Textile Clothing Technology Corporation, 1990). Planning which marker will be on which cutting table and in which order is important to keep the flow of cut fabric moving into the sewing plant. Merchandisers for apparel manufacturers definitely need to know how many units of each product are needed for each size in the product offering. This information may come from the retail buyer or may be suggested by the apparel merchandiser based on previous sales data for similar products and forecasts for this product.

SEW SPECS. As with cut specs, the sew specs are of primary concern of the product manufacturers; however, the retail merchandiser and buyer, especially those developing private label products, may desire input about stitch and seam characteristics for their products. The **sew spec** contains detailed information about the stitches, seams, and order of assembly for the product. The merchandiser needs to select the best stitch class, stitch length, and seam class for the product. Because stitches and seams vary in strength, stiffness, use of thread and cost, the merchandiser needs to consider the price point, the fabric weight, the intended look of the product, and the consumer's expectations when selecting these features. Use of the ISO 4915 and 4916 or ASTM D6193-97 **stitch standards** and **seam standards** helps clarify the stitches and seams needed. Pictures, either 2D or 3D, of the stitches and seams can further illuminate the communication among merchandiser, plant manager, and sewing operator.

The sew specs for a holiday dress may require simple and less costly seams such as a 301 SSa, a simple superimposed seam with a straight lock stitch (see

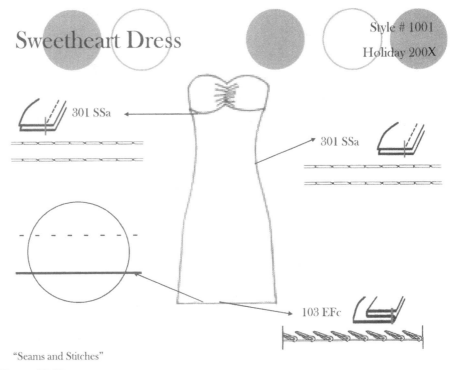

"Seams and Stitches"

Figure 12.13
Stitches and seams on sew spec.

Figure 12.13). It is fast, inexpensive, and easy to sew but is not highly durable—just right for a party dress for a Gen Y customer. In contrast, a merchandiser who is preparing a spec for a pair of corduroy pants for a child 2 to 4 years old knows the child will be walking and crawling and needs sturdy but soft leg seams. For this product, the merchandiser specifies that the stitch and seams is a LSc 403-2 seam. With the flat felled or enclosed lapped seam, no raw edges will be exposed inside the garment. With the chain stitch, the seam will have some flexibility and the double needle stitch will reinforce the seam. Overall, this stitch and seam combination will give a soft, flexible but durable seam—just right for a young, active child.

In addition to the basic stitch and seam information, the sew spec may include detailed descriptions or pictures about specific design areas on the product. For example, the back pocket on blue jeans is often stitched with a pattern that is unique to the brand of jeans, and the top stitching on the front pocket or placket on a tailored dress shirt is often unique to the shirt brand. The front of the holiday dress requires specific information about the shirring at the front bodice (see Figure 12.14). The sew spec can contain a sketch of the stitching pattern, including a count of the stitches from corner to corner on the pocket or the embroidery on premium jeans. The color of the thread, the stitch length, and other information are specified to make every pocket on every pair of jeans the same for that brand, such as the signature squiggle placed on many of the 7 for All Mankind Jeans.

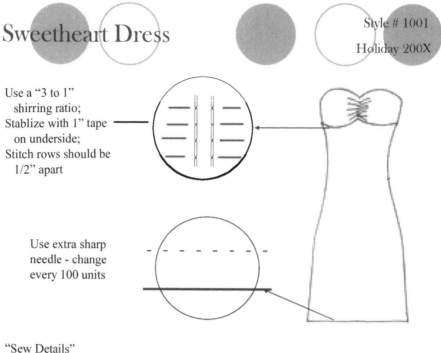

Sweetheart Dress

Style # 1001

Holiday 200X

Use a "3 to 1"
 shirring ratio;
Stablize with 1" tape
 on underside;
Stitch rows should be
 1/2" apart

Use extra sharp
needle - change
every 100 units

"Sew Details"

Figure 12.14
Sew detail for sew spec.

SIZING SPECS. Most apparel products come in a variety of sizes in an attempt to provide a product that is sized for an array of body sizes and types. Because humans come in an infinite combination of heights, weights, and body type, the task of getting the right size assortment is a daunting responsibility for a merchandiser. Sizes for the apparel product are first categorized in groupings by gender and body type (see Chapter 3). The **size spec** would include the gender of the consumer, the size classification, and the size range for the product. Some companies do not try to produce all sizes and concentrate on one size category or produce products that are one size fits all, which usually is one size fits no one, yet is satisfactory to most consumers. In addition, within certain size classifications, not all manufacturers produce all possible sizes and not all retailers include all classifications and the complete size ranges for every product.

Merchandisers must decide what combination of size classifications and ranges will best accommodate the needs of their customers. The merchandiser needs detailed information about the dimensions of the consumer, including heights, weights, and body type to determine the best size class for the product and may need information about style preferences to judge if the class is appropriate.

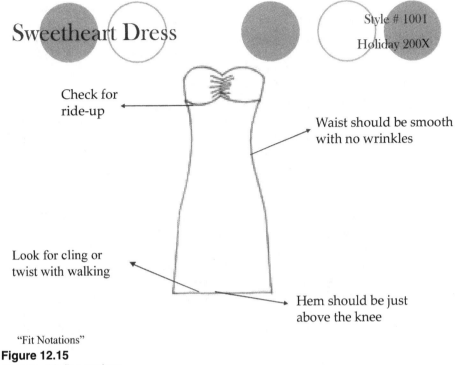

Sweetheart Dress Style # 1001

 Holiday 200X

Check for
ride-up

 Waist should be smooth
 with no wrinkles

Look for cling or
twist with walking

 Hem should be just
 above the knee

"Fit Notations"

Figure 12.15
Sketch with fit notations.

FIT SPECS. Size and fit specs may be considered together because of the integration of information about these two product features; however, they are two distinctly different features. Size involves a standardized set of dimensions for the product, whereas **fit** defines how the apparel product relates to the body. Fit is how the product feels to the wearer when wearing the garment and is often a factor not only of size classifications but of cultural forces and fashion. **Fit specs** include descriptions or pictures, illustrating the placement of the product on the body, and the looseness or tightness of the product relative to the body (see Figure 12.15). The amount of **ease,** or the difference between the body dimensions and the garment dimensions that is built into the product, will dictate the fit. This ease can come from the size of the pattern pieces or from the stretch that is natural to the fabric. What is considered a close fit for one segment of consumers may be too loose a fit to satisfy another segment of consumers. Circumference is the first point of fit that most consumers consider; however, lengths of sleeves, pant crotch positioning and leg lengths, and placement of seams are also important in fit.

The merchandiser must determine if the samples and the first runs from the production are fitting as intended. Merchandisers must work with manufacturing personnel, sample makers, pattern makers, and fit models to assure that each style maintains the fit specifications set by the company. The merchandiser

also works to guarantee that the fit of the style maintains the original design concept of the designer. Depending on the style of the product, two, three, or more fit sessions may be needed. Fit studios may be located in the corporate offices near the product development and merchandising teams or located close to the production plants.

Final Inspection Specs. The final inspection spec ensures that the product will be packaged and delivered to the customer as dictated by a contract agreement. Contents of **final inspection specs** for apparel products include the placement of hangtags, the fold of the product, bagging or hanging information, and packaging of the products. For apparel manufacturers, the final inspection spec for fabric could include the size of the fabric roll, the placement of rolls within the delivery truck, and the types of inspection information that will be delivered with the fabric rolls. The final inspection spec may also include any information needed about finishes that are applied to the product after it is sewn. Some of the "washes" such as stone washing or acid stripping are done on the finished garment to develop the desired streaks or seam shading that may be popular.

Whether the final spec is for an apparel manufacturer, one of the raw materials producers, or a retailer, the spec ensures that the product is **floor ready,** or ready for the customer's immediate use. For the apparel manufacturer, floor ready is being able to off-load a roll of fabric directly from the truck to a cutting table. For a retail merchandiser, floor-ready merchandise can be hung on a t-stand immediately after bringing the shipment from the loading dock. Items already have hangtags, price tags, and company-specific hangers or folds in place. This readiness enables the retailer to reduce time and labor in putting the products on the floor for sale and removes redundancy in the work between the apparel manufacturer and the retailer. The merchandiser will save time and money by having a comprehensive final inspection spec that ensures floor-ready merchandise.

Developing Product Specifications

The issue of who sets the standards and other guidelines for the specifications must be determined early in the FTAR process, preferably before the design stage begins. Each company, regardless of level in the FTAR Complex, may have its own set of specifications; however, all of the specifications must mesh together for the finished product to be satisfactory in style, fabrication, color, and price to all trading partners and to the consumer. For example, synthetic fiber manufacturers have specifications that cover the content of the fiber, the diameter of the fiber, the process of finishing the fiber and other fiber features, and these must coordinate with the specs written by the apparel manufacturer and the retailer.

Specifications can be established by anyone in the supply chain who has determined the needs and wants of the consumer for that product. Merchandisers

working for the apparel manufacturer often develop the specifications because they know both the potential product characteristics for everything that can be made by their manufacturing company and the wants and needs of the consumer market segment that buys their products. They will have examined both the past sales history of their products and the forecasting information available from their Consumer Marketing Division and Image Communications Division. From this thorough and meticulous research, the merchandiser develops a full set of specifications to coordinate with the designer's fashion concepts, to guide the ordering of fabric and findings, and to provide standards to the manufacturing plants for cutting, sewing, and final inspection. Additionally, the merchandiser must develop specifications to assist in maintaining the desired look and fit of the product in fit sessions and other checkpoints in the process. Development of a specification set will be a joint venture with input from team members who have expertise in each specification area. These specs should be shared with the raw materials producers to ensure the right fabric and will be discussed with key retail buyers to gain further input.

Behind each detail on the specification must be exhaustive research about the consumer. In addition to the usual marketing analysis of products and customers (see Chapter 9), FTAR companies may use some quality tools for specifying products from customer information. The House of Quality is a procedure that asks consumers to itemize product features and to prioritize these features according to their level of importance to the consumers. The House of Quality is so called because participating consumers use a diagram that appears to be a house to help prompt them for product features. Companies can also use techniques such as the **Voice of the Consumer (VOC)** and nominal or other focus group processes to elicit product information from consumers. Information from a nominal group session can be analyzed, tallied, and used to determine what specifications are most important for a quality product for similar consumers (see Figure 12.16). In all of these procedures, merchandisers work with consumers with sample garments, sketches, and plain paper to bring consumer ideas into technical terms.

Companies can also use industry guidelines and government standards when developing specifications. Some trade associations (e.g., Apparel and Footwear Manufacturers Association) and standards organizations (e.g., International Organization of Standardization [ISO]) have product guidelines that can be purchased and used for apparel and home fashions manufacturing. Few standards beyond the basic requirements for labeling and issues of flammability are available for the guidance of producing an apparel product sold in the United States. Additional legislation exists to cover some aspects of home fashions such as rug flammability and sanitation of fillings. Merchandisers should be well aware of government standards and legalities involving product safety and other features when establishing specifications. Specifications must be made in compliance with any government standards. When products are sold in countries other than the United States, merchandisers should

#	Consumers' Comments from a Nominal Group	Coding	Tally of Key Issues
1	I hate those little fuzzy balls that get on my sweaters.	Pilling	
2	My sweaters always seem to stretch out of shape and the sleeves get too long and the sides droop.	Dimensional change	
3	I had this great sweater that I really loved and the front began to get all out of shape.	Dimensional change	Pilling (5)
4	I paid $150 for a sweater and it also got those little pill balls.	Pilling	
5	When I sent my sweater to the dry cleaners it came back all fuzzy with little stuff I had to cut off.	Pilling	
6	I hate it when I buy something and it fits just right and then it gets washed and it is too small.	Shrinkage	Dimensional Change (4)
7	What I don't like is when you think you have something that is going to be very soft and it is actually rather stiff.	Hand	
8	I agree that those stupid little balls on sweaters are terrible and they ruin the looks of the sweater.	Pilling	Shrinkage (2)
9	The elbows of my sweaters always get big baggie places and make the sweater look old.	Dimensional change	
10	When the neck of my sweaters stretch I try to push it back into shape but it always sags in the front.	Dimensional change	Hand (1)
11	I had a sweater that said you could wash it by hand in cold water, and I did, but it still drew up and I couldn't wear it.	Shrinkage	
12	When the surface of the sweater around the waist gets all rough, I use scissors and trim off the fuzzy stuff.	Pilling	

Figure 12.16
Results of a nominal group process with tally on key quality issues.

seek information about government restrictions or other legislation that may affect product specifications.

Controlling Product Specifications

Specifications are based on detailed knowledge of the raw materials, the product, and the consumer and are developed to ensure that the right product is delivered at each level of the FTAR Supply Chain. Because of the multiple companies and the cross-country processes involved in most product development, production, and delivery, the use of specifications must be controlled and enforced through some method.

When setting specifications, a company may seek firms that have similar specification packages to its own package, may require firms to adopt its specifications, or may allow employees in the other firms to develop specifications cooperatively. Companies may also seek trading partners that have certifications showing that the company employees already know how to work with standards and that procedures are in place in the company to maintain the standards set within the specifications. The **ISO 9000 certification** for qual-

ity and other ISO certifications are universally recognized as an indication that a company knows about standards and maintains procedures for quality processes and specified production and service output. Companies may also require that their trading partners have the computer equipment and networks to support computerized specifications and the communications needed to work with this type of specification. When the software is company specific or proprietary, a firm may need to make a large financial investment in order to enter into the partnerships. Merchandisers must examine costs and benefits before accepting partnerships when large financial investments are required. The initial investments may not be financially viable or may not have long-term payoffs if the product is a fashion product that will not be popular in a short period. The decisions on specifications may be made as a team with input from many sources, but the final decisions and the ability to change specifications once the initial decisions have been made must rest with only one source.

Some companies are moving their design and merchandising teams closer to the production sites. With so much of the world's apparel production now done in the Far East, the location of some employees near these places of production make sense for companies that wish to manage production. Controlling the adherence to specifications is much easier if the company has trained employees located so they can readily visit the sewing factories; then, these employees can have easy and expedient access to visit those production sites. For example, Liz Claiborne located the design and merchandising teams for the Sigrid Olsen line to China (Clark, 2006). The appropriate members of the team can immediately check for color matches, sewing quality, and package details. Other companies are locating personnel in Hong Kong so they have ready access to China, Vietnam, and Pakistan while having the benefits of a modern, business-oriented major city. When companies do not relocate employees close to the source of production, they are requiring what employees at Liz Claiborne call "high-velocity travel." This term indicates that an employee may be overseas about every other month for periods of two or more weeks.

Fabric Sourcing

Merchandisers and product developers may work from fabric as the inspiration for the line, which means they have the fabric early in the concept stage (see Chapter 11). Or they may develop concepts about the colors, prints, and hand of the fabric and then search for the perfect fabric to fulfill this concept. Searching for the fabric for a line is **fabric sourcing.** As with production sourcing (see Chapter 13) and with product sourcing (see Chapter 15), merchandisers or sourcing personnel must have a specific plan for finding the needed item, and they must follow guidelines and other documents as they make their choices to be certain that the choices fit within the purview of the company. Merchandisers may be restricted as to which vendors they can use, which price ranges are workable, whether the products are domestic or imported, and many other parameters.

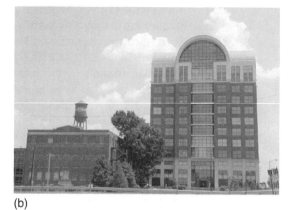

(b)

(a)

Figure 12.17
(a) Sales exec Teresa McGee previewing the line for a buyer in (b) one of the many showrooms in the Textile Tower, High Point, North Carolina.
(Courtesy of Altizer Company (a). Photographers: Katie Banner (a), Alice E. Dull (b))

To select fabrics for a line, merchandisers may shop the market by attending fabric trade shows or they may shop on the Internet. Many merchandisers depend on fabric companies to develop lines they can review to make the right fabric selection. To develop their seasonal lines, fabric companies study their previous product lines to make adjustments for trends in color, print styles, and other fabrication characteristics within their manufacturing capacities. Fabric companies and textile mills usually produce two product lines per year (i.e., spring and fall). These companies show their product lines biannually at textile trade shows and trade fairs all over the globe (see Figures 12.17a and 12.17b).

In Frankfurt, Germany, at the **Interstoff Trade Fair,** fabric producers from around the world exhibit their products for both manufacturers and retailers to preview. A new show in Frankfurt is the **Techtextil Show,** which highlights nonwovens and technical textiles used for a variety of purposes in medical, athletic, and other products (Borneman, 2005). At **Premiere Vision** in Paris, France, fabric producers exhibit their latest lines semiannually. Other international fabric and yarn shows include **Ideacomo** in Como, Italy; the **Pitti Filati** yarn show in Florence, Italy; and the **Canton Trade Fair** in Canton, China. A number of fabric or textile shows such as the **Premiere Vision Preview,** the **Turkish Fashion Fabric Exhibition,** and **Texworld USA** are staged in New York City; many of these shows are held in the Jacob Javis Center (Tucker, 2007). The **International Fashion Fabric Exhibition (IFFE)** is also held in New York City. Additionally, several specialized fabric shows are showcased in New York City, including ones for high-performance textiles. **Material World** is held each year in Miami, Florida, and is opening a new venue in Los Angeles, California. Vendors at Material World include textile producers, trim producers, technology firms, and cut-and-sew contractors (Todaro, e-mail communication, 2001).

Many of the textile shows are now organized or managed by giant international marketing firms or other corporate owners (Tucker, 2007).

In addition to or instead of attending the trade shows, some merchandisers continue to visit textile mills or preview fabric lines of major textile companies during **mill weeks,** and some end product merchandisers may work with raw materials producers to create the perfect fabric exclusively for the product line. Sourcing techniques follow the specifics outlined in the sections on sourcing production in Chapter 13 and selecting vendors in Chapter 15.

When sourcing fabric that will be used in a cut-and-sew operation, the merchandisers or sourcing personnel should review the proximity of the raw materials producer to the cut-and-sew operation (i.e., contractor or manufacturer). When the raw materials producer is located near the cut-and-sew operation, shipping time is reduced. For this reason, many merchandisers are sourcing fabric producers that are located near their production sources and not necessarily near their design facilities or corporate headquarters. This trend has caused many U.S. domestic fabric producers to close or move their operations offshore. If the merchandiser does select a domestic raw materials producer and an offshore cut-and-sew contractor, he or she will have to schedule extra time for shipping of the fabric and/or the findings.

First Pattern Development

In the process of converting the design idea into a product that can be sold to consumers, the production approval sample must be used to prepare the production patterns and markers. Information about these tools are included in the cut-and-sew specifications. Each design feature of the product must be transferred from the design concept and technical design to the sample and then to a pattern to provide guidance for producing the right product for the consumer. Many pattern makers work from **basic slopers,** or company-specific pattern shapes, which are stored in a computer. A company that makes jackets has the basic parts of the tailored jacket stored in a computerized library, and the pattern maker can alter quickly these shapes in the CAD system on the computer. Pattern makers also work from tagboard cutouts of patterns and digitize the outlines into the computer (see Figure 12.18). These pieces often have holes punched for hanging on specialized hangers. The designer may have worked in muslin or other fabric and draped a sample of the product or the merchandiser may be working with a knockoff design and has an actual garment, which is deconstructed or taken carefully apart and spread on a table. The pattern maker may use the deconstructed muslin or garment to do a **rub-off,** or a tracing of the product onto paper; however, with CAD technology, the pattern maker is more likely to digitize the outline of the deconstructed garment into the computer. In making a rub-off, the pattern maker covers the garment pieces with paper or muslin and draws outlines of pieces, pinches up paper to create locations for pleats and darts, and indicates grain lines and other style features.

In some companies, the design sample is used for developing and preparing the **first pattern** for creating the production samples (see Figure 12.19). The merchandiser works with a first pattern maker to test the potential for capturing the design features of the product and to suggest pattern possibilities.

Figure 12.18
Sloper, made of tagboard, for bodice and sleeve.

Figure 12.19
Pattern pieces for a size 7 child's top.
(Designer: Peggy Quesenberry)

The **first pattern maker** is a highly paid employee with extensive experience. This employee may create the pattern from a number of methods. He or she may construct the pattern from a blank page or blank computer screen with drawing methods similar to an architect creating a floor plan.

Although the merchandiser is probably not the employee responsible for creating these tools, the merchandiser is usually the one who must place orders for their creation and must coordinate the delivery of these to the selected

cutting and/or sewing facilities. When companies are vertically integrated and have the entire pipeline of processes within the organizational umbrella of the firm, this task of coordination may be easy. But today, many companies out-source not only production but also pattern and marker making. Outsourcing these processes can be faster and more efficient than keeping a staff of pattern and marker makers who work periodically, especially in a design house that has limited seasonal offerings. Even when the processes are done in house, the location of these processes may no longer be at the locations of the design, product development, or merchandising teams. To coordinate the development, and delivery of these tools, the merchandiser should know some of the techniques used in making the patterns and markers and some of the key features that must be checked and aligned with the design.

Fabric and Color Checks

Once the fabric and colors have been selected for the seasonal product line, the merchandiser must monitor their development and production to ensure that these very important visual product attributes remain consistent with the initial line plan. Merchandisers work with product development personnel to assist in selecting colors and in developing unique fabrics, trims, and findings. Because color and the fabrications that carry the color are vital to the theme, image, and consumer appeal, these features must be monitored critically and closely. In addition, merchandisers must routinely check colors for matching. Colors of all components (i.e., base fabric, secondary fabrications for details, trims, zippers, other fasteners) of the product must match not only each other but the sample fabric or sketch that was approved. This check is especially important when the fabric is being developed from a sketch or other color source and must be developed or dyed to specification by the textile producer or other supplier.

When colors are selected either for a long-term use as a brand image or as a seasonal color, the selected color is identified and determined as a **color standard,** which is noted in the design specification. Many companies use a commercial color system such as the Pantone Colors, or they may use the color samples provided by one of the color forecasting companies (see Chapter 10). Regardless of the initial color source, colors can be quantified and read by specialized computer equipment so the exact color, which was carefully selected in the Line Plan Summary, can be reproduced each time the fabric or other materials are dyed. All samples of products and a sampling of finished products will be checked for **color consistency,** or a match to the color standard (see Figure 12.20).

Product development personnel, along with the merchandiser, must submit a request that a sample of the woven fabric, or **lab dip,** be dyed (see Figure 12.21a). Then the lab dip must be matched to the original color standard to ascertain if the color components are true to standard and a compatible match with other components of the product (see Figure 12.21b). Occasionally, the supplier may create a **hand-loomed** sample. For knit fabrications, there are **knitdowns,** or hand-knitted samples, that provide both color and pattern samples for approval

Figure 12.20
Color matching standard.
(Courtesy of the AmeriTech Group, USA, Inc.)

by both product development personnel and merchandisers. If the fabric is being developed from a specified yarn that must be dyed in the yarn stage, a **yarn dip,** or sample of the dyed yarn, must be approved by product development personnel and the merchandiser. Merchandisers may also be responsible for checking the trueness and accuracy of a printed pattern; this sample is a **strike off,** which must be approved by the merchandiser or product development personnel before the fabric may be printed. When examining a strike off, the merchandiser checks for clarity of the print design elements as well as the color trueness of the prints

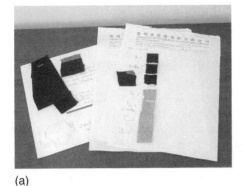
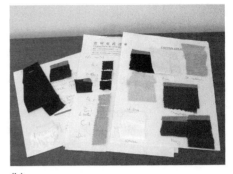

(a) (b)

Figure 12.21
Color matching (a) with black, gray and white, and (b) with other colors.
(Courtesy of The AmeriTech Group, USA, Inc. (a and b))

and graphics. The merchandiser also checks the color and images on all materials used in packaging, hangtags, and labels. This check against the color standard is of particular importance to companies that have brand logos embroidered on products or have a logo stamped on labels and hangtags. Consumers depend on the right colors on familiar logos to find their favorite products and to have some insurance that the product is real and not a knockoff or counterfeit item.

With high-quality monitors and printers, many characteristics of the product can be adequately represented; however, color and other aspects of fabrication remain the one area where the computer image is not always an accurate representation of the actual product. For example, product manufacturers may have sample fabrics printed from their computers after downloading files from the fabric producer. With the right technologies, these printed samples may be adequate representations of the fabrics to be produced. Using this technology for sample approval can greatly reduce costs and time. Printing sample fabrics in a typical fabric plant may require over 1,000 yards to feed through the entire production process, whereas a computer-printed sample may involve only 1 to 3 yards. As printers improve in speed and color accuracy, this capacity to avoid production will increase in accuracy.

The merchandisers must give the final approval for lap dips and other color checks, samples for fabrications, and strike offs for prints and graphics. Until this approval is sealed, the line product development process comes to a standstill. Approval for each of the product attributes that were finalized in the Line Plan Summary are important to allow the line product development process to continue. To speed the process, some merchandisers and product developers are sharing color information in digital format. Making approvals based on electronic images is often risky because the quality of the computer monitor, the lighting of the images, the file size and pixel resolution; and many other factors can cause the image to be different from the reality. Merchandisers who must make color decisions based on digital information want to use the number coding systems for color, such as the Pantone system, where each color gets a unique number. Many

of these systems work on a digital quantification of color, based on the hues of red, green, and yellow, with appropriate numbering for the value and tones of the hue.

Manufacturability

When the design sample and first pattern are approved, the merchandiser sends the design sample and first pattern to the manufacturing facility (company owned or contractor owned) that has been selected for producing the products. From these tools, the **production sample,** also called the **counter sample,** is requested. Many companies require a minimum quantity of three production samples to be made to ensure that all personnel involved have access to a sample. The production sample is used for evaluation of **manufacturability,** an agreement that the product sample made in the designer's sample room can be made efficiently and effectively on the sewing production floor. After the production sample is created, it is sent from the manufacturing plant back to the merchandiser for approval. This sample should be an exact duplicate of the product as it will be made ready for the final consumer. The merchandiser, working with the designer, pattern maker, and other product development personnel, compares the production sample to the design sample and to the design, cut, and sew specifications to check for fit, quality, and construction specifications (e.g., stitches per inch, seam allowance width) (see Figure 12.22). And, at times, the merchandiser may ask to see a sample of the packaging that will be done by the production plant for comparison to the final inspection spec. The merchandiser may also consult with the retail buyer or merchandiser, depending on who initiated the design, but ultimately the merchandiser or his or her team is responsible for approving the production samples.

Production Sample Sewability

Sewability is the determination of whether the product can be easily sewn in the selected production facilities. Sample room hands can skillfully manipulate fabric and interpret limited design directions because of their expertise and history with the company, and they usually work directly with the designer and the designer's sketch when creating the first pattern and sewing the design sample. This intense level of skill may not be found in the sewing plants of the typical apparel manufacturer or contractor, especially those whose operations are focused on high volume and low cost.

Sewability is affected by the hand of the fabric and the shape of pattern pieces as well as the placement and attachment of any trim or other findings. For example, sharp, square corners are much harder to sew than rounded curves. Placing two pattern pieces with straight lines together are easier and faster to sew than putting together two pieces with dissimilar curves. However, easier to sew does not always produce the desired product look. Standardization of procedures and parts can reduce the variances in moving from product design to finished product. For the apparel and home fashions product, standardization

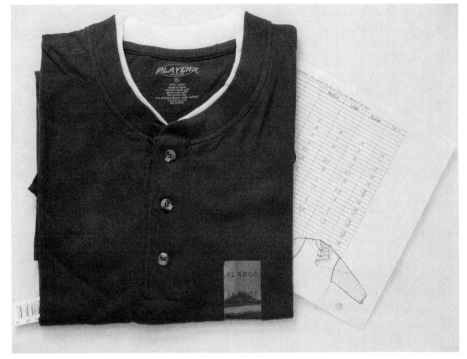

Figure 12.22
Floor-ready sample with tag and size sticker and inspection spec sheet.
(Courtesy of The AmeriTech Group, USA, Inc.)

becomes the removal or reduction in the number of size options, limitations in color and fabrication choices, and the sameness in design features. Although standardization of design results in a faster process from idea to delivery, the inherent features of standardization can result in a sameness that is contrary to the variances needed in fashionability of a product.

Merchandisers can work toward standardization of processes and procedures to improve sewability and can emphasize communication, data sharing, and team planning to achieve some of the benefits of standardized products without losing the uniqueness of a fashion product. Some merchandisers are working with designers and manufacturers to develop product components that are somewhat interchangeable to achieve more rapid prototyping and production with the variability of design that consumers want. For example, a shirt can be made with a variety of sleeves. If the shirt bodice or body of the shirt is standard and each sleeve is made to fit in the armhole opening, a number of sleeve types (e.g., long sleeve, long sleeve with a cuff, short sleeve) can be set into that opening with limited changes in production. The customer can be offered a long-sleeve shirt or a short-sleeve shirt with limited additional work and reduced time for the manufacturer. **Componentization** offers options for a company to be more consumer-centric with less work on developing a new product (see Figure 12.23).

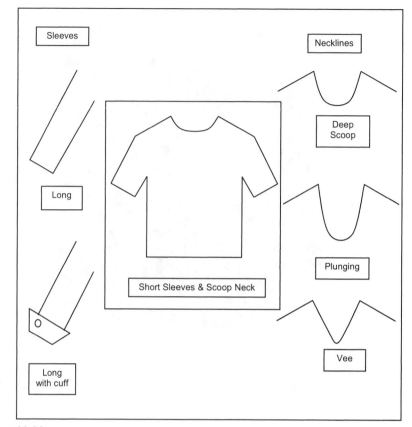

Figure 12.23
Basic T-shirt with componentization options.

Production Sample Quality

Product specifications are used at each step of the production process from line concept development to product delivery to the retail company. These guidelines are particularly relevant when determining the quality aspect of manufacturability. Quality is having a product that meets the needs of the customer. When specifications are generated, the product company, the retail customer, and the target consumer are considered. The specifications are written so the product will meet the expectations of these customers. During the analysis of manufacturability, the merchandiser refers to the specifications and checks these against the production sample.

Reiteration of Change Negotiation

If any changes are noted between the production sample and the design sample, the merchandiser must determine why the changes were made. Numerous reasons are possible. For example, the manufacturer was unable to follow the

specifications because of lack of skill by sewing operators or because of misunderstanding of or lack of clarity in the specifications. Changes that are noted must be corrected or must be negotiated. If variance is noted, the merchandiser discusses the changes with the plant manager and requests an additional production sample. If the manufacturer is unable to produce a satisfactory product (i.e., one that meets the specifications), the merchandiser has several options: (1) find a new source for production; (2) seek confirmation from the designer, product development team, or marketing personnel that the change will not affect the sale of the product; or (3) work with the manufacturer to develop a satisfactory product. In some situations, the design or marketing team may not be willing to approve the changes. Any unanticipated changes in the product may result in a product that is no longer satisfactory to the retail customer or to the final consumer.

Developing a product with acceptable manufacturability (i.e., meets specifications) may take several productions of the sample, or several **reiterations,** and many hours of negotiation with the design team and the production team. Merchandisers must anticipate the potential manufacturability of the product and factor this negotiation time into the Merchandising Calendar. Involving the production team early in the Line Concept Process should reduce reiterations of production samples from nonmanufacturability because manufacturability is planned into the product instead of forced on the completed design.

The manufacturability of the product must be approved by the merchandiser and other personnel. This approval generally occurs in the **Manufacturing Meeting.** During this meeting, the merchandiser, designers, product developers, and production personnel, including engineers and floor managers, discuss any and all changes proposed for the product. Each change must be reviewed based on the initial design concepts and all guidelines that have been previously stated. If costing and other factors are in place, this meeting may be combined with several subsequent meetings to reduce meeting time and to shorten the product development time.

Quick Costing

Along with other approvals, a quick costing is computed. This can be done before sending the product for manufacturability testing or can be done simultaneous to that process. From the manufacturability review, the manufacturing plant manager may provide the merchandiser with a final cost for each unit of the product. Or the merchandiser uses a quick cost method. The **quick cost,** also called the **preliminary cost,** is an estimate based on the best information at that point for the wholesale cost of the product. The more accurate the information, the more useful the cost is to the merchandiser; however, waiting for complete and firm prices on all inputs to the product may make the costing process too late to be useful for evaluating manufacturability. The traditional quick cost was a three-part costing based on the cost of the fabric. The fabric cost was considered a third of the cost, the labor was a third, and overhead was a third (see Figure 12.24).

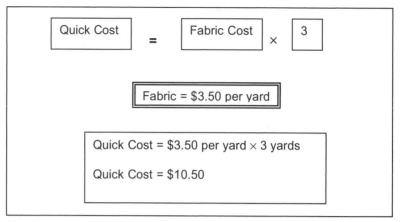

Figure 12.24
Quick cost of a T-shirt.

This method requires a fairly exact estimation of the cost of the fabric; therefore, the merchandiser must know the per yard cost of the fabric and must know how much fabric is needed to make the product, or the **yardage needed.** Determining yardage is a bit difficult in production sewing because the pattern pieces for one product are collated with pattern pieces of many products to maximize the usage of the fabric. To estimate yardage, merchandisers can determine the length of the longest pattern piece. For many products, the standard fabric width of 45 or 60 inches allows enough room for all pattern pieces for one item to be placed within that longest length. If that situation is not possible, the merchandiser must calculate additional fabric usage. Determining yardage needed is affected by any style changes made in sample approval or any pattern changes made in manufacturability approval.

Other companies may have their own methods for doing a quick costing. Some companies base costs of products in the new seasonal line on costs of current or previous products with a price adjustment for inflation or other price changes. Occasionally, firms may have a fixed price for the product and the merchandiser must alter the proposed product to come within the price range. Any product that cannot be costed within the target price range will be dropped from the product line unless supported for brand management, fashion image, or other strategies. A final cost decision will be made when the product is close to market.

The quick cost can be inserted into the PDM system, as requested, and is then approved by merchandising managers and other top executives who have final review of the line. Gaining approval for cost by using computer software and other networking capabilities can shorten the time for product development. If the cost is at a price point above that anticipated by the merchandiser, the merchandiser must work with the manufacturer to lower the price or work with the designer to alter the product. The merchandiser may seek to reduce numbers of seams, remove or reduce trim, or find a cheaper source of labor to lower the production cost. Again, it is to the benefit of all trading partners in a consumer-

centric partnership to stay focused on the consumer so the right product is produced at the right price and to work as a team throughout all stages of planning to develop a product that will have the right price the first time.

Final Costing

During the Line Product Development Process, a quick cost is done by the merchandiser to be certain the product is in the right price range for the zone, the retailer, and the target consumer. When fabrications and production sources are finalized, the merchandiser has the necessary information for calculating a final or wholesale cost for the product. When finalizing the cost, the merchandiser must be certain that two goals are accomplished: (1) the costs of designing and producing the product are covered and profit goals may be achieved and (2) the cost will be appealing to the retailer and result in an attractive price to the consumer. In some companies, costing specialists complete the final calculations, or in other firms the merchandiser has this responsibility. Some companies have costing software programs that allow the merchandiser or other personnel to enter the values for raw materials and other inputs, and the program reaches a final cost with preset calculations and company margins. Regardless of who makes the calculations, the merchandiser wants to check that the costs meet the company goals. As with quick costs, the components of the final cost are basically the fabrications, the labor, and the company's overhead. Each one of these is calculated based on exact information and entered into a **cost sheet,** or spreadsheet of all related product costs.

Fabrications

Fabrications include the base fabric for the product, the trim, and other findings that may be needed to complete the construction or sewing of the product. Fabric is sourced from a variety of sources (e.g., company-owned mills, jobbers, contractors). Regardless of whether the fabric is selected from the product line of a well-known corporate producer or is custom made by a small exclusive family-owned firm, the merchandiser, the sourcing assistant, or other purchasing personnel have to negotiate a per yardage cost for the fabric and the total **fabric cost** (see Figure 12.25).

To complete this calculation the merchandiser needs to know not only the price of the fabric but also the amount of fabric needed. This amount of fabric is called the **yield** and is given in terms of yardage. For example, a yield of 1.54 indicates that it requires slightly more than 1.5 yards of fabric to make one item. The fabric yield for a specific product would most likely be given to the merchandiser from someone in manufacturing or from a pattern maker. Measuring the dimensions of the product would provide an approximate yield but is not accurate enough for this stage of calculations. Previous information about similar products might also be used for yield. The yield is relative to the size of the product, the product's length, any overly wide pattern pieces, the complexity

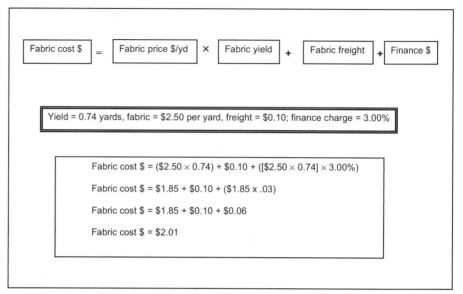

Figure 12.25
Fabric cost for a T-shirt.

Table 12.2
Mini-chart for subcalculations on trim or other miscellaneous materials.

Findings	Supplier	Part Number	Req. Qty	Unit Cost	Total Cost
Thread	Thread AB	#124	3 yds	$0.01	$0.03
Label	Woven Plus	#32678	1	$0.04	$0.04
Buttons	Button UP	#222411	4	$0.12	$0.48
Total					$0.55

of the product, and the width of the fabric. For example, a pair of long pants takes more fabric than a pair of shorts. A circle skirt requires more fabric than the same length skirt that is a slim straight skirt. Freight charges for shipping the fabric to the production plant and finance charges may also be added.

To calculate trim cost and the cost of other findings requires the merchandiser to know the individual price or unit cost of the trim items and the amount of items needed of each. A small chart might be used to help the merchandiser keep track of the trim items and to calculate each cost to calculate **trim cost.** To find trim cost, the merchandiser multiplies the unit cost (e.g., cost of one button) times the number of units or required quantity (e.g., four buttons) (see Table 12.2). Other miscellaneous items may also be calculated in this minichart, including the hangtags and polybag for shipping. Some companies may have a separate miscellaneous category for their tags and packaging costs.

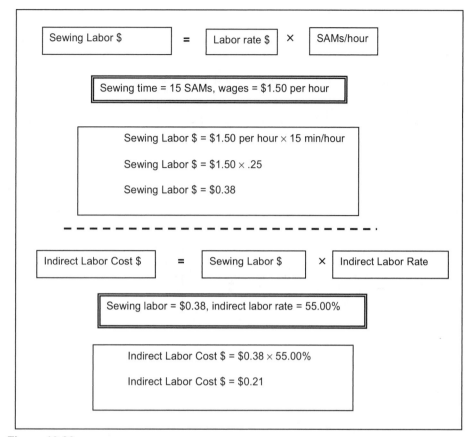

Figure 12.26
Labor rates for a T-shirt.

In addition, any finishing such as an enzyme wash could be calculated at this time or added as a separate category. The importance of the wash, hangtags, or other costs may be relative to the product classification.

Labor

Next, the cost of labor must be calculated. Some companies call this CM, or cut and make. Labor includes not only the wages paid to workers for sewing the components together to make the product but also the wages paid for preproduction work such as pattern work and cutting. Cost for sewing labor is generally calculated based on **SAMs,** or **standard allowable minutes** (see Figure 12.26). SAMs are the amount of time needed to complete the sewing operations for making the product. This time is usually standardized by production engineers who watch one or more skilled sewing operators complete a sample product. The **sewing labor cost** is a result of the SAMS times the

Table 12.3
Costing sheet for T-shirt.

Season: Fall		**Costing Sheet for Knitwear Company**							
Category: Basic Tops									
Date: 10-01-XX									
Style #	Style Description	Fabric Source/#	Fabric Price $/yd FOB	Yield (yd)	Fabric Freight	Fabric Finance Charge	Total Fabric Cost	Trim	
112-2-1	Cotton Jersey T	Knitts Nice/324	$2.50	0.74	$0.10	3.00%	$2.01	$0.55	

labor rate. Although sewing operators are typically paid by the number of pieces they sew in an hour or piece rate, labor rate or wages is reported by the hour. SAMs are reported in minutes and must be converted to portions of an hour or divided by 60 minutes.

Indirect labor costs or the fee for work needed for pattern work, cutting, and other preproduction labor may be calculated by wages multiplied times SAMs or may be calculated as a percentage of the sewing labor cost. Shipping of the cut parts may also be added at this stage if the cutting and other preproduction work is done at a location that is not at the sewing facility.

Wholesale Cost

The sum of costs for fabrications, labor, and other miscellaneous charges are the **total manufactured costs (TMC).** The merchandiser would add the following expenses: total fabric cost, total findings costs, sewing labor cost, and indirect labor costs. If these values are placed into a spreadsheet, the merchandiser would have a cost sheet such as the one in Table 12.3.

The TMC value is not the wholesale price. To the TMC, the merchandiser must add additional charges for duty and freight as appropriate. Shipping the

Sew Labor	Indirect Labor	TMC	Duty	Freight	Over Head	Vendor LC	Vendor Retail	IMU
$0.38	$0.21	$3.15	$0.74	$0.27	25%	$4.95	$12.09	59.06%

item from the production location to the retailer is calculated regardless of who pays for shipping (negotiations for shipping are discussed in Chapter 15). Duty may be necessary depending on the origin of the product shipped. In addition, the merchandiser adds an overhead that includes a profit margin for the company. This overhead is usually given as a percentage and calculated on the TMC cost. The formula for the **total cost,** or the final wholesale cost to the retailer, is a summation of the TMC, duty, freight, and an overhead (see Figure 12.27). This total cost is also called the vendor's **landed cost (LC)** because it is the cost of the product when it lands at the retailer's loading dock.

Vendor's Retail Price

Some product merchandisers calculate a projected retail price for their customers (i.e., retailers) to be certain the product is within the price range for the target consumer. This is called the vendor retail price and is found when the retailer's initial markup (IMU) is known. The IMU is subtracted from 100% to find the vendor's cost percentage (see Chapter 14 for details on retail price). The **vendor retail price** is calculated from the cost dollars divided by the complement of the initial retail markup percentage; in other words, the cost

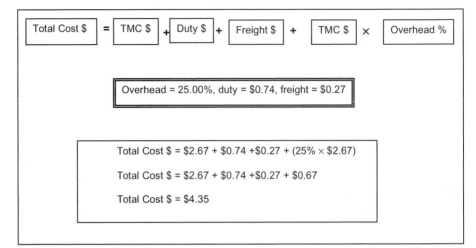

Figure 12.27
Total wholesale cost for a T-shirt.

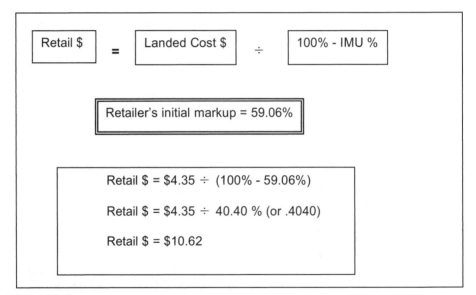

Figure 12.28
Retail price for a T-shirt.

percentage (see Figure 12.28). Some manufacturers also make this calculation to provide a suggested retail or list price for prospective retailers (see Chapter 4).

Final costing concludes with the **Price Meeting,** where a team composed of merchandisers, product development personnel, patternmakers, and purchasing as well as finance personnel finalize the cost of each SKU. Product merchandisers recommend wholesale costing and retail pricing based on research.

Merchandisers must consider current and future prices of raw materials (e.g., fibers, finishing agents, fabrics) and the cost of production, including rising costs of equipment, technologies, and utilities. If the information reveals that the costs for production are too high, the merchandising team must return to their research to find alternative manufacturing sources and renegotiate the contract with the selected source, or they may drop the product from the line.

Line Release

Toward the end of the Line Product Development Process, the merchandiser needs to give a final approval to release the production sample. In addition to checking for manufacturability in the production samples and final costs, the merchandiser checks this sample closely for its adherence to **product trueness** to the initial design concept. The merchandiser needs to be certain that the product not only satisfactorily meets construction requirements but also continues to maintain the desired image that was established during Line Concept Development (see Figures 12.29a1, 12.29a2, 12.29b1, and 12.29b2). For many consumers, the number of stitches and other details may ultimately mean the product has the value they desire, but what sells the product is the color, look, and fashion level of the product. Manufacturability may mean the product lasts through numerous washings, fits well, and performs as expected, but product trueness is important to be sure that product attracts the consumer at the point of sale.

Prototype Approval Samples

When the productions samples are judged to meet the established specifications of the merchandiser, these samples are released by the merchandiser and become **production approved samples (PAS).** If changes are accepted, comparable changes must be made in the related product specifications, and a final set of specifications is approved. Some approvals are possible to accomplish through digital imaging and file sharing. However, many designers and merchandisers prefer to have the actual sample in their hands to make final decisions. Holding the product, seeing the product on the body, and being able to stretch, pinch, and otherwise test the **hand,** or the sensory evaluation of the product, is important to buyers, merchandisers, and designers. With the high cost of travel, the desire for fast fashion, and the improved capabilities of digital imaging, some companies are choosing to approve samples by viewing digital pictures. Some merchandisers are approving samples of products by viewing the product from a 3D computer rendition that was generated from the production patterns. With the right software and the Internet, sharing this information can span any geographic distance instantaneously.

Whatever method merchandisers choose for any approval step, they should select the method with care because trueness to the design concept is of maximum importance in achieving a product that is right for the consumer. The intensive planning from top management in the strategic plan and by merchandisers,

(a2)

(a1)

Figure 12.29
Design sketch compared to sample: (a1) back sketch and (a2) back sample,
(Fashion Designer: Amber Roth (a1, a2, b1, and b2). Photographer: Carol Roth (a2 and b2))

(b2)

(b1)

Figure 12.29 (b1) front sketch and (b2) front sample.

designers, and developers in Line Concept Development would be wasted if the approval process is not accurate for maintaining the product attributes. Judgment accuracy versus cost and time must be carefully weighed when selecting an approval method.

Freeze Meeting

With the final inspection of the production sample and the acceptance of the PAS, the merchandiser can bring a conclusion to Product Line Development. With the PAS, the production manager and merchandiser negotiate the final costs associated with producing the product. For apparel and home fashions products, the major components to finalize the cost are the wages and time needed to sew the product. At this point in Line Product Development, a number of people are involved with the final determination of whether the product stays in the product line or is eliminated.

The decisions to finalize the seasonal line come in the **Freeze Meeting,** which culminates with personnel from across the multiple functions in a company previewing the new seasonal line. At this point product merchandisers must have completed the development of all SKUs in the line groupings. They may have small yarn swatches or CAD renderings of the SKUs or they may have completed samples of the products. Regardless of the sample types, all approvals must be completed at this date in time. Only then can the firm, producer, or manufacturer begin producing specific SKUs for delivery to the customer (e.g., manufacturer or the retailer). Depending on the company's policies and procedures, the approval for the line freeze may be given electronically. The final selection of products in the product line is the **Line Freeze.** When the merchandisers know exactly what products will be offered in the line, a **Line Release** is issued, and the PASs are ready to move to the next stages. Merchandisers request **duplications,** or **dups,** of the PASs to be made ready for the subsequent sales and marketing activities; and preparations, including the placement or finalization of fabric orders and cut orders for manufacturing, begin.

Preparing the Line for Market

To finalize the marketing materials for each line, a team consisting of product merchandisers, product developers, and marketing personnel attend a **Marketing Freeze Meeting.** In this meeting, marketing personnel present the marketing materials (e.g., hangtags, educational materials, PAS pieces, advertisements) that will be used to present the seasonal line to the company's retail clients. While product merchandisers have been preparing the line products, visual merchandisers—retail are working to create a fun, unique, entertaining sales environment to showcase their company's merchandise classifications for competitive selling. This includes take-aways or other promotional literature that

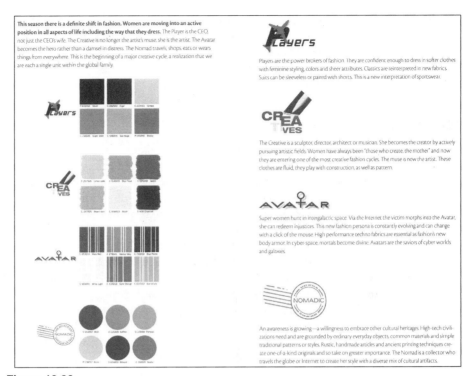

Figure 12.30
A marketing "take-away" for a retail buyer.
(Courtesy of Tobē)

will catch the eye of the buyer and reflect the product and company image (see Figure 12.30). They have defined and created plan-o-grams, shop concepts, and in-store special events and promotions. These merchandisers have also been working with Web site developers or catalog layout specialists to create the same retailtainment type environment for these retail formats. These visual merchandisers—retail are the link between the manufacturing company and the client (i.e., retailer); therefore, these merchandisers conduct research with their major retail clients to identify additional opportunities with those clients.

The final step for marketing the line is educating the sales team or account managers on how to sell the line to the retail client. Most manufacturers hold a regional or national **Sales Meeting** to educate the sales force on how to sell the line. This meeting is in preparation for showing at market weeks, fashion shows, and Sales Meetings with retailers. In the Sales Meeting, product merchandisers present the product offering for the new season while marketing personnel present the marketing materials to the sales representatives or account executives, who sell in the merchandise to the retailer and manage the retail accounts to build optimum sales volume and a profitable endeavor for both the retailer and the manufacturer. These account executives are the liaison

between the manufacturer and retailer and many times are the key to building a strong and positive vendor/retailer partnership. The merchandiser wants to be sure the line is presented and promoted in an optimal way so sales of the products are maximized.

Summary

The Line Product Development Process is key to get the product from a design idea to a product purchased by the consumer. Many activities and approvals must be completed to push the product through the process. At the start of Line Product Development, the product is merely an idea that has been approved. At the end of the process, the product is a concrete real item that is ready to be cut, sewn, and shipped to the retail customer. Many of the processes in the Line Product Development occur simultaneously or must be coordinated before the Line Release.

Fast timing is essential to the success of fashion products; however, the merchandiser must plan for, and take, the time needed to review the product at each step and check that the tools and guidelines that were created in Line Concept Development are followed. The product must continue to adhere to the design concepts that were approved in the Line Plan Summary. Checking the progress and the outcomes of the Line Product Development is vital to the successful sale of the product, both to the retailer and to the final consumer.

Key Terms

Basic slopers
Canton Trade Fair
Color consistency
Color standard
Componentization
Cost sheet
Counter sample
Cut order
Cut order planning
Cut spec
Design sample
Design spec
Duplications
Dups
Ease
Fabric cost
Fabric sourcing
Fabric spec
Fashion sketches
Final inspection spec
Findings

Findings spec
First pattern
First pattern maker
Fit
Fit spec
Flat
Floor ready
Freeze Meeting
Hand
Hand-loomed
Ideacomo
Indirect labor cost
International Fashion Fabric
 Exhibition (IFFE)
Interstoff Trade Fair
ISO 9000 certification
Knitdowns
Lab dip
Landed cost (LC)
Line Development Meeting
Line Freeze

Line Product Development
Line Release
Line sheet
Manufacturability
Manufacturing Meeting
Marketing Freeze Meeting
Material World
Mill week
Pitti Filati
Preliminary cost
Premiere Vision
Premiere Vision Preview
Price Meeting
Product data management
 (PDM)
Production sample
Product specifications
Product trueness
Production approved samples
 (PAS)
Protospec

Prototype
Prototyping
Quality
Quick cost
Reiterations
Rub-off
Sales Meeting
Sample room hands
Seam standard
Sew spec
Sewability
Sewing labor cost
Size spec

Spec book
Spec sheet
Specification book
Standard
Standard allowable
 minutes (SAMs)
Stitch standard
Storyboards
Strike off
Style Adoption Meeting
Style boards
Style number
Techtextil Show

Texworld USA
Total cost
Total manufactured
 cost (TMC)
Trim cost
Turkish Fashion Fabric
 Exhibition
Vendor retail price
Voice of the Consumer (VOC)
Yardage needed
Yarn dip
Yield

Review Questions

1. What are the basic activities in the Line Product Development Process to prepare the product for market?
2. Why does a merchandiser need specifications?
3. What are the basic specs included in a specification book?
4. How does a merchandiser decide what textile tests to require for the fabric specifications?
5. Why are cut-and-sew specifications important to product trueness?
6. Who has responsibility for developing specifications? Why?
7. What is the purpose of controlling specifications?
8. How is quick costing calculated?
9. What are the components of the wholesale cost?
10. What happens in the Freeze Meeting?

References

Borneman, J. (2005). What is your future in textiles? *Textile World*. Retrieved July 29, 2005, from http://www.textileworld.com

Clark, E. (2006, May 16). Turning away from the low-cost model. *Women's Wear Daily*, p. 4B. Retrieved September 5, 2007, from http://www.wwd.com

The Textile Clothing Technology Corporation. (1990). *Cut Order Planning*. Cary, NC: National Apparel Technology Center.

Tucker, R. (2007, July 10). Venue changes give new look to N.Y. textile shows. *Women's Wear Daily*, p. 14. Retrieved August 8, 2007, from http://www.wwd.com

chapter

13

Line Product Management

Objectives

After completing this chapter, the student will be able to

- Discuss management of the supply chain
- Explain the importance of product line management to the consumer-centric company
- Identify sourcing strategies for FTAR companies
- Discuss the issues a company must consider when selecting a sourcing strategy
- Compare the advantages and disadvantages of sourcing strategies
- Justify why a merchandiser would choose a full package as an option for getting a product to market
- Explain how globalization affects a sourcing strategy
- Describe issues the merchandiser must consider when sending employees to other countries on sourcing duties
- Discuss ways to evaluate a source company
- Compare and contrast sourcing in a selection of countries

Introduction

Following the making, testing, and approval of samples, the merchandiser for an apparel manufacturer needs to have the products for each product classification produced in the volume determined, based on the retailer's assortment plan,

through sales orders, or the manufacturer's Initial Marketing Calendar. The finished products must then be delivered to the customer. **Line Product Management** is the process of making the desired product a reality through sourcing, negotiations, quality control, and shipping and inventory logistics. Each step is planned and managed in order to have the right products cut and sewn for retail delivery and sale to the consumer. Some merchandisers call this process the product execution. In **product execution,** merchandisers are moving the concepts for the product in the seasonal lines from the planning stages to actual production and shipment to the customer (see Figure 13.1). Merchandisers work with sourcing and purchasing personnel to determine the best sourcing methods and opportunities for production. They must select not only the type of sourcing but also the country in which to source if the product is not to be made domestically.

In addition to selecting production sources, the merchandiser needs to purchase the fabrications for making the product. Fabric sourcing decisions are usually made in Line Product Development so the color, prints, and other product

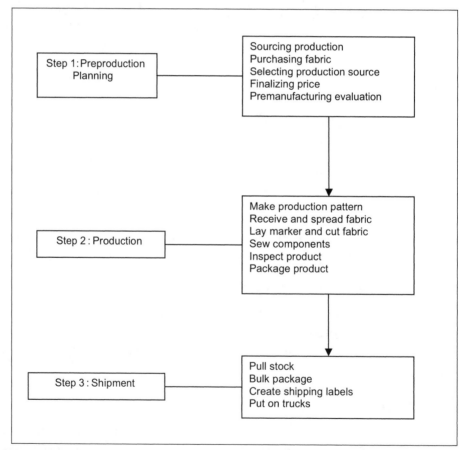

Figure 13.1
Overview of Line Product Management Process.

features are clarified for the design. Fabric purchasing as well as production sourcing can also be done by retail merchandisers, who are choosing to source private label or other exclusive products, instead of choosing from products designed and made by manufacturers. With fabrications and production sources in place, merchandisers need to finalize the price of the item. When the production source for the item is determined, labor costs are known. When fabrics and other raw materials are ordered, fabrication costs are established. And last but not least in importance, the merchandiser must be careful to check that the product to be produced is true to the sample, the designer's ideas, and the company's image.

Supply Chain Management

Throughout the FTAR Supply Chain, merchandisers work with the functional areas of Operations or Merchandising Services to facilitate the smooth flow of merchandise from line product concept and development through product execution to shipment to retailers for sale to the consumer. Managing the activities along this supply chain is called **supply chain management (SCM)** and becomes an important role for merchandisers in the FTAR Complex. Making and selling goods is not enough to be successful in a competitive market. Companies must ensure that the goods are the right goods in the right quantities and that these arrive at the right locations at the right time. The goal of SCM is an efficient flow so that orders are filled quickly with no missing stock; meanwhile, inventory is kept as low as possible and costs are reduced to provide profitable margins for all trading partners in the chain. Variables within the supply chain can and do fluctuate. For example, shipments become delayed because of weather in shipping channels, docks are crowded with preholiday shipments and the crowding causes delays in unloading, production capacity is either not met or is overextended, buyers change their minds and want to change their orders, a dye needed for printing is out of stock, and a bridge is closed and the truck shipment is rerouted incurring extra travel time. With so many places for variance and unexpected events to occur, the merchandiser with the help of the personnel in Merchandising Services must constantly monitor and manage the activities in the supply chain for each product classification in the company. SCM is designed to reduce inefficiencies in the supply chain and to increase the speed and accuracy of the flow of products from raw materials to the retail store.

With SCM, someone within the FTAR Supply Chain must be in charge of the product. A **channel captain,** or the leader, for the development, production, and delivery of the product must be established. In other words, one company must take ownership of the design, the consumer, and the final product. Decisions on which company will be the channel captain are negotiated as part of the trading agreements and done when sourcing a supplier for a product or when seeking customers for the product. Companies that have established partnerships with their customers and suppliers have clear guidelines as to who controls the design and other specification decisions for the product.

SCM activities can be grouped into six dimensions: partnership, information technology, operation flexibility, performance measurement, management commitment and leadership, and demand characterization (Lee & Kincade, 2003b). Activities include information sharing with trading partners, forecasting, computer-to-computer communications, use of electronic data interchange (EDI), small lot purchases and productions, measurement of fill rate and delivery time, and training of employees.

Some industry personnel summarize these six activities into two issues: sourcing and logistics. **Sourcing** is the process of finding the raw materials and products from vendors that the customer needs (see Figure 13.2). The goal of sourcing is to get the right products to the right customers in all the right quantities, prices, colors, sizes, and all the other right product attributes. This effort becomes a balance between getting the product features that the customer wants and getting the right price that the supplier wants. **Logistics** is the process of coordinating timing of raw materials and product shipments, methods of materials and product shipments, and storage and inventory of the finished products. R. Birkins, Jr., director of sourcing at JCPenney Private Brands, says that logistics "is all about speed" ("What Is "Sourcing," 2002, para. 4). Successful supply chain management requires a close relationship with trading partners but does not require that the company restrict suppliers to a single partnership. Loose networks of suppliers and customers at all points in the FTAR Supply Chain benefit from SCM. Studies show that SCM can reduce in-

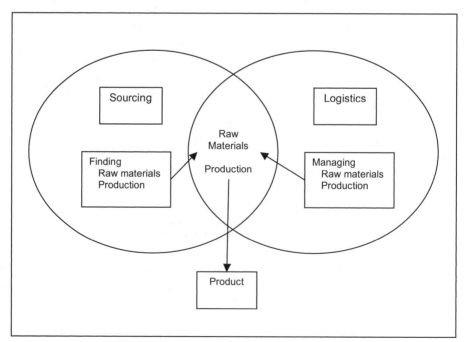

Figure 13.2
Sourcing and Logistics for Line Product Management.

ventory levels, eliminate excess or surplus inventory, and increase the delivery performance (Lee & Kincade, 2003a). Every company has suppliers and customers that must be managed for the right products to arrive at the right place with the right price tag.

SCM requires investments from all partnering companies, including the purchase of computer equipment and electronic networking capabilities, training for employees, management commitments of time and financial resources, and employee time and skills to manage the processes. Zara, a Spanish-based retailer that offers a wide variety of fashion items with a high product turn, reported implementation of some SCM strategies with significant financial returns. Between their stores and the supplying apparel manufacturers, they worked on SCM activities to bring cycle times down to 15-day cycles and increased the influx of new products to a level of twice-a-week replenishments. These changes are reported to have increased same-store sales by 25% with the result of a 34% increase in profits ("Quick Response," 2004).

Software may be purchased to assist Merchandising Services in reaching their goals of the right product in the right place at the right time and price (Kanakamedala, Ramsdel, & Srivatsan, 2003). Tracking where a shipment of product is within the FTAR Supply Chain and knowing when that shipment is expected to be shipped for arrival at the next link in the chain can be valuable information for companies that are trying to keep inventories low and product turns high. Software that tracks inventory flow, along with financial information, vendor/ supplier details, and product characteristics, helps the merchandisers and personnel in Merchandising Services know what is where in the supply chain. Although software installations are not a replacement for employees lacking skills or vendors unable to produce because of lack of capacity or inadequate suppliers, the correct software is a valuable tool when employees have the right training and the software tracks the desired information.

Production Sourcing Strategies

Once the concepts for product in a seasonal line are concrete and approved, the merchandiser must determine what production strategies will be used to obtain the product. At each step in the FTAR Supply Chain, the merchandiser must determine where to get the product made (i.e., production) or how to buy the finished product—be it fiber, fabric, or apparel. Determining where to have the product made is the **sourcing strategy** (see Figure 13.3). Determining how and where the product will be made involves many decisions about ownership and provision of services that will impact many future steps in getting the product to the consumer. Having a dependable supply chain or network of companies that will provide goods and services to support the company's strategic plan is important for the success of any consumer-centric company.

Top management at each company—raw materials producer, product manufacturer, or retailer—must determine if the product is to be made in the company's facilities or if the product will be bought in whole or in parts from

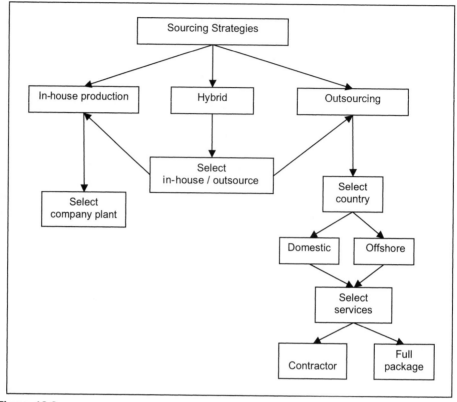

Figure 13.3
Decision tree for production sourcing strategy.

outside vendors or suppliers. For example, synthetic fiber producers must source the petroleum and other chemicals used to make the fibers; fabric producers must source fibers and dyes used in making fabric; product manufacturers must source or have the resources to make fibers and/or fabrics, finishing agents, preproduction services of pattern and marker making, and cut-and-sew operations. Retailers must source either the finished apparel product or some or all steps and fabrications from fiber and fabric to packing and shipping the end product. Wise merchandisers know they need to control the sourcing process instead of having the process control what they are doing. The choices for sourcing strategies are varied and involve many decisions, such as a choice of domestic or international locations, company-owned or contracted operations, and cut and sew or full package.

In-House Sourcing

The initial decision made in product execution is who will make the product or who will have ownership of the production processes. The traditional choice for many firms, especially raw materials producers and sewn products

manufacturers, is to make products within **company-owned production** facilities and to hire employees for services such as designing, pattern making, and dyeing. When the company owns the facilities and hires the employees, regardless of where these are located, this is an **in-house sourcing strategy.** For an apparel manufacturer or retailer, producing in-house requires an extensive vertical company, if all steps in the fiber to product process are included in the in-house operation. For a retailer to have a complete **vertical operation** (i.e., fiber to retail), their ownership would include fiber mills, fabric mills, cut-and-sew plants, and the retail stores.

For some large retailers or branded product manufacturers who wish to maintain extensive control over the process or who have highly specialized products, this might be the ownership choice. Zara, the mega-retailer in Spain, has successfully managed this type of operation through the parent company of Inditex. Through Inditex, Zara has access to design, production, delivery, and sales processes ("The Future of Fast," 2005). In-house design facilities coupled with geographically close cut-and-sew operations gives Zara a fast turn on design and production. Production is done in small batches by local sewing cooperatives, which involve large numbers of low-cost human labor to remain flexible and profitable ("Cheap Chic," 2006).

The choice to make products in-house requires substantial financial investments, and it can limit flexibility of future product decisions unless the cut-and-sew operations hire highly skilled people with limited dedicated equipment. For most companies, owning enough production capacity to satisfy its retail customers would require investments in equipment, materials, real estate, and personnel. If the company chooses to be a vertical operation, the knowledge base and personnel skills needed within the company would be very broad and diverse, and equipment purchases would be extensive (see Figure 13.4). For example, producing synthetic fibers takes very different skills and equipment from those needed to cut and sew a bathing suit. Few companies choose to be vertically integrated today, but some may choose to own production facilities for the production of their part of the FTAR Supply Chain. For example, apparel manufacturers may have in-house production facilities for cutting and sewing the product but choose to purchase fabric from a supplier. This amount of in-house production is typical of traditional product execution for most fiber, fabric, and apparel companies. However, with globalization of the entire supply chain, many textile and apparel companies are currently sourcing the product in countries outside of their domestic offices to obtain a competitive advantage in the marketplace.

Outsourcing

Outsourcing is at the other extreme of product execution from an in-house strategy or vertical ownership. In an **outsourcing strategy,** a company buys production processes and services from outside of the company (see Figure 13.3). This sourcing strategy may involve purchasing products and services from domestic companies (i.e., those located in the same country—or the home country—as the buyer's company) or from companies located in countries outside of the buyer's

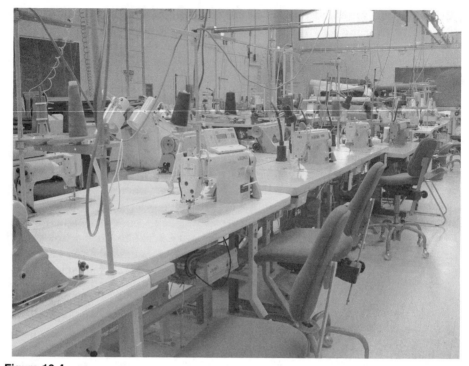

Figure 13.4
Sewing production floor.
(Courtesy of College of Textiles, North Carolina State University)

home country. When a company obtains, or **sources,** products and services from noncompany sources, the company does not own the production facilities. Some companies use this strategy for their complete product mix. Companies such as Nike and Li & Fung, a Hong Kong–based company, are well known for their outsourcing strategy. Neither of these companies owns the production facilities that manufacture their products. These companies are often described as brand managers, marketers, or orchestrators instead of manufacturers.

Approaches to Outsourcing

The merchandiser or sourcing specialists for a company may work directly with producers or manufacturers who make the products that are needed or they may work with middlemen or jobbers who help them seek the appropriate companies. A merchandiser at any link in the FTAR Supply Chain may work with **jobbers** who do not own production facilities but who make business arrangements with contractors, usually one for each operation needed to complete the product. For example, merchandisers for a retailer may use a jobber when seeking a company to make private label products, especially for their stores. The jobbers can find contractors who are willing to find fabric; design product; and cut, sew, and ship products under the label or brand specified by the retailer.

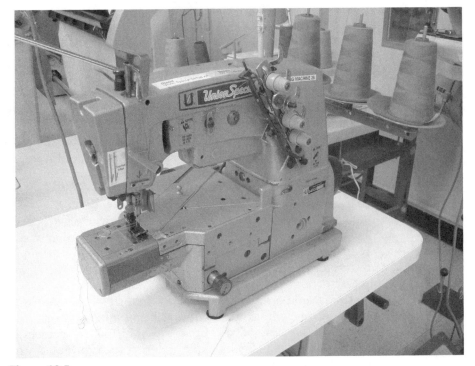

Figure 13.5
Specialized equipment used by contractors.
(Courtesy of College of Textiles, North Carolina State University)

Apparel manufacturers also source using jobbers. A merchandiser for an apparel manufacturer might work with a jobber when this season's products require a specialized sewing operation that is not often done in the manufacturer's own plants. The jobber would help the merchandiser find the right sewing facility to make the needed product or provide the needed sewing operation. Or a merchandiser with a fabric producer might work with a jobber to find a screen printer needed for a print operation that is required for next season's product line. A merchandiser may also work with individual contractors on an operation-by-operation basis, making each of the deals and planning for each stage of the production process. Many apparel companies have their own in-house design facilities but work with a **cut, make, and trim (CMT) contractor** to provide the cutting of fabric and the sewing of the cut parts (see Figure 13.5).

In addition, the merchandiser may source from an apparel manufacturer who offers to provide the entire production set of operations from fiber to finished product. In this arrangement, the retail merchandiser would be working with a company that provides a **full package,** or **full value costing.** Full package contractors may provide services to cover all processes or only a portion of the processes in the various links of the supply chain. These services may

range all the way from fiber sourcing to the delivery of a floor-ready product for the retail store buyer. Or full package may include specific specified services agreed on by the contractor and the retail client. Depending on the contractor, full package services may include any process needed to design, produce, and distribute a floor-ready product to the retail sales floor. A full package program may include product development, including fabric and trim sourcing and computer design, and fabric cutting, sewing, finishing (including hangtags and packaging), and distribution of product. The choice between CMT and full package is often a decision on speed. Having a contractor handle all of the details for getting the product to the customer is often more efficient than dealing with multiple contractors across multiple organizations. This model has been very useful for Li & Fung, the Hong Kong firm that is well known for its fast to market logistics and its efficient sourcing (Haisley, 2003).

When the idea of full packaging was first introduced, many industry experts thought this type of sourcing would be a quick solution to supplying a quality product with the least company personnel in a reasonable amount of time. However, with all the benefits of full packaging, there are some drawbacks. The process is more costly upfront than a CMT contractor. For a contractor who is creating a full package for a retailer, "[f]abric—high-quality fabric from a reputable vendor will ensure a [full package] program runs smooth. Fabric is at least half the cost of the program" (M. Todaro, personal communication, December 13, 2002). For example, ordering the right fabric, the right amount of fabric, the right weight of fabric, and fabric with the correct dyeing standard is a necessity for initiating a full package process. To assure the development of a successful package, some full package producers have bought fabric mills, others have invested in flexible machinery that can be easily adjusted to handle different patterns, and some are training workers to produce more varied garments. And trim vendors with specialized equipment (see Figure 13.6) have opened shops inside the manufacturing plant of the full package contractors to assure supply chain just-in-time full package production (M. Todaro, personal communication, February 7, 2002).

Some retailers choose to have products developed exclusively for their companies. A few large retailers have in-house designers and product developers who are creating product ideas (i.e., the activities in Line Concept Development). When the ideas are developed, the retail merchandisers need assistance in finding contractors for the cut-and-sew portion of the process. These merchandisers may work with buying offices to search for contractors to make these products. The process of using a buying office for sourcing production would be similar to the processes used by apparel producers in finding a CMT contractor. Buying offices, and their many functions, are discussed in detail in Chapter 15.

Advantages and Disadvantages of Outsourcing

Regardless of the type or method selected for outsourcing, by choosing to outsource production, a company is relieved of the ownership problems of manag-

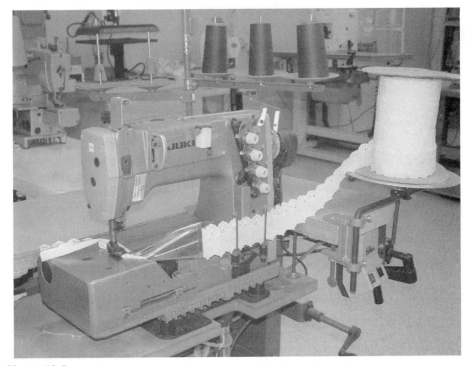

Figure 13.6
Sewing machine with folder attachment.
(Courtesy of College of Textiles, North Carolina State University)

ing real estate, hiring knowledgeable and skilled production operators, and maintaining specialized production equipment. The biggest advantage to outsourcing is the flexibility that the company gains. The company Li & Fung gained significant competitive advantage by using a wide variety of suppliers to achieve its fast turn and fashion-forward product mix (Brown, Durchslag, & Hagel, 2002). With product line changes and an outsourcing strategy, the company can change vendors. Although this change allows for maximum flexibility in Line Product Development, it creates many new problems and costs. As the company gains flexibility and capacity, the company releases control over the production process and the final product. When outsourcing crosses national boundaries, the merchandiser may find additional problems with language barriers, limitations from quotas and other laws, and increased costs from shipping distances. Some consumers are sensitive to the "made in X" labels and may object to products made in certain countries.

If a merchandiser is constantly changing sources, added time is needed for negotiating contracts and long-term relationships are difficult to maintain. With interruptions in or lack of partnership agreements, the merchandiser will face the need for more testing of samples and additional manufacturability analyses. Carefully planned contracts, standard partnership agreements, demands for

certification, and other quality control mechanisms can be employed to improve control over the process and to reassure the merchandiser that the product from an outsource will be satisfactory for the customer. To cope efficiently with over 6,000 suppliers, the large firm Li & Fung has clearly defined specifications and detailed benchmarks for each stage gate. Other companies choose to work closely with a few vendors and develop close partnerships with those vendors (Brown et al., 2002). Although this outsourcing strategy reduces flexibility, it increases the control that the company has over the vendors and improves the time-to-market efficiency. Although not restricted to narrow product lines, this strategy works well for companies that have niche markets and a focused product. Regardless of the company's approach to outsourcing, communication technologies, a management highly skilled in networking and negotiating, and well-developed specifications are needed to make this business method work well for a company. New computer software and the expansion of the Internet help companies communicate with their vendors and customers and allow for rapid sharing of product information, including factory profiles, forms for negotiations, order forms, shipment tracking, and access to specifications (M. Todaro, personal communication, 2001).

Hybrid Sourcing

Some companies choose to use both in-house production and outsourcing. When choosing both sources of production, the company has a **hybrid sourcing strategy** (see Figure 13.3). The decision to use hybrid sourcing often depends on the product, the current equipment owned by the company, time to market for the product, and the desired fashion turn. Hybrid sourcing can have the benefits of outsourcing without the investment restrictions of in-house production; however, hybrid sourcing can also generate the worries and loss of control from outsourcing and the need for skillful employees associated with in-house sourcing. Hybrid strategies may include joint ventures, where the domestic company purchases overseas facilities with a company in the host country. Hybrid sourcing is an option when the company has more orders than it can fulfill with its own plants and needs extra production capacity or if the current product line has a fashion item or fabrication that the company plants are not used to handling. The company may choose to outsource that aspect of the product line on a trial basis before purchasing equipment and hiring permanent employees. Outsourcing can be a beneficial supplement to a company and a way of gaining expertise beyond the skills of current employees and beyond the capacity or capabilities of current equipment.

In determining the best sourcing strategy for a company, the merchandiser must consider what is to be accomplished with the strategy. Direction for this decision comes from the strategic plan. When determining "who are we" and "where we want to go," companies make decisions relevant to the type of product they wish to produce, the place they wish to maintain or gain in the marketplace, and the image they want represented through their products, including the fashion level and quality of the product. Many consumers never know or care who actually makes the products they buy. Consumers recognize

brands but rarely know the names of contractors or manufacturers, and most consumers do not care who made the products as long as the items meet their expectations on price, quality, fashion level, or other product criteria. Most consumers are not interested in acting as a jobber for their own product. So the company must choose a sourcing strategy that will produce the desired product and appear seamless to the consumer. Selection of the strategy is contiguous with the selection of the actual source.

Selection of the Production Source

In conjunction with determining the strategy, companies must determine what sources, if any, are to be selected when needing outsourcing. Companies need also to consider the cost of the product and all associated costs of product execution, the time to market, and the technologies or other special skills and equipment needed to produce the product or the raw materials for the product. In addition, they must constantly evaluate if the source will provide a product that fits with the company or brand image, fashion and quality level, and price tag.

The issues involved in selecting a production source are often discussed in the Manufacturing Meeting with a team of merchandisers, sourcing and purchasing personnel, pattern makers, and finance personnel. In some companies these tasks are not merchandising tasks but are the responsibility of the production managers who source contractors and of the purchasing personnel who place orders for fabric and findings. Regardless of who is responsible for these decisions, merchandisers are concerned about the selection of a production source because timely shipment of supplies, production that meets deadlines, products that adhere to the design concepts, and on-time delivery of this product is crucial at each level in the FTAR Supply Chain so the right product is delivered at the right time to the right customer. Issues in selecting production facilities include costing, dating, payment, geographic location, social compliance, and other complex factors.

Costs

For product manufacturers, sewing labor and other associated labor costs are a major factor in costing the product; therefore, the cost of production is a major factor in determining the final cost of the product (see Chapter 12). Some sewn products manufacturers are cost driven and outsource the sewing to whatever country can offer the lowest labor costs. This strategy means that merchandisers are constantly seeking contractors paying low labor wages. However, in addition to the cost of the product, the merchandiser should consider other associated costs such as shipping, travel expenses as well as travel time for the buyer and other product personnel, cost of shipping returns back to the production facility, and any loss or gain in customer acceptance of the product.

Sometimes the lowest cost product may have the highest associated costs. For example, a product sewn in a Central American country for a U.S. manufacturer may have a higher labor cost than a product sewn in China (see Figure 13.7).

	China		El Salvador		United States
Labor rate per hour	$1.08		$1.79		$11.00
Time for sewing (SAMs)	20		20		20
Sewing labor	$0.36		$0.60		$3.67
Indirect labor @ 55%	$0.20		$0.33		$2.02
Labor subtotal	$0.56		$0.92		$5.68
Fabric 2/3 yd @ $6.00	$4.00		$4.00		$4.00
Binding	$4.38		$4.38		$4.38
Thread	$0.01		$0.01		$0.01
Tag	$0.05		$0.05		$0.05
Findings subtotal	$4.39		$4.39		$4.39
Miscellaneous (hangtag and pin)	$0.03		$0.03		$0.03
Total manufactured costs (TMC)	$8.98		$9.34		$14.10
Overhead @ 45%	$4.04		$4.21		$6.35
Manufacturer's list price	$13.02		$13.55		$20.45
Transportation	$0.35		$0.18		$0.05
Wholesale price	$13.37		$13.73		$20.50
Retail markup @ 48%	$12.34		$12.67		$18.92
Retail price	$25.71		$26.40		$39.42

Figure 13.7
Cost comparision for country of production.

However, if the company wishes to have a manufacturing facility closer to its domestic headquarters, it may pay the higher labor costs to have more control over the process because the proximity of the facility allows for more frequent plant visits that are less costly than traveling to Asia. Also, the cost of transportation and trade rules and regulations might favor the Central American contractor because each trade bloc has trade rules with unique opportunities that favor a particular geographic trading area. However, if the same U.S. manufacturer wished to source a product with intricate embroidery details, the merchandiser may wish to source the product in the Philippines to take advantage of the skilled labor force and availability of equipment needed to produce the product there, even though the time to market and shipping costs might be much higher than making the product in a domestic manufacturing plant. Seeking only the lowest cost product is not always the best sourcing strategy.

Quality Process

Ensuring product quality is another important consideration in selecting a source or deciding to keep production in-house. For some products, especially at higher price points, or for branded products, the merchandiser may be extremely interested in the quality of the product. Assurance that the ordered product will be as planned is important to these merchandisers. A strict adherence to specifications is expected when product quality is important. As part of the sourcing agreement, the merchandiser itemizes how and when products are evaluated for specifications and what the penalties are if the product does not meet expectations. Many quality decisions are made during Line Product Development (see specifications and quality in Chapter 12). The merchandiser's interest in quality while selecting a production source is to find a supplier that will provide and maintain the quality planned for the product.

Dating

With fashion products, speed to market may be more important than cost. The **time-to-market** for a product is the time that elapses between inception of a product idea to the delivery of the product on the sales floor. For fashion goods, this time must be short to achieve the product turns that are required and to stay ahead of the competition in delivering new products to the sales floor. For a retailer, time-to-market would include product development; fiber and fabric production; cut, sew, and pack; and shipment to the distribution center (DC) and from the DC to the retail sales floor. When the raw materials are produced and processes performed around the globe, this time span may be rather lengthy. For products sold in the United States, the time to market for products coming from China may vary from 14 to 26 weeks with an average of 20 weeks. Products being cut and sewn in Central America may take 8 to 9 weeks for time-to-market in the United States. Although few apparel manufacturers still remain in the United States, these domestic manufacturers often have a time-to-market of only 4 to 8 weeks. For delivery to U.S. retailers, when time-to-market is a critical issue for the merchandiser, having work done in a geographically close location is often the best solution, even if labor or other costs are higher. However, as with most strategic decisions, the answer is complex.

In addition to time-to-market, the merchandiser should consider the lead time required to work with the source. **Lead time** is the amount of time the source company needs from the finalization of the contract to the start of production. The production time could be very short, but the lead time to develop samples, make patterns, and other startup activities could be long or short. A manufacturer's use of Quick Response, collaborative planning, and other partnership strategies can provide benefits that reduce the time-to-market, especially the lead time, for any supply chain. Manufacturers and retailers with efficient supply chain partnerships are reported by Cheh of Esequel Group to be manufacturing knit cotton shirts in China from fiber made in China and shipping them to the United States in less than four weeks (M. Todar, e-mail communication, May 8, 2006).

Closely related to time-to-market is the meeting of delivery dates and order fulfillment. For the **delivery date,** the merchandiser, regardless of location or link in the supply chain, expects the products to be delivered on time. **Order fulfillment** indicates that the shipment will contain the amount of product expected at the merchandiser's specified delivery date. Many customers now want their order shipped over time in subunits of the total order (see Figure 13.8).

Fiber manufacturers need their chemicals or natural raw fibers to be delivered when expected, and retailers need to have the finished product delivered on time. Fabric producers need fibers to arrive so the fabric can be woven, dyed, and finished in time to ship for the delivery date to the cut-and-sew operation. At each production stage, raw materials must be delivered on time so the output can be shipped on time. Suppliers must deliver on agreed upon dates. In addition, the order must be fulfilled in the volume anticipated for the costs and deliver times to remain as planned. For example, if only part of an order is delivered to an apparel manufacturer, the cutting and production scheduling has to be altered from the plan, which can affect labor costs and obviously will affect shipping dates. Merchandisers will want to negotiate penalties for failure to comply to delivery dates and order fulfillment. The power of

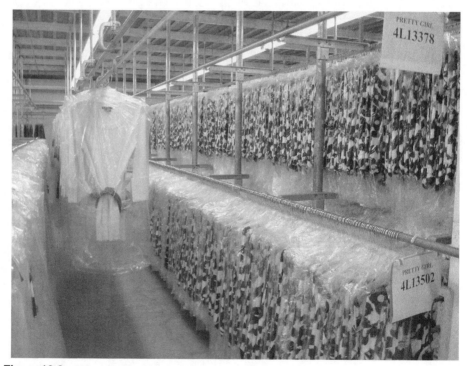

Figure 13.8
Floor-ready merchandise on racks in distribution area.
(Courtesy of Karen Kane)

the merchandiser to negotiate a favorable contract depends on the size and record of the customer and the size and record of the supplier.

Payment

Payment issues are important but often overlooked considerations when selecting sources and include exchange rates, payment methods, and bank accessibility. The merchandiser must know the money exchange rates between countries so the actual cost of the product or service can be finalized. With fluctuating exchange rates, the cost when ordered might not be the cost when delivered. Stabilizing the exchange rate to an agreed upon rate might be part of the sourcing contract. In addition, the payment method will be negotiated for the outsourced purchases. When companies are transacting business, a number of payment methods are possible. **Cash on order** would be required when the merchandiser's company has a limited track record or if the payment record is poor. A **letter of credit (LC)** or other method of delayed payment may be accepted by the contractor if the company is a continuing customer or has other credentials to ensure payment (see Chapter 15 for additional information on terms of payment). Interest or partial payments are also considerations depending on the financial viability of the company and any previous transactions. When transacting business for sourcing across countries, merchandisers must be aware of the banking facilities in the location for the product or services source, and should not assume the local bank on the corner will be able to handle an international transaction. Or that the bank in the other country will be amenable to the international trade.

Shipping

Shipping, or the transport of the product from the plant's loading dock to the customer's loading dock, should not be ignored when selecting a source. The product must be shipped so it arrives on time and in the volume and condition that is usable to the retail buyer. Specifications on shipping are determined by either the apparel manufacturer or the retailer. Some manufacturers have preset shipping arrangements, and others negotiate shipping relative to the demands of the retail buyer (see Chapter 15). Negotiations on shipping may include who pays for shipping, who has possession of the goods during shipping, how the product will be packaged prior to shipping, and what methods of shipping will be used (see Figure 13.9).

Considering the distance, the geographic land features, and the costs, a merchandiser can choose to ship by truck, by rail, by container ship, or by air freight (see Figures 13.10a, 13.10b, and 13.10c). Obviously, truck and rail are only part of the solution when dealing with sources that are a great distance from the customer or are overseas. The distance from source to customer is also a consideration because the further the distance, the greater the shipping costs. Cut-and-sew contracts may choose to source fabric in the same country or in nearby countries to reduce shipping costs and time in transit, and fabric producers

Figure 13.9
Packing merchandise for shipping.
(Courtesy of Karen Kane)

may choose to locate plants near sources for raw materials. For example, Cone Mills, a denim manufacturer, has located plants in China so they are close to the source of their raw material (i.e., cotton) and, in China, they are close to the contractors that make jeans from their denim and sell the product to their retail partners (Borneman, 2006).

Another consideration about shipping distance is where the products are being shipped. The products can be shipped to one of several locations: to the consumer directly (common in customized products and with some catalog or Web-based businesses), to the retailer's distribution center, or direct to a retail store. The **distribution center (DC)** is a centralized warehouse that services a large retail chain. Some retail chains have more than one DC. The DC may be only a stopping point for redistribution of products or may be a point from which store managers or retail merchandisers can pick product and customize what is placed in each store.

If shipping merchandise across an ocean, the merchandise will probably be placed in boxes and then into containers that are loaded onto seagoing ships. These containers can be unloaded by cranes at the destination port and placed on wheeled beds attached to trains or semitrailers for local distribution (Nocera, 2006). When considering shipping from overseas, the merchandiser

(a)

(b)

(c)

Figure 13.10 Loading docks for (a and b) truck and (c) airfreight.

must understand about containers and the size of shipping vessels. Shipping from Central America to the United States sounds as if it might be easier than shipping from China to the United States; however, mega-ships can carry over 9,000 containers and may be too large to traverse the Panama Canal and other similar old shortcuts around the globe ("Books and Arts," 2006). Understanding the logistics of how to get the product from Point A to Point B efficiently and cost effectively is part of sourcing. In addition to how the products will be shipped, the merchandiser will also want to clarify who has ownership during the shipping and who has insurance on the products during shipping, including during the time the products sit in loading docks or in distribution centers.

Related to shipping is **product security** during shipping. Products are costly to make, and loss of a product is disastrous in terms of wasted payments, lost income, and customer disappointment. If the product is not available when and where it was planned to be, then the company not only loses the direct cost of sales but also loses customer loyalty and future sales. A chain of security for products is paramount to their prompt and expected delivery. The merchandiser must determine how the products will be inventoried when leaving the producer or manufacturer (e.g., bar code scan, hand count) and how this inventory will be

transferred to the merchandiser (e.g., joint database, shipping manifesto). For example, merchandisers know how many units of a product classification, such as a T-shirt, can be cut from a yard of fabric. Based on the fabric yardage provided to the contractor, the merchandiser can calculate approximately the number of dozen tees that should have been cut and sewn. If the actual quantity shipped by the contractor does not coincide with those calculations, the merchandiser will then need to take actions to resolve the problem. In addition, the merchandiser must determine how the products will be protected when on the loading docks, when en route, and when moved into distribution centers and backdoors of plants or stores. The chain of security also covers how the products are secured (e.g., placed in locked containers, specialty tape on boxes) and when and by whom the boxes can be opened. Clear lines of authority must be stated so the products arrive in full at the expected loading docks.

Social Compliance

In addition to the costs associated with the sourcing transactions, many customers are concerned about the way the sourcing company does business, or the **business ethics** of the supplier. For example, the merchandiser should check on the credibility of the producer. The merchandiser can ask for references and ask for permission to contact other customers of the sourcing company. The merchandiser should check on the company's compliance with delivery dates. Many firms consider that a 98.5% on-time, complete SKU delivery is excellent. The merchandiser may also want to check on the suppliers that provide raw materials or components of the finished product such as fabric, trim, and findings to the sourcing company. For a company to have reliable delivery dates, the company must have dependable suppliers.

The **social compliance** of the sourcing company or the way that company treats its employees is another issue a merchandiser may investigate. Although many customers are not concerned with who actually makes the product, they do care that the producing companies treat their employees fairly and pay a living wage. Consumer concerns about fair wages and sweat shop conditions have been highlighted in the news, so many consumers find this issue important and many companies do not want to be surprised about the conditions of factories for their suppliers. The American Apparel and Footwear Association (AAFA) has an extensive Web site about social compliance and offers guidelines and certification methods to ensure that companies are aware of the need to produce products under humane and lawful conditions. The AAFA works in cooperation with Worldwide Responsible Accredited Production (WRAP) to offer certification to manufacturers (see Figure 13.11a). WRAP is a nonprofit and independent organization that promotes the "certification of lawful, humane, and ethical manufacturing throughout the world" ("Welcome to WRAP®," 2006). This organization, which started with apparel-related production, is widening its scope to provide certification for many types of manufacturing ("New WRAP®," 2007). With this change, they have modified their logo to include the phrase, the Universal Code for Ethical Conduct, or UCEC (see Figure 13.11b).

(a) (b)

Figure 13.11
WRAP® logos (a) for apparel and (b) for apparel and other manufacturing.
(Courtesy of WRAP®)

In addition, AAFA awards recognition to companies that follow best practices in the treatment of their employees, and a buyer can recognize these manufacturers by the Excellence in Social Responsibility Award (ESR Awards) (Social Responsibility Committee, 2006). Other similar certifications may be offered by various country-specific or international nonprofit groups or by individual companies.

Other Selection Issues

Local laws, national laws, and **international laws** or regulations must also be considered when selecting a source. When sourcing out of the country, a merchandiser must be familiar with regulations about quotas, customs, and other issues covered by the World Trade Organization (WTO). In addition, when crossing state or national boundaries with products and services, the merchandiser should be aware that insurances, liabilities, and other legalities may change from country to country. The well-informed merchandiser is an asset to his or her company when sourcing.

Finally, the merchandiser must consider the **expertise of the source company** or factory. Depending on the operations or services needed, the merchandiser must be sure the sourcing company has the equipment and skilled employees to perform the needed processes. Although this seems to be an obvious consideration, the merchandiser will find it is often difficult to determine the exact capabilities of the sourcing company. Today, many companies that wish to be contractors for other companies maintain a company Web site that provides information about the firm. As users of the Internet, merchandisers know they should be wary of information found there.

In addition to these many factors, the merchandiser seeking a production source must consider **geographic location** of the production facility. Regardless of whether a company owns production facilities or contracts with outside vendors, the location of the raw materials, design and pattern workers, cut-and-sew operations, and retail customer must all be considered when selecting the site for production. This geographic location affects not only shipping but many other factors that must be managed. This factor is decided when a company selects the right country for the right product.

Selecting the Right Country for the Right Product

As companies around the globe seek ways to be competitive and to position themselves differently and effectively from the competition, they seek niches in which to operate. Countries also are being designated as niche markets. Some countries, because of the resources within the country, the location of the country, or traditions and industry heritage in the country, have a concentration of firms that offer specific types of production. Merchandisers who are aware of these regional areas of concentration may reduce their search for the right company by focusing on the right country (see Figure 13.12). However, each person seeking the best source for production of the product should be

Figure 13.12
World map showing WRAP's global presence.
(Courtesy of WRAP®)

aware that within each country are companies that may or may not be appropriate for the situation.

North America

Companies in the *United States* may be interested in sourcing domestically because of the elimination of overseas travel, language barriers, and exchange rates. Although the U.S. FTAR Complex is much smaller in the 2000s than in the 1970s and 1980s, some excellent small cut-and-sew firms continue to operate in niche markets, and some large manufacturers of synthetic fibers and technology-related products (e.g., fabrics with internal wiring and other "smart fibers") manufacture only in the United States. Merchandisers who source within the United States may encounter high volumes and long lead times as well as high labor costs. American Apparel has been very successful in making products in the United States in sweatshop-free sewing plants for wages that are competitive with other industry jobs. Their fast turn and fashion-forward looks come from the owner's design savvy and management techniques, vertical integration, and the close proximity of production to its retail stores (Ordoñez, 2006).

Mexico seems a logical choice for sourcing when the merchandiser and the consumers are located within the United States. The trade agreements promulgated by the North American Free Trade Agreements (NAFTA) and the benefits of geographic proximity provide advantages to Mexican companies that wish to be sources for U.S. companies ("The Top 10," 2005). However, wages have risen in Mexico so that the Chinese wage for operators is much lower, and transportation issues of Mexican trucks being restricted from travel in the United States has removed the benefits from geographic proximity.

The NAFTA treaty has also added growth to the Canadian apparel industry. Manufacturing products in *Canada* have many of the same advantages for U.S. companies as manufacturing domestically, and offer geographic closeness for retailers located in the northern tier of states in the United States ("The Top 10," 2005).

Central America and the Caribbean

The Central American Free Trade Agreement-Dominican Republic (CAFTA-DR), or more commonly called DR-CAFTA, was designed to eliminate the trade barriers among the Central American nations. CAFTA-DR provides U.S. companies with another option for sourcing production that has advantages of domestic production with lower wage structures. The trade policy includes the countries of Costa Rica, Dominican Republic, El Salvador, Guatemala, Honduras, and Nicaragua (Abernathy, Volpe, & Weil, 2005; Office of the U.S. Trade Representative, 2006). Because of their intensive cut-and-sew operations in preparing finished apparel products for global markets, DR-CAFTA countries are the second largest buyer in the world of U.S. textiles. Companies in this region buy not only finished fabrics but also fibers and yarns. For U.S. apparel companies, using contractors in the DR-CAFTA region provides product with reduced transportation times and associated costs. In addition to or instead of using local

contractors, some U.S. companies are relocating their own production facilities in DR-CAFTA countries. Apparel companies from Asia and other parts of the world are locating plants in the DR-CAFTA region to benefit from the skilled labor and the nearness to the U.S. market.

China

China is the country that most merchandisers associate with outsourcing. Many merchandisers select companies within China because of the known low labor costs. However, doing business in China may also be beneficial to a merchandiser because of the excellent supply chain that has been developed there. When a Chinese manufacturer needs a specific finding it can be produced locally (Beal, 2005). Presently, the low cost of labor in China is the primary benefit of selecting a company there. In contrast, the travel costs can be extensive when sourcing from China depending on the location of the merchandiser's office. Issues of living conditions for the merchandiser or buyer, modes and distance of travel, and treatment of workers are considerations when selecting a source in China. In addition, the cost of shipping the finished goods depending on the destination of the shipped products can be expensive. The hidden costs of doing business in China should be closely examined.

India

Firms in *India* have gained some notice for exceptional work in cotton products, especially those with hand embroidery or other handwork. Companies interested in the product classifications of lingerie and children's wear may find sources for these products in India because of the amount of handwork normally found in these classifications. India is also recognized as a location for outsourcing services, which might be of interest to companies that wish to process orders for customization or products that require extensive consumer input ("The Top 10," 2005). Because of the government and social structures (i.e., problems with infrastructure) that impact business procedures, companies who are not accustomed to doing business overseas may have difficulty negotiating favorable contracts and problems maintaining desired product quality when working with some Indian contractors.

Other Countries

Various other countries are potential sources for products and services within the FTAR Supply Chain. Europe is still a good source for finding producers of silk and leather and associated products, although the lead times may be extensive and the labor costs expensive (Beal, 2005). Countries in the Eastern Hemisphere that have not been traditional or major sources of textiles and apparel, such as Vietnam, Indonesia, and Pakistan, are now open for the sourcing business. Textile producers in Pakistan are making use of the regionally available short staple cotton to make terry or fleece-based products, and companies in Vietnam are specializing in products sewn from man-made fibers (Clark, 2006;

"The Top 10," 2005). Merchandisers may also consider seeking sources in other countries not traditionally known as major apparel or textile exporters, such as Israel for seamless underwear and activewear products and Turkey for a variety of high-quality sewn products.

Merchandisers may find well-known or little known but highly skilled designers willing to develop branded product lines in some of these countries (Clark, 2006). The governments in a number of these countries are investing in the textile and apparel companies so that some companies now have state-of-the-art facilities for design or production. Hong Kong was once the center of a booming apparel and textile trade. With changing politics in that area, many companies left Hong Kong; however, some knitting and cut-and-sew contractors have invested large amounts of capital for equipment to provide customers with quality products, short lead times, and high capacities (Clark, 2006). Searching for the right country and the right company takes diligent and extensive research. The decision should be made carefully and thoughtfully with consideration given to resources, employees, customers, products, and both long- and short-term results of the decision.

Sourcing Personnel

For companies that do a high volume of outsourcing when purchasing products, they need a large number of personnel to facilitate the sourcing. According to Beal (2005), a former Senior Vice President for Manufacturing and Operations at Jockey International, a company using primarily an outsourcing strategy may have both a strategic sourcing team and a tactical sourcing team. The **strategic sourcing team** is responsible for picking the source country and the company. They examine the selection criteria that are important to their own company. For example, they select a company and the country by considering the issues of labor rates, money exchange rates, shipping, and security. The **tactical sourcing team** supervises daily operations of the production or services that are being purchased. This team follows the product or service throughout the entire process from process start to delivery. This team is responsible for observing the progression of the product from inception to completion. Members of this team may be located in the source companies' factories so they can see what is happening with the product day to day or even hour to hour. Companies that wish assistance with international sourcing may attend shows such as MAGIC and ASAP Expo in Las Vegas where sourcing experts help select countries, train employees, and find contractors (see Figure 13.13).

Safety

The **safety and routine of employees** is a consideration in choosing the workers and in choosing the source. Employees who must work overseas should be trained not only in their area of expertise for the company but also in the culture in which they will work. Research shows that expatriate employees or

Figure 13.13
WRAP's booth at MAGIC with (left) Steven Jesseph and (right) Avedis Seferian.
(Courtesy of WRAP®. Photographer: Laura Sampson)

those who work outside of their home country need personalities appropriate for the situation, cultural and language training, and support for their personal and family responsibilities (Woodard, Kincade, & Owens, 2002). For employees to be successful in working for extensive periods in a foreign country, they must be carefully screened and selected for the position and then must receive country-specific training. An outstanding employee in a domestic office may not function well in a foreign office.

In addition to having the right personnel for the international position, the company must consider a number of other issues related to placing employees in international travel or foreign offices as a result of outsourcing or other company business. The safety of employees should be one of the first considerations when selecting a source, particularly a nondomestic source. Some regions of the world are embroiled in bitter internal struggles for authority or are known for kidnapping foreigners. Companies must try not to place their employees in physical danger and to warn those who must travel in such regions to take additional precautions for personal safety. Safety within the country can be considered on a number of fronts, including issues of politics and health. Many companies choose not to source in certain regions because of the potential harm to their employees.

Companies must also consider that a region in the world that is currently politically safe or health-issue free may suddenly become a threat to their employees. Stories about travel during the severe acute respiratory syndrome (SARS) incidents in Asia in the mid-1990s are a scary reminder of how safety can quickly change to terror. Many companies accustomed to sending employees on buying trips and site visits for face-to-face business operations were faced with trying to do business by phone, fax, and e-mail. Through new software packages for processing ideas and information about color, design, patterns, and finished products, some companies have adapted to e-business strategies to replace travel. However, many merchandisers still want the control of being in the factories and meeting their trading partners in person.

Travel

Another employee issue in international sourcing or other modes of international business is **travel safety** and the **length of travel time.** Although the destination for the employee may be a safe location, the employee may have to travel extended distances or through unsafe airports or airspaces to reach the remote location for a source. Compounded with the travel safety is the amount of time change the employee must endure to function in the new location. This time factor is affected by the "jumping-off-point," or the point where the travel begins. For example, an employee who is normally based in Hong Kong will not have as long a travel time or as large a cultural change when going to Malaysia from Hong Kong in contrast to the employee traveling to Hong Kong whose point of origin is Dallas, Texas. With extremely difficult conditions or extensive travel periods, even employees who are highly adaptable and the best of world travelers may not be productive employees. The amount of time the employee is out of the home country is also a consideration for the employee. Protracted travel times are more reasonable when the stay in the country is lengthy, but the personal demands on the employee for housing, food, and family relations are more extensive when the stay is long. Language as well as distance can be a barrier for employees in operating profitability in foreign business situations. Companies need to train employees not only in basic language skills but in words and phrasing that will be needed in business as well as cultural mores and manners for business meetings. Many language classes provide a student with conversational skills but not with the word skills needed for a specific industry or specific business negotiations. Well-equipped employees, regardless of location, are essential to successful business operations.

Evaluating a Source Company: Premanufacturing

Once the merchandiser has found several companies that seem to offer the services or products that are to be outsourced, he or she has to provide an evaluation of the capabilities of the company and the products or services. Research

about the company is important. The obvious best choice is a site visit. On a **site visit,** the merchandiser travels to the plants where the product would be made (e.g., screen printing) or travels to the offices of personnel who would perform the needed services (e.g., fabric design). The merchandiser should obtain a plant tour and ask to meet with employees. One sourcing expert employed by a well-known designer commented that when he visited a plant he always watched the expressions of the employees when management left the room and always asked to use the rest room facilities of the employees before completing his evaluation. He reported that in one plant, when the plant manager turned his back to the employees to leave the area, the employees stuck out their tongues at the manager. Of course, he then questioned the working conditions of those employees. In addition, the merchandiser should be allowed to see similar products being produced and to examine the products as they are coming off the production line. Site visits can be very costly for the merchandiser because of the travel and may be inconvenient for the plant managers because of interruptions to the schedule. And, unless the merchandiser is well versed in the production or service techniques, his or her observations may not be instructive. In addition, the site visit could also be "rehearsed" by the company because the true production facility may not be shown to the merchandiser.

Other ways to evaluate an outsourcing facility, before selecting the company, include acknowledgment of certification both for quality and for human rights, and requests for references and sample products. Companies can obtain **certification** from the **International Organization for Standardization (ISO)** for a variety of production and service characteristics. The most common certification is that for quality: ISO 9000. Other indications of quality could be companies who practice the 5 S or Six Sigma strategies and the receipt of an award, such as the Baldrige Award. Organizations such as ISO or the American Society of Quality (ASQ) can provide merchandisers with information about quality certifications. Some companies have their own certifications for human rights issues; other companies follow the guidelines set by WRAP® or other organizations. Their site provides any manufacturer or buyer with extensive information about their certification and accreditation processes and guidance for companies who are seeking such information. Buyers can look or ask about the WRAP® certification when they are investigating potential new suppliers (see Figure 13.14).

Asking for **references** and **sample products** can be a way for the merchandiser to investigate the way the company does business and the quality of the product. Companies who do business for brand name products may advertise that they are contractors for the branded products. Companies who are open and willing to do business may supply the names and contact information about recent customers; however, because of confidentiality agreements and concerns about industrial espionage and the vulnerability of fashion leadership, some companies are unwilling or unable to share contact information and to divulge the identity of their customers. Plant visits may also be restricted when certain products are being made in the plant.

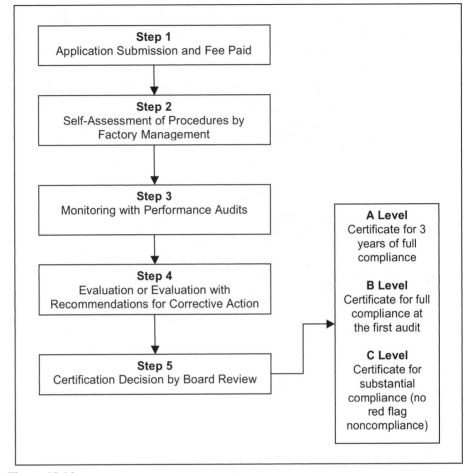

Figure 13.14
WRAP®'s certification process and three tiers of certification.

Production Patterns, Grading, and Markers

At the end of Line Product Development, samples are approved and released for marketing and sale. Most product manufacturers spend many hours marketing their goods through fashion shows, sales calls, showroom meetings, and other interactions with the retail customer. From these meetings, the salespeople take orders and can determine the number of products that will be sold. When orders are booked, the merchandisers can make final decisions on fabric and trim purchases and issue the okay for the first cuts or the requests for cut order planning to initiate, including the creation of production patterns, graded patterns, and production markers.

Figure 13.15
Production patterns ready to use.
(Courtesy of Karen Kane)

From the sample patterns, production patterns are created. **Production patterns** are the patterns used to cut out the pieces for the products in the cutting facility prior to sewing (see Figure 13.15). These are created after the tests for manufacturability and production samples are approved. As the first patterns are digitized or otherwise manipulated to make the production patterns, the merchandiser checks the trueness of the pattern with the original design and the design sample. This approval step is one that can be easily done through file sharing and examination of digital images or paper printouts. In creating the production pattern, any adjustments in silhouettes, grain lines, corners, or other construction points could cause the final product to have a different look, fit, or feel from the original design. Production pattern makers are thinking about what is easy and efficient to cut with industrial machines and what would be fast and easy to sew. For example, a gentle curve would be easier to cut accurately than a sharp corner. They may also true lines or otherwise change edges and exterior outlines to make cutting and sewing easier.

Next the production patterns are graded. **Grading** is the process of creating patterns to make the product in the sizes specified in the size range noted on the Size Spec. Most companies have very specific techniques for grading patterns. A set of **grade rules** delineates exactly how the dimensions of a pattern piece change from one size to the next size. If the product line is new to the company or if the style features greatly impact the fit or shape of the product, a new set of grade rules may need to be developed. The merchandiser would work with the pattern makers to create these new rules as part of the development of specifications. When the grading procedure is completed, a nest of patterns are available for each piece (see Figure 13.16). The nest of patterns means that each pattern piece is now made in each size for every pattern piece in the product and for every size in the size range. This could be an extensive number of pattern pieces. A simple sweatshirt may have as few as five pattern pieces (i.e., front, back, sleeve, neck trim, cuff trim), whereas a tailored jacket could have as many as 100 or more pattern pieces. If the jacket is made in the standard size range of 6 to 14, that would be 100 pattern pieces for each of the five sizes.

When the production patterns are finalized and graded, the production markers can be made. **Production markers** are the layouts of all pattern pieces for one specific SKU of merchandise and contain enough pieces when calculated with the numbers of fabric layers cut for cutting the entire order (see Figure 13.17). For example, an order of 5,000 pairs of jeans includes an assortment of sizes. In cut order planning, decisions are made on how these sizes will be arranged within the marker. One marker may contain a mix of sizes 6, 8, and 14. Depending on the number and size of the cutting tables, more than one marker may be needed to cut an entire order. Markers today are almost always created with computer software. This method is fast, allows marker makers to use previously stored markers, and provides for reorganization of pattern pieces to achieve a highly efficient marker. For example, the number of pattern pieces can affect the cost of sewing and the amount of fabric needed, which will affect the overall cost of the product. More pattern pieces, especially small pieces, enable the marker maker to make a more efficient marker (i.e., higher fabric utilization). **Marker efficiency** is important in costing; however, more pieces and more seams in the product increase cutting time and increase sewing time.

Although efficient utilization of fabric is important, placing pattern pieces within a marker must be done with extreme care and skill. Patterns must be placed so the grain of the pattern piece is on the true grain of the fabric; only then will the product hang correctly and fit correctly. When the fabric has a distinctive pattern (e.g., stripes, plaids, lifelike prints), special care must be made when placing pattern pieces on the marker. Considerations must be given to where the fabric colors and figures will appear on the pattern pieces and thereby on the finished product. For example, the designer may intend for the bold blue stripe in a plaid fabric to run directly from the farthest point on the shoulder seam to the hem. The pattern maker must indicate this placement in

Figure 13.16
Set of nested patterns.
(Designer: Peggy Quesenberry)

Bodice Back

Size 6

creating the pattern, the marker maker must show this placement when showing where the pattern is in the marker and how that must align with the fabric, and the merchandiser must check this placement when examining the production sample.

Figure 13.17
Production marker.

Managing Product Trueness

In addition to selecting the production facility and initiating pattern and marker work, the merchandiser must consider how product trueness will be maintained throughout production. Lack of control during the production process is one of the major concerns for outsourcing but can also be a concern for in-house manufacturing when merchandisers are not located near production facilities. Failure to manage the production process can be the reason that a finished product does not match the line concept and therefore would not be satisfactory to the retailer or to the consumer. Although manufacturability is checked as part of the Line Product Development process, a constant check must be made for product trueness in comparison to the design concept. Throughout product execution, changes may be made to the pattern to improve the manufacturability of the pattern. Slight variations may be found in the volume of raw materials when compared to sample materials. Individual production operators or individual plant locations and equipment may contribute to variance in the finished product relative to the sample or the designer sketches.

The merchandiser must continue to check samples from the production line for the overall image of the product relative to the designer's concept. Slight variations may not change the overall look of the product, or they may create a product that does not have the same impact on the customer as the product concept. For example, the number of buttons on a shirt cuff may be reduced from two to one to reduce the cost of the shirt to obtain the desired margin. Or a screen print that has ten colors may be reduced to a print that has seven. The variation could make limited to no difference to someone who has never seen the product. The customer of the shirt may be more interested in the cut of the sleeve or the color of the fabrication instead of the simple buttons. In the case of some dyes or other chemicals, the slight variation could result in a health hazard.

Specifications

As part of the negotiations for the contract, the buying company will have specified ways that are planned for keeping track of product trueness and for evaluating and dealing with the trueness of the shipped product. As discussed in

Chapter 12, during product line management, specifications or standards are developed for the product and the associated services needed to handle or sell the product. Some companies call these specifications, **packs,** because they package together product details, including stitching and measurements (Beal, 2005). Packs can be divided into **concept packs, tech packs,** and **vendor packs.** ISO and other certification and AATCC and ASTM standards remain important tools for assuring the buying company that the product will arrive at the loading docks in the expected format or quality level. Levels of expectations, data test levels, and other sets of requirements should be negotiated as part of the sourcing contract and used throughout the production process (see Figure 13.18).

Inspections

Some measure of control and ongoing evaluation can be achieved when a customer is allowed to place **on-site inspectors** within the production facilities of a source company. The on-site inspector would be an employee of the customer company but would be on location at the source company and allowed to visit freely within the production plant. Although this provides the merchandiser with hands-on control, the expense of maintaining on-site inspectors can be enormous and can be very demanding and stressful for those employees. Some

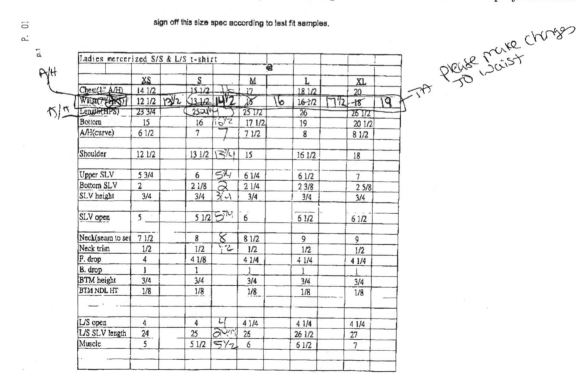

Figure 13.18
Spec sheet with notations for pattern adjustments.
(Courtesy of The AmeriTech Group, USA, Inc.)

companies also try to provide training for the source company's employees. On-site trainers can be helpful when the product has special features.

Product Sampling

When choosing and evaluating a source, the merchandiser requests samples of the products being produced. The first set of sample products are the production samples for evaluating manufacturability (see Chapter 12). As the regular production begins and continues, the merchandiser continues to request a sampling of the items as they come from the production line. What gets sampled, how often samples are taken, and how many samples are taken must be determined by the merchandiser. For what gets sampled, the merchandiser determines if the samples should be the final product that come from the end of the production line or if he or she wants samples of in-process products at various stages throughout the production process. For how often, some merchandisers want to see daily samples or a sample from each shift every day. In contrast, some merchandisers only want samples selected from boxes of products prior to shipping. The decision on how many samples are taken can vary from one sample in an order of thousands to 10% of the order to 100% of the shipment. In 100% sampling, the merchandiser or some associated personnel would examine each and every product. The buying company may request that in-process samples be provided during the production process as well as the preproduction samples and the final inspection samples. To make sampling more efficient and effective, some companies request to have their own personnel established in the production facilities. These decisions are coordinated with the inspection process.

Quality

As part of checking for overall design trueness, the merchandiser must check for production quality and final dimensions that may impact fit and other product attributes. Quality is checked by comparison to the tech packs or the specifications (see Figures 13.19a and 13.19b) provided by the product line developers. This information may be available to the merchandiser online through the PDM software or may be in written form. If information is available online and shared with trading partners, some quality evaluation can be done in the plant with on-site inspectors. When the production sample information is incorrect (see Figure 13.19c), corrections should be made quickly to avoid costly production errors.

Fit

Fit should be continually checked if the item is an apparel product. **Fit models** are live models representing the exact size and shape of the target customer. Using the same fit model for testing all products ensures a consistency in this process. Changes in which the fit model is used or physical changes in a single fit model may result in incorrect fit, which may necessitate adjustments to the production sample (see Figure 13.20). Fit models have the benefit of not only responding to the merchandiser about the closeness of the product to the body but also can verbalize the feel of the product when wearing or using the product.

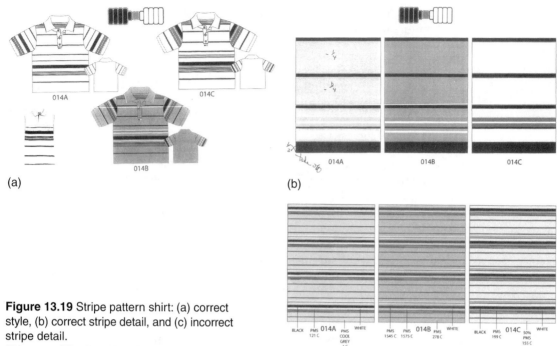

(a)

(b)

(c)

Figure 13.19 Stripe pattern shirt: (a) correct style, (b) correct stripe detail, and (c) incorrect stripe detail.
(Courtesy of The AmeriTech Group, USA, Inc.)

Because of the compression characteristic of human skin and the sensors in the skin, a fit on a human gives the best evaluation of the product. To improve the speed and accuracy of fit sessions, some companies are choosing to have on-site location of the fit models. The fit models are located near the production facilities. This solution for managing product trueness is often used by companies for which product fit is a significant part of the brand (Beal, 2005). Traditionally companies have had final evaluation samples flown or trucked into one central location, typically a corporate office, for test wearing by the fit model. More recently companies have relocated their fit models to locations geographically closer to production. Gap, Inc. recently located all of its fit models, along with their families and other support services, to Hong Kong (Beal, 2005).

Using fit models is the most accurate way of checking the fit; however, the merchandiser may also use product dimensions and a physical measure of the production sample for measuring fit. In addition, some companies are now using mannequins that have realistic skin surfaces that do compress as replacements for live fit models. Companies must continually weigh the costs of creating and producing the right product against the cost of getting the wrong product at the wrong price and place that interpret into late deliveries and lost sales, returns, and unhappy customers.

Alternative Methods for Evaluating Product Trueness

Regardless of available technologies, many merchandisers still wish to visit the plants, see the product come off the production line, and hold the actual prod-

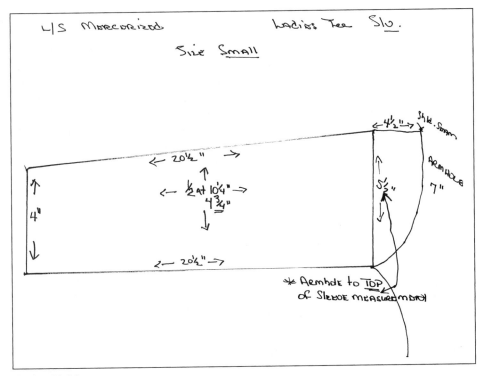

Figure 13.20
Sleeve with notations for fit adjustments.
(Courtesy of The AmeriTech Group, USA, Inc.)

uct in their hands. Travel and other costs may make this method of monitoring production cost prohibitive, but many industry personnel still consider that an in-person check is the best way to control product trueness and be assured the quality in all product characteristics meets specifications and will satisfy the consumer. Specifications are important to managing quality and product trueness, but variances and problems may be introduced into the product because of the humans involved in production maintenance or in sewing for apparel. The decision on managing the line based on electronic inputs or in-person visits is part of the company's strategic planning and must reflect its capabilities and mission. For example, low cost may be more important to a company and its customers than the exact fit of the product. In contrast, high-quality precision in fit may be the fashion image of a product, and for that, the company must depend on actual samples and in-person viewing of the product. The choice must be made with care and must support the strategic planning of the company.

Summary

As product lines are conceptualized and developed, they must be executed so the right products reach the right customers. Sourcing and logistics are important for achieving both the production and delivery of the products. Companies must make careful decisions relative to where the product will be made and who will

do the work. Issues of social compliance, time to market, and quality are important considerations when selecting companies as suppliers of raw materials and companies as producers of the finished products. Once the merchandiser or sourcing agents have selected the raw materials and sent orders for cutting and sewing, they must have processes in place for checking product trueness. With careful, diligent, and creative concept and product development, the merchandising team will have created a product line that will delight the retailer and the consumer. Now they must ensure that this product is properly produced, maintains its style and concept during production, and arrives at retailers in the packaging and condition that will continue to support the design concept. Managing the product line is an important step to complete the line product process.

Key Terms

Business ethics
Cash on order
Certification
Channel captain
Company-owned production
Concept pack
Cut, make, and trim
 contractor (CMT)
Delivery date
Distribution center (DC)
Expertise of the source company
Fit models
Full package
Full value costing
Geographic location
Grade rules
Grading
Hybrid sourcing strategy
In-house sourcing strategy
International laws

International Organization for
 Standardization (ISO)
Jobbers
Lead time
Length of travel time
Letter of credit (LC)
Line Product Management
Local laws
Logistics
Marker efficiency
National laws
On-site inspectors
Order fulfillment
Outsourcing strategy
Pack
Payment issues
Product execution
Product security
Production markers
Production patterns

References
Safety and routine of employees
Sample products
Shipping
Site visit
Social compliance
Sources
Sourcing
Sourcing strategy
Strategic sourcing team
Supply chain management
 (SCM)
Tactical sourcing team
Tech pack
Time-to-market
Travel safety
Vendor pack
Vertical operation

Review Questions

1. How do companies manage their supply chain?
2. What is the importance of product line management to the consumer-centric company?
3. What are the sourcing strategies for FTAR companies?
4. What are the issues a company must consider when selecting a sourcing strategy?
5. What are the major advantages and disadvantages of a hybrid sourcing strategy?
6. Why would a merchandiser choose a full package as an option for getting a product to market?
7. How does globalization affect a sourcing strategy?
8. What are the major factors that a merchandiser must consider when sending employees to other countries on sourcing duties?
9. What criteria does a merchandiser use to evaluate a source company?
10. What are the advantages and disadvantages of sourcing in El Salvador?

References

Abernathy, F. H., Volpe, A., & Weil, D. (2005, December). The future of the apparel and textile industries: Prospects and choices for public and private actors. Harvard University: Harvard Center for Textile and Apparel Research.

Beal, B. (2005, March 30). Global logistics. Paper presented as part of the Executive-in-Residence Program, North Carolina State University, Raleigh.

Books and Arts: The world in a box; The container industry. (2006, March 18). *The Economist: London, 378*(8469), 90.

Borneman, J. (2006, June 7). "The John Bakane talk. An interview at the ACA Conference, Manuagua.

Brown, J. S., Durchslag, S., & Hagel, III, J. (2002). Loosening up: How process networks unlock the power of specialization. *The McKinsey Quarterly, 2002 Special Edition.* Retrieved September 5, 2007, from http://www.mckinseyquarterly.com

Cheap chic. (2006). Zara's fast track to fashion. *Business Week Online.* Retrieved September 8, 2006, from http://www.businessweek.com

Clark, E. (2006, May 16). Turning away from the low cost model. *Women's Wear Daily,* 4B. Retrieved May 19, 2006, from http://www.wwd.com

The future of fast fashion; Inditex. (2005, June 18). *The Economist (US), 375*(8431), 57.

Haisley, T. (2003, April 1). LF brands tackles full package and PDM. *Apparel Magazine.* Retrieved April 18, 2003, from http://apparelmag.com

Kanakamedala, K., Ramsdel, G., & Srivatsan, V. (2003). Getting supply chain software right. *The McKinsey Quarterly* 1. Retrieved March 31, 2003, from http://www.mckinseyquarterly.com

Lee, Y., & Kincade, D. H. (2003a). Impact of fabric supplier characteristics on apparel manufacturers' inventory performance. *Journal of the Textile Institute, 93* Part 2(1 & 2), 26–39.

Lee, Y., & Kincade, D. H. (2003b). US apparel manufacturers' company characteristic differences based on SCM activities. *Journal of Fashion Marketing and Management, 7*(1), 31–48.

New WRAP® mandate expands factory certification beyond apparel. (2007, August 30). Press Release. WRAP®, Arlington, VA. Retrieved September 4, 2007, from http://www.wrapapparel.org

Nocera, J. (2006, May 13). A revolution that came in a box. *New York Times.* Retrieved May 13, 2006, from http://www.nytimes.com

Office of the U.S. Trade Representative. (2006). CAFTA-DR final texts. Retrieved April 13, 2007, from http://www.ustr.gov/Trade_Agreements/Bilateral/CAFTA/CAFTA-DR_Final_Texts/Section_Index.html

Ordoñez, J. (2006, June 26). California hustlin'; Urban hipsters love American Apparel's 'sweatshop free' clothes. Can the quirky company find investors? *Newsweek,* p. 38.

Quick Response: Speeding up added value. (2004, June 25). *Just-Style.* Retrieved June 25, 2004, from http://www.just-style.com

Social Responsibility Committee. (2006). American Apparel Footwear Association. Retrieved April 17, 2006, from http://www.apparelandfootwear.org

The Top 10: U.S. suppliers of textiles and apparel. (2005, January 3). *Women's Wear Daily.* Retrieved January 3, 2005, from http://www.wwd.com

Welcome to WRAP®. (2006). Worldwide Responsible Apparel Production. Retrieved June 13, 2006, from http://www.wrapapparel.org

What is "sourcing." (2002). Retrieved August 13, 2003, from http:www.textileindustries.com

Woodard, G., Kincade, D. H., & Owens, S. (2002). Training of expatriates in the textile and apparel industries. *Clothing and Textiles Research Journal, 20*(4), 227–237.

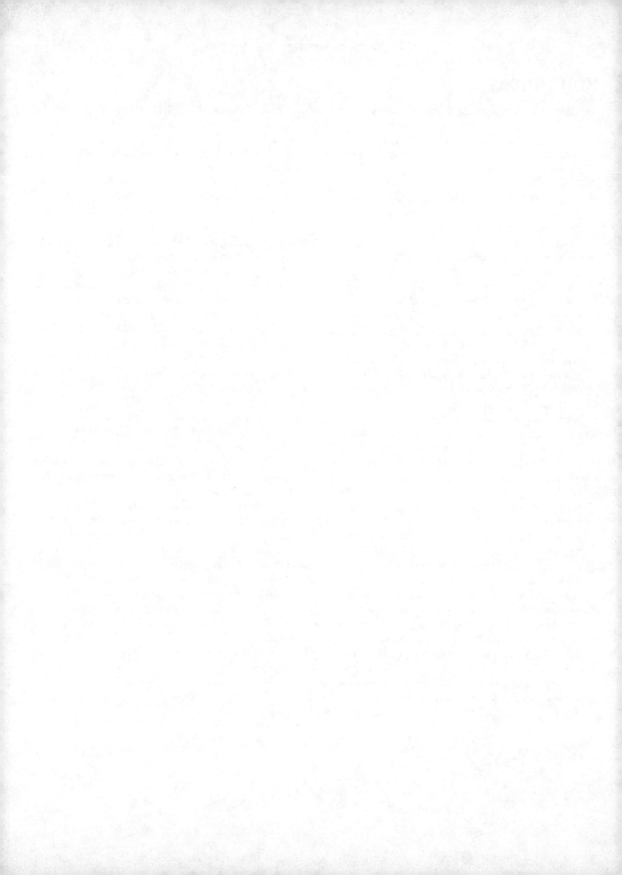

SECTION
V

Buying-Selling Cycle

I n a cyclic process, similar to the Line Development Process Cycle, retail merchandisers and buyers must determine the right products to sell and make arrangements for the products to be shipped to stores or other locations and be available for the consumer at the right time and for the right price. For the retailer, the merchandising process flow or cycle of activities is known as the *Retail Buying-Selling Cycle* or the *Buying-Selling Cycle*. It consists of all the processes and activities the retailer must complete to plan, procure, present, and promote the right merchandise at the right price to the appropriate target consumer in the appropriate channel of distribution. In addition, for some retailers the retail merchandiser must merchandise the department, supervise sales personnel, and manage the maintenance and customer service for the department, store, or other sales facility.

The six components of the Buying-Selling Cycle are: (1) planning and evaluating, (2) procuring merchandise, (3) promoting merchandise, (4) merchandising the selling space, (5) supervising merchandising and selling personnel, and (6) managing the selling space. Not all buyers are responsible for each of these components (see Figure S.5.1). The cycle starts as the buyer or merchandiser reviews the strategic planning information and confirms the target consumer and the company position for the upcoming season. The buyer then spends time searching for, evaluating, and selecting merchandise for the retailer.

Depending on the size of the retail organization and the number of employees within divisions, the buyer may also be responsible for tasks after selecting the merchandise. Promoting the merchandise involves development of the store and fashion image while defining the promotional mix. Many buyers work with the Sales Promotions Division or other marketing and advertising personnel at this stage of the cycle. Because the buyer is well informed about the target consumer and the selected merchandise, he or she should have input into merchandising the department. If the retail company is large, the buyer works with the Sales Promotions Division and the Operations Division for this stage. Supervising personnel, including hiring and training new employees, may also be required for the buyer unless the Operations Division or the Human Resource Division has trainers or skilled department managers. For small retailers, the buyer may also have duties for overseeing the activities of maintenance, customer service, and daily supervision of employees. Regardless of direct assignment or not, the buyer wants the selling space to be in keeping with the company and fashion image and to support the selected merchandise. Everyone in the retail organization wants to aid the sale of merchandise to the target consumer.

For the retail buyer, the six activities in the Buying-Selling Cycle may be addressed by asking three questions: (1) How does the buyer prepare for market or what preplanning steps must be addressed before going to market? (2) How does the buyer shop the market efficiently and effectively? (3) How does the buyer translate the marketing findings (i.e., industry, retail, fashion, promotional trends) into a retail environment to reach the target consumer and to provide profit for the retailer? Preparing for the market (question 1) is covered in Chapter 14; shopping the market (question 2) is discussed in Chapter 15; and Chapter 16 explains how the market findings are translated into store offerings (question 3).

Figure S.5.1
Merchandising activities for the Retail Buying-Selling Cycle.

chapter

14

Retail Buyers Prepare for Market

Objectives

After completing this chapter, the student will be able to

- Itemize the stages and substages of the Buying-Selling Curve
- Identify the strategic planning information that the buyer uses in financial planning
- Identify the merchandising budgets that the buyer develops
- List the three steps used in making a Six-Month Merchandise Budget
- Describe the activities in the Preplan Step
- Discuss how the Buying-Selling Curve can assist the buyer in the Buying-Selling Cycle
- Identify what information the buyer will collect in the information step
- List the calculations done in the calculation step
- Discuss the buyers techniques for development of model stock
- Explain how the retail buyer or merchandiser prepares an assortment plan before going to market
- Discuss the six rights of merchandising and their importance to the retail buyer

Introduction

Merchandisers in all linkages of the FTAR Supply Chain develop product lines for their customers. Some of the merchandising activities or processes for the retailer are similar to those of the textile producer or apparel manufacturer; some of the processes are very different. The retail buyer, as any merchandiser, is developing a cohesive package of merchandise for the customer. This cohesive package or merchandise mix of the retailer should reflect the company image as well as the trend direction of the market and its position on the Fashion Cycle (see Figure 14.1). In addition, the retail merchandise package should reflect the product zone and position of the product in the Product Life Cycle that the target consumer demands while taking into consideration the company's supply chain capabilities as well as the competition. Although private label brands, house brands, and other brands created or initiated by the retailer are becoming more popular, most retail merchandisers are sourcing products from their vendors.

Many of the activities and tasks of retail merchandisers must be conducted simultaneously because many of the happenings and findings in one merchandising activity may and should impact, overlap, or support the decisions made in some or all other activities. For example, the retail buyer continuously conducts and reviews market and trend research, regardless of the selling season or buying period for the retail firm. Therefore, buyers must multitask every day. With the continuous cycle of the introduction of new products, the decline of old products, and the changing of the seasons, buyers and other merchandisers must work on several stages, steps, procedures, and activities at once. The buyer may be calculating the Six-Month Merchandise Budget for early spring of the next year; meanwhile, he or she might be buying merchandise for the holiday season of the current year while directing markdown procedures for the present spring and summer seasons as well as planning sales promotional events for the fall of the present year. Investigating this multitasking, continuously changing process starts with the question: "How does the buyer prepare for market or what preplanning steps must be addressed before going to market?"

Financial Planning

The **Retail Buying-Selling Cycle** (see Section 5 introduction) for the retail merchandiser or buyer begins with the activities of financial planning or with developing merchandise plans by estimating consumer demand and budgeting monies to meet those demands. The buyer starts planning with information that has been previously determined by executive or top management. During the Strategic Planning Process for the firm, top management has formulated a mission statement and identified the target consumer of the retail organization (see Chapter 2). This executive planning has also es-

Figure 14.1
When preparing for market, the buyer considers the interior store image.
(Courtesy of Meg's)

tablished the company and fashion image and positioned the retail business in the channel of distribution that best fits the lifestyle of the target consumer. These plans are necessary to generate sales by properly positioning the product classifications carried by the company. Top management, along

with the company's merchandisers, have also identified major product categories and key items to be offered to the target consumer, determined the number of buying seasons from which to source merchandise offerings for the retailer's target consumer, plus pinpointed the emphasis to be placed on those seasons for each product classification and established major vendors for each department or major category of merchandise. The buyer has much information from this Executive Planning Process to analyze and use in his or her merchandise planning.

In addition, top management and personnel in the Finance Division, sometimes with the assistance of other key merchandising divisional personnel, develop an Income Statement or Profit and Loss Statement (P & L Statement) for the firm. From analyzing that income statement, the General Merchandising Manager (GMM) then is able to allocate a specified sum of money for each division under his or her supervision. From these allocated monies and from analyzing merchandising statistics, divisional merchandisers and buyers prepare specific budgets that estimate what sales volume, markdowns, and units of merchandise are needed to meet the needs and desires of the target consumer. These employees calculate budgets for each department, keeping in mind goals and directives of the company. At this point in the Buying-Selling Cycle, a calendar or timeline for making final decisions and other plans concerning any particular activity is also developed.

Buying-Selling Curve

In preparing to shop the market and throughout the Buying-Selling Cycle, one tool that the merchandiser uses is the **Buying-Selling Curve,** which depicts the sales during the Product Life Cycle, showing the product's rise, its acceptance and its decline, and denotes the appropriate merchandising activities for each of the six substages (see Figure 14.2). This tool helps the merchandiser combine consumer behavior information, including customer acceptance behavior from the Product Life Cycle (see Figure 14.2), with the merchandising activities of the buyer and the marketing and selling activities of other company divisions. By knowing where a product is on its Product Life Cycle and the appropriate merchandising activities for that cycle location from the Buying-Selling Curve, the merchandiser can pinpoint the right merchandise mix for the company, including the right amount of stock to keep in the store or to have on order. This mix includes the right color, size, and silhouette, in the right quantities, and at the right price. The right quantities are important for the buyer to know how much merchandise to order and what inventory levels to maintain. The **merchandise amount** on Figure 14.2 is shown on the bell curve and represents the amount of inventory or **stock** owned by the retailer. This includes both **stock on order** and the **stock on hand,** which may be **backroom stock** or **floor stock.** One item in this inventory list is a **stock-keeping unit,** or **SKU.**

The merchandiser wants to identify where a product is on its life cycle so he or she can place orders, schedule deliveries at the right time, and distribute the

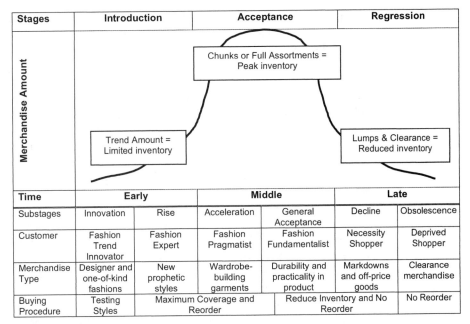

Stages	Introduction		Acceptance		Regression	

(Buying-Selling Curve diagram)

Chunks or Full Assortments = Peak inventory

Trend Amount = Limited inventory

Lumps & Clearance = Reduced inventory

Merchandise Amount

Time	Early		Middle		Late	
Substages	Innovation	Rise	Acceleration	General Acceptance	Decline	Obsolescence
Customer	Fashion Trend Innovator	Fashion Expert	Fashion Pragmatist	Fashion Fundamentalist	Necessity Shopper	Deprived Shopper
Merchandise Type	Designer and one-of-kind fashions	New prophetic styles	Wardrobe-building garments	Durability and practicality in product	Markdowns and off-price goods	Clearance merchandise
Buying Procedure	Testing Styles	Maximum Coverage and Reorder		Reduce Inventory and No Reorder		No Reorder

Figure 14.2
Buying-Selling Curve with information about merchandise amount and substages.
(Adapted from Kincade, Gibson, & Woodard (2004))

merchandise in the right place. To be successful, the merchandiser must know the direction and speed of fashion. In addition, the Buying-Selling Curve helps the merchandiser select the right appeals and approaches for sales promotions and advertising, including themes for displays and special events.

During the innovation substage, the product will be new and have limited acceptance among all customers except the most daring fashion-conscious consumers. Most manufacturers and retailers at this substage seek to inform their customers about the product and order limited amounts of inventory in selected styles and colors to test the styles. With slow sales growth and high initial costs, especially for companies that may have spent extensive amounts on market research and/or product development, the pricing of the product will be set high; however, profit return will be low.

In the rise substage, the product is still new but many customers are aware of the product and are shopping for the product even if they are not yet buying it (see Figure 14.2). This **trendy merchandise, or fashionable merchandise,** is already established as the right merchandise and has been recognized by peers, family members, or other style setters in the community. Advertising continues to inform the customer about the newness of the merchandise along with the fashion authority of the company. Many times because of advertising, nationally branded goods become very popular or hot items and are a fast-selling merchandise classification. Trends created by advertising may be generated by retailers, sewn product manufacturers, or by raw material manufacturers. For

example, manufacturers of a new high-technology fiber may advertise in sports magazines and on sporting events on TV to promote consumer interest in the fiber and a demand by consumers for products containing this fiber. End products manufacturers and retailers, respectively, must react by producing and selling this right merchandise. The consumer who purchases the trendy items feels accepted as a part of the social scene when wearing this type of apparel.

The merchandiser must be very careful with the quantity of the product ordered; however, he or she will want to be quick to place orders at this substage because growth of sales will accelerate during this substage and continue rapidly into the acceleration substage. The merchandiser must order enough product so it is available for sale prior to the peak demand by the customer. Without enough inventory, there will be a loss of sales created by **stockouts** or lack of the right merchandise available for the target consumer (see Figure 14.2). When stockouts appear in random places in the inventory, **broken assortments** occur. With a broken assortment, the customer may find a red jacket in size 8 and brown pants in a size 4. Stockouts or other breaks in inventory at this point would disappoint the customer and result in lost sales and often result in extreme markdowns (see Figure 14.3).

The peak amount of stock is carried at the acceleration substage. The merchandiser must check daily on the sale of products during this substage so

Figure 14.3
Sidewalk sales can be used to clear broken assortments from the store.

reorders can be placed in time for the product to be delivered. **Reorders** are those placed for the same merchandise to replenish sold merchandise. Some manufacturers do not maintain additional or back stock to fill reorders, or they cannot supply the reorders in a timely manner. Therefore the buyer must determine in the initial order what quantity of stock is needed to meet the forecasted demands of the target consumer. Some manufacturers allow the buyer to place orders initially for the volume of stock and allow for adjustments in color and sizes during the reorder process (see Table 14.1).

Reorders may continue into the acceptance stage, especially during the acceleration substage, as long as demand for the product continues to be strong. Profits during this time should be substantially improved during the rise in sales. The initial high price or the regular price can be maintained and volume sales will improve profit margins. Buying activities should continue to be performed to maintain maximum stock and reduce occurrences of stockouts or broken stock assortments. As the product moves toward the end of the general acceptance substage, the merchandiser shifts the emphasis from ordering and reordering to reducing the inventory. This emphasis requires advertising to persuade the customer to buy or to continue to buy the product. No reorders should be placed as the demand for the product flattens or lessens. Also, the inventory levels should be lowered to prevent heavy markdowns or loss of sales because of an incorrect merchandise assortment. The merchandiser will continue to persuade the customer to buy the product and will emphasize benefits and features of the product along with completeness of assortments.

During the regression stage, the merchandiser continues to monitor inventory levels and seeks to reduce inventory. The merchandiser strives to remind the customer that the company is continuing to carry some of this product; however, the major emphasis is on markdowns to entice the consumer to buy more of the product. Reduction of inventory is the primary thought for the merchandiser, especially for specific styles and classifications. Depending on the fashion image of the company, some companies may move stock at this point to locations where the sales are continuing to be strong; other companies may sell stock to wholesalers or off-price retailers to remove the stock from the sales

Table 14.1
Best sellers are reordered throughout the season.

Style No.	Initial Order Date: April 15 Units	1st Reorder Date: August 20 Units	2nd Reorder Date: September 8 Units
104567	100	25	20
104569	150	X	X
116790	280	X	X
116792	40	30	X
116798	60	60	50
145798	35	5	X

floors. Sales will be declining along with a decline in profitability of the product because of the reduction in price and the increased costs in promotions and handling.

In the final substage of the Buying-Selling Curve, the merchandise is considered clearance merchandise. Broken assortments are to be expected, and the fashion trend represented by this product is an outgoing trend. No new orders are placed for this merchandise and no reorders are made. Promotions continue to remind the customer about the product and to illuminate the markdown prices for the price-conscious customer. Sales and profits have definitely eroded on this product, and the company will want to divest itself of the product and ideally regain its initial cost of the product.

Although the Buying-Selling Curve is a useful and necessary tool for the buyer and other merchandisers, the curve is only a tool. The buyer must be able to identify the product's placement on the curve and interpret the sales figures into realistic merchandise plans. Predicting the exact rise, decline, and length of sales during a product life is very difficult. When studying POS data the merchandiser will have an idea about past sales but must use trend information and other market research to determine if the sales from yesterday will continue to rise or remain stable for a day, a week, or a month, or if yesterday's sales will be the peak and tomorrow's sales will signal the beginning of the decline. Knowing where the product is on the Product Life Cycle is one of the toughest tasks the merchandiser must perform.

Developing Six-Month Merchandise Budgets

One of the most important processes in planning, estimating and budgeting is the creation and development of the Twelve-Month and Six-Month Merchandise Budgets. These budgets are blueprints, maps, or guides that outline the dollar plan to control all merchandising activities in each department or the store. The **retail year** runs from February 1 of one year to January 31 of the next year; therefore, for the **Six-Month Merchandise Budgets,** the first Six-Month, or **Spring Merchandise Budget,** is from February 1 to July 31, and the second Six-Month, or **Fall Merchandise Budget** is from August 1 to January 31. The **Twelve-Month Merchandise Budget,** or **annual budget,** is a summary of the two six-month budgets: Spring Six-Month Budget and Fall Six-Month Budget. These budgets are tools for the retailer to use for estimating the value of the departmental inventory, and they are also vehicles to coordinate or provide a clear picture of the relationships among sales, inventory or stock, purchases, reductions, initial markup, gross margin, and turnover. Retailers use these budgets as a how-to guide for spending the budgeted **open-to-buy (OTB)** or purchase dollars used to procure the right merchandise to reach their projected sales goals and profit margins.

Three sequential steps of development are used for constructing a Six-Month Merchandise Budget: (1) the preplan step for collecting and gathering information, (2) the information step for collecting numerical data to build the

budget, and (3) the calculation step for actually calculating workable figures that guide the Procurement and Buying Process (Kincade, Gibson, & Woodard, 2004). Each step contains a number of activities for the buyer, who must research background information and then calculate the value of needed merchandise (see Figure 14.4).

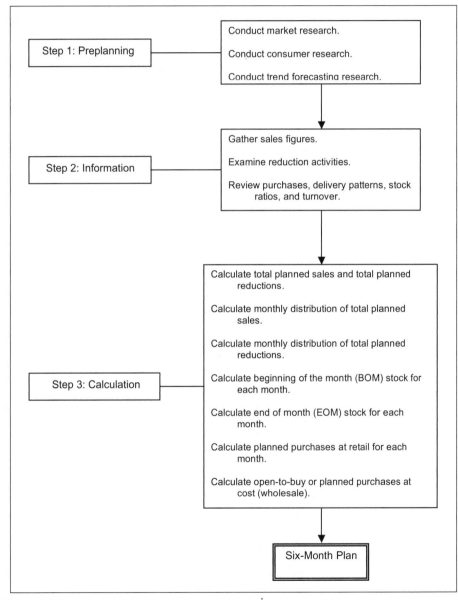

Figure 14.4
Steps to creating a Six-Month Plan.

Step 1: Preplanning

The **preplan step** is a time for gathering information, both on the domestic and international scenes, and both externally and internally in the retail business that will assist the buyer in developing a workable merchandise budget. Just as management conducts an environmental scan, or an examination of external factors impacting the business environment, when developing the strategic business plan and the Profit and Loss Statement, the merchandiser or buyer must also scan any factors that might impact the merchandise budget. The key issues that the retail merchandiser or buyer must address are the identification and impact of external factors such as cultural barometers, sociological and psychological trends, and political and legislative policies, both domestically and internationally, that impact the development of the merchandising plan and budget or that affect the buying patterns and purchasing power of the target consumer. Other external elements that must be tracked are technological and environmental trends affecting the industry as well as economic trends impacting both the product and the target consumers (see Chapters 8 and 9). Also, the buyer will be evaluating market research to anticipate the needs and desires of the target consumer.

Also at this stage the buyer must develop an insight into the demographics, psychographics, lifestyles, and life stages of the store's consumers as well as the buying patterns and changing behavior of those target consumer segments (see Chapter 9). Additionally, the retailer must not only establish and maintain a clear, concise company and fashion image, but the merchandiser or buyer must constantly monitor these images to assure that the target consumer perceives them as they were initially planned. The buyer must constantly monitor not only the merchandising activities of the competition but also the sales promotional activities and marketing strategies of those competitors as compared to the sales promotional and marketing strategies in the store for which the Six-Month Merchandise Budget is being developed.

As the buyer concludes the preplan step, he or she must also develop a listing of the most effective vendors from which to shop. This listing must be approved by upper management. Some companies provide this list to buyers; other companies form the list in conjunction with buyer input. The **Retail/Vendor Matrix,** or a listing of the top vendors and resources from which the store buys product, is specific for each particular geographic location and for each product classification (see Figure 14.5). The listing is solidified by GMMs and head buyers and provides all buyers and merchandisers with an approved listing of the best and most profitable vendors for obtaining the desired merchandise.

Step 2: Information

The **information step** consists of the buyer collecting numerical data that will be used in the calculation step. If the buyer is developing a merchandise budget for an existing retail business, he or she analyzes the actual sales figures for the same season of the previous year and identifies selling patterns, monthly

Vendor	Percentage of Total Budget Open-to-Buy for Better Department
Jones New York Signature	10%
Jones New York	20%
AK Anne Klein	10%
Lauren by Ralph Lauren	15%
Liz Claiborne	25%
Private Label (Store)	20%

Figure 14.5
Retail/Vendor Matrix for Better Sportswear Department for Store B.

sales distribution patterns, and peaks and valleys of sales and other happenings in the Buying-Selling Process. Additionally, the buyer examines the reduction percentage, including the percentages for markdowns and other reductions to sales, as compared to the sales volume, and also pinpoints the monthly distribution pattern of those reductions. Purchases, delivery patterns, stock-to-sales ratios, and turnover are also analyzed.

As the buyer reviews the company's sales history, he or she is looking for the atypical: for special promotions held only one time, for community events and special holiday events that impacted sales, markdowns, and purchase patterns in the same season the previous year. In other words, an astute buyer examines the happenings that took place in the same months the previous year and looks at any special circumstances that might affect the sales and markdown patterns for the upcoming same period. Most retail establishments track the weather and even special promotions and advertisements of competitors. Many retailers maintain an advertising and special events calendar that identifies the most and/or least successful sales promotion activities of the previous year (see Table 14.2). Holidays must be pinpointed and their impact assessed on the product classifications carried by the retailer. And, of course, changing market and economic conditions must be constantly monitored because they impact not only the cost of the product but also the spending patterns and purchasing power of the target consumer.

If the buyer is planning for a new store, catalog, or Web site, he or she will have no historical records on which to base the merchandise plan and budget. Trade associations and other business resources provide information about expected sales relative to the size of the company. Trade organization and reporting services such as the National Retail Federation (NRF) and the Johnson Redbook Index provide retail statistics from department and specialty stores located throughout the United States. The buyer of a new retail business can use these figures as "educated estimations" for predicting sales. These figurers are

Table 14.2
Buyer's record for sales in women's lingerie with notes to help with planning.

February	Sales	Promotions	Notes
Week 1	$8,540	Clearance (first weekend— newspaper ad in Thursday's paper)	*Very cold on Saturday, but good turnout for the sale*
Week 2	$12,879	Valentine's Day (end of week— best customer coupons mailed previous week)	*Great sales on red pjs and other red items*
Week 3	$4,500	None	*Heavy snowstorm on Tuesday; store closed early*
Week 4	$7,070	President's Sale (storewide on Thursday, Friday, Saturday)	*No items promoted in lingerie; Icy conditions on Wednesday and Thursday*

averages for all reporting stores in the United States and are not the sales figures for any one store in any one geographic region; therefore, the merchandiser must adapt this information to a specific retail type or format in a specific geographic location for specific target consumers. Additionally, shopping center and mall ownership corporations and other retail trade groups and organizations as well as business reporting services such as Standard & Poor's, Hoover's, Moody's Investor Services, Value Line Investment Survey, and other financial organizations collect retail sales information that can be purchased by a new retailer.

Step 3: Calculation

The **calculation step** consists of a seven-step procedure (see Figure 14.4). These steps include the calculations needed to complete a Six-Month Merchandising Budget. The needed totals are first calculated for the year and then for each of the two six-month periods (i.e., spring, fall). Finally, the buyer must distribute the values across the months within the Six-Month Plan.

STEP 3.1A: CALCULATE TOTAL PLANNED SALES. All merchandise budgets begin with **total planned sales,** or planned sales, and all other components of the budget are based on this planned sales figure; therefore it is of the utmost importance that the total planned sales figure is realistic and attainable. The total planned sales are also the starting point for the P & L Statement. These figures are adjusted by percentages for changes in economic conditions in the current marketplace as well as for recent trends in retail sales and any noticeable changes in the store itself, such as renovations or downsizing of departments. Usually management provides direction of the percentage of increase or decrease for a business or department within that business. When planning annual sales based on percentage of increase or decrease of a retailer's sales of the previous year, **base year** sales are always the previous year's

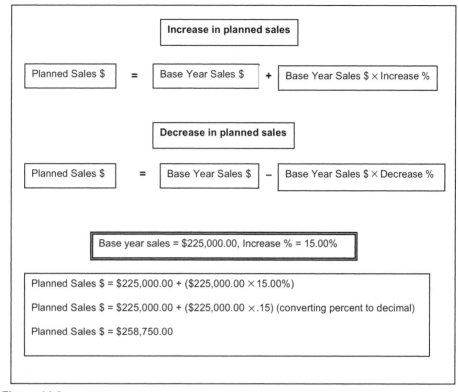

Figure 14.6
Increase or decrease in sales to calculate next year's sales.

(i.e., last year's) sales (see Figure 14.6). This calculated planned sales figure is the **annual sales volume,** or **yearly sales volume,** for a retail business.

Based on the recommendations by management and findings in the environmental scan, buyers and merchandisers must determine the amount or the percentage of increase or decrease in sales volume for the planned budget. It is very unusual for a buyer to plan for a decrease in sales or to plan for sales to remain stagnant. However, a buyer may be forced to plan for a decrease or stagnant sales if a portion of the selling space is being reassigned to another area by management or if a downturn in economic conditions or business changes forces this negative outlook. The buyer may decide to make no changes in the sales volume because of the positioning of the product classification on the Buying-Selling Curve or its Product Life Cycle or a slowing of sales for a specific product category.

If sales are planned to remain at the same level as the previous year, many times the retail business, department, or product category will actually realize a loss in sales due to lack of less fresh inventory arriving periodically throughout the selling season or due to a rise in the cost of merchandise. If the costs of merchandise increase and sales remain the same, then less purchase dollars

Table 14.3
Six-month percentages for split of annual or total sales.

Location or Other Characteristic	1st Six-Months: Spring	2nd Six-Months: Fall
Cold weather region	40%	60%
Hot weather region	60%	40%
National average	44%	56%
Best for cash flow	45%	55%
Holiday-dependent merchandise	25%	75%*

*For stores that are highly dependent on sales for holiday merchandise, 50% of their sales may be in November and December.

will be available to support the planned sales volume. It is customary for most buyers to increase sales in relation to a standard rule of thumb set by management, by the national average of increase for certain product categories, or by market conditions and previous merchandising experience with that particular retail type, retail format, or product category.

The buyer must next determine what percentage of those annual sales will be realized in the two six-month periods. The split of the annual sales can be affected by geographic regions and temperatures, accounting and cash flow balance, and other company-specific reasons (see Table 14.3).

Buyers have to review their company research or depend on averages to determine the best split for their company, their merchandise, and their departments. The calculation for determining the six-month split is based on the percentages (see Figure 14.7).

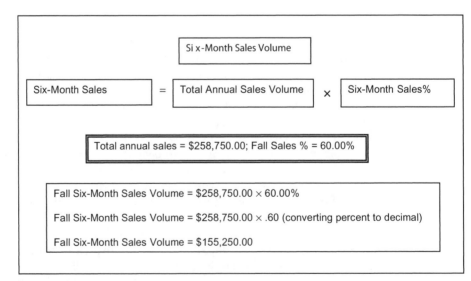

Figure 14.7
Six-month sales volume for a Six-Month Plan.

If the business is a new retail establishment, the retailer must estimate the annual retail sales volume instead of depending on making an adjustment from the previous year. Estimations must also be used if the retailer is starting to carry a new product line. For example, a small store may decide to carry shoes, which have very different space and inventory requirements from tops, bottoms, dresses, and other apparel items. Several methods can be used to determine annual sales, including dependency on national averages, trade data, and per capita expenditures. One of the best methods for calculating planned sales for a new business is the **square foot method** where the sales volume is determined by how many square feet of **selling space** or the overall size of the selling floor the retailer has in the physical retail store and how many sales can be realized within that specific selling space. The calculation requires the buyer to determine the number of square feet of selling floor space planned for the new merchandise. This value is multiplied by the expected dollars generated from each square foot of space. Statistics for sales per square foot can be obtained from one of the many retail reporting services. This method can be used for a store, a department, or a department within a store. Size and numbers of pages for a catalog can be used in a similar fashion to estimate sales for that type of nonstore retailing.

STEP 3.1B: CALCULATE TOTAL PLANNED REDUCTIONS. Total planned reductions are also calculated in Step 3.1. Reductions include markdowns, shrinkage/shortages, employee discounts, and customer returns. These are tracked both in dollars and in percentages. For a new store, the buyer consults an organization or reporting service such as the NRF Index for guidance in determining the average annual total planned reductions percentage including an appropriate markdown percentage for a department store, specialty store, or other retail business. The calculation for total planned reductions is often a simple calculation based on total planned sales and the percentage of reductions that are expected (see Figure 14.8).

STEP 3.2: CALCULATE MONTHLY DISTRIBUTION OF TOTAL PLANNED SALES. The sales dollars for the six-month period must be divided into monthly increments and allocated across the months within the six-month period. After total planned sales are calculated, the buyer needs a guide or method for determining the monthly distribution of the total planned sales. Sales volumes vary from month to month, season to season, and year to year, as well as by product category and channel of distribution in which the product is sold.

For an established retail business, figures or percentages for monthly sales distribution can be calculated from the same season of the previous year's actual attained sales. Monthly sales increments, or monthly planned sales, are calculated as percentages of the total sales volume (see Figure 14.9).

For new retail businesses, averages for monthly sales distribution as well as other ratios and figures for department and specialty stores and other retail formats in the United States may be accessed from the same reporting services that provide sales volume figures. Buyers should remember that reporting services provide only averages of reporting businesses; however, seasons of the

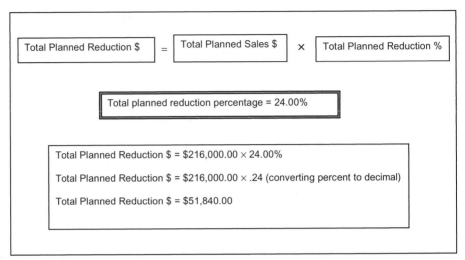

Figure 14.8
Total planned reductions for a Six-Month Plan.

year, product categories and classifications, and geographic locations of the retail business impact the monthly distribution values. The buyer will need a set of percentages, one for each month. Using selected percentages for sales per month and the formula for calculating monthly planned sales, the monthly planned sales for a new boutique are calculated (see an example in Table 14.4).

STEP 3.3: CALCULATE MONTHLY DISTRIBUTION OF TOTAL PLANNED REDUCTIONS. The total reductions volume must also be divided into monthly increments and

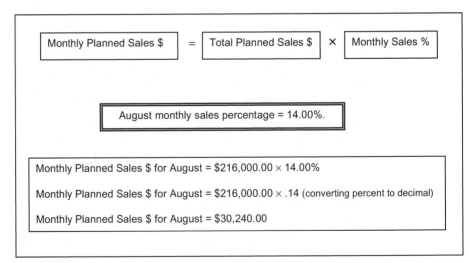

Figure 14.9
Monthly planned sales for a Six-Month Plan.

Table 14.4
Monthly distribution of total planned sales for fall merchandise budget.

Fall	Aug.	Sept.	Oct.	Nov.	Dec.	Jan.	Total
Monthly % Plan	14.00%	16.00%	14.00%	17.00%	28.00%	11.00%	100.00%
Sales $ Plan	30,240.00	34,560.00	30,240.00	36,720.00	60,480.00	23,760.00	216,000.00

allocated across the months in the six-month period. As sales, these monthly increments are calculated as percentages based on merchandising activities for each of the months within the six-month period (see Figure 14.10). A merchandiser must decide what types of reductions are needed to meet the planned sales goals and still maintain an adequate gross margin and profit for the department.

Based on merchandising activities, the dollar amount for monthly reductions vary from month to month. When determining these monthly percentages, the buyer considers the planned sales for the month, any special events or promotions to be staged during that month, the position of the merchandise in its Product Life Cycle and on the Buying-Selling Curve, and the length of time remaining in the selling season as well as consumer demand and the expectations of the target consumer. As found for sales, guidance for monthly reduction percentages can be found from national trade organizations and can be estimated from the same season in previous years if that information is available. Using the selected percentages for monthly reduction percentages and the formula for calculating monthly planned reduction dollars, the monthly planned reduction dollars for the newly opened store may be viewed in Table 14.5.

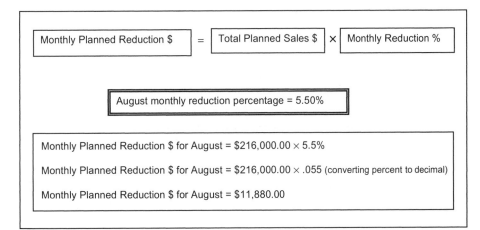

Figure 14.10
Monthly planned reductions for a Six-Month Plan.

Table 14.5
Monthly distribution of total planned reduction dollars for fall merchandise budget.

Fall	Aug.	Sept.	Oct.	Nov.	Dec.	Jan.	Total
Monthly % Plan	5.50%	2.50%	2.50%	2.50%	5.00%	6.00%	24.00%
Red $ Plan	11,880.00	5,400.00	5,400.00	5,400.00	10,800.00	12,960.00	51,840.00

STEP 3.4: CALCULATE BEGINNING OF THE MONTH (BOM) STOCK FOR EACH MONTH. Once the monthly sales and reductions are determined, the buyer must decide the stock or inventory needed for the business. The terms stock and inventory are often interchanged by buyers. Stock needs are calculated as the **beginning of the month (BOM) stock** or the amount of inventory needed by the retailer to open the store at the beginning of each month. As with sales, different levels of merchandise are needed each month to maintain enough stock or inventory to reach sales goals, to avoid stockouts (i.e., missing stock in sizes, colors, or styles) or too little stock that cause both a loss of sales and profit, or to avoid having too much inventory that translates into slow sales, markdowns, and lost profits. Enough inventory must be available for the opening merchandise assortment to attract the repeat or target customer until replenishment for the sold merchandise arrives in the store. Additionally, retail buyers plan for **peak stock** or well-balanced and complete inventories in the selling season prior to the time sales will reach a major peak. For a brick-and-mortar store, merchandise must be in the store before it can be sold; therefore, the buyer must plan deliveries of goods so that the merchandise will be in the store before the consumer needs or demands the goods. The rule of thumb is to attempt to have a merchandise mix composed of minimum quantities of each item or stock-keeping unit (SKU) in each product classification by size, color, and price points.

One method for calculating BOM stock uses stock-to-sales ratios. **Stock-sales ratios** represent the amount or value of stock or inventory that it takes the retailer to sell one dollar of merchandise. These ratios for each month may be calculated from the same month of the previous season for last year and used as a guideline for an established retailer. The calculation is simple if the buyer has stock values and sales values from the previous year. The buyer simply divides the BOM stock value by the monthly net sales value for each month. A retailer with a new merchandise classification or a new store or business may use an average stock-sales ratio reported by a trade organization or business reporting firm. Regardless of which method is used to ascertain the ratio for each month, the buyer needs to calculate the planned BOM stock dollars for each month (see Figure 14.11).

The buyer needs a monthly stock-sales ratio for each month because the needs for stock vary throughout the year. This ratio varies from month to month, from retail type to retail type, from department to department, and from product classification to product classification. From experience, retail buyers learn to limit the amount of merchandise remaining in the store, department,

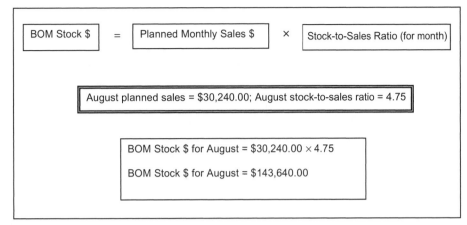

Figure 14.11
Beginning of the month (BOM) monthly stock for a Six-Month Plan.

Table 14.6
Monthly BOM stock $ for fall merchandise budget.

Fall	Aug.	Sept.	Oct.	Nov.	Dec.	Jan.	Six-Month AVG	Feb.
Monthly S/S Ratio	4.75	4.34	5.13	4.18	2.10	6.17		5.43
BOM $ Plan	143,640.00	149,990.40	155,131.20	153,489.60	127,008.00	146,599.20		

or distribution center at the beginning of the month so they may plan for a constant flow of merchandise into the business throughout the month. Using the selected stock-sales ratios for each month and the formula for calculating BOM Stock $, the BOM Stock $ for the new boutique are shown in Table 14.6.

STEP 3.5: CALCULATE END-OF-MONTH (EOM) STOCK FOR EACH MONTH. To keep track of the sales progress, buyers also calculate the **end of the month (EOM) stock,** or the amount of stock remaining in the store at the end of each month. For five of the six months, this calculation is easy because the EOM is the planned BOM of the next month. For example, if a retailer closes his business day at 9 P.M. on April 30 and has an inventory of $149,000, this same retailer will have that same amount of inventory when he opens the store on May 1 at 10 A.M. to begin the new business day. The BOM stock figures can be copied from one month back to the previous month (see Figure 14.12a). The final EOM in a Six-Month Merchandising Budget will depend on the BOM desired for the next planning period (see Figure 14.12b). A buyer in a continuing business, with

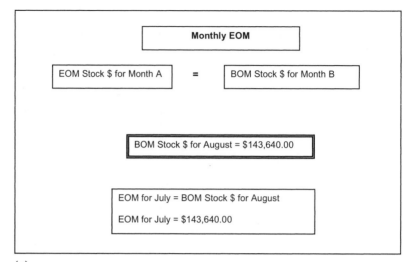

(a)

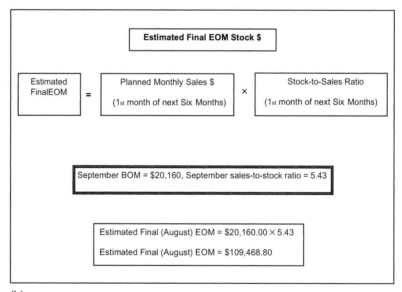

(b)

Figure 14.12
(a) Determining end of the month stock (EOM) for a Six-Month Plan. (b) Estimating final end of the month stock (EOM) for a Six-Month Plan.

records of past sales, may use the actual stock-sales ratio for the same month from the previous year. A buyer at a new store or other retail business may consult a reporting service to ascertain this figure. The buyer with store history may wish also to consult the business reporting service to evaluate the historical sales figures and ratios with the national averages.

Table 14.7
Monthly EOM stock $ for fall merchandise budget.

Fall	Aug.	Sept.	Oct.	Nov.	Dec.	Jan.	AVG	Feb.
BOM $	143,640.00	149,990.40	155,131.20	153,489.60	127,008.00	146,599.20		109,468.80
EOM $	149,990.40	155,131.20	153,489.60	127,008.00	146,599.20	109,468.80		

For the buyer doing the merchandising plans for the new boutique, the next planning period would be the Spring Six-Month Merchandise Budget of the next year. In other words, the EOM dollars for the last month of the Fall Season, January, are the BOM dollars for February, which is the first month of the next Spring Season. The February BOM dollars for the next year have to be calculated before the Fall Six-Month Merchandising Plan of the current year is completed. With the final EOM calculation, the EOMs for the Six-Month Plan can be determined by the buyer (see Table 14.7).

In addition to knowing the stock-sales ratio and BOM and EOM stock levels, the buyer must track other information about the inventory levels in a business. The retail buyer needs to know how much **average stock** is available in the store during any period. Average stock may also be called average inventory because the terms *stock* and *inventory* are often interchanged by merchandisers. In the Six-Month Merchandise Budget, there are always six BOMs, or one for each month (i.e., August, September, October, November, December, and January) and one EOM value for the last month in the period. In the Fall budgets, the last month is January; therefore, the EOM dollars for January are the same as the BOM dollars for February of the Spring Budget. The buyer must calculate that figure so he or she might calculate the average inventory and turnover for the Fall Six-Month Merchandise Budget.

The average stock value is needed for calculating the turnover of merchandise. **Turnover,** or **turn,** is calculated using net sales and average stock: Net sales is divided by average stock. Turnover has no modifiers or units and is only a number (or ratio). This information provides the buyer with a measure of how quickly or slowly the inventory, stock, or merchandise sells within a given period of time. Knowing the turnover is important information because the buyer tries to keep fresh, new, and interesting stock for consumers to see.

Turnover for the Spring Season of a retail year may be averaged with the turnover of the Fall Season of the same retail year to determine how often the retailer sold his or her inventory during that particular year. Retailers that carry the five major seasonal lines of merchandise (i.e., spring, summer, early fall, fall, holiday) attempt to achieve at least five turns during a retail year in order to have new stock coming into the store and to maintain an acceptable cash flow. However, there is no set number of turns for a store. Turns vary across product classifications, types of stores, seasons of the year, fashion level of the merchandise, and retail price of the merchandise items.

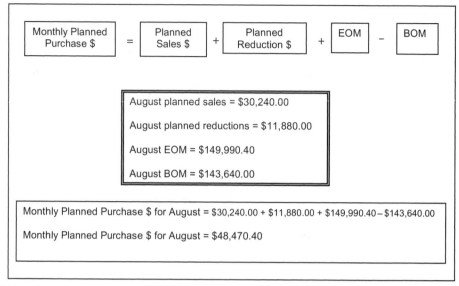

Figure 14.13
Monthly planned purchases for a Six-Month Plan. BOM, beginning of the month;
EOM, end of the month.

STEP 3.6: CALCULATE PLANNED PURCHASES AT RETAIL FOR EACH MONTH. From
the figures on the Six-Month Merchandising Budget, the buyer can now
determine the amount of money available to buy new stock, or the **planned
purchases at retail.** The planned purchases at retail are calculated to provide
the dollar amount available to purchase new product for each month (see
Figure 14.13). The retailer who is opening the new boutique would calculate the
planned purchases for the month of August using the dollars for planned sales,
planned reduction, and EOM for August as well as BOM for August. As with
each month, EOM for the month of August is the BOM for the subsequent
month, which for August would be September.

STEP 3.7: CALCULATE OPEN-TO-BUY (OTB) OR PLANNED PURCHASES AT COST
(WHOLESALE). When the buyer has determined the planned purchases at
retail, he or she must convert those retail dollars to cost dollars because the
vendors at market will be selling products at a wholesale price. This valuation
of planned purchases at cost is the open-to-buy (OTB) (see Figure 14.14). To
calculate the OTB, the buyer must know the initial markup percentage. This
percentage is usually provided by management and based on the strategic plan,
and it is part of the P & L Statement of the business.

At the end of Step 3.7, the buyer for the new boutique will have a completed
Six-Month Merchandising Budget for the Fall Season in the store and will have
a start on planning for the Spring Season (see Table 14.8). The final budget that
the buyer constructs will have both the planned sales and reductions and the

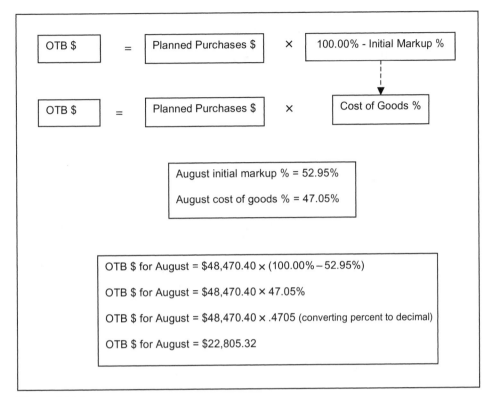

Figure 14.14
Open-to-buy (OTB) for a Six-Month Plan.

initial markup values in the heading for the budget. The remaining items will be in rows below the heading with a column for each month, a season total, and the next month for the new season in the far-right column.

When calculating Six-Month Merchandise Budgets, retail buyers and merchandisers must gather reams of information, be diligent in analyzing and evaluating all factors that might impact retail sales, and make sure that calculations are not only accurate but also realistic for that particular geographic region and for the company's target consumers. Buyers usually spend approximately 75% of their work week crunching numbers, tracking trends, and doing paperwork. Although the buyer's job is very interesting and exciting, only a small amount of the buyer's time is spent in traveling and shopping in the market. Many mundane and time-consuming responsibilities must be completed by the buyer in the office before going to market to visit showrooms, view fashion shows, attend business seminars, and select beautiful merchandise. To be successful in today's retail environment, the retail buyer must be astute not only in tracking and pinpointing the fashion trends that the company's target consumer will buy but also knowledgeable in all business procedures for conducting business in the marketplace.

Table 14.8
Six-month merchandise budget.

ADB Retail Company: Six-Month Merchandise Budget

Season: Fall

Month	Aug.	Sept.	Oct.	Nov.
BOM $	$143.64	$149.99	$155.13	$153.49
Sales %	14.00%	16.00%	14.00%	17.00%
Sales $	$30.24	$34.56	$30.24	$36.72
Purch %	20.74%	19.30%	14.55%	6.69%
Purch $	$48.47	$45.10	$34.00	$15.64
Red %	5.50%	2.50%	2.50%	2.50%
Red $	$11.88	$5.40	$5.40	$5.40
EOM $	$149.99	$155.13	$153.49	$127.01
S/S Ratio	4.75	4.34	5.13	4.18
OTB cost	$22.81	$21.22	$15.99	$7.36

Note: 1. *All calculations were based on national averages for department stores.
2. The plan is written in thousands; therefore total sales of $216,000.00 is written as $216.00 and total reduction dollars of $51,840.00 is written as $51.84.
3. [†]TO is turnover.
4. [††]a. Purchases for December are very high due to the high sales for the holiday season. Because of the fiscal year-end in January, some retailers will delay a portion of those sales until February 1 so taxes will not have to be paid on spring inventory.

Technique for Developing Model Stock Merchandise Budgets

To assure that an item is always available to the consumer, retailers may set up a **model stock** program that has been valued and calculated for a predetermined supply of specific products. This program may be used on various goods but is most appropriate for basic or commodity goods. To develop the program, the buyer uses a basic stock method for calculating the monthly volume of planned sales and open-to-buy. The **basic stock method** provides a basic amount of merchandise at the beginning of each month while taking into consideration the monthly sales during the same month. The retailer first has to determine the amount of basic stock needed to be maintained in inventory at all times and then

	Year	20XX	
	Sales	$216.00*	
	Red %	24.00%	
	Red $	$51.84	
	Markup	52.95%	
Dec.	**Jan.**	**Season**	**Feb.**
$127.01	$146.60	AVG/140.76	$109.47
28.00%	11.00%	100.00%	14.00%
$60.48	$23.76	$216.00	$20.16
38.88%	(.002%)	††100.00%	
††$90.87	(.41)	$233.67	
5.00%	6.00%	24.00%	
$10.80	$12.96	$51.84	
$146.60	$109.47		
2.10	6.17	†TO / 1.53	5.43
††$42.75	($.19)	$109.94	

b. A negative open-to-buy in the month of January is due to of the amount of inventory taken into the store/department in December as compared to the sales for January.

c. Some variance in the dollars or percentages figures is due to rounding of numbers,

estimates the planned sales for the month in order to buy enough merchandise to cover the planned sales while maintaining the basic amount of stock specified.

Two steps are needed to create the monthly values for the model stock. First, the merchandiser or buyer must calculate an overall basic stock amount that is needed for the business. This calculation compares average stock to average sales (see Figure 14.15). Average stock is calculated from an average of BOM dollars in a period along with the final EOM for that period, and average sales are calculated from the monthly sales of the same period. When the merchandiser has calculated the basic stock for a period, the BOM or the model stock needed for a month can be calculated (see Figure 14.15).

With today's computer technology, the model stock method is now a less expensive and more efficient and effective method of ordering basic stock. As previously discussed, to maintain the planned inventory level at all times, the retailer must reorder the set amount of goods needed to maintain the basic

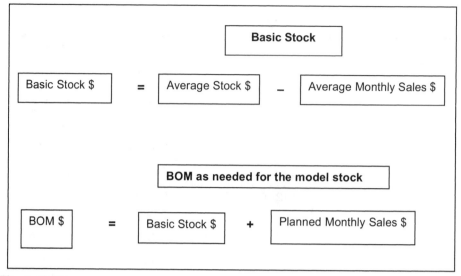

Figure 14.15
Formulas needed to create a Model Stock for one month.

stock level plus the planned sales for the month. Using electronic data inter-change (EDI) and scanners, the retailer can create an electronic system that alerts the vendor to ship specified SKUs in a certain size and color to **replenish** the merchandise sold during the week or month. When a model stock program includes not only the levels of stock but also the preset time for the stock to enter the store, they are considered **automatic replenishment programs.** Some retailers alert the vendor on Thursday what was sold during that week, and the vendor is expected to replenish those goods or fill the reorder of goods by Monday of the next week. Without an automatic replen-ishment program, reorders would have to be handwritten or placed electroni-cally by the buyer or clerical staff.

Product Planning

In coordination with the development of the merchandise budget, the develop-ment of the retail buying plan is created. As previously discussed, merchandisers and buyers as well as market personnel are constantly conducting and reviewing trend research and market analysis to evaluate the current business climate (see Chapters 7, 8, and 10). Consumer trends or the "consumer mindset" must be analyzed (see Chapter 9); current retail and advertising trends must be evaluated; and competitors, their market share and product offerings, must be analyzed to anticipate impact on a retailer's sales. Also, merchandisers and buyers must maintain a close watch on fashion and product trends while considering the past, present, and future direction of those trends. More importantly, the retail

merchandiser or buyer must not only identify those trends but must also forecast which trends will become popular with the target consumer and determine how to interpret those trends into the buying habits of the retailer's target consumer.

Based on the environmental scan, trend research, current and future business climates, and analysis of previous sales records and merchandise budgets, merchandisers and buyers then develop market plans, which for the retail buyer are called the Six-Month Merchandising Plan. This plan, along with the Six-Month Merchandising Budget, is collectively considered to be the **initial retail plan.** The **Six-Month Merchandise Plan** pinpoints what trends will be emphasized for the coming season, what product classifications will be featured, and what vendors will most likely supply merchandise needed to meet the needs and desires of their target consumers. When the buyer interprets this trend information into specific products, he or she develops a merchandise mix. The merchandise mix is the total product offering for that company.

Using the Six-Month Merchandise Budget and the trend forecast, the retailer, before attending market week, develops **assortment plans,** an organized collection of related merchandise and the number of units for each product classification, before attending market weeks. The assortment plan is a critical instrument in organizing product categories (e.g., bridal, sportswear, suits) and product classifications (e.g., shirts, blouses, skirts, pants). It contains both product **classifications,** the first level of the organizational classification system, and **subclasses,** or products within a class that are distinguishable from one another through differences in style features such as color, fabrications, and silhouette characteristics (e.g., sleeve length, neckline type, hem length). Using this organized plan for procuring product, the buyer builds the merchandise assortment for the company, a store, or a department within a store. For example, from the buyer's research, he or she thinks that the retailer's updated consumers will wish to purchase a new white shirt with a fitted bodice and three-quarter length cuffed sleeves instead of the traditionally styled shirt, with long sleeves, button-down collar, and a loose fit that the retailer usually carries. The results would be an assortment plan for white shirts (see Table 14.9).

The buyer must consider how much stock to carry in the new trendy merchandise and in the more traditional or basic merchandise. In other words, the buyer must determine the percentage of stock to carry in each subclass of the shirt classification. From these percentages, the buyer can determine the total dollars to spend on each subclass and the number of units that might be purchased of each subclass, based on the unit cost of each SKU in the subclass.

In addition the buyer must determine the ratio of sizes that must be purchased. When selecting volume in **size assortments,** retailers must offer the largest quantity of products in the meat sizes or those sizes they believe to be the best-selling sizes. As the U.S. population and other cultural groups have gradually gained weight and become larger, the best-selling sizes for a current retailer may change, and traditional meat sizes may need to be purchased in smaller quantities. As adjustments are made in the size assortments by retailers, end products manufacturers must make similar adjustments in product assortments that are offered to the retailers.

Table 14.9
Sample assortment plan for fall.

Retail Store		Assortment Plan		
	Season: Fall	Total Sales: $25,000.00		
White Shirts	**Percentage of Stock**	**Dollars for Class/Subclass**	**Unit Cost per Item**	**Number of Units**
Fitted Bodice Fashion Shirt	60.00%	$15,000.00	$45.00	333
¾ Sleeve				
Pointed Collar	20.00%	$5,000.00	$45.00	111
Bow Neckline	10.00%	$2,500.00	$45.00	56
Long Sleeve				
Pointed Collar	20.00%	$5,000.00	$45.00	111
Bow Neckline	10.00%	$2,500.00	$45.00	56
Basic Shirt	40.00%	$10,000.00	$30.00	333
¾ Sleeve				
Button-Down Collar	15.00%	$3,750.00	$30.00	125
Bow Neckline	10.00%	$2,500.00	$30.00	83
Long Sleeve				
Button-Down Collar	15.00%	$3,750.00	$30.00	125
Bow Neckline	0.00%	$0.00	$30.00	0
Total	100.00%	$25,000.00		667

Both the Six-Month Merchandise Budget and the assortment plan are used in the market to guide the merchandiser or buyer in making intelligent and appropriate decisions when procuring the merchandise. For a successful trip, these plans are developed based on market and trend research, past sales history and buyer expertise of product classifications, store and fashion image, and needs and demands of the target consumer. Without this background research, more than likely the market trip will not be successful nor will the selling season be profitable for the retailer.

Six Rights of Merchandising

As the retail buyer makes the assortment plan and other merchandising plans, he or she must be certain to get the right merchandise for the company. Determining what is the right merchandise is a difficult, complex, vital decision for

any company within the FTAR Complex, most especially for the retail buyer. One right decision for one company and one customer is one tiny piece in an enormous matrix of decisions; and, with fashion products, these decisions must be continuously made, reviewed, and adjusted. For determining the merchandise assortment offered by any company including the retailer, the **six rights of merchandising** are the right merchandise, the right quantities, the right colors, sizes, and silhouettes/styles, the right time, the right price, and the right place.

The Right Merchandise

Selecting and presenting the right merchandise to the company's customers is one of the most critical requirements or functions of an FTAR organization. Enough stock must be on hand to meet the planned sales figures for a given selling period so there is enough merchandise at any given time during the selling period to provide a good assortment of product for target customer selection. It is crucial for a company to maintain an adequate turnover of inventory to provide a proper cash flow to meet expenses and to replace merchandise assortments, thus ensuring a profit level to sustain the business operation. Many buyers, planners, or other personnel who select merchandise or product assortments have a fantastic talent for forecasting future fashion trends but are unable to translate or adapt those trends into merchandise that meets the needs, desires, and wants of the company's customer and/or the supply chain's target consumer. Without careful and accurate planning, retailers may accumulate excess inventory, which may be seen on the selling floor where it is stacked high on tables, squeezed onto fixtures, or hung from the ceiling, or it may be placed in some out-of-the-way location. Without the right planning, some manufacturers may have to rent storage facilities to house their unsold merchandise. Excess inventory is not the right merchandise because too much stock slows turnover, creates an overbought situation, and prevents the retailer from reordering new, fresh merchandise assortments to meet the seasonal needs of the target consumer.

When planning for and procuring fashion goods, the retail buyer, product developers, or other product assortment planners in an FTAR company must select a balance of seasonal and basic, distinctive and classic, and exclusive and trendy merchandise to differentiate the company from its competition and to attract a sufficient target customer base to build and sustain market share. Some consumers may expect the merchandise to be both distinctive and exclusive. Consumers who buy very early in the retail selling-season (i.e., early in the Product Life Cycle) expect new and prophetic merchandise that reflects the latest incoming fashion trends. In addition, many of these consumers buy **exclusive apparel,** often an exclusive designer line, which is sold at only one retail establishment in a particular geographic location, or merchandise that is carried by one specific retailer. These customers, the fashion trend innovators, enjoy expressing individuality in apparel items or wish to express their personality through clothing. Retailers who cater to this type of consumer usually buy from sewn product manufacturers and other vendors who maintain

exclusive and/or selective distribution patterns or channels of distribution. These companies must understand the needs of the retail company and be ready with the right merchandise. Other customers, such as the fashion expert and the fashion pragmatist, desire trendy merchandise that is fashionable but already established as the "right merchandise" by peers, family, and other social groups (see Figure 14.16).

Another component of the "right merchandise" is the quality anticipated for the price paid. The customers' **expectations of quality** involve their choices in fineness of materials, workmanship standards, construction techniques, and care requirements for a product. In keeping with these expectations, the quality standards for all merchandise classifications must be established by the Merchandising Division with the approval of management. Quality standards must be stated by a retail company to reflect all characteristics of the apparel product, including textile features and sewn properties. This aspect of merchandise is usually considered by executive management when formulating the mission statement and by GMMs, buyers, and other merchandisers when setting merchandising policies. Merchandise quality must not only support the company's image but must also meet the standards expected by the consumer.

The Right Colors, Sizes, and Silhouettes

Unlike several years ago, with today's technology, a company in the FTAR Complex tracks not only best-selling styles but also best-selling sizes, colors, and even fabrications. Fiber companies can track which fiber with which texturization, finish, and color is the best-selling fiber in their assortment of product offerings. This sale can be tracked through the end products manufacturer to the retailer as the fiber is made into fabric, the fabric is made into an apparel item, and the product is sold to the consumer.

Also, for the retail buyer, the right merchandise must be offered in the right sizes, colors, and silhouettes to fulfill the needs and desires of the target consumer. If a manufacturer does not cut a product classification in the sizes that sell best for a specific retailer, the retail buyer will shop with another vendor for the merchandise to supply the store because he or she knows that without the right size merchandise in the store the consumer will shop at another retailer to find the right size. For example, sizing and fit of work apparel for women differs greatly from sizing and fit of work apparel for men. Consequently, some companies have created product lines for this product classification to get the right size for the right customer (see Figures 14.17a and 14.17b).

Even if a consumer can find the correct size in a specific style at a retailer, the color desired or needed may not be available from that retailer. Many times, instead of compiling a detailed assortment plan, retail buyers tend to buy heavily in basic colors because they believe the selling period is longer for basic goods and thus fewer items will need to be marked down. This tendency toward basic colors is perpetuated by some end product manufacturers and textile producers as they also plan their assortments. Retail buyers depend

Figure 14.16 A trendy suit accepted for corporate wear is the right merchandise. (Courtesy of The Hosiery Association)

(a)

(b)

Figure 14.17
The right product has the right fit, such as these items for women's work wear, (a) hooded jacket and (b) bib overalls with tool pockets.
(Courtesy of Carhartt Inc. (a and b))

on end product manufacturers to obtain the right colors; therefore, these suppliers must have the right assortment of colors available in their inventory. Having the right colors within the FTAR Complex requires suppliers of fiber, dyestuffs, and fabrics to have the right colors available for use in production. As with size, without fashion colors being made available in certain

products, sales are lost not only for those particular items but also for other related merchandise categories that are needed for matching or coordinating an ensemble.

When the best-selling sizes, colors, and fabrications can be found, the desired silhouettes must still be found. Each market segment, as well as physical body types within the segment, demand different types of silhouettes. In addition, seasonal and trend changes affect what silhouette is desired by the consumer. For example, variations in necklines, sleeve lengths, and fit within a T-shirt classification are bought by consumers within the same population segment, depending on style preferences, trend influences, time of the year, and other cultural and societal changes. Meanwhile, specific figure types or ethnic groups within that market segment might desire sleeves versus sleeveless or shaped versus oversized fit tees. The right silhouettes for products must be anticipated by retail buyers and end product merchandisers so the right amount of fabrics and the right types of fabrications can be obtained from textile manufacturers. For example, changing silhouettes because of season change will mean an end product designer will be ordering lightweight, stretchy fabrics for a summer-weight sweater and bulky, stable fabrics for a thick, heavy winter sweater. Fiber, yarn, and fabric producers must either have flexibilities to respond in their production to these changing demands for raw materials to produce the right silhouette, or they will find they have no sales during some periods of the year.

The Right Quantities

A balance must be reached by any FTAR company between the amount of inventory on hand and the amount of sales realized by the company for any given selling period. At some levels of the pipeline, customers may be willing to wait for deliveries of the product, but at the retail level the consumer wants the right product when they are shopping in the store. The retailer must be especially careful about having the right quantities or levels of inventory. At retail, if there is too little stock in the store, there will be a loss of sales created by a stockout. If there is a heavy inventory or too much merchandise, the retailer usually has a cash flow problem from a slow turnover plus costly markdowns. Appropriate quantities of each merchandise classifications must be planned throughout the supply chain (see Figure 14.18). Retailers cannot have the right quantities if the end product manufacturers do not have the right levels of raw materials to make the products. For many companies, these quantities are usually based on unit and dollar sales from previous seasons, from the economic environment in which the company is operating, and from the fashion trend direction impacting each product classification.

The Right Time

It is critical for the retailer to attempt to plan deliveries of merchandise so there is a constant flow of new merchandise to be shopped by the repeat customer. To

Figure 14.18
Right quantity for better selection.
(Courtesy of The AmericTech Group, USA, Inc.)

achieve this goal, those companies that are upstream in the supply chain (e.g., end product manufacturers, textile companies, fiber manufacturers) must also have the right products at the right time. For example, buttons must be received by the apparel manufacturer at the right time to be sewn on a product that must be delivered at the right time to the retailer. For any FTAR company, deliveries are negotiated by buyers, purchasing agents, sourcing agents, logistics personnel, or merchandisers with the vendor when the merchandise is selected and ordered. Selecting the right delivery time is often difficult. Sometimes, vendors cannot guarantee delivery of goods when the customer wishes to receive them. Other times, the vendor attempts to get the customer to take ownership of the goods either early or late in the producing or selling season.

Developing strong vendor/retailer partnerships helps with the negotiating process because both the vendor and customer have developed trust and a working relationship. For retailers, if merchandise is shipped too early or before the selling season, there is not an adequate turnover or the merchandise does not sell quickly enough for the retailer to maintain a fresh inventory. Retailers must plan for special events, sales, and promotions. Merchandisers will select product and time delivery of the product to reach the store to coincide with sales flyers, newspaper ads, and store window displays (see Figure 14.19).

Heavy inventories for any FTAR company cause at least two problems. First, if a company finds itself with a heavy inventory, that company usually incurs heavy markdowns, and heavy markdowns usually cause a reduction in profit. The second problem is that cash flow is limited when sales volume goals are not achieved; therefore, innovative items cannot be added to the merchandise mix in a timely manner. With most fashion goods, the inventory

Figure 14.19
Promotions at the right time.

cannot simply be held for a later season because the changes in fashion may dictate that the inventory is no longer viable as a fashion item later. For example, a fabric manufacturer makes more blue corduroy than is sold in the current selling season and holds that fabric in a warehouse until the same season next year. When the end products manufacturers begin to look for new fabric next year, they are looking for brown suede. The blue corduroy is no longer salable at its original price and for some fashion products may not be salable at any price. The manufacturer incurs a loss of sales, plus has the holding costs of the excess inventory, and the customer is unable to procure the right product at the right time.

In contrast, goods delivered too late in the season foster a loss of sales or stockouts, heavy markdowns at the end of the season, and poor profit. If partial shipments are delivered by the vendor or if shipments are received by a company after cancellation dates, many times other products or other merchandise classifications already in stock do not sell because there are no coordinating fabrics or garments. For example, an apparel manufacturer cannot manufacture a specific jacket if the right lining is not delivered at the right time and the retailer cannot sell the pants that coordinate with the jacket if the jackets are not delivered at the right time in relationship to the delivery of the pants. It definitely behooves any logistic manager, merchandiser, or buyer to keep a close eye on shipment of goods, to call vendors requesting shipment of late goods, to cancel out-of-date orders, and to refuse partial shipments.

The Right Price

What is the "right price" for one customer might not be the "right price" for that customer's competitor. The right price must be high enough for the company to make a profit, yet low enough to meet competition and customer demand. The price to the customer is usually based on economic market conditions, the competition, and the sales volume and markdowns the company has experienced in previous selling seasons. After analyzing the Profit and Loss Statement and further examining the cost of goods sold, expenses, and profits, the company is better able to develop a pricing policy that meets the expectation of both the consumer and retailer and provides direction for the retail prices set by the buyer.

The right price for a product at retail can only be achieved if the right price for fiber, fabric, end product production, and sales are actualized. For example, a merchandiser that is planning a private label product for a specialty retailer may find the cost of 100% cashmere will result in a fabric cost that is too high to achieve the targeted retail price, and a fabric containing 60% cashmere and 40% wool may have to be substituted. The right price must then be evaluated against the other five rights to be certain that the right merchandise is available for the target consumer.

The Right Place

The right place for a retailer could be a Web site, a catalog, a retail store, or the home of a customer as the sales representative shows merchandise from a sample case. End product manufacturers (e.g., apparel producers, furniture manufacturers, shoe companies) often pick market events in major cities to display and sell their products. Textile companies send samples and well-trained sale representatives to trade shows throughout the world. In addition to choosing the right place, a company must select how the merchandise is to be displayed within the right place. For textile producers or end product manufacturers showing products at a trade show or market, decisions on lighting and music for a fashion show are as important to creating a right place as the selection of the fabric or the products that are shown. For retailers, the decision on the right place is a two-part decision. First, the retailer must choose the location for the store (see Figure 14.20a). Second, the retailer must choose the location or placement of departments within

(a)

(b)

Figure 14.20
Location in the right place for (a) a
retailer and (b) merchandise.
(Courtesy of Meg's (b))

the store as well as the location or placement of the merchandise within depart-
ments. A well-planned presentation of merchandise becomes a silent seller and
may create additional or add-on sales to any FTAR company (see Figure 14.20b).
Attraction may be created and interest maintained by presenting and displaying
the most trendy or fashionable merchandise, new arrivals, and exclusive brands,
or the most expensive product offerings in the front of the selling space. Direction
and flow of traffic paths in the selling space are crucial to the success of meeting
planned sales goals and profit levels. Similar rules of presentation must be fol-
lowed for placement of merchandise in a trade show, a catalog, or a Web site.

Summary

The fashion industry thrives on, and survives because of, the element of change. Unlike fine wine that becomes more valuable with age, the acceptance for, and sale of, dated fashion products usually decrease in demand, creating less sales volume and thus less profit. The product may even become obsolete, especially if the consumer deems the fashionability of the product to be major criteria for purchasing. Fashion trends or products may change instantly or overnight because of a sudden shift in consumer preference, a seasonal or climatic change, or other external forces impacting trend direction or consumer desire for a particular product classification. For these reasons, the retail buyer must prepare with care and due diligence for shopping the market. Both financial and product related issues must be planned. The buyer starts the planning process by using the information provided as outputs of the strategic planning process. These include the designation of the target consumer, selection of product classifications, company image, and other aspects of product, and company placement and positioning. With this information the buyer must prepare a Six-Month Merchandising Budget and a Six-Month Merchandising Plan including an assortment plan for the designation of dollars for product classifications. The result of this careful Planning Process must be the selection of the right merchandise for the target consumer.

Key Terms

Annual budget
Annual sales volume
Assortment plans
Automatic replenishment programs
Average stock
Backroom stock
Base year
Basic stock method
Beginning of the month (BOM) stock
Broken assortments
Buying-Selling Curve
Calculation step
Classifications
End of the month (EOM) stock
Exclusive apparel
Expectations of quality
Fall Merchandise Budget

Fashionable merchandise
Floor stock
Information step
Initial retail plan
Merchandise amount
Model stock
Open-to-buy (OTB)
Peak stock
Planned purchases at retail
Preplan step
Reorders
Replenish
Retail Buying-Selling Cycle
Retail year
Retail/Vendor Matrix
Selling space
Six-Month Merchandise Budgets
Six-Month Merchandise Plan

Six rights of merchandising
Size assortments
Spring Merchandise Budget
Square foot method
Stock
Stock-keeping unit (SKU)
Stock on hand
Stock on order
Stockouts
Stock-sales ratio
Subclasses
Total planned sales
Trendy merchandise
Turn
Turnover
Twelve-Month Merchandise Budget
Yearly sales volume

Review Questions

1. What are the substages of the Buying-Selling Cycle, and how do these stages help the buyer know about the customer and the merchandise?
2. What strategic planning information is used in the development of the Six-Month Plan?
3. What are the budgets that the buyer will develop when preparing for market?
4. What are the three main steps in making a Six-Month Merchandising Budget?
5. What research activities does the buyer perform during the preplan step of the Six-Month Plan?
6. What information does the buyer need from company records to complete the information step?
7. What calculations are made by the buyer during the calculation step?
8. How does information about average stock for the past year help the buyer establish a model stock plan?
9. What is an assortment plan, and why does the buyer need this before going to market?
10. What are the six rights of merchandising, and why are they important to the retail buyer?

Reference

Kincade, D., Gibson, F., & Woodard, G. (2004). *Merchandising math: A managerial approach.* Upper Saddle River, NJ: Prentice Hall.

15

Retail Buyers Shop the Market

Objectives

After completing this chapter, the student will be able to

- Explain how the retail buyer or merchandiser shops the market efficiently and effectively
- List the major market centers and describe the importance of each center to the buyer when procuring merchandise
- Explain the major techniques for shopping the market
- Discuss the major criteria for vendor selection
- Explain how to write a purchase order
- Compare the terms on a purchase order to the items on an invoice
- Discuss how to negotiate with vendors
- Identify the criteria for building sound vendor relationships

Introduction

For the retailer, developing a cohesive package of seasonal merchandise or the product mix for the retail store, catalog, or Web site consists of all the activities and processes needed to make the mathematical calculations or the budgets and merchandising plans come to life, as a concrete, attractive merchandise

mix with appropriate assortments of seasonal merchandise classifications to meet the needs, wants, and desires of the target consumer. The steps in developing the merchandise or product mix for the retailer include (1) market planning and (2) procuring the appropriate merchandise mix to attract the retailer's target consumer. **Procuring merchandise** consists of searching and selecting specific merchandise classifications that build the merchandise mix for the retailer. To achieve success in the procurement of the right merchandise for a specific targeted consumer, merchandisers in all links of the supply chain must make sure that the end products reflect the attributes envisioned in the initial retail plan or the initial line plan as offered by manufacturers or raw materials providers.

Fashion Weeks

The right line plan or cohesive package of seasonal merchandise depends on the channel of distribution; the product classifications, the retail type and format; the company, store or nonstore, and fashion images; and the industry zones of merchandise carried by the retailer. Although some retail buyers and end product manufacturers are working on a system with an endless and seamless supply of merchandise, most buyers purchase merchandise that is sold during the market weeks. **Market weeks, or fashion weeks,** are the weeks in the merchandising calendar designated by the apparel manufacturers and designers as the time for showing the new seasonal lines of fashion items (see Chapter 11, Table 11.1). The scheduling of market weeks is done by various organizations or by the marts themselves. In Paris, the weeks are scheduled by the Fédération Française de la Couture. The women's wear market in New York City is scheduled by the Fashion Week Advisory Committee, which includes executives from the Council of Fashion Designers of America, IMG Fashion, and the Fashion Calendar (Karimzadeh & Feitelberg, 2007).

IMG Fashion, which purchased the rights to produce the New York fashion shows from Seventh on Sixth, is a branch of IMG, a sport-marketing company with rights to produce fashion shows in Log Angeles, Miami, Sidney, and other locations around the world (Kapner, 2006). IMG Fashion along with corporate sponsors, such as automaker Mercedez-Benz, international carrier DHL Express, and electronics giant Olympus, are responsible for the fashion shows staged at the historic Bryant Park in New York City (Armbruster, 2007) (see Figure 15.1). The Fashion Calendar has been the official keeper of the calendar dates for the New York fashion weeks for 50 years, and its calendars are now available through the Internet on a members-only basis (Feitelberg, 2007).

Menswear organizations that sponsor New York market weeks throughout the year to showcase men's apparel and accessories include the National Association of Men's Sportswear Buyers (NAMSB) and the Clothing Manufacturers Association (CMA). Men's Apparel Guild of California (MAGIC) sponsors the major market weeks in Las Vegas. Other fashion weeks may be scheduled by local organizations of designers and manufacturers; city, state,

Figure 15.1
Fashion tents in New York City's Bryant Park.

or other government offices; and other marketing groups. For example, the Single Market Events (SME) marketing company works with the British Fashion Council (BF) to organize the London Fashion Week (LFW) ("SME Signs," 2007). White, which will be adding menswear, is the women's fashion show during the market weeks in Milan, and Pitti Uomo is the men's trade shows with market weeks in Florence (Epiro, 2007). The scheduling of market showings is a very important decision because each market and each segment of the industry wants to be the first to show the newest fashions, which can cause controversy and conflicts among the market centers. Each buyer must select the right market and market weeks for his or her retailer and target consumers.

Geographic Locations of Market Centers

The functions of design, development, and production of fashion apparel for women in today's FTAR Complex are definitely global. The major European market centers include Paris, France; Milan, Italy; and London, England; the largest market center in the United States is New York, New York; and other large market centers exist throughout the world. A **market center** is a geographic location or city where product is sometimes produced and/or imported

Figure 15.2
Showroom buildings on 39th Street.

and then presented for sale by manufacturers, jobbers, wholesalers, and importers to their retail clients for purchasing at wholesale costs (see Figure 15.2).

Some of these locations are also called a **fashion center** because the companies located there are leaders in the introduction of new fashions. The retail-

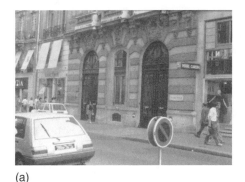

(a)

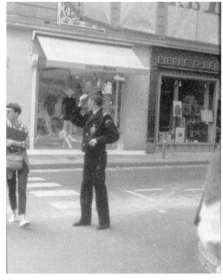

(b)

Figure 15.3
A buyer in Pairs would shop (a) in major design houses and (b) in trendy shops.

ers located in these areas always have the newest fashions in stock, and consumers who live there are seen frequently wearing these new fashions. For many of these cities, the words *fashion center* and *market center* are interchangeable. Many apparel market centers are also the cities for finding the newest in raw materials and textiles; however, some fabric shows are found in unique locations specific for fabrics or other products. Within the cities known to be major market centers, some manufacturers maintain **showrooms** with permanent display and office spaces for meeting customers and exhibiting the latest products. Other companies rent showrooms or other space periodically.

International Fashion Centers

Traditionally, because of the availability of raw materials, a well-developed industry that fostered creativity, and a moderate climate that permits wearing of a variety of garments, Paris has been designated as the fashion capital of the world. It is both a fashion center and a market center. Noted for exclusive fabrications as well as short runs of fabric yardage, customized findings, trims, accessories, and governmental support, the French Couture ruled the fashion world for decades. The power of the French Couture has been fortified through the strong organization of designers called the **Chambre Syndicale de la Haute Couture.** The executive organization of La Chambre is the **Fédération Française de la Couture** ("Tout Savoir," 2007). This organization schedules the fashion shows of the major design houses in Paris for both the haute couture and prêt-à-porter collections (see Figures 15.3a and 15.3b).

Although Paris is still a major center of fashion, during the fashion revolution of the 1960s, its global role was challenged by other fashion centers that ultimately diminished its power.

Known for exquisite, high-quality fabrics; intricate, colorful knitwear; beautifully constructed, and high-quality, unique leather goods, Italy maintains its fashion center in Milan. And, traditionally, Savile Row in London has been recognized as the mecca for men's tailored clothing. Additionally, during the 1960s and 1970s, the ladies clothing industry in London set the standards of fashion for the entire fashion world. During that period, designers such as Mary Quant and Zandra Rhodes were known on a global scale for creating unique trends and lines of merchandise. Many fashion trends have originated in the London fashion center. With the growth of manufacturing in China and the growing economies in the Far East, Tokyo, Shanghai, and other Asian cities have become prominent locations for exciting and new designs in the fashion world. Models from Russia and fabric designs from Korea are often found in the innovative designs shown on the runways in these cities. Berlin, since the collapse of the Berlin Wall, is becoming a well-known fashion center with the introduction of the Mercedes-Benz Fashion Week Berlin, and the Premium trade shows with over 700 international collections (Drier & McGuinness, 2007). With the help of marketing firms, trade organizations, and government agencies, Copenhagen, Toronto, and other international cities are beginning to grow or revitalize their fashion industries and are encouraging young new designers.

New York Fashion Center

In the United States, New York City (NYC) has been recognized traditionally as the country's center of fashion, not only because many U.S. designers reside in the city and maintain their design studios there but also because of the history of the industry. Early in the development of the apparel industry, immigrants skilled in the needle trades immigrated to NYC and provided an expert labor force for the industry (see Figure 15.4).

Developing around the fashion industry, the city itself is synonymous with fashion and the excitement that fashion events create. New York City is also considered the oldest fashion market center in the United States. The NYC **Garment District,** often coined as **Seventh Avenue** (i.e., the **Fashion Avenue**), includes Fifth, Sixth or the Avenue of the Americas, Eighth, and Ninth Avenues, plus Broadway, from 40th to 34th streets (see Figure 15.5). Specific areas within this district hold concentrations of certain product lines, concentrating on women's apparel and accessories. The fur market is concentrated between Seventh Avenue and Broadway along 29th and 30th streets. The bridal market is located primarily between Seventh Avenue and Broadway on the streets from 35th to 39th Street. The menswear market in New York City is concentrated in the area of 1290 Avenue of the Americas, the Empire State Building, and between Fifth Avenue and Seventh Avenue on 51st, 52nd, and 53rd streets.

Figure 15.4
The sculpture in New York City dedicated to the many immigrants in the fashion industry who have worked in the city.

Like other segments of the industry in the United States, NYC has lost major manufacturers and thousands of apparel jobs and has witnessed the closing of numerous showrooms, buying offices, and other auxiliary companies and segments of the industry. Although no longer a leader in manufacturing, NYC still maintains its leadership position as the fashion and market center of the United States, and every type and category of merchandise can be found during the fashion weeks there.

Figure 15.5
Fashion Avenue in New York City.

Regional Fashion Centers

Regional fashion centers, or geographic segments of the apparel industry, can be found in all regions of the United States. These regional centers are mid-size market centers and usually housed in large buildings or a grouping of buildings known as **marts.** Apparel manufacturers rent space in these buildings and exhibit their seasonal lines in showrooms within the buildings. Some

of the companies keep their showrooms open year round and maintain an office there to service their retail clients in that region. Other showrooms are open only during market weeks. Manufacturers showing during the regional markets primarily carry women's wear, but they may also carry children's wear and accessories. The marts with their numerous showrooms are the locations for meeting with vendors; however, the fashion shows during the market weeks may be located at more trendy spots, such as the shows in Culvert City for the Los Angeles Fashion Weeks (Medina, 2007). Because of the fashion element in today's menswear and home fashions market, many markets are now showing menswear and gifts during regularly scheduled market weeks.

California regional centers are located in Los Angeles and San Francisco. The California designers are recognized for their casual lifestyle product lines and merchandise assortments based on the philosophy of "try it you might like it designs." During the 1960s California designers were given credit for creating such fashion-forward items as the topless swimsuit, the miniskirt, and see-through blouses. The apparel industry in California is noted for its sportswear, swimwear, contemporary, and junior apparel. The **California Market Center (CMC),** in Los Angeles, California, is a central location with a large facility, 1,000 showrooms, and almost 10,000 product lines ("About the CMC," 2007) (see Figure 15.6). Los Angeles is becoming a base for sourcing from Asia as well as a market center for California companies, such as American Apparel Inc., that are again manufacturing apparel in the United States (Gogoi, 2005).

Other regions in the United States focusing on the fashion industry are Miami and Atlanta in the Southeast, Dallas in the Southwest, Seattle and Portland in the Pacific Northwest, and Chicago and Kansas City in the Midwest plus Boston and Philadelphia in the Northeast and Denver in the mountain region. Miami is known for swimwear and active sportswear; Atlanta headquarters many large apparel firms that produce children's wear and athletic and active wear. Atlanta is a fast growing market center with its large three-building facility called **AmericasMart®.** With over 6.2 million square feet, a wide variety of products including men's, women's, children's, and special occasion or bridal apparel can be shopped by buyers ("About Us," 2007). Dallas has the **Dallas Market Center (DMC),** a major market center with a wide variety of product lines including gifts. Buyers also go to the DMC for conducting international trade, especially useful for importing products from Mexico, South America, and the southern and western Caribbean. Some buyers attend the markets in High Point, North Carolina, for fabrics, trims, home fashions, and furniture (see Figure 15.7).

Seattle, Washington, and Portland, Oregon, have market centers noted for active sportswear, including extreme sports with technical fabrications for young men and outerwear. Chicago, housing the headquarters of Hartmarx, is known for menswear as well as ladies dresses and bridal wear. Recently the mayor of Chicago appointed a fashion director to promote the city as an international fashion center. During the Fashion Focus Chicago or the Chicago Fashion Week, talented young local designers are featured, and the fashion

Figure 15.6
Entrance to the California Mart in Los Angeles.

community is recognized for its contribution to the city (Wilson, 2007). More information about this revitalization of the Chicago market can be found on www.fashionfocuschicago.com.

One of the major markets for menswear is the **MAGIC** trade show sponsored by the Men's Apparel Guild of California (MAGIC) and held in Las Vegas. The MAGIC show has developed into an international affair with not only menswear but also women's attire, children's apparel, and even private label or contractor sources (see Figure 15.8). Las Vegas, Nevada, has also become the location of the fastest growing home furnishings market center, opening semiannually at the **World Market Center.**

Other Fashion Centers

Smaller or minor market centers are also found throughout the United States. Lee Jeans, a division of VF Corporation, is located near Kansas City and often does market week shows at the headquarters. Philadelphia, headquarters for some of the major better sportswear companies, is known as the location for ladies career wear, sportswear, and children's wear. Traditionally Philadelphia was the center for the U.S. millinery industry; however, now that few people wear hats and due to the intense labor component in making hats, most of that business is outside of the United States. Boston, a smaller market center, is

Figure 15.7
World's largest chest of drawers (38 feet high) with socks at the High Point,
North Carolina, market.
(Photographer: Alice E. Dull)

noted for accessories and a limited amount of apparel. And the Denver market is known for western wear.

Some U.S. children's wear firms are located in NYC and maintain showrooms there to showcase their seasonal collections, especially companies such as Levi and Wrangler that produce children's wear within divisions of their companies. Other children's wear companies, such as Carter's and OshKosh B'Gosh, along with a number of small manufacturing children's wear companies, exhibit product in showrooms at regional markets such as Miami, Los Angeles, Dallas, and Atlanta. In a more recent trend similar to that in women's apparel, retailer buyers are sourcing a large proportion of children's clothing in many other areas of the world such as Asia and Europe.

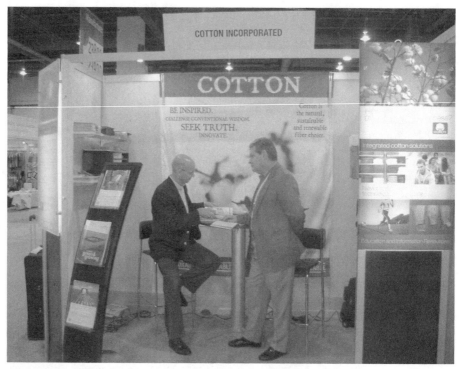

Figure 15.8
Cotton Incorporated booth at MAGIC with (left) Lou Protonentis and (right) Michael Tyndall.
(Courtesy Cotton Incorporated. Photographer: Laura Sampson)

Factors to Consider for Shopping the Market

The buyer or merchandiser has many decisions to make with regard to the procurement of merchandise classifications. Based on an assessment of these variables, the buyer must select specific market centers or market locations to visit to locate the right merchandise for the target consumer. For example, if a specialty department store is carrying designer or haute couture merchandise, the buyer may travel to Europe and attend market weeks in Paris, Milan, or London. But, if the buyer is buying for a midtier department store in the United States, he or she might travel to NYC or Dallas to attend market. A buyer who shops for a catalog company that sells exotic silk fashions from the Far East might travel to selected Asian countries or might work with wholesalers or importers based in Los Angeles. The initial decision to be made with regard to market is which markets are to be shopped by the buyer.

Market Selection

The first decision will be the **market selection:** which markets to attend and which market weeks to attend. Several factors are considered when making the

Figure 15.9
LAX airport is a common sight for many buyers.

market selection: resources available—time, money, and buyer skill; geographic location of the retail businesses; product classification being sought; amount of fashion change anticipated; the preferences of the target consumer; and always company policy. A merchandiser quickly learns that the geographic location of the market center often determines what type of product can be procured at that particular location. Additionally, the location of the market may impact not only the cost of doing business to obtain the product but also the final selling price of the product. For example, a company located on the East Coast of the United States has to pay more travel costs to get to a West Coast market location (see Figure 15.9) and may also have to pay higher freight costs to get the finished product into the hands of the target consumer. Many companies find they must visit several markets to find the right product for their target consumer and therefore have added overhead costs in securing product for their merchandise mix. Every buyer will have some restrictions.

A buyer traveling on a limited budget may select to go only twice a year to a major market center, whereas a buyer with a more expansive budget may go to a market center at least six times a year (one trip for each season) and perhaps more often for reorders and fill-in merchandise. If a buyer would go only twice a year, he or she would probably pick the spring and early fall/fall market weeks because these are considered the primary or major market weeks. This market

selection would also be chosen by a buyer who purchases classic menswear items or very basic women's wear. In addition, buyers who shop for retail businesses located in some geographic areas have fewer seasonal changes experienced by their customers and will not be as interested in some markets as other markets. For example, a buyer who purchases products for target consumers in northern states or colder climates will be very interested in the heavyweights of merchandise offered for late fall and will find the selling season very short for early spring merchandise. Buyers who want new fashion items to appear frequently for their target consumers may choose to go as often to the market as their budgets allow. These buyers may also go to a variety of market centers so they have the widest choices of products for their selections.

Some buyers conduct **virtual buying,** buying online or Internet buying. This market buying method works well for buyers who purchase a large percentage of their merchandise in classic styles or have regular vendors so they are familiar with their pricing policies, delivery patterns, and product quality. Internet buying also is convenient for reorders with vendor partners and for some minor seasons when travel dollars are restricted.

Any buyer can be overbought or have too much merchandise in stock and have no money to purchase new merchandise. This buyer is in a very difficult position. With too much merchandise, the buyer will consider not going to new market weeks but will have to go to market to have new merchandise for the target consumer in future months. The buyer will have to work closely with the Operations Division and Marketing Division to sell more of the merchandise currently in the stores, catalogs, or Web sites. The buyer will also want to review the previous Six-Month Merchandise Plan and other planning documents to see "what went wrong."

Market Week Plan

Most retail buyers and merchandisers are required to formulate an organized **market week plan** before going to market. This market or buying plan is based on both the Six-Month Merchandise Budget and the Six-Month Merchandise Plan, including the assortment plan. This market or buying plan also includes other documents, such as a listing of vendors or resources to shop for each product classification, a daily list of vendor appointments (scheduled in advance of the market event), and a listing of seminars and other events to attend during market week. The buyer will also have a list of other retail stores nearby the market center to shop, if time allows, to look for new vendor sources or merchandising techniques.

Because travel is so expensive and time is so limited and also very valuable, the buyer must use every available minute at market. The market day for a buyer may begin as early as 7 or 8 A.M. and last until 7 or 8 P.M., depending on the events of the day and the availability of vendor appointments. Sometimes the buyer may eat lunch in a busy showroom, "grab any available food in the market center," eat a granola-type bar while walking to an appointment, or even do without breakfast or lunch to make appointments on time and make the most of the buying trip. Throughout the day, buyers visit numerous showrooms and view many lines and product classifications of merchandise (see Figures 15.10a and 15.10b).

Each buyer or merchandiser usually has some method or technique for organizing all of the information collected in each showroom. Some vendors allow buyers to take pictures of the product line; others provide sample swatches of fabrications and sketches of key items in the line, whereas others only allow buyers to take notes on an order pad or worksheet and they must make their own brief sketches. Buyers must have a system to help them remember what they saw in every showroom because as many as 20 or 30 vendors may be viewed in one day's time. It is imperative that buyers remember what product classifications in what color and fabrications at what prices they previewed during the show because many times there are duplications of styles, colors, and fabrications at different price points for the exact same item or for the same department.

Techniques for Shopping the Market

There are several techniques for **shopping the market** or searching for the right merchandise to build the appropriate assortment plan and merchandise mix. Depending on the market location, the product classifications, the amount of time available for market, and the costs incurred for the buying trip, the buyer may organize the market trip by location, key vendors, or product classification. In addition, the buyer may use the retailer's buying office or other types of buying offices to procure the goods. Some buyers source private

(a)

(b)

Figure 15.10
New York City: (a) Fur District
and (b) Times Square.

label goods through contractors or through the retailer's own private label/product development division or source goods through specification buying. Sourcing imported goods may be done through trips to importers' showrooms in a major market city, by using a buying office, or through independent agents or wholesalers. When sourcing imported goods directly from the overseas manufacturers, retail buyers would follow similar procedures as apparel merchandisers when sourcing contractors for cut-and-sew production (see Chapter 13).

For markets such as NYC, where vendors may be spread out over a large area and transportation modes are sometimes very costly, untimely, and not very dependable, many buyers shop by location. **Locations** may be buildings located in specific city blocks, or in a regional mart the location may be floors within the market center buildings. In major market centers, a building or specific floors may house similar merchandise classifications or industry zones. For example, many of the vendors located at 1411 Broadway consists of an entirely different industry zone, and have different product classifications of merchandise at entirely different price points than those vendors housed in 1441 Broadway (see Figure 15.11). The experienced buyer learns what vendors, product classifications, and zones of merchandise are housed where in the marketplace. To save time and to compare similar production classifications and zone merchandise, a buyer may make appointments in one building and visit showrooms in that building for the entire day. When the buyer is shopping a large mart with several buildings and many floors, the location method may also be used.

Most retail buyers like to shop by visiting their **key vendors** (i.e., top vendors on Retail/Vendor Matrix) for each product classification. By shopping the top resources first, the buyer gets a feel for "market and trend direction" and is able to determine exactly what is available for or lacking in the key vendors' seasonal line in order to fill the assortment plan for each department or product classification (see Figure 15.12). If time permits, with the idea of probably not purchasing the merchandise, a buyer may shop vendors who carry merchandise similar to their top vendors. By shopping vendors that carry product lines that are more or less costly and that are more or less trendy than their key vendors, buyers can make sure the competition does not have similar or identical product that is less expensive or more trendy than the products selected from their key vendors. Or the buyer may decide to drop a key vendor whose products has not been performing well (e.g., a consistent drop in sales figures) to add a new line of merchandise from a new vendor. However, it is very important not to drop a key vendor without analyzing the market direction and making sure the new vendor will perform to or above the level of the vendor being dropped. As a rule of thumb, in the retail industry, vendors are not dropped for their products performing poorly for just one season because it is important that the retailer and vendor build a partnership that is workable and profitable for each company.

If a buyer is having difficulty finding a specific product classification, he or she might shop by **product classification.** For example, during specific seasons or for some fashion trends, sweaters may be more important than blouses.

Figure 15.11
On the corner at Broadway with cut-and-sew contractors moving product.

Many times when this dramatic change takes place in the marketplace, not all vendors realize the trend; therefore, a shortage of a particular product classification occurs in the market. If this is the situation, the buyer must scour the market to find enough product to present the trend, such as through store displays and advertisements, and to build the merchandise mix for the retailer's target consumer. Many times, buyers in large corporate stores and those in buying offices buy only one product classification, such as bottoms or tops or dresses. These buyers must view many lines of the same type of product classifications to build their assortments. This technique for buying is very time consuming and sometimes costly, but it may be the most effective method for searching for and selecting the right merchandise at the right price for the retailer's customer.

Another resource available to the retail buyer for shopping the market is the buying office. Buying offices serve as the eyes and ears of a retail merchandiser to help with product sourcing and procurement. In this role, **buying offices,** as agents for the merchandiser, can provide all of the services needed to help the retail merchandiser develop or locate the needed product classifications to satisfy the wants and needs of the retailer's target consumers. Buying offices operate primarily as an auxiliary service between the apparel manufacturing link, in the FTAR Supply Chain, and the retail link. Geographically, buying offices are located in a major market city, and large firms may have offices in more than one market city to provide services across multiple product lines. Some buying offices that specialize in imports and international sourcing have offices located throughout the world.

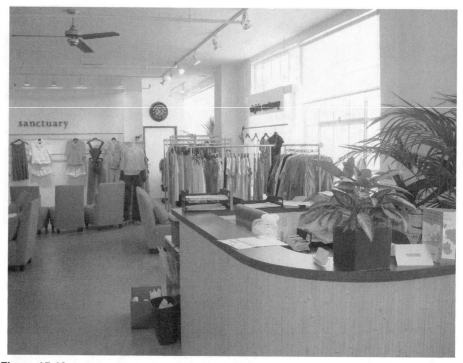

Figure 15.12
Buyers shop showrooms that carry their key vendors.
(Courtesy of Cohen Showroom Inc.)

Buying offices can be structured or formed in a number of ways; primarily they are either independent buying offices or offices that are corporate (company) owned or affiliated buying offices (see Figure 15.13). The most well-known U.S. independent office is The Doneger Group located in New York. On the West Coast, the offices of Directives West are well known to the buyer who shops in L.A. The **independent buying office** is not associated with any retail chain or store and services many independent retailers and buyers at smaller chain retailers. Companies pay a fee to use the services of the independent buying office, traditionally based on the amount of product purchased, although specialized services (e.g., expediting through customs) may have additional fees. Some buying offices have a fee schedule based on flat rates. The **corporate** (company) **owned** or **affiliated buying offices** are owned by a retail corporation or company and service only the buyers for that retailer. In the United States, company-owned offices are maintained by a number of the major retailers, including the Buying Offices of Macy's, Inc. and those owned by JCPenney.

In line with the procedures that a retail buyer or single merchandiser would follow when preparing for the market, the personnel in the buying office provides services related to information, procurement, promotions, and fashion

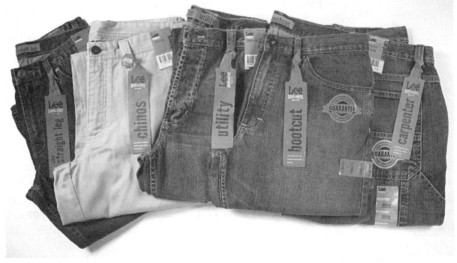

Figure 15.13
Many buyers in large buying offices buy only one product classification.
(Courtesy of Lee®)

Figure 15.14
Storyboard for forecasting information at the buying office.
(Designer: Soak Wai Wong)

education. For trend and forecasting information, someone covers the market daily
for new products, identifying hot items and emerging trends (see Figure 15.14).
This provides the merchandiser with fashion information through trend reports
and seminars. Some companies publish comprehensive trend reports providing

style, silhouette, and fabrication information with fabric swatches and fashion sketches.

Other employees or buyers in the buying office shop the market daily to locate the most profitable and salable merchandise for their clients, the retailer. Buying office buyers may be given permission to place orders for the store, catalog, or Web site retail buyer, or the buying office buyers may provide information that will assist the retail buyer in making the appropriate selections for his or her specific retail firm. In addition, before the retail buyer visits the market, buying office buyers may visit key vendors to assess the offerings for a particular season. Then the buying office buyer presents those findings to the retail buyer to give an overview of the market as well as to identify key resources to visit first (see Figure 15.15). Also, the buying office buyers may assist the retail buyers in setting up market week appointments or by shopping the market with the retail buyer during market week. Some buying offices also assist in developing private label for the retailer and sourcing that merchandise for the retail buyers.

Some retail buyers and merchandisers work with the company's **private label product development** department or division to develop unique private label product for the store, catalog, or Web site. This merchandise may be manufactured according to the specifications of the retailer, or the retailer may accept the standards and specification of the manufacturer producing the product. Many times this merchandise fills a void in a product classification that cannot be found in the marketplace or is at a better price point or at a different fashion level than merchandise found in the product lines of national brands. Many large store groups are relying on private label sourcing to bolster their profit margins and sales volume. In fact, most major retail corporations, such as Walmart, JCPenney, and Kohl's, have appointed directors or vice presidents of brand management to assure that each brand is positioned and presented consistently throughout the corporation.

Sometimes retail buyers or retail merchandisers develop their own set of specifications for a product and search the market for products that fit these specifications or search for manufacturers or sourcing agents who will create a product that matches the retailer's specifications. This type of buying is called **specification buying.** Sometimes this merchandise is private label, and at other times it might be national branded goods that met the buyer's specifications.

Vendor Selection

Selecting the right vendors is one of the major responsibilities of the retail buyer or merchandiser because the right vendor should supply the right merchandise at the right price in the right quantities at the right time (see Figure 15.16). There are many criteria for a retailer to consider for evaluating and selecting vendors. Some of the most important ones to consider include the following: (a) the industry zone in which the vendor operates, (b) the initial

(a)

(b)

(c)

Figure 15.15
Buying offices assist in developing private label for the retailer (a, b, and c).
(Designer: Peggy Quesenberry. Artist: Katherine Heising)

cost of goods or the wholesale price of the vendor's merchandise, (c) the vendor's terms of the purchase order, (d) the exclusivity of the vendor's merchandise, (e) the merchandise quantity requirements of the vendor, (f) the availability of cooperative advertising and promotional aids provided by the vendor, (g) the quality of the vendor's product, (h) the reorder capabilities of the manufacturer, (i) the return policies of the vendor, and (j) on-time deliveries from the vendor.

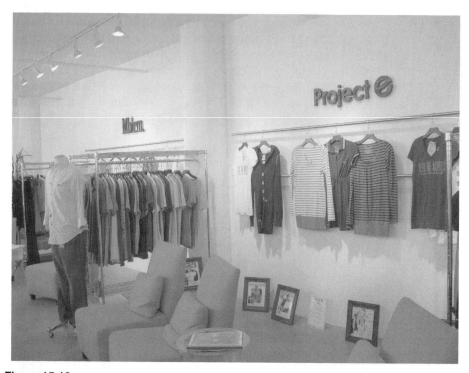

Figure 15.16
Multiple product lines in an L.A. showroom.
(Courtesy of Cohen Showroom Inc.)

Industry Zones

Many times the retailer must shop vendors that produce merchandise within a specific industry zone such as bridge, better, or moderate. Vendors in these zones target their seasonal product lines not only specific to retailers in specific channels of distribution but also to the target consumers of those retailers. The industry zone in which the vendor operates dictates the price ranges and price points and the styles or silhouettes offered to the client or the retailer (see Chapter 3). In addition, vendors within a zone usually have similar, or even identical, choices of fabrications, trims, and findings with costs in similar price ranges from which to select to produce their seasonal lines. For example, a missy customer buying a "silk-like" blouse of a synthetic fabrication in the moderate area may wish to purchase a blouse that is washable and made of a durable fabric at a moderate price. This same customer may also buy a moderately priced "silk-like" blouse that is a blend, is hand washable only, and is slightly higher priced than the synthetic blouse. However, another customer buying merchandise in the bridge area will want to purchase an expensive 100% silk blouse even though the fabrication may be very fragile and may be dry cleanable only. Usually many or at least several vendors operate in each in-

dustry zone. Therefore, the retailer or merchandiser must select the vendors within the zone that best supply the retailer with the merchandise that the target consumer wishes to purchase. In the better zone, the Jones Apparel Group, Inc. is known for developing its better lines of AK Anne Klein, Jones New York Collection, Jones New York Signature, and Jones New York Sport plus Nine West and several other lines. The same manufacturer also has a moderate division of apparel and denim and produces such lines as Evan-Picone and Gloria Vanderbilt.

Depending on the retail type and target consumer, the buyer or merchandiser must first make a decision whether or not to select merchandise from the better zone, the moderate zone, or both. Next, the buyer or merchandiser must decide which brands fit the price points and product classifications needed by the retailer. For example, Jones New York Signature is the "best" price point of the Jones New York brands. If a retailer were attempting to attract a new updated consumer, he or she might select the Signature line instead of the Jones New York Collection line that targets the career customer. Buyers and merchandisers must select those product lines from each vendor that best fulfill the needs of the target consumer. It would be very unusual for a store to carry all of the Jones New York brands in the Better industry zone because no one vendor can supply the variety in styles, fabrications, and other product attributes of the very diverse demands of any one store or target consumer.

The retailer must offer a good assortment of merchandise so the consumer has a choice of selection (i.e., styles, sizes, fabrications, color palettes, price points). And, the retailer should never buy from only one vendor because sometimes, regardless of how sound the manufacturer, the company may have a problematic season or the line direction may not be appropriate for the retail client. Each season the retailer analyzes the dollar amount and/or percentage of sales volume and the sell-thru percentage of the product classifications contributed to the firm's total sales volume by each vendor. Also, the amount of markdown dollars and a percentage of those dollars in relation to the retailer's total sales volume is determined. Based on these actual happenings, the retailer can determine which vendors within each industry zone are providing the right merchandise for the retailer's target consumer (see Figure 15.17).

Wholesale Cost of Goods

Many times a retailer may find a wonderful new vendor that has splendid updated merchandise, yet the retailer cannot buy the product of the vendor because of the high wholesale costs of the merchandise. Retailers usually set price lines with a floor and ceiling for their retail price points. When the retailer, using company or department markups on the wholesale costs, calculates the retail price for the item, the price point must fall between the lowest and highest points that the retailer has set for that particular product classification. However, the vendor may allow the buyer to select specific items from

Figure 15.17
The buyer carefully reviews pieces in the line with showroom director, Betsee Isenberg.
(Courtesy of 10 eleven Showroom)

the company's product line to test the merchandise or to attempt to get on the retailer's Retail/Vendor Matrix listing. Also, buyers may consider other compensations that the vendor may provide to offset the high cost of goods. For example, vendors may offer good discounts, give extra dating, supply cooperative advertising or promotional aids at a nominal cost, require low minimum quantities of merchandise to be purchased, or develop exclusive merchandise for the retailer. Depending on the store, many other factors may be important to a specific retailer instead of cost of goods only. However, if the cost of merchandise is too high the retailer may not be able to achieve the planned sales volume, initial markup, or profit goals. Also, goods that are priced too high may contribute to high markdown dollars and thus a loss of profit.

Terms of Purchase

In many sectors of the FTAR Complex, vendors provide terms of purchase to entice the client to purchase more goods. Each sector has it own set rule of standards for determining what types of terms will be offered to the client. **Terms** of a retail purchase order include **discounts,** or the reduction in the wholesale

costs of goods (i.e., quantity, trade, cash discounts), and the **dating,** or length of time in which to pay and take the discounts on the invoiced cost of merchandise or, as often stated, the bill for the merchandise received from the vendor by the retailer. These discounts are dollars saved by the retailer and are considered as profit for the company. Additionally, if the retailer is given a lengthy amount of time from which the goods are received into the company to pay the invoice, the retailer will have time to sell the merchandise before the company has to pay the invoice for the goods. Thus the cash flow of the retailer is improved and other merchandise may be brought into the retail establishment to create a new, fresh merchandise assortment from which the repeat customer may make purchases. Usually the better the terms offered to the retailer by the vendor, the larger the order the retailer will place with that vendor. However, a buyer or merchandiser should never base the final selection of merchandise solely on the terms given by the vendor. Even if the terms are excellent and the merchandise is of good quality, if the end consumer does not want and purchase the merchandise, the buyer has made a poor decision for the retail firm.

Exclusivity of Merchandise

Many times vendors offer exclusive merchandise to specific retail customers. This merchandise might be a national brand that is distributed geographically to select customers within a particular area, or the goods may be merchandise such as private label for one specific retail establishment or a branded line developed specifically for one retailer only (see Chapter 5). Retailers use exclusive merchandise to create a competitive advantage, to position their company and its products, and to attract the repeat customer targeted by the firm (see Figure 15.18). Many times this merchandise might be the fashion image cue that helps the retailer build a larger sales volume, reduce markdowns, and reach profit goals.

Merchandise Quantity Requirements

Because of the channel of distribution, the type and price of the product classification, and the sourcing venue, some vendors have their goods **prepacked,** or packed in certain quantities with a preset combination of sizes and/or colors. For example, for a top that is sized S-M-L, a vendor may pack a specific style in a quantity of one dozen, with the pack containing two smalls, six mediums, and four larges. The vendor requires the retail buyer or merchandiser to buy the sizes as packed as well as the entire dozen of the one style and maybe in just one color. Sometimes the buyer cannot feasibly purchase the amount of each style, size, or color that the vendor requires for a purchase order to be placed. To have variety in the merchandise assortment and to offer a good selection of merchandise to the end consumer, most buyers or merchandisers do business with vendors that require minimum quantities of one SKU or product classification. For example, if a retail buyer is buying an exclusive, expensive designer

Figure 15.18
Exclusivity of the line is reinforced by the use of an old bank vault in the L.A. showroom.
(Courtesy of 10 eleven Showroom)

dress, he or she will not want to purchase a dozen of the dresses, regardless of the store's sales volume; more than likely, the buyer will buy one size 4 and a size 8 with the hopes that these two garments can be altered to fit sizes 4 through 10. With limited quantities in the store, the consumer will know it is unlikely that the same designer dress she is purchasing will show up at the social event she is attending. On the other end of the spectrum, if a discounter wants to buy 50 dozen of one style garment in specific prepacked sizes and colors, the vendor prepacks the colors. With prepacked colors, some of these colors may not coordinate with the retailer's merchandise mix. The vendor offering these prepacked goods is also not right for this retailer.

Cooperative Advertising and Promotional Aids

To control the company and fashion image as well as to promote the seasonal line, many vendors develop television, radio, newspaper, mailers, and other types of media advertisements to communicate with the target consumer. Many times the vendor invites the retailer either to use the advertisement as created by the vendor or allows the vendor to tag on to the ad. Both the vendor and the retailer contribute to paying for the ad. This type of advertisement is called **cooperative advertising.** Most of the time a vendor places stipulations, such

as the size of the ad, the day to present the ad, or in what type of media the ad is to be presented, for payment of the advertisement. Or the retailer will have to send in a tear page of the ad to be approved before it can be run in the newspaper or other medium. The vendor may also require that no other brands of merchandise be presented in the ad or that the ad include only that vendor's product classifications.

Some vendors create promotional aids for special store events in hopes of selling-in more goods to the retailer and in aiding the retailer to sell-thru more goods to the target consumer. Many times these advertisements and promotional aids entice the retail buyer to purchase an additional amount of goods or to select product classifications not formerly purchased from the manufacturer. However, a retail buyer should never purchase more merchandise than needed or select merchandise that is questionable as to its salability to obtain the cooperative advertising or promotional aids. This arrangement should be a win-win arrangement for both the retailer and the vendor.

Quality of Products

Target consumers shop certain retail establishments in expectations of finding a specific level of quality not only in products but also in customer service and company image. Consumers often use a brand name as a shortcut for determining the level of quality of the merchandise. Buyers also use brand names, showroom image, expertise of account executives, and examinations of the samples to judge quality of the product (see Figure 15.19). A vendor is expected to ship constantly a consistent quality of product so that both the retailer and the target consumer recognize the value for the retail price charged. Goods that do not meet quality standards of either the retail buyer or the target consumer or both make for unhappy customers, returns to the retailer, and eventually returns to the vendor. Vendors that do not monitor quality of their product many times have higher return-of-goods percentages and eventually lose good retail clients. The retailer must carefully select the vendor that will provide the right quality for the target consumer and constantly monitor quality consistency and quality level of a vendor's goods to provide the right merchandise for the retail customer.

Availability of Reorder

For some retailers, one of the most important criteria for selecting a vendor is that of the reorder availability of quick-selling items or SKUs. Items that sell quickly need to be replaced quickly, especially if they are seasonal fashion items. Some manufacturers only cut and sew what the retail client orders in the initial order and, after that initial order, they stop producing or sourcing that particular item in order to add production of new items during the current season, to maintain low levels of inventory, or to begin production of the next season. However, some retail buyers cannot place a large initial order due to limited open-to-buy or do not place a large initial order because they wish to

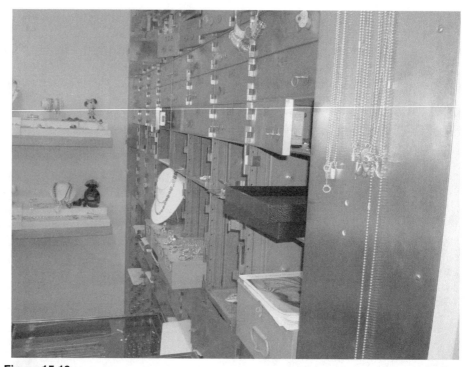

Figure 15.19
Inside the vault is an exciting way to display jewelry in a showroom.
(Courtesy of 10 eleven Showroom)

test the product in-store before buying large quantities. Therefore, these buyers or merchandisers search for vendors that can supply reorders of best-selling SKUs throughout the season. For example, when this author was a specialty store buyer, she selected one particular vendor because the manufacturer could ship reorders of seasonal goods. Each Monday morning an order was placed for specific styles of garments in specific sizes and in specific colors. These orders were usually received in the store by the next Thursday. The initial order was only a third of the total sales volume that the retailer purchased from the vendor. When an item is hot and is selling at a rapid rate, the buyer needs to replace goods that have sold at regular price to maintain the planned markup percentage as well as control the planned markdown dollars.

Vendor Return Policies

It is very important that the retail buyer has a clear **return policy** agreement with the vendor so that damaged, late delivered goods, poor quality merchandise, or items incorrectly shipped or not ordered may be returned to the vendor. Each vendor has its own return policy that the retailer must adhere to (see Figure 15.20). However, some vendors are more lenient than others on the

Figure 15.20
Vendor policies can be negotiated at the showroom's main desk.
(Courtesy of Cohen Showroom Inc.)

timing of the return, reason for the return, and the amount that may be charged back to the vendor for the merchandise. Vendors that refuse legitimate returns (i.e., poor quality or damaged goods, late deliveries, incorrectly shipped items) because of time limitations or other limited stipulations make it very difficult for the retail buyer to buy the goods. Thousands of dollars of merchandise are legitimately returned by the retailer to the vendor every year. Many retailers have been forced to drop vendors, that otherwise have high ratings, due to the vendor's refusal to accept returns. In contrast, some major retailers have taken advantage of their key vendors and have returned goods without adequate reasons or cause, thus causing the vendor to lose both profit and sales volume.

One aspect of return policies that has received extensive review since the 1980s is the use of chargebacks or markdown allowances. **Chargebacks** are

dollar amounts that a retailer requires the vendor to pay because of losses the retailer took when merchandise had to be marked down and was not sold at full price with a full markup (O'Donald, 2007). To calculate chargebacks, the retailer reduces the amount owed to the vendor for merchandise or, in some cases, bills the vendor for costs the retailer incurred to make the vendor share the risks of selling to the consumer.

Chargebacks and other allowances are part of a bigger issue of vendor compliance. These fees can also be claimed by retailers for mistakes that the vendor makes, such as late deliveries, incorrectly marked merchandise, errors in packaging, and shipments that lack promised variety and/or volume of merchandise. In each of these instances the retailer is not going to have the full planned assortment of merchandise to sell at the proper point. Some of these vendor errors can cause harm, such as improper packaging that causes mechanical failures (e.g., hangers jamming in conveyor belts) in a retailer's distribution center. Merchandisers must track these expenses carefully. Decisions on what and how much to charge back to the vendor should be part of the formal contract made at the time of merchandise purchase (Barry, 2006). In addition, vendors will want to track these errors to remove their causes and reduce their costs.

Most vendors do set time limitations in which the goods may be returned. For example, calculating from the shipping date of the goods to the time the retailer writes a return request form and sends to the vendor, many vendors allow only six weeks. Sometimes this short time span does not allow enough time for the retailer to inspect the goods for quality or defects. For example, when this author was a retail buyer, she worked with a bridge vendor that refused to take back several expensive damaged blazers because the time limitation of six weeks from shipping had elapsed. Although this vendor shipped on time and had fashionable merchandise that the target consumer wanted, the return rate was so high for that particular season, the buyer realized no profit for the line. Most retail buyers calculate the **return rate percentage,** or the number of returns in relation to the amount of merchandise purchased, for each vendor and for each product classification by vendor. Additionally, it is wise for all buyers to take note of any stipulations with regard to the vendor's return policies when placing orders with the vendor.

On-Time Deliveries

For every purchase order, the buyer or merchandiser designates the shipping dates, especially the begin shipping date and the cancellation date. **Cancellation dates** are needed so buyers can refuse shipments that arrive too late to be of interest to the retailer's target consumer. Buyers must plan delivery dates for all shipments to maintain a continuous flow of merchandise into the retail establishment, to assure freshness of the merchandise mix, to provide a variety of selection for the consumer, to prevent overbought situations, and to maintain a cash flow for the retail firm. Late deliveries can become the nightmare of a buyer, especially if the merchandise is in an

advertisement or featured for a special promotion or event. Additionally, if items in a coordinated grouping are shipped separately at different dates, the entire grouping may not sell at regular or full price because the total assortment is not in the store together. If an expensive blazer, pant, and skirt are shipped without the coordinating blouses, tops, and sweaters, many times the entire grouping falls into the markdown category. If there are no **fillers,** or blouses, tops, or sweaters to coordinate with the **hard pieces,** such as the blazers and jackets, many consumers will not purchase any of the available merchandise at full price.

In addition, the late delivery of one product classification may have a negative ripple effect on other products. Other related merchandise classifications may not sell as well if related items are not shipped in a timely manner. For example, when this author was a retailer buyer, she ordered beautiful wool blazers to coordinate with all bottoms in the contemporary department. Not one blazer was shipped by the vendor; therefore, the entire season for the contemporary department was a disaster. Many of the bottoms, blouses, and accessories did not sell because there were no coordinating hard pieces to sell with these items. Not only did the department not meet planned sales, but it also had high markdowns and a huge loss in profit. To make matters worse, these circumstances impact the OTB for the department for the same season the next year. Vendors that deliver on time and that deliver complete orders are usually more successful in being selected for the buyer's Retail/Vendor Matrix listing.

There are many criteria that retailers use for evaluating vendor performance. Usually, a combination of factors determine vendor selection. Each retailer must establish its firm's criteria for evaluating vendors based on management philosophy, successfulness of meeting planned sales and markdown goals, and ultimately the satisfaction of the target consumer (see Figure 15.21).

Writing Purchase Orders and Paying Invoices

Placing the merchandise order or actually **buying merchandise** is the end result of the procurement process for the retailer. Regardless if the order is written at market and the buyer **leaves paper** or **drops paper** or if the buyer returns back to his or her office after the market trip to "write the order," it is most important that buyers evaluate and compare vendor resources to assure a balance of merchandise for building the merchandise assortments and completing the merchandise mix. From these evaluations, the buyer then selects specific product classifications and specific SKUs in select styles, colors, and sizes from specific vendors. Many buyers now place their orders via the computer with direct data entry or e-mail attachment. Regardless of the method used for buying when selecting merchandise, the buyer develops a cohesive package or merchandise

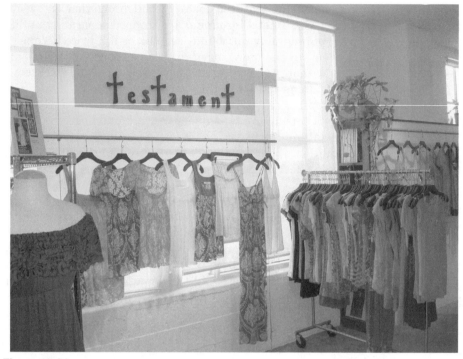

Figure 15.21
Having a concise product line is one criteria buyers use in evaluating vendors.
(Courtesy of Cohen Showroom Inc.)

mix that reflects fashion trend direction, including current fashion themes, styles/silhouettes, color palettes, fabrications, and patterns and graphics, which should all be consistent with the planning done when developing the assortment plan.

Some retailers have their own forms for the **purchase order (PO)** or **order copy,** and all orders must be written using the format created by the retail organization; other buyers use order copies provided by the vendor (see Figure 15.22). Writing orders is one of the most important responsibilities of the buyer. A purchase order is written and signed by the buyer and received and acknowledged by the vendor with a **written acknowledgment form.** It is a legal agreement; therefore, the buyer must include specific, accurate, and exact information when ordering merchandise. All order copies have the retail company's name and address so the vendor will know where to send the invoice and a shipping address so the vendor knows where and to whom to ship the ordered merchandise. Additionally, all order copies have a column for each of the following purposes: listing the style number, description of that style number as to color and silhouette features of the product classification, sizes ordered, quantity of each SKU, cost of each SKU, total cost dollars for all of the same SKU, retail price of each SKU, and total retail dollars for all of the same

						P. O. Number:			

Bill To — Retail Company / Corporate Headquarters / Street Address / City, State, Zip

Ship To — Retail Store / Big Mall / Mall Street Address / City, State, Zip

Do not ship without authorization after cancellation date shown

Buyer: _____

Delivery Date: _____

Cancellation Date: _____

Source: _____

Address: _____

City, State, Zip: _____

Country: _____

Insure for full value ☐
Do not insure ☐

Order Date	Season: ☐ Reorder: ☐ Special: ☐	Terms Dating:				Ok to preship with dating ☐	Do not preship ☐	Ship Via	FOB	Dept
Style number	Style Description	Color		Sizes		Quantity	Unit Cost	Total Cost	Retail Price	Total Retail

Figure 15.22
Purchase order form.

SKU. A column for total costs and one for total retail dollars for each SKU are added to calculate the total cost dollars and retail dollars purchased on the order copy.

Style numbers for a PO are an absolute must. They are the identifier for the SKU and used to track the product from shipping through sales to the final consumer, and beyond for sell-in and sell-thru analysis. The style number for the retailer contains the vendor style number (i.e., vender identifier for the SKU) plus additional numbers added by the retailer to indicate the color code and size of the item (see Chapter 12 for more information on style numbers).

As orders are placed, the buyer must continually keep track of OTB. The totals on each PO must be subtracted by the buyer from his or her planned OTB for a specific delivery period to determine the amount, if any, of OTB remaining. Also, the initial markup on the order is calculated using these totals. Usually on the back of the order, the retailer lists shipping specifications, penalties incurred by the vendor if not following those shipping specifications, and other company-specific requirements, such as markings or identifications on the boxes for routing the contents inside the boxes to various doors or rooftops of the retail group or for accepting the merchandise in the distribution center.

Additionally, on the front or face of the order copy, the retailer has a space to specify the delivery information (i.e., begin shipping and end shipping or

cancellation dates), the terms of the order (i.e., discounts and dating), and other specified negotiated items between the vendor and the retailer. After placing the order and when receiving acknowledgment, the retailer must always match the written purchase order requirements to those on the written order acknowledgment from the vendor. If there is a discrepancy, the retailer must contact the vendor immediately to negotiate for the wanted requirements or maybe even cancel the order if a solution cannot be reached between the two parties (i.e., vendor and retailer).

When the merchandise is shipped, the vendor sends the **invoice,** or bill, for the goods to the retailer. The invoice contains style numbers, style descriptions, sizes, and quantities plus the wholesale costs. Shipping and insurance are also delineated. If the invoice is sent directly to a billing department, a **packing invoice** or **packing slip** is added on or inside the shipping carton (see Figure 15.23). The packing slip contains the same information as the invoice, except costs are not listed. After the retail firm's receiving room personnel **check in the merchandise,** or match the merchandise (i.e., style, color, size, costs) that comes in the boxes from the vendor to what was ordered on the purchase order, the finance division must match what was received on that purchase order to the same items billed on the invoice. Although buyers do not usually remit or pay those invoices, many times they must work with finance personnel in troubleshooting problem in-

Source:	Manufacturing Company		Ship To	Retail Store: _____
Address:	XX Broadway			Address: _____
City, State, Zip: New York, New York 10018				City, State, Zip: _____
Country:	USA			Country: _____

Customer P.O.	Store		Department		Shipped via			
Style number	Style Description	Color		Sizes				Quantity
Special Notes:								Total Quantity:

Figure 15.23
Packing invoice form: provides style number with quantities without prices.

voices, in determining substitutions, or in locating shipment shortages. For developing good vendor/buyer relationships and for assisting the financial division in remitting invoices in a timely manner to receive the available cash discounts, the buyer or merchandiser must be familiar with the vendor's payment policies.

Because the vendor must purchase the fabric and other product components sometimes six to eight months in advance of shipping that final finished product to the retailer, the vendor usually works with an outside source to secure money for operating expenses to create a steady cash flow for the company. The organization that supplies the operating capital and becomes the credit and collection division for the vendor is called a **factor.** Vendors sell the retail buyers' orders to the factors for a percentage of the value of the order copy. When the merchandise is received by the retailer (or at another date determined by terms), the retailer must **remit,** or pay the amount of the invoice to the factor, instead of the vendor from which the merchandise was purchased. It is very important that the retailer maintains a good relationship with the factor because the factor may have the final decision as to whether or not the manufacturer may ship merchandise to the retailer. The factor is the party that takes the credit risk; thus, for assuming this risk, the factor charges the vendor a fee plus interest on money that the manufacturer borrowed. Factors not only handle domestic manufacturing accounts; they also manage international sourcing throughout the globe.

Negotiating with Vendors

Vendor negotiations involve discussion and agreement between the buyer and the vendor on at least three main issues, which include (1) a reduction in the wholesale cost of goods, (2) terms or discounts and dating, and (3) payment of transportation charges (see Figure 15.24). Other issues that might be negotiated include securing cooperative advertising monies and promotional aids, determining the amount of merchandise to be purchased to buy the seasonal line, and securing exclusivity of merchandise for a specific retailer. Each retailer experiments to determine which of these issues are the most important for the operation of a profitable, successful business. Skillful negotiations are important because the cost of goods is one of the largest expenditures, in addition to employee salaries and markdowns, that the retailer must control to make profit or to impact the bottom line. Terms of the purchase order and the payment of transportation costs many times impact the profit margin of the retailer. Only the three major reasons for negotiation are discussed in this section because other issues involving vendor relations have been addressed in vendor selection criteria.

Reduction in Wholesale Cost of Goods

Buyers negotiate with vendors for the cost of goods to assure their retailer will achieve the planned initial markup, maintained markup, gross margin, and

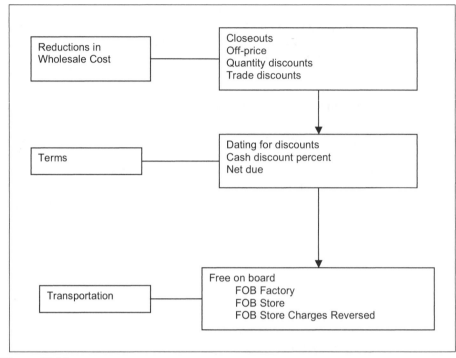

Figure 15.24
Items for vendor negotiations.

profit. Vendors shave, or reduce, the cost of goods according to how quickly they wish to sell the merchandise, how important the account is to the vendor's current sales volume goals or the future sales potential of the account, and the time of the selling season or the product life cycle position of the merchandise. The buyer's desire to get the best price and the vendor's need to move the product may or may not merge at the same point when the buyer is negotiating the cost of goods.

As a starting point, an astute buyer must have some idea of the expected cost of goods and must know when to attempt negotiations for a reduction in price and when to be willing to pay the full price. For price changes, vendors offer a discount based on the quantity bought, the dollar amount of merchandise being purchased initially, or the time position of the vendor's selling period. Vendors usually ship merchandise before or at the very beginning of the retailer's selling season. By the time the retailer is at the peak selling point in a season, the vendor is already working with its next season's merchandise. While the vendor is attempting to ship the next season's merchandise to retailers before or early in the next retail selling period, the vendor is also trying to get rid of the old leftover inventory the retailer is currently selling. These goods in the industry are known as **closeouts,** the vendor's leftover or excess merchandise at the end of the vendor selling season. Closeouts are sold to the retailer at a

reduced cost. Based on the quantity and condition of these goods, many times the vendor offers these closeouts from 25% to 50% or even 60% off the wholesale cost. This reduction on end-of-the-season merchandise gives the retailer an opportunity for taking an additional initial markup, to sell present inventory at full price instead of reduced price, and/or the opportunity to reduce markdown dollars and percentages.

Seasonal discounts are usually offered to the retailer for ordering, purchasing, and/or receiving goods out of season. This assists the manufacturer in scheduling production, in reducing personnel problems, in sustaining employees with unique expertise, and with managing inventory. These seasonal goods may be new prophetic merchandise that is accepted by the retailer before the beginning of or very early in the retail selling season; goods shipped **off-price,** or at a reduced cost, during the peak of the retail selling season; or closeout goods shipped near or at the end of the retail selling season. Therefore, depending on the time of shipping and the reduction in the cost of goods, these goods may be first-quality, distressed, damaged or returned goods, and/or closeouts.

Retailers negotiate for the quoted cost of goods, regardless of the time of the placement of the orders, the delivery date of the goods, or the condition or quality of the merchandise. The initial cost of goods depends on the classification of the product, the quality of the merchandise, the zone in which the merchandise is positioned, its position in the Buying-Selling Curve, and the quantity purchased.

Terms

One of the most important items the retail buyer can negotiate with the vendor is that of the terms of the order. Because these terms affect the cost of goods for the retailer, it behooves the buyer to negotiate the best terms available but within legal trade regulations set by the state and federal government in which the company operates.

Discounts are really added profit for the retailer; therefore, buyers usually receive bonuses or other perks for negotiating the "best" wholesale cost per SKU. There are three major types of discounts offered the retail buyer: quantity, trade, and cash. **Quantity discounts** (i.e., patronage discounts) are a reduction of wholesale cost price for buying a specified larger number of units for a product classification or SKU and are offered to the buyer so he or she will buy more units of the product classification or SKU and continue to patronize the vendor. In other words, the buyer who can purchase the larger quantity of merchandise is rewarded for buying in larger quantities. Quantity discounts should benefit both the manufacturer and the retailer. The manufacturer can save money on handling, shipping, and even manufacturing costs because the product is produced in a larger quantity and the cost per unit is usually less. The retailer benefits in the reduction of the cost of goods but must make sure the product classification and the quantity purchased fit the merchandise plan and are wanted by the target consumer at the price offered. Quantity discounts are deducted by the vendor before any other discounts are deducted and regardless of when the invoice is paid.

A **trade discount** (i.e., functional discount) is a **series of discounts** that are deducted from the vendor's list price. Sometimes this list price features retail prices or higher cost prices because the vendor displays the merchandise in a catalog for everyone to view. Trade discounts are not the same as quantity discounts. The amount of the discount may depend on whether the purchaser is a wholesaler, retailer, interior designer, or other type of business that resells product. Also, the function of the buyer or the services that the vendor performs for the buyer may impact the quantity of merchandise purchased. For example, the vendor may render services such as placing the products on specialized hangers, securing hangtags with small brass safety pins, or bagging each individual item.

Trade discounts are offered in a series of percentages, such as 25%, 10%, and 5%. The series of discounts taken from the vendor's list price may not be added together to form one discount, nor may the discounts be rearranged to form a different series of the discounts. Each discount has to be taken from the previous amount or remaining balance after the discount is taken and before applying the next discount. For example, the retail buyer who purchases decorative pillows for the store's home furnishings department will pay more at the wholesale cost for each unit of the pillow than the wholesaler who purchases the same pillows; and the exporter who purchases those same pillows will probably get an additional discount for distributing the manufacturer's product in the international market. Because the wholesaler will resell the pillows, the wholesaler may not require the vendor to package the merchandise for shipping in the same manner as the retailer. The wholesaler may receive many pillows packaged loosely into large cartons, and the retailer may require that each pillow be bagged separately before placing a few pillows in smaller cartons. Or, the exporter may not require a specific color range or fiber blend for the pillows, whereas the retailer wants only a few pillows in the top five colors. The retail buyer may receive a 5% discount on her or his purchase, the wholesaler may receive not only the 5% discount but also an additional 10% discount and finally the exporter may receive the 5% discount, the 10% discount plus an additional 20% discount. Thus the discounts for the exporter would be listed as 5%, 10%, and 20%.

If the pillow was purchased at the wholesale cost of $50, and the discounts were deducted in a series of increments of 5%, 10%, and 20%, the calculations in Figure 15.25 show how the list price is adjusted for the various discounts and how the wholesale cost or purchase price differs for each of the three buyers. The retail buyer with one discount has the highest cost, and the exporter with three series discounts has the lowest purchase price.

Cash discounts, or a reduction in the wholesale costs of goods for paying the bill or invoice as specified by the terms on the order copy, is a standard in the industry, especially for the children's and women's wear markets. Cash discounts do not mean the retailer must pay the invoice in cash but rather that if the invoice is paid within a specified time, the discount may be taken by the retailer. Cash discounts and time or date of payment are included in the terms

	Retailer's Discount and Wholesale Cost	Wholesaler's Discounts and Purchase Price	Exporter's Discounts and Purchase Price
List Price	$50.00	$50.00	$50.00
Discounts Offered			
5%	$2.50	$2.50	$2.50
10%	n/a	$4.75	$4.75
20%	n/a	n/a	$8.55
Total Paid	$47.50	$42.75	$34.20

Figure 15.25
Series discounts offered for various FTAR companies.

written on the order copy. The common standard of cash discounts terms for the women's wear industry is 8/10 EOM. In addition to EOM, other types of dating includes "X Dating," "as of dating," ROG, and COD (see Table 15.1).

The EOM, or another dating term, is the dating or the time when the cash discount period begins. The date of the invoice is very important when calculating cash discounts. The date of the invoice is usually the date the merchandise was shipped; thus the retailer has time to receive, check in, and place the merchandise on the selling floor before the invoice must be paid. The number "8" in the terms designates that the retailer may deduct 8% from the billed gross wholesale cost of goods on the invoice; however, this does not include a reduction on the shipping costs and insurance costs. The number "10" indicates the number of days from the end of the month in which the invoice is dated and the bill is due and must be paid for the retailer to receive the discount. With the example of the 8/10 EOM terms, the "10" is read as 10 days from the end of the month in which the invoice is dated, regardless of how many days are in that particular month.

For an invoice with the terms of 8/10 EOM dated January 15, with a billed gross wholesale cost of $1000.00 for cost of goods, a charge of $10.00 for shipping, and a charge of $3.95 for insurance, the calculations in Figure 15.26 determine how much money the retailer would have to remit or pay to the vendor.

Another term used frequently in the industry is Net, or "N" with a number. **Net** means there is no discount and the full amount is due. In the menswear industry, this term is used frequently; however, it is usually followed by 30, 60, 90, or 120. These numbers indicate the number of days from the date of the invoice that the retailer has to pay, yet no discount may be taken. When using this dating, the retailer may have time enough to receive the goods and sell the

Dating Term	Explanation of Dating Term	Written as . . .	Cash Discount Day for Invoice, January 15, and Receipt of Goods, February 2	Used When . . .
EOM	End of the month: The dating starts at the end of the month in which the invoice is dated. Invoices dated from the 1st to the 25th day of the month must be paid during the next month. For invoices dated the 26th to the 31st days, the retailer is given an additional month for dating.	8/10 EOM	January 15 → January 31 + 10 days = February 10 *(if invoice was dated January 26th or later)* January 15 → February 28 + 10 days = March 10	vendor and customer have standard industry situations.
X Dating	Extra dating: extended beyond the standard cash discount days.	8/10-40	January 15 + 50 days (10 + 40) = March 5	vendors wish to ship goods early or out of season, this type of dating is used to tempt the retailer into taking the early delivery dates. retailer needs time to sell the goods before paying.
	With no additional dating information the dating starts with the invoice date.	8/10	January 15 + 10 days = January 25	vendor is working with a new and untested customer.
as of	The payment date or dating is calculated from the "as of" date on the invoice and not from the date of the invoice or the receipt of goods into store date.	8/10 "as of" March 10	March 10 + 10 days = March 20	vendors are at a great distance from customers, the product has a long development time, or the manufacturer does not know how long the shipping process will take.
ROG	Receipt of goods: The retailer has ten days after the goods are received into the store.	8/10 ROG	February 2 + 10 days = February 12	vendors are at a great distance from customers or shipping time is uncertain.
COD	Cash on delivery: The retailer receives no discounts and must pay when goods are delivered.	COD	February 2	the customer has not been certified for credit or has a poor credit rating.

Invoice Cost of Goods	$1000.00	
−Cash Discount of 8.00%	− 80.00	($1000.00 × .08)
Remit for Goods	$ 910.00	
+ Shipping Charges	10.00	
+ Insurance Charges	3.95	
Total of Invoice	$ 923.95	

Figure 15.26
Example of a calculation for total invoice.

goods before the invoice is due. If terms on the invoice are written as 2 / 10, Net (N), most vendors assume the net is automatically 30 days. If the retailer fails to pay beyond the net date, a penalty or carrying charges may be added by the vendor to the invoice.

Although the order writing process is tedious, laborious, and time consuming, the buyer must make sure that all items on the purchase orders are accurate and complete. The merchandising assistants or assistant and associate buyers often write orders following the instructions of the head buyer; however, the head buyer is still responsible for the accuracy and completeness of the buying process. Because cash discounts are used as a profit cushion by the retailer, it is imperative that the buyer negotiate the best terms possible. Many specialty store retailers save enough money by paying their bills on time to pay their rent or buy other needed merchandise.

Transportation Charges

Transportation costs increase the billed wholesale costs of the merchandise. Many times transportation costs can add from 2% to 5% to the cost of goods. Therefore, many retail buyers or merchandisers negotiate who pays for the transportation charges. Transportation charges are determined based on the time at which the title of the goods passes from the vendor to the retailer. The transportation terms of **free on board (FOB)** indicate when that title passes from the vendor to the retailer. **FOB Factory** indicates that the title of the goods passes to the retailer at the factory loading dock and the retailer must pay transportation charges and insurance costs (see Figure 15.27). **FOB Store** or **FOB Retail** indicates that the title of the goods passes to the retail company at the retailer's receiving dock

	Who Has Title during Transit	Who Pays for Transportation	Who Pays for Insurance
FOB Factory	Retailer	Retailer	Retailer
FOB Store	Manufacturer	Manufacturer	Manufacturer
FOB Store Charges Reversal	Manufacturer	Manufacturer— reimbursed by retailer	Manufacturer— reimbursed by retailer

Figure 15.27
Terms of payment for transportation.

(e.g., store loading dock, warehouse) and the vendor pays transportation charges including the insurance. If the vendor offers this type of shipping to one retail client, it must offer to pay the freight and insurance on shipments for all clients. However, the most prevalent system used today to compensate for shipping charges is that of **FOB Store Charges Reversal.** The vendor ships the goods and assumes the liability of freight and insurance; later, the retail company (more commonly called *the store*) reimburses the vendor for all shipping and insurance charges when the invoice is paid. The title of the goods passes to the retailer at the retailer's receiving dock. If a retailer is located at a great distance from the vendor, many times the retailer may negotiate the costs of shipping or may ask the vendor to pay a portion of the shipping costs. If the vendor is located at a great distance from the retailer and is late in shipping the ordered goods, the vendor may ship by air freight, which is very expensive, and pay the freight in order to keep the retail account. In a highly competitive retail environment, few vendors will pay for freight charges.

Vendor Relationships

In a competitive market environment, retailers must build sound vendor relationships with major vendors. In fact, all key players in the FTAR Supply Chain should communicate, collaborate, and even form alliances or partnerships. "A **partnership** is: A balanced sharing of business systems, information, risks and any other elements to effectively and efficiently meet the demands of the mutually targeted consumers" (Lewis, 1996). Traditionally, FTAR Supply Chain members did not share business information, nor did many of them trust the other members of the supply chain to assist them in driving a successful

business. However, it is imperative that retailers share figures on sales, mark-downs, and other business information not only with the vendor that supplied the merchandise but also with other suppliers such as fabric mills and fiber producers that are upstream in the supply chain. At each supply chain level, a value-added component should be added to the product to cause the end consumer to purchase more merchandise, more often from the same retail establishment. A seamless supply chain with cooperating vendors and customers may become a competitive advantage for all of the businesses participating to deliver the end product to the end consumer.

For example, a children's wear manufacturer created an alliance composed of one of its major knit fabric suppliers, the children's wear company, and its major retail clients. To create a smooth working relationship, a cooperative environment and a successful business partnership for all supply chain members, management of the children's wear firm provided in its company headquarters an office for an account executive of the knit fabric supplier; however, this employee was provided compensation (i.e., salary) by the knit fabric supplier. The account executive could talk directly to the designers, merchandisers, and other key personnel of the apparel firm to provide the right fabric at the right time in the right color, pattern, and weight. Additionally, the account executive could talk directly to the retail clients to troubleshoot any problem returns or to track consumer demand and selling patterns. This type of working relationship was a win-win-win situation for the knit fabric mill, the apparel company, and the retail clients.

This example is an ideal scenario, which does not usually happen often in today's competitive environment. However, with retailers requiring exclusive lines for their retail businesses and contracting with nationally known branded manufacturers to produce private label for them, retailers must share sales and other financial information and must also trust the manufacturer to accept more responsibility for product development and for management, distribution, and marketing of the product to the point of sale of the retailer (Lewis, 1996). The retailer must have a good working relationship with major vendors to negotiate the best initial prices, the best terms, and the best closeout or off-price assortments and purchases available in the market. The retailer and the vendor should work as partners, not adversaries, in the negotiations.

Developing good vendor relationships is imperative for the retail buyer, who must maintain a professional business relationship with vendors. Throughout the procuring and buying process, the buyer needs to contact the vendor often to check on the status of deliveries, to obtain permission for return of goods, to secure exclusive merchandise and/or distribution of exclusive branded goods, and to be offered special cuts, off-price, or closeouts before the competition. Some vendors are now working closely with retailers to track performance of merchandise classifications by retail door and then supplying the merchandise assortment that delivers the highest sales volume at regular price with the fewest markdowns and the highest profit margins at each door (McDonald, 2005). With today's technology, all members of the supply chain can share the right information to deliver the right product at the right time in the right quantities at the right place and at the right price to the right consumer.

Summary

Shopping the market is hard work. Organizing the market trip, searching for, evaluating, and selecting the right merchandise in the right quantities to be delivered at the right time into the retail store or in time for delivery from a catalog or Web site order is an awesome task. Selecting the most profitable vendors and negotiating for the best costs, terms, and shipping can sometimes become very stressful. The market trip might sound glamorous, but the grueling schedule, lack of rest, and the rigor of travel place great demand and stress on buyers and merchandisers. There is no more exciting event than attending market week, going from showroom to showroom to view trendy seasonal product lines or previewing fashion shows and attending seminars. However, when the buyer or merchandiser returns to the retail firm, all of the work at market must be translated into merchandise and happenings in the retail store, in the catalog, or on the Web site that result in planned sales volumes and profit margins.

Key Terms

Affiliated buying office
AmericasMart
Buying merchandise
Buying office
California Market Center (CMC)
Cancellation dates
Cash discounts
Chambre Syndicale de la Haute Couture
Chargeback
Check in the merchandise
Closeouts
Company-owned buying office
Cooperative advertising
Corporate owned buying office
Dallas Market Center (DMC)
Dating
Discounts
Drops paper
Factor
Fashion Avenue
Fashion center
Fashion weeks

Fédération Française de la Couture
Filler
FOB Factory
FOB Retail
FOB Store
FOB Store Charges Reversal
Free on board (FOB)
Garment district
Hard pieces
Independent buying office
Invoice
Key vendors (shopping)
Leaves paper
Locations (shopping)
MAGIC
Market center
Market selection
Market week plan
Market weeks
Marts
Net
Off-price
Order copy
Packing invoice

Packing slip
Partnership
Prepacked
Private label product development
Procuring merchandise
Product classification (shopping)
Purchase order (PO)
Quantity discounts
Regional fashion centers
Remit
Return policy
Return rate percentage
Series of discounts
Seventh Avenue
Shopping the market
Showrooms
Specification buying
Terms
Trade discount
Vendor negotiations
Virtual buying
World Market Center
Written acknowledgment form

Review Questions

1. How does the retail buyer shop the market efficiently and effectively?
2. What are the major market centers?
3. What is the importance of each major market center to the buyer when procuring merchandise?
4. What are the major techniques for shopping the market?
5. What are the major criteria that the buyer uses for vendor selection?
6. What does the buyer have to include on a purchase order?
7. What is the difference between an invoice and a purchase order?
8. What elements of the purchase and sale should be negotiated with vendors?
9. What are four methods of billing for transportation?
10. How does a buyer build a sound vendor relationship?

References

About the CMC. (2007). The California Market Center. Retrieved August 8, 2007, from www.californiamarketcenter.com

About Us. (2007). AmericasMart. Retrieved August 8, 2007, from www.americasmart.com

Armbruster, W. (2007, February 26). A passion for fashion: DHL says sponsorship of Fashion Week will broaden its ties with designers, manufacturers and retailers. *Shipping Digest,* n.p.

Barry, C. (2006, August). Keeping vendors compliant. *Multi-Channel Merchant, 23*(8), 1.

Drier, M., & McGuinness, D. (2007, July 9). The wild west; a creative center develops with an eye for business. *Women's Wear Daily,* p. 2S.

Epiro, S. (2007, July 24). White adds men's wear for Jan. *Women's Wear Daily,* p. 14.

Feitelberg, R. (2007, July 13). The Fashion Calendar hitting web next week. *Women's Wear Daily,* p. 20.

Gogoi, P. (2005, August 11). The serious cachet of "Secret Brands." *BusinessWeek.* Retrieved August 11, 2005, from www.businessweek.com

Kapner, S. (2006, September 12). Model recovery—IMG brings profit back into fashion. *New York Post,* p. 41.

Karimzadeh, M., & Feitelberg, R. (2007). Show dates pressure: An earlier N.Y. calendar creates designer angst. *Women's Wear Daily,* p. 1.

Lewis, R. (1996, May). Consumer response: Partnership paradox. *Daily News Record Supplement—DNRinfotracs.,* (suppl), 30–31.

McDonald, M. (2005, September 27). The impact of change on business. Paper presented as part of the Executive-in-Residence Program. North Carolina State University, Raleigh, NC.

Medina, M. (2007, March 14). Back to downtown: Runway branches out. *Women's Wear Daily,* p. 7.

O'Donald, V. (2007). Saks settles vendor lawsuits: Retailer was accused of forcing suppliers to share in markdowns. *Wall Street Journal, Eastern Edition,* p. B4.

SME signs five-year Fashion Council deal. (2007, March 7). *Marketing Event,* p. 6.

Tout savoir sur la Fédération. (2007). Mode à Paris. Retrieved June 19, 2007, from www.modeaparis.com

Wilson, B. (2007, June 27). Chicago fashion week seeks to elevate city's style. *Women's Wear Daily,* p. 8.

chapter
16

Retail Buyers Translate Market Findings

Objectives

After completing this chapter, the student will be able to

- Identify the purpose of several marketing communication tools: presentation, promotion, publicity, and packaging
- Select appropriate presentation techniques for a FTAR company
- Relate the presentation tools to the company image
- Define the steps in preparing a presentation that highlights the company's image
- Identify the components of store environment
- Discuss store environment relative to store image
- Explain how the 3 × 3 Merchandise Presentation can be used for any FTAR company
- Itemize activities used in promotions with an explanation of why each activity is used
- Explain the difference between publicity and public relations
- Discuss the importance of packaging attributes to a consumer-centric company

Introduction

Raw materials producers, apparel manufacturing companies, and retailers organized with a consumer-centric organizational structure stress using the 10 P's of marketing tools, including the lesser known P's of presentation, promotion, publicity, and packaging, when doing business in today's global economy and highly competitive marketplace. With a better educated, more sophisticated target consumer demanding more information, in less time, in an entertaining and friendly-user retail environment, the retailer has found that as much as 30% of the store's sales volume can be impacted by appropriate and well-planned presentation techniques. All divisions/departments within the manufacturing or production firm work as a team and implement presentation and promotional techniques to produce the seasonal line for the company, whether the line contains new fibers, new fabric, or new finished sewn products. And all divisions/departments in the retail store also work as a team to present the company's products and services in the best format to reach the firm's target consumer most efficiently and effectively. Additionally, company divisions/departments from the various links of the FTAR Supply Chain must work together to market product to the customers or companies within the chain as well as to the target consumer.

Presenting, Promoting, Publicizing, and Packaging the Image

Businesses, whether operating as fiber and fabric producers, apparel manufacturers, brick-and-mortar retailers, Internet entities, or catalog companies, manipulate company cues to build both a visual and mental perception of the company and its products in the minds of their clients or target consumers. The marketing mix (e.g., the company's interpretation of the 10 P's) developed as a result of the Strategic Marketing Process sets the stage for the details needed to answer "How do we get there?" (see Chapter 2). The marketing mix gives direction to the major planning tool for presentations, promotions, publicity, and packaging—the **promotional mix** (i.e., advertising; special events and promotions; visual merchandising, including display; fashion coordination; sales training; publicity) (see Figure 16.1). Combining, adjusting, and blending these promotion mix components becomes the **promotional image,** or the personality, character, or mental impression that the company, brand, or store represents to the customer for a specific product or for a specific event. For some products or events, the promotional image may be the same as the image or company image generated for a brand or the retail type (see Chapters 5 and 6). An example of this integrated promotional image is Nike, where the products, brand, store, and company are all part of a single image. In contrast, the promotional image may be similar, related, or very different from the company image. The various ads that Old Navy runs for its products has a central theme of fun and dance, but the products, the graphics, and other features of the promotional image varied with each promotion.

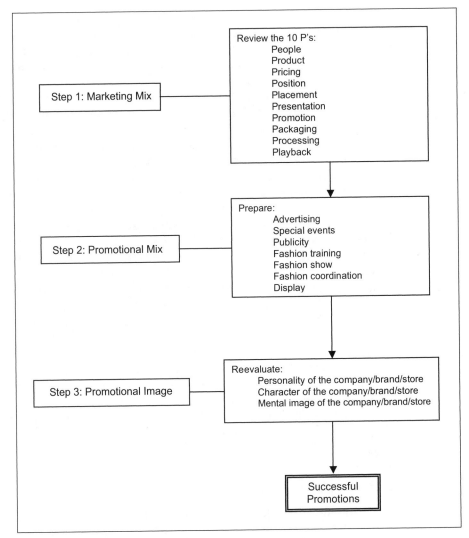

Figure 16.1
Development of successful promotions for a company, brand, or store.

Management must determine which cues used in the company image are the most useful for creating an effective environment for presentation and promotion of its products and services in order to communicate with its customers, maintain the patronage of those customers, and attract new customers. For example, an apparel manufacturer may select the cues of brand name, the logo for the company or product, the label, the hangtag, the color story/theme of the promotional materials, the merchandise itself, or the quality and zone positioning of the product as the most important attributes for promoting and presenting product.

An apparel firm that combined the most appropriate image cues to build not only a very profitable company but also an internationally renowned brand was Ruff Hewn. Two brothers and a marketing manager converted a contract operation into an apparel company by creating a fictitious historical character who was an American hero as well as a trained clothing designer. According to the story that was created, Barclay Ruffin Hewn "designed outfits for the Boy Scouts of America, which led to a design for the Rough Riders with whom he rode. During World War I, Ruff outfitted the Dough Boys for overseas duty. His was the first navy blazer. He designed army cloth. He improvised the original Olympic uniform and fashioned the first running shoe" (Paysour, 1987, p. B4).

Ruff Hewn became the prefect image for the brand. His biography was written on the hangtags and in brochures attached to the apparel, his picture was incorporated in retail display areas, and he wrote cover letters for press releases (Black, 1993). Although Ruff Hewn never existed, he lived in the minds of the retailers and their customers! The innovativeness of the approach combined with a quality product, a nostalgic setting within a planned shop concept, and the positioning of the apparel line as comfortable, classic, casual weekend wear created an image that sold the product ("Ruff Hewn: Capturing," 1991).

From the mid-1980s to mid-1990s, the company was very successful; however, with changes in company strategies, the name *Ruff Hewn* was sold to another apparel firm in the late 1990s (Black, 1993). Because images are products of popular culture and must appeal to customers, they must change, flex, and be retired as the cultural medium in which they exist and the customers who must be attracted are not stagnant but constantly changing. Thus the image of Ruff Hewn was used in the P's of presentation, promotion, publicity, and packaging for a successful marketing plan and then wisely retired when the culture supporting the image changed.

Presentation Techniques

In the later decades of the twentieth century, producers, manufacturers, and retailers neither placed a concentrated emphasis on presentation techniques nor allocated adequate budgets to support the presentation functions. However, in the twenty-first century with the highly competitive FTAR Complex, the use of the marketing tool presentation has become one of the most important techniques for creating and maintaining not only company or store image but also for organizing in-store merchandise presentations to attract the desired target consumer. Many industry experts, especially those in consumer-centric companies, believe a well-planned and aesthetically pleasing merchandise presentation is essential to doing business in today's competitive retail environment.

Merchandise presentation is the technique used by any firm to store, house, arrange, and promote merchandise categories while maximizing floor and wall space to build optimum sales potential. This technique is extremely important to the retailer, who must sell to thousands of consumers to be a profitable company. The techniques are also used by producers and manufacturers

in showrooms and trade show booths as they sell to their customers, the buyers. Presentation has become important at every level of the FTAR Complex, both for the individual company and for the company's industry partners.

Presentation is an organized manipulation of the image elements of signage, graphics, floor plan layout, decor, and fixturing, plus merchandise presentation and display to showcase specific product or merchandise classifications for sale to both internal and external customers of the business. **Display** is the technique of presenting select merchandise in a unique, dramatic, or sensational manner to excite, stimulate, and encourage consumer enthusiasm and interest plus retail sales. All links in the supply chain use this tool when building and positioning the brand, product, company, or store; when executing brand extensions; when establishing image for both the company and product; and when attempting to reach maximum sell-thru of product to the target customer. For example, the apparel manufacturer's seasonal product offerings must be visually presented at the company's National Sales Meetings to train account executives or sales representatives how to present and sell-in product lines to the retail buyer; also these product lines must be exhibited at industry trade shows (see Figure 16.2) and/or "romanced" in the manufacturer's market showroom to entice retail buyers or merchandisers to purchase more product.

Figure 16.2
Display at a trade show.
(Photographer: Laura Sampson)

Fiber and fabric manufacturers follow similar presentation techniques to entice product manufacturers to purchase these raw materials when making new products. And the retailer uses the presentation marketing tool for creating and maintaining a consistent and constant store and fashion image, for positioning the store and its products in specific channels of distribution, and for organizing in-store merchandise categories to maximize floor space for building optimum sales per square foot of selling space. According to Cotton Incorporated *Lifestyle Monitor*™ data (2001), 72% of women indicated they view store displays for fashion trend information, and another study indicated that 30% of consumers make purchasing decisions based on store displays.

Creating the Image through Presentation

Companies, including producers, manufacturers, and retailers, actuate four steps while manipulating the image components to establish the company, brand, product, or store presentation and image: profile the target consumer, develop a fashion image and merchandising policy, develop a sales environment, and plan a merchandise presentation (see Figure 16.3).

Profile the Target Consumer

When developing a strategic plan, the management in a company asks, "Where are we going?" As part of that discussion, the target customer is identified. This information becomes part of the marketing plan, and specific information about the target customer is detailed by the Marketing Division. Company personnel research the demographics and the psychographics of a population, as well as the lifestyles and life stages of that population (see Chapter 9). Population size, niche markets, and social attitudes that translate into consumer behavior and buying patterns are identified when analyzing these market segments. Each targeted market segment, whether the final consumer or an FTAR trading partner, must be addressed in marketing with methods and techniques that attract the attention of and have meaningful messages related to the needs and wants of both the company's customer and the final consumer group.

Develop a Fashion Image and Merchandising Policy

The **fashion image** of the raw materials producer, manufacturer, or retailer is one aspect of the company image and reflects the degree or level of fashion leadership the firm seeks to project in the marketplace. This fashion image is measured in relation to the stage of the Buying-Selling Curve that its products represent and the types of target consumers it attempts to attract. To develop the fashion image, a firm must first decide on the zone (i.e., designer, bridge, better, moderate, popular) in which it wishes to produce or stock product (see Figure 16.4). Additionally, the merchandise mix or assortment must be pinpointed and price ranges must be established to meet the expectations of the

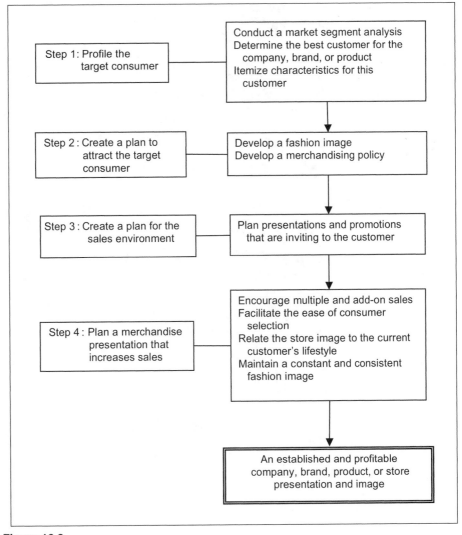

Figure 16.3
Steps to creating a profitable fashion image.

target consumer. And the standards of quality for the product assortment and the value system, or value-added attributes, built into the product must reflect the fashion level of the company.

Companies also must develop selling techniques that support the fashion image because customers have preconceived ideas of what to expect from the account executive or other customer service person employed by a raw materials producer or an apparel manufacturer, or the sales associates in a retail store. For example, a salesperson from a small wholesaler may travel from account to account and sell the product out of a garment bag or trunk, whereas the account

Figure 16.4
Designer zone merchandise reflects a fashion image.
(Courtesy of The Hosiery Association)

Figure 16.5
A showroom showcases the product.
(Courtesy of 10 eleven Showroom)

representative in other companies work in an elaborate showroom with beauti-
ful decor and tasty refreshments to showcase product (see Figure 16.5).

Once the fashion level is selected, the company must develop policies for
educating the target customer or the community with regard to the fashion sta-
tus of its products, brands, or store. For example, most consumers expect exclu-
sive specialty stores to provide more than adequate sales personnel to coordinate
up-to-date fashion ensembles. These consumers also look for upscale special
events, such as special trunk showings, fashion shows, or other educational sem-
inars, to "train the fashion eye" to detect new and futuristic trends.

While developing the fashion image of the company, the firm must simulta-
neously establish its **fashion merchandising policies,** or **merchandising
policies.** The merchandising policies provide direction on the implementation
of the promotion mix and are part of the merchandising plans set as a result of
the Strategic Planning Process (see Chapter 2). Policies give guidance on ac-
tivities that must always be included, colors or themes that are company stan-
dards, and other must-do or must-not-do guides when developing the
presentations. Merchandising policies must be developed with care so they
are companioned with the fashion image, resulting in purchased merchandise
that supports the targeted fashion image. All links in the supply chain must

consider several factors when establishing merchandising policies and the specific procedures needed to implement these policies. The raw materials producer and the apparel manufacturer must select appropriate vendors from which to purchase materials to create the product and also determine which customers should carry the products and through which channels of distribution and retail type the product will be sold. Everything selected within the channel of distribution must be chosen to support the defined fashion image. Additionally with the merchandising policies and procedures, purchasing and other buying procedures must be delineated and those trading partners or links in the supply chain involved must agree on distribution and return policies. All companies must establish their markup goals, markdown policies, pricing procedures, and promotional endeavors, including both push and pull marketing techniques.

Maintaining a constant and consistent fashion image with a clear and directive fashion merchandising policy is a must for consumer-centric firms to do business in today's complicated business environment. With global sourcing and new technological methods of purchasing supplies and buying product, a company must position itself through a carefully selected fashion image and maintain its position on the Buying-Selling Curve to meet the expectations of the target consumer and to compete against its strongest competitors.

Develop a Sales Environment

The sales environment for the fiber and fabric producers and apparel manufacturers varies from showrooms at corporate offices to spare conference rooms at production facilities to booths at exhibit halls and multiple spaces at various other locations, including hotel rooms and the company car. In other words, sales representatives for these companies meet with their customers at many and diverse locations. For some transactions, the sales environment consists only of two telephones or an Internet connection, where the trading partners negotiate product and sales without a face-to-face interchange. These vastly different environments are expected and often ignored with business-to-business transactions. However, some companies, especially those where the company and the brand are intertwined, spend extra care in the development of the external and internal environments of the company. For example, the Nike campus in Beaverton, Oregon, is famous for its beautiful landscaping, spa-like facilities, and dramatic architecture. Even the address of the building in which the showroom is housed can be a consideration. Certain addresses in New York City are considered the designer buildings, whereas other manufacturers settle for showrooms with less prestigious addresses (see Figures 16.6a and 16.6b). For example, showrooms and offices for Donna Karan and Bill Blass are located at 550 Seventh Avenue. Donna Karan leases four floors of this prestigious address. A few blocks away, better sportswear and some bridge lines are located at 1411 Broadway. Housed in this building on Broadway are the showrooms for Caribbean Joe, one of the brands for Apparel Holdings Group; Jones of New York; and Rocawear, the brand for the ROC Apparel Group founded by the Hip-Hop artist Jay-Z. With New York City markets, a merchandiser can not tell

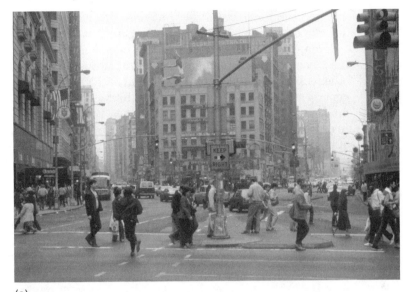

(a)

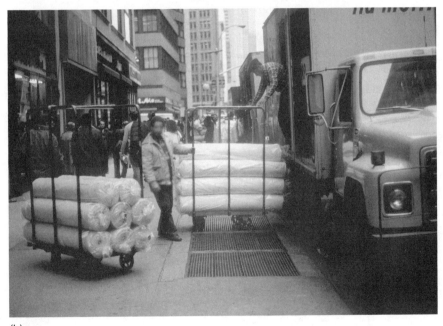

(b)

Figure 16.6
Looking up Broadway (a) toward the garment district and (b) fabric push carts on Broadway.

by the exterior of a building what prestige brand, luxury styles, or exciting new designs may be exhibited in a showroom just a few floors up from the street.

Even when the sales environment begins as a warehouse or bare showroom, the presentation of merchandise within the basic environment of showrooms and other exhibit space is carefully planned in the fourth step of this process, and any generic showroom, warehouse, or exhibit hall can be magically transformed with much work and the appropriate budget by the marketing team (see Figure 16.7). In contrast to the factory or warehouse-type conditions for the sales environment of many producers or manufacturers, the most upscale retailers must carefully create a stimulating, pleasant, and motivating sales environment for the final consumer because of the consumer's expectations about the shopping environment. However, some mass merchants, Big Box retailers, and other discounters

Figure 16.7
Exterior of a showroom at MAGIC.
(Photographer: Laura Sampson)

use spartan surroundings effectively to promote their everyday low-price image. Specific details on developing the retail sales environment are discussed in the next sections on unique presentation methods for retailers.

Plan a Merchandise Presentation

The fourth step in establishing an image or planning the actual presentation of the merchandise is used not only by the retailer to increase sales and relate the company image to the current lifestyle of the consumer but also by raw materials producers and product companies when planning, creating, and implementing trade show setups, showroom presentations, and/or shop concepts for the retail client. Also, chain stores, with multiple rooftops or doors that have locations in a variety of geographic areas, usually maintain a staff of visual merchandisers in the corporate office, to develop plan-o-grams with organized merchandise presentations and thus maintain a constant and consistent image in all stores. The **plan-o-gram** is a sketch or layout of the store, sales floor, or exhibition space drawn to scale with furnishings, fixtures, merchandise, and displays placed in specified locations within the store, department, or shop. Specifics on preparing a merchandise presentation, applicable to many companies, are given in the next section on retail store presentation.

Retail Environment and Retail Image

Retail firms, whether represented through brick-and-mortar stores, catalogs, Internet sites, or multiple retail types, are very concerned with image because of the impact of store image and presentations on sales to the final consumer. The choices of the retailer also become a consideration for manufacturers as they choose their retail customers within their channels of distribution. Retailers must manipulate image components or cues to create and build the fashion image and the store environment, catalog pages, or Web pages that are the vehicle for that image. A retailer follows the four steps in presentation development as noted for all FTAR companies with specific interest in focusing on the final target consumer and added importance on the retail environment and the merchandise presentation. For the retailer, some of the **retail image** components are similar to those of the raw materials producer or apparel manufacturer; others are unique or more significant to this particular channel of distribution. For example, a brick-and-mortar retailer depends on consumers visiting the store and may have the opportunity to select the type of building materials, the architectural style, or the color scheme for the store building that initiates and projects a unique store image. Many customers of raw materials producers or apparel manufacturers never visit plant sites or see the corporate headquarters. In addition, catalog and Internet retailers face additional unique

challenges when selecting cues to build their image because these businesses have limited use of specific cues due to the nature of their retail type. For example, catalog retailers have only stationary pictures to use when displaying the product, in contrast to brick-and-mortar retailers who encourage consumers to handle and view products from all angles.

The three most important factors in the success of a brick-and-mortar retailer are said to be location, location, location. However, location is only one element in developing a retail image and a store environment that is inviting to the target consumer. Oftentimes the **physical location** of the store is the most important element in attracting and maintaining the desired target consumer (see Figures 16.8a, 16.8b, 16.8c, and 16.8d). The geographic locality, the

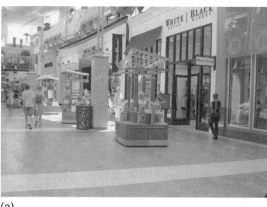

(a)

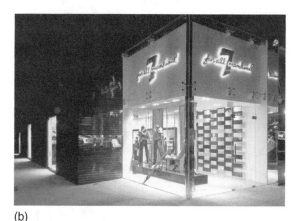

(b)

(c)

(d)

Figure 16.8
A retailer can choose among many locations: (a) power center, (b) exclusive shopping district for the Hollywood stars, Robertson Boulevard, Los Angeles, California, (c) lifestyle center, and (d) strip center.
(Courtesy of 7 for All Mankind (b))

ease of access for traveling to and from the store, and the exterior environment are critical to developing the store image. The quantity and access to major arteries leading into the retail area, the safety of the traffic patterns of roads, the quantity of both vehicular and pedestrian traffic, the specific site availability, parking facilities, the tenant mix, and surrounding environment should be considered when developing a store image. Catalog retailers contemplate similar cues as they develop the catalog pages and consider how a consumer will flip through page by page or peruse a catalog. And Internet retailers, when creating Web pages, must determine the most effective method or technique to assist consumers in negotiating the Web page as well as the links on the page.

For brick-and-mortar retailers, adequate parking spaces with sufficient lighting and a neat, clean, beautifully landscaped environment attract consumers. Additionally, the **tenant mix,** or the number and types of stores within the shopping center, are of utmost importance to building a loyal customer following (see Figures 16.9a, 16.9b, and 16.9c). Other stores that offer compatible products or augment consumer selection within a close distance assist a retailer in developing repeat or loyal customers as well as new customers.

The first component that the consumer observes when searching for a retail store is the retailer's signage. This signage is usually on a marquee and also on the storefront. A retailer located within a mall may depend on the mall's signage for this cue. The **signage** should automatically identify the personality of the store and provide information about products, services, and interior store environment. Signage sets the mood and is the first image indicator to assist in establishing an image for the retailer. The lettering of the signage is most important. The letter type, style, color, and materials from which the sign is made are all significant elements that help tell a story.

The size and scale of the sign in relation to the front of the store and the exterior of the building and/or marquee must be aesthetically pleasing and appropriate for both the shopping center and the retailer. The lighting of the sign is also critical. A partially lit sign, a sign that is difficult to see or read at night, or an unlit sign calls out to the customers just as quickly, although negatively, as the beautifully designed sign that positively supports the retailer's image. Images should be positive and positively supported; however, negative images and negative impact on a positive image do occur. Remember, the sign is the retailer's first introduction to the customer and the retailer's signature to that particular geographic area (see Figure 16.10).

Any additional outside signage, whether developed by the retailer or superfluous to the location, also reflects on the image of a retailer. Banners and awnings should relate the exterior to the interior of the store and should be compatible in size, scale, type, and color of the store materials and/or the storewide promotional event the retailer is staging. In addition, the logo, graphics, and colors on banners and awnings should denote and support positively the personality and the image of the retailer. **Awnings** should be both functional and decorative (see Figures 16.11a and 16.11b). Adding color and eye appeal to the storefront, awnings are used by the retailer to introduce a storewide

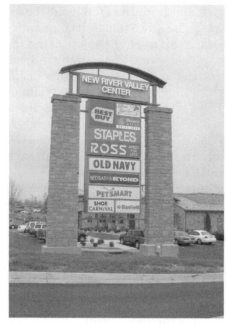

(a)

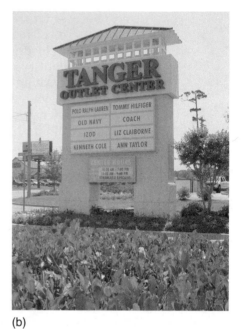

(b)

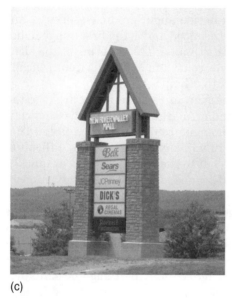

(c)

Figure 16.9 Tenant mix of the location for a retail business as shown by mall signs: (a) big box center, (b) outlet center, and (c) regional mall.

event, institutional theme, and/or new product classification. In the 1980s at the height of the popularity of designer fragrances, the gold stripe awnings became an international symbol of Giorgio of California and exciting fragrances. More recently the pastel striped awnings of Lilly Pulitzer have become easily

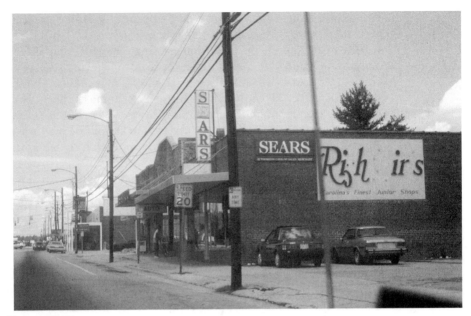

Figure 16.10
Signs can be your signature to the consumer.

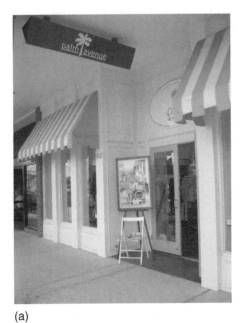

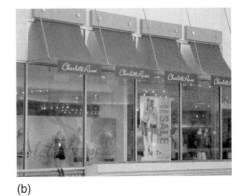

(a) (b)

Figure 16.11
Awnings support the store image (a) and (b).

recognized images for the upscale specialty retailer, particularly along the streets of some of the newest lifestyle centers in the United States.

Banners should be attention getting, colorful, and informative. Because they are usually an inexpensive form of marketing, the retailer can change them often and coordinate them with the color scheme of the special store event being staged at the time or with the color scheme of the store decor. The length of time a specific banner graces the storefront as well as the interval of time it remains hanging during the selling season should be monitored by the retailer. Repeat customers become bored quickly and wish to see new, exciting visuals when visiting their favorite retailer.

Another element for the retailer to consider when developing a store environment that is exciting and attractive to the target consumer is the **store exterior** and the store entrance. Not only the building materials as to type (e.g., brick, stucco, or wood) and colors, but also the condition of the exterior materials "paint a picture" about the retailer and help set an image cue. Retailers and other companies naturally desire a positively reinforced image. Cracking, peeling or fading paint, or stained and soiled storefronts speak loudly and negatively to the consumer. However, at times the retailer cannot completely control this cue. In many shopping complexes the property owners maintain or fail to maintain certain building requirements and exteriors, and/or regional or local governments regulate certain aspects of the building codes. Additionally, corporate-dictated store-planning trends affect building material selection, color schemes used, and architectural designs rendered.

The **store entrance** should tie the store to the community or the shopping center, set the mood and atmosphere for the merchandise presentation, and make the consumer feel welcome and encourage shopping (see Figure 16.12). Starting with the store entrance, the store interior should be established and the ambience of the store should immediately become evident as the customer enters the store. The store theme and color scheme should be selected to emulate the consumer's home environment or their fantasy environment. This establishes a connection between the customer, the retailer, and the product offering.

The entrance should appeal to four of the five senses. The overall general lighting should be well planned to draw the customer's attention to the details of the merchandise; other lighting techniques should be attention getting or dramatic to highlight displays and other visual presentations. Also, the types and loudness of the music should assist in setting and maintaining the mood for the store and reinforce store image plus accentuate merchandise assortments and price ranges available at the retail establishment. Additionally, the retailer should pay close attention to the aroma or air quality in the store because research studies indicate that specific fragrances, even subliminally positioned, impact not only the amount of merchandise purchased by the customer but also influence the price the customer will pay for the product (Hirsch, 1993)! And, texture, or "the hand," of the store decor components, such as the wallpaper, carpet, or building materials; plus the types of materials used in the

Figure 16.12
A dramatic store image.

fixturing and furnishings; and the merchandise itself is most important in grabbing and maintaining the attention of the customer. In summary, at the entrance of the store, the store and fashion images should be established and an environment should be staged for the merchandise presentation.

Merchandise Presentation Using the 3 × 3 Method

The management of the merchandising component in the showroom, store, or department is of utmost importance to the merchandiser, both the retail merchandiser and the merchandiser for the product or raw materials manufacturer. This activity can control the merchandise flow, the sales volume for the retailer, as well as for the product or raw materials manufacturer. Everyone in the FTAR Supply Chain (i.e., raw materials producer, apparel manufacturer, and retailer) depends on the successful sale of products at retail to the consumer. **Merchandising the selling space** consists of managing the floor space, the Web site, or the catalog pages. **In-store merchandising,** or **store merchandising** takes into consideration the **departmental anatomy,** or **layout of the department,** including boundaries and arrangement of fixtures in relation to floor and wall space to create an environment for optimum selling of all merchandise classifications. Store merchandising also includes the merchandise presentation and display techniques or visual

merchandising. Similar consideration is given for the layout of a page for a catalog or a Web site.

Even discount stores and price-competitive producers and manufacturers, which have the smallest profit margins and reach for the lowest overheads, no longer have the option of ignoring the visual presentation of merchandise in their stores (Bhatnagar, 2004; "Walmart to De-Clutter," 2006). Target is an excellent example of a discounter that implements presentation techniques to foster sales volume and to communicate with the customer. Every three to four years Target management, based on sales volume and profit margins, rethinks and reworks store design to enlarge floor space devoted to one product category while shrinking the space for another product classification (see Figure 16.13). The corporation has experimented with department placement and has now moved the Electronics Department near the Menswear Department to make it more convenient for the male customer to shop in the stores ("Target: About Target," 2006).

Additionally, the company has found it productive to create artful displays for "mass-couture" in a discount environment. Even Walmart has built a lab store in Plano, Texas, to test new concepts in merchandising and customer service to assist in creating a new image that ties low-cost items to the newly created "fashion apparel" now offered in its stores ("Walmart Opens," 2006). When selecting any product classification, regardless of fashion level, quality, or price

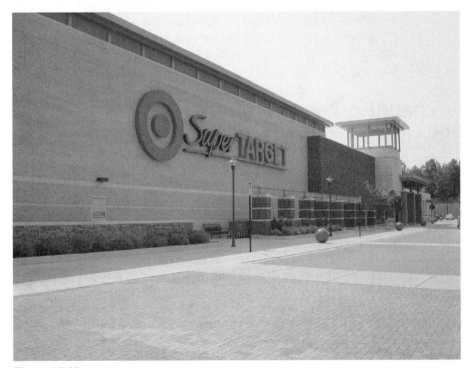

Figure 16.13
A new format for this retailer.

range, the consumer now has so many options and choices that all retail channels of distribution are forced to create a consumer-friendly store layout and merchandise presentation.

The presentation space can be a brick-and-mortar store, a department within a store, a shop concept (i.e., a small semienclosed space, resembling a miniature department within the department or the store), or an exhibit booth or showroom space for trade presentations. The shop concept is also called a **concept shop** and can be a **store-within-a-store.** A major technique of any presentation space is the **3 × 3 Merchandise Presentation.** The **3 × 3 visual presentation strategy** is based on three levels of the line of sight (aisle, floor, and wall) of the consumer. Each level should contain information, merchandise, and display for achieving the highest sales per square feet while creating an ambience conducive to stimulate customer interest. The 3 × 3 Merchandise Presentation segments the store into the sections of aisle (windows-on-the-aisle), core (bread and butter), and top wall (vista wall) (see Figure 16.14). Almost all sellers accumulate more sales per square feet in the front third of the selling space; therefore, it is imperative that sellers plan their merchandise placement and presentation to attract the customer's attention.

This presentation format is used by both apparel companies and raw materials producers when building trade show exhibits, showroom presentations, and retail shop concepts (i.e., a simulated store space within a manufacturer's showroom). This presentation technique takes into consideration the perimeters of the space (e.g., store, department, shop layout, or exhibit booth), including the floors, walls, and ceilings as well as the fixturing and furnishings in the areas plus the merchandise classifications and displays. It is based on the concept that a logical arrangement and presentation of the merchandise mix unconsciously directs and draws the customer from the front to the back of the space while encouraging the

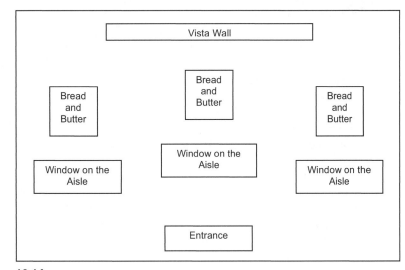

Figure 16.14
Components of the 3 × 3 Merchandise Presentation.

customer to stop, look, touch, or try on the product. When this concept is implemented, all merchandise is seen by the customer, who can view the latest fashion trends presented as a "total look" (e.g., accessorized coordinated ensembles). This method of merchandising facilitates the ease of selection on the customer's behalf and encourages impulse or add-on sales for the seller (e.g., retailer).

Implementation of the 3 × 3 presentation begins with determining the type of floor plan layout for the presentation space. The three traditional types of floor plan layouts are maze, grid, and spoke (circular) layouts. In the **maze,** or **free-flowing floor plan** arrangement, fixtures are placed without a set pattern or set of aisles. The customer's path is determined by the placement of fixtures or a planned arrangement of fixtures, furniture, merchandise, and displays that logically leads or gently leads the customer through the space. For an aesthetically pleasing arrangement, all fixtures should still be set in the same direction or at the same angle when creating a maze layout. Although the plan appears to be without a set pattern, it is not random or disorganized. This type of layout is the most interesting and most exciting way to plan the merchandise organization; however, careful planning is needed so the schematic does not confuse the customer or cause any inconvenience.

With the **grid method,** all fixtures are placed in a grid-like pattern or in a series of uniformly spaced sections in relation to the floor space. This placement creates clear-cut aisles for the customer to follow. As with the maze method, all fixtures should be positioned at the same angle in the space, and separate displays should be located next to or near the merchandise categories being featured. The **spoke method** resembles a wheel with sections of the space arranged around the hub of the wheel. Thus the aisles to the major areas within the space are in a circular pattern, and aisles within each area are set by specific fixture arrangements.

Regardless of which of the three layouts are used in the 3 × 3 presentation, the presentation space is segmented into three areas: windows-on-the-aisle, core, and top wall. Every layout has **aisles,** or traffic paths for customers between groupings of merchandise. The **windows-on-the-aisle,** or the visual front space of each department, is the number-one area for presenting merchandise. For the front of the store, this space can be a window that faces into the mall or street. For the remaining areas in the store, this is the foremost space of the area adjoining the aisle. It is the prime selling space in the department. From observation, many retailers believe that the first one/third portion or space of the department may contribute as much as 50% of the sales volume for that particular department. Thus aisle areas should provide a strong merchandise statement that immediately attracts the consumer. Because color is the single most important concept of merchandise presentation, the color scheme for the entire department should be established on the windows-on-the-aisle and should then be carried throughout the department. In the aisle area, especially the windows-on-the-aisles, the merchandise should consist of the latest arrivals, seasonal merchandise with impact, fashion or trend merchandise that creates interest, or a representation of merchandise classifications carried within the department or by the company.

To create the departmental sight line, fixtures on the windows-on-the-aisle should be low in height and face outward toward the aisle. This placement corresponds with the view or line of sight that the customer will have of the space when walking down an aisle. The **departmental sight line** is the path of sight or direction that the customer's eyes follow when scanning the merchandise mix and presentation in the store, department, or shop concept (see Figure 16.15). A strategically planned creation of this line should be the inducement that gently motivates the customer to look at all merchandise on the aisle, core, and vista wall in the store, department, or shop concept. In presentation spaces, visual merchandisers place T-stands and two-way fixtures so the "total look" can be presented on each arm. Some retailers and other companies use signature tables and four-way fixtures on the aisle. Signature tables are used for folded products and display presentations that create multiple sales and entice the customer to enter the core area. Regardless of the type fixture, merchandise should be limited on the fixture so there is one hanger per hook on T-stands and a total look presented on all fixtures. Crowded fixtures discourage shopping and handling by customers, which negatively impacts image and ultimately reduces purchases.

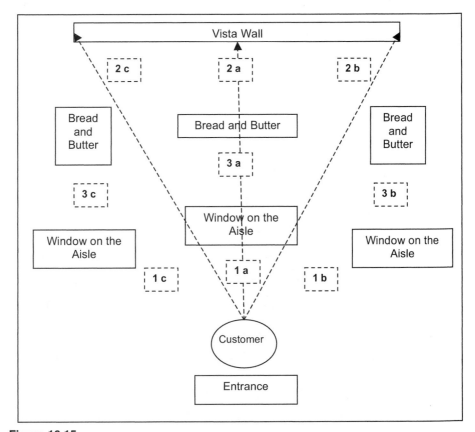

Figure 16.15
The 3 × 3 Merchandise Presentation with sight line.

Merchandise is arranged by color, product classification, and fabric plus silhouette. Products in the display are colorized from light to dark of a color range and from neutral to warm to cool colors to use the natural rhythm and harmony of the colors to improve departmental sight for the customer.

All techniques in a marketing presentation are done to encourage the customer to look longer, shop longer, and buy more. After arranging each product classification by color, each style within each color is sized from left to right and from small to large. Also, products made from different types of fabrications are separated and then colorized and sized. In retail stores, especially those that have self-service features, displays should be located adjacent to the merchandise being presented for easy selection by the consumer and sufficient backup merchandise should be on the floor or in backroom inventory for all items on display. In summary, merchandisers should present only one strong fashion statement, major trend, or color story on the aisle, and they should dramatize the aisle to make the shopper enter the presentation space and travel throughout the area.

The second most important area for achieving major sales per square foot in the presentation space is the **top wall,** or **vista walls,** which are the side and back walls that can be seen above the presentations of the merchandise on the aisles and in the core (see Figure 16.16). In this area, color is again the number-one design element for merchandise presentation followed by line, proportion, and balance. Avoid off-centered arrangements in this section. A focal point or dominant area in any large expansive section of the top wall is important for visual balance and harmony. The focal point usually contains a display that

Figure 16.16
Vista walls are important for display space and merchandise presentation.
(Courtesy of 7 for All Mankind)

should always feature exciting and interesting merchandise. In addition, the large wall expanses along the top wall should be broken with intermixed water-falls and straight hanging bars varied in height. These expanses of wall should be merchandised with a major classification in each section of the wall in correspondence to the merchandise in the space below the top wall.

The **core of the presentation space** or center space in a store, a department, or a concept shop is the area for presenting volume merchandise such as large coordinate groups, promotional merchandise, reduced or off-price merchandise, or related separates and basics that are offered in a narrow and deep assortment mix. **Fixturing** becomes important for all companies making presentations (see Figure 16.17). For volume merchandise, merchandisers should use the following fixtures: four-way fixtures, signature tables, large fixtures, and

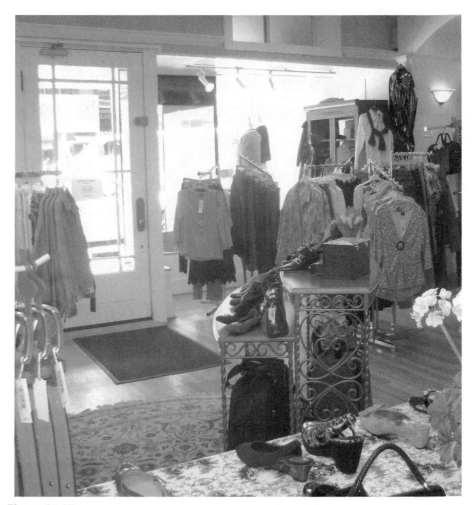

Figure 16.17
A variety of fixturing for merchandise presentation.
(Courtesy of Meg's)

rounders. Fixtures in this area should vary in height and types and be selected for the greatest stock capacity. Merchandise should be color coordinated on fixtures, then sized. Additionally, there should be coordinated ensembles and displays in the area with appropriate signage. The entire area should be neatly and attractively organized.

In addition to merchandising each of the 3 × 3 segments of a presentation space, the visual merchandiser must also pay close attention to the artistic displays, light and lighting, and graphics and signage used within the space. Lighting should highlight important details of the merchandise presentation and may serve as an attention-getting device for a display or fixture. Effective signage helps support the image and communicates with the customer to stimulate a desire to buy. Signage can help establish the theme of the display, accentuate the color scheme of the merchandise presentation, or set the stage for the area's merchandise presentation. Identification signs (e.g., departmental signage) direct the traffic flow of the presentation space as well as give cohesiveness to appearance of the space. Good signage helps a company compete effectively by increasing sales and boosting profits at a minimum expense.

Coordinating the Marketing Tools of Promotions, Publicity, and Packaging

Three marketing tools that must be coordinated closely with the marketing tool of presentation are those of promotion, publicity, and packaging. Maximum value can be obtained from each marketing tool if they are well integrated and used together as a team. Items, which are most prominent in an advertisement, should also be featured in a window and/or interior display; and, for greater emphasis, special events are planned to coordinate with advertising and display themes. All special events should be reinforced by timely advertisements plus window/interior displays and appropriate merchandise presentation techniques. Coordination of these components is important for all companies within the FTAR Complex and is not an exclusive concern for retailers.

Promotions

A **special event** or **sales promotion** is any activity, other than advertising and publicity, that entices or persuades the customer to purchase; that informs or educates the customer about the company, its products, or trends related to those products; or that assists the producer, manufacturer, or retailer in communicating with the trading partner or final consumer to build image and create good community relationships. These events or promotions can include fashion shows, contests and sweepstakes, coupons, prizes, samples, demonstrations, gift with purchase (GWP), purchase with purchase (PWP), and frequent shopper programs, and they are usually grouped into the following three category types: merchandise events, institutional events, and sales or price promotional events.

Many times to increase sales, companies stage **special merchandise promotions** or **special merchandise events** with the objectives of building additional customer traffic, targeting new consumers, or introducing new products, brands, and trends. These events produce excitement and create the "retailtainment" environment in the retail store or a similar excitement among the wholesale companies in this FTAR Complex. One of the most traditional of these merchandise events is that of the fashion show; however, most companies have found that this type of event is very costly and time consuming. These shows must be well planned with specific consumers targeted and measurable objectives delineated to be a successful event. Companies also use trunk shows, merchandise seminars, and product demonstrations as well as museum-like exhibits, videos, and displays to entertain, educate, and communicate with the customer. Accessorizing a display can increase sales of other items, including belts, shoes, and jewelry (see Figure 16.18).

For example, *Dress with Style* or *How to Tie a Scarf* seminars might attract the fashion-forward consumer who is eager to learn about the latest fashion trends and how to wear those trends. The video on tying a scarf could be shown by a retailer for its target consumer or shown by a fiber manufacturer to convince a retailer that the target consumer will use the product made by the promoted fiber contained in the scarf. Sometimes the manufacturer creates a product demonstration or merchandise clinic for its top-volume retail store clients. Usually the retailer is required to purchase specific amounts of product for stock or meet a minimum quantity purchase requirement for the season to participate in the events. One of the most successful types of special merchandise events is that of the theme promotion. In the United States, both Bloomingdale's and Neiman-Marcus were recognized for their earlier promotions featuring themes of other countries. Through the large-scale special events associated with these promotions, these American retailers were very successful in building store image and positioning themselves as fashion leaders in their channel of distribution.

Another type of special event is that of the **institutional event,** or an event sponsored by the company as a public service. Usually these events are for a charitable cause or for a happening in the community, and these promotions usually do not feature the company's products. These events build goodwill or tie the company to the community. The producer, manufacturer, or retailer may sponsor an athletic team or a celebrity appearance, or pay for a guest lecturer or consultant for a special community event. Some of the more popular institutional-type events sponsored by companies include art exhibits, flower and auto shows, or radio programs that are of special interest to the company's target consumers. Probably one of the best known institutional events, recognized by most U.S. and many other consumers, is that of the Macy's Thanksgiving Day Parade held each year in New York City. It is such a spectacular event with entertainment celebrities performing, colorful floats gliding down Seventh Avenue, and high-flying air-filled inflatable figures filling the sky that some people kick off their holiday season by attending the event as a family affair.

When hearing the terminology "sales promotion" or special event, most customers immediately think of the **sales event** or **price promotion event** that

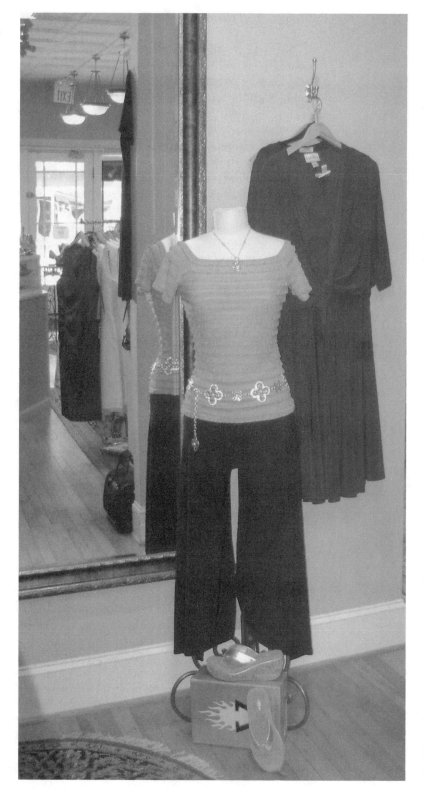

Figure 16.18 Accessorizing a display for creating multiple sales.
(Courtesy of Meg's)

features the company's merchandise at a reduced or marked-down price. Many of these events are tied to anniversary sales, founder's day sales, or seasonal sales, such as spring or autumn sales events. Usually merchandise is bought specifically to be sold at a reduced price for these events; however, the event may be held to remove aging merchandise from the company's inventory. The markup may or may not be the markup the company usually achieves; however, the firm hopes to sell more regular-price merchandise to compensate for the lesser markup and to release cash tied in inventory for future merchandise purchases. Many times the company creates a contest, drawing, or game to coincide with or initiate these events; or the company may send select customers special coupons to initiate the promotion. In addition, the company may develop a frequent purchase program to build consumer loyalty and continued patronage.

Promotional Vehicles

The company may also have merchandise or **promotional vehicles** that are bundled or priced together to promote purchasing. **Gifts with a purchase (GWP)** and **purchase with a purchase (PWP)** are two techniques used to entice customers to buy and to move merchandise (see Figure 16.19). Many times the gift or the companion purchase items are special purchase merchandise with lower margins or merchandise that is not currently selling quickly for the company. Manufacturers, as well as retailers, can use this technique for moving overstocked items or new lines of merchandise to tempt the customer (e.g., retail buyer) into taking the less desirable merchandise or to get the buyer to test the waters with new lines of merchandise.

Regardless of the type of promotion, the timing of the sales promotion is extremely important to the success of the event and to the coordination of this marketing component with other marketing tools. Promotions, except end-of-season sales, should occur in advance of the peak selling period. The company must consider the traditional buying patterns of its customers, whether trading partners or final consumers, when planning these events and must make sure the merchandise is wanted or needed by the target customer. Today bigger and better special events are more important than ever because companies are competing constantly for the same customers and the same final consumer. Today's firms must create an exciting environment for the customer, develop fun-filled instructional events, and reach out to the community to compete and position itself in this marketplace with more than enough companies, stores, products, and places to shop!

Promotions Including Advertising

To be successful, special event coordinators must alert the target customer of the timing and location of the special event or promotion. The **media mix** (e.g., newspapers, magazines, circulars/flyers, catalogs, radio, television, billboards,

Figure 16.19
Purchase with purchase is a type of retail promotion.

and Web page) must be selected with care to fit the company, the product, and the consumer. The usual technique used by the Marketing Division of a company is to communicate with customers through advertising (see Figure 16.20). **Advertising** is directly controlled by the creator (i.e., producer, manufacturer, or retailer), contains a controlled message written by the creator, is presented and positioned in the media selected by the creator, appears at a prearranged date specified by the creator, and is paid for by the creator. Additionally, the advertiser's "signature" is contained within the ad. The **signature** may be the logo, a musical jingle associated with the company, or the company name itself.

Figure 16.20
Print advertisement.
(Courtesy of Carhartt Inc.)

Vehicles for advertising includes print media (e.g., newspapers, magazines, flyers, brochures, inserts, postcards, posters, billboards, transportation), electronic media (e.g., radio, television, Internet), and product (e.g., coffee mugs, key rings, mouse pads, calendars, pens, pencils).

For many decades, retailers considered the newspaper as the major vehicle for advertising to the target consumer, and the producer or manufacturer used trade journals or market brochures to reach its clientele. Today, however, that scene has changed dramatically. With a better educated, more sophisticated, highly traveled consumer, companies have found it is imperative to match the advertising medium to the target customer, the product classification, and the channel of distribution. In other words, a company should consider where its customers look for information, how its customers use the information to impact the purchasing process, and who influences the purchases of these customers.

Large conglomerate companies manufacturing and distributing a diversity of products have recently examined their advertising channels and adjusted the advertising to consumers' ideal information sources. This adjustment is particularly true for companies that are reaching directly to the consumer. For example, in 2006, Procter & Gamble announced in the national media that it had diverted a substantial portion of its advertising dollars from television commercials to more unconventional methods of advertising, such as the Internet. Baby Boomers may read newspapers and watch television commercials or listen to radio; however, their children, the Echo Boomers, better known as

Generation Y, do not respond to that medium (American Sports Data, Inc., 2004; OnPoint Marketing & Promotions, 2004). Generation Y wants the medium to come to them, to their locations or activities at their desired time slot; therefore, the Internet, sporting events, and special promotional events that provide entertainment are techniques to reach this generation. Otherwise, the advertising message is never received, and the advertising monies are spent without desired results on behalf of the advertiser.

Product placement, buzz marketing, and code switching are representative examples of new techniques for advertising. **Product placement** is positioning products as an integral part of a television show, a movie, or a video. "Plot [product] placements mean a brand gets worked into a script" (Sarkisian-Miller, 2004, p. 7). The success of the product placement depends on matching the brand or product with the cast of the show as well as the show itself. For example, at a price of $20 million to $30 million per season, Coca-Cola placed its can of cola on the judges' table during the airing of Fox's *American Idol*. The design house of Halston staged a fashion show during the broadcast of the popular television show *Desperate Housewives,* and the highly recognized brand name Nike has appeared numerous times on prime-time television shows (Sarkisian-Miller, 2004).

Buzz marketing is advertising on message boards, Internet blogs, or public accessible sites, even literally taking the message to the streets. Street promotions may include celebrities promoting product or an interactive promotion with customers actually testing or using the product. And code switching is one of the most innovative techniques to reach all segments of an immigrant population. **Code switching** is a technique of incorporating two languages, such as English and Spanish, in one commercial to attract the attention of the bilingual consumer. In 2006, during a Super Bowl advertisement, a well-known car company introduced a television commercial that incorporated both Spanish and English in the same commercial. It was created to appeal to several generations of the Latino marketplace (Sanchez, 2006).

Even with the use of recent creative and innovative types of medium, retailers, manufacturers, and producers still find that the traditional print and electronic media are necessary to promote their product or brand. Many retailers still rely on newspaper ads to showcase their products, and producers and manufacturers continue to use trade newspapers. The newspaper is a *fast read* that usually elicits *fast results*. The advertiser can zero in on the target customer with local coverage in a select trading area, can buy any size of advertisement, can place the ad in a specific section of the paper, and can run the ad on a specific date, even at a specified time. When using newspapers, the retailer may place an insert of lifestyle products into the newspaper on a specified day. Additionally, daily newspapers allow the company a short lead time for production of the advertisement when immediacy is important. As a negative side to newspapers, they give a short life to the advertisement and the target customer may never see the ad if the paper is discarded before the right customer scans the ad section of the paper. Also, with so many advertisements in most papers today, the clutter may distract the reader.

The high costs of advertising in magazines, either consumer or trade oriented, prohibit many companies from using this type of medium in their media mix. Although the magazine ad can be targeted to a specific customer in a particular locale, many businesses do not consider this medium as a wise return on their advertising investment dollars. Magazine ads may be financially feasible when a manufacturer or producer partners with its major retail clients to place an ad in a popular consumer magazine that will reach the majority of the desired target market. The manufacturer or producer usually produces the ad and then permits the retailer to "tag on" to the ad with the retail store name and location. These ads are usually cooperative ads paid for by all companies included in the advertisement.

Other **print ads** include direct mail such as postcards, flyers, catalogs, and brochures; billboards; and **transportation advertisements** on buses, taxicabs, trucks, or other modes of transportation (see Figure 16.21). With direct mail, the raw materials producer, product manufacturer, or retailer can select a specific audience, can assure the quality of the ad, and can control the length of the advertising materials. The negative side to direct mail includes the high costs of production and postage, the long lead time in producing this marketing tool, and the possibility that the recipient (i.e., the customer) will toss the mail without reading the message.

Because of today's highly mobile society, billboards have become a very popular advertising medium for many companies. Although it is very costly to produce or create the billboard, if the board is situated in a highly traveled area

Figure 16.21
Transportation advertisement.

and the customer passes the board frequently, the cost of the billboard may be worth the investment. A well-lit board, with colorful graphics and concise wording, not only reaches a loyal customer but also attracts a new customer.

And, even though viewers are *spacing out* television commercials and listeners are ignoring radio commercials, these two types of medium are still viable for some customers. With both of these media, there is usually a very large geographic coverage but the audience is usually selected via the programming choices, so that with some research a customer can be accurately targeted. Also, there is great flexibility with the airing of the commercials: The time of day and the day of the week may be designated by the advertiser. With television there are high production costs. In addition, the best air times for showing the ad are very costly and usually reserved for large well-known companies with big advertising budgets. The type of product and the retailer's channel of distribution must be considered when considering television advertising. On the positive side for this media, a television ad incorporates sight, sound, motion, and color that give an explicit description of the product and can establish the image and fashion direction of the company.

Radio, a prime summer medium, is a flexible advertising tool that allows both high frequency and demographic selectivity (e.g., age, sex, income, interests). The only major drawbacks with this medium are that the product cannot be seen, and the length of the message is usually very short—either a 30-second or 60-second commercial. The Internet is a valuable electronic source for advertising for all segments of the marketplace, especially Generations X and Y, and it does add the ability to see and sometimes manipulate the product. Some companies are adding interactive features to their ads on the Internet. For example, some Web sites allow the customer to enter personal or company characteristics into a profile for a personalized presentation. Also, companies provide coupons and e-mail notices to preferred customers who register with their sites.

Advertising is an integral part of the marketing communications and promotional mix. Matching the advertising media to the target customer, the product classification, and the channel of distribution is a necessity for doing business in today's highly competitive marketplace. Advertising monies well spent equate to a larger market share for the retailer, a greater sales volume for the producer, manufacturer, and retailer, and more profit for all links of the FTAR Supply Chain.

Publicity

Publicity is one of the most complex elements that the raw materials producers, the product company, or the retailer must address when creating a marketing mix to promote both the company and product image. **Publicity** is a nonpaid, unsigned promotional vehicle or message, both oral and written, that is uncontrolled by the producer, apparel company, or retailer. Publicity may be found in a newspaper article or magazine feature, seen on a billboard, heard on a television or radio program or news broadcast, or even distributed by word of mouth.

Figure 16.22
Coordination of signage, packaging, and logo for publicity.

Publicity is usually a result of a happening within the company or an outside event that the company has created, supported, or sponsored that becomes newsworthy. Companies may tie in signage, packaging, and logos to maximize the benefits from the publicity event (see Figure 16.22). It is then reported at the discretion of the media initiator (e.g., magazine or newspaper editor, television or radio program director, news reporter) and becomes the sole message composed from the perception of that particular information medium.

Publicity is not an unpaid advertisement or free advertising. An advertisement, unlike publicity, is directly controlled by the creator (i.e., producer, manufacturer, or retailer), contains a controlled message written by the creator, is presented and positioned in the media selected by the creator, appears at a prearranged date specified by the creator, and is paid for by the creator. In direct contrast, publicity cannot be controlled by the company featured in the media message; therefore the type of medium, where the message appears, the manner in which the message is presented, or the timing of the message is not controlled by the raw materials producer, product manufacturer, or retailer. At times the company is unaware that the news media has obtained information about a company event. At other times, the company itself attempts to influence the media to get favorable publicity for a happening, promotion, or event. For example, fabric producers and product manufacturers frequently send sample products to major fashion magazines to encourage the art directors to use the products in a photo shoot or to endear the product to an editor so a mention of the product is included in an article.

As part of the Marketing Division, major companies maintain a **Public Relations (PR) Department** and/or **Publicity Department** to gain as much favorable publicity for the company as possible or to address and attempt to soften or eradicate unfavorable publicity about the company. Personnel in the PR Department are responsible for providing accurate descriptive information about the company and for attempting to highlight the company's best attributes and offerings with regard to the particular happening or event.

To disseminate their company's information, PR personnel create press kits that contain fact sheets about the company and its products as well as new innovations, happenings, and events within the company. Of course, they present this information in a most favorable manner to depict the company policies most appreciated and recognized as worthy attributes by the public community and especially the target consumer. Or these PR personnel may use the press kits to provide background information about a soon-to-be announced innovative company product, present biographies of individuals connected with a special event or happening, or provide speeches presented by company management. In addition, these press kits may contain written press or media releases oftentimes accompanied with photographs or sketches. Sometimes when these announcements are presented as written or prerecorded audio or video announcements about a charitable event or happening, they may become a public service announcement.

The source of the publicity is most important to the value of the publicity in the minds of the customers. The advantages and success of favorable publicity for a company can usually be measured by the customers through their view of the objectiveness and authoritativeness of the publicity source. In other words, if the medium is well respected and speaks with authority, the customers and potential customers will be more impressed with the message disseminated in the publicity and the company will benefit more from the publicity. Also, the type of sponsored event will make an impression on customers. If the sponsorship, charity, or event is valued by the customer, the company will be seen in a most favorable light. Many companies are now sponsoring breast cancer awareness campaigns, cancer research support events and products, and domestic violence prevention programs. Other companies are providing scholarships for qualified target customers and their families. Both Talbots and Walmart have been recognized for providing scholarships for target consumers and for employees or children of employees who meet specified criteria. The merchandiser must select carefully the charity or nonprofit organizations that will be in accordance with the company's image so the association will be satisfactory to the customer and of benefit to the company.

Packaging

A marketing tool that is many times taken for granted, ignored, or even forgotten is that of packaging. Calculated planning and preparation is a must for vibrant, effective packaging. **Packaging** may include the permanent wrappers, cartons, or other devices used for containing the product, usually installed by the

manufacturer, and may also include the wrappings, boxes, or bags used by retailers for sending the product home with the consumer. Packaging is one of the most important marketing tools that a company can use to build company and product image and attract the target consumer. Thousands of dollars are spent each year by companies that attempt to use packaging of their products to increase sales volume and even increase profits for the company. The packaging for a product can become a "silent seller" or an additional sales tool for the company. It can also be an educational tool to tell the consumer "how to" use or "when to" wear the product or provide other product information for the customer. It is usually expected that packaging will protect the product for shipment and presentation. In addition, many times, the placement or location for bar codes for electronic scanning or the microchips for radio frequency transmissions, if that technology is being used by the company, is found on the packaging.

Packaging can become an image builder for the company and product or can assist in positioning the brand. Hosiery companies are known for using packaging to build and position a brand within specific channels of distribution. Packing of hosiery has a long and interesting history of various types of packages. Since the 1940s, packaging for this product has included flat boxes with tissue paper, reusable plastic pouches, flip-top boxes simulating the hard cigarette box, plastic eggs, simulated small milk cartons, and stiff paper with shrink wrap (see Figures 16.23a and 16.23b).

(a) (b)

Figure 16.23
Historic packaging for hosiery (a) and (b).
(Courtesy of Glen Raven, Inc.)

There have even been lawsuits concerning the type of packaging or the wording on the packaging of competitors designing and selling the same type product classifications. In the 1980s and 1990s, the plastic egg and milk carton packaging of the *L'eggs*™ hosiery brand were sold in grocery stores and drug stores. At that time, Sara Lee sued its rival, Kayser-Roth Hosiery Corporation, because of the wording on the packaging of a Kayser-Roth product. The logo in question was *Leg Looks*™, which was placed on a product in the Kayser-Roth *No Nonsense*™ line sold in department stores. Sara Lee thought that Kayser-Roth was using the Sara Lee well-established heritage of the *L'eggs*™ brand to market its *Leg Looks*™ product and to gain market share for the company. A district court judge ruled that no company had rights to the word *leg* so the case was dismissed. With implications for other product companies, the judge ruled that it is customary for competitive companies to borrow ideas and concepts with regard to products and packaging. In another incident, to deter a lawsuit with its competitor, Jockey pulled thousands of hosiery SKUs off the shelf because of a packaging dispute with Sara Lee.

Issues of packaging that recently have concerned companies and consumers are the volume and content of packaging. Consumer and companies who are concerned about the environment worry that too much paper, cardboard, plastic, and other materials are used in packaging products and then tossed into the trash and subsequently landfills. This concern has led to a heightened awareness and the use of **green packaging,** which includes packaging that makes use of recycled or postconsumer paper as well as packaging that can be recycled or reused. Green packages also exhibit a reduction in the volume of materials used in packaging. The volume of materials is a difficult issue because many products are manufactured a great distance from the consumer and must be shipped by air or by sea container as well as trucked to reach the retailer and/or the consumer. Reducing the amount and type of packaging materials may satisfy some consumers but may enhance or reduce the fashion image of the product for other consumers. With the increased interest in fast fashion, products are arriving daily in small quantities at various retailers. Consumers who order from online and catalog retailers often have quantities of one shipped directly to their home. To prevent damage to the products, plastics, blister packs, plastic foam, and other nonbiodegradable products are used to protect the product. Retailers and manufacturers need to be aware of the importance of green packaging to their consumers. Walmart has begun to rate its vendors on their use of green packaging and is using that criteria as part of their vendor assessment ("Walmart Pushes Green," 2007). Likewise, consumers may rate brands, companies, and products on the packaging that is used and make their shopping choices accordingly.

Another segment of the industry noted for the use of packaging is the fragrance and cosmetics industries. Many times the packaging or bottle or container for the fragrance costs more than the fragrance itself! The distinctive color or shape of the package not only holds and protects the product but definitely becomes a marketing tool, carrying the image of the product through all

channels. Packaging becomes increasingly important during periods of intense advertising for these products, such as Mother's Day, Christmas, or Valentine's Day. Special edition or collectors' packages are often offered during this time, further increasing the cost and value of the product.

Logos, labels, and hangtags are oftentimes considered components of packaging by many companies and incorporated into the *total package* to deliver the company and brand image. Unique, easily identifiable packaging becomes an advertising vehicle for the brand or product (see Figure 16.24). Coordinated packaging, logos, hangtags, and POS/POP messages build brand and fashion image and assist in positioning a company's product in specific channels of distribution. One of the best examples of this coordination of packaging, logo, labeling, and hangtag that serves as advertising is that of Talbots. The unique shopping bags stuffed with attractive tissue and designed with the company logo in the signature red and black become immediate advertisements for the retailer. Every detail of the packaging, down to the small envelope that contains the customer's transaction or receipt, was strategically planned and implemented by the company as a marketing tool. Through the use of color, logo design, lettering, and materials of the packaging, the consumer automatically recognizes the classic, traditional appeal of the retailer. In fact, many consumers can identify the retailer by the red doors at the entrance of the store and on its packaging without any indication of the name of the store.

Figure 16.24
Logos and labels are considered components of packaging to support company and brand image.

Summary

To gain optimum benefits from its marketing plans, especially from the marketing tools of presentation, promotion, publicity and packaging, and to attract and retain its customers and their target consumers, a raw materials producer, an apparel firm, or a retailer should coordinate its company image and merchandise presentations with its promotional mix, publicity efforts, and packaging design, including logos, hangtags, and labels. Each of these marketing tools should reinforce the others to impact the customer's perception of the company, the brand, and the product. These marketing tools should assist the company in building a stronger customer base, in gaining additional market share, and in increasing sales volume and profits for the company. In addition to building an image that helps sell product, the merchandiser must be careful to plan these marketing tools so the results are legal, ethical, and appealing to each customer in the chosen channel of distribution and to the final target consumer.

Key Terms

Advertising
Aisles
Awnings
Banners
Buzz marketing
Code switching
Concept shop
Core of the presentation space
Departmental anatomy
Departmental sight line
Display
Fashion image
Fashion merchandising policies
Fixturing
Free-flowing floor plan
Gifts with purchase (GWP)
Green packaging
Grid method
Institutional event
In-store merchandising
Layout of the department

Maze floor plan
Media mix
Merchandise presentation
Merchandising policies
Merchandising the selling
 space
Packaging
Physical location
Plan-o-gram
Presentation
Price promotion event
Print ads
Product placement
Promotional image
Promotional mix
Promotional vehicles
Publicity
Publicity Department
Public Relations (PR)
 Department
Purchase with purchase (PWP)

Retail image
Sales event
Sales promotion
Signage
Signature
Special event
Special merchandise event
Special merchandise promotions
Spoke method
Store entrance
Store exterior
Store merchandising
Store-within-a-store
Tenant mix
3 × 3 Merchandise Presentation
3 × 3 visual presentation
 strategy
Top wall
Transportation advertisements
Vista walls
Windows-on-the-aisle

Review Questions

1. What are the purposes of the marketing communication tools: presentation, promotion, publicity, and packaging?
2. What are the marketing communications tools used by FTAR companies?
3. How do presentation tools support the company image?
4. What are the steps in preparing a presentation that highlights the company's image?
5. List the components of the store environment.

6. How does store environment relate to store image?
7. What is the 3 × 3 Merchandise Presentation?
8. What are the major activities used in promotions?

9. What is the difference between publicity and public relations?
10. How is packaging used to increase the success of a consumer-centric company?

References

American Sports Data, Inc. (2004). *A stereotype of generation "Y"*. Retrieved June 10, 2007, from http://www.americansportsdata.com/pr-generation-y.asp

Bhatnagar, P. (2004, August 27). *Best and worst places to shop*. Retrieved August 27, 2004, from http://money.cnn.com

Black, S. S. (1993, October). Rough and ready Ruff Hewn. *Bobbin, 35*(2), 19–20, 22.

Cotton Incorporated *Lifestyle Monitor*. (2001, Holiday–Fall/Winter). Through the looking glass, p. 11.

Hirsch, A. R. (1993, January). *Sensory marketing sight + sound + smell = sales!* Paper presented at the National Retail Federation Annual Convention, New York, NY.

OnPoint Marketing & Promotions. (2004). *Generation Y defined*. Retrieved June 10, 2007, from http://www.onpoint-marketing.com/generation-y.htm

Paysour, D. D. (1987, March 19). The man. the mystery. The moneymaker . . . Ruff Hewn. *News & Record*, pp. B1, 4.

Ruff Hewn: Capturing the spirit of today's lifestyle. (1991, June). Press Release, Harrington Branstetter & Associates, New York, NY.

Sanchez, M. (2006, February 16). TV ads speak new language: Spanglish. *News & Record*, pp. 10, 13.

Sarkisian-Miller, N. (2004, December). A whole new show in product placement. *Women's Wear Daily*, p. 7.

Target: About Target: Our focus on design. (2006). Retrieved June 10, 2007, from http://www.target.com

Wal-Mart to de-clutter the store, boost the Web. (2006, March 8). *Home Textiles Today Extra*. Retrieved March 8, 2006, from http://www.hometextilestoday.com

Wal-Mart opens experimental upscale store. (2006, March 23). *Home Textiles Today Extra*. Retrieved March 23, 2006, from http://www.hometextilestoday.com

Wal-Mart pushes green agenda with packaging score cards. (2007, March 19). *Retailing Today, 46*(4), 9.

Index